BOLLINGEN SERIES LXXXIX

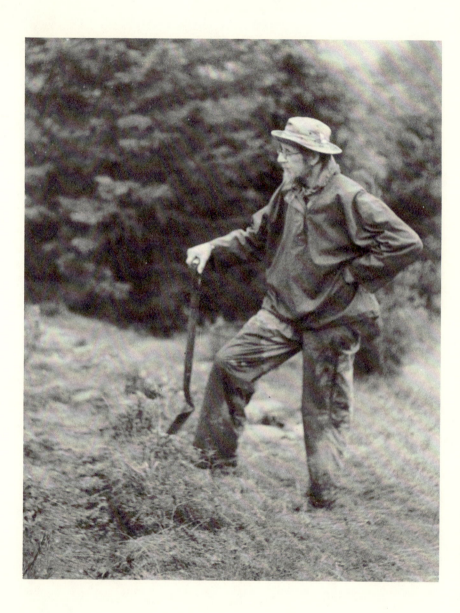

Coomaraswamy

1: SELECTED PAPERS

TRADITIONAL ART
AND SYMBOLISM

EDITED BY

Roger Lipsey

BOLLINGEN SERIES LXXXIX

PRINCETON UNIVERSITY PRESS

Copyright © 1977 by Princeton University Press

Published by Princeton University Press,
Princeton, New Jersey
In the United Kingdom: Princeton University Press,
Guildford, Surrey

ALL RIGHTS RESERVED

THIS THREE-VOLUME WORK IS THE EIGHTY-NINTH
IN A SERIES SPONSORED BY BOLLINGEN FOUNDATION

Library of Congress Cataloging in Publication Data will
be found on the last printed page of this book

This book has been composed in Linotype Granjon

Printed in the United States of America
by Princeton University Press, Princeton, New Jersey

Editor's Note

The fifty-six essays in these volumes have been chosen from among many hundred.[1] Without exception, they were written in the period 1932–1947, corresponding to Coomaraswamy's tenure as a Research Fellow at the Museum of Fine Arts, Boston, a position that gave him time for the speculation and scriptural research to which he was particularly drawn in later years. These years were indisputably Coomaraswamy's high period, by which he must and would wish to be judged; his correspondence and conversation corroborate this point. Articles dealing with specific works of art have in general been excluded from these volumes because, although Coomaraswamy continued in this period to write detailed accounts of museum objects, his more characteristic work lay elsewhere. To the best of my knowledge, all the essays have been out of print for many years or were never previously published. After a gap of more than twenty-five years, it is a privilege to present the series of essays at the end of Volume 2 which, although unpublished in Coomaraswamy's lifetime, bear the stamp of finished work. Finally, regarding the selection, it must be mentioned that these volumes do not exhaust the reserve of essays of special merit.

Coomaraswamy's addenda to the essays have been a matter of interest to scholars and friends. He kept desk copies of his published works and added notes to them over the years, doubtless with a view to an edition of collected writings enriched by retrospective insight. After his death in the late summer of 1947, his widow, Doña Luisa (who had served for many years as his daily assistant), determined to incorporate these addenda into the essays. Inasmuch as her husband had already established a working relationship with Bollingen Foundation—he had, in particular, aided Joseph Campbell in the preparation of several posthumous

[1] A bibliography of Coomaraswamy's writings in the period 1900–1942 is published in *Ars Islamica* IX (1942). Currently on press, *A Working Bibliography of Ananda K. Coomaraswamy*, ed. R. P. Coomaraswamy (London: Books From India, Ltd.), is considerably more complete and includes data on late and posthumous publications. Inasmuch as Mr. James Crouch (Melbourne, Australia) has well underway an exhaustive new bibliography of Coomaraswamy's writings, we have decided against including a nominally complete bibliography in the *Selected Papers*. The first installment of Mr. Crouch's work has already appeared: "Ananda Coomaraswamy in Ceylon: A Bibliography," *The Ceylon Journal of Social and Historical Sciences*, N. S. III, No. 2 (1973), 54–66.

publications of the great Indologist Heinrich Zimmer—Mrs. Coomara-
swamy successfully applied for a Bollingen Fellowship to carry on this
work. For many years, with the help of research assistants recruited from
the Harvard University community, near which she lived, she transcribed
and incorporated the addenda, meticulously verified references, and filled
out bibliographical data where necessary. In due course the editors of
Bollingen Series made a place in the program for a publication of se-
lected writings.

Mrs. Coomaraswamy's death in 1971 left the project still incomplete
and requiring redirection. Her patient work had brought many treasures
to light from the mine of the addenda, but the time had come for re-
fining and selection, a task which devotion to her late husband rendered
unpleasant and perhaps impossible, rather as surgeons refuse to operate
upon members of their own family. In reformulating the editorial task,
I found it appropriate to include no addenda other than those which are
genuinely finished paragraphs or clear references; with regret, I eschewed
a great many addenda that cannot be taken to be more than raw ma-
terial for revisions, tending to encumber the essays like barnacles rather
than speed them on their way. This policy makes the essays less rich in
addenda than was expected by scholars and friends close to the project.
With few exceptions, addenda have been placed in footnotes, and in all
cases they have been enclosed in brackets [] to distinguish them from
the text as Coomaraswamy published it. (Editorial notes are also given
in brackets, with the designation ED.)

A list of abbreviations, short titles, and editions customarily used by
Coomaraswamy is included in the front matter of each volume; readers
will find this list indispensable at first but should gradually discover, as
did Coomaraswamy, that the abbreviations are convenient and easily
recalled. Coomaraswamy's own writings are cited by title and date; fur-
ther information is available in a short list of cited works at the front of
each volume. Punctuation and spelling throughout the papers have been
altered where necessary for the sake of uniformity.

While preparing these papers for publication, editor and copy-editors
alike have found occasional errors in the enormous mass of references
made by Coomaraswamy to literary and scriptural tradition. Such errors
as have escaped us will generally do no more harm to the reader than
to lead him, for example, to a paragraph in Plato's writings immediately
adjacent to the passage that Coomaraswamy wished to cite. Coomara-
swamy also, on occasion, refined the translation of passages in standard

sources such as the Loeb Classical Library, but neglected to notify the reader of his interventions. Furthermore, he worked from memory more often than one might imagine. Called to the dock on this issue of accuracy by his friend Walter Shewring, Coomaraswamy replied in a letter:

> I am more than appreciative of your corrections. I can only say I am conscious of fault in these matters. It is no excuse to say that checking references and citations is to me a wearisome task. I am sometimes oppressed by the amount of work to be done, and try to do too much too fast. . . . In certain cases I have not been able to see proofs. . . .
>
> One word about the errors. I would like to avoid them altogether, of course. But one cannot take part in the struggle for truth without getting hurt. There is a kind of "perfectionism" which leads some scholars to publish nothing, because they know that nothing can be perfect. I don't respect this. Nor do I care for any aspersions that may reflect upon me personally. It is only "for the good of the work to be done" that one must be as careful as possible to protect oneself. . . . I am so occupied with the task that I rarely have leisure to enjoy a moment of personal realisation. It is a sort of feeling that the harvest is ripe and the time is short. However, I am well aware that all *haste* is none the less an error. I expect to improve.[2]

Recognizing the existence of this problem from the very beginning of my work, and reflecting upon the example of Doña Luisa Coomaraswamy, who worked perhaps too many years to perfect in the letter texts that already approached perfection of spirit, I decided not to verify every reference but rather to let Coomaraswamy bear the responsibility for his occasional errors as he bears responsibility for his frequent grandeur.

A NOTE should be added about Figure 5. It was allegedly found at Sophia, Bulgaria, with a belt-set similar to ones forged at Odessa (A. A. Iessen, *Arkheologicheskii Sbornik*, No. 2, pp. 163–177 [Leningrad, 1961]). Although the piece may well be a forgery, its iconography is identical to that of authenticated pieces of the same era (cf. Fig. 27 in the introductory text of M. I. Artamanov, *The Splendor of Scythian Art; Treasures from Scythian Tombs* [New York, 1969]).

[2] Letter to Walter Shewring, 4 March 1936, from the collection of Coomaraswamy's papers and books bequeathed to Bollingen Foundation by Doña Luisa Coomaraswamy and now in Princeton University Library.

EDITOR'S NOTE

T<small>HE</small> *Selected Papers* of Amanda K. Coomaraswamy owes a great deal to its friends. Professional and moral support have been provided from the beginning by William McGuire and Carol Orr of Princeton University Press. Herbert S. Bailey, Jr., the director of the Press, has been a persistent friend throughout the complex task. Ruth Spiegel did her initial copy-editing with extraordinary care. Wallace Brockway, Joseph Campbell, Mircea Eliade, I. B. Horner, and Stella Kramrisch have all contributed their mature judgment regarding both selection and editing. Lynda Beck, Alice Levi, and Carole Radcliffe have been invaluable research assistants. The Indologists Carole Meadow, Svatantra Kumar Pidara, and Kenneth J. Storey have reviewed Sanskrit and Pāli, and Lois Hinckley, Kathleen Komar, and Pamela Long have helped with translations and various bibliographic problems. James Crouch and S. Durai Raja Singam have shared their extensive knowledge of Coomaraswamy's writings.

Preparation of the index required the help of many individuals: Ann Suter compiled the Greek index and also reviewed Greek in the essays; Kenneth J. Storey compiled the Sanskrit index; and a team of some twelve students in the University of Texas, Austin, joined me for the final stages of assembling the general index. I hesitate to list twelve names, but I want very much to thank these participants.

Special acknowledgment must be made to Kurt Kleinman, who set the type for these volumes with such rigor and patience; he gives meaning to Coomaraswamy's cherished aphorism: "Every man is a special kind of artist." Eleanor Weisgerber and her staff in the proofroom of the Press completed an exceedingly difficult task as if it were all in a day's work. Margaret Case, who took over the task of copy-editing at an early stage, thereafter shared every problem as a colleague and friend.

Dr. Rama P. Coomaraswamy and his wife, Bernadette, have helped in countless ways.

R.L.

Contents of Volume I

CONTENTS

Traditional Symbolism

Methodology

Four Studies

The Sundoor and Related Motifs

List of Illustrations

List of Abbreviations and
Short Titles

A	*The Book of the Gradual Sayings* (*Anguttara-Nikāya*), ed. F. L. Woodward and E. M. Hare, 5 vols., London, 1932–1939 (PTS).
AĀ	*Aitareya Āraṇyaka*, ed. A. B. Keith, Oxford, 1909.
AB	(= *Aitareya Brāhmaṇa*). *Rigveda Brahmanas: The Aitareya and Kauṣītaki Brāhmaṇas of the Rigveda*, ed. A. B. Keith, Cambridge, Mass., 1920 (HOS XXV).
Abhidharmakośa	*L'Abhidharmakośa de Vasubandhu*, tr. Louis de la Vallée-Poussin, 6 vols., Paris, 1923–1931.
Abhinaya Darpaṇa	*The Mirror of Gesture: Being the Abhinaya Darpaṇa of Nandikeśvara*, ed. A. K. Coomaraswamy, with Gopala Kristnaya Duggirala, Cambridge, Mass., 1917.
Aeschylus, *Fr.*	In Nauck (see below).
Ait. Up.	(= *Aitareya Upaniṣad*). In *The Thirteen Principal Upanishads*, ed. R. E. Hume, 2nd ed., rev., London, 1931.
Angelus Silesius	(Johann Scheffler) *Cherubinischer Wandersmann*, new ed., Munich, 1949. *The Cherubinic Wanderer*, selections tr. W. R. Trask, New York, 1953.
Anugītā	*The Bhagavadgîtâ, with the Sanatsugâtîya, and the Anugîtâ*, ed. Kâshinâth Trimbak Telang, Oxford, 1882 (SBE VIII).
Apuleius	*The Golden Ass*, tr. W. Adlington, revised by S. Gaselee (LCL).
Aquinas	1. *Sancti Thomae Aquinatis, doctoris angelici, Opera omnia ad fidem optimarum editionum accurato recognita.* 25 vols. Parma, 1852–1872. 2. See also *Sum. Theol.* below.
Aristotle	1. *De anima*, tr. W. S. Hett (LCL). 2. *The Metaphysics*, tr. Hugh Tredennick (LCL). 3. *The Nichomachean Ethics*, tr. H. Rackham (LCL). 4. *The Physics*, tr. Francis M. Cornford (LCL). 5. *The Poetics*, tr. W. Hamilton Fyfe (LCL).
Arthaśāstra	*Kauṭilya's Arthaśāstra*, ed. R. Shamasastry, 2nd ed., Mysore, 1923.

Āryabhata *Āryabhaṭīya*, tr. Walter Eugene Clark, Chicago, 1930.

'Aṭṭār, Farīdu'd-Dīn
1. Farid ud-Din Attar, *The Conference of the Birds* (Mantiq ut-Tair), tr. C. S. Nott from the French of Garçin de Tassy, London, 1954.
2. *Mantic Uttair, ou le langage des oiseaux*, tr. Garçin de Tassy, Paris, 1863.
3. *Salámán and Absál, ... with a Bird's-Eye View of Faríd-Uddín Attar's Bird-Parliament*, by Edward Fitzgerald, Boston, 1899.

Atthasālinī *The Expositor (Atthasālinī): Buddhaghosa's Commentary on the Dhammasangaṇi*, ed. P. Maung Tin and C.A.F. Rhys Davids, 2 vols., London, 1920–1921 (PTS).

AV
1. *Atharva Veda*, ed. W. D. Whitney and C. R. Lanman, Cambridge, Mass., 1905 (HOS VII, VIII).
2. *The Hymns of the Atharva-Veda*, ed. R.T.H. Griffith, 2 vols., 2nd ed., Benares, 1916–1917.

Avicenna *Metaphysices compendium*, Rome, 1926.

Avencebrol (Solomon Ibn Gabirol) *Fons Vitae*, see *Fountain of Life*, tr. Alfred B. Jacob, Philadelphia, 1954.

BAHA *Bulletin de l'Office Internationale des Instituts d'Archéologie et d'Histoire d'Art.*

Baudhāyana Dh. Sū *Das Baudhāyana-Dharmasūtra*, ed. Eugen Hultzsch, Leipzig, 1922.

BD *The Bṛhad Devatā of Śaunaka*, ed. A. A. Macdonell, Cambridge, Mass., 1904 (HOS VI).

BÉFEO *Bulletin de l'École Française d'Extrême-Orient* (Hanoi).

BG *The Bhagavad Gītā*, ed. Swami Nikhilananda, New York, 1944.

Boethius *The Theological Tractates and the Consolation of Philosophy*, ed. H. F. Stewart and E. K. Rand (LCL).

Bokhāri Muhammad ibn-Ismā al-Bukhari. *Arabica and Islamica*, tr. V. Wayriffe, London, 1940.

BrSBh (= *Brahma Sūtra Bhāṣya*) *The Vedānta-Sûtras with the Commentary by Saṇkarâkârya*, ed. G. Thibaut, 2 vols., Oxford, 1890–1896 (SBE 34, 38).

BSOS *Bulletin of the School of Oriental and African Studies*

BU (= *Bṛhadāraṇyaka Upaniṣad*) In *The Thirteen Principal Upanishads*, ed. R. E. Hume, 2nd ed., London, 1931.

Chuang-tzu *Chuang Tzu: Mystic, Moralist, and Social Reformer*, ed. H. A. Giles, London, 1889.

Cicero 1. *Academica*, tr. H. Rackham (LCL).
2. *Brutus*, tr. G. L. Hendrickson (LCL).
3. *De natura deorum*, tr. H. Rackham (LCL).
4. *De officiis*, tr. Walter Miller (LCL).
5. *Pro Publio Quinctio*, tr. John Henry Freese (LCL).
6. *Tusculan Disputations*, tr. J. E. King (LCL).

Claudian, *Stilicho* *On Stilicho's Consulship*, tr. Maurice Platnauer, London and Cambridge, Mass., 1956.

Clement 1. *Miscellanies*, tr. F.J.A. Hart and J. B. Mayor, London, 1902.
2. *The Clementine Homilies*, Ante-Nicene Christian Library, vol. XVII, Edinburgh, 1870.

Cloud of Unknowing *A Book of Contemplation the Which is Called the Cloud of Unknowing in the Which a Soul is Oned with God*, anon., ed. E. Underhill, London, 1912.

Coptic Gnostic Treatise *A Coptic Gnostic Treatise Contained in the Codex Brucianus*, ed. Charlotte A. Baynes, Cambridge, 1933.

CU (= *Chāndogya Upaniṣad*) In *The Thirteen Principal Upanishads*, ed. R. E. Hume, 2nd ed., London, 1931.

D (= *Dīgha-Nikāya*) *Dialogues of the Buddha*, ed. T. W. and C.A.F. Rhys Davids, 3 vols., London, 1899–1921 (PTS).

DA (= *Dīgha-Nikāya Atthakathā*) *The Sumaṅgala-vilāsinī: Buddhaghosa's Commentary on the Dīgha Nikāya*, ed. T. W. Rhys Davids and J. Estlin Carpenter (vol. I), and W. Stede (vols. II and III), London, 1886–1932 (PTS).

Damascene St. John of Damascus. See Migne, PG, Vols. 94–96.

Dante 1. *Convito* (1529); facsimile edition, Rome, 1932. *Dante and his Convito: A Study with Translations*, W. M. Rossetti, London, 1910.
2. *Dantis Alighieri Epistolae: The Letters of Dante*, ed. P. Toynbee, Oxford, 1966.
3. *The Divine Comedy of Dante Alighieri*, tr. Charles Eliot Norton, 3 vols., Boston and New

York, 1895–1897. (This is AKC's preferred edition, but he had a dictionary of Dante's Italian and may have done translations on his own in addition to using Norton; he also used the Temple Classics edition.)

Daśarūpa	*The Daśarūpa: a Treatise on Hindu Dramaturgy*, tr. G.C.O. Haas, New York, 1912.
Dh	*The Dhammapada*, ed. S. Radhakrishnan, London, 1950.
DhA	(= *Dhammapada Atthakathā*) *Dhammapada Commentary*, ed. H. C. Norman, 4 vols., 1906–1914 (PTS).
Dionysius	1. *De coelesti hierarchia*, see *La Hiérarchie céleste*, ed. G. Heil and M. de Gandillac, Paris, 1958 (*Sources chrétiennes* LVIII). 2. *De divinis nominibus* and *De mystica theologia*, see *The Divine Names* and *The Mystical Theology*, ed. C. E. Rolt, London, 1920. 3. Epistles, see *Saint Denys L'Aréopagite, Oeuvres*, ed. Mgr. Darboy, Paris, 1932.
Divyāvadāna	*Divyāvadāna*, ed. E. B. Cowell and R. A. Neil, Cambridge, 1886.
Dpv	*Dipavamsa*, ed. H. Oldenberg, London, 1879.
Epiphanius	*Epiphanius* (*Ancoratus und Panarion*), ed. K. Holl, Leipzig, 1915–1933.
Erigena	John Scotus Erigena. See Migne, PL, Vol. 122.
Euripides	1. *Euripides*, tr. A. S. Way (LCL). 2. *Fragments* in Nauck.
Garbha Up.	(= *Garbha Upaniṣad*) In *Thirty Minor Upanishads*, tr. K. Nārāyanasvāmi, Madras, 1914.
Gāruḍa Purāṇa	1. *The Garuda Puranam*, tr. M. N. Dutt, Calcutta, 1908. 2. *The Gāruḍa Purāṇa*, tr. Ernest Wood and S.U. Subrahmanyam, Allahabad, 1911 (SBH IX).
GB	*Gopatha Brāhmaṇa*, ed. R. Mitra and H. Vidyā-bushana, Calcutta, 1872 (Sanskrit only).
Grassmann	H. G. Grassmann, *Wörterbuch zum Rig-Veda*, Leipzig, 1873 (cf. also *Rig-Veda*; *übersetzt und mit kritischen und erläuternden Anmerkungen versehen*, 2 vols., Leipzig, 1876–1877).
Greek Anthology	*The Greek Anthology*, tr. W. R. Paton (LCL).
Harivaṃsa	*Harivamsha*, ed. M. N. Dutt, Calcutta, 1897 (prose English translation).

Haṃsa Up.	(= *Haṃsa Upaniṣad*) In *Thirty Minor Upaniṣads*, tr. K. Nārāyaṇasvāmi, Madras, 1914.
Heracleitus, *Fr.*	*Heracliti Ephesi Reliquiae*, ed. Ingram Bywater, Oxford, 1877 (see modern editions by G. S. Kirk and Philip Wheelwright; Coomaraswamy numbers Fragments according to Bywater).
Hermes	*Hermetica: The Ancient Greek and Latin Writings which Contain Religious or Philosophic Teachings Ascribed to Hermes Trismegistus*, ed. W. Scott, 4 vols., 1924–1936.
Hesiod	*Theogony* and *Works and Days*, tr. Hugh G. Evelyn-White (LCL).
Hippocrates	*Works*, tr. W.H.S. Jones (LCL).
HJAS	*Harvard Journal of Asiatic Studies.*
Homer	*The Iliad* and *The Odyssey*, tr. A. T. Murray (LCL).
Homeric Hymns	*Homeric Hymns*, tr. Hugh G. Evelyn-White (LCL).
Horace	*Epistula ad Pisones* (= *Ars Poetica*), tr. H. Rushton Fairclough (LCL).
HOS	Harvard Oriental Series.
IPEK	*Jahrbuch für prähistorische und ethnographische Kunst.*
Īśā Up.	(= *Īśā*, or *Īśāvāsya, Upaniṣad*) In *The Thirteen Principal Upanishads*, ed. R. E. Hume, 2nd ed., London, 1931.
Itiv	(= *Itivuttaka*) *The Minor Anthologies of the Pali Canon, Part II: Udāna: Verses of Uplift, and Itivuttaka: As It Was Said*, ed. F. L. Woodward, London, 1935 (PTS).
J	*The Jātaka, or Stories of the Buddha's Former Births*, ed. E. B. Cowell, 6 vols., Cambridge, 1895–1907.
Jacob Boehme	1. *Signatura rerum*, see *The Signature of All Things, and Other Writings*, new ed., London, 1969 (includes *Of the Supersensual Life* and *The Way from Darkness to True Illumination*). 2. *Six Theosophic Points, and Other Writings*, ed. J. R. Earle, Ann Arbor, 1958. 3. *The Way to Christ*, new ed., London, 1964.
Jāmī	*Lawā'ih, A Treatise on Sufism*, ed. E. H. Whinfield and M. M. Kazvīnī, London, 1906.
JAOS	*Journal of the American Oriental Society.*

JB
1. *The Jaiminīya-Brāhmana of the Samveda*, ed. R. Vira and L. Chandra, Nagpur, 1954 (Sanskrit).
2. *Das Jaiminīya Brāhmana in Auswahl*, text and German translation by W. Caland, Amsterdam, 1919.

JHS
Journal of Hellenic Studies.

JISOA
Journal of the Indian Society of Oriental Art.

Jan van Ruysbroeck
The Adornment of the Spiritual Marriage; The Sparkling Stone; The Book of Supreme Truth, tr. C. A. Wynschenk, ed. Evelyn Underhill, London, 1914.

JRAS
Journal of the Royal Asiatic Society.

JUB
(= *Jaiminīya Upaniṣad Brāhmana*) *The Jaiminīya or Talavakāra Upaniṣad Brāhmana*, ed. H. Oertel, *Journal of the American Oriental Society*, XVI (1896), 79–260.

Kauṣ. Up.
(= *Kauṣītaki Upaniṣad*) In *The Thirteen Principal Upanishads*, ed. R. E. Hume, 2nd ed., London, 1931.

KB
Kauṣītaki Brāhmana. Rigveda Brahmanas: The Aitareya and Kauṣītaki Brāhmanas of the Rigveda, ed. A. B. Keith, Cambridge, Mass., 1920 (HOS XXV).

Kena Up.
(= *Kena Upaniṣad*) In *The Thirteen Principal Upanishads*, ed. R. E. Hume, 2nd ed., London, 1931.

KhA
(= *Khuddakapāṭha*) *The Minor Readings, The First Book of the Minor Collection (Khuddakanikāya)*, ed. Bhikkhu Nāṇamoli, London, 1960 (PTS).

Kindred Sayings
See S

KSS
(= *Kathā-Sarit-Sāgara*) *Kathāsaritsāgara*, ed. C. H. Tawney, Calcutta, 1880–1887; 2nd ed., 1924.

KU
1. (= *Katha Upaniṣad*) In *The Thirteen Principal Upanishads*, ed. R. E. Hume, 2nd ed., London, 1931.
2. *Katha Upaniṣad*, ed. Joseph N. Rawson, Oxford, 1934.

Lalita Vistara
Lalita Vistara, ed. S. Lefmann, 2 vols., Halle, 1902–1908.

Laṅkâvatāra Sūtra
Laṅkâvatāra Sūtra, ed. Bunyiu Nanjio, Kyoto, 1923.

LCL
Loeb Classical Library.

Lucian
De Syria Dea, tr. A. M. Harmon (LCL).

M
($= Majjhima-Nikāya$) *The Middle Length Sayings* (*Majjhima-Nikāya*), ed. I. B. Horner, 3 vols., London, 1954–1959 (PTS).

Mahavamsa
See Mhv.

Maṇḍ. Up.
($= Maṇḍūkya Upaniṣad$) In *The Thirteen Principal Upanishads*, ed. R. E. Hume, 2nd ed., London, 1931.

Mantiqu't-Tair
See 'Aṭṭar, Faridu'd-Dīn

Mānasāra
Architecture of Mānasāra, tr. Prasanna Kumar Acharya, London, 1933.

Mañjuśrīmūlakalpa
Mañjuśrī: An Imperial History of India in a Sanskrit Text, ed. Ven. Rāhula Sāṇkṛtyāyana, Lahore, 1934.

Manu
($= Mānava Dharmaśāstra$) *The Laws of Manu*, ed. G. Bühler, Oxford, 1886 (SBE XXV).

Marcus Aurelius
Marcus Aurelius, tr. C. R. Haines (LCL).

Markaṇḍeya Purāṇa
Markaṇḍeya Purāṇa, ed. J. Woodroffe, London, 1913.

Mathnawī
The Mathnawí of Jalálu'ddín Rúmí, ed. R. A. Nicholson, 8 vols., Leiden and London, 1925–1940.

Mbh
1. *Mahābhārata. The Mahabharata of Krishna-Dwaipayana Vyasa*, ed. P. C. Roy, Calcutta, 1893–1894.
2. *Mahābhārata*, ed. Vishnu S. Sukthankar, Poona, 1933– [24 vols. to date].

Meister Eckhart
1. *Meister Eckhart*, ed. F. Pfeiffer, 4th ed., Göttingen, 1924 (mediaeval German text).
2. *Meister Eckhart*, ed. C. de B. Evans, 2 vols., London, 1924–1931 (English).

MFA Bulletin
Bulletin of the Museum of Fine Arts, Boston.

Mhv
The Mahāvaṃsa, or The Great Chronicle of Ceylon, ed. W. Geiger, London, 1908 (PTS).

Migne
Jacques Paul Migne, *Patrologiae cursus completus*
1. [*P. G.*] *Series Graeca*, Paris, 1857–1866, 161 vols.
2. [*P. L.*] *Series Latina*, Paris, 1844–1880, 221 vols.

Mil
($= Milinda Pañho$) *The Questions of King Milinda*, ed. T. W. Rhys Davids, 2 vols., Oxford, 1890 (SBE XXXV, XXXVI).

Mīmaṃsā Nyāya Prakaśa
The Mīmamsā Nyāya Prakaśa of Āpadeva, ed. F. Edgerton, New Haven, 1929.

MU
($= Maitri Upaniṣad$) In *The Thirteen Principal Upanishads*, ed. R. E. Hume, 2nd ed., London, 1931.

Muṇḍ. Up. (= *Muṇḍaka Upaniṣad*) In *The Thirteen Principal Upanishads*, ed. R. E. Hume, 2nd ed., London, 1931.

Mv (= *Mahāvagga*) *Vinaya Texts*, ed. T. W. Rhys Davids and H. Oldenberg, 2 vols., Oxford, 1881–1882 (SBE XIII, XVII).

Nārāyaṇa Up. (= *Nārāyaṇa Upaniṣad*) In *Thirty Minor Upanishads*, ed. K. N. Aiyar, Madras, 1914.

Nāṭya Śāstra *The Nāṭya Śāstra* of Bharata, ed. M. Ramakrishna Kavi, Baroda, 1926 (Sanskrit).

Nauck August Nauck, *Tragicorum Graecorum Fragmenta*, Leipzig, 1856.

NIA *New Indian Antiquary.*

Nicholas of Cusa (= Nicolaus Cusanus)
1. (*De visione Dei*) *The Vision of God*, ed. E. G. Salter, London, 1928.
2. *De filiatione Dei*, in *Schriften des Nikolaus von Cues*, Leipzig, 1936–, Vol. II.

Nirukta *The Nighaṇṭu and Nirukta of Yāska*, ed. L. Sarup, Oxford, 1921.

Origen *Writings of Origen*, tr. Frederick Cromble, 2 vols., Edinburgh, 1869.

Ovid 1. *Fasti*, tr. Sir James George Frazer (LCL).
2. *Metamorphoses*, tr. Frank Justus Miller (LCL).

OZ *Ostasiatische Zeitschrift.*

Pañcadaśi *Pañchadaśi, A Poem on Vedānta Philosophy*, ed. & tr. Arthur Venis, in *Pandit*, V–VIII (1883–1886).

Pañcatantra *The Panchatantra Reconstructed*, ed. Franklin Edgerton, New Haven, 1924. American Oriental Series, III.

Pāṇini *The Ashtādhyāyi of Pāṇini*, ed. S. C. Vasu, 8 vols., Allahabad, 1891–1898.

Parāśara *The Parāśara Dharma Samhitā, or, Parāśara Smṛiti*, ed. Pandit Vāman Śāstrī Islāmapurkar, 2 vols., Bombay, 1893–1906.

Pausanias *Pausanias*, tr. W.H.S. Jones (LCL).

PGS *Pâraskara-gṛhya-sūtras*, tr. H. Oldenberg, Oxford, 1886.

Philo 1. Complete works published in LCL; Vols. I–X, ed. F. H. Colson; *Supplements* I, II, ed. R. Marcus. All works cited by full title with exception of: a) *Aet.* (*On the Eternity of the World*, vol. IX); b) *Congr.* (*On the Preliminary Studies*, vol.

IV); c) *Deterius* (*The Worse Attacks the Better*, vol. II); d) *Heres.* (*Who is the Heir*, vol. IV); e) *Immut.* (*On the Unchangeableness of God*, vol. III).

Philostratus, Flavius Philostratus, *The Life and Times of Apol-*
 Vit. Ap. *lonius of Tyana*, tr. Charles P. Ellis, Stanford, 1923.

Pindar *The Odes of Pindar*, tr. Richard Lattimore, Chicago, 1947.

Pistis Sophia 1. *Pistis Sophia, A Gnostic Miscellany*, ed. & tr. G.R.S. Mead, London, rev. ed., 1921; 1947.
 2. *Pistis Sophia*, ed. J. H. Petermann, Berlin, 1851.

Plato *The Collected Dialogues of Plato, including the Letters*, ed. Edith Hamilton and Huntington Cairns, Princeton, 1961 (Bollingen Series LXXI).

Plotinus *Plotinus, The Enneads*, tr. Stephen MacKenna. 3rd ed. rev. by B. S. Page, London, 1962.

Plutarch 1. *Moralia*, tr. Frank Cole Babbitt and others; includes *De genio Socratis* (LCL).
 2. *Pericles*, in *Lives*, tr. Bernadotte Perrin (LCL).

PMLA *Publications of the Modern Language Association.*

Praśna Up. (= *Praśna Upaniṣad*) In *The Thirteen Principal Upanishads*, ed. R. E. Hume, 2nd ed., London, 1931.

Prema Sāgara *Prema-Sāgara*, ed. and tr. Edward B. Eastwick, Westminster, 1897.

PTS Pali Text Society Translation Series.

Pythagoras *Golden Verses*, see *Les Vers d'or pythagoriciens*, ed. P. C. van der Horst, Leyden, 1932.

PugA *Puggala-paññatti-atthakatha*, ed. G. Lansberg and C.A.F. Rhys Davids, London, 1914 (Pāli).

Pūrva Mīmāṃsā *The Pūrva Mīmāṃsā Sūtras* of Jaimini, ed. M.
 Sūtras Ganganatha Jha, Allahabad, 1916 (SBH X).

Quintilian *Institutio Oratoria*, tr. H. E. Butler (LCL).

Rāmāyaṇa *The Rāmāyaṇa*, ed. M. N. Dutt, Calcutta, 1891–1894.

Rūmī, *Dīvān* *Selected Poems from the Dīvani Shamsi Tabrīz*, ed. R. A. Nicholson, Cambridge, 1898.

RV *The Hymns of the Rgveda*, ed. R.T.H. Griffith, 2 vols., 4th ed., Benares, 1963.

S *The Book of the Kindred Sayings* (*Saṃyutta-Nikāya*), ed. C.A.F. Rhys Davids and F. L. Woodward, 5 vols., London, 1917–1930 (PTS).

ŚA *Śāṅkhāyana Āraṇyaka*, ed. A. B. Keith, London, 1908.

Sa'dī (Muslih-al-Dīn) *The Bustān of Sadi*, ed. A. H. Edwards, London, 1911.

Ṣaḍva. Brāhmaṇa (= *Ṣaḍviṅśa Brāhmaṇa*) *Daivatabramhana and Shadbingshabramhana of the Samveda with the Commentary of Sayanacharya*, ed. Pandit J. Vidyasagara, Calcutta, 1881.

Sāhitya Darpaṇa *The Mirror of Composition, A Treatise on Poetical Criticism, being an English Translation of the Sāhitya-Darpana of Viśwanatha Kaviraja*, ed. J. R. Ballantyne and P. D. Mitra, Calcutta, 1875 (reprinted, Benares, 1956).

Śakuntala *Abhijñāna-Śakuntala* of Kalidāsa, ed. M. B. Emeneau, Berkeley, 1962.

Sanatsujātiya *The Bhagavadgîtâ, with the Sanatsugâtîya, and the Anugîtâ*, ed. K. T. Telang, Oxford, 1882 (SBE VIII).

Śatapatha Brāhmaṇa See ŚB.

Sāyaṇa *Ṛg Veda Samhitā, with Sayana's Commentary*, ed. S. Pradhan, Calcutta, 1933.

ŚB *Śatapatha Brāhmaṇa*, ed. J. Eggeling, 5 vols., Oxford, 1882–1900 (SBE XII, XXVI, XLI, XLII, XLIV).

SBB The Sacred Books of the Buddhists, London.

SBE The Sacred Books of the East, Oxford.

SBH The Sacred Books of the Hindus, Allahabad.

Scott See Hermes.

Sextus Empiricus *Sextus Empiricus*, tr. R. G. Bury (LCL).

Shams-i-Tabriz See Rūmī, *Dīvān*.

Siddhāntamuktāvalī 1. *The Vedānta Siddhāntamuktāvalī of Prakāśananda*, tr. Arthur Venis, in *The Pandit*, Benares, 1890.
2. Tr. J. R. Ballantyne, Calcutta, 1851.

Sikandar Nāma Nizam al-Dīn Abu Muhammad Niẓamī, *Sikandar Nāma e bara*, tr. H. Wilberforce, Clarke, London, 1881.

Śilparatna *The Śilparatna* by Śrī Kumāra, ed. Mahāmahopādyāya T. Ganapati Sāstri, Trivandrum, 1922–1929.

Sn *The Sutta-Nipāta*, ed. V. Fausböll, Oxford, 1881 (SBE X).

SnA	*Sutta-Nipāta Atthakathā*, ed. H. Smith, 2 vols., London, 1916–1917 (PTS).
SP	*The Saddharma Puṇḍarīka, or the Lotus of the True Law*, ed. H. Kern, Oxford, 1909 (SBE XXI).
Śrī Sūkta	*The Purusha Sukta*, Aiyar, Madras, 1898.
St. Augustine	1. *The City of God against the Pagans*, tr. William M. Green (LCL). 2. *A Select Library of the Nicene and Post-Nicene Fathers of the Christian Church*, ed. Philip Schaff, New York, 1886–1890, vols. I–VIII, *Collected Works of St. Augustine* (in English tr.).
St. Bernard	St. Bernard of Clairvaux, *Opera omnia* in Migne, *Series latina*, vols. 182–185 (1854–1855).
St. Bonaventura	1. *The Works of Bonaventure, Cardinal, Seraphic Doctor, and Saint*, tr. José de Vinck, Paterson, N.J., 1966– (in progress); Vol. III, *Opuscula, Second Series*, 1966, includes "On Retracing the Arts to Theology" (*De reductione artium ad theologiam*). 2. *Doctoris Seraphici S. Bonaventurae S. R. E. Episcopi Cardinalis opera omnia . . .*, Florence, 1883–1902, 10 vols.; vols. I–IV, *Sententiarum Petri Lombardi* (abbreviated *I Sent.*, etc.).
St. Clement	See Clement.
St. Cyril of Jerusalem	*A Select Library of Nicene and Post-Nicene Fathers*, 2nd ser. ed. Philip Schaff and Henry Wace, New York, 1894. Vol. VII.
St. Jerome	*S. Eusebii Hieronymi opera omnia*, in Migne, *Series latina*, vols. 22–30.
St. John of the Cross	*The Complete Works of Saint John of the Cross, Doctor of the Church*, ed. and tr. E. Allison Peers, Weathampstead, 1974.
Sukhāvatī Vyūha	*Buddhist Texts from Japan*, ed. F. Max Müller and Bunyiu Nanjic, Oxford, 1881 (*Anecdota oxoniensia, Aryan Series* I).
Śukranītisāra	*The Sukranīti of Śukrācārya*, ed. B. K. Sarkar, Allahabad, 1914 (SBH XII).
Sum. Theol.	*The Summa Theologica of St. Thomas Aquinas.* Literally translated by Fathers of the English Dominican Province. London, 1913–1942, 22 vols. Also in Parma ed., 1864; see Aquinas.

Suparṇādhyāya	*Die Suparṇasage*, ed. J. Charpentier, Uppsala, 1922 (Sanskrit text, German translation, commentary).
Suśruta	*The Suśruta-Saṃhita*, tr. Udoy Chand Dutt and Aughorechunder Chattopadhya, 3 fasc., Calcutta, 1883–1891.
Svātma-nirūpaṇa	*Select Works of Sri Saṅkaracharya*, tr. S. Venkataramanan, Madras, 1911 (includes *Svātma-nirūpaṇa*).
Śvet. Up.	(= *Śvetāsvatara Upaniṣad*) In *The Thirteen Principal Upanishads*, ed. R. E. Hume, 2nd ed., London, 1931.
TA	*The Taittirīya Āraṇyaka of the Black Yajur Veda (with the Commentary of Sayaṇacharya)*, ed. R. Mitra, Calcutta, 1872 (Sanskrit).
Taittirīya Pratiśākhya	*The Tâittirîya Prâtiçâkhya, with its Commentary, the Tribhâshyaratna*, ed. W. D. Whitney, JAOS, IX (1871), 1–469.
Tao Te Ching	Arthur Waley, *The Way and Its Power*, London, 1934.
TB	*The Taittirīya Brāhmaṇa of the Black Yajur Veda, with the Commentary of Sayaṇa Archaryya*, ed. R. Mitra, 3 vols., Calcutta, 1859–1890 (Sanskrit).
Tertullian	*The Writings of Q.S.F. Tertullianus*, tr. S. Thelwall, *et al.*, 3 vols., Edinburgh, 1869–1870.
Theragāthā Therīgāthā	1. *Psalms of the Early Buddhists*, I. *Psalms of the Sisters*, II. *Psalms of the Brethren*, tr. C. A. F. Rhys Davids, 4th ed., London, 1964 (PTS). 2. *The Thera- and Therī-gāthā*, ed. H. Oldenburg, London, 1883 (PTS).
TS	*Taittirīya Saṃhitā: The Veda of the Black Yajur School*, ed. A. B. Keith, Cambridge, Mass., 1914 (HOS XVIII, XIX).
TU	(= *Taittirīya Upaniṣad*) In *The Thirteen Principal Upanishads*, ed. R. E. Hume, 2nd ed., London, 1931.
Ud	(= *Udāna*) *The Minor Anthologies of the Pali Canon, Part II: Udāna: Verses of Uplift, and Itivuttaka: As It Was Said*, ed. F. L. Woodward, London, 1948 (PTS).
UdA	(= *Udāna Atthakathā*) *Paramattha-Dīpanī Udānatthakathā (Udāna Commentary) of Dhammapālâcariya*, ed. F. L. Woodward, London, 1926 (PTS).

Uvāsaga Dasāo	*Uvāsaga Dasāo*, ed. N. A. Gore, Poona, 1953.
VbhA	(= *Vibhanga Atthakathā*) Buddhaghosa, *Sammoha-vinodanī Abhidhamma-piṭake Vibhangattakatha*, ed. A. P. Buddhadatta Thero, London, 1923 (PTS)
Vikramorvaśī	*The Vikramorvasiya of Kalidasa*, tr. and ed. Charu Deva Shastri, Lahore, 1929.
Vin	(= *Vinaya Piṭaka*) *The Book of the Discipline* (*Vinaya Piṭaka*), ed. I. B. Horner, 5 vols., London, 1938–1952 (PTS).
Vis	*The Visuddhi Magga of Buddhaghosa*, ed. C.A.F. Rhys Davids, London, 1920–1921 (PTS).
Viṣṇudharmottara	*The Vishnudharmottara*, ed. S. Kramrisch, 2nd ed., Calcutta, 1928.
Viṣṇu Purāṇa	*The Vishnu Purana: A System of Hindu Mythology and Tradition*, ed. H. H. Wilson, London, 1864–1877.
VS	*Vājasaneyi Saṃhitā: The White Yajur Veda*, ed. R.T.H. Griffith, 2nd ed., Benares, 1927.
Witelo	Clemens Baeumker, *Witelo, ein Philosoph und Naturforscher des XIII. Jahrhunderts* (with text of his *Liber de intelligentiis*), Münster, 1908.
Xenophon	1. *Memorabilia*, tr. E. C. Marchant (LCL). 2. *Oeconomicus*, tr. E. C. Marchant (LCL).
ZDMG	*Zeitschrift der deutschen morgenländischen Gesellschaft.*
Zohar	*The Zohar*, ed. H. Sperling and M. Simon, 5 vols., London, 1931–1934.

List of Works by A. K. Coomaraswamy
Cited in These Volumes

"Angel and Titan: An Essay in Vedic Ontology," JAOS, LV (1935), 373–419.

"Chāyā," JAOS, LV (1935), 278–83.

The Darker Side of Dawn, Smithsonian Miscellaneous Collections, XCIV (1935), 18 pp.

"Dīpak Rāga," *Yearbook of Oriental Art and Culture*, II (1924–1925), 29–30.

"Early Indian Architecture: I. Cities and City Gates, etc.; II. Bodhigaras," *Eastern Art*, II (1930), 208–35, 45 figs. "III. Palaces," *Eastern Art*, III (1931), 181–217, 84 figs.

"An Early Passage on Indian Painting," *Eastern Art*, III (1931), 218–19.

"Eckstein," *Speculum*, XIV (1939), 66–72.

Elements of Buddhist Iconography. Foreword by Walter E. Clark. Cambridge, Mass., 1935, 95 pp., 15 pls.

Figures of Speech or Figures of Thought. London, 1946. 256 pp.

"Gradation and Evolution: I," *Isis*, XXXV (1944), 15–16.

"Gradation and Evolution: II," *Isis*, XXXVIII (1947), 87–94.

Hinduism and Buddhism. New York, 1943, 86 pp.

"The Iconography of Dürer's 'Knots' and Leonardo's 'Concatenation,'" *Art Quarterly*, VII (1944), 109–28, 18 figs.

The Indian Craftsman. Foreword by C. R. Ashbee. London, 1909. 130 pp.

Mediaeval Sinhalese Art. Broad Campden, 1908. 340 pp., 55 pls. (425 copies).

A New Approach to the Vedas: An Essay in Translation and Exegesis. London, 1933. 116 + ix pp.

"Nirmāna-kāya," JRAS (1938), pp. 81–84.

"A Note on the Aśvamedha," *Archiv Orientalni*, VII (1936), 306–17.

"Notes on the Katha Upaniṣad," NIA, I (1938), 43–56, 83–108, 199–213.

"On Being in One's Right Mind," *Review of Religion*, VII (1942), 32–40.

"The Pilgrim's Way," *Journal of the Bihar and Orissa Research Society*, XXIII (1937), 452–71.

"Prāṇa-citi," JRAS (1943), pp. 105–109.

"The Reinterpretation of Buddhism," NIA, II (1939), 575–90.

"Sir Gawain and the Green Knight: Indra and Namuci," *Speculum*, XIX (1944), 104–25.

"Some Sources of Buddhist Iconography," in *B. C. Law Volume*, Poona, 1945, pp. 469–76.

Spiritual Authority and Temporal Power in the Indian Theory of Government. New Haven, 1942. 87 pp., 1 pl.

"Spiritual Paternity and the 'Puppet-Complex,'" *Psychiatry*, VIII (1945), 287–97.

"The Sun-kiss," JAOS, LX (1940), 46–67.

"The Symbolism of Archery," *Ars Islamica*, X (1943), 104–19.

"The Technique and Theory of Indian Painting," *Technical Studies*, III (1934), 59–89, 2 figs.

Time and Eternity. Artibus Asiae Monograph Series, suppl. no. 8, Ascona, Switzerland, 1947, 140 pp.

The Transformation of Nature in Art. Cambridge, Mass., 1934 (2nd ed., 1935), 245 pp.

"Uṣṇīṣa and Chatra: Turban and Umbrella," *Poona Orientalist*, III (1938), 1–19.

Why Exhibit Works of Art? London, 1943, 148 pp. Reprinted under the title *Christian and Oriental Philosophy of Art*, New York, 1956.

"The Yakṣa of the Vedas and Upaniṣads," *Quarterly Journal of the Mythic Society*, XXVIII (1938), 231–40.

Yakṣas [*I*], *Smithsonian Miscellaneous Collections*, LXXX:6 (1928), 43 pp., 23 pls.

Yakṣas, II, Smithsonian Institution Publication 3059 (1931), 84 pp., 50 pls.

Introduction

Although Ananda K. Coomaraswamy's longer works are not difficult to find, many of the best articles have been inaccessible to readers at a distance from major libraries. He wrote many hundred articles, reviews, and books, and contributed to Eastern and Western periodicals of every description. The present selection is a gathering of what was scattered so widely; it should now be possible to meet Coomaraswamy's mind as unknown, and to discover vividly, without doubt, what his full range was. The selection is drawn from the years 1932–1947, that is, from the last period of his life (1877–1947), when he had reached his unique balance of metaphysical conviction and scholarly erudition. To published writings of this period have been added six previously unpublished essays, at least one of which ("On the Indian and Traditional Psychology, or rather Pneumatology") deserves to be ranked among his masterpieces; the unpublished essays generally date into the 1940s and would have seen print in the normal course of things, had he lived longer. Soon after Coomaraswamy's death, Bollingen Foundation interested itself in sponsoring an edition of selected writings (cf. Editor's Note), but the project did not come to term until now, nearly thirty years later, when there exists a much broader public interest in the realms of knowledge that Coomaraswamy investigated.

During the years when these essays were written, Coomaraswamy lived in the town of Needham, near Boston, Massachusetts; since 1917, he had been a curator in the Department of Asiatic Art at the Boston Museum of Fine Arts. The path is intricate that led from his birthplace, Colombo, Ceylon (now Sri Lanka), to New England. Born of an eminent Ceylonese legislator and his English wife, Coomaraswamy was raised in England. The death of his father when he was only a few years old left his mother little reason to return to Ceylon. In his early twenties, after studying geology at the University of London, he went to Ceylon with the intention of surveying its mineral resources. His work prospered and gained government sponsorship, and his published findings served

as a portion of the doctoral dissertation in geology that won him a D.Sc. at the University of London in 1905. Just at this point, however, he passed through one of the changes that occurred periodically in his life. They were not subtle changes leaving the surface smooth while the depths altered, but something far more inclusive and visible. Extensive travel in Ceylon on his geological mission convinced him that its traditional culture had been unjustifiably weakened by the English and Western culture exported to it by the British (Ceylon had been a colony since the early nineteenth century). He accordingly started a movement for cultural revival, similar in character to the nationalist movement in India known as swadeshi, but less political. He also found himself drawn toward study of the traditional arts and crafts of Ceylon, then still practiced to some extent, and evident in objects of art that had survived from the precolonial Kandyan kingdom. Coomaraswamy's inclination toward art had been prepared in youth by the influence of William Morris, the craftsman, poet, and humanitarian socialist who dominated an entire sector of Victorian intellectual life; as soon as Coomaraswamy began to write about art and its social setting, he seemed an Eastern William Morris. His life at this period can be best understood as an Imitation of William Morris, a missionary extension eastward of Morris's hardy rhetoric and intense concern for crafts (as opposed to industrial production). Coomaraswamy's professional interest in geology dropped away as art historian, writer, lecturer, and social reformer appeared.

The next significant phase in Coomaraswamy's life occurred in Calcutta and north India, to which he was drawn by the extremely active swadeshi movement. The Bengali poet, Rabindranath Tagore, among others, helped to provide an intellectual and romantic character to the movement, which in Coomaraswamy's view raised it above mere politics. Coomaraswamy lived in Calcutta for several years and achieved independent stature as a spokesman for Indian values. There was at this point something very accomplished, refined, smooth about the man he had become: his writings on Indian manufactures, music, and life—their verbal elegance and emotional warmth—give the impression of one who had found himself, found his place.

Meanwhile he was building an art collection and doing art-historical research in that relaxed, *amateur* way that seems hardly possible now, although it led to such gracious works as Henry Adams' *Mont-Saint-Michel and Chartres* and to Coomaraswamy's own *Rajput Painting* (Oxford, 1916). In this book, which enlarged on earlier articles, he distin-

guished for the first time between Rajput and Moghul painting and demonstrated, in part through his own collection of Rajput works, the spectacular variety and profundity of this period of Hindu art.

Throughout the years prior to World War I, Coomaraswamy lived effortlessly between England and India: an English country gentleman in England, radical but not subversive; an Indian cultural leader in India.[1] This harmonious movement was broken by the war. Coomaraswamy could not conceive why Indians and Ceylonese should participate in a European war on behalf of their colonial oppressor, although he by no means sympathized with the enemies of the British Empire. He declared himself a conscientious objector. This attitude edged him toward legal conflict with the government, doubtless because he argued for it publicly. At the same time, in India, he was unable to generate enough interest in his new project to found a National Museum of Indian Art. Failing to gain sympathy among the politically influential English, he also found that leading Indian nationalists had little interest in what they took to be a merely "cultural" project that promised no political gain. Indian philanthropists apparently hesitated to associate themselves with this *persona* somewhat *non grata*, however well conceived his project. At the same time, in England he was threatened with the unpleasant treatment meted out to war dissenters. The personal stresses of this period can easily be imagined, but there is little sign of them in biographical sources.[2] What is clear is that Coomaraswamy, now forty years old, emerged with a brilliant new opportunity to continue his work in the young field of Indian art: Denman W. Ross, a patron of the Museum of Fine Arts in Boston, arranged for Coomaraswamy to come there with his entire art collection to found the first subdepartment of Indian art in an American museum.

Coomaraswamy settled in Boston and became a great art historian— not merely a lucky and tasteful one, such as he had been in the Calcutta years. He outgrew the nineteenth-century, *amateur* mode of art historiography and forged the sturdy series of books, articles, and catalogues that make him still a principal figure and acknowledged founding father of this branch of scholarship. The annual meeting on Indian art held under

[1] The Tamil, i.e., south Indian, ancestry of his father enabled him to identify as closely with India as with Ceylon.

[2] I cannot make this remark without adding that new biographical sources always appear; Coomaraswamy's life, as I reconstruct it, is known to me largely through the important resources in America.

the auspices of the College Art Association of America in 1973 was introduced with the idea, somewhat tongue in cheek, that all such meetings must start by either agreeing or disagreeing with Coomaraswamy's views on some matter.

He was a well-known figure in the Museum of Fine Arts, strict with himself and others but also remembered for kindnesses. There was a romantic touch to him through this time: photographs show him seated sternly at his desk in the department offices, but many who knew him recall another *rasa*, typified by a friend's memory of the tall, lanky Coomaraswamy standing in a white suit at sunset on the broad steps of the museum, with his pair of superb Afghan dogs at his side. Again, there was a certain fullness of identity: he was a central figure in world scholarship, with an erudition and keenness that required no alteration. His mind was richly furnished with things to think about for a whole life through. Good company was never lacking. Beneath the surface, however, Coomaraswamy was dissatisfied.

> Into blind darkness enter they
> That worship ignorance;
> Into darkness greater than that, as it were, they
> That delight in knowledge.[3]

It was not, of course, this particular verse that disturbed the apparent completeness of the man he was in the late 1920s; but it was verses of this kind, with all that they imply, falling on a man after all not complete, that led toward another metamorphosis. In addition to the Indian religious tradition, to which Coomaraswamy had never turned his back, there was a second influence at work: the writings of the Western metaphysician René Guénon, whom Coomaraswamy began to read in this period. In Guénon's study of the Vedānta and his powerful analysis of the spiritual emptiness of the West,[4] Coomaraswamy came in touch with a "universe of discourse," to use a term that he brings to life in the essay on Socrates in Volume 2, for which he had a deep essential predisposition.

Once again, the personal stresses of Coomaraswamy's transformation are almost entirely hidden beyond reach of biographical inquiry, but the results come into view with the publications of 1932: abandoning none of

[3] Īśā Up. IX.

[4] Cf. René Guénon, *Introduction générale a l'étude des doctrines hindoues* (Paris, 1921); *Orient et Occident* (Paris, 1924); *L'Homme et son devenir selon le vedānta* (Paris, 1925); and *La Crise du monde moderne* (Paris, 1927).

his scholarly discipline and breadth of reading, he acquired a new dimension, religious and metaphysical.

The writings on art now tended to be theoretical and conceptual, although richly illustrated with examples. They shed light on questions of most general significance, such as the nature of vision, of the creative process, of religious art; the artist's relationship with his talent, the role of art in other societies and ours, the psychology of the good spectator, who is not only delighted by high art but led to reexamine the *chiaroscuro* of his life. Coomaraswamy constructed what can without exaggeration be described as a new world of ideas regarding art. Yet it is in a certain sense a mistake, an inevitable one, to speak of his ideas as new, for they are in the first place his synthesis (and often quotation) of ideas formulated in Indian, Platonic, and other sources; and second, they are indeed *his* observations, but based on such sources and in intimate agreement with them. Nevertheless, to this second category must be assigned much of what is irreplaceable in the essays on art. To affirm this is by no means to take an "antitraditional" stand, a stand that values the receiving individual while remaining blind to the given knowledge. Coomaraswamy expressed what he called the "traditional" theory of art, expressed it in his own manner with his own formidable strengths, and from time to time his own weaknesses. The gift from tradition was extraordinary, his gifts were extraordinary.

I WOULD like to point to several recurrent themes in Volume 1. There are two paradigms of the work of art in Coomaraswamy's thought: the religious icon and the useful object. The icon, whether carved Buddha image or painted head of Christ, is a "support of contemplation"; through its traditionally prescribed iconographic features, brought to life and beauty by the artist, the spectator or worshipper is reminded of an aspect of truth. It is a truth that enters first by way of vision as an image, but it is intended to circulate more deeply in him and to transform, minutely, his inner life. The useful object "well and truly made"[5]—bowl, textile, or house—is conceived as both physically efficient and metaphysically linked to the inner life of a people by its form or ornamentation. Both kinds of work of art are functional, corresponding to different human needs. Coomaraswamy often attacked, on the one hand, works of "fine"

[5] The expression "well and truly made" is often used in the art studies; it refers to Coomaraswamy's demand for *well*-made artifacts that *truly* reflect, in an external material, the artist's inward vision.

art that are merely pleasurable to look at, but lack higher meaning, and, on the other, useful objects that are merely functional, without qualities that touch one as one puts the objects to use.

Throughout the art studies of this period, Coomaraswamy was as much concerned with expounding true principles as with presenting true art-historical data: traditional works of art from Hindu, Buddhist, mediaeval Christian, Muslim, and many other premodern sources appeared to him to be expressions of truth, truth decidedly more complete, intellectual, and moving than such truth as he generally found in Western art since the death of Leonardo. Furthermore, he did not see these traditional cultures as fundamentally opposed to each other in their conceptions of truth, although their means of expression and their emphasis differed considerably. His was an oecumenical mind, not of the cheap sort that *assumes* one thing to be much like another and so not worth fighting over, but of a sort that examines myriads of details. His concern with truth led him to such formulations as, "Connoisseurship rightly understood can be achieved only by a rectification of the whole personality, not by the mere study and collecting of works of art,"[6] and to the stirring first paragraphs of "The Nature of Buddhist Art" (see Volume 1). Fellow art historians have not been wrong to read in such passages a challenge to standard procedure.

Coomaraswamy was both art historian and pilgrim, pilgrim among the great religious and metaphysical ideas; it was not an impossible amalgam, for knowledge of art enriched his account of ideas by giving him concreteness of expression—a sense for the materiality and descriptability of ideas—while knowledge of metaphysics put his art-historical writings in touch with essences and principles. Insofar as he followed his inner necessity and merely "reported" to others through his writings, he was not disturbing to the community of scholars. "The object is a point of departure and a signpost," "no splendor but the *splendor veritatis*"[7]—these are the blameless sayings of a pilgrim. But when this pilgrim turned toward the more stationary (or differently directed) community around him, he was apt to seem, apt to be, a prophet, speaking harshly against the status quo. This was in part Coomaraswamy's fate; he delighted in it, and could not evade it. The relative unpopularity of his approach, the lukewarm praise from many (for which the intensity of certain of his friendships among seekers and scholars amply compensated) sharpened

[6] "The Part of Art in Indian Life," Volume 1 95.
[7] "The Nature of Buddhist Art," Volume 1, 154, 162.

his mind. And so there came from him the veritable cascade of aphorisms and the deeply poetic but precisely formulated passages that are the man at his best.

Coomaraswamy's treatment of literary symbolism deserves brief comment. In several essays at the end of Volume 1, he develops a repertoire of traditional symbols or figures, each immemorially old, well known in myth, epic, romance, and fairy tale. They acquire layers of meaning through analysis and comparative study, and finally appear to be possessed of immense potential for expression, inexhaustible by any particular work of art. The dangerous gate, the bridge, disguising, forgetting, the ordeal, the boon—these are a few of the motifs, keyed to traditional religious and metaphysical principles, that he examines. They lend themselves to independent study as if works of art themselves, separable from the literary works in which they appear. It is possible to drown in the details of Coomaraswamy's essays on traditional literature; this conception of precise symbolic motifs, migrating from tale to tale, may be of use in keeping afloat.

It would be useful to consider whether Coomaraswamy was a conservative, and if so, whether his conservatism impedes our contemporary strivings. Certainly his single-minded interest in traditional religious art, and the psychology of the artists and patrons who needed it, was conservative and backward-looking. He viewed the modern world as a cul-de-sac. Yet he wished very much for a bright continuation to culture. It was this that gave him so much energy to examine the artistic principles and forms of the premodern world. He had, I think, very little hope for the modern world, yet he acted as if he could contribute to a splendid new day. In this paradox is the man: his mind told him that the truth of the Vedic rishis, the severe psychology and compassionate teaching of the Buddha, the clear light of Plato, the visionary grandeur of Plotinus, the Christian insight into God's intimacy with man—that all of these, and the arts that expressed them, are dead letters in the modern world. But his writings betray hope that these things could be assimilated. In his wish that we "somehow get back to first principles"—particularly in the disarmed simplicity of this phrase, which he used at times—it can be recognized that he did not know how the modern world could make this change, but that he knew what sort of change it is.

With regard to art itself: he damned modern art, no doubt unfairly, but this negative view is redeemed many times over by his brilliant and

positive account of traditional art. The painters Albert Gleizes and Morris Graves, the composer John Cage, the sculptor and typographer Eric Gill, the choreographer Erick Hawkins, the poet Kathleen Raine—these may not be the only artists of this century who can find themselves at home with his ideas and find in them grounds for some part of their personal evolution as artists. His essays were not meant to pile laurels upon the dead, but to quicken the living.

THE metaphysical essays of Volume 2 represent the other half of his synthesis of culture. There is not here a smoothly integrated system, nor can it be denied that the essays themselves are more than that; they remain separate essays, separate avenues of approach to a common goal—uniform, but not unified like the chapters of a book. Nonetheless, we encounter a consistent "foreign" culture, Coomaraswamy's culture as it formed late in life. Certain kinds of knowledge are proposed for study, as well as sources and methods for study, the whole accompanied by a warning that this constitutes only "intellectual preparation,"[8] wayfaring, and not journey's end. The language of this culture and its typical ideas will convince many readers that they have strayed into a foreign land, although Coomaraswamy argues from the very beginning that this foreign land is really our forgotten homeland.

> Becoming is not a contradiction of being but the epiphany of being.[9]

> From one point of view, embodiment is a humiliation, and from another a royal procession.[10]

> Our life is a combustion.[11]

> If an ultimate "end" is accomplished in him who understands (*rasika, ya evaṃ vidvān*), that befalls not in pursuit of any end, but by a disordering of anything to any end, as an act of understanding, not of will.[12]

[8] The phrase, an important one for Coomaraswamy, is used in certain letters quoted in Roger Lipsey, *Coomaraswamy: His Life and Work* (Princeton, 1977) and is strongly implied by such a discussion as that which concludes "Who is 'Satan' and Where is 'Hell'?" (Volume 2).

[9] "On the Indian and Traditional Psychology, or rather Pneumatology," Volume 2, 336n.

[10] "Literary Symbolism," Volume 1, 326.

[11] "On the Indian and Traditional Psychology," Volume 2, 340n.

[12] "The Part of Art in Indian Life," Volume 1, 92n.

Coomaraswamy sought knowledge of being, part of which is knowledge of becoming. As piece after piece became clear to him intellectually, he wrote of it. The essays are often encyclopedic, and only tiring in this respect; an unfriendly critic would liken them in places to an overworked telephone switchboard. But within the intricate mass of references to Indian, Greek, Christian, Muslim, and Gnostic sources, there are sudden clearings, moments when Coomaraswamy synthesizes the meanings that have been attained or refines a thought to the point that it shines. For example, Christians may recognize in his sentence on embodiment, quoted just above, a stirring evocation of the meaning of the Incarnation.

Coomaraswamy did not wish to be quite the *emissary* of the culture he found in traditional religious and metaphysical writings; he did not travel lightly, as emissaries do. On the contrary, he brought his entire library with him. His mind was such that, when he wished, he could write without references and still communicate a high order of meaning; several of the essays, particularly among the introductory and unpublished ones adapted from lectures, make this clear. But generally he investigated a theme as it is treated in a multiplicity of trusted sources, giving the reader not only his own reflections but the passages themselves where the theme appears. This makes him at first difficult to read—there is a habit to be acquired—but in the long run one is grateful to have the texts. Their presence, and that of still more brief references that might be consulted, makes the essays nearly limitless in instruction: one can pursue ideas to their limit, to one's limit. The major conceptions of traditional metaphysics have been thought and rethought through centuries, often not diluted or distorted by perennation, but better understood; the essays foster an appetite to know these revisions of understanding. Sacrificed for the sake of comprehensiveness is at times a certain beauty of form, but Coomaraswamy lightens even the most encyclopedic study by the exquisite poetry of the occasional passage or the stunning precision of a summary. This is, in sum, a working literature, at times as inelegant as a manual, and as useful.

Coomaraswamy nonetheless knew that beauty of expression is not just a superficial criterion to be applied when one judges the value of less high-minded authors than himself; it can also be the measure of an author's repose in his subject, of the degree to which his being is occupied by his theme. The essays would be much the poorer had Coomaraswamy excluded the kinds of phrases that surely just "came to him"; but he, who wrote so movingly of the marriage of Manas and Vāc, Mind

and Voice, as the paternity of literature,[13] clearly welcomed such phrases and bound them to his purpose.

Such, then, are the metaphysical essays: on the one hand, encyclopedic collections of traditional data on a given theme, and on the other, the meditative language of Coomaraswamy himself: often strictly intellectual, pursuing a thought through its changes, but at times poetic in the sense that his being as a whole recorded its response to the ideas being entertained. The latter point has not frequently been made concerning these essays, as if, out of respect for a very great mind, one should not mention its instinctive support, its various marriages. As a young man, it is worth noting, Coomaraswamy was a terrible poet. His actual verse, such of it as was published, was stylistically an odd scramble of William Morris and Bengali love lyrics. The poetic prose of his late years, where it appears, resulted from close work with traditional texts such as the *Ṛg Veda* and *Upaniṣads*, the *Mathnawī* of Rūmī, and the Bible, all of which employ intensely poetic language. They must little by little have tempered his innate skill.

Coomaraswamy had intended to devote his years of retirement to contemplative discipline,[14] as well as to translating anew certain Indian scripture. However, he died shortly before retiring from the Museum of Fine Arts. He was a curious sort of pioneer, one who went backward to abandoned lands of the spirit. But he did so as a modern man, as burdened as any of us, and the understandings that he found prompted him to say, with the *Upaniṣad*,

All else is but a tale of knots.[15]

Roger Lipsey

[13] Coomaraswamy discusses this in a number of places in these volumes, e.g., "A Figure of Speech or a Figure of Thought?" Volume 1, 36–37.

[14] Cf. "The Seventieth Birthday Address," Volume 2.

[15] This line is from Coomaraswamy's translation of MU VI.34; cf. "Manas," Volume 2, 211.

THE INDIAN TEMPLE

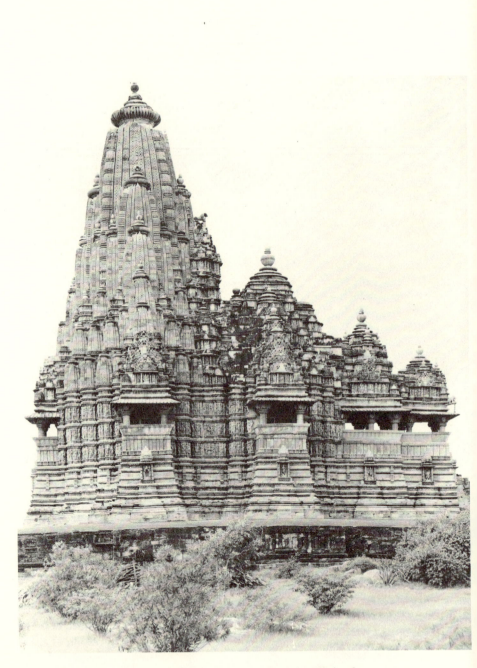

Figure 1. Kandarya Mahadeo Temple, Khajuraho

An Indian Temple:
The Kandarya Mahadeo

The nature of the present symposium suggests the use of a single illustration, but the reader is asked to understand that my subject in the present short article is really that of *the* Hindu temple, irrespective of period and relative complexity or simplicity. The choice of this subject is one that is made especially appropriate by the recent [1946] publication of Dr. Stella Kramrisch's magnificent work, *The Hindu Temple.*

It may be remarked, in the first place, that the most essential part of the concept of a temple is that of an altar on which, or a hearth in which, offerings can be made to an invisible presence that may or may not be represented iconographically. The types of the oldest shrines are those of the "stone tables"[1] of megalithic cults and those of the stone altars of tree or pillar cults;[2] or the shrine may be a hearth, the burnt offering being conveyed to the gods with the smoke of the fire, Agni thus functioning as missal priest. In all these cases the shrine, even when walled or fenced about, remains hypaethral,[3] open to the sky. On the other hand, the oldest Indian type of sacred architecture both enclosed and roofed is that of the *sadas* ("seat," the sacrificial operation being itself a *sattra,* "session") of the Vedic Sacrifice or Mass. Made only for temporary use, this enclosure is a place "apart" (*tiras, antarhita*) to which the gods resort and in which the Sacrificer, having put on the "garment of initiation

[Published both in *Art in America,* XXXV (1947), and in *Śilpi,* II (1947), the article was Coomaraswamy's contribution to the American review's special issue on the theme "Art as Symbol."—ED.]

[1] Cf. J. Layard, *Stone Men of Malekula* (London, 1942), pp. 625, 701, on dolmens as altars, used also as seats.

[2] Cf. Coomaraswamy, *Yakṣas* [I], 1928, p. 17.

[3] Cf. Coomaraswamy, "Early Indian Architecture: II. Bodhigharas," 1930. The Greek word (as applied to Cynics and Indian Gymnosophists) = *abhokāsika* (as applied to Buddhist monks); cf. *vivattacado* ("whose roof has been opened up," said of a Buddha).

and ardor," sleeps, becoming "as it were one of themselves" for the time being; he becomes, indeed, an embryo, and is reborn from the sacred enclosure as from a womb.[4] This "hut or hall is a microcosm," of which the corners, for example, are called the "four quarters."[5] At the same time, it must be recognized that no fundamental distinction can be made between the god-house as such and the dwellings of men, whether huts or palaces, as is evident in the case of those cultures, notably the Indian, in which the paterfamilias himself officiates as household priest, daily performing the Agnihotra in the domestic circle.

In addition to this, it must be realized that in India, as elsewhere, not only are temples made with hands, the universe in a likeness, but man himself is likewise a microcosm and a "holy temple"[6] or City of God (*brahmapura*).[7] The body, the temple, and the universe being thus analogous, it follows that whatever worship is outwardly and visibly performed can also be celebrated inwardly and invisibly, the "gross" ritual being, in fact, no more than a tool or support of contemplation, the external means having (just as had been the case in Greece) for its "end and aim the knowledge of Him who is the First, the Lord, and the Intelligible"[8]—as distinguished from the visible. It is recognized also, of course, that the "whole earth is divine," i.e., potentially an altar, but that a place is necessarily selected and prepared for an actual Sacrifice, the validity of such a site depending not upon the site itself but on that of the sacerdotal art; and such a site is always theoretically both on a high place and at the center or navel of the earth, with an eastward orientation, since it is "from the east westwards that the gods come unto men."[9]

It is constantly emphasized, accordingly, that the Sacrifice is essentially a mental operation, to be performed both outwardly and inwardly, or in any case inwardly. It is prepared by the Sacrificer's "whole mind and whole self." The Sacrificer is, as it were, emptied out of himself, and is himself the real victim.[10] The true end of the cult is one of reintegration and resurrection, attainable not by a merely mechanical performance of the service, but by a full realization of its significance, or even by this comprehension alone.[11] The Agnihotra, or burnt offering, for example, may

[4] ŚB iii.1.1.8, iii.1.3.28; TS vi.1.1.1, vi.2.5.5.

[5] TS vi.1.1.1, with Keith's comment in HOS, XIX, 483, n. 4.

[6] i Cor. 3:16, 17. [7] AV x.2.30; CU viii.1.1–5.

[8] Plutarch, *Moralia* 352A. [9] ŚB i.1.2.23, iii.1.1.1, 4.

[10] ŚB ii.4.1.11, iii.3.4.21, iii.8.1.2, ix.5.1.53.

[11] ŚB x.4.2.31, x.4.3.24.

be—and is for the comprehensor—an interior self-sacrifice, in which the heart is the altar, the outer man the offering, and the flame the dompted self.[12]

The human frame, the constructed temple, and the universe being analogical equivalents, the parts of the temple correspond to those of the human body no less than to those of the universe itself.[13] All these dimensioned (*nirmita, vimita*) forms are explicitly "houses," indwelt and filled by an invisible Presence and representing its possibilities of manifestation in time and space; their *raison d'être* is that it may be known. For this unifying and constructive Principle, the Spirit or Self of all beings, is only apparently confined by its habitations which, like other images, serve as supports of contemplation, none being ends in themselves but more or less indispensable means to liberation from every sort of enclosure. The position, in other words, is primarily iconolatrous, but teleologically iconoclastic.

Each of the "houses" we are considering is dimensioned and limited in six directions, nadir, quarters, and zenith—the feet, floor, or earth; bulk, interior space, or atmospheric space; and cranium, roof, or sky— defining the extent of this man, this church, and this world respectively. Here we can consider only one or two particular aspects of these and other analogies. The temple has, for example, windows and doors from which the indweller can look out and go forth, or conversely return to himself; and these correspond in the body to the "doors of the senses" through which one can look out in times of activity, or from which one can return to the "heart" of one's being when the senses are withdrawn from their objects, i.e., in concentration. There is, however, in theory, another door or window, accessible only by a "ladder" or the "rope" by which our being is suspended from above, and through which one can emerge from the dimensioned structure so as to be no longer on a level with its ground, or within it, but altogether above it. In man, this exit is represented by the cranial foramen, which is still unclosed at birth, and is opened up again at death when the skull is ritually broken, though as regards its significance it may be kept open throughout one's life by appropriate spiritual exercises, for this God-aperture (*brahma-randhra*) corresponds to the "point" or "eye of the heart," the microcosmic City

[12] ŚA x; ŚB x.5.3.12; S 1.169.
[13] Cf. Stella Kramrisch, *The Hindu Temple* (Calcutta, 1946), II, 357–61, "The Temple as Puruṣa."

5

of God (*brahmapura*) within us, from which the Spirit departs at death.[14] Architecturally, the *brahma-randhra* or foramen of the human cranium or man-made temple corresponds to the luffer, smoke hole, or skylight (*Lichtloch*) of the traditional house; and in some ancient and even relatively modern Western temples, this oculus of the dome still remains an open circular window, and the structure therefore remains hypaethral.[15] In the early Indian timbered domes, the opening above is apparently closed by the circular roof-plate (*kannikā*) on which the rafters rest like the spokes of a wheel or the ribs of an umbrella, but this plate is perforated, and in any case functions as a doorway or place of exit through which the Perfected (Arahants) movers-at-will and "skyfarers" are repeatedly described as making their departure; it is an "upper door" (*agga-dvāra*).[16] In later Indian lithic structures, in the same way the

[14] BU IV.4.2; CU VIII.1.1–4; Haṃsa Up. 1.3. For the breaking of the skull, see *Gāruḍa Purāṇa* x.56–59, *bhitvā brahmarandhrakam*, corresponding to *bhitvā kannikā-maṇḍalam* architecturally (DhA III.66) and to *bhitvā sūryamaṇḍalam* ("breaking through the solar disk") microcosmically (MU VI.30). In the Purāṇa, this "breaking through" represents explicitly the rebirth of the deceased from the sacrificial fire in which the body is burnt; cf. JUB III.11.7.

For the "eye of the heart," cf. J. A. Comenius, *The Labyrinth of the World* (1631, based on J. V. Andreae, *Civis Christianus*), tr. Spinka (Chicago, 1942), chs. 37, 38, 40 ("in the vault of this my chamber, a large round window above," approachable only by ladders; through it on the one hand Christ looks down from above, and on the other "one could peer out into the beyond").

[15] For instance, the Roman Pantheon; cf. Piranesi's engraving of the Tempio della Tossa. "Even today lest he [Terminus] see aught above him but the stars, have temple roofs their tiny aperture" ("exiguum . . . foramen," Ovid, *Fasti* II.667–668). For Islamic architecture, cf. E. Diez in *Ars Islamica*, V (1938), 39, 45: "Space was the primary problem and was placed in relation to, and dependence on, infinite space by means of the widely open *opaion* in the zenith of the cupola. This relation to open space was always emphasized by the skylight lantern in Western architecture. . . . Islamic art appears as the individuation of its metaphysical basis (*unendlichen Grund*)."

[16] See Coomaraswamy, "The Symbolism of the Dome," "Pāli *kannikā*," and "Svayamātṛṇṇā: Janua Coeli" [all in this volume—ED.]; for the *agga-dvāra*, cf. Coomaraswamy, "Some Sources of Buddhist Iconography," 1945, p. 473, n. 12. For the exit via the roof, cf. *Odyssey* 1.320 where Athene, leaving Odysseus' house, "flew like a bird through the oculus"; Cross and Slover, *Ancient Irish Tales* (1936), p. 92, "And he [the god Mider] carried her [Etain] off through the smokehole of the house . . . and they saw two swans circling"; and H. Rink, *Tales and Traditions of the Eskimo* (London and Edinburgh, 1875), pp. 60, 61, when "the angakok [shaman] had to make a flight, he started through an opening which appeared of itself in the roof."

It is through the cosmic opening that the Man, the Son of God, looks down, and descends (Hermes, *Lib.* 1.14). And just as the *kannikā* is a symbol of *samādhi*, "syn-

summit of the spire is apparently closed by a circular stone slab (*āmalaka*), but this, too, is perforated for the reception of the tenon of the finial that prolongs the central axis of the whole structure; and the term *brahma-randhra* remains in use. Finally, in the world of which the sky is the roof, the Sun himself is the Janua Coeli, the "gateway of liberation" (*mokṣa-dvāra*), the only way by which to break out of the dimensioned universe, and so "escape altogether."[17]

We have considered so far the altar (always in some sense a sacrificial hearth, analogous to the heart) and the oculus of the dome (always in some sense a symbol of the Sun) as the proximate and ultimate goals of the worshiper who comes to visit the deity, whose man-made "house" is the temple, there to devote himself. The altar, like the sacred hearth, is always theoretically at the center or navel of the earth, and the solar eye of the dome is always in the center of the ceiling or *coelum* immediately above it; and these two are connected in principle, as in some early structures they were in fact, by an axial pillar at once uniting and separating floor and roof, and supporting the latter; as it was in the beginning, when heaven and earth, that had been one, were "pillared apart" by the Creator.[18] It is by this pillar—regarded as a bridge[19] or ladder, or, because of its immateriality, as a bird on wings,[20] and regarded in any case from

thesis," so is this Greek capstone a "harmony," as Pausanias says, "of the whole edifice" (Pausanias, VIII.8.9 and IX.38.7).

In connection with the term *agga-dvāra* it may be observed that *agga* (= *agra*, cf. Plato, *Phaedrus* 247B and Philo, *De opificio mundi* 71), "summit," is predicated of the Buddha (A II.17, D III.147), who "opens the doors of immortality" (Vin 1.7, D II.33, M 1.167) and is in this sense a "Door-God," like Agni (AB III.42) and like Christ (John 10:9; *Sum. Theol.* III.49.5), this Janua Coeli being the door at which the Buddhas are said to stand and knock (S II.58).

Further pertinent material will be found in P. Sartori, "Das Dach im Volks-glauben," *Zeit. des Vereins f. Volkskunde*, XXV (1915), 228-241; K. Rhamm as reviewed by V. Ritter von Geramb, *ibid.*, XXVI (1916); R. Guénon, "Le Symbolisme du dôme," *Études traditionelles*, XLIII (1938); F. J. Tritsch, "False Doors in Tombs," JHS, LXIII (1943), 113-115; and more generally in W. R. Lethaby, *Architecture, Mysticism, and Myth* (New York, 1892).

[17] JUB 1.3.5, i.e., "through the midst of the Sun," JUB 1.6.1, the Janua Coeli, JUB IV.14.5, IV.15.4 and 5, or the "Sundoor" of MU VI.30 and Muṇḍ. Up. 1.2.11.

[18] RV *passim*. In general, the axial column of the universe is a pillar (*mita*, *sthūnā*, *vaṃśa*, *skambha*, etc.) of Fire (RV 1.59.1, IV.5.1, X.5.6) or Life (RV X.5.6) or solar Light (JUB 1.10.10), Breath or Spirit (*ranāḥ*, *passim*), i.e., the Self (*ātman*, BU IV.4.22). The primordial separation of heaven and earth is common to the creation myths of the whole world.

[19] D. L. Coomaraswamy, "The Perilous Bridge of Welfare," HJAS, VIII (1944).

[20] PB V.3.5.

its base, for "there is no side path here in the world"[21]—that the "hard ascent after Agni" (*dūrohaṇa, agner anvārohaḥ*)[22] must be made from below to the Sundoor above; an ascent that is also imitated in countless climbing rites, and notably in that of the ascent of the sacrificial post (*yūpa*) by the Sacrificer who, when he reaches its summit and raises his head above its capital, says on behalf of himself and his wife: "We have reached the heaven, reached the gods; we have become immortals, become the children of Prajāpati."[23] For them the distance that separates heaven from earth is temporarily annihilated; the bridge lies behind them.

The nature and full significance of the cosmic pillar (*skambha*), the Axis Mundi referred to above, can best be grasped from its description in *Atharva Veda* x.7 and 8,[24] or understood in terms of the Islamic doctrine of the Qutb, with which the Perfect Man is identified, and on which all things turn. In the Vedic *Sadas* it is represented by the king-post (*sthūṇa-rāja*, or *śālā-vaṃśa*) that the Sacrificer himself erects, and that stands for the Median Breath,[25] in the same way as within man, as the axial principle of one's own life and being.[26] In the Vedic (Fire-) altar, a constructed image of the universe, this is also the axial principle that passes through the three "self-perforated bricks" (*svayamātṛṇṇā*), of which the uppermost corresponds to the Sundoor of the later texts; it is an axis that—like Jacob's ladder—is the "way up and down these worlds." In visiting the deity whose image or symbol has been set up in the womb of the temple, the worshiper is returning to the heart and center of his own being to perform a devotion that prefigures his ultimate resurrection and regeneration from the funeral pyre in which the last Sacrifice is made.

We are thus brought back again to the concept of the three analogous—bodily, architectural, and cosmic—"houses" that the Spirit of Life inhabits and fills; and we recognize at the same time that the values of the oldest

[21] MU vi.30.

[22] TS v.6.8; AB iv.20–22.

[23] TS i.7.9, v.6.8, vi.6.4.2; ŚB v.2.1.15. Cf. Coomaraswamy, "*Svayamātṛṇṇā: Janua Coeli*" [in this volume—ED.].

[24] AV x.7.35 and 8.2, "The *skambha* sustains both heaven and earth . . . and hath inhabited all existences. . . . Whereby these twain are pillared apart, therein is all this that is enspirited (*ātmanvat*), all that breathes and blinks."

[25] AĀ iii.1.4, iii.2.1; SA viii; cf. Coomaraswamy, "The Sun-kiss," 1940, p. 58, n. 30.

[26] BU ii.2.1, where in the subtle and gross bodies of individuals, "the Median Breath is the pillar" (*madhyamaḥ prāṇaḥ . . . sthūṇā*).

8

architectural symbolism are preserved in the latest buildings and serve to explain their use.[27] I shall only emphasize, in conclusion, what has already been implied, that the Indian architectural symbolism briefly outlined above is by no means peculiarly or exclusively Indian, but rather worldwide. For example, that the sacred structure is a microcosm, the world in a likeness, is explicit among the American Indians; as remarked by Sartori, "Among the Huichol Indians . . . the temple is considered as an image of the world, the roof as heaven, and the ceremonies which are enacted during the construction almost all relate to this meaning,"[28] and as related by Speck in his description of the Delaware Big-House, "the Big-House stands for the universe; its floor, the earth; its four walls, the four quarters; its vault, the sky-dome atop, where resides the Creator in his indefinable supremacy . . . the centre-post is the staff of the Great Spirit with its foot upon the earth, with its pinnacle reaching to the hand of the Supreme Being sitting on his throne."[29] In the same way, from the Indian point of view, it is said with respect to the way up and down that "within these two movements the Hindu temple has its being; its central pillar is erected from the heart of the Vāstupuruṣa in the Brahmasthāna,

[27] "En effet, il est bien connu que la construction de l'autel du feu est un sacrifice personnel déguisé. . . . L'activité artistique de l'Inde s'est toujours ressentie, nous l'avons reconnu, de ce que la première oeuvre d'art brāhmanique ait été un autel où le donataire, autrement dit le sacrifiant, s'unissait à son dieu," Paul Mus, *Barabuḍur* (Paris, 1935), I, *92, *94.

[28] Sartori, "Das Dach im Volksglauben," p. 233.

[29] F. G. Speck, on the Delaware Indian big-house, cited from *Publications of the Pennsylvania Historical Commission*, II (1931), by W. Schmidt, *High Gods in North America* (Oxford, 1933), p. 75. Fr. Schmidt remarks, p. 78, that "the Delawares are perfectly right in affirming this, the fundamental importance of the centre-post," and points out that the same holds good for many other Indian tribes, amongst whom "the centre-post of the ceremonial hut has a quite similar symbolical function and thus belongs to the oldest religious elements of North America."
On the importance of the center-post, cf. also J. Strzygowski, *Early Church Art in Northern Europe* (New York, 1928), p. 141, in connection with the mast-churches of Norway: "The steeple marking the apex of the perpendicular axis appears to be a relic of the time when the only type was the one-mast church." For China, cf. G. Ecke, "Once More Shen-T'ung Ssu and Ling-Yen Ssu," *Monumenta Serica*, VII (1942), 295 ff. Cf. the invocatory verse of the *Daśakumāracarita*: "May the staff of His foot, the Three-strider's (Viṣnu), bear thee across—viz. the staff of the umbrella of the Brahmāṇḍa, the stalk of the Hundred-Sacrificer's (Brahmā's) cosmic lotus, the mast of the ship of the earth, the flag pole of the banner of the nectar-shedding river, the pole of the axis of the planetary sphere, the pillar of victory over the three worlds, and death-dealing club of the foes of the gods—may this be thy means of crossing over."

from the center and heart of existence on earth, and supports the Prasāda Puruṣa in the Golden Jar in the splendor of the Empyrean."[30]

Finally, inasmuch as the temple is the universe in a likeness, its dark interior is occupied only by a single image or symbol of the informing Spirit, while externally its walls are covered with representations of the Divine Powers in all their manifested multiplicity. In visiting the shrine, one proceeds inwards from multiplicity to unity, just as in contemplation; and on returning again to the outer world, one sees that one has been surrounded by all the innumerable forms that the Sole Seer and Agent within assumes in his playful activity. And this distinction between the outer world and the inner shrine of an Indian temple, into which one enters "so as to be born again from its dark womb,"[31] is the same distinction Plotinus makes when he observes that the seer of the Supreme, being one with his vision, "is like one who, having penetrated the inner sanctuary, leaves the temple images behind him—though these become once more first objects of regard when he leaves the holies; for There his converse was not with image, not with trace, but with the very Truth."[32]

The deity who assumes innumerable forms, and has no form, is one and the same Puruṣa, and to worship in either way leads to the same liberation: "however men approach Me, even so do I welcome them."[33] In the last analysis, the ritual, like that of the old Vedic Sacrifice, is an interior procedure, of which the outward forms are only a support, indispensable for those who—being still on their way—have not yet reached its end, but that can be dispensed with by those who have already found the end, and who, though they may be still in the world, are not of it. In the meantime, there can be no greater danger or hindrance than that of the premature iconoclasm of those who still confuse their own existence with their own being, and have not yet "known the Self"; these are the vast majority, and for them the temple and all its figurations are signposts on their way.

[30] Kramrisch, *The Hindu Temple*, II, 361.
[31] *Ibid.*, p. 358.
[32] Plotinus, *Enneads* VI.9.11.
[33] BG IV.11.

SYNOPTIC ESSAYS

A Figure of Speech or a
Figure of Thought?[1]

Ἐγὼ δὲ τέχνην οὐ καλῶ, ὃ ἂν ᾖ ἄλογον πρᾶγμα.
Plato, *Gorgias* 465A[2]

We are peculiar people. I say this with reference to the fact that whereas almost all other peoples have called their theory of art or expression a "rhetoric" and have thought of art as a kind of knowledge, we have invented an "aesthetic" and think of art as a kind of feeling.

The Greek original of the word "aesthetic" means perception by the senses, especially by feeling. Aesthetic experience is a faculty that we share with animals and vegetables, and is irrational. The "aesthetic soul" is that part of our psychic makeup that "senses" things and reacts to them: in other words, the "sentimental" part of us. To identify our approach to art with the pursuit of these reactions is not to make art "fine" but to apply it only to the life of pleasure and to disconnect it from the active and contemplative lives.

Our word "aesthetic," then, takes for granted what is now commonly assumed, viz. that art is evoked by, and has for its end to express and again evoke, emotions. In this connection, Alfred North Whitehead has remarked that "it was a tremendous discovery, how to excite emotions

[This essay was written for *Figures of Speech or Figures of Thought: Collected Essays on the Traditional or "Normal" View of Art* (London, 1946).—ED.]

[1] Quintilian IX.4.117, "Figura? Quae? cum orationis, tum etiam sententiae?" Cf. Plato, *Republic* 601B.

[2] "I cannot fairly give the name of 'art' to anything irrational." Cf. *Laws* 890D, "Law and art are children of the intellect" (νοῦς). Sensation (αἴσθησις) and pleasure (ἡδονή) are irrational (ἄλογος; see *Timaeus* 28A, 47D, 69D). In the *Gorgias*, the irrational is that which cannot give an account of itself, that which is unreasonable, has no *raison d'être*. See also Philo, *Legum Allegoriarum* 1.48, "For as grass is the food of irrational beings, so has the sensibly-perceptible (τὸ αἰσθητόν) been assigned to the irrational part of the soul." Αἴσθησις is just what the biologist now calls "irritability."

13

for their own sake."[3] We have gone on to invent a science of our likes and dislikes, a "science of the soul," psychology, and have substituted psychological explanations for the traditional conception of art as an intellectual virtue and of beauty as pertaining to knowledge.[4] Our current resentment of meaning in art is as strong as the word "aesthetic" implies. When we speak of a work of art as "significant" we try to forget that this word can only be used with a following "of," that expression can be significant only *of* some thesis that was to be expressed, and we overlook that whatever does not mean something is literally *in-significant*. If, indeed, the whole end of art were "to express emotion," then the degree of our emotional reaction would be the measure of beauty and all judgment would be subjective, for there can be no disputing about tastes. It should be remembered that a reaction is an "affection," and every affection a passion, that is, something passively suffered or undergone, and not—as in the operation of judgment—an activity on our part.[5] To equate the love of art with a love of fine sensations is to make of works of art a kind of aphrodisiac. The words "disinterested aesthetic contemplation" are a contradiction in terms and a pure non-sense.

"Rhetoric," of which the Greek original means skill in public speaking, implies, on the other hand, a theory of art as the effective expression of theses. There is a very wide difference between what is said for effect, and what is said or made to be *effective*, and must *work*, or would not have been worth saying or making. It is true that there is a so-called rhetoric of the production of "effects," just as there is a so-called poetry that consists only of emotive words, and a sort of painting that is merely spectacular; but this kind of eloquence that makes use of figures for their own sake, or merely to display the artist, or to betray the truth in courts of law, is not properly a rhetoric, but a sophistic, or art of flattery. By "rhetoric" we mean, with Plato and Aristotle, "the art of giving effectiveness to truth."[6] My thesis will be, then, that if we propose to use or understand any works of art (with the possible exception of contemporary

[3] Quoted with approval by Herbert Read, *Art and Society* (New York, 1937), p. 84, from Alfred North Whitehead, *Religion in the Making* (New York, 1926).

[4] *Sum. Theol.* I-II.57.3c (art is an intellectual virtue); 1.5.4 *ad* 1 (beauty pertains to the cognitive, not the appetitive faculty).

[5] "Pathology . . . 2. The study of the passions or emotions" (*The Oxford English Dictionary*, 1933, VII, 554). The "psychology of art" is not a science of art but of the way in which we are affected by works of art. An affection (πάθημα) is passive; making or doing (ποίημα, ἔργον) is an activity.

[6] See Charles Sears Baldwin, *Medieval Rhetoric and Poetic* (New York, 1928), p. 3. "A real art of speaking which does not lay hold upon the truth does not exist and never will" (*Phaedrus* 260E; cf. *Gorgias* 463–465, 513D, 517A, 527C, *Laws* 937E).

works, which may be "unintelligible"[7]), we ought to abandon the term "aesthetic" in its present application and return to "rhetoric," Quintilian's "bene dicendi scientia."

It may be objected by those for whom art is not a languge but a spectacle that rhetoric has primarily to do with verbal eloquence and not with the life of works of art in general. I am not sure that even such objectors would really agree to describe their own works as dumb or ineloquent. But however this may be, we must affirm that the principles of art are not altered by the variety of the material in which the artist works— materials such as vibrant air in the case of music or poetry, human flesh on the stage, or stone, metal, clay in architecture, sculpture, and pottery. Nor can one material be called more beautiful than another; you cannot make a better sword of gold than of steel. Indeed, the material as such, being relatively formless, is relatively ugly. Art implies a transformation of the material, the impression of a new form on material that had been more or less formless; and it is precisely in this sense that the creation of the world from a completely formless matter is called a "work of adornment."

There are good reasons for the fact that the theory of art has generally been stated in terms of the spoken (or secondarily, written) word. It is, in the first place, "by a word conceived in intellect" that the artist, whether human or divine, works.[8] Again, those whose own art was, like mine, verbal, naturally discussed the art of verbal expression, while those who worked in other materials were not also necessarily expert in "logical" formulation. And finally, the art of speaking can be better understood by all than could the art of, let us say, the potter, because all men make use of speech (whether rhetorically, to communicate a meaning, or sophistically, to exhibit themselves), while relatively few are workers in clay.

All our sources are conscious of the fundamental identity of all the

[7] See E. F. Rothschild, *The Meaning of Unintelligibility in Modern Art* (Chicago, 1934), p. 98. "The course of artistic achievement was the change from the visual as a means of comprehending the non-visual to the visual as an end in itself and the abstract structure of physical forms as the purely artistic transcendence of the visual . . . *a transcendence utterly alien and unintelligible* to the average [sc. normal] man" (F. de W. Bolman, criticizing E. Kahler's *Man the Measure*, in *Journal of Philosophy*, XLI, 1944, 134–135; italics mine).

[8] *Sum. Theol.* 1.45.6c, "Artifex autem per verbum in intellectu conceptum et per amorem suae voluntatis ad aliquid relatum, operatur"; 1.14.8c, "Artifex operatur per suum intellectum"; 1.45.7c "Forma artificiati est ex conceptione artificis." See also St. Bonaventura, *II Sententiarum* 1-1.1.1 *ad* 3 and 4, "Agens per intellectum producit per formas." Informality is ugliness.

arts. Plato, for example, remarks that "the expert, who is intent upon the best when he speaks, will surely not speak at random, but with an end in view; he is just like all those other artists, the painters, builders, shipwrights, etc.";[9] and again, "the productions of all arts are kinds of poetry, and their craftsmen are all poets,"[10] in the broad sense of the word. "Demiurge" (δημιουργός) and "technician" (τεχνίτης) are the ordinary Greek words for "artist" (artifex), and under these headings Plato includes not only poets, painters, and musicians, but also archers, weavers, embroiderers, potters, carpenters, sculptors, farmers, doctors, hunters, and above all those whose art is government, only making a distinction between creation (δημιουργία) and mere labor (χειρουργία), art (τέχνη) and artless industry (ἄτεχνος τριβή).[11] All these artists, insofar as they are really makers and not merely industrious, insofar as they are musical and therefore wise and good, and insofar as they are in possession of their art (ἔντεχνος, cf. ἔνθεος) and governed by it, are infallible.[12] The primary meaning of the word σοφία, "wisdom," is that of "skill," just as Sanskrit kauśalam is "skill" of any kind, whether in making, doing, or knowing.

Now what are all these arts for? Always and only to supply a real or an imagined need or deficiency on the part of the human patron, for whom as the collective consumer the artist works.[13] When he is working for himself, the artist as a human being is also a consumer. The necessi-

[9] *Gorgias* 503E. [10] *Symposium* 205C.

[11] See, for example, *Statesman* 259E, *Phaedrus* 260E, *Laws* 938A. The word τριβή literally means "a rubbing," and is an exact equivalent of our modern expression "a grind." (Cf. Hippocrates, *Fractures* 772, "shameful and artless," and Ruskin's "industry without art is brutality.") "For all well-governed peoples there is a work enjoined upon each man which he must perform" (*Republic* 406C). "Leisure" is the opportunity to do this work without interference (*Republic* 370C). A "work for leisure" is one requiring undivided attention (Euripides, *Andromache* 552). Plato's view of work in no way differs from that of Hesiod, who says that work is no reproach but the best gift of the gods to men (*Works and Days* 295–296). Whenever Plato disparages the mechanical arts, it is with reference to the kinds of work that provide for the well-being of the body only, and do not at the same time provide spiritual food; he does not connect culture with idleness.

[12] *Republic* 342BC. What is made by art is correctly made (*Alcibiades* 1.108B). It will follow that those who are in possession of and governed by their art and not by their own irrational impulses, which yearn for innovations, will operate in the same way (*Republic* 349–350, *Laws* 660B). "Art has fixed ends and ascertained means of operation" (*Sum. Theol.* II-II.47.4 *ad* 2, 49.5 *ad* 2). It is in the same way that an oracle, speaking *ex cathedra*, is infallible, but not so the man when speaking for himself. This is similarly true in the case of a guru.

[13] *Republic* 369BC, *Statesman* 279CD, *Epinomis* 975C.

ties to be served by art may appear to be material *or* spiritual, but as Plato insists, it is one and the same art—or a combination of both arts, practical and philosophical—that must serve both body and soul if it is to be admitted in the ideal City.[14] We shall see presently that to propose to serve the two ends separately is the peculiar symptom of our modern "heartlessness." Our distinction of "fine" from "applied" art (ridiculous, because the fine art itself is applied to giving pleasure) is as though "not by bread alone"[15] had meant "by cake" for the elite that go to exhibitions and "bread alone" for the majority and usually for all. Plato's music and gymnastics, which correspond to what we seem to intend by "fine" and "applied" art (since one is for the soul and the other for the body), are never divorced in his theory of education; to follow one alone leads to effeminacy, to follow only the other, to brutality; the tender artist is no more a man than the tough athlete; music must be realized in bodily graces, and physical power should be exercised only in measured, not in violent motions.[16]

It would be superfluous to explain what are the material necessities to be served by art: we need only remember that a censorship of what ought or ought not to be made at all should correspond to our knowledge of what is good or bad for us. It is clear that a wise government, even a government of the free by the free, cannot permit the manufacture and sale of products that are necessarily injurious, however profitable such manufacture may be to those whose interest it is to sell, but must insist upon those standards of living to secure which was once the function of the guilds and of the individual artist "inclined by justice, which rectifies the will, to do his work faithfully."[17]

As for the spiritual ends of the arts, what Plato says is that we are endowed by the gods with vision and hearing, and harmony "was given by the Muses to him that can use them intellectually (μετὰ νοῦ), not as an aid to irrational pleasure (ἡδονὴ ἄλογος), as is nowadays supposed,

[14] *Republic* 398A, 401B, 605–607; *Laws* 656c.

[15] Deut. 8:3, Luke 4:4.

[16] *Republic* 376E, 410A–412A, 521E–522A, *Laws* 673A. Plato always has in view an attainment of the "best" for both the body and the soul, "since for any single kind to be left by itself pure and isolated is not good, nor altogether possible" (*Philebus* 63B; cf. *Republic* 409–410). "The one means of salvation from these evils is neither to exercise the soul without the body nor the body without the soul" (*Timaeus* 88B).

[17] *Sum. Theol.* I-II.57.3 *ad* 2 (based on Plato's view of justice, which assigns to every man the work for which he is naturally fitted). None of the arts pursues its own good, but only the patron's (*Republic* 342B, 347A), which lies in the excellence of the product.

17

but to assist the soul's interior revolution, to restore it to order and concord with itself. And because of the want of measure and lack of graces in most of us, rhythm was given us by the same gods for the same ends";[18] and that while the passion ($\pi\acute{\alpha}\theta\eta$) evoked by a composition of sounds "furnishes a pleasure-of-the-senses ($\dot{\eta}\delta ov\acute{\eta}$) to the unintelligent, it (the composition) bestows on the intelligent that heartsease that is induced by the imitation of the divine harmony produced in mortal motions."[19] This last delight or gladness that is experienced when we partake of the feast of reason, which is also a communion, is not a passion but an ecstasy, a going out of ourselves and being in the spirit: a condition insusceptible of analysis in terms of the pleasure or pain that can be felt by sensitive bodies or souls.

The soulful or sentimental self enjoys itself in the aesthetic surfaces of natural or artificial things, to which it is akin; the intellectual or spiritual self enjoys their order and is nourished by what in them is akin to it. The spirit is much rather a fastidious than a sensitive entity; it is not the physical qualities of things, but what is called their scent or flavor, for example "the picture not in the colors," or "the unheard music," not a sensible shape but an intelligible form, that it tastes. Plato's "heartsease" is the same as that "intellectual beatitude" which Indian rhetoric sees in the "tasting of the flavor" of a work of art, an immediate experience, and congeneric with the tasting of God.[20]

This is, then, by no means an aesthetic or psychological experience but implies what Plato and Aristotle call a *katharsis*, and a "defeat of the sensations of pleasure" or pain.[21] *Katharsis* is a sacrificial purgation and purification "consisting in a separation, as far as that is possible, of the soul from the body"; it is, in other words, a kind of dying, that kind of dying to which the philosopher's life is dedicated.[22] The Platonic *katharsis* implies an ecstasy, or "standing aside" of the energetic, spiritual, and imperturbable self from the passive, aesthetic, and natural self, a "being out of oneself" that is a being "in one's right mind" and real

[18] *Timaeus* 47DE; cf. *Laws* 659E, on the chant.

[19] *Timaeus* 80B, echoed in Quintilian IX.117, "docti rationem componendi intelligunt, etiam indocti voluptatem." Cf. *Timaeus* 47, 90D.

[20] *Sāhitya Darpaṇa* III.2-3; cf. Coomaraswamy, *The Transformation of Nature in Art*, 1934, pp. 48-51.

[21] *Laws* 840C. On *katharsis*, see Plato, *Sophist* 226-227, *Phaedrus* 243AB, *Phaedo* 66-67, 82B, *Republic* 399E; Aristotle, *Poetics* VI.2.1449b.

[22] *Phaedo* 67DE.

Self, that "in-sistence" that Plato has in mind when he "would be born again in beauty inwardly," and calls this a sufficient prayer.[23]

Plato rebukes his much-beloved Homer for attributing to the gods and heroes all-too-human passions, and for the skillful imitations of these passions that are so well calculated to arouse our own "sym-pathies."[24] The *katharsis* of Plato's City is to be effected not by such exhibitions as this, but by the banishment of artists who allow themselves to imitate all sorts of things, however shameful. Our own novelists and biographers would have been the first to go, while among modern poets it is not easy to think of any but William Morris of whom Plato could have heartily approved.

The *katharsis* of the City parallels that of the individual; the emotions are traditionally connected with the organs of evacuation, precisely because the emotions are waste products. It is difficult to be sure of the exact meaning of Aristotle's better-known definition, in which tragedy "by its imitation of pity and fear effects a *katharsis* from these and like passions,"[25] though it is clear that for him too the purification is *from* the passions ($\pi\alpha\theta\dot\eta\mu\alpha\tau\alpha$); we must bear in mind that, for Aristotle, tragedy is still essentially a representation of actions, and not of character. It is certainly not a periodical "outlet" of—that is to say, indulgence in—our "pent-up" emotions that can bring about an emancipation from them; such an outlet, like a drunkard's bout, can be only a temporary satiation.[26] In what Plato calls with approval the "more austere" kind

[23] *Phaedrus* 279BC; so also Hermes, *Lib.* XIII.3, 4, "I have passed forth out of myself," and Chuang-tzu, ch. 2, "Today I buried myself." Cf. Coomaraswamy, "On Being in One's Right Mind," 1942.

[24] *Republic* 389–398.

[25] [Aristotle, *Poetics* VI.2.1449b].

[26] The aesthetic man is "one who is too weak to stand up against pleasure and pain" (*Republic* 556c). If we think of impassibility ($\dot\alpha\pi\dot\alpha\theta\epsilon\iota\alpha$, not what we mean by "apathy" but a being superior to the pulls of pleasure and pain; cf. BG II.56) with horror, it is because we should be "unwilling to live without hunger and thirst and the like, if we could not also *suffer* ($\pi\dot\alpha\sigma\chi\omega$, Skr. *bādh*) the natural consequences of these passions," the pleasures of eating and drinking and enjoying fine colors and sounds (*Philebus* 54E, 55B). Our attitude to pleasures and pains is always passive, if not, indeed, masochistic. [Cf. Coomaraswamy, *Time and Eternity*, 1947, p. 73 and notes.]

It is very clear from *Republic* 606 that the enjoyment of an emotional storm is just what Plato does not mean by a *katharsis*; such an indulgence merely fosters the very feelings that we are trying to suppress. A perfect parallel is found in the *Milinda Pañho* (Mil, p. 76); it is asked, of tears shed for the death of a mother or shed for love of the Truth, which can be called a "cure" (*bhesajjam*)—i.e. for man's

of poetry, we are presumed to be enjoying a feast of reason rather than a "break-fast" of sensations. His *katharsis* is an ecstasy or liberation of the "immortal soul" from the affections of the "mortal," a conception of emancipation that is closely paralleled in the Indian texts in which liberation is realized by a process of "shaking off one's bodies."[27] The reader or spectator of the imitation of a "myth" is to be rapt away from his habitual and passible personality and, just as in all other sacrificial rituals, becomes a god for the duration of the rite and only returns to himself when the rite is relinquished, when the epiphany is at an end and the curtain falls. We must remember that all artistic operations were originally rites, and that the purpose of the rite (as the word τελετή implies) is to sacrifice the old and to bring into being a new and more perfect man.

We can well imagine, then, what Plato, stating a philosophy of art that is not "his own" but intrinsic to the Philosophia Perennis, would have thought of our aesthetic interpretations and of our contention that the last end of art is simply to please. For, as he says, "ornament, painting, and music made only to give pleasure" are just "toys."[28] The "lover of art," in other words, is a "playboy." It is admitted that a majority of men judge works of art by the pleasure they afford; but rather than sink to such a level, Socrates says no, "not even if all the oxen and horses and animals in the world, by their pursuit of pleasure, proclaim that such is the criterion."[29] The kind of music of which he approves is not a multifarious and changeable but a canonical music;[30] not the sound of "poly-harmonic" instruments, but the simple music (ἁπλότης) of the lyre accompanied by chanting "deliberately designed to produce in the soul that symphony of which we have been speaking";[31] not the music of Marsyas the Satyr, but that of Apollo.[32]

All the arts, without exception, are imitative. The work of art can only be judged as such (and independently of its "value") by the degree to which the model has been correctly represented. The beauty of the

mortality—and it is pointed out that the former are fevered, the latter cool, and that it is what cools that cures.

[27] JUB III.30.2 and 39.2; BU III.7.3-4; CU VIII.13; Śvet. Up. v.14. Cf. *Phaedo* 65–69.

[28] *Statesman* 288c.

[29] *Philebus* 67B.

[30] *Republic* 399–404; cf. *Laws* 656E, 660, 797–799.

[31] *Laws* 659E; see also note 86, below.

[32] *Republic* 399E; cf. Dante, *Paradiso* I.13–21.

work is proportionate to its accuracy (ὀρθότης = *integritas sive perfectio*), or truth (ἀλήθεια = *veritas*). In other words, the artist's judgment of his own work by the criterion of art is a criticism based upon the proportion of essential to actual form, paradigm to image. "Imitation" (μίμησις), a word that can be as easily misunderstood as St. Thomas Aquinas's "Art is the imitation of Nature in her manner of operation,"[33] can be mistaken to mean that that is the best art that is "truest to nature," as we now use the word in its most limited sense, with reference not to "Mother Nature," Natura naturans, Creatrix Universalis, Deus, but to whatever is presented by our own immediate and natural environment, whether visually or otherwise accessible to observation (αἴσθησις). In this connection it is important not to overlook that the delineation of character (ἦθος) in literature and painting is, just as much as the representation of the looking-glass image of a physiognomy, an empirical and realistic procedure, dependent on observation. St. Thomas's "Nature," on the other hand, is that Nature "to find which," as Meister Eckhart says, "all her forms must be shattered."

The imitation or "re-presentation" of a model (even a "presented" model) involves, indeed, a likeness (ὁμοία, *similitudo*, Skr. *sādṛśya*), but hardly what we usually mean by "verisimilitude" (ὁμοιότης). What is traditionally meant by "likeness" is not a copy but an image akin (συγγενής) and "equal" (ἴσος) to its model; in other words, a natural and "ad-equate" symbol of its referent. The representation of a man, for example, must really correspond to the idea of the man, but must not look so like him as to deceive the eye; for the work of art, as regards its form, is a mind-made thing and aims at the mind, but an illusion is no more intelligible than the natural object it mimics. The plaster cast of a man will not be a work of art, but the representation of a man on wheels where verisimilitude would have required feet may be an entirely adequate "imitation" well and *truly* made.[34]

[33] Aristotle, *Physics* II.2.194a 20, ἡ τέχνη μιμεῖται τὴν φύσιν—both employing suitable means toward a known end.

[34] Art is iconography, the making of images or copies of some model (παράδειγμα), whether visible (presented) or invisible (contemplated); see Plato, *Republic* 373ʙ, 377ᴇ, 392–397, 402, *Laws* 667–669, *Statesman* 306ᴅ, *Cratylus* 439ᴀ, *Timaeus* 28ᴀʙ, 52ʙᴄ, *Sophist* 234ᴄ, 236ᴄ; Aristotle, *Poetics* I.1–2. In the same way, Indian works of art are called counterfeits or commensurations (*anukṛti, tadākārata, pratikṛti, pratibimba, pratimāna*), and likeness (*sārūpya, sādṛśya*) is demanded. This does not mean that it is a likeness in all respects that is needed to evoke the original, but an equality as to the whichness (τοσοῦτον, ὅσον) and whatness (τοιοῦτον, οἷον)—or form (ἰδέα) and force (δύναμις)—of the archetype. It is this

21

It is with perfect right that the mathematician speaks of a "beautiful equation" and feels for it what we feel about "art."[35] The beauty of the admirable equation is the attractive aspect of its simplicity. It is a single form that is the form of many different things. In the same way Beauty absolutely is the equation that is the single form of all things, which are themselves beautiful to the extent that they participate in the simplicity of their source. "The beauty of the straight line and the circle, and the plane and solid figures formed from these . . . is not, like that of other things, relative, but always absolutely beautiful."[36] Now we know that Plato, who says this, is always praising what is ancient and deprecating innovations (of which the causes are, in the strictest and worst sense of the word, aesthetic), and that he ranks the formal and canonical arts of Egypt far above the humanistic Greek art that he saw coming into fashion.[37] The kind of art that Plato endorsed was, then, precisely what we know as Greek Geometric art. We must not think that it would have been primarily for its decorative values that Plato must have admired this kind of "primitive" art, but for its truth or accuracy, *because* of which it has the kind of beauty that is universal and invariable, its equations being "akin" to the First Principles of which the myths and mysteries, related or enacted, are imitations in other kinds of material. The forms of the simplest and severest kinds of art, the synoptic kind of art that we call "primitive," are the natural language of all traditional philosophy; and it is for this very reason that Plato's dialectic makes continual use of *figures* of speech, which are really figures of thought.

"real equality" or "adequacy" (αὐτὸ τὸ ἴσον) that is the truth and the beauty of the work (*Laws* 667–668, *Timaeus* 28AB, *Phaedo* 74–75). We have shown elsewhere that the Indian *sādṛśya* does not imply an illusion but only a real equivalence. It is clear from *Timaeus* 28–29 that by "equality" and "likeness" Plato also means a real kinship (συγγένεια) and analogy (ἀναλογία), and that it is these qualities that make it possible for an image to "interpret" or "deduce" (ἐξηγέομαι, cf. Skr. *ānī*) its archetype. For example, words are εἴδωλα of things (*Sophist* 234C), "true names" are not correct by accident (*Cratylus* 387D, 439A), the body is an εἴδωλον of the soul (*Laws* 959B), and these images are at the same time like and yet unlike their referents. In other words, what Plato means by "imitation" and by "art" is an "adequate symbolism" [cf. distinction of image from duplicate, *Cratylus* 432].

[35] "The mathematician's patterns, like the painter's or the poet's, must be *beautiful*" (G. H. Hardy, *A Mathematician's Apology*, Cambridge, 1940, p. 85); cf. Coomaraswamy, *Why Exhibit Works of Art?*, 1943, ch. 9.

[36] *Philebus* 51C. For beauty by participation, see *Phaedo* 100D; cf. *Republic* 476; St. Augustine, *Confessions* x.34; Dionysius, *De divinis nominibus* iv.5.

[37] *Laws* 657AB, 665C, 700C.

Plato knew as well as the Scholastic philosophers that the artist as such has no moral responsibilities, and can sin as an artist only if he fails to consider the sole good of the work to be done, whatever it may be.[38] But, like Cicero, Plato also knows that "though he is an artist, he is nevertheless a man"[39] and, if a free man, responsible as such for whatever it may be that he undertakes to make; a man who, if he represents what ought not to be represented and brings into being things unworthy of free men, should be punished, or at the least restrained or exiled like any other criminal or madman. It is precisely those poets or other artists who imitate anything and everything, and are not ashamed to represent or even "idealize" things essentially base, that Plato, without respect for their abilities, however great, would banish from the society of rational men, "lest from the imitation of shameful things men should imbibe their actuality,"[40] that is to say, for the same reasons that we in moments of sanity ($\sigma\omega\phi\rhoo\sigma\acute{v}\nu\eta$) see fit to condemn the exhibition of gangster films in which the villain is made a hero, or agree to forbid the manufacture of even the most skillfully adulterated foods.

If we dare not ask with Plato "imitations of what sort of life?" and "whether of the appearance or the reality, the phantasm or the truth?"[41] it is because we are no longer sure what kind of life it is that we ought for our own good and happiness to imitate, and are for the most part convinced that no one knows or can know the final truth about anything: we only know what we "approve" of, i.e., what we *like* to do or think, and we desire a freedom to do and think what we like more than we desire a freedom from error. Our educational systems are chaotic because we are not agreed for what to educate, if not for self-expression. But all tradition is agreed as to what kind of models are to be imitated: "The city can never otherwise be happy unless it is designed by those painters who follow a divine original";[42] "The crafts such as building and carpentry . . . take their principles from that realm and from the thinking there";[43] "Lo, make all things in accordance with the pattern that was shown thee upon the mount";[44] "It is in imitation (*anukṛti*) of the divine forms that any human form (*śilpa*) is in-

[38] *Laws* 670E; *Sum. Theol.* I.91.3, I-II.57.3 *ad* 2.
[39] Cicero, *Pro quinctio* xxv.78.
[40] *Republic* 395C; cf. 395–401, esp. 401BC, 605–607, and *Laws* 656c.
[41] *Republic* 400A, 598B; cf. *Timaeus* 29C.
[42] *Republic* 500E.
[43] Plotinus, *Enneads* v.9.11, like Plato, *Timaeus* 28AB.
[44] Exod. 25:40.

23

vented here";[45] "There is this divine harp, to be sure; this human harp comes into being in its likeness" (*tad anukṛti*);[46] "We must do what the Gods did first."[47] *This* is the "imitation of Nature in her manner of operation," and, like the first creation, the imitation of an intelligible, not a perceptible model.

But such an imitation of the divine principles is only possible if we have known them "as they are," for if we have not ourselves seen them, our mimetic iconography, based upon opinion, will be at fault; we cannot know the reflection of anything unless we know itself.[48] It is the basis of Plato's criticism of naturalistic poets and painters that they know nothing of the reality but only the appearances of things, for which their vision is overkeen; their imitations are not of the divine originals, but are only copies of copies.[49] And seeing that God alone is truly beautiful, and all other beauty is by participation, it is only a work of art that has been wrought, in its kind (ἰδέα) and its significance (δύναμις), after an eternal model, that can be called beautiful.[50] And since the eternal and intelligible models are supersensual and invisible, it is evidently "not by observation" but in contemplation that

[45] AB vi.27.

[46] ŚA viii.9.

[47] ŚB vii.2.1.4; cf. iii.3.3.16, xiv.1.2.26, and TS v.5.4.4. Whenever the Sacrificers are at a loss, they are required to contemplate (*cetayadhvam*), and the required form thus seen becomes their model. Cf. Philo, *Moses* ii.74–76.

[48] *Republic* 377, 402, *Laws* 667–668, *Timaeus* 28AB, *Phaedrus* 243AB (on ἁμαρτία περὶ μυθολογίαν), *Republic* 382BC (misuse of words is a symptom of sickness in the soul).

[49] See *Republic* 601, for example. Porphyry tells us that Plotinus refused to have his portrait painted, objecting, "Must I consent to leave, as a desirable spectacle for posterity, an image of an image?" Cf. Asterius, bishop of Amasea, ca. A.D. 340: "Paint not Christ: for the one humility of his incarnation suffices him" (Migne, *Patrologia graeca* xi.167). The real basis of the Semitic objection to graven images, and of all other iconoclasm, is not an objection to art (adequate symbolism), but an objection to a realism that implies an essentially idolatrous worship of nature. The figuration of the Ark according to the pattern that was seen upon the mount (Exod. 25:40) is not "that kind of imagery with reference to which the prohibition was given" (Tertullian, *Contra Marcionem* ii.22).

[50] *Timaeus* 28AB; cf. note 34, above. The symbols that are rightly sanctioned by a hieratic art are not conventionally but *naturally* correct (ὀρθότητα φύσει παρεχόμενα, *Laws* 657A). One distinguishes, accordingly, between *le symbolisme qui sait* and *le symbolisme qui cherche*. It is the former that the iconographer can and must understand, but he will hardly be able to do so unless he is himself accustomed to thinking in these precise terms.

they must be known.[51] Two acts, then, one of contemplation and one of operation, are necessary to the production of any work of art.[52]

And now as to the judgment of the work of art, first by the criterion of art, and second with respect to its human value. As we have already seen, it is not by our reactions, pleasurable or otherwise, but by its perfect accuracy, beauty, or perfection, or truth—in other words, by the equality or proportion of the image to its model—that a work of art can be judged as such. That is to consider only the good of the work to be done, the business of the artist. But we have also to consider the good of the man for whom the work is done, whether this "consumer" (χρώμενος) be the artist himself or some other patron.[53] This man judges in another way, not, or not only, by this truth or accuracy, but by the artifact's utility or aptitude (ὠφέλεια) to serve the purpose of its original intention (βούλησις), viz. the need (ἔνδεια) that was the first and is also the last cause of the work. Accuracy and aptitude together make the "wholesomeness" (ὑγιεινόν) of the work that is its ultimate-rightness (ὀρθότης).[54] The distinction of beauty from utility is logical, not real (in re).

[51] The realities are seen "by the eye of the soul" (Republic 533D), "the soul alone and by itself" (Theaetetus 186A, 187A), "gazing ever on what is authentic" (πρὸς τὸ κατὰ ταὐτὰ ἔχον βλέπων ἀεί, Timaeus 28A; cf. πρὸς τὸν θεὸν βλέπειν, Phaedrus 253A), and thus "by inwit (intuition) of what really is" (περὶ τὸ ὂν ὄντως ἐννοίαις, Philebus 59D). Just so in India, it is only when the senses have been withdrawn from their objects, only when the eye has been turned round (āvṛtta cakṣus), and with the eye of Gnosis (jñāna cakṣus), that the reality can be apprehended.

[52] The contemplative actus primus (θεωρία, Skr. dhī, dhyāna) and operative actus secundus (ἀπεργασία, Skr. karma) of the Scholastic philosophers.

[53] "One man is able to beget the productions of art, but the ability to judge of their utility (ὠφελία) or harmfulness to their users belongs to another" (Phaedrus 274E). The two men are united in the whole man and complete connoisseur, as they are in the Divine Architect whose "judgments" are recorded in Gen. 1:25 and 31.

[54] Laws 667; for a need as first and last cause, see Republic 369BC. As to "wholesomeness," cf. Richard Bernheimer, in Art: A Bryn Mawr Symposium (Bryn Mawr, 1940), pp. 28–29: "There should be a deep ethical purpose in all of art, of which the classical aesthetic was fully aware. . . . To have forgotten this purpose before the mirage of absolute patterns and designs is perhaps the fundamental fallacy of the abstract movement in art." The modern abstractionist forgets that the Neolithic formalist was not an interior decorator but a metaphysical man who had to live by his wits.

The indivisibility of beauty and use is affirmed in Xenophon, Memorabilia III.8.8, "that the same house is both beautiful and useful was a lesson in the art of building

So when taste has been rejected as a criterion in art, Plato's Stranger sums up thus, "The judge of anything that has been made ($\pi o i \eta \mu a$) must know its essence—what its intention ($\beta o \acute{\nu} \lambda \eta \sigma \iota s$) is and what the real thing of which it is an image—or else will hardly be able to diagnose whether it hits or misses the mark of its intention." And again, "The expert critic of any image, whether in painting, music, or any other art, must know three things, what was the archetype, and in each case whether it was correctly and whether well made . . . whether the representation was good ($\kappa a \lambda \acute{o} \nu$) or not."[55] The complete judgment, made by the whole man, is as to whether the thing under consideration has been both truly *and* well made. It is only "by the mob that the beautiful and the just are rent apart,"[56] by the mob, shall we say, of "aesthetes," the men who "know what they like"?

Of the two judgments, respectively by art and by value, the first only establishes the existence of the object as a true work of art and not a falsification ($\psi \epsilon \hat{\nu} \delta o s$) of its archetype: it is a judgment normally made by the artist before he can allow the work to leave his shop, and so

houses as they ought to be" (cf. iv.6.9). "Omnis enim artifex intendit producere opus pulcrum et utile et stabile. . . . Scientia reddit opus pulcrum, voluntas reddit utile, perseverantia reddit stabile" (St. Bonaventura, *De reductione artium ad theologiam* 13; tr. de Vinck: "Every maker intends to produce a beautiful, useful, and enduring object. . . . Knowledge makes a work beautiful, the will makes it useful, and perseverance makes it enduring.") So for St. Augustine, the stylus is "et in suo genere pulcher, et ad usum nostrum accommodatus" (*De vera religione* 39). Philo defines art as "a system of concepts co-ordinated towards some useful end" (*Congr.* 141). Only those whose notion of utility is solely with reference to bodily needs, or on the other hand, the pseudomystics who despise the body rather than use it, vaunt the "uselessness" of art: so Gautier, "Il n'y a de vraiment beau que ce qui ne peut servir à rien; tout ce qui est utile est laid" (quoted by Dorothy Richardson, "Saintsbury and Art for Art's Sake in England," PMLA, XLIX, 1944, 245), and Paul Valéry (see Coomaraswamy, *Why Exhibit Works of Art?*, 1943, p. 95). Gautier's cynical "tout ce qui est utile est laid" adequately illustrates Ruskin's "industry without art is brutality"; a more scathing judgment of the modern world in which utilities are really ugly could hardly be imagined. As H. J. Massingham said, "The combination of use and beauty is part of what used to be called 'the natural law' and is indispensable for self-preservation," and it is because of the neglect of this principle that civilization "is perishing" (*This Plot of Earth*, London, 1944, p. 176). The modern world is dying of its own squalor just because *its* concept of practical utility is limited to that which "can be used directly for the destruction of human life or for accentuating the present inequalities in the distribution of wealth" (Hardy, *A Mathematician's Apology*, p. 120, note), and it is only under these unprecedented conditions that it could have been propounded by the escapists that the useful and the beautiful are opposites.

[55] *Laws* 668c, 669AB, 670E. [56] *Laws* 860c.

a judgment that is really presupposed when we as patrons or consumers propose to evaluate the work. It is only under certain conditions, and typically those of modern manufacture and salesmanship, that it becomes necessary for the patron or consumer to ask whether the object he has commissioned or proposes to buy is really a true work of art. Under normal conditions, where making is a vocation and the artist is disposed *and free* to consider nothing but the good of the work to be done, it is superfluous to ask, Is this a "true" work of art? When, however, the question must be asked, or if we wish to ask it in order to understand completely the genesis of the work, then the grounds of our judgment in this respect will be the same as for the original artist; we must know of what the work is intended to remind us, and whether it is equal to (is an "adequate symbol" of) this content, or by want of truth betrays its paradigm. In any case, when this judgment has been made, or is taken for granted, we can proceed to ask whether or not the work has a value for us, to ask whether it will serve our needs. If we are whole men, not such as live by bread alone, the question will be asked with respect to spiritual and physical needs to be satisfied together; we shall ask whether the model has been well chosen, and whether it has been applied to the material in such a way as to serve our immediate need; in other words, What does it say? and Will it work? If we have asked for a bread that will support the whole man, and receive however fine a stone, we are not morally, though we may be legally, bound to "pay the piper." All our efforts to obey the Devil and "command this stone that it be made bread" are doomed to failure.

It is one of Plato's virtues, and that of all traditional doctrine about art, that "value" is never taken to mean an exclusively spiritual or exclusively physical value. It is neither advantageous, nor altogether possible, to separate these values, making some things sacred and others profane: the highest wisdom must be "mixed"[57] with practical knowledge, the contemplative life combined with the active. The pleasures that pertain to these lives are altogether legitimate, and it is only those pleasures that are irrational, bestial, and in the worst sense of the words seductive and distracting that are to be excluded. Plato's music and gymnastics, which correspond to our culture and physical training, are not alternative curricula, but essential parts of one and the same education.[58] Philosophy is the highest form of music (culture), but the philosopher

[57] *Philebus* 61B–D. [58] *Republic* 376E, 410–412, 521E–522A.

who has escaped from the cave must return to it to participate in the everyday life of the world and, quite literally, play the game.[59] Plato's criterion of "wholesomeness" implies that nothing ought to be made, nothing can be really worth having, that is not at the same time correct or true or formal or beautiful (whichever word you prefer) *and* adapted to good use.

For, to state the Platonic doctrine in more familiar words, "It is written that man shall not live by bread alone, but by every word of God, . . . that bread which came down from heaven,"[60] that is, not by mere utilities but also by those "divine realities" and "causal beauty" with which the wholesome works of art are informed, so that they also live and speak. It is just to the extent that we try to live by bread alone and by all the other in-significant utilities that "bread alone" includes—good as utilities, but bad as *mere* utilities—that our contemporary civilization can be rightly called inhuman and must be unfavorably compared with the "primitive" cultures in which, as the anthropologists assure us, "the needs of the body and soul are satisfied together."[61] Manufacture for the needs of the body alone is the curse of modern civilization.

Should we propose to raise our standard of living to the savage level, on which there is no distinction of fine from applied or sacred from profane art, it need not imply the sacrifice of any of the necessities or even conveniences of life, but only of luxuries, only of such utilities as are not at the same time useful *and* significant. If such a proposal to return to primitive levels of culture should seem to be utopian and impracticable, it is only because a manufacture of significant utilities would have to be a manufacture for use, the use of the whole man, and not for the salesman's profit. The price to be paid for putting back into the market place, where they belong, such things as are now to be seen only in museums would be that of economic revolution. It may be doubted whether our boasted love of art extends so far.

It has sometimes been asked whether the "artist" can survive under modern conditions. In the sense in which the word is used by those who ask the question, one does not see how he can or why he should survive. For, just as the modern artist is neither a useful or significant, but

[59] *Republic* 519–520, 539E, *Laws* 644, and 803 in conjunction with 807. Cf. BG III.1–25; also Coomaraswamy, "Lilā," 1941, and "Play and Seriousness," 1942 [both in Vol. 2 of this edition—ED.].

[60] Deut. 8:3, Luke 4:4, John 6:58.

[61] R. R. Schmidt, *Dawn of the Human Mind* (*Der Geist der Vorzeit*), tr. R.A.S. Macalister (London, 1936), p. 167.

only an ornamental member of society, so the modern workman is nothing but a useful member and is neither significant nor ornamental. It is certain that we shall have to go on working, but not so certain that we could not live, and handsomely, without the exhibitionists of our studios, galleries, and playing fields. We cannot do without art, because art is the knowledge of how things ought to be made, art is the principle of manufacture (*recta ratio factibilium*), and while an artless play may be innocent, an artless manufacture is merely brutish labor and a sin against the wholesomeness of human nature; we *can* do without "fine" artists, whose art does not "apply" to anything, and whose organized manufacture of art in studios is the inverse of the laborer's artless manufacture in factories; and we *ought* to be able to do without the base mechanics "whose souls are bowed and mutilated by their vulgar occupations even as their bodies are marred by their mechanical arts."[62]

Plato himself discusses, in connection with all the arts, whether of potter, painter, poet, or "craftsman of civic liberty," the relation between the practice of an art and the earning of a livelihood.[63] He points out that the practice of an art and the wage-earning capacity are two different things; that the artist (in Plato's sense and that of the Christian and Oriental social philosophies) does not earn wages by his art. He *works by* his art, and is only accidentally a trader if he sells what he makes. Being a vocation, his art is most intimately his own and pertains to his own nature, and the pleasure that he takes in it perfects the operation. There is nothing he would rather work (or "play") at than his making; to him the leisure state would be an abomination of boredom. This situation, in which each man does what is naturally ($\kappa\alpha\tau\grave{\alpha}$ $\phi\acute{\upsilon}\sigma\iota\nu$ = Skr. *svabhāvatas*) his to do ($\tau\grave{o}$ $\dot{\epsilon}\alpha\upsilon\tauο\hat{\upsilon}$ $\pi\rho\acute{\alpha}\tau\tau\epsilon\iota\nu$ = Skr. *svadharma*, *svakarma*), not only is the type of Justice,[64] but furthermore, under these conditions (i.e., when the maker loves to work), "more is done, and better done, and with more ease, than in any other way."[65] Artists are not trades-

[62] *Republic* 495E; cf. 522B, 611D, *Theaetetus* 173AB. That "industry without art is brutality" is hardly flattering to those whose admiration of the industrial system is equal to their interest in it. Aristotle defines as "slaves" those who have nothing but their bodies to offer (*Politics* 1.5.1254b 18). It is on the work of such "slaves," or literally "prostitutes," that the industrial system of production for profit ultimately rests. Their political freedom does not make of assembly-line workers and other "base mechanics" what Plato means by "free men."

[63] *Republic* 395B, 500D. Cf. Philo, *De opificio mundi* 78.

[64] *Republic* 433B, 443C.

[65] *Republic* 370C; cf. 347E, 374BC, 406C. Paul Shorey had the naïveté to see in Plato's conception of a vocational society an anticipation of Adam Smith's division

men. "They know how to make, but not how to hoard."[66] Under these conditions the worker and maker is not a hireling, but one whose salary enables him to go on doing and making. He is just like any other member of a feudal society, in which none are "hired" men, but all enfeoffed and all possessed of a hereditary standing, that of a professional whose reward is by gift or endowment and not "at so much an hour."

The separation of the creative from the profit motive not only leaves the artist free to put the good of the work above his own good, but at the same time abstracts from manufacture the stain of simony, or "traffic in things sacred"; and this conclusion, which rings strangely in our ears, for whom work and play are alike secular activities, is actually in complete agreement with the traditional order, in which the artist's operation is not a meaningless labor, but quite literally a significant and sacred rite, and quite as much as the product itself an adequate symbol of a spiritual reality. It is therefore a way, or rather *the* way, by which the artist, whether potter or painter, poet or king, can best erect or edify (ἐξορθόω) *himself* at the same time that he "trues" or cor-rects (ὀρθόω) his work.[67] It is, indeed, only by the "true" workman that "true" work can be done; like engenders like.

When Plato lays it down that the arts shall "care for the bodies and souls of your citizens," and that only things that are sane and free and not any shameful things unbecoming free men (ἀνελεύθερα)[68] are to be rep-

of labor; see *The Republic*, tr. and ed. P. Shorey (LCL, 1935), I, 150–151, note b. Actually, no two conceptions could be more contrary. In Plato's division of labor it is taken for granted not that the artist is a special kind of man but that every man is a special kind of artist; his specialization is for the good of all concerned, producer and consumer alike. Adam Smith's division benefits no one but the manufacturer and salesman. Plato, who detested any "fractioning of human faculty" (*Republic* 395B), could hardly have seen in *our* division of labor a type of justice. Modern research has rediscovered that "workers are *not* governed primarily by economic motives" (see Stuart Chase, "*What* Makes the Worker Like to Work?" *Reader's Digest*, February 1941, p. 19).

[66] Chuang-tzu, as quoted by Arthur Waley, *Three Ways of Thought in Ancient China* (London, 1939), p. 62. It is not true to say that "the artist is a mercenary living by the sale of his own works" (F. J. Mather, *Concerning Beauty*, Princeton, 1935, p. 240). He is not working in order to make money but accepts money (or its equivalent) in order to be able to go on working at his living—and I say "working at his *living*" because the man *is* what he does.

[67] "A man attains perfection by devotion to his own work . . . by his own work praising Him who wove this all. . . . Whoever does the work appointed by his own nature incurs no sin" (BG xviii.45–46).

[68] *Republic* 395c. [See Aristotle on "leisure," *Nicomachean Ethics* x.7.5–7.1177b.]

resented, it is as much as to say that the true artist in whatever material must be a free man, meaning by this not an "emancipated artist" in the vulgar sense of one having no obligation or commitment of any kind, but a man emancipated from the despotism of the salesman. Whoever is to "imitate the actions of gods and heroes, the intellections and revolutions of the All," the very selves and divine paradigms or ideas of our useful inventions, must have known these realities "themselves ($αὐτά$) and as they really are ($οἷά ἐστιν$)": for "what we have not and know not we can neither give to another nor teach our neighbor."[69]

In other words, an act of "imagination," in which the idea to be represented is first clothed in the imitable form or image of the thing to be made, must precede the operation in which this form is impressed upon the actual material. The first of these acts, in the terms of Scholastic philosophy, is free, the second servile. It is only if the first be omitted that the word "servile" acquires a dishonorable connotation; then we can speak only of labor, and not of art. It need hardly be argued that our methods of manufacture are, in this shameful sense, servile, nor be denied that the industrial system, for which these methods are needed, is an abomination "unfit for free men." A system of manufacture governed by money values presupposes that there shall be two different kinds of makers, privileged artists who may be "inspired," and underprivileged laborers, unimaginative by hypothesis, since they are required only to make what other men have imagined, or more often only to copy what other men have already made. It has often been claimed that the productions of "fine" art are useless; it would seem to be a mockery to speak of a society as "free" where it is only the makers of useless things who are supposedly free.

Inspiration is defined in Webster as "a supernatural influence which qualifies men to receive and communicate divine truth." This is stated in the word itself, which implies the presence of a guiding "spirit" distinguished from but nevertheless "within" the agent who is in-spired, but is certainly not inspired if "expressing himself." Before continuing, we must clear the air by showing how the word "inspire" has been scabrously abused by modern authors. We have found it said that "a poet or other artist may let the rain inspire him."[70] Such misuse of words

[69] *Republic* 377E, *Symposium* 196E.

[70] H. J. Rose, *A Handbook of Greek Mythology* (2d ed., London, 1933), p. 11. Clement Greenberg (in *The Nation*, April 19, 1941, p. 481) tells us that the "modern painter derives his inspiration from the very physical materials he works

debar the student from ever learning what the ancient writers may have really meant. We say "misuse" because neither is the rain, or anything perceptible to sense, *in* us; nor is the rain a kind of *spirit*. The rationalist has a right to disbelieve in inspiration and to leave it out of his account, as he very easily can if he is considering art only from the aesthetic (sensational) point of view, but he has no right to pretend that one can be "inspired" by a sense perception, by which, in fact, one can only be "affected," and to which one can only "react." On the other hand, Meister Eckhart's phrase "inspired by his art" is quite correct, since art is a kind of knowledge, not anything that can be seen, but akin to the soul and prior to the body and the world.[71] We can properly say that not only "Love" but "Art" and "Law" are names of the Spirit.

Here we are concerned not with the rationalist's point of view, but only with the sources from which we can learn how the artist's operation is explained in a tradition that we must understand if we are to understand its products. Here it is always by the Spirit that a man is thought of as inspired (ἔνθεος, sc. ὑπὸ τοῦ ἔρωτος). "The Genius breathed into my heart (ἐνέπνευσε φρεσὶ δαίμων) to weave," Penelope says.[72] Hesiod tells us that the Muses "breathed into me a divine voice (ἐνέπνευσαν δέ μοι αὐδὴν θέσπιν) . . . and bade me sing the race of the blessed Gods."[73] Christ, "through whom all things were made," does not bear witness of (express) himself, but says "I do nothing of myself, but as my Father taught me, I speak."[74] Dante writes, I am "one who when Love (Amor, Eros) inspires me (*mi spira*), attend, and go setting it forth in such wise as He dictates within me."[75] For "there is no real speaking that does not lay hold upon the Truth."[76] And who is it ("What self?") that speaks the "Truth that cannot be refuted"? Not this man, So-and-so, Dante, or Socrates, or "I," but the Synteresis, the Immanent Spirit, Socrates' and Plato's Daimon, he "who lives in every one of us"[77] and "cares for noth-

with." Both critics forget the customary distinction of spirit from matter. What their statements actually mean is that the modern artist may be excited, but is not inspired.

[71] Eckhart, Evans ed., II, 211; cf. *Laws* 892BC.

[72] Homer, *Odyssey* XIX.138. [73] *Theogony* 31–32.

[74] John 8:28; cf. 5:19 and 30, 7:16 and 18 ("He that speaketh from himself seeketh his own glory"). A column in *Parnassus*, XIII (May 1941), 189, comments on the female nude as Maillol's "exclusive inspiration." That is mere hot air; Renoir was not afraid to call a spade a spade when he said with what brush he painted.

[75] *Purgatorio* XXIV.52–54.

[76] *Phaedrus* 260E; *Symposium* 201C (on the irrefutable truth).

[77] *Timaeus* 69C, 90A.

ing but the Truth."[78] It is the "God himself that speaks" when we are not thinking our own thoughts but are His exponents, or priests.

And so as Plato, the father of European wisdom, asks, "Do we not know that as regards the practice of the arts (τὴν τῶν τεχνῶν δημιουργίαν) the man who has this God for his teacher will be renowned and as it were a beacon light, but one whom Love has not possessed will be obscure?"[79] This is with particular reference to the divine originators of archery, medicine, and oracles, music, metalwork, weaving, and piloting, each of whom was "Love's disciple." He means, of course, the "cosmic Love" that harmonizes opposite forces, the Love that acts for the sake of what it has and to beget itself, not the profane love that lacks and desires. So the maker of anything, if he is to be called a creator, is at his best the servant of an immanent Genius; he must not be called "a genius," but "*in*genious"; he is not working of or for himself, but by and for another energy, that of the Immanent Eros, Sanctus Spiritus, the source of all "gifts." "All that is true, by whomsoever it has been said, has its origin in the Spirit."[80]

We can now, perhaps, consider, with less danger of misunderstanding, Plato's longest passage on inspiration. "It is a divine power that moves (θεία δὲ δύναμις, ἣ . . . κινεῖ)"[81] even the rhapsodist or literary critic, insofar as he speaks well, though he is only the exponent of an exponent. The original maker and exponent, if he is to be an imitator of realities and not of mere appearances, "is God-indwelt and possessed (ἔνθεος, κατεχόμενος) . . . an airy, winged and sacred substance (ἱερόν, Skr. *brahma-*); unable ever to indite until he has been born again of the God within him (πρὶν ἂν ἔνθεός τε γένηται)[82] and is out of his own wits (ἔκφρων), and his own mind (νοῦς) is no longer in him;[83] for every

[78] *Hippias Major* 288D. [79] *Symposium* 197A.

[80] Ambrose on 1 Cor. 12:3, cited in *Sum. Theol.* I-II.109.1. Note that "a quocumque dicatur" contradicts the claim that it is only Christian truth that is "revealed."

[81] *Ion* 533D. For the passage on inspiration, see *Ion* 533D–536D. Plato's doctrine of inspiration is not "mechanical" but "dynamic"; in a later theology it became a matter for debate in which of these two ways the Spirit actuates the interpreter.

[82] *Ion* 533E, 534B. γίγνομαι here is used in the radical sense of "coming into a new state of being." Cf. *Phaedrus* 279B, καλῷ γενέσθαι τἄνδοθεν, "May I be born in beauty inwardly," i.e., born of the immanent deity (δ᾽ ἐν ἡμῖν θείῳ, *Timaeus* 90D), authentic and divine beauty (αὐτὸ τὸ θεῖον καλόν, *Symposium* 211E). The New Testament equivalents are "in the Spirit" and "born again of the Spirit."

[83] *Ion* 534B. "The madness that comes of God is superior to the sanity which is of human origin" (*Phaedrus* 244D, 245A). Cf. *Timaeus* 71D–72B, *Laws* 719C; and MU VI.34.7, "When one attains to mindlessness, that is the last step." The subject needs a longer explanation; briefly, the supralogical is superior to the logical, the logical to the illogical.

man, so long as he retains *that* property is powerless to make (ποιεῖν) or to incant (χρησμῳδεῖν, Skr. *mantrakṛ*). . . . The men whom he dements God uses as his ministers (ὑπηρέται) . . . but it is the God[84] himself (ὁ θεὸς αὐτός) that speaks, and through them enlightens (φθέγγεται) us. . . . The makers are but His exponents (ἑρμηνῆς) according to the way in which they are possessed."[85] It is only when he returns to himself from what is really a sacrificial operation that the maker exercises his own powers of judgment; and then primarily to "try the spirits, whether they be of God," and secondarily to try his work, whether it agrees with the vision or audition.

The most immediately significant point that emerges from this profound analysis of the nature of inspiration is that of the artist's priestly or ministerial function. The original intention of intelligible forms was not to entertain us, but literally to "re-mind" us. The chant is not for the approval of the ear,[86] nor the picture for that of the eye (although these senses can be taught to approve the splendor of truth, and can be trusted when they have been trained), but to effect such a transformation of our being as is the purpose of all ritual acts. It is, in fact, the ritual arts that are the most "artistic," because the most "correct," as they must be if they are to be effectual.

The heavens declare the glory of God: their interpretation in science or art—and *ars sine scientia nihil*—is not in order to flatter or merely "interest" us, but "in order that we may follow up the intellections and

[84] "The God" is the Immanent Spirit, Daimon, Eros. "He is a maker (ποιητής) so really wise (σοφός) that he is the cause of making in others" (*Symposium* 196E). The voice is "enigmatic" (*Timaeus* 72B), and poetry, therefore, "naturally enigmatic" (*Alcibiades II* 147B), so that in "revelation" (scripture, Skr. *śruti*, "what was heard") we see "through a glass darkly" (ἐν αἰνίγματι, 1 Cor. 13:12). Because divination is of a Truth that cannot (with human faculties) be seen directly (Skr. *sākṣāt*), the soothsayer must speak in symbols (whether verbal or visual), which are reflections of the Truth; it is for us to understand and use the symbols as supports of contemplation and with a view to "recollection." It is because the symbols are things seen "through a glass" that contemplation is "speculation."

[85] See *Ion* 534, 535. Related passages have been cited in notes 82–84, above. The last words refer to the diversity of the gifts of the spirit; see 1 Cor. 12:4–11.

[86] "What we call 'chants' . . . are evidently in reality 'incantations' seriously designated to produce in souls that harmony of which we have been speaking" (*Laws* 659E; cf. 665c, 656E, 660B, 668–669, 812c, *Republic* 399, 424). Such incantations are called *mantras* in Sanskrit.

34

revolutions of the All, not those revolutions that are in our own heads and were distorted at our birth, but correcting (ἐξορθοῦντα) these by studying the harmonies and revolutions of the All: so that by an assimilation of the knower to the to-be-known (τῷ κατανοουμένῳ τὸ κατανοοῦν ἐξομοιῶσαι),[87] the archetypal Nature, and coming to be in *that* likeness,[88] we may attain at last to a part in that 'life's best' that has been appointed by the gods to men for this time being and hereafter."[89]

This is what is spoken of in India as a "metrical self-integration" (*candobhir ātmānaṃ saṃskaraṇa*), or "edification of another man" (*anyam ātmānaṃ*), to be achieved by an imitation (*anukaraṇa*) of the divine forms (*daivyāni śilpāni*).[90] The final reference to a good to be realized here *and* hereafter brings us back again to the "wholesomeness" of art, defined in terms of its simultaneous application to practical necessities and spiritual meanings, back to that fulfillment of the needs of the body and soul together that is characteristic of the arts of the uncivilized peoples and the "folk" but foreign to our industrial life. For in that life the arts are *either* for use *or* for pleasure, but are never spiritually significant and very rarely intelligible.

Such an application of the arts as Plato prescribes for his City of God, arts that as he says "will care for the bodies and the souls of your citizens,"[91] survives for so long as forms and symbols are employed to express a meaning, for so long as "ornament" means "equipment,"[92] and until what were originally imitations of the reality, not the appearance, of things become (as they were already rapidly becoming in Plato's time) merely "art forms, more and more emptied of significance on their

[87] *Timaeus* 90D. The whole purpose of contemplation and yoga is to reach that state of being in which there is no longer any distinction of knower from known, or being from knowing. It is just from this point of view that while all the arts are imitative, it matters so much *what* is imitated, a reality or an effect, for we become like what we think most about. "One comes to be of just such stuff as that on which the mind is set" (MU VI.34).

[88] "To become like God (ὁμοίωσις θεῷ), so far as that is possible, is to 'escape'" (*Theaetetus* 176B; φυγή here = λύσις = Skr. *mokṣa*). "But we all, with open face beholding as in a glass the glory of the Lord, are changed into the same image . . . looking not at the things which are seen, but at the things which are not seen . . . the things which . . . *are* eternal" (II Cor. 3:18, 4:18). "This likeness begins now again to be formed in us" (St. Augustine, *De spiritu et littera* 37). Cf. Coomaraswamy, "The Traditional Conception of Ideal Portraiture," in *Why Exhibit Works of Art?*, 1943.

[89] *Timaeus* 90D. [90] AB VI.27. [91] *Republic* 409–410.
[92] See Coomaraswamy, "Ornament" [in this volume—ED.].

way down to us"[93]—no longer figures of thought, but only figures of speech.

We have so far made use of Oriental sources only incidentally, and chiefly to remind ourselves that the true philosophy of art is always and everywhere the same. But since we are dealing with the distinction between the arts of flattery and those of ministration, we propose to refer briefly to some of the Indian texts in which the "whole end of the expressive faculty" is discussed. This natural faculty is that of the "Voice": not the audibly spoken word, but the ὄργανον by which a concept is communicated. The relation of this maternal Voice to the paternal Intellect is that of our feminine "nature" to our masculine "essence"; their begotten child is the Logos of theology and the spoken myth of anthropology. The work of art is expressly the artist's child, the child of both his natures, human and divine: stillborn if he has not at his command the art of delivery (rhetoric), a bastard if the Voice has been seduced, but a valid concept if born in lawful marriage.

The Voice is at once the daughter, bride, messenger, and instrument of the Intellect.[94] Possessed of him, the immanent deity, she brings forth his image (reflection, imitation, similitude, *pratirūpa*, child).[95] She is the power and the glory,[96] without whom the Sacrifice itself could not proceed.[97] But if he, the divine Intellect, Brahmā or Prajāpati, "does not

[93] Walter Andrae, *Die ionische Säule* (Berlin, 1933), p. 65 [cf. Coomaraswamy's review, in this volume—ED.]. The same scholar writes, with reference to pottery, especially that of the Stone Age and with reference to Assyrian glazing, "Ceramic art in the service of Wisdom, the wisdom that activates knowledge to the level of the spiritual, indeed the divine, as science does to earthbound things of all kinds. Service is here a voluntary, entirely self-sacrificing and entirely conscious dedication of the personality . . . as it is and should be in true divine worship. Only this service is worthy of art, of ceramic art. To make the primordial truth intelligible, to make the unheard audible, to enunciate the primordial word, to illustrate the primordial image —such is the task of art, or it is not art." ("Keramik im Dienste der Weisheit," *Berichte der deutschen keramischen Gesellschaft*, XVII:12 [1936], 623.) Cf. *Timaeus* 28AB.

[94] ŚB VIII.1.2.8; AB V.23; TS II.5.11.5; JUB I.33.4 (*karoty eva vācā . . . gamayati manasā*). Vāc is the Muse, and as the Muses are the daughters of Zeus, so is Vāc the daughter of the Progenitor, of Intellect (*Manas*, νοῦς)—i.e., *intellectus vel spiritus*, "the habit of First Principles." As Sarasvatī she bears the lute and is seated on the Sunbird as vehicle.

[95] "This the 'Beatitude' (*ānanda*) of Brahmā, that by means of Intellect (*Manas*, νοῦς), his highest form, he betakes himself to 'the Woman' (Vāc); a son like himself is born of her" (BU IV.1.6). The son is Agni, *bṛhad uktha*, the Logos.

[96] RV X.31.2 (*śreyāṃsam dakṣam manasā jagṛbhyāt*); BD II.84. The governing authority is always masculine, the power feminine.

[97] AB V.33, etc. Śrī as *brahmavādinī* is "Theologia."

36

precede and direct her, then it is only a gibberish in which she expresses
herself."[98] Translated into the terms of the art of government, this means
that if the Regnum acts on its own initiative, unadvised by the Sacer-
dotium, it will not be Law, but only regulations that it promulgates.

The conflict of Apollo with Marsyas the Satyr, to which Plato alludes,[99]
is the same as that of Prajāpati (the Progenitor) with Death,[100] and the
same as the contention of the Gandharvas, the gods of Love and Science,
with the mundane deities, the sense powers, for the hand of the Voice,
the Mother of the Word, the wife of the Sacerdotium.[101] This is, in fact,
the debate of the Sacerdotium and the Regnum with which we are most
familiar in terms of an opposition of sacred and profane, eternal and
secular, an opposition that must be present wherever the needs of the
soul and the body are *not* satisfied together.

Now what was chanted and enacted by the Progenitor in his sacrificial
contest with Death was "calculated" (*saṃkhyānam*)[102] and "immortal,"

[98] ŚB III.2.4.11; cf. "the Asura's gibberish" (ŚB III.2.1.23). It is because of the
dual possibility of an application of the Voice to the statement of truth or falsehood
that she is called the "double-faced"—i.e., "two-tongued" (ŚB III.2.4.16). These
two possibilities correspond to Plato's distinction of the Uranian from the Pandemic
(Πάνδημος) and disordered (ἄτακτος) Aphrodite, one the mother of the Uranian
or Cosmic Eros, the other, the "Queen of Various Song" (Πολύμνια) and mother
of the Pandemic Eros (*Symposium* 180DE, 187E, *Laws* 840E).

[99] *Republic* 399E.

[100] JB II.69, 70, and 73.

[101] ŚB III.2.4.1–6 and 16–22; cf. III.2.1.19–23.

[102] *Saṃkhyānam* is "reckoning" or "calculation" and corresponds in more senses
than one to Plato's λογισμός. We have seen that accuracy (ὀρθότης, *integritas*)
is the first requirement for good art, and that this amounts to saying that art is
essentially iconography, to be distinguished by its *logic* from merely emotional and
instinctive expression. It is precisely the precision of "classical" and "canonical"
art that modern feeling most resents; we demand organic forms adapted to an
"in-feeling" (*Einfühlung*) rather than the measured forms that require "in-sight"
(*Einsehen*).
A good example of this can be cited in Lars-Ivar Ringbom's "Entstehung und
Entwicklung der Spiralornamentik," in *Acta Archaeologica*, IV (1933), 151–200.
Ringbom demonstrates first the extraordinary perfection of early spiral ornament
and shows how even its most complicated forms must have been produced with
the aid of simple *tools*. But he resents this "measured" perfection, as of something
"known and deliberately made, the work of the intellect rather than a psychic ex-
pression" ("sie ist bewusst und willkürlich gemacht, mehr Verstandesarbeit als
seelischer Ausdruck") and admires the later "forms of freer growth, approximat-
ing more to those of Nature." These organic ("organisch-gewachsen") forms are
the "psychological expression of man's instinctive powers, that drive him more
and more to representation and figuration." Ringbom could hardly have better
described the kind of art that Plato would have called unworthy of free men; the

and what by Death "uncalculated" and "mortal"; and that deadly music played by Death is now our secular art of the "parlor" (*patnīśālā*), "whatever people sing to the harp, or dance, or do to please themselves (*vṛthā*)," or even more literally, "do heretically," for the words "*vṛthā*" and "heresy" derive from a common root that means to "choose for oneself," to "know what one likes and to grasp at it." Death's informal and irregular music is disintegrating. On the other hand, the Progenitor "puts himself together," composes or synthesizes himself, "by means of the meters"; the Sacrificer "perfects himself so as to be metrically constituted,"[103] and makes of the measures the wings of his ascension.[104] The distinctions made here between a quickening art and one that adds to the sum of our mortality are those that underlie Plato's *katharsis* and all true puritanism and fastidiousness. There is no disparagement of the Voice (Sophia) herself, or of music or dancing or any other art as such. Whatever disparagement there is, is not of the instrument; there can be no good use without art.

The contest of the Gandharvas, the high gods of Love and Music (in Plato's broad sense of that word), is with the unregenerate powers of the soul, whose natural inclination is the pursuit of pleasures. What the Gandharvas offer to the Voice is their sacred science, the thesis of their incantation; what the mundane deities offer is "to please her." The Gandharvas' is a holy conversation (*brahmodaya*), that of the mundane deities an appetizing colloquy (*prakāmodaya*). Only too often the Voice, the expressive power, is seduced by the mundane deities to lend herself to

free man is not "driven by forces of instinct." What Plato admired was precisely not the organic and figurative art that was coming into fashion in his time, but the formal and canonical art of Egypt that remained constant for what he thought had been ten thousand years, for there it had been possible "for those modes that are by nature correct to be canonized and held forever sacred" (*Laws* 656–657; cf. 798AB, 799A). There "art . . . was not for the delectation . . . of the senses" (Earl Baldwin Smith, *Egyptian Architecture*, New York, 1938, p. 27).

[103] AĀ III.2.6, *sa candobhir ātmānaṃ samādadhāt*; AB VI.27, *candomayam . . . ātmānaṃ saṃskurute*.

[104] For what Plato means by wings, see *Phaedrus* 246–256 and *Ion* 534B. "It is as a bird that the Sacrificer reaches the world of heaven" (PB V.3.5). *Phaedrus* 247BC corresponds to PB XIV.1.12–13, "Those who reach the top of the great tree, how do they fare thereafter? Those who have wings fly forth, those that are wingless fall down"; the former are the "wise," the latter the "foolish" (cf. *Phaedrus* 249C, "It is only the philosopher's discriminating mind that is winged"). For the Gandharva (Eros) as a winged "maker" and as such the archetype of human poets, see RV X.177.2 and JUB III.36. For "metrical wings," see PB X.4.5 and XIX.11.8; JUB III.13.10; AV VIII.9.12. The meters are "birds" (TS VI.1.6.1; PB XIX.11.8).

the representation of whatever may best please them and be most flattering to herself; and it is when she thus prefers the pleasant falsehoods to the splendor of the sometimes bitter truth that the high gods have to fear lest she in turn seduce their legitimate spokesman, the Sacrificer himself; to fear, that is to say, a secularization of the sacred symbols and the hieratic language, the depletion of meaning that we are only too familiar with in the history of art, as it descends from formality to figuration, just as language develops from an original precision to what are ultimately hardly more than blurred emotive values.

It was not for this, as Plato said, that powers of vision and hearing are ours. In language as nearly as may be identical with his, and in terms of the universal philosophy wherever we find it, the Indian texts define the "whole end of the Voice" (*kṛtsnaṃ vāgārtham*). We have already called the voice an "organ," to be taken in the musical as well as the organic sense. It is very evidently not the reason of an organ to play of itself, but to be played upon, just as it is not for the clay to determine the form of the vessel, but to receive it.

"Now there is this divine harp: the human harp is in its likeness . . . and just as the harp struck by a skilled player fulfills the whole reason of the harp, so the Voice moved by a skilled speaker fulfills its whole reason."[105] "Skill in any performance is a yoking, as of steeds together,"[106] or, in other words, implies a marriage of the master and the means. The product of the marriage of the player, Intellect, with the instrument, the Voice, is Truth (*satyam*) or Science (*vidyā*),[107] not that approximate, hypothetical, and statistical truth that we refer to as science, but philosophy in Plato's sense,[108] and that "meaning of the Vedas" by which, if we understand it, "all good" (*sakalam bhadram*) is attainable, here and hereafter.[109]

[105] ŚA VIII.10.

[106] BG II.50, *yogaḥ karmasu kauśalam*. If yoga is also the "renunciation" (*saṃnyāsa*) of works (BG V.1 and VI.2), this is only another way of saying the same thing, since this renunciation is essentially the abandonment of the notion "I am the doer" and a reference of the works to their real author whose skill is infallible: "The Father that dwelleth in me, he doeth the works" (John 14:10).

[107] ŚA VII.5 and 7; cf. *Phaedo* 61AB.

[108] What is meant by *vidyā* as opposed to *avidyā* is explicit in *Phaedrus* 247C-E, "All true knowledge is concerned with what is colorless, formless and intangible (Skr. *avarṇa, arūpa, agrahya*)" "not such knowledge as has a beginning and varies as it is associated with one or another of the things that we now call realities, but that which is really real (Skr. *satyasya satyam*)." Cf. CU VII.16.1 and 17.1, with commentary; also *Philebus* 58A.

[109] ŚA XIV.2.

The *raison d'être* of the Voice is to incarnate in a communicable form the concept of Truth; the formal beauty of the precise expression is that of the *splendor veritatis*. The player and the instrument are both essential here. We, in our somatic individuality, are the instrument, of which the "strings" or "senses" are to be regulated, so as to be neither slack nor overstrained; we are the organ, the inorganic God within us the organist. We are the organism, He its energy. It is not for us to play our own tunes, but to sing His songs, who is both the Person in the Sun (Apollo) and our own Person (as distinguished from our "personality"). When "those who sing here to the harp sing Him,"[110] then all desires are attainable, here and hereafter.

There is, then, a distinction to be drawn between a significant (*padārthābhinaya*) and liberating (*vimuktida*) art, the art of those who in their performances are celebrating God, the Golden Person, in both His natures, immanent and transcendent, and the *in-significant* art that is "colored by worldly passion" (*lokānurañjaka*) and "dependent on the moods" (*bhāvāśraya*). The former is the "highway" (*mārga*, ὁδός) art that leads directly to the end of the road, the latter a "pagan" (*deśī*, ἄγριος) and eccentric art that wanders off in all directions, imitating anything and everything.[111]

If now the orthodox doctrines reported by Plato and the East are not convincing, this is because our sentimental generation, in which the power of the intellect has been so perverted by the power of observation that we can no longer distinguish the reality from the phenomenon, the Person in the Sun from his sightly body, or the uncreated from electric light, will not be persuaded "though one rose from the dead." Yet I hope to have shown, in a way that may be ignored but cannot be refuted, that our use of the term "aesthetic" forbids us also to speak of art as pertaining to the "higher things of life" or the immortal part of us; that the distinction of "fine" from "applied" art, and corresponding manufacture of art in studios and artless industry in factories, takes it for granted that neither the artist nor the artisan shall be a whole man; that our freedom to work or starve is not a responsible freedom but only a legal fiction that conceals an actual servitude; that our hankering after a leisure state, or state of pleasure, to be attained by a multiplication of labor-saving

[110] CU 1.7.6–7. Cf. Coomaraswamy, "The Sun-kiss," 1940, p. 49, n. 11.

[111] For all the statements in this paragraph, see CU 1.6–9; *Sāhitya Darpaṇa* 1.4–6; and *Daśarūpa* 1.12–14.

devices, is born of the fact that most of us are doing forced labor, working at jobs to which we could never have been "called" by any other master than the salesman; that the very few, the happy few of us whose work is a vocation, and whose status is relatively secure, like nothing better than our work and can hardly be dragged away from it; that our division of labor, Plato's "fractioning of human faculty," makes the workman a part of the machine, unable ever to make or to co-operate responsibly in the making of any whole thing; that in the last analysis the so-called "emancipation of the artist"[112] is nothing but his final release from any obligation whatever to the God within him, and his opportunity to imitate himself or any other common clay at its worst; that all willful self-expression is autoerotic, narcissistic, and satanic, and the more its essentially paranoiac quality develops, suicidal; that while our invention of innumerable conveniences has made our unnatural manner of living in great cities so endurable that we cannot imagine what it would be like to do without them, yet the fact remains that not even the multimillionaire is rich enough to commission such works of art as are preserved in our museums but were originally made for men of relatively moderate means or, under the patronage of the church, for God and all men, and the fact remains that the multimillionaire can no longer send to the ends of the earth for the products of other courts or the humbler works of the folk, for all these things have been destroyed and their makers reduced to being the providers of raw materials for our factories, wherever our civilizing influence has been felt; and so, in short, that while the operation that we call a "progress" has been very successful, man the patient has succumbed.

Let us, then, admit that the greater part of what is taught in the fine arts departments of our universities, all of the psychologies of art, all the obscurities of modern aesthetics, are only so much verbiage, only a kind of defense that stands in the way of our understanding of the wholesome art, at the same time iconographically true and practically useful, that was once to be had in the marketplace or from any good artist; and that whereas the rhetoric that cares for nothing but the truth is the rule and method of the intellectual arts, our aesthetic is nothing but a false rhetoric, and a flattery of human weakness by which we can account only for the arts that have no other purpose than to please.

The whole intention of our own art may be aesthetic, and we may wish

[112] [See John D. Wild, *Plato's Theory of Man* (Cambridge, Mass., 1946), p. 84.]

to have it so. But however this may be, we also pretend to a scientific and objective discipline of the history and appreciation of art, in which we take account not only of contemporary or very recent art but also of the whole of art from the beginning until now. It is in this arena that I shall throw down a minimum challenge: I put it to you that it is not by our aesthetic, but only by their rhetoric, that we can hope to understand and interpret the arts of other peoples and other ages than our own. I put it to you that our present university courses in this field embody a pathetic fallacy, and are anything but scientific in any sense.

And now, finally, in case you should complain that I have been drawing upon very antiquated sources (and what else could I do, seeing that we are all "so young" and "do not possess a single belief that is ancient and derived from old tradition, nor yet one science that is hoary with age"[113]) let me conclude with a very modern echo of this ancient wisdom, and say with Thomas Mann that "I like to think—yes, I feel sure—that a future is coming in which we shall condemn as black magic, as the brainless, irresponsible product of instinct, all art which is not controlled by the intellect."[114]

[113] *Timaeus* 22BC.

[114] In *The Nation* (December 10, 1938). Cf. Socrates' dictum at the head of this chapter.

The Philosophy of Mediaeval
and Oriental Art

Subtract the mind, and the eye is open to no purpose.
Meister Eckhart[1]

Instead of "The Philosophy of Mediaeval and Oriental Art" we might have said "The Traditional Doctrine of Art." For what we have to say applies to all human manufacturing, or making by art, only excepting the two most conspicuous ages of human decadence, the one late classical, and the other in which we live. We must not, of course, confuse "traditional" with "academic": fashions change with time and place, while the tradition or "handing on" of which we are speaking is an Eternal Philosophy. For greater convenience I shall rely chiefly upon mediaeval sources, but please remember at every step that the principles of mediaeval and Oriental art are identical. That this must be so will be obvious when we consider that for both art comes much nearer to what we understand by science than it does to the naïve behaviorism of the modern "artist." Christian art, as Émile Mâle has so well said, is a calculus; and as Zoltán Takács puts it, "the chief aim [of Oriental art] is precise expression." If modern art cannot be explained in terms of the same philosophy, it may be because it has no ends beyond itself, because it is too "fine" to be "applied," and too "significant" to mean anything. We are somewhat confirmed in these suspicions by the words of the professor who assures us that " 'unintelligibility' is of the essence of 'meaning' in modern art," and by the common assertion that the "work of art is its own

[First published in Zalmoxis, I (1938).—ED.]

[1] Meister Eckhart, Evans ed., I, 288. Cf. BU 1.5.3, "It is with the mind, indeed, that one sees"; [also Plotinus v.8.11, and Witelo, *Liber de intelligentiis* xxxviii.2]. From the traditional point of view, the objects of the senses are implicit in the powers by which they are registered, and were it otherwise, there would be no recognition, but only sensation.

meaning."[2] So far from this, the Middle Ages and the East held that "beauty has to do with cognition," that the "operative habit is an intellectual virtue,"[3] and that by whatever is indefinite in a work of art, it is so much the less in being as a work of art.

Our remarks are primarily offered to those who are either teachers or learners in what is called the appreciation of art or the history of art. Incidentally, these expressions are misnomers; what we mean is the "appreciation of works of art," and the "history of things made by art." Of art itself there can no more be a history than there can be of metaphysics; histories are of persons and not of principles. The current view of art is historically and geographically a most exceptional one, or in other words an abnormal and provincial view. It is precisely this view of art, built up in the last few hundred years, and now taken for granted, that most of all stands in the way of our understanding of the artifacts of the Middle Ages and the East, and of folk art generally. It is another view of art that we must understand if we want to understand and "appreciate" the works of art that were made in accordance with it.[4]

Just to show that this is another world than is dreamt of in our philosophy, I ask how many of my readers know what St. Bonaventura means by the title of his tract *On the Reduction of Art to Theology*[5] or by the expression "the light of a mechanical art" that occurs in it; or grasp the full significance of the expression "operative light" (*kārayitrī pratibhā*) as it is used in Indian rhetoric; or realize that phrases such as our "sparkling wit" and "lucid exposition," or, for that matter, also "sunny disposition," are no mere figures of speech or ornaments of language, but are the vestiges of a consistent metaphysics of light, in which they originated. In this world, "light" is the primordial essence from which all other essences derive whatever truth or being or goodness they possess.[6] In this world, beauty is a formal cause, and one of the Divine Names. It is into this world that we have to enter if we would understand its

[2] E. F. Rothschild, *The Meaning of Unintelligibility in Modern Art* (Chicago, 1934), p. 98.

[3] See *Sum. Theol.* 1.5.4 *ad* 1 and 1-11.57.3c.

[4] [As Plotinus tells us, "Everywhere a wisdom presides at a making," *Enneads* v.8.5; cf. *Sum. Theol.* 1.117.1.]

[5] St. Bonaventura, *Opera omnia* (Florence, 1891), Op. 4.

[6] Witelo, *Liber de intelligentiis* vi-viii: "Prima substantiarum est lux. . . . Unumquodque quantum habet de luce, tantum retinet esse divini. Unaquaeque substantia habens magis de luce quam alia dicitur nobilior ipsa. Perfectio omnium eorum quae sunt in ordine universi est lux."

productions, whether plastic, literary, or musical; for as Goethe put it once and for all,

> Wer den Dichter will verstehen,
> Muss in Dichters Lande gehen.

Throughout this essay I shall be using the very words of the Middle Ages. I have nothing new to propound; for such as I am, the truth about art, as well as about many other things, is not a truth that remains to be discovered, but a truth that it remains for every man to understand. I shall not have a word to say for which I could not quote you chapter and verse. These pages are littered with quotation marks.[7] Many of the quotations are from the *Summa* of St. Thomas; many from Augustine, Bonaventura, and Eckhart; Oriental sources are both too many and too unfamiliar to be listed here. My use of the actual words of the contemporary writers may present some difficulty, but it is intentional; because in order to understand, we must learn to think about art in the way that the patrons and artists of whom we are talking thought about art; we cannot use the phraseologies that we have devised to express our own ideas about art without distorting the views that we are trying to investigate.

Very likely the mediaeval and Oriental world will seem strange. We are romanticists; it is because we know so little about it that we talk of the "mysterious East," and describe as "mystical" much that is merely expressed with the precision of a technical vocabulary to which we are not accustomed. To put it plainly, no one can be regarded as qualified to expound the philosophy of mediaeval or Indian art who is not familiar with mediaeval Latin and Sanskrit literature, at least in translation. The Middle Ages accepted the Aristotelian dictum that the "general end of art is the good of man," and held that "there can be no good use without art."[8] It will be quite impossible for us to understand or account for the nature of the corresponding art unless we know what was regarded as the "good of man" and what was meant by "good use." In other words, if we mean to go far, we must begin by asking what was the meaning of life for those whose works of art we propose to understand and "appreciate." We cannot go far in this essay; I shall be content if you realize that the way is a long one. And I ought perhaps to warn you that if you

[7] ["Littered with": On this choice of word, cf. Roger Lipsey, *Coomaraswamy: His Life and Work*, Volume 3 of this publication, p. 190.—ED.]

[8] *Sum. Theol.* I-II.57.3 *ad* I.

ever really enter into this other world, you may not wish to return: you may never again be content with what you have been accustomed to think of as "progress" and "civilization." If, in fact, you should ever come to this, it will be the final proof that you have "understood" and "appreciated" mediaeval and Oriental art.

The active life of man is of two sorts, either a doing or a making. These are the realms respectively of conduct and of art; the one is governed or corrected by prudence, the other by art.[9] These activities are of equal import in the life of every man, who may fall short in either, but in accordance with the command, "Be ye perfect," should strive for perfection in both. Each is absolute in its own domain; in the field of art, the perfection of the artifact is a final end, but in the realm of conduct, the end to be served by the artifact itself is of prior significance. What it is important for us to observe at present is that just as conduct may be called regular or irregular as judged by prudence, so works of art can be called good or bad as judged by art. Just as there is a conscience about doing, so there is a conscience about making; and these two consciences operate independently, notwithstanding that both are referable to one common principle, that of the spark of Divine Awareness, to which the Middle Ages referred by the name "Synteresis."[10] In the same way, in the East, there is presumed an absolute standard of rectitude both for doing and for making; which *pramāṇa*, or "fore-measure" is possessed absolutely only by God, but participated in by man according to his capacity, so that we speak of the artificer as "in possession of his art." The art or wisdom of God is identified with the Universal Man, the Exemplar "through whom all things were made." Art in itself is thus, in this philosophy, an absolute principle, in the same sense that we can speak of Beauty as an absolute, from which all beautiful things derive their beauty in kind; in the same way man participates in the Divine Art. The possession of any art is such a participation. The possession of an art is, furthermore, a vocation and a responsibility; to have no vocation is to have no place in the social order and to be less than a man: "no one without an art comes into Teamhair," there is no place

[9] *Sum. Theol.* I-II.3.2 *ad* 1; II-II.179.2 *ad* 1 and *ad* 3.

[10] O. Renz, "Die Synteresis nach dem Hl. Thomas von Aquin," in *Beiträge zur Geschichte der Philosophie des Mittelalters*, X (Münster, 1911), p. 172, "However in art the will is not arranged according to the moral synteresis (*voluntas recta*), but rather according to 'artistic synteresis,' according to the laws of art."

for him in the City of God. For the East "it is by intense devotion to his own vocation that Everyman attains his own perfection."[11] In the Neoplatonic philosophy of which the Middle Ages were the inheritors, the artificer "cooperates with the will of God when by the use of his body and by his daily care and operation he gives to anything a figure that he shapes in accordance with the divine intent,"[12] that is to say, in the terms of a later formula, when he is "imitating Nature in her manner of operation." And whereas the Christian artist prays as a man "Thy will be done on earth as it is in heaven," "the crafts such as building and carpentry which give us matter in wrought forms may be said, in that they draw on pattern, to take their principles from that realm and from the thinking there."[13] Or again, in the words of Indian texts, "Human works of art are imitations of angelic works of art,"[14] and, for example, "There is a heavenly harp; the human harp is a copy of it."[15] The Zohar tells us of the Tabernacle that "all its individual parts were formed in the pattern of that above," and this accords with the Mosaic "Lo, make all things in accordance with the pattern that was shown thee upon the mount."[16] In Indian literature, the artificer is again and again referred to as "visiting heaven," that is, of course, by an act of contemplation, and as bringing back with him a pattern which he imitates down here; or alternately, as indwelt by the All-maker. "Truth to Nature" in this realm does not infringe the interdiction of idolatry: the artifacts that we are now considering "are not found in that form of similitude in reference to which the prohibition was given."[17] Exod. 20:4-5, in fact, forbids a naturalistic art. The "truth" of traditional art is a formal truth, or in other words, a truth of meaning, and not a truth that can be tested by comparing the work of art with a natural object. The artifact need no more resemble anything than a mathematical equation need look like its locus. The Apocalyptic Lamb is seven-eyed, and to have depicted one with only two would have been "untrue" to the first cause of the work to be done, which was to represent a certain aspect of the "nature" of God. Many an Indian form of deity is many-armed or, like St. Christopher, animal-headed, and where such forms are required by the meanings to be expressed, to represent a figure designed as though to function biologically would be to sin against art and nature both.

[11] BG xviii.45.

[12] Hermes, *Asclepius* i.11.

[13] Plotinus, *Enneads* v.9.11.

[14] AB vi.27.

[15] ŚA viii.9.

[16] Exod. 25:40.

[17] Tertullian, *Contra Marcionem* ii.22.

Our traditional art is thus "ideal" in the philosophical sense of the word; as Guénon expresses it with bitter clarity, "in the whole of mediaeval art, and otherwise than as in modern art, we meet with the embodiment of an idea, and never with the idealization of a fact." Traditional art is never "idealistic" in the modern and sentimental sense, according to which we conceive "ideals" or "heart's desires" after which we could wish to reshape the world. For the mediaeval philosopher, the world could not have been better or more beautifully made than it is, for him the perfection of artistic judgment and height of aesthetic pleasure was touched when "God saw everything that he had made, and behold, it was very good."[18] It is just so with the human artificer, in degree, when he feels that he has made anything well, that is to say well and truly, or as *it* ought to be, rather than as *he* might have liked it to be, had he not known by his art what it ought to be like.

In this philosophy, God is taken for granted, and cannot be disentangled from the theory of art and of the manner of the artificer's operation: "Thou madest," as Augustine says, "that innate skill whereby the artificer may take his art, and may see within what he has to do without: thou gavest him the sense of his body, with which as his interpreter, he may convey from his mind into the material that which he is a-making, and by which he may report unto his mind again what has been made, so that he may inwardly take counsel with the truth that governs him, whether or not it has been well made."[19]

This "truth that governs" the artificer is the same thing that we alluded to above by the name of Synteresis, Neoplatonic *hegemon*, and Indian Immanent Spirit as "inward controller": in short, the practical intellect regarded as an extension of the Universal Intellect by which all natural things have been made, "the goodness of which is derived from their form (Skr. *nāma*), which gives them their species, or figure (Skr. *rūpa*)."[20] "For as a workman anticipating the form of anything in his mind taketh his work in hand, and executeth by order of time that which he had simply and in a moment foreseen, so God by his Providence disposeth," etc.[21]

[18] *Gen.* 1:31. Cf. St. Augustine, *Confessions* xiii.28. The "most beautiful order given to things by God" (*Sum. Theol.* 1.25.6 *ad* 3, cf. 1.48.1) is a favorite theme of mediaeval Christian philosophy. A notable description of the beauty of the world occurs in St. Chrysostom's *Homilies on the Statues* (Catholic University of America, Patristic Studies, XXII, 107, Washington, D.C.).

[19] St. Augustine, *Confessions* xi.5. [20] *Sum. Theol.* 1-ii.18.2c.

[21] Boethius, *De consolatione philosophiae* iv.6.

Observe, moreover, that the word *ingenium*, translated above by "innate skill" and equivalent to the Sanskrit "inborn formative light," is the source of our word "engineer," and that the mediaeval concept of artistry is, in fact, far more like our conception of engineering than it is like our concept of "art": the traditional artificer's business is to make things that will work, and not merely please, whether the body or the mind. He was, in fact, a builder of bridges for both at once, and these bridges were expected to bear the weights for which they were designed; their beauty depended upon their perfection as works of art, not their perfection on their beauty.

From the point of view of the individual apprentice, fitted by nature for a given vocation, the art by which he is to work is not a gift, but a knowledge to be acquired. Dürer is thinking still in a traditional way when he says, "It is ordained that never shall any man be able, out of his own thoughts, to make a beautiful figure, unless, by much study, he hath well stored his mind. That, then, is no longer to be called his own; it is art acquired and learnt, which soweth, waxeth, and beareth fruit after its kind. Thence the gathered secret treasure of the heart is manifested openly in the work, and the new creature which a man createth in his heart, appeareth in the form of a thing."[22]

"Never out of his own thoughts," for as Eckhart expresses it, there cannot be conceived a property in ideas. Invention, or intuition,[23] is the discovery or uncovering of particular applications of first principles, all of which applications are implicitly contained in these principles, only awaiting the occasion for their explicitation. The Synteresis, in other words, and not the individual as such, is the ground of the inventive power. Invention in this philosophy means vision or audition, as when Dante says, "I am one who when Love inspires me, take note, and go setting it forth in such wise as He dictates within me,"[24] and it is this, and not personal flair, that is held to account for his *dolce stil nuovo*. In a pertinent Indian myth it is related how there is revealed to a liturgist a heavenward-leading chant; asked by his fellows whence he has it, he immodestly replies: "It was just I that am the author," with the result that his fellows find their way to heaven, but he is left behind, "for he had told a lie."[25]

[22] Cited from T. A. Cook, *The Curves of Life* (New York, 1914), p. 384.

[23] Defined by St. Augustine as a *simplex intelligentia* extending to the Eternal Reasons, *super aciem mentis* (*De Trinitate* IX.6.12; Migne, *Series latina* XLII.967). Not what Bergson means by "intuition."

[24] Dante, *Purgatorio* XXIV.53-54. [25] PB XII.II.10-11.

Every commission demands a corresponding invention. But this invention is no more the artificer's "own" than is the occasion that demanded it; it is a discovery of *the* right way of solving a given problem, and not a private way. The traditional art is not, then, in any current sense of the word, a "self-expression." Whoever insists upon his *own* way is rather an egoist than an artist; just as the mathematician who "finds" that two and two make five, and insists upon the beauty, or perfection, of this his own solution, is a peculiar person rather than a mathematician. There is no more place in art than there is in science for any private truths or perfections of statement; the thing is either right or wrong. What we are interested in for the present is the *fact* that in mediaeval and Oriental art it is the exception rather than the rule for the artist to attach his name to any work.[26] The further we go back in any cycle of art, the more difficult it becomes to satisfy *our* curiosities about the artists' personalities, the more we are nonplused by the impossibility of substituting a knowledge of biographies for a knowledge of art. The artist's personality was a matter that did not concern the traditional patron; all that he demanded was a man "in possession of his art."

Nor can we isolate this or understand it apart from the spiritual background of the whole environment in which our works of art were produced. We cannot understand it from our individualistic position which aims at the greatest possible freedom for oneself. The traditional philosophy also aims at a greatest possible freedom; but *from* oneself. We say deliberately "aims," because just as traditional art is not a practice of art for art's sake, so the traditional philosophy, or rather metaphysics, does not aim at truth for the sake of satisfying a curiosity, nor at virtue for the sake of virtue, but all for the attainment of man's last and present end of happiness. Eckhart's word holds good for Occident and Orient alike: "All scripture cries aloud for freedom from self." It is simply an illustration of the integrated consistency of the traditional life that the religious ideal should be recognized in the artificer's characteristic anonymity, which is as conspicuous in the field of literary as it is in that of plastic art.

[26] Cf. B. Belpaire, "Sur Certaines Inscriptions de l'époque T'ang," in *Mélanges chinoises et bouddhiques* III (1938). These are mostly inscriptions in praise of works of art. The editor remarks: "Dans cette vingtaine d'inscriptions aucune ne nous parle de l'artiste, de son nom, de la date . . . presque toujours le sujet représenté intéresse seul l'inscription."

Art is defined as "the right reason of things that can be made," or "right way of making things."[27] The operation of the artificer is above all a rational procedure, governed by a knowledge rather than a feeling. Not that feeling is excluded; but what is loved is what is known. Here the will follows the intellect: one learns to like what one knows, rather than boast that one knows what one likes. The concept "art" is not in any way limited to the context of making or ordering one kind of thing rather than another: it is only with reference to application that particular names are given to the arts,[28] so that we have an art of architecture, one of agriculture, one of smithing, another of painting, another of poetry and drama, and so forth. It is perhaps with the art of teaching that the mediaeval philosopher is primarily concerned; rhetoric is then for him the type of the arts, and it belongs to the nature of all the arts "to please, to inform, and to convince,"[29] or, in other words, to please and to serve their purpose. Here there is no distinction of a "fine" from an "applied" art, but only one of a "free" from a "servile" operation, which operations are not allotted to different kinds of men, but to every artificer, whatever it may be that he makes or arranges: the painter, for example, working freely in the conception of the work to be done, and working as a laborer, as soon as he begins to use his brush.[30] In other words, there is no such thing here as a "useless" art, but only a freedom of the artificer to work both "by a word conceived in intellect" and by means of tools controlled by his hands. Nor was it conceived that anything could be made otherwise than "by art." To bring into being an industry without

[27] *Sum. Theol.* I-II.57.3 and 5.

[28] St. Chrysostom, *Homilies on the Gospel of Saint Matthew* [tr. George Prevost, 3 vols., Oxford, 1851–52], "The name of art should be applied to those only which contribute towards and produce necessaries and mainstays of life" (cf. *Sum. Theol.* II-II.169.2 *ad* 4).

[29] St. Augustine, *De doctrina christiana* IV.12–13. (For the text see Catholic University of America, Patristic Studies, XXIII, Washington, D.C., 1930). Cf. C. S. Baldwin, *Medieval Rhetoric and Poetic* (New York, 1928), and Coomaraswamy, "The Mediaeval Theory of Beauty" [in this volume—ED.].

[30] "Inasmuch as the body is in servile subjection to the soul, and man, as regards his soul, is free (*liber*)" (*Sum. Theol.* I-II.57.3 *ad* 3). Arts such as those of rhetoric, requiring a minimum of physical labor, are distinguished as "liberal" from the "servile" arts "that are ordained to works done by the body." "But if the liberal arts are more excellent, it does not follow that the notion of art is more applicable to them" (*ibid.*). In modern terms, this means that painting and poetry cannot be distinguished from carpentry or agriculture, as art from labor: whoever makes or arranges anything, whatever the material, is an "artist."

art remained for us. We nowadays think of what we call "art" as useless only because *we* have no use for art; we have found out how to live by bread alone.

"Art is the imitation of Nature in her manner of operation."[31] Nature's manner is to imitate the form of humanity in a nature of flesh. The form of humanity does not only exist in this way, but also—for the Middle Ages and the East, if not for us—in a nature of light, transformally. This means that to make our statue right we must have understood both human nature and the nature of stone, or wood, or whatever our material: only so can we imitate the form of a man in the nature of stone or wood.

"Similitude is with respect to the form."[32] Do not take it for granted that you know what is meant by "form" in this definition. "Form" in this philosophy does not mean outward appearance, unless we speak advisedly of "actual" or "accidental" form; in this philosophy, for example, we say that "the soul is the form of the body." "Form" is logically prior to the thing; the artist conceives the form before he makes the thing, or as the Middle Ages put it, the artist proceeds "by a word conceived in intellect."[33] This procedure is the act of imagination, viz. the entertainment of an idea in an imitable form. This is the "art" *by* which the artist works. The knowledge of form is not a knowledge derived from the finished artifact or from nature: I need not tell you that the form of an arch was not suggested by the interlacing branches of trees, nor that of the crook of a crosier by the fronds of ferns, nor that of the "acanthus" ornament by the acanthus plant, nor need I say that the *svastika*, as Jung has pointed out, has no prototype in nature, however "true to nature," the nature of the cosmos, it may be. As Augustine says, "The standard of truth in the artifact is the artificer's art; for then only is the arch truly an arch when it agrees with this art," so that "it is by their ideas that we judge of what things ought to be like."[34]

It is almost impossible for us to outgrow a judgment of ancient and

[31] *Sum. Theol.* 1.117.1. [Cf. 1.45.8 ad 4.]

[32] *Sum. Theol.* 1.5.4: St. Basil, *De spiritu sancto* (Migne, *Series graeca*, Vol. 32), XVIII.45, ἐπὶ τῶν τεχνητῶν κατὰ τὴν μορφήν ἡ ὁμοίωσις.

[33] *Sum. Theol.* 1.45.6 [and 1.33.3 ad 1].

[34] St. Augustine, *De Trinitate* IX.6.11. Cf. E. Gilson, *Introduction à l'étude de Saint Augustin* (Paris, 1929), p. 121 and note 2. Similarly St. Bonaventura, *II Sententiarum* 1.1.1 ad 3 and 4, "Agens per intellectum producit per formas, quae non sunt aliquid rei, sed idea in mente, sicut artifex producit arcam." [Cf. *Sum. Theol.* 1.16.1, "adaequatio rei et intellectus," "but in no way can the senses know this," and *ibid.* 1.17.1 ad 3, and 3 ad 2, realism is "falsity" in art.]

folk art based upon the assumption that the artist has always been trying to do what we imply when *we* speak of "truth to nature." We daily deny St. Augustine's truth when we tell the student of art to observe and follow nature, and teach him to know what nature is like by means of an articulated skeleton, and mean by "nature," not the Mother Nature, Natura naturans, Creatrix universalis, Deus, of the Eternal Philosophy, but ourselves and others of Mother Nature's natured children, Nature "as effect." When a child begins to draw, he draws in Augustine's fashion; he draws what he means, and not what he sees. He does this acting spontaneously in accordance with human nature simply, rather than as trailing clouds of glory in any sentimental sense. It is in this way that traditional art is a truly human art; it exists and has always existed to express and communicate ideas, as well as to serve its practical purposes, and never to tell us what "things" are like. But we very soon tell the child to look at what we presume to have been his model, and to "correct" his drawing by it; a little later on we shall give him cubes and cones, and finally the nude, to imitate. We feel that we should have liked to have taught the primitive or savage artist in like manner to draw in "correct perspective." We take it for granted that an increasing naturalism, such as is recognizable at a certain point in every cycle of art, represents a progress in art. We hail the shift of interest from form to figure that marked the "Renaissance,"[35] out of which our own materialism and sentimentality are only the inevitable and more complete development. It hardly occurs to us that prehistoric art was a more intellectual art than our own; that like the angels, prehistoric man had fewer (and more universal) ideas, and used fewer means to state them than we; just as we do not realize that the ideas that he expressed with such austere precision, by means of his spirals, for example, which have become nothing but "art forms" for us, and which are indeed superstitions for us in the etymological sense of this excellent word, are only meaningless to us because we no longer understand them. The ideas and the art of the Middle Ages and the East, even at the height of accomplishment, are far more nearly related to the ideas and the art of prehistory than they are to those of our advanced decadence. As a curator of one of the greatest of our American museums recently remarked to me, "From the Stone Age until now: *quelle dégringolade!*"

We are all, of course, aware that abstract and savage art have recently

[35] Cf. A. Gleizes, *Vers une Conscience plastique: la forme et l'histoire* (Paris, 1932).

come into fashion. But this abstract art of ours is nothing but a caricature of primitive art; it is not the technical and universal language of a science, but an imitation of the external appearances or style of the technical terms of a science. The configurations of cubist art are not informed by universals, but are only another outlet for our insistent self-expressionism. I am obliged to interpolate these remarks lest you should wish to tell me that our art, too, is becoming intellectual.

The word "abstract" and the closely related word "conventional" are inadequate descriptions of the nonrepresentative character of traditional art. We even speak of "conventionalizing" natural forms and thus making them "decorative." Our abstraction is merely a taking away from things what rightly belongs to them: conventionalizing is what the Taoist (whose philosophy is so important for an understanding of Far Eastern art) calls a "destruction of the natural integrity of things in order to produce articles of various kinds—the fault of the artisan."[36] It is not what Eckhart means when he says that "All creatures come into my mind and are rational in me. I alone prepare all creatures to return to God." Our abstraction means at best the elimination of nonessentials; what we get in this way are not universals, but only generals, which do not differ from particulars in kind, but only in convenience. It is in the same way that empirical science deduces "laws," which are not really absolutes, but only statistical summations of experience. This is not the method of traditional art, which starts from universals in which the whole of the natural integrity of things is contained not less but more eminently, and deduces from these first principles whatever applications may be required. The forms of the cross, the circle, and the spiral, of which the traces can be recognized in nature, are not themselves unnatural, but super-natural, that is to say superlatively or extragenerically "natural."

"Art imitates Nature in her manner of operation." In other words, as every traditional treatise on metaphysics or theology continually asserts, the human artificer works like the Divine Artificer, with only this important distinction, that the human artificer has to make use of already existing materials, and to impose new forms on these materials, while the Divine Artificer provides his own material out of the infinitely "possible," which is not yet, and is therefore called "nothing," whence the expression *ex nihilo fit*. We take for granted what our traditional artificer

[36] Chuang-tzu, ch. 9, p. 108, cf. pp. 147, 155.

took for granted, for he was not in his office as artificer a heretic,[37] that the ideas of all things inhere in the Divine or Universal Intellect, of which our intellects are, so to speak, reflections or facets. These "Eternal Reasons" or "Forms" represent the metaphysically first or permissive cause of the coming into being of anything, whether natural or artificial. God, or Being absolutely, is presupposed by the definition "art has to do with the making of things that can be made (*ars circa factibilia*)." The idea of God is the "explanation" of the being of all things. In this philosophy, however, "God does not govern directly, but by means of the operation of mediate causes, without which the world would be deprived of the perfection of causality."[38] But as we are concerned with the explanation of particular things, taking for granted the possibility proven by the fact of their existence, we shall be concerned at present only with the particular causes of their whatness. In this relation the place of the first cause absolutely is taken by the patron and artist jointly, the former as knowing what is to be done, the latter as the intellect in which the idea of the thing to be made subsists in an imitable form. In this situation it will be evident that Man is the more like God the more the patron and the artificer are of one mind, and not a power divided against itself. The more like God, at the same time, the more the making of things is an intellectual and not merely a physical operation. For if the Divine Artificer does not work with his hands or with already existing materials, but "thinks things, and behold they are," it is toward this perfection that the human artificer tends: at least, if he did *not* think things, they would not be.

The Divine "making" is not an operation apart from being: it is an act of being. The "image-bearing" and "true-speaking" light carries with it the ideal forms that inhere in it, and wherever any ray of this light meets with a corresponding possibility of realization, there the particular idea to which the possibility corresponds is realized and becomes a phenomenon. "The one true light that lighteth everyman," the source of all being, is also the source of all beauty and of all intelligibility: light, that is, as being that *by* which the eye sees, rather than any brilliance which it sees. In the same way physical light is the source of the colors of physical objects, of which the beauty is visually apprehended: each

[37] St. Bonaventura, *I Sent.* 6, q.3, concl., "Qui negat ideas esse, negat Filium Dei esse"; Aquinas, *De veritate* 3 *ad* 1, "sed contra, Qui negat ideas esse, infidelis est, quia negat Filium esse."

[38] *Sum. Theol.* 1.103.7 *ad* 2; 1.116.2, etc.; St. Augustine, *De civ. Dei* v.8.

thing reflecting what its own nature permits it to reflect, viz. a given color out of the totality of colors inherent in white light: which given color is the basis of the appearance on which the recognition of beauty depends, beauty being defined as "that which pleases when seen," and that which can be seen consisting of nothing but colored areas.

In his first and contemplative act, the artist is self-possessed, and sees only that which is to be made, and not all sorts of things that might have been made. It is like this (very slightly adapting the words of Eckhart): "Wouldst thou portray an angel? Go hence and withdraw into thyself until thou understandest; give thy whole self up to it, then look, refusing to see anything but what thou findest there. It will seem to thee at first as though thou art the angel," the artificer thus, as Plotinus puts it in a discussion of contemplative vision, i.e., Latin *contemplatio* and Sanskrit *dhyāna*, taking "ideal form under the action of the vision while remaining, potentially, himself,"[39] that self to which he returns, when he turns from the *actus primus* to the *actus secundus*, in which he imitates the form that was inwardly seen. Just as in the case of the swordsmith cited by Chuang-tzu: "'Is it your skill, sir, or have you a trick?' 'It is concentration. If a thing was not a sword, I did not see it. I availed myself of whatever energy I did not use in other directions in order to secure efficiency in the direction required.' "[40] It is in this way that a definite image arises in response to the patron's need, whether this patron be the artist himself or another; and as Blake expressed it, "He who does not imagine in clearer and better lineaments than this perishing mortal eye can see, does not imagine at all."[41] We begin to understand in what sense the form of the thing is what is called the "formal cause" of its appearance and how the perfection of the thing itself is measured by the degree to which it faithfully reflects the form or idea of the thing as it subsists in the image-bearing light or, in other words, in the Divine Intellect. If it be deformed (Skr. *apratirūpa*), it is "untrue" to its archetype, or "untrue to nature"; a man born blind, for example, is to that extent not "truly" a man.[42]

[39] Plotinus, IV.4.2. Cf. Coomaraswamy, "The Intellectual Operation in Indian Art" [in this volume—ED.].

[40] Chuang-tzu, ch. 22, p. 290.

[41] [Cf. *Blake: Complete Writings*, ed. Geoffrey Keynes (London, 1966), p. 576. —ED.]

[42] In this philosophy, ugliness or evil is a matter of informality. For example, St. Augustine, *Confessions* XIII.2, "For a body simply to be, is not all one with being beautiful, for then it could no ways be deformed." Similarly BU 1.3.4, "Whatever

In this way, then, in the case of artifacts, the human artificer projects the image-bearing light of his own more limited intellect upon the available material. The image of what the thing is to be like already exists in his mind, before the coming into being of the thing, and continues to subsist even after the thing has been made, or even after it may have ceased to exist. This mental image or form according to which the thing is made is called the "art in the artist" and, as in the case of the Divine Art, is the "formal cause" of the thing's appearance. The human artist, however, has not only to make use of already formed material on which to impose a new form; but the selection of this material is very important, because it is only a suitable material in which the form in the artist's mind can be realized. If, for example, he has imagined a man in stone, and is provided only with clay, he cannot reproduce in clay the form that has been imagined in stone. What happens in this case is that he forms a new and different mental image; this image is imitated in the clay; but even if the form of the clay is transferred to stone by the use of a pointing machine, it will still be a form imagined in clay, and the work in stone will be untrue to the artist's first conception and unsatisfactory to the knowing patron, who had commissioned a figure in stone. In any case, the material is another cause of the finished product being what it is, and as such it is called the "material cause." We have defined two of the causes, viz. the formal and the material, by which the character of the finished product is determined.

The human artist, however, is not able by a mere act of the will to project his formal image upon the material in such a manner that material will of itself conform to his idea of what the thing is to be like. He has to resort to means, or in other words employ a technique. He must work with tools, which may be either his own hands, or these hands empowered by tools such as chisels or brushes; with which tools, for example, he either disengages from the stone the form he sees within it, having put it there himself, or builds up the clay until the outward form measures up to the form in his mind. These tools, and likewise the

it entertains, the eye reports to the powers-of-the-soul; whatever it sees beautiful (*kalyānam*), to the Spirit. . . . The ugly (*pāpman*) is whatever it sees deformed (*apratirūpam*)." All beauty is essentially formal, or in other words ideal (in the philosophical sense of this word, so much abused in the vernacular). It follows that the work of art is always thought of as less beautiful than the "art in the artist," by which it is judged. Cf. K. Svoboda, *L'Esthétique de saint Augustin et ses sources* (Brno, 1933), pp. 105, 109.

skill with which he uses them, may or may not be adequate. If the hand of the potter slips, the pot will be unshapely; if the plane is blunt, the surface of the table will be rough; if the pigment is ephemeral, the painting will fade. The operation is a "servile" one in this sense, that the artist himself is now an instrument directed by his art: he is acting now as a means to an end, which end has already been foreseen in the "free" act of the imagination. We recognize thus, in all the "means" employed, a third cause of the finished product being what it is: and this is called the "efficient" or working cause.

We have still to speak of a fourth cause. The artist has in view to make some definite thing: one does not just "make." Even if images seem to rise in the artist's mind spontaneously, these images have their seeds, in the same sense that dreams are wish-fulfillments: these random and un-invited images are set aside by the single-mindedness of a consciously directed act of the imagination. In any case, we call the man who is in need of goods, the patron, and the man who makes, that is to say has the knowledge and will to make whether or not himself in need, we call the artist or artificer. In such unanimous cultures as we are considering, patron and artist are never at cross-purposes; their concepts of good and of the ends to be attained by means of artifacts are virtually held in common. The needs of the aristocrat and the peasant are of the same kind, with only sumptuary, and not formal, distinction. Under these conditions we get what is properly called a folk art, that is to say, an art of the whole people. The fact that when cultures are perverted the traditional art only survives superstitiously over against the individualistic and supposedly more sophisticated, though really naïve, art of the bour-geoisie, prevents us from realizing that the sacerdotal and royal arts of the Middle Ages and the East were the arts of a people, and not the arts of individuals or classes. Furthermore, in societies based on vocation, it is taken for granted that the artist is not a special kind of man, but every man a special kind of artist. From this it follows that every man as patron possesses a general knowledge of the principles of making by art, although not the particular knowledge which he has a right to expect in the artist whom he commissions to make a particular thing for his use.

For our purpose, then, the artist and the patron are Everyman; we only distinguish the particular knowledge of the one from the particular need of the other. But this is an important distinction for us; because it is the patron's need of certain goods—a house, a picture, or a spade, for example—that is the first cause of the whole undertaking, and also its last end,

since it is being made for him. We have now recognized a fourth, and in some respects the most important, cause of the artifact's being what it is—for example, a spade and not a picture; which patron's need is called the "first" or "final" cause, first because it was a spade, or rather, something to dig with, that was wanted, and final, because it is a spade that is produced.

This first and final cause is the occasion or necessity of the work, according to which we speak of the job as a task or "work to be done." In the case of the Divine Artist this is what is called an "infallible necessity"; but to go into the meaning of this would take us too far afield. In the case of the human artist the necessity is what is called "coactive," the primary coagent being the patron. The nature of this necessity has nothing to do with the artist as such; it is only as a man that, before the work is undertaken, he can on moral grounds refuse or consent to make what is wanted by the patron, whether himself or another. Once the commission has been accepted, the artist has no further concern with prudence; his only concern is with the work to be done, that it be good in itself.[43] This does not mean that the artist cannot sin or come short, but only that as an artist he cannot sin morally. At the same time no man can be an artist and nothing but an artist, except at the cost of his humanity.[44]

The artist is working now "for the good of the work to be done," and for nothing else; "every artist intends to give to his work the best disposition . . . as regards the proposed end,"[45] it is no business of his, as an artist, whether the knife be used to heal or slay; his only concern is to make it sharp. This working for the good of the object to be made has nothing, of course, to do with a working "for art's sake": this expression is altogether devoid of meaning from the point of view of the Middle Ages and the East, according to which things are made by, and not for, art, *per artem* and not *pro arte*. The artist having consented to the task is working now "by art and with a will." The making of the thing has

[43] *Sum. Theol.* I-II.57.3 *ad* 2. "It is evident that a craftsman is inclined by justice, which rectifies his will, to do his work faithfully."

[44] Cf. *Sum. Theol.* II-II.169.2 *ad* 4: it is morally sinful to undertake things which can only be put to evil use, and undesirable to make such things as are for the most part put to evil uses, but not sinful to make such things as may be put either to a good or to an evil use. The jeweler, for example, does not sin (unless "by inventing means that are superfluous and fantastic,") because a becoming adornment of the person is by no means necessarily sinful.

[45] *Sum. Theol.* I.91.3c.

become his end, as the use of the thing is the patron's end. The patron should know better than the artist how to use the thing when it has been made; and it is from this point of view that the patron is called the "judge of art."[46] This judgment is something distinct from the pleasure that may be taken in the work itself, which is a pleasure taken in its perfection either while it is a-making or when it has been made. This "perfection" of the work is the essence of its "beauty." In the meantime, the artist enjoys his work; and this "pleasure perfects the operation."[47] This pleasure is of two kinds, "one in the intelligible good, which is the good of reason; the other is in good perceptible to the senses."[48] One is a pleasure taken in order; the other a pleasure taken in the aesthetic surfaces. The artist's mind and body are both involved: this pleasure is both intellectual and aesthetic (not as we now imagine, merely aesthetic). He both understands what he is doing, and feels it. The same holds good throughout the operation, and also when the artist looks at the finished work and judges it as a work of art, a thing made by art, an artifact, not proposing to use it himself. And the same will hold good for the patron, insofar as he understands what the artist is doing or has done, and insofar as the artifact is also for him the source of a direct sensation or aesthetic experience ("sensational" being what the word "aesthetic" means): or in other words, insofar as he is qualified by knowledge and sensibility to take both a rational and an animal pleasure in the qualities of the work itself, without respect to the using of it otherwise than as a source of pleasure.

"Beauty is what pleases when seen":[49] but how seen, and by whom? Beauty is not just what we like, for as Augustine says, "Some people like deformities."[50] Nor is beauty that which pleases when seen by the bird that mistakes the painted grapes for real ones. Beauty has nothing to do with recognition: the beauty of a portrait does not depend upon our feeling for the model; from this point of view an eye in the flesh is much better than an eye in pigment. Beauty is that which pleases when seen

[46] Plato, *Cratylus.* [47] *Sum. Theol.* I-II.33.4c.

[48] *Sum. Theol.* I-II.30.1c. Cf. Witelo, *Liber de intelligentiis* XVIII–XIX: the intelligible good is a vital operation, the sensible satisfaction only a function or vegetative habit.

[49] *Sum. Theol.* I.5.4 *ad* I, "Beauty relates to the cognitive faculty; for beautiful things are those which please when seen"; cf. I-II.27.1 *ad* 3, "Those senses chiefly regard the beautiful, which are most cognitive, viz. sight and hearing."

[50] St. Augustine, *De musica* VI.38.

by such a one as the artist himself, who both understands and feels. Presuming a beautiful, that is, perfect, artifact, the degrees of pleasure that can be experienced by the spectator will correspond to the measure of his own understanding and sensibility: if the bare statement "pleases when seen" is to stand, we cannot allow the spectator to be either stupid or callous.

At this point the problem of aesthetic pleasure can be dismissed, not because an αἴσθησις is hierarchically inferior to a νόησις, as the body is inferior to the mind, or the active to the contemplative life, but chiefly because we have a right to assume in every normal human being an adequate capacity for response to physical stimuli. If our social order is such as to permit a normal sensibility only to some men, and to take it for granted that other men must be taught to feel, this must be attributed to the kind of civilization that we put up with: it is a defect of government, rather than of such arts as we are now considering. We ought not to have to teach the student how to feel; that is a job for "the skin one loves to touch." All that we have to remind the student of in this respect is that certain materials are suitable to certain purposes, and that each material has its own proper qualities; we must teach him to expect and like in stone the texture of stone, and not to ask for the texture of flesh where such a texture would be impertinent. We perceive at this point that psychology cannot help us to understand the aesthetic surfaces of a work of art directly; we cannot, in fact, understand them directly, but only react to them; psychology has to do with how we react, how we experience pleasure or pain, and registers our preferences. If the psychologist proves statistically that the majority prefers circles to squares, or red to green, this has nothing whatever to do with the beauty or perfection of circles or squares, or with the relative artistic merits of paintings in which red or green predominates. These things belong to iconography, that is to say, to the first or final cause or prescription for the work to be done; the artist does not "choose" these forms or colors, but uses those which are demanded by the nature of the work to be done. We, in turn, can only judge of their right or wrong use, that is to say of the rightness, perfection, or beauty of the work, if we know what was to be done. In this philosophy, "art has fixed ends, and ascertained means of operation";[51] the patron decides what shall be made, "the artist has his art,

[51] *Sum. Theol.* II-II.47.4 *ad* 2 and 49.5 *ad* 2. Cf. Plotinus, *Enneads* v.8.1, 9.3 and 9.5 (art gives form to the work and exists independent of the matter); St. Augustine, *De immortalitate animae* v (the art in the artist is immutable), and *De musica*

which he is expected to practice."[52] It will be observed that the patron is always right—provided he knows what he wants, and has given his commission accordingly. If the patron has known what, and the artist has known how, the patron will be pleased by the artifact "when seen," and not only because he can put the artifact itself to work.[53]

We have now, as they say, "got somewhere." Because in teaching what we call the "appreciation of art" in connection with ancient or exotic works of art for which we have for the most part no actual use at the present time or in our own environment (unless to use them as a magpie uses ribands to decorate its nest), we are proposing to show the *post factum* patron or spectator how to derive all possible pleasures, both intellectual and aesthetic, from a given work which he does not propose to "use." As we have already suggested, the problem of aesthetic pleasure is not a difficult one, only demanding a clear distinction of personal preference for certain colors, forms, or flavors from the pleasure taken in the perception of colors, forms, or flavors in their right place. Even if we prefer ice cream to stew, we know better than to be pleased by a stew that tastes like ice cream.

Of the two sorts of pleasure, the one directly felt by the senses contacting the aesthetic surfaces, and the other a pleasure of the understanding, it is evidently the latter or intellectual pleasure that we have in mind when we speak of an education to be communicated in a university, or think of a cultured man. This pleasure of comprehension does not infringe or forbid the pleasure of the senses, but includes a very great deal more than can be registered or enjoyed by the "eye's intrinsic faculty." For "whereas other animals take delight in the objects of the senses only as ordered to food and sex, man alone takes pleasure in the beauty of sensible objects for their own sake."[54] To enjoy this pleasure

vi.34 (art is superior to the artist, and apart from space and time); [cf. J. Huré, *St. Augustin musicien* (Paris, 1924)].

[52] Second Council of Nicaea.

[53] A distinction of enjoyment from use (*frui* from *uti*), as of the beautiful from the convenient (*pulcher* from *aptus*) is made by Augustine in several places, and must have formed the theme of the lost *De pulchro et apto* (*Confessions* iv.13). He remarks, "An iron style is made by the smith on the one hand that we may write with it, and on the other that we may take pleasure in it; and in its kind it is at the same time beautiful and adapted to use" (*Lib. de ver. rel.* 39). Art, in other words, is the principle of manufacture, and Ruskin was perfectly correct in saying that "industry without art is brutality," since it is animal man that *labors*, and "industry without art" takes no account of the whole man.

[54] *Sum. Theol.* 1.91.3 *ad* 3.

we must learn to see through and not merely with the eye. From this point of view, the artifact "pleases when seen" to the extent that it is comprehended when seen. The artifact is a whole, and not an accidental aggregate of parts; and as Augustine says, "the whole is comprehended when seen, if it is seen in such a way that nothing of it is hidden from the seer."[55] From the analyses of the work of art in terms of the "four causes," we know exactly what it means to comprehend a work of art in such a way "that nothing of it is hidden from us." And once we have understood any work of art from all these points of view we shall once and for all have understood how to derive all kinds of intellectual pleasure that can be derived from the sight of anything that has been "well and truly made." By such an understanding as we have suggested, the patron's need is made our own, and so is his satisfaction in the finished product: we occupy the house that has been built for him, we wear his clothes, and share in his devotions. By such an understanding we participate in the artist's act of imagination, and share with him the pleasure that "perfected the operation"; we select and prepare with him the materials, strike or mold where he struck or molded, and know as he knew how each step must be taken.

We now know the work as the artist knew it. And how did the artist know the work? Not by observation, but providentially and vitally. Providentially, for "every agent acting rationally, and not at random, foreknows the thing before it is"[56] by means of the idea of it to which his intellect is conformed: "no painter can portray any figure if he have not first of all made himself such as the figure ought to be. . . . He who would draw a figure, cannot do so, if he cannot be it";[57] because "the form of the intellect is the principle of the operation."[58] And vitally, because the idea of the thing to be made "is alive in the artist" with his life, before he makes the thing itself, and after it has been made; what we call the vitality of a work of art belongs accordingly to its formality, and not to the material in which the form has been embodied, so as to be manifested: "similitude is with respect to the form." Thus Bonaven-

[55] *De vid. Deum*, ep. cxii [cf. *Sum. Theol.* 1.14.3 *ad* 1]. Cf. Witelo, *De perspectiva* iv.148, "Pulchritudo comprehenditur a visu ex comprehensione simplici formarum visibilium placentium animae."

[56] St. Bonaventura, *I Sent.*, d.35, a.unic., q.1, fund. 2.

[57] Dante, *Convito, Canzone* iii.53–54 and iv.10.106.

[58] *Sum. Theol.* 1.14.8 [cf. 1.17.1].

tura, Thomas, and Dante; we shall not pause to quote the Neoplatonic and Oriental parallels.

An identification of the artist with the form or *exemplar* of the thing to be made is both the formal cause of the work itself and the occasion of the artist's pleasure in it; and in the same way the spectator's pleasure in the artifact considered as "that which pleases when seen" depends, in turn, upon a like identification of himself with its essential form. These two pleasures or delights are, respectively, "direct" and "reflex."[59] We only separate these because the maker's ("conveying from his mind into the material that which he is a-making") and the spectator's ("reporting unto his mind again that which he has made") acts are for us successive acts. They depend, however, in us, as *in divinis* where they are coincident and indivisible, upon an identity of the causal consciousness with the form of the pattern (*exemplar*) of the thing that is caused: "the pleasure in which the cognitive life subsists arises from a unification of the active power with the pattern (of the thing to be), to which this active power is ordered"[60] (by a necessity, infallible *in divinis*, coactive in us): which pleasure is in God an eternal beatitude, because in him the identity of the active power with the ideas of things to be is perpetual. It is because of this identity that things as they are in Him (ideally) are not merely alive, but "life itself,"[61] so that "what was made was life in Him."[62] The analogy in time is that of the artist's lifelong enjoyment of his art, and that of the spectator for whom the thing of beauty is a joy "forever," both of these enjoyments depending upon the extent to which the thing to be made, or that has been made, is not merely a material object, but "alive" in the artist whether as creator or spectator.

If, then, we have so followed up the history of a work of art that it is

[59] Witelo, *Liber de intelligentiis* xx (*delectatio et delectatio reflexa*—the first being delight of imagining, the second, delight in the thing that was imagined and now is).

[60] *Ibid.*

[61] St. Bonaventura, *I Sent.*, d.36, a.2, q.1, *ad* 4, citing Augustine ("res, factae . . . in artifice creato dicuntur vivere, sed in Deo non tantum dicuntur vivere, sed etiam ipsa vita"). As remarked by J. M. Bissen, *L'Exemplarisme divin selon Saint Bonaventure* (Paris, 1929), p. 75, "Ceci permet même de dire qu'elles vivent dans l'esprit de l'artiste crée; en Dieu, toutefois, l'artiste divin, elles ont droit à être appelées *vie* tout court." Cf. Witelo, *Liber de intelligentiis* xviii–xx.

[62] John 1:3, 4: "was" to be taken as "eternal now." [Coomaraswamy discusses the implications of this rendering of the verses in the Gospel According to St. John in a still-unpublished essay, "*Quod factum est in ipso vita erat*: ὁ γέγονεν ἐν αὐτῷ ζωὴ ἦν." The manuscript is among the Ananda K. Coomaraswamy Papers, Princeton University Library.—ED.]

64

as if it had been made both by and for ourselves, our knowledge of it is no longer merely an accidental knowledge about it, but an essential knowledge. We have acquired a "lively sense" of it. We have performed what is no mere empathy or "in-feeling" (*Einfühlung*), but an act of the intellect, in-wit, "in-knowing." The work has become a part of our life forever; and this life of ours has been extended so as to include not merely an anticipated future but also a living past. We have no further use for "history" as such. And this is an education, this belongs to the realization of all the potentialities of humanity, this pertains to deification; more and more to learn to live in an eternal now, "where every where and every when is focused."[63]

We have left ourselves with but little space to expound the traditional theory of Beauty. No distinction in principle is made between the beauty of natural objects and that of artifacts. Beauty in either case is the visible and attractive aspect of the perfection of the thing in its kind. The absolute Beauty of the first and formal cause of all things is participated in by all things natural or artificial to the extent that they really are what they purport to be. Particular things can only be beautiful or perfect in their kind, and not in ways that belong to other kinds. For example, claws and stripes belong to the beauty of a tiger, which would not be a good or perfect tiger without them; the beauty of metal belongs to a bronze, in which the texture of human skin would be a hideous informality; and these beauties cannot be substituted for one another or replaced by those of other kinds. They can only coexist in an absolute Beauty with which we are not at present directly concerned; just as all colors can only coexist where none is color but all are Light.

The beauty of particular things is defined as follows: "In the first place, integrity or perfection; for the less of these, the uglier the thing. Then due proportion, or harmony. And finally, illumination, whence those things that have a clear color are called beautiful."[64] All of these terms have a broad content, and are to be understood, not vaguely, but as tech-

[63] Dante, *Paradiso* XXIX.12, cf. XVII.18.

[64] *Sum. Theol.* I.39.8c. For St. Augustine, number (i.e., as determining species, Skr. *rūpa* as *mātrā*), equality (similitude), unity, and order are the conditions of beauty (K. Svoboda, *L'Esthétique de saint Augustin*, p. 108); Witelo, *De perspectiva* IV.148, gives a long list of conditions of beauty, beginning with light: "Lux, quae est primum visibile facit pulchritudinem . . . color etiam," etc. It may be observed that in the whole of this philosophy it is taken for granted that beauty is objective, and not a matter of taste.

nical terms defined in their place. Integrity and perfection both imply real being; for the less a thing *is* a thing, and the less perfect it is, the less it is at all what it is supposed to be. Note that the word "perfect" is literally "thoroughly made," or "well and truly made," and that the perfect artifact and perfect man are perfect in the same way; that is, ontologically, when each is all that it can be, or "has become what it is" (*geworden was er ist*, Skr. *kṛtakṛtya*) potentially, and therefore what it ought to be actually; "the last end corresponding to the first intention."[65] And similarly as regards ugliness, or the imperfection of sin: the artist is said to sin against Art, just as the man is said to sin against Nature, "by any departure from the order to the end."[66] You will begin to see now how the parts of this world that we have been trying to understand are as intimately fitted into one another as are those of a living organism, and what we mean by a reference of all activities to first principles. It is precisely this quality of consistency or correctness and logical rectitude that is implied by the word "integrity" in our definition of beauty, just cited from St. Thomas; "integrity" in mediaeval rhetoric, and indeed already in Cicero, meaning "accuracy." "Integrity," then, in a visual art will imply a formal accuracy or iconographic perfection; whatever is informal being unlovely, and whatever is "good form," lovely. Just as in India, "that only is considered lovely, by those who know, which agrees with the canons of the art, and not that which simply pleases our fancy."[67] Composition, in other words, is here for the sake of logic, and not for the sake of optical plausibility, or for the comfort and convenience of the eye; if that which is logically ordered is also pleasing it is not that this pleasure has been directly sought (it is not the *aim*, but rather the *method* of traditional art, to please) but because the principle of order inherent even in the physical machinery of human nature responds to its like. The problem of the relation of beauty to truth is clearly involved here, with the conclusion that beauty and truth are inseparable concepts. For example, a representation of the Virgin seated in the crescent moon, if the work of a skilled painter, should be beautiful, but one of the Virgin

[65] *Sum. Theol., passim.* Note that *intentio* is used in two senses, (1) as intended meaning to which essential form corresponds, and (2) as expressed meaning, corresponding to actual form. Aesthetic surfaces are therefore "visible meanings" (*intentiones visibiles*, Witelo, *Liber de intelligentiis* IV.148).

[66] *Sum. Theol.* I-II.21.1 *ad* 3.

[67] *Śukranītisāra* IV.104–106; see Coomaraswamy, *The Transformation of Nature in Art*, 1934, p. 115.

as a solar principle by however skilled a workman could not be beautiful, because it would not be true; the workman, however manually skilled, would not have been "in possession of his art." In the same way, to take an example used by St. Thomas, an iron saw is more perfect than one of glass, as a saw, however we may think of glass as a nobler material than iron. And conversely, a representation of Christ is not as such any more beautiful than one of Satan, the relative nobility of the types not entering into the problem of artistic perfection, although a matter of concern to the man.

Now as to "due proportion and harmony": these are explained in terms of the ordering of all the parts of the work to one common end, which is at the same time that of their own perfection and that of their aptitude with respect to the environment in which they are to be used, the beauty of a work being not entirely contained within itself, but depending also upon its adaptation to its intended context. So that, for example, we cannot call a sword altogether beautiful unless its pommel is adapted to the hand that is to wield it; and the icon which may be beautiful in the architectural environment for which it was designed may be incongruous, and thus lose a part of its beauty, when we see it in a museum or in a drawing room.

The dependence of beauty on clarity or illumination can hardly be more than touched on here. The dicta of St. Thomas are based on those of Dionysius, and derive through him from the Neoplatonists and still older sources. What he has to say in this respect is this, that "God is the cause of this clarity, in that he sends upon each creature, together with a certain flashing, a distribution or carrying-over of his own luminous raying, which flashing distributions are participations of likeness (to himself) and are the causes of beauty in things that are beautiful."[68] In the same connection Ulrich of Strassburg, "Just as the sun by pouring out and causing light and colors is the maker of all physical beauty, just so the true and primal Light pours out from itself all the formal light, which is the beauty of all things . . . which the more light they have, the more beautiful they are."[69] So also Witelo, for whom the uncreated Light is the primordial substance, "and the more light a thing possesses, the more of deity there is in it, and whatever substance has more light than

[68] Dionysius, *De div. nom.* IV.5.
[69] Ulrich Engelberti, *De pulchro.* [Cf. the work of Martin Grabmann; and "The Mediaeval Theory of Beauty" in this volume.—ED.]

another is thereby the nobler"; "light, which is the principle of visibility, is the cause of beauty,"[70] of which he cites abundant instances. Witelo is also perfectly aware of the relativity of taste, which he treats as an idiosyncracy according to which we are so constituted as to be able to recognize one kind of beauty rather than another.

One very important conclusion to be derived from all these definitions is this, that the beauty of anything, natural or artificial, is an objective beauty, dependent only for its recognition upon the spectator, but itself intrinsic to the object seen, which is in itself more or less beautiful independently of our liking or disliking its kind. The beauty of the thing depends upon *its* perfection; our powers of recognition, on *our* perfection. The personal equation is admitted, but discounted; whatever is strictly a personal reaction, is not a judgment—"judgment is the perfection of Art."[71]

We shall conclude our discussion by asking what, in this philosophy, is the value of beauty in kind; what is the function of this beauty, which is not the same thing as the perfection of the object, but rather the attractiveness of this perfection. Does the appreciation of art consist in "loving fine colors and sounds," "the inordinate pleasure of the ear," or can we ask with Plato, "about what is the sophist so eloquent?"[72] The answer to these questions is bound up with the doctrine of the value and meaning of life itself.

The truly human "life" may be either contemplative or active; the life of pleasure, in which the only motifs of action are affective, is less than human, however natural to animals, or even to inanimate things, which nevertheless have their own affinities. Man, as such, does not live to eat, but eats to live, and this holds good as well for mental as for physical nutriments, both of which are necessary if the man, as such, is to be kept in being. The satisfaction of the natural appetite, however legitimate or necessary it may be, is not in the technical sense of the words a "life," but only a "habit."[73] The traditional philosophy could not then possibly have understood by the "good" of art a mere pleasure of the senses, such as the word "aesthetic" implies, and so could not have thought of "beauty" as the final end and use of art. To suppose that the work of art has no

[70] Witelo, *Liber de intelligentiis* vi–viii, and *De perspectiva* iv.148.

[71] *Sum. Theol.* ii-ii.47.8.

[72] *Protagoras* 312e.

[73] Witelo, *Liber de intelligentiis* xx ("delectatio . . . in corporibus non operatur vitam, quia in eis non est actus, sed habitus").

other function than to please, Augustine calls a "madness."[74] That "pleasure perfects the operation," and as we may add also the use, does not mean that the pleasure can properly be substituted either for the operation or the use: for "to enjoy what we should use,"[75] to be a mere lover of beauty as such, is a sin; "a Brahman should do nothing merely for the sake of enjoyment." Most of our "love of art" is, strictly speaking, an indulgence and a luxury. *We* even go so far as to deprecate any intellectual interpretation of works of art because we are afraid that this might rob us of some part of the abundance of our sensational, or as we call them "aesthetic" pleasures.

All of our authors are agreed with Plato, who cannot be accused of indifference to beauty, in speaking of the "attractive" or "summoning power of beauty."[76] As a Buddhist text also expresses it, "it is for the sake of attracting man that the picture is painted in colors," etc.[77] But an attraction or summons is *to* something, and not to itself: or ought we to be so entranced by the sound of the dinner bell as to forget to eat? That would be aestheticism, not an appreciation or understanding of the ringer's art. Our texts are sufficiently explicit. As St. Basil expresses it, "it is not the colors or the art that we honor in the image, but the archetype whose image it is."[78] The Buddhist text already cited continues, "it is for the sake of a picture that is not in the colors that the colors are employed," another adding, "it is not the clay of the molded figure that is worshiped, but the immortal principles that are referred to by the molded forms."[79] Augustine makes the situation equally clear when he says that the purpose of the orator is not to hear himself speak, but "to please, to inform, and to convince." When the greatest of European poets speaking of his own masterwork assures us that "the whole work was undertaken, not for a speculative but a practical end . . . the purpose of the whole and of this portion [the *Paradiso*] is to remove those who

[74] It is clear from St. Thomas, *Sum. Theol.* II-II.167.2 (as interpreted in the Turin edition, 1932, VI, Index, p. 154) that ornament (*decor*) may be the occasion of mortal sin if it is made the chief end of the work to be done, or our main concern in our relation to it; as the Index words it, "libido pulchritudinis tunc non excusaretur a peccato mortali."

[75] St. Augustine, *De Trinitate* X.10.

[76] [Cf. *Timaeus* 47D, "And harmony . . . itself."]

[77] *Laṅkāvatāra Sūtra* II.112-114. [Cf. *ibid.* II.118 and 119, where a painting is said to be produced in colors "for the sake of attracting (*karṣaṇa*) spectators," though the very picture is not in the colors (*raṅge na citram*), but subsists only as art in the artist, and again by the spectator's own effort as art in him.]

[78] *De spiritu sancto*, ch. 18. [79] *Divyāvadāna* XXVI.

are living in this life from the state of wretchedness to the state of blessedness,"[80] he is in perfect agreement with Clement of Alexandria, who says that "prophecy does not employ figurative forms in the expressions for the sake of beauty of diction."[81] As late as the fifteenth century, Dionysius the Carthusian has to say "not to speak volubly, but to speak uprightly is my purpose in this work."[82] The traditional artist was serving patrons who expected to be fed, as well as amused; he had to provide an artifact, whether sermon, house, or spade, which would work, and not merely a product to be admired. It is the modern manufacturer whose works are designed to catch the patron's eye, rather than to serve a purpose. The manufacturer for profit is not always "inclined by justice to do his work faithfully." Insofar as modern art is devoid of content and truth, the modern artist is no better than the manufacturer.

I hope that I have been able to persuade the reader that in order to understand and appreciate the art of any people one must be united with them in spirit: that we need not only to be able to feel, but also to understand, and not only to feel and understand as we feel and understand ourselves, but as they felt and understood who made, and for whom were made, the works of art that we may be considering; and if so, that the study and appreciation of ancient or exotic arts may have a far greater and more profound value than we suspected when we thought of this merely as an "aesthetic" experience.

[80] Dante, *Ep. ad Can. Grand.* 15 and 16 (*Opera omnia*, Leipzig, 1921, p. 482).
[81] *Miscellanies* VI.15 (*Ante-Nicene Christian Library*, A. Roberts and J. Donaldson, eds., 25 vols., Edinburgh, 1867–1873, XII, 380).
[82] *Opera omnia*, Tournai, 1869, XL, 331a.

The Part of Art in Indian Life

I

Works of art (*śilpa-karmāṇi*) are means of existence made (*kṛta, saṃskṛita*) by man as artist (*śilpin, kāraka, kavi*, etc.) in response to the needs of man as patron (*kārayitṛ*) and consumer (*bhogin*) or spectator (*draṣṭṛ*).[1] The production of works of art is never an end in itself; "the work of the two hands is an otherwise determined element of natural being";[2] "all expressions, whether human or revealed, are directed to an end that is over and beyond the fact of expression";[3] "as the purpose, so the work."[4] Art (*śilpa, kalā, kāvya*, etc.) in its becoming (*utpatti*) is the manipulation or arrangement (*saṃskaraṇa, vidhāna*, etc.) of materials according to a design or pattern, preconceived (*dhyāta, nirmāta*) as the theme (*vastu*) may demand,[5] which design or pattern is the idea or intelligible aspect (*sattva-jñāna-rūpa*) of the work (*karma*) to be done (*kārya*) by the artist.

[First Published in *Cultural Heritage of India*, III (Calcutta, 1937; a publication of the Śrī Ramakrishna Centenary Committee). A revised and enlarged edition of *The Cultural Heritage of India* is being published in eight volumes by the Ramakrishna Mission Institute of Culture, Calcutta.—ED.]

[1] Distinction of things made (*factum*) from things done (*actum*). The thing made and the thing done, art and ethics, are one and the same only for the artist, whose function (*svadharma, svakārya*) is to make; for any other, to make is inordinate (*adharma*). That is with respect to any one kind of making; the artist is not a special kind of man, but every man—either vocationally, or at least upon occasion and in some capacity—is a special kind of artist.

It is possible, of course, for the artist to be his own patron, as when a man builds a house for himself, or weaves his own garment. In this case, however, as soon as he proceeds from intention (*kratu*) to action (*kriyā*) his function as patron ceases, and he becomes the other man. When the work is finished, he becomes a consumer, or *ex post facto* patron, and is in a position to judge the work done, viz. from the artist's point of view, with respect to its intrinsic quality (*sukṛtatva*), and from the consumer's, with respect to its convenience (*yogyatā, puṇyatā*).

[2] Kauṣ. Up. III.5.

[3] *Sāhitya Darpaṇa* v.1, Commentary. [4] *Yatkratuḥ tatkarma*, BU IV.4.5.

[5] *Śukranītisāra* IV.4.159, *sevya-sevaka-bhāveṣu pratimā-lakṣaṇam smṛtam*, where in more general terms, *sevya* corresponds to *vastu, anukārya*, and *sevaka* to *kāraka*.

71

Works of art, regarded as a food (*anna*), can only be thought of as "luxuries" when the patron's appetites (*kāma*) are excessive (*puruṣārtha-visaṃvādī*); man eats to live, and can only be thought of as "greedy" (*lubdha*) when he lives to eat.[6] By works of art the self is nourished in its vegetative (*annamaya*) modes of being, and re-minded in its intellectual (*manomaya*) modes of being;[7] for in every work of art there is combination of formal-intelligible (*nāmavat*) and material-sensible (*rūpavat*) factors, the former corresponding to the "ear" as symbol of angelic understanding, the latter to the "eye" as symbol of sensational experience.[8]

[6] "For so it is that his children (*prajā*) carry on as though obeying orders, they live dependent on (*upajīvanti*) their such and such desired ends (*yaṃ yamanta-mabhikāmāḥ*), CU VIII.1.5. "Prajāpati emanated children (*prajā*). He said, 'What are your desires?' 'Our desires are to eat food (*anādyakāmāḥ*),'" JUB I.11.1–3; and wherewith he feeds his children is the *Sāma Veda*, that is, precisely the ritual work of art (*śilpa-karma*) as distinguished from the *Ṛg Veda*, which remains within as art in the artist (*śilpa*) until sung outwardly.

Food is all that nourishes the conscious self as living individual (*jīva*); works of art are foods in that men by them accomplish their "such and such desired ends." In that desires or appetites are here envisaged simply as *sine qua non* of existence, it is clear that the ends desired are the necessities of life, as determined by the nature of the species—identical with all that every creature "milks" from Virāj according to its own specific virtue. The "morality" of desire and the "morality" of existence are thus one and the same; "I am the desire that is not counter to the law of heaven in living beings," BG VII.12. Man as an animal (*paśu*) has no other end in view than that of existence, and can subsist as animal on "bread alone" without recourse to works of art; but man as a person (*puruṣa*) has other ends before him (*puruṣārtha*) which are attainable only by means of works of art ordered accordingly.

Appetite (ordinate desire) as rightly understood above must not be confused with greed (inordinate desire). Appetite or Will (*kāma*) is the son of the Law of Heaven (*dharma*), begotten on Obedience (*śraddhā*); Greed (*lobha*) is the son of Arrogance (*dambha*) begotten on Well-Being (*puṣṭi*)—say the Purāṇas. The mothers are one or sister principles, the fathers contrary principles.

The case of him who is disgusted (*vairāgin*) and regards all appetites as evil—because *kāmaḥ saṃsāra-hetuḥ* ("desire is the cause of transmigration," Mbh III.313.98)—will be considered later in connection with the concept of "poverty." Note that this point of view, though one extraneous to a discussion of the place of art in *life*, is by no means exclusively Buddhist.

[7] "Re-minded," that is to say, "regenerated." This is conspicuously seen in the case of rites involving the notion of transubstantiation (*abhisambhava*), notably those of integration (*saṃskāra*) and initiation (*dīkṣā*). The duality of the ritual work of art is usually evident even when the motive is primarily practical, for example, PB XXII.10.4, "The Viśvajit is metaphysically (*parokṣa*) the rite (*vrata*), and thereby outwardly (*pratyakṣa*) he obtains food (*anna*)."

[8] But every work of art has in the same way in its formal or expressive aspect an ideal meaning or value, and in its material aspect a practical application or value; the congruity of these aspects determining its perfection or beauty as a work of

Works of art, in other words, are specifically human, distinguishable from natural objects as not merely sensible, but also intelligible, and from their angelic prototypes (*devaśilpāni*)[9] as not merely intelligible, but also sensible.[10]

It is true that amongst actually existing works of art men have attempted to distinguish limiting types, on the one hand purely intelligible, and on the other merely serviceable; calling the former "beautiful (*rasavat*)," the latter merely informative (*vyutpatti-mātra*) or merely useful (*prayojanavat*).[11] An actual existence (*sthiti*) of such limiting types is, however, impossible. In the first place, it is established by the definition

art. On the other hand, a mere utility, though made, is not a work of art—though *karma*, is not *śilpa-karma*; a bird's nest is not architecture, a bare statement is not poetry, a literal representation is no more than a plaster-cast sculpture. It is within man's power to maintain his existence as an animal by means of mere utilities and bare statements of fact, as also to make use of works of art in the same way, exclusively from the pleasure-pain standpoint. But he who thus lives by means of utilities and facts alone, the "practical" man who ignores the theoretical aspects of his existence, the laborer without art, is intellectually an outlaw (*avrata*) and suffers privation of being as a person (*puruṣa*). Not that the vegetative mode of being is despicable in itself, which is indeed the "foremost aspect" (*param rūpam*) of the Self (MU vi.11), but that to ignore all other modes of being of the Self is "devilish" (CU viii.8).

[9] AB vi.27. Observe that the *deva-śilpāni* (art in the artist) are to be distinguished from *śilpa-karmāṇi* (works of art) as *ādhidaivata, parokṣa,* from *ādhyātma, pratyakṣa.*

[10] Distinction of art from nature; for example, if we throw a stone, the stone remains a natural object, merely a thing, but if we set up a stone in the ground, and call it a *liṅga*, then the stone in connection with its support becomes an intelligible construction, a significant thing, a work of art.

[11] A division of "fine" from "applied" art has been made in India only in connection with literature and dancing, viz. in the distinction of *kāvya* (statement informed by *rasa*) from *itihāsa* (merely veridical statement), and of *nṛtya* (dance exhibiting a theme) from *nṛtta* (merely rhythmical movements). A broader distinction of pure or fine from applied or decorative art, and of beauty from use, has been drawn in Europe only within the last two centuries, before which time the terms "artist" and "artisan" designated only the professional maker, without regard to the kind of thing made. The new distinction belongs to the ideology of industrialism, seeming to explain and justify a division of craftsmen into artists on the one hand and laborers on the other; the human consequences for "laborer" and consumer were clearly enunciated by Ruskin in the stinging aphorism, "industry without art is brutality"; while the so-called "artist" of today is reduced to the position of the workman in the ivory tower, or as we should express it, that of the man who comes with his materials to paint a picture on the air (*ākāśe rūpaṃ likheyya*, M 1.127). Actually, there never has been, and never can be agreement as to the point at which art ends and industry begins; the categories as defined being always opinionative (*vikalpita*) and without authority (*aprameya*).

itself that what is purely formal or intelligible is not also sensible, for this would contradict the predication of purity or mereness. Pure form (*śuddha nāma*) has only being (*bhāva*), not a becoming (*bhava*); explaining existence, but not existing, it can only be referred to, and not identified with the physical symbol.[12] Meaning cannot have position;[13] one and the same meaning can be referred to again and again by means of the appropriate symbols, which may be thought of as its stations (*avasthāna*), but do not confine it—"the picture is not in the colors"[14]—but in the "heart (*hṛdaya*)," viz. of the artist (*kāraka*) before the work is done, and of the spectator (*bhogin*) who, when the work is done, has grasped (*grah*) its reference.[15] And in the second place, only a natural (*sahaja*) object, the existence of which is its own end (*svārtha*), can be spoken of as unintel-

[12] Note that "abstract form" (or better, "abstract shape") is not the same as "pure form." Abstract form is merely a general aspect deduced from particular aspects; pure form—*a priori* and *post factum* at the same time—is that by which or after which (*anu*) the aspect is induced, so as to exist before our eyes (*pratyakṣa*).

What is said above particularly with respect to works of art is stated more generally with respect to things of all kinds as follows: "Intelligibles and sensibles (*prajñā-mātrā, bhūta-mātrā*) are indivisibly connected, neither can exist apart. For from neither by itself could any aspect (*rūpa*) ensue. Nor is this aspect a multiplicity, but like a wheel with respect to its center" (Kauṣ. Up. iii.8, summarized).

[13] To illustrate the sense of "meaning": *deva* is a meaning, not a thing, *Brahman* is all-meaning, not all things.

[14] *Range na vidyate citram . . . tattvam hyakṣara-varjitam* (*Laṅkāvatāra Sūtra* ii.117-118). Compare Kauṣ. Up. iii.8, *Na rūpaṃ vijijñāsīta rūpa-draṣṭāram vidyāt*, "It is not the aspect that one should seek to understand, but the seer of aspects." To paraphrase BU ii.4.5, "Verily not for the love of art is art desirable, but for the sake of the Self."

Observe that if we define beauty (*rasa*) as the self or principle of art, as in the *Sāhitya Darpaṇa* i.3, *Vākyaṃ rasātmakam kāvyam* ("Poetry is statement informed by beauty"), it follows in the same way that beauty cannot have position; and this is, in fact, asserted in the equation *raso rasāsvādanam* ("beauty subsists in the experience of beauty"). The work of art can be called *rasavat* ("beautiful") only by ellipsis, and with considerable risk of lowering the level of reference from that of "intelligible beauty" to that of "sensible charm." We can, nevertheless, speak discreetly of works of art, and also of natural objects, as "beautiful" if we mean by this that they are perfect in their kind; for whatever is perfect in its kind (whether the kind be pleasing or not) reflects or refers to intelligible beauty, and may be regarded as an entry (*avataraṇa, pravṛtaka*) or station (*avasthāna*) thereof, though in and by itself a veil (*āvaraṇa*).

[15] Thus in Rabindranath Tagore's "*Āmi chini go chini*," where beauty is personified by the name *Bideśini, hṛdi-mājhe ākāśe śunechi tomāri gān* (cf. A. H. Fox-Strangways, *The Music of Hindostan*, Oxford, 1914, p. 96).

ligible,[16] and merely sensible, accessible only to animal or estimative knowledge. Estimative knowledge, viz. of things as pleasant or unpleasant in themselves, is altogether different from intelligible knowledge, the animal, or man as animal, responding to sensation instinctively, not intelligently. The eye sees nothing but colored surfaces, and has no other capacity: these surfaces have no meaning as such, but only are—"that there is an appearance of color is simply that color appears."[17]

So, then, the terms "pure art" or "fine art" and "applied art" or "useful art" have reference only to limiting concepts without separate existence in fact; every work of art is at one and the same time *nāmavat* and *rūpavat*. One and the same work of art can therefore be utilized from either point of view, or from one of many points of view: the Vedic *mantra* may, for example, be used as means to the integration of the self in the mode of meter, or may be regarded as a lullaby; a surgical instrument may be considered merely as beautiful, that is to say, at once expressing and adapted to its purpose, or may be considered simply as pleasing in color or shape, or may be thought of merely as a means of relieving pain.

Works of art are good or bad in themselves and as such, not according to their themes or applications (*vastu, prayojana*); "of themes that may be chosen there is none in the world but can be endowed with the quality of beauty."[18] A cathedral (*vimāna*) is not as such more beautiful than an airplane, a *śānta* more than an *ugra* image, a hymn than a mathematical equation, nor Bhartṛhari's *Vairāgya Śataka* more than the *Śṛṅgāra Śataka*; a well-made sword is not more beautiful than a well-made scalpel, though one is used to slay, the other to heal. Works of art are only good or bad, beautiful or ugly in themselves, to the extent that they are or are not well and truly made (*sukṛta*), that is, do or do not express, or do or do not serve their purpose (*kratvartha*); a work of art being "bad" or "poor" (*hīna*) which does not at one and the same time clearly express *and* well

[16] The Absolute (Para Brahman, Aditi) is also, of course, unintelligible; but in another way, being neither an object, natural or artificial, nor even an intellectual form or idea. The Absolute, being *amūrta* ("formless"), *nirābhāsa* ("unmanifested"), not in any likeness, impossible to symbolize because not a form, does not fall to be considered here. The concept of art, even of art in the artist, cannot be extended to range beyond the level of reference implied in the symbols Apara (*lower*) Brahman, Iśvara as Viśvakarman ("all-doing"): the Person in a likeness (*mūrta*), the source of image-bearing light (*bhā-rūpa, citra-bhāsa*), whose intrinsic form (*svarūpa*) is the form of very different things (*viśvarūpa*).

[17] *Vanna va nibhā vannanibhā, Atthasālini* 635.

[18] *Daśarūpa* iv.9, *āpya vastu . . . tannāsti yanna rasabhāvam upaiti loke.*

serve its purpose, whatever that may have been. Works that are bad in this sense will abound where men are either physically insensitive or intellectually inert.

The purposes to be served by and themes to be expressed in works of art are good or bad from other points of view, ethical and speculative; good or bad ethically according as the theme or purpose is noble (*puṇya*) or ignoble (*pāpa*), and good or bad intellectually according to the level of reference, metaphysical—angelic (*parokṣa, adhidaivata*) or literal— individual (*pratyakṣa, adhyātma*), universal or particular. These values are very commonly projected onto the work of art, which is then spoken of as if noble or ignoble, intellectual or sensual in itself.

Henceforth we shall employ the terms beautiful and ugly with respect to the intrinsic virtue or lack of virtue in the work of art; noble and ignoble with respect to ethical values; and intellectual and sensual with respect to the level of reference. It may be observed that these qualities in or projected onto works of art will correspond to those of the men by and for whom the works are produced; skilled and obedient men producing beautiful works, good men demanding noble works, and metaphysically minded men demanding intellectual works. Furthermore, these qualities, inherent or attributed, will not in any way reflect conditions of economic prosperity or poverty; the least costly may be as good in any sense as the most costly work.

It has been pointed out by Śukrācārya that affection or taste is not an aesthetic criterion (*pramāṇa*).[19] Taste reflects affectability and is not by any means disinterested. As expressed in the work of art, where it becomes the determinant of "style (*rīti*),"[20] taste, whether we call it "good" or "bad," reflects the character (*svabhāva*) of the artist as indivdual, or more generally within unanimous (*sammata*) groups that of the environment (*kāla-deśa*); "the painter's own likeness comes out in the picture."[21] The character of the individual or age may be predominantly static, energizing, or inert, determining accordingly the qualities of latent power, power in action, or relaxation which can be distinguished in the different kinds (*varṇa*) of art, those, viz. which we speak of with more or less

[19] *Śukranītisāra* iv.4.106.

[20] Cf. *New English Dictionary*, s.v. "style": "the manner in which a work of art is executed, regarded as characteristic of the individual artist, or of his time and place . . . what suits [a person's] taste."

[21] *Lekhakasya yad rūpaṃ citre bhavati tad rūpam, Devī Purāṇa* (Bombay, 1919), xcIII.150, hence the injunctions of the *Śilpa Śāstras*, which require that the artist be a good man, hale in every sense of the word.

precision as classical or reserved, romantic or exuberant, and weak or senti-mental. Style can be thus defined in terms of *sattva, rajas*, and *tamas*; but it must not be overlooked that when a prescription (*sādhana, dhyāna*) specifies that a given angel is to be represented in a *sāttvika, rājasika*, or *tāmasika* aspect, as the case may be, then the determination is referred back to the patron, according to whose nature (*bhāva*) must be the aspect of the angel to be worshiped.[22] In the latter case no question of style is involved; the angelic character to be expressed by means of suitable signs (*lakṣaṇa*) becomes a part of the artist's problem, and has nothing to do with his own nature, which, in turn, determines his style. So, then, the image required to be gruesome in itself may be reserved, exuberant, or sentimental in style (*rīti*). Sentimentality in art is the excessive laying of stress upon a transient mood (*vyabhicāri-bhāva*), and this in the case of a *tāmasika* image will mean that appearances of violence and effort are presented, where only the manifestation of a given modality of power should have been shown; in a serene (*śānta*) image sentimentality would have taken the form of excessive sweetness. In either case there is mis-conception of the theme; for the permanent mode or mood (*sthāyi-bhāva*) of angelic being is neither sweet nor violent, but static (*sāttvika*). But the misconception is not an aesthetic fault; the artist may have exhibited sweetness or violence with great skill and complete success, and that is all that we can demand of him as an artist, ignoring his manhood.[23]

In isolating the concept of style and comparing two different styles it is taken for granted that the theme (*vastu, anukārya*) remains constant. In fact, however, this is not so, nor can it be so; things known are always in the knower according to the mode of the knower, and not as they are in themselves. Notwithstanding that the label "Buddha" and the details of the iconography remain the same, the theme "Buddha" as a problem set before the Gupta artist is not in fact identical with the theme "Buddha" set before the Kuṣāṇa artist. Now the perfection (*sukṛtatva*, entelechy) of any thing taken by itself is reached when its specific potentiality is actually realized; and this holds for all works of art, where we have a right to demand an exact correspondence of aspect and form, lacking which we

[22] *Śukranītisāra* IV.4.159.

[23] However careful of the good of the work to be done, the artist cannot be other than himself, and cannot conceal himself. That is why stylistic subservience, or any imitation of a supposedly superior style, as in archaism or exoticism, results in travesty; and here aesthetic fault is involved, the aspect of the work not having been made after the artist's own conception of the theme, but as he imagines someone else would have done the work.

recognize an element of contradiction (*viruddhatva*) which defines a proportionate privation of being as a work of art. If then we find the Buddha represented as a man, who is more than man, we can only judge the work aesthetically for what it is, viz. the representation of a man, at the same time that from other points of view we, who desired not the likeness of a man but the symbol of a meaning, reject it. We have to distinguish between things which are good of their kind, and things which in their kind are good for us. The thing good of its kind will remain such for ever, without respect to the variability of such and such desires by which the course of man's life is determined in different individuals or in different ages. This is all that concerns the historian of art, the student of stylistic sequences, who makes his business the demonstration and explanation of styles, without regard to human values.

All this, however, is to treat the work of art as a natural object, an end in itself, not as a thing made by and for man. If there are some artists who come with their colors and brushes to paint pictures on the air,[24] there are also on the one hand aesthetes, and on the other historians of art who take it for granted that works of art are always and necessarily pictures that have been painted on the air, whereto the artist has betaken himself in the pursuit of beauty or, what amounts to the same thing, in an attempted flight from life. To all of these it may be replied that "Man is not emancipated from the task by merely shirking it, nor can he achieve perfection by mere abstention . . . they indeed who cook only for themselves are eaters of evil . . . it is by action that a man reaches his last goal . . . act therefore with due regard to the welfare of the world."[25] It is true that the artist, like other men in their respective vocations, should work for the good of the work itself, and not with regard to the ends, however noble or ignoble, to which the work is ordered; as artist he is not a philanthropist, but has his art which he is expected to practice, and for which he expects payment, the laborer being worthy of his hire. But we are now considering precisely the case of the artist who sets up to be his own patron, and thus assumes immediate and entire responsibility, not only for the work itself, but for the ends to which it is ordered and may be expected to promote; if this responsibility is willfully ignored, the artist is not merely diminished in his

[24] A proverbial illustration of the futile; see, for example, M 1.127.

[25] BG III.4–20, summarized; "action" and "cooking" are, of course, general concepts, to be taken in our context in the narrower sense of "making." Cf. *Parāśara* XI.49: He who, being in the order of the householder (i.e., within the social order, no longer a student, not yet a hermit or total abandoner), still makes no gift whatever, is referred to as "one who never cooks for others."

humanity individually, but proceeds to extinction as species. "He who does not do his part to keep in motion the wheel that has been set agoing, whose life is loveless and whose playground is sensation, lives in vain."[26] The world has every right to inquire with respect to works of art, what are they about, and what for; and if the artist answers, about nothing and for nothing, or about myself and for myself, the world owes him nothing. Offering stones for bread, he will be repaid in kind, and sooner or later buried without regret.[27]

Nor is the proper artist, in fact, at all of this kind; none is more justly angered than the artist who, when he presents the finished work to the patron or spectator *for whom it was made*, finds that only his skill (without which it would have been presumption to make anything) or only his style (which he admits only when his attention is called to it, and then only as accident and not as essence in his work) is praised, while the theme of his work, to which he has literally devoted and given *himself*, is treated merely as a label attached to it. "I am not," he says in effect, "a performing animal, but also a person."[28] The Vedic *kavi* refers to his artistry as a skill exercised for the sake of the angels to whom the *mantras* are addressed; it is not himself that speaks, but Vāc-Sarasvatī through him; he is not a stylist, but an auditor, and a reporter; the *mantra* is very surely directed to an end beyond itself. The Vedic *kavi* is essentially Savitrī,[29] and more than man (*apauruṣeya*), but in that the Supernal Sun shines upon the world in the likeness of man,[30] man having his being as the counterimage in the mirror,[31] or, if the mirror be tarnished, suffers privation in fullness of being what he is, it follows, proceeding from whole

[26] BG iii.16. We are not at present considering his case, the hour of whose revulsion has come, and who *understands what it means* to escape from life, not from the world, but from himself; it may only be pointed out that such a man expects nothing from the world, he indeed supports the world, and for him the world can do nothing.

[27] The case of the artist who asserts that his work is not ordered to any end, but is its own meaning, is sufficiently disposed of by the *Sāhitya Darpaṇa* v.1, Commentary: "or if not thus ordered to an end over and above the mere fact of expression, can only be compared to the ravings of a madman." If the work be such as he cannot understand, and therefore cannot use, the patron has a perfect right to demand a return of his money, or the spectator not to purchase.

[28] To expect the artist to be pleased when we admire his skill or style is to offer him a last offense; for in so doing we assume that his intention was to display his skill, or to make an exhibition of himself. If he is pleased, that is his human weakness, not his strength.

[29] RV v.81.2.

[30] AĀ ii.2.1, *abhyarcat puruṣarūpeṇa*.

[31] Kauṣ. Up. iv.2, *aditye mahat . . . ādarśe pratirūpaḥ*.

to part, that man's powers in their perfection are reflections of his power; the human artist has his being in the likeness of the Solar *kavi*, or, if not, suffers privation in fullness of being as artist.[32] And this is seen in the relation of the artist to his work, the theme being precisely the angel whom he praises by his work, as *pūjaka* and *upacārin*.

II

It is the business of the artist to *know how things ought to be made* and to be able accordingly, as it is the business of the patron to know *what things ought to be made*, and of the consumer to know what things *have been well and truly made* and to be able to use them after their kind.[33] The individual artist is not, indeed, expected to find out for himself how things ought to be made, but he is expected to make this knowledge a part of himself, so that he acquires the habit (*śliṣṭatva, anuśīlana*) of his art. No less than for the thinker or doer, there is for the artist a norm or ratio (*pramāṇa*), according to which, as subdivided into particular canons (*naya, vidhi, māna*) recorded (*smṛta*) in the technical books (*śilpa-śāstra, upaveda*) the work is to be done. Only such works as conform to these standards (*śāstra-māna*) are lovely (*ramya*) in the judgment of those

[32] I am well aware, of course, that by certain rhetoricians the Vedas are excluded from the category *kāvya* (*Sāhitya Darpana* 1.2, Commentary). But this is based merely on the ground that while "scripture" and "literature" are equally valid as means to the attainment of *puruṣārtha* in its four divisions, the "literary" way is the easier and pleasanter. As to this it need only be said that while Śruti may well be excluded from the category *belles lettres*, just as Indian sculpture would fall outside the category "art" as nowadays understood, it would be absurd to assert that what the Vedic *kavis* have uttered is not, in a less restricted and technical sense of the word, *kāvya*, just as it would be absurd to say that the sculpture is not within the full and true meaning of the word *śilpa-karma*! Or is the Vāc-Sarasvatī of the Vedas less Muse than the Vāc-Sarasvatī of the *littérateur*? And if the "genius" of the *kavi* of the *Alaṃkāra Śāstras* is spoken of as a *pratibhā* or *śakti*, what are these but reflections of the powers intrinsic to the Solar Angel? We must accordingly regard the Vedic *kavi* as the archetype of every "poet" (within the root meaning of ποιεῖν, "to make"), and the Vedic *mantra* as the *exemplum* of all art.

[33] It may be repeated that while man universally is patron, artist, and consumer at once, man individually is only rarely patron, artist, and consumer with respect to any particular work of art. By way of further illustration take the case of the actor who, functioning both as artist and consumer, appreciated his own art (*āsvādo nartakasya na vāryate, Daśarūpa* iv.51). A very different case is that of the actor who merely exhibits his own emotions, that is, merely behaves; here he is not an artist at all, nor is he producing a work of art that can be appreciated as such by himself or anyone else.

who know (*vipaścit*), individual taste (*tat lagnaṃ hṛt = ruci*) being no criterion.[34]

There is, indeed, but one authority (*pramātṛ*) whose knowledge is universal (*viśva*) and innate (*sahaja*), not acquired by instruction or practice, that is, the Lord as Viśvakarman or Tvaṣṭṛ,[35] and in or with him (*sālokyavat*) those Comprehensors (*vidvān, sādhya, prabuddha, buddha,* etc.) whose omniscience (*sarvajñatva*) is as his, and who share his absolute "skill in the field of art (*śilpa-sthāna-kauśala*)."[36] Criteria (*pramāṇāni,* pl.) known to others are necessarily limited and particular (*viśeṣa*); an innate knowledge of criteria being, as it were, divided amongst the angels (*deva, devatā*), whose nature (*bhāva*) is altogether intellectual, for "that is what it means to be an angel."[37] Now whereas "all the activities (*kriyāḥ*) of the angelic beings, whether at home in their own places or abroad in the breaths of life,[38] are intellectually emanated (*mānasī sṛṣṭiḥ*), those of men are put forth by conscious effort (*yatnatas*); therefore it is that the works to be done (*kārya-kriyāḥ*) by men are defined in detail (*lakṣaṇābhihitāḥ*)."[39] Man's works of art, in other words, are properly deduced only when they are made in imitation (*anukṛti*) of the angelic arts (*deva-śilpāni*).[40] It follows, indeed, directly from the principle "As above, so below (*amuṣya lokasyāyaṃ loko 'nurūpaḥ*)"[41] that works of art (*śilpa-*

[34] *Śukranītisāra* iv.4.106. The individual who has been rightly educated should not "know what he likes" only, but "like what he knows." The man who asserts "I do not know anything about art, but I know what I like" is governed by sensual appetite in the same sense as is he who says "I do not know what to think, but I know what I like thinking," or "I do not know what is right, but I know what I like doing."

[35] Or Śiva, *sarva-śilpa-pravartaka*, Mbh xii.285.14.

[36] *Abhidharmakośa* ii.71–72; viii.40; cf. Coomaraswamy, *The Transformation of Nature in Art*, 1934, n. 74.

[37] Śaṅkarācārya on Ait. Up. iii.14: "In that the angels are wonted to the use of (*grahaṇa-priyāḥ*) metaphysical notions (*parokṣa-nāmāni*), thereby it is that they are angels (*yasmād devāḥ*)"—that is to say, in that theirs is the habit of first principles. Cf. CU viii.12.5, "Intellect is his angelic eye."

[38] In the text, *gṛheṣu pavaneṣu ca*; a gloss now embodied in the text explains, "that is, put forth according to their natures and every human nature"—correctly, for "all these angels are in me (*mayyetās sarvā devatāḥ*)" JUB 1.14.2.

[39] *Nāṭya Śāstra* ii.5.

[40] AB vi.27. It will be understood, of course, that the angelic arts (*deva-śilpāni*) are not like human works of art (*śilpa-karmāṇi*) actually, but only metaphorically made with hands; the angelic arts are inwardly knowable intellectual forms awaiting their embodiment in manufactured things. As examples of things made by man after the heavenly patterns are cited "a clay elephant, a brazen object, a garment, a gold object, a mule chariot."

[41] AB vii.2.

karmāṇi) can only be regarded as conceived in accordance with the law of heaven (*ṛtaprajātāni*) and as well and truly made (*sukṛtāni*, as the works of the Ṛbhus are said to be, and as before defined, "beautiful") when they are made after (*anu*) the angelic prototypes, which are intellectually begotten in the revolution (*pravartana*) of the Year (*saṃvatsara*, Prajāpati); for example, "the Year is endless; its two ends are Winter and Spring; after (*anu*) this it is that the two ends of a village are united, after this it is that the two ends of a necklet meet."[42]

It is, indeed, as aforesaid, precisely the willed embodiment of a foreknown form or pattern in the work of art that removes it from the category of "natural object" and makes it artificial (*kṛtrima*), that is to say, humane (*mānuṣa*); not that natural objects have not also their forms, but that these are not foreknown by the artist, nor has he any part in the creation of the natural object. There are, however, two distinct aspects of the act of art, according as the artist proceeds from universal to particular, or from particular to universal. In the first case the intellectually known form precedes, and operation follows—*dhyātvā kuryāt*; in the second, a thing is first perceived sensibly, then the intellect at work in the heart discovers the corresponding form, this form in turn being, as art in the artist, foreknown and precedent with respect to operation—*dṛṣṭvā dhyāyet, dhyātvā kuryāt*. In modern terms the cases are spoken of as his who works from imagination, and his who works from nature or from memory. In the first case the artist forms material symbols directly after angelic images, which are not things; in the second he takes existing things out of their sense, and sacrificing their sensible appeal, transforms them. The artistry of the Vedic *mantras*, which are the cause of the becoming of things in their kind,[43] is of the first sort; that of the actual sacrifice, where things are offered up and returned to their source, of the second—*jo ha vai evaṃvit, sa hi suvar gacchati*.[44]

[42] JUB 1.35. The cases cited are elementary; but the student of ancient Indian symbolism and iconography (whether in ancient iconography or surviving folk art) will find in the *pratīkas* "lotus," "wheel," etc., more detailed correspondences. Notable analogies are: that of the macrocosmic warp and woof, thought of as a veil or garment (*vavri, vastra*) comparable to the tissues woven on human looms; that of the solar chariot (*ratha*), of which the wheels are heaven and earth, with vehicles employed on earth; and that of the axis of the universe—the axle-tree of the aforesaid wheels—that pillars apart (*viṣkambhayat*) heaven and earth, as a roof is supported here.

[43] Śaṅkarācārya on *Vedānta Sūtra* 1.1.3 (Veda as *paribhāgahetu*).

[44] JUB III.14; cf. BU 1.4.16, *sa yajjuhoti yadyajate tena devānāṃ lokaḥ* (*bhavati*), and *Śukranītisāra* IV.4.74, *devānāṃ pratibimbāni kuryācchreyaskarāṇi svargyāṇi*

The normal procedure of the Indian imager (*pratimā-kāraka*) is of the first kind, and this applies also to the case of the poet and other artists within narrower categories. The details of the angelic prototypes are remembered (*smṛta*) for the imager's guidance in the canonical treatises, and incidentally are to be found elsewhere wherever the angels or their houses, vehicles, thrones, weapons, or other possessions are described. This does not mean that the artist's knowledge must be got only directly from texts actually written down or recited, though these have been, and are still resorted to; it may as well be gained from instruction (*upadeśa*) and in practice (*abhyāsa*). The master (*ācārya*) stands in relation to the pupil as *guru* to *śiṣya*, and so professional men following one another in pupillary succession (*guru-paramparā*) learn to work "according to their craft (*śilpānurūpeṇa*)."[45] At the same time, the possibility of a direct access to the highest source of knowledge—Vāc-Sarasvatī, or the Lord through whose creative emanation of image-bearing light (*bhārūpa, citra-bhāsa*)[46] all possibilities are realized—is by no means excluded. The creative light (*kārayitrī pratibhā*) or power (*śakti*) in the poet himself may be either natural (*sahajā*), acquired (*āhāryā*), or learned (*aupadeśikā*); in the first case the poet is "Sarasvatī's" (*sārasvata*).[47]

The artist's perception of angelic prototypes is spoken of in many different ways: it may be revealed to him in sleep; he may visit an angelic world and there take note of what he sees (whether the aspect of a given angel, or that of the angelic architecture, or that of the heavenly song and dance), or Viśvakarman may be said to operate through him.[48] These

manavādīnām asvargyānyaśubhāni ca. By "going to" or "becoming" the angelic world we understand, of course, a reintegration (*saṃskaraṇa*) in the intellectual mode of being (*manomaya*), as in AB vi.27, where he who imitates (*anukṛ*) the *deva-śilpāni* is said to be reintegrated (*ātmānaṃ saṃskurute*) in the metric mode (*chandomaya*).

[45] J vi.332. [46] MU vi.4; RV vi.10.3.

[47] *Kāvya-mīmāṃsā*, ch. 2. Cf. the various discussions of *kāvyahetu*, e.g. in P. V. Kāne, *Sāhitya Darpaṇa*, 2nd ed., p. cxliv; and S. K. De, *Studies in the History of Sanskrit Poetics* (London, 1923).

An example of a *sārasvata* poet might be cited in Tirujñanasambandha-svāmi; innate poetic genius (*sahajā kārayitrī pratibhā*) is, however, more fully represented in the Vedic *kavi, sārasvata* in that his access to Sarasvatī is immediate. In any case an innate genius must be one thought of as *apūrva* ("original"). The Indian conception of genius, however, differs from the modern notion as not implying a disregard of norm (*pramāṇa*) but, on the contrary, a perfect knowledge of all norms, and corresponding virtuosity.

[48] E.g. *Mahāvamsa* xxvii.9–20, *dibbavimāna* . . . *tadālekhyaṃ lekhayitvā* . . . *ālekhyatūlaṃ kāresi.*

metaphors all imply an awareness at levels of reference superior to that of observation and deliberation—levels apparently objective, but in reality "within you," *antarhrdayākāśe*, for as before cited, "all these angels are in me."

The most perspicuous accounts of artistic "invention" (*anuvitti*) are to be found in the *Rg Veda*, where we are told time and again how and where the poet, whose incantations (*mantra*) are the cause of the becoming of things in their variety, finds (*anuvid*) his words and measures. Foremost and archetype of these is the Solar Angel (Savitṛ) in that he reveals (*pratimuñcate*) the aspects of all things (*viśva-rūpāni*).[49] Others, angels, prophets, or patriarchs, co-creators in his likeness, "ward the footprints of the law of heaven and in the innermost (*guhā*) are pregnant of the ultimate ideas (*parāni nāmāni*)";[50] "then what was best and flawless in them, implanted in the innermost (*guhā nihitam*), that by their love was shown forth."[51] "In the innermost," literally "hidden," that is, immanent in the hollow of the lotus of the heart, where only are to be realized all the possibilities of our being, "both what is ours now, and what is not yet ours."[52] It is in the heart (*hrt*) that Wisdom (Vāc-Sarasvatī) is seen or heard (*dṛś, śru*), in the heart that the swift instigations of the intellect are fashioned, or thought is formulated, "as a carpenter hews wood,"[53] and "even as Tvaṣṭṛ with his axe wrought the angelic chalices, even so do ye that are Comprehensors of the hidden footprint whet those chisels wherewith ye carve the vessels of undying life."[54]

The aesthetic process, the making (*karma*, ποίησις) of things, is thus clearly conceived in its two essential aspects, on the one hand as the exercise of a theoretical power (*mantra-śakti*), and on the other of a practical power (*utsāha-śakti*). The procedure of the artist is defined accordingly: "The imager (*pratimā-kāraka*) should prepare the images

[49] RV v.81.2 and *Nirukta* XII.13.

[50] RV x.5.2. [51] RV x.71.1.

[52] CU VIII.1.1–3. *Guhānihitam* in RV x.71.1 = *hrdā* in the same laud, verse 8, and *hrdaye āhitam* in RV VI.9.6. "What is ours here," that is, human goods (*mānusha vitta*) known sensibly (*cakṣuṣā*), "what is not ours here," that is, angelic (*daiva vitta*) known intelligibly (*śrotreṇa*), as in BU 1.4.17. Cf. *āvih . . . ca guhā vasūni*, RV x.54.5.

"Heart" (*hrt, hrdaya*) corresponds to Islamic *qalb*, and partly to Christian "soul," better to "within you."

[53] RV x.71.8, *hrdā taṣṭeṣu manasah javeṣu yat*; RV III.38.1, *abhi taṣṭeṣu dīdhayā manīṣam*, and Sāyaṇa's comment, *yathā taṣṭā takṣaṇena kāṣṭham saṃskaroti*. Note that Vedic *dhī* and *dhīta* correspond to Aupanishada and Yoga *dhyai* and *dhyāta*.

[54] RV x.53.9–10.

that are to be used in temples by means of the visual formulae (*dhyāna*) that are proper to the angels (*svārādhya-devatā*) whose are the images to be made. It is for the successful attainment of visual formulation (*dhyāna-yoga*) that the lineaments (*lakṣaṇa*) of images are recorded (*smṛta*), so that the mortal imager may be expert in visual formulation (*dhyāna-rata*), for it is thus and in no other way, least of all (*va khalu*) with a model before his eyes (*pratyakṣa*) that he can accomplish his task."[55] And so, to summarize the injunctions which are scattered through the books in which are collected the prescriptions for images, the imager is required, after emptying his heart of all extraneous interests, to visualize within himself (*antarhṛdayākāśe*) an intelligible image (*jñānasattva-rūpa*), to identify himself therewith (*tadātmānaṃ dhyāyet* or *bhāvayet*), and holding this image as long as may be necessary (*evaṃ rūpaṃ yāvad icchati tāvad vibhāvayet*), then only to proceed to the work of embodiment in stone, metal, or pigment—*dhyātvā kuryāt*. In case (which is unusual) he works from a sketch, that is to say, from a visual rather than a verbal *sādhana* or *dhyāna*, the principle remains the same; for here he works actually from a mental image evoked in himself according to the sketch, and not from the sketch directly.

As we have seen above, the resort to a living model accessible to observation (*pratyakṣa*) is prohibited, and the representation of "men, etc.," that is, of "nature," is dismissed as "not heavenward leading." Let us not forget that the problem (*kartavya*) before the artist is that of communicating to others a given idea, and though this can only be done by means of sensible symbols—perceptible shapes or audible sounds—it is evidently essential that these shapes or sounds be such as can be understood, and not merely seen or heard, by the patron or spectator who rightly expects to be able to understand and make use of the work of art to procure those ends to which it was ordered on his behalf.[56] Now the living model as natural (*sahaja*) object and end in itself (*svārtha*) is not a symbol, and has no meaning; its appeal is merely sensational and affecting, our reaction being

[55] *Śukranītisāra* IV.4.70–71. *Dhyāna dhyāna-mantra, sādhana,* i.e. the canonical prescription required to be realized in the image to be made; the *dhyānas* of the artist are the same as those made use of in "subtle" (*sūkṣma*) worship, where the form is not embodied in a material symbol. *Svārādhya-devatā* is *adhidaivata,* in other words, *parokṣa*; it is well known that "the angels are wonted to the supersensuous (*parokṣa-priyāḥ*) and mislike the sensible (*pratyakṣa-dviṣaḥ*)," BU IV.2.2.

[56] "The work of art can only nourish the spectator, he can only have delight in it, when he is not cut off from its meaning" (*Daśarūpa* IV.52).

either of pleasure or pain, and not disinterested.[57] To the extent that the work of art is "true to nature," and the more its appearance approximates to that of the natural model, the more what was true of the object will be true of the work; until finally the work becomes "illusionistic" or "very like" (*susadṛśa*), and at this point we are suddenly awakened to the fact of its insignificance (*anarthatva*). As the natural object as such is clearly a far better thing than any shadow or imitation of it that can be made, we realize that the only use of the illusionistic work is to serve as substitute for the natural object in the absence of the latter, viz. as a means of consolation in longing (*utkaṇṭhā-vinodana*);[58] our attachment to the work is then, strictly speaking, a fetishism or idolatry, a worship of "nature." At the same time, insofar as the work is merely informative as to the manner in which a certain man or other thing presents itself to the eye's intrinsic faculty (*māṃsa-cakṣus*), it is not properly a work of art, but merely a convenience or utility.[59]

It is only because in sculpture or painting the language is visual rather than aural, and a fully developed (*vyakta*) image of an angel or other meaning, therefore, more like a man or a tree than are the words *puruṣa* or *vanaspati*, that the notion has arisen that it is the primary function or nature of these arts to reproduce the appearances of things. This indeed

[57] Absence of meaning is predicated equally whether we consider the object in its individual, specific, or generic aspect. By "generic aspect" we mean one idealized or conventionalized, an abstracted form. The genus has no more meaning than the species, the species than the specimen; the notion of genus is derived from experience, and its use is to summarize, not to explain experience. An elimination of individual or specific details, whether arrived at deliberately, or, as in memory drawing, by a resort to forgetfulness of aspects in which we are not interested, can never lead us to the forms of things, but merely to a simplified or selected aspect adequate to the given classification or congruent with our taste. In other words, "idealistic" art and "ideal" art are two very different things: simplification is not transformation (*parāvṛtti*).

It is true that a natural object *can* be used as a symbol; for example, when a natural stone is set up and called a *liṅga*, or when an actual lotus leaf is laid on the fire altar. But the symbolic value thus projected upon the natural object has nothing to do with its individual idiosyncrasy, to which our attention is chiefly directed in a "drawing from life"; and in most cases we can make our meaning very much clearer by employing a symbol expressly designed *ad hoc*.

[58] *Mālatīmādhava* 1.33.9-10.

[59] It is by no means to be understood that a reasonable attachment to things as they are in themselves, or a proper use of utilities, is sinful; on the contrary, as already pointed out, no distinction can be drawn between the morality of existence itself, and the morality of ordinate desires. All that is asserted is the evident fact that even an ordinate attachment to things as they are in themselves is *asvargya*, not heavenward leading, but tends to a coming back again, *punar āvṛtti*.

has never been clearly asserted in India, but has been constantly denied; nevertheless there can be found allusions to sculpture or painting as intriguing deceptions,[60] and this seems to imply at least a popular view of the art as imitative in kind. That a popular interest must have been felt in the representative aspects of art is further illustrated by the fact that a preference for color is always ascribed to the layman, a preference for line to the connoisseur, while in more than one passage the *vidūṣaka* is referred to "stumbling over" the represented relievo.[61] Actually to think of likeness to anything as a criterion of excellence in sculpture or painting would be the same as to think of onomatopoetic words as superior to others in literature. If, because of our human preoccupation with the facts of experience, and being *pratyakṣa-priya*, we should make use only of onomatopoetic words in our communications, these communications would be restricted to the range of such as animals are able to make to one another by means of grunts and whines; accepting only those words which are made in the likeness of things, we should have none with which to make those references which are not to things but to meanings.

The considerations outlined above have determined the Muhammadan interdiction of representative art, as a thing giving the appearance and not the reality of life; in making such representations, man is working, not like the Divine Architect from within outwards, not with significant forms (*nāmāni*), but only with aspects, and in reducing these from life to likeness imposes on them a privation of their proper being, which is one informed by the spirit (*rūḥ, prāṇa*) of life. From the Hindu, Buddhist, or Jaina monastic point of view, and that of such teachers as Śukrācārya (who expresses the consensus of authority), representative art is condemned as such more on account of its worldly theme than on strictly theological grounds. Finally, the modern critic who is in agreement with Hindu theory condemns representative art *as art*, because of its informative (*vyutpatti-mātra*) character, or because the spectator regards it primarily from the standpoint of its affective associations, and sensationally. It is true that the work of art which takes the natural object or human theme for its starting point need not be merely informative or imitative in itself;[62] nevertheless, in spite of ourselves, it is only too

[60] MU iv.2, *mithyā-manoramam*, with reference to painted walls.

[61] *Śakuntalā* vi.13–14, apparently with reference to the exuberant forms of beautiful women.

[62] The Ch'an-Zen art of the Far East provides the best illustration of an art that takes "nature" as its starting point, and yet is not a representation of, but a transformation of nature. The Sung painter, indeed, "studies" nature; but this study is

easy to be curious of and seduced by the individual and accidental aspects of the things before us, and thus to be drawn away by our affections from the vision of pure form. The possibility of such distractions is avoided by the imager who, emptying his mind of all other content, proceeds to work directly from an inwardly known image; and similarly in the case where the form is not evoked by the craftsman individually, but is handed down from generation to generation in the collective consciousness of the craft.[63] All this is borne out in the character of the actual art, the *vyakta* (developed and anthropomorphic) image (*mūrti*) being no more realistic in principle than the *avyakta* (undeveloped or abstract) diagram (*yantra*) which is ordered to the same ends. The Hindu image of an angel, or Hindu ancestral image, is not in fact made as if to function biologically, and cannot be judged as if it were so made. The plastic image has no more occasion to counterfeit a man than has the verbal image; and if, for instance, the latter may have a thousand arms or theriomorphic elements, so may the former.[64] It need hardly be added that it is taken for granted that those who look at earthen images "do not serve (*na abhyarch*) the clay as such (*mrtsamjña*), but without regard thereof (*anādrtya*) honor (*nam*) the deathless principles referred to (*amarasamjña*) in the earthen images (*mrnmaya pratikrti*)."[65]

not an observation, but an absorption, a *dhyāna* (*ch'an*) resulting in the discovery of a pure form, not like the thing as it is in itself, but like the image of the thing that is in the thing; the idea of the thing, and not the object itself, being the "model" to which the painter works. Even in the case of Indian representations of "men etc.," it will be found that though the artist is working in presence of the thing, he nevertheless resorts to *dhyāna*; see, for example, *Śukranītisāra* VII.73-74, where the image of a horse is to be made from a horse actually seen, and yet the artist is required to form a mental image in *dhyāna*, and also *Mālavikāgnimitra* II.2, where defect in portraiture is attributed not to lack of observation, but to imperfect identification (*śithila samādhi*).

[63] In this way the intellectual element has been preserved in the traditional minor and folk arts of the villages until today, while the major arts in the *bourgeois* environment have been denatured.

[64] Needless to observe that our arithmetical ability to count up arms, or to recognize theriomorphic elements in the artist's vocabulary, is not an aesthetic capacity. The *laksanas* required are an integral part of the artist's problem (*kārya, kartavya*), presented to him *a priori*; what we judge in him is not the problem, but the solution.

[65] *Divyāvadāna*, ch. 26. These are also the principles underlying Christian iconolatry; cf. the *Hermeneia* of Athos, 445. "In no wise honor we the colors or the art, but the archetype of Christ, who is in heaven. For as Basilius says, the honoring of the image passes over to the prototype."

"Portraiture" in Hindu art falls to be considered from two different points of view, first, that of the ancestral effigy, and second, that of the likeness of a person still living. The principles involved are more divergent than might at first sight appear. The ancestral effigy is not in fact a "portrait" in the accepted sense of the word, it is not the likeness of a mortal, but the image of an angel (*deva*) or archetypal meaning (*nāma*). For of the deceased we say that he has become an angel (*deva*), or attained angelic nature (*devatva*); and that it is an idea (*nāma*) that remains when a man dies.[66] The nature of the angel or idea will be such as the man's own thoughts and works have been, and so the man is represented not as he was seen on earth, but as he was in himself, and is now transubstantiated (*abhisambhūta*). An actual "likeness" of the deceased could only be desired by those most attached to what was mortal in him, who would be persuaded that it is precisely thus that he is now.[67] Hence we do not "recognize" the individual in the effigy; in the *Pratimā-nāṭaka*, Bharata does not recognize the effigies of his own parents, and in the presence of Javanese or Cambodian sculpture we are today in just the same way unable to distinguish, unless by an inscription, between a royal effigy and the image of a deity. The angel, whether *ājānaja* or *karma-deva*, is represented as at home (*gṛhe, gṛhastha*) and despirated (*apāna*), not as abroad in the breaths of life (*prāṇeṣu, pavaneṣu*); that is to say, formally (*nāmika*, Lat. *formaliter*), not as if embodied (*śārīraka*) in a life (*āyus, asu*), but in the manufactured image (*kṛtrima rūpa*).

[66] *Devabhūyam gata*, and *devatvam* (or *devītvam*) *prāpta*, etc., are common expressions; in JUB III.9, we find *devatām anusambhavati*. For *nāma* is that which remains and is "without end" when a man dies; see BU III.2.12.

[67] Portraiture in the accepted sense is history. History has its legitimate practical values; the Indian attitude, apart from some exceptions, has been to let the dead bury the dead; what India valued more than life was to preserve the great tradition of life, and not the names of those by whom it was handed down. We cannot imagine what it means to be interested in biography; our greatest "authors" are either anonymous or impersonally named, and none lays claim to originality but rather regards himself as merely an exponent. It has been well said that "portraiture belongs to civilizations that fear death. Individual likeness is not wanted where it suffices for the type to continue" (S. Kramrisch, *Indian Sculpture*, Calcutta, 1933, p. 134); in fact, it was not until the production of works of art had practically ceased that it occurred to men to protect them in museums, which can only be compared to tombs, and not until folksong and folklore were seen to be actually in imminent danger of death that it occurred to men to preserve their lifeless images on the dead pages of books. It was not until men began to fear that living books might be no more, that the scriptures were written down.

The representation of living persons according to their factual likeness (*yathā-veṣa-saṃsthānākāraḥ*), and where the possibility of recognition is a *sine qua non*, belongs entirely to the domain of "worldly" or "fashionable (*nāgara*)" painting, and has always an erotic (*śṛngāravat*) application (*prayojana*);[68] and is, furthermore, always an avocation or accomplishment attributed to princes and other cultured men rather than to the professional *śilpin* and *pratimā-kāraka*.[69] If portraiture of this kind is called *asvargya*, not heavenward leading, that is not so much a prohibition, as by way of pointing out the undeniable distinction of what is mortal (*martya*) and individual (*adhyātma*) in kind, from what is angelic (*adhidaivata*) and heavenward leading (*svargya*).[70] At the same time, even in this kind of portraiture it is the concept of the type discovered in the individual that really governs the representation: the portrait of a queen made for a lovesick king is given all the lineaments of a *padminī*, and yet thought of as a good likeness (*susadṛśa*);[71] and even when the portrait of an animal is required, the artist is expected to visualize (*dhyai*) the form in agreement with preestablished canonical proportions.[72]

It is in connection with an unsuccessful portrait, indeed, that we find allusion made to the fundamental cause of an artist's failure; this failure is attributed neither to lack of skill nor to lack of observation, but to a lax realization or "slackened integration (*śithila samādhi*)";[73] and elsewhere, in connection with the drama, imperfections of acting are attributed not to lack of skill or charm, but to the actor's "empty-heartedness" (*śūnya-hṛdayatā*),[74] which is tantamount to calling the production formless, in that the inwardly known form after which the gesture follows is a form known only within, as art in the artist. The use of the terms *samādhi, hṛdaya*, is significant when we realize, as we must have realized, that the practice of art is a discipline (*yoga*) beginning with at-

[68] The portraits of donors to be introduced in their donations (as, for example, described in *Mañjuśrimūlakalpa*, printed text, p. 69) are to be excepted from this generalization, but even here the purpose is individual, and in this sense profane.

[69] For the four classes of painting (*satya, vaiṇika, nāgara, miśraṇ*), see *Viṣṇudharmottara*, III.41. On the characteristics and functions of "fashionable" painting, see Coomaraswamy, "Nāgara Painting," 1929.

[70] *Śukranītisāra* IV.4.76.

[71] *Vikrama-caritra*, story of Nanda and his queen, Bhānumatī.

[72] *Śukranītisāra* VII.73–74.

[73] *Mālavikāgnimitra* II.2. In medical usage, *śithila samādhi* is *post coitum* lassitude, a state of disintegration (*visraṃsana*), cf. AĀ III.2.6.

[74] *Priyadarśikā of Harsha*, tr. G. K. Nariman, *et al.* (New York, 1923), Pt. III; and *Vikramorvaśi of Kālidāsa*, tr. C. D. Shastri (Lahore, 1929), II (introductory stanzas).

tention (*dhāraṇa*),[75] consummated in self-identification (*samādhi*), viz. with the object or theme of contemplation, and eventuating in skill of operation (*kauśala*).[76]

If we have so far considered only the case of what are commonly known as the major arts, let us not forget that Śaṅkarācārya is reported to have said, "I have learnt concentration (*samādhi*) from the maker of arrows." Not only in fact does the ordinary workman, weaver, or potter, work devotedly, but—though he may not practise *yoga* in the formal sense of sitting in *padmāsana*, etc.—he always forms mental images, which he remembers from generation to generation, and is so far identified with that he has them always at his ready command, at his fingers' ends, without need for conscious "designing"; and in that he works thus above the level of conscious observation, his capacity as artist by far exceeds what would be his capacity as individual "designer." At the same time his work remains comprehensible, and therefore nourishing and beautiful in the eyes of all those who, like himself, still live according to the immemorial tradition (*sanātana dharma*), or, in other words, according to the pattern of the Year (*saṃvatsara*). Preeminently of this kind, for example, are on the one hand those unlettered and obscure women of the villages, whose drawings executed in rice-powder and with the finger-brush in connection with domestic and popular festas (*vrata*) represent an art of almost pure form and almost purely intellectual significance;[77]

[75] Cf. *sādhāraṇya* as prerequisite to *rasāsvādana* on the part of the spectator.

[76] Art is a *yoga*, of course, only from the human point of view, in which there is presumed a duality; integrity being from this point of view "restored" in *samādhi* —though from the standpoint of the Self, that cannot be thought of as restored which has never been infringed. Accordingly in the Comprehensor (*vidvān*), who has transcended human modes of being, the *śilpa-sthāna-kauśala* is not attributed but essential, and thus no *yogyā kṛtā* (*Lalita Vistara*, 1.1); in the last analysis, and where no work is done because there are no ends to be attained, *śilpa* becomes *līlā, śilpāni āyavaḥ.*

While we are on the way we are not there. In the meantime, to work at his art, having always in view the good of the work to be done, and not the advantage to be derived from it (for the artist as for all others, *karmaṇyevādhikāraste mā phaleṣu*, BG 11.47) is the specific *karma-yoga* of the artist, his way (*mārga*) to *sāyujya* with the Lord in his aspect as *nirmāṇa-kāraka*. In other words, the *śilpin's ishṭa devatā* is Viśvakarman.

[77] "*Alpanā*" drawings are outstanding examples of "fine art" within the customary definitions of the category; being at once exalted in theme, astonishing in virtuosity, and, practically speaking, useless.

For examples see A. N. Tagore, *Bāṅgālār Vrata* (Calcutta, n.d., but before 1920). Attention may be called to Plate 99, illustrating two representations of the "House

and on the other, those trained and learned architects (*sthapati*) of southern India to whom rich tradesmen still entrust the building of cathedrals (*vimāna*), and who for their part lay claim to an equality with Brāhmaṇas in priestly function, being in fact the modern representatives of the Vedic *rathakāra*. Artists of this rank have long since disappeared from Europe, and are becoming rarer every day in India—those who do not understand, and therefore cannot use such arts as these, refusing, as the case may be, to "waste their time" or "waste their money" on them.

III

We have so far spoken of art mainly as utilitarian (*vyāpāra-mātra*) on the one hand and significant (*abhidhā-lakṣya*) on the other; as at once means of existence in the vegetative (*annamaya*) mode of being, and of reintegration in the intellectual (*manomaya*) mode of being. We have seen that the forms of things to be made are ordered (*prativihita*) to these ends, and that the knowledge of their right determination (*pramāṇa*) proceeds from a condition of consciousness in which the artist is fully identified with (*samādhi, tadākāratā,* etc.) the theme of the work to be done. With respect to the consumer (*bhogin*) and spectator (*draṣṭṛ*), it has been made clear that he only can make an adequate and intelligent use of the work of art who understands its determination; and, finally, that which distinguishes the work of art from a natural object or mere behavior is precisely its lucidity or expressiveness, its intellectual application.

But this is not all. It is agreed that works of art are for the competent spectator, if not causes of, nor ordered to,[78] at least occasions or sources

of the Sun"; here the theme is purely metaphysical, and can only be translated into symbols of verbal understanding when reference is made to the Vedic notions of the Supernal Sun as *aja ekapad*, and as moving in a ship or swing (*preṅkha*), which is the vehicle of Life over the cosmic waters (*āpaḥ*) that are the source (*yoni*) of his omnipotence (*mahiman*).

[78] *Daśarūpa* iv.47, *atatparatva*. We may call beauty the ultimate meaning (*paramārtha*) of the work; but only in the same sense that we can speak of death as the ultimate meaning of life, for it would be a contradiction in terms to speak of either art or life as *ordered* to the denial of itself. Works of art and things done are necessarily willed to proximate ends (as is well seen in the case of the Vedic sacrifice and all worship); if an ultimate "end" is accomplished in him who understands (*rasika, ya evaṃ vidvān*), that befalls not in the pursuit of any end, but by a disordering of anything to any end, as an act of understanding, not of will.

(*nisyanda*)[79] of an unrelated delight (*ānanda*), transcendent with respect to any or all of the specific pleasures or meanings subserved or conveyed by the work itself. That is the delight felt when the ideal beauty (*rasa*) of the work is seen or tasted (*svādyate*) in "pure aesthetic experience." This delight or tasting of ideal beauty (*rasāsvādana*), though void of contact with intelligible things (*vedyāntara-sparśaśūnya*), is in the intellectual-ecstatic order of being (*ānanda-cinmaya*), transcendental (*lokottara*), indivisible (*akhaṇḍa*), self-manifested (*svaprakāśa*), like a flash of lightning (*camatkāra*), the very twin of the tasting of Brahman (*Brahmasvāda-sahodara*).[80] Nor is this experience in any way determined by ethical qualities of any kind predicated with respect to the theme.[81] On the other hand, just as the artist starts from the theme or purpose of the work, and must be identified with its meaning before he can express it, so, conversely, the spectator may not attain to the vision of beauty without respect to the theme, but only by way of an ideal sympathy (*vāsanā*) with and consent (*sādhāraṇya*) to the passions animated in the theme,[82] only by way of an imaginative integration of oneself with the meaning of the theme (*arthabhāvanā*).[83] The vision of beauty is thus an act of pure contemplation, not in the absence of any object of contemplation, but in conscious identification with the object of contemplation. Just as the concept of the artist is most perfectly and only perfectly realized in the person of the Divine Architect, so the concept of the spectator is most perfectly and only perfectly realized in the Self, one Person, single Self, who at one and the same time and forever sees all things (*viśvam abhicaṣṭe*), seeing without duality (*dṛṣṭādvaita*), verily seeing though he does not look (*paśyan vai tanna paśyati*), and whose intrinsic aspect (*svarūpa*) is the single image of all things (*viśvarūpa, rūpaṃ rupaṃ pratirūpa*). His is the perfection of aesthetic contemplation who as "very Self surveys the variegated world-picture as nothing other than the Self depicted on the mighty canvas of the Self, and takes a great delight therein"[84]—that is, the

[79] *Daśarūpa* i.6.

[80] *Sāhitya Darpaṇa* iii.2–3. [81] *Daśarūpa* iv.90.

[82] *Sāhitya Darpaṇa* iii.9, *na jāyate tadāsvādo vinā ratyādivāsanam*, and Dharmadatta, *nirvāsanāstu rangāntāḥ kāṣṭhā-kuḍyāśma-saṃnibhāḥ*; *Sāhitya Darpaṇa* iii.12, *sādhāraṇyena ratyādirapi tadvat pratīyate* and Commentary, *ratyāderapi svātmagatatvena pratītau sabhyānām*. Aesthetic experience does not depend upon the particular theme expressed; but in the absence of any theme, there cannot be any occasion for the *pratīti* of *rasa*.

[83] *Daśarūpa* iv.51, *arthabhāvanāsvādaḥ*.

[84] *Svātma-nirūpaṇa* 95.

consummation equally of art and understanding. That is the pure being of the Self, in the identity of its essence and its nature, within you, where there are neither works to be done nor thought to be communicated, but a simple and delighted understanding; one perfection, though reflected brokenly in all things perfect in their kind, one image-bearing light, though refracted in all things well and truly made.

IV

Thus art reflects and answers to man's every need, whether of affirmation (*pravṛtti*) or denial (*nivṛtti*), being no less for the spectator than the artist a way (*mārga*), one way amongst the "many paths that Agni knows." Now with respect to every way, the means and their fruit must be understood; not merely explicitly and theoretically, but also implicitly and actually, for the way is of no use to him who will not walk in it. There are still those, though few, whose use and understanding of art are innate and untaught, and who in their innocence (*bālya*) have never thought of art as a function added on to life, but only as a skill appropriate to every operation; and others, the majority, who have been mistaught to think of art as present or wanting in human work by calculation, and of beauty as a kind of varnish (*lepa*) or ornament (*alaṃkāra*) that can be added to or omitted from things at will. What service can be rendered to either of these kinds of men by the exposition of a theory of beauty, however correct (*pramiti*) and authoritative (*prameya*) it may be?[85] According to our understanding, the only service that can be rendered to the innocent is one of protection, whether indirectly, by taking care that they shall not be corrupted or robbed of their inheritance by ignorant

[85] In expounding the theories of art and beauty we have refrained from the expression of any opinions (*dṛṣṭi*) or hypotheses (*kalpana*) of our own; relying only upon authority (*śruti* and *smṛti*, Veda and Upaveda), we speak of our exposition as authoritative (*prameya*).

In making such an exposition, we have had regard only to the good of the work to be done (*kārya-svārtha*), not to its value for us or others, and the exposition is open to criticism only from this point of view, viz. as to whether it is well and truly made. From our individual point of view, the work is vocational (*svadharma*), and undertaken not by choice but at the instigation of the editors, as *kārayitāraḥ*. On the other hand, the undertaking as such, and as distinguished from the performance, can be justified only with respect to human value (*puruṣārtha*) generally; the pursuit of knowledge for its own sake, like that of art for art's sake, being nothing better than painting on the air and cooking for oneself alone. Hence the inquiry, "What service can be rendered?"

educationists or patrons, on the one hand, nor by exploitation[86] on the other; or directly, by the continuation of an understanding patronage, considering that a connoisseurship (*vicakṣaṇatva*) not expressed in active interest and patronage overshoots its mark (*prayojanam atikrāmati*). Here, then, the function of a correct exposition of the theory of art is conservative. Service that can be rendered to the perversely educated (*mithyā-paṇḍita*) is of another sort, these having already broken away from, or been torn away from traditional modes of understanding, and now depending for guidance merely upon individual opinion, taste, and passing fashion. These need above all to be reminded that the practice of art is a vocation, not an accomplishment; that the primary virtue in the artist is obedience or faith; that connoisseurship rightly understood can be achieved only by a rectification of the whole personality, not by the mere study or collecting of works of art; that competence (*svādakatva*) in the spectator, no less than skill (*kauśala*) in the artist, must be earned —they cannot be imparted in the classroom. The "collector" and "lover of art," who thinks of museums and galleries as the proper destination of works of art, has more to learn from than to teach the man whose works of art are still in honor (*pūjita*) and in use (*prayukta*).[87] The service that can be rendered to the wrongly educated, and this means to most of those who at the present day pretend to education, must and can only be destructive of their fondest ideals.

Let us consider the present situation and some specific instances. It may be said without fear of contradiction that our present poverty, quantitative and qualitative, in works of art, in competent artists, and in effective connoisseurship, is unique in the history of the world, and that in all these respects the present day can be most unfavorably contrasted with the past, from which we have inherited a superabundance of works of art for which, however, we have little positive use. All this is not to say that manhood is dead in us, but that a certain aspect of manhood is lacking in us. Those of us who have recognized this state of affairs, and have sought to remedy it, have generally put the cart before the horse, thinking our

[86] By "exploitation" is meant, on the one hand, a procuration of the craftsman's skill to the making of trivialities appropriate to the tourist trade, and on the other, a tolerance of industrial forces tending to drive the craftsman from his workshop to the mills.

[87] I have learned as much from living men, hereditary craftsmen working after the fashion of their craft (*śilpānurūpeṇa*), as from the books. The practice of the hereditary craftsman, and the theory as set forth in the books, are in complete agreement.

need to be for works of art in greater number, or aspiring individually to become artists, rather than to become more profoundly and fully men. Others maintain that "art" is a luxury that an impoverished nation cannot "afford," materials being costly, and time "valuable"—one may ask, in this connection, valuable for what? Now the economic factor is practically without any bearing on the issue; our situation is not such that only the rich can afford to patronize the artist, or that he must be rich who would have about him things at once utilitarian and significant, but that the rich man could not, if he would, obtain for himself goods of such quality as was once common in the market, and can now be found only in glass cases; not that the consumer is dissatisfied with the quality of goods offered to him, but that he is insensitive to their defect; not that the clerk and his wife are literally penniless, but that they actually prefer a piece of jewelry made according to the meaningless patterns to be found in the catalogues of foreign manufacturers to one made after an "outmoded" angelic prototype;[88] not that we have no so-called works of art, but that those we have, particularly those purporting to be heroic or religious in theme, are in fact tawdry and meretricious; not that the nationalist does not wish to express an Indian content in his emblems, but that he no longer knows what is Indian, nor understands the nature of symbolism; not that no attempts have been made to "revive" the arts of ancient India, but that our "Pre-Raphaelites" have imitated ancient styles rather than reiterated ancient meanings;[89] not that an art and artists of a higher order have not survived sporadically, even in our cities, but that, infatuated by a supposedly higher taste, we have held aloof from these, or else have thought of what was an essential grace in us as merely raw material for anthropological and historical research.

It is a thankless task, but necessary to our purpose, to demonstrate our meaning by an analysis of specific instances; nor can we bring ourselves to illustrate by actual reproduction samples of our arts that are not arts;

[88] Incidentally, the lifting (*luṇṭhana*) of these designs is an example of "flagrant plagiarism" (*pariharaṇa*).

[89] Meanings (*artha*) are all created by the revolution of the Year (*saṃvatsara-pravartana*), that is, without beginning or end (*anādi, ananta*); and having neither place nor date, cannot be thought of as the private property of anyone. He who identifies himself with any meaning or idea, finding it then at its source (Lat. *origo*, Skr. *udriṇa,* as in RV x.101.5, *udriṇaṃ suseḳam anupakṣitam*) within himself, is equally "original" with him who found it a thousand years ago; only the modality of the expression, the individual style, which is an accident and not an essence in the work of art, must be unique and cannot be repeated.

these overcrowd our palaces and drawing rooms, and those who would understand should earn their judgments, not have judgments ready made for them. A citation of a few cases will suffice; there will be recognized in each a reduction of the work of art from its proper nature, that of a tangibly presented work informed by a given intellectual content or meaning, to another and lower nature, that of a tangibly presented object uninformed by any meaning, and merely informative or useful.[90] "Reduction" is the converse of "transformation"; the reduction of an already known symbol to the condition of insignificant and merely sensible objectivity represents a fall or decadence precisely contrary in direction to that ascent which is accomplished when in taking "nature" for our starting point we proceed from appearance to form. If we take the symbol "lotus (*puṣkara*)," which communicates the notion of a "ground (*pṛthivī, bhūmi*)," as the means of our support (*pratiṣṭhā*) in the boundless waters (*āpaḥ*) of the possibilities of existence,[91] and proceed to depict an angel standing or seated on a lotus which in every respect and to the best of our ability repeats the semblance of the natural flower as known to the botanist or to the bee, that is a decadence of art; for there has been introduced an incongruity (*viruddhatva*) between the notion of firm support proper to the concept, and that of frail delicacy proper to the natural flower; and so far from there being any possibility of a concurrence in the meaning and consequent delight, the spectator is made to feel a positive discomfort, for in this kind of "art" the angel, too, is made to take on flesh, and could the work be brought to life, would forthwith sink.[92] Or consider the sculptured portrait, not in the intelligible image of,

[90] In the work of art, utility is by no means precluded, but in the expression of a meaning and consequent possibility of a concurrence (*sādhāraṇya*) of the spectator therewith, there is provided an occasion of aesthetic experience in him. In the mere work, no meaning being expressed, there can be no concurrence; there is no possibility of aesthetic experience, but an occasion only for pleasure-pain reactions on the part of the consumer.

[91] Sāyaṇa on RV VI.16.3 (*agni puṣkarāt*): *puṣkara-parṇasya sarva-jagaddhārakatva*.

[92] Incongruity (*viruddhatva*) is the reverse of concordance (*sādṛśya*). "Concordance" in the *pratīka* "lotus" subsists on the likeness of the relation of cosmic "ground" to cosmic "waters" on the one hand, and actual lotus to actual lake on the other, not at all on any resemblance between the painted form and the natural flower.

Nothing of what has been said above denies the propriety of literal imitation in any work intended to serve the purposes of a science; in the treatise on botany we expect, and have a right to expect, to learn what the lotus actually looks like, not what the symbol lotus "means"; in the treatise on botany, formality would be a fault.

but exactly like (*susadṛśa*) a given man, and distinguishable from him only by the sense of touch or smell; here again is a decadent work, not well and truly made, but a travesty, for it pretends to be one thing, a living man, and is another, a piece of stone. Or consider the well-known representation of Mother India as an *allzumenschliche* (altogether too human) woman outlined against the map of India; here again the work is inanimate, in that the intellectual form (*parokṣa nāma*) is not expressed at all; here there is nothing but an arbitrary juxtaposition of a sign for "any woman" (*sāmānyā strī*), and a symbol for "India" as known to the cartographer, that is over against himself objectively, by no means as the ground of his existence. Only the politician could be fed on such food as this; he who loves the Mother more than her position in the world is not fed, but starved by works of this kind, incongruity (*viruddhatva*) and inexpressiveness (*anirdeśatva*) inhibiting assimilation. It is true that by the intensity of the spectator's ardour (*tapas*) the defect (*doṣa*) of any image may be overcome;[93] but the spectator's virtue, even when really a virtue and not merely an idle sentimentality, by no means excuses the artist's fault, whose business (*svadharma*) it is to *know* how things ought to be done. Here the defect is primarily aesthetic; at the same time, further offense is offered in that the actual representations of this motif are glaring examples of bad taste, whereby the draughtsman is betrayed, not as artist, but as man. Rendered into verbal symbols, all that the nationalist actually voices in this emblem is, not a dedication to a Motherland, but service promised to the genus *homo*, species *indicus*, and sex female. Or finally, turning to the stage, when the actor forgets to register (*sūc, rūp*) the determinants (*vibhāva*) of feeling (*bhāva*) proper to the theme (*vastu*), and merely exhibits his own emotions, that is not an art at all, not acting (*nāṭya*), but merely behavior (*svabhāvāt*), and a crying baby achieves no less: "or," as Śaṅkarācārya expresses it, "does the actor, playing a woman's part, pant for a husband, thinking himself a woman?"[94]

Thus all direction has been lost, and there is revealed the dark disorder of our life. Can we refer to any sign of life, or evidence of a reintegration, to any art bespeaking the entire man? Judging by the criteria deduced from scripture and tradition, we must answer "Yes." The weaving of homespun cloth (*khaddar*), an art in itself of immemorial antiquity, is effectively a new thing in our experience. This is an art that answers exactly to our such and such desired ends, to human values as we under-

[93] *Śukranītisāra* IV.4.160. [94] *Śataślokī* 7.

stand them in the light of our present environment (*kāla-deśa*); one that in practical application answers to our material necessity, and is at the same time an image in his likeness whom we worship in his ultimate simplicity (*samatā*) rather than as arrayed in all his glory. It was not indeed "taste" that brought us to the use of homespun, nor, on the other hand, was this merely an outwardly imposed privation; it was only by a monastic simplicity of demeanor that man could imitate divine poverty: now that we understand the significance of what we did, we feel that nothing else could "become us"; for the present we are assured that to be arrayed in glorious garments is not merely bad economy, but also bad taste.

A canvas had to be prepared (*parikṛta*), cleansed of its disfigured images, and whitened, before it could be looked for that He who is eternally the same, but takes on unsuspected likenesses which we cannot yet imagine, could be revealed again in linear or brightly colored shapes reflecting His intellectually emanated forms.[95] It does not depend on any will of ours as "lovers of art," but only on our willingness, upon obedience (*śraddhā*), whether or when newborn aspects of His image-bearing light (*sarūpa-jyotish*)[96] may blossom (*unmīl*) on the walls of human temples and on tissues woven by human hands. In the meantime, homespun cloth and whitewashed walls are works of art perfected in their kind, no less expressive of an intellectual reintegration than practically serviceable, fully befitting the dignity of man. For the present we have neither ends to be served nor meanings to express for which another and more intricate art would be appropriate; to aspire to any other art would be merely an ambition, analogous to his who claims another vocation (*para-dharma*) than his own. In speaking of the most austere style as the only style at once appropriate and well-becoming now, we do not mean to say that another and infinitely richer style may not as well become man's dignity upon another occasion, whether soon or late. To be attached to an austere style would be an error no less than to be attached to one more various (*vicitrā*): man's entelechy as man lies not in nonparticipation (*akarma*), but in virtuosity (*karmasu kauśalam*) without attachment (*asaktatva*).[97] If the asceticism of the student (*brahmacarya*) becomes us now, we must

[95] Metaphor based on *Pañcadaśī*, sect. 6; the notion *unmīlita-citra-nyāya*; MU IV.2 (*āditye mahat . . . ādarśe pratirūpaḥ*), and similar texts.

[96] RV x.55.3; cf. *citra-bhāsa, citra śoci*, and *bhā-rūpa* elsewhere.

[97] BU 1.4.15, *vedo vānanukto anyadvā karmākṛtam* (*na bhunakti*); BG 11.47, *mā te saṅgo 'stvakarmaṇi*; BG 111.4; and similar texts.

expect to play the part of wealthy householders (*grhastha*) when that is required of us in turn, only at last and after all our work is done, returning to a comparable austerity, but of a higher order. Art, whether human or angelic, begins in a potentiality of all unuttered things, proceeds to expression, and ends in an understanding of the absolute simplicity or sameness of all things; ours is a beginning and a promise.

Introduction to the Art
of Eastern Asia

To look for the first time at the art of Asia is to stand on the threshold of a new world. To make ourselves at home here will require sensibility, intelligence, and patience. It is the business of the historian of art to disengage the intrinsic character of an art, to make it accessible. This can be done in various ways, complementary rather than alternative. All that has been attempted here is to state a philosophy of Asiatic art; what is said takes into account all the arts. Comparisons have been avoided as far as possible. But in writing mainly for non-Asiatic readers, some reference to Europe has been inevitable, and it must therefore be pointed out that there are two different Europes, the one "modern" or "personal," the other "Christian." The former, roughly speaking, begins with the Renaissance, the latter includes the "Primitives" and a part of Byzantine art; but the two Europes have always overlapped and interpenetrated. One might say in the same way that there have been two Greeks arts, Hellenic and Hellenistic. On the whole, Asiatic art is quite unlike that of "modern" Europe, in appearance and principle, but very like that of Christian Europe, in both respects. Two works on the principles of Christian art might be described as adequate introductions to the art of Asia, and may serve to make the latter more comprehensible, because the principles enunciated are so near to those of Asiatic art.[1]

It has been unavoidable to neglect the earlier art of Asia; what has been said applies chiefly to the art of the last two thousand years, which will include the greater part of what will be most readily accessible to the reader. The scope of the present essay excludes also the art of Western Asia, more specifically Muhammadan art, though it would have been

[First published in *The Open Court*, XLVI (1932), this essay was issued as a pamphlet later in that year in the New Orient Society Monograph Series (No. 2).—ED.]

[1] Eric Gill, *Art Nonsense* (London, 1929); and Jacques Maritain, *Art and Scholasticism* (2nd Eng. tr., London, 1930) ("art is an undeviating determination of work to be done, *recta ratio factibilium*").

interesting and well worth while to show to what extent Muhammadan art is truly Asiatic. It would be obvious, of course, that Sūfī thought provides a near equivalent to Zen, and to Vaiṣṇava mysticism, and could easily have inspired a like visual art, notwithstanding that historically speaking, the Sūfī point of view has found expression only in poetry and music and in the Persian love of gardens.[2] This reflection will call to mind the aniconic and iconoclastic character of Muhammadan art: it would have been attractive to expound the sources of this attitude in certain aspects of Mazdean religion and the analogy which it presents with Indian and Far Eastern tendencies aniconic in effect. It might have been shown, in particular, that the traditional Muhammadan interdiction of the representation of the forms of living things really involves no more than a confusion as to what is meant by "imitation," a subject which is discussed at some length below. The Doctors of Islam held that the painter would be condemned on the Day of Judgment because in imitating the forms of life he has presumptuously reproduced God's work, but is not himself like God able to endow the forms with sentient life. When we consider, however, the ideal character of the Indian or Chinese icon, which is not designed "as if to function biologically," it will appear that the use of such idols offends against Muhammadan doctrine only in the letter, not in the spirit; and, on the other hand, when we examine what has been said about art in India and the Far East, we find many and clearly expressed condemnations of the merely illustrative and illusionary aspects of art.[3] Christian art, regarded by orthodox Muhammadans as idolatrous, in the same way by no means makes its criterion the likeness of any created thing; as one of its exponents has said, "Naturalism has always and everywhere been a sign of religious decay." Thus Muhammadan, Hindu-Buddhist, and Christian art all in reality meet on common ground.

THAT Asia, in all her diversity, is nevertheless a living spiritual unity, was first and eloquently affirmed by Okakura in 1904. This diversity in unity embraces at the very least one half of the cultural inheritance of human-

[2] [Cf. "Note on the Philosophy of Persian Art," in this volume, for Coomaraswamy's later views.—ED.]

[3] Cf. Śukranītisāra IV.73–76: "One should make images of deities, for those are productive of good, and heavenward-leading, but those of men or other (earthly beings) lead not to heaven nor work weal. Images of deities, even with lineaments (lakṣaṇa) imperfectly depicted, work weal to men, but never those of mortals, even though their lineaments (be accurately shown)."

ity.[4] Yet it is still customary in Europe to compile histories of art, aesthetics, or philosophy in general with tacit claims to universality, while in fact such works are restricted in contents to the history of Europe. What has been learned about Asia remains at best a series of disconnected facts, apparently arbitrary, because not exhibited in relation to a human will. It will be self-evident, then, that the true discovery of Asia represents for the majority an adventure still to be achieved. Without some knowledge of Asia, no modern civilization can come into maturity, no modern individual can be regarded as civilized, or even fully aware of what is properly his own. Not that Asia can have importance for Europe as a model—in hybrid styles, authentic forms are merely caricatured, whereas a genuine assimilation of new cultural ideas should and can only result in a development formally altogether different from that of the original mode. What Asia signifies for Europe is means to the enlargement of experience, means to culture in the highest sense of the word, that is, to an impartial knowledge of style; and this implies a better understanding of the nature of man, a prerequisite condition of cooperation.

It must not be supposed that we can take possession of new experiences without effort or preparation of any kind. It is not enough to admire only what happens to appeal to our taste at first sight; our liking may be based on purely accidental qualities or on some complete misunderstanding. Far better to begin by accepting for the time being the dicta of competent authority as to what is great and typical in Asiatic art, and then to seek to understand it. We must particularly remember that no art is exotic, quaint, or arbitrary in its own environment, and that if any of these terms suggest themselves to us, we are still far removed from any understanding of what is before us. It is hard for most people to appreciate even the art of mediaeval Europe. Edification and theology are so far from

[4] Strzygowski's division of Asia into North and South, and exclusion of the South (ZDMG, X, 1897, 105), seems to me to be based on a mistaken conception of the sources and significance of Mazdaism. It is valid only to this extent, that whereas in India the development of devotional (*bhakti*) theism involved a predominance of anthropomorphic imagery during the last two thousand years, the Far East, had it not been influenced by the iconographic necessities of Buddhism, might have remained predominantly aniconic from first to last. Thus Central and Far Eastern Asia (the "North") may be said to owe their anthropomorphic art to a movement of southern origin: but it has also to be remembered that an aniconic style of animal, plant, or landscape symbolism originated in a long pre-Aryan antiquity and was a common property of all Asia, and that this style has survived in all areas, the Indian "South" by no means representing an exception.

the interests of the majority that the once indivisible connection of religion with art is now conceived as an infringement of human liberty. Moreover, to the modern consciousness, art is an individual creation, produced only by persons of peculiar sensibilities working in studios and driven by an irresistible urge to self-expression. We think of art, not as the *form* of our civilization, but as a mysterious quality to be found in certain kinds of things, proper to be "collected" and to be exhibited in museums and galleries. Whereas Christian art and the arts of Asia have always been produced, not by amateurs, but by trained professional craftsmen, proximately as utilities, ultimately *ad majorem gloriam Dei*.

We approach the essential problem, What is art? What are the values of art from an Asiatic point of view? A clear and adequate definition can be found in Indian works on rhetoric. According to the *Sāhitya Darpaṇa*, 1.3, *Vākyam rasātmakam kāvyam*;[5] "Art is a statement informed by ideal beauty." Statement is the body, *rasa* the soul of the work; the statement and the beauty cannot be divided as separate identities. The nature of the statement is immaterial, for all conceivable statements about God must be true. It is only essential that a necessity for the particular statement should have existed, that the artist should have been identified in consciousness with the theme. Further, as there are two Truths, absolute and relative (*vidyā* and *avidyā*), so there are two Beauties, the one absolute or ideal, the other relative, and better termed loveliness, because determined by human affections. These two are clearly distinguished in Indian aesthetics.

The first, *rasa*,[6] is not an objective quality in art, but a spiritual activity or experience called "tasting" (*āsvāda*); not affective in kind, not dependent on subject matter or texture, whether lovely or unlovely to our taste,[7] but arising from a perfected self-identification with the theme, whatever it may have been. This pure and disinterested aesthetic experience, indistinguishable from knowledge of the impersonal Brahman, impossible to be described otherwise than as an intellectual ecstasy, can be evoked only in the spectator possessing the necessary competence, an in-

[5] *Kāvya*, specifically "poetry" (prose or verse), can also be taken in the general sense of "art." Essential meanings in the root *kū* include wisdom and skill.

[6] *Sāhitya Darpaṇa* III.2–3. See also P. Regnaud, *La Rhétorique sanskrite* (Paris, 1884), and other works on the Indian *alaṃkāra* literature. It should be noted that the word *rasa* is also used in the plural to denote the different aspects of aesthetic experience with reference to the specific emotional coloring of the source; but the *rasa* that ensues is one and indivisible.

[7] Dhanaṃjaya, *Daśarūpa* IV.90. *Rasa* is thus quite other than taste (*ruci*).

ward criterion of truth (*pramāṇa*); as competent, the true critic is called *pramātṛ*, as enjoyer, *rasika*. That God is the actual theme of all art is suggested by Saṅkarācārya, when he indicates Brahman as the real theme of secular as well as spiritual songs.[8] More concretely, the master painter is said to be one who can depict the dead without life (*cetana*, sentience), the sleeping possessed of it.[9] Essentially the same conception of art as the manifestation of an informing energy is expressed in China in the first of the Six Canons of Hsieh Ho (fifth century), which requires that a work of art should reveal the operation of the spirit in living forms, the word here used for spirit implying the breath of life rather than a personal deity (cf. Greek *pneuma*, Sanskrit *prāṇa*.). The Far Eastern insistence on the quality of brush strokes follows naturally; for the brush strokes, as implied in the second of the Canons of Hsieh Ho, form the bones or body of the work; outline, *per se*, merely denotes or connotes, but living brushwork makes visible what was invisible. It is worth noting that a Chinese ink painting, monochrome but far from monotone, has to be executed once and for all time without hesitation, without deliberation, and no correction is afterwards permissible or possible. Aside from all question of subject matter, the painting itself is thus closer in kind to life than an oil painting can ever be.

The opposite of beauty is ugliness, a merely negative quality resulting from the absence of informing energy; which negative quality can occur only in human handiwork, where it plainly expresses the worker's lack of grace, or simple inefficiency. Ugliness cannot appear in Nature, the creative energy being omnipresent and never inefficient. Relative beauty, or loveliness (*ramya, śobhā*, etc.)[10] on the other hand, that which is pleasing to the heart, or seductive (*manorama, manohara*, etc.), and likewise its opposite, the unlovely or distasteful (*jugupsita*), occurs both in nature and in the themes and textures of art, depending on individual or racial taste. By these tastes our conduct is naturally governed; but conduct itself should approximate to the condition of a disinterested spontaneity, and in any case, if we are to be spiritually refreshed by the spectacle of an alien culture, we must admit the validity of its taste, at least imaginatively and for the time being.

Aesthetic ecstasy, as distinct from the enjoyment of loveliness, is said to arise from the exaltation of the purity (*sattva*) of the *pramātṛ*, which

[8] Commentary on BrSBh 1.1.20–21. [9] *Viṣṇudharmottara* XLIII.29.

[10] *Śobha*, for example, is defined in drama as the "natural adornment of the body by elegance of form, passion, and youth" (*Daśarūpa* II.53).

purity is an internal quality "which averts the face from external appearances (*bāhyameyavimukhatāpādaka*)"; and the knowledge of ideal beauty is partly "ancient," that is to say, innate, and partly "present," that is to say, matured by cultivation.[11] This ideal delight cannot vary in essence, or be conceived of as otherwise than universal. Apprehended intuitively, without a concept, that is, not directed to or derived from specific knowledge (Kant), *id quod visum placet* (St. Thomas Aquinas), and consisting, not in pleasure, but in a delight of the reason (*nandicinmaya*), it cannot as such be analyzed into parts, discoursed upon, or taught directly, as is proved both by the witness of men of genius and by experience. In any case, the ecstasy of perfect experience, aesthetic or other, cannot be sustained. Returning to the world, its source becomes immediately objective, something not merely to be experienced, but also to be known. From this point of view, a real indifference to subject matter, such as professional aesthetes sometimes affect, could only be regarded as a kind of insensibility; the "mere archaeologist," whose impartiality is a positive activity far removed from indifference, is often, in fact, nearer to the root of the matter, humanly speaking, than is the collector or "lover" of art.

The work of art is not merely an occasion of ecstasy, and in this relation inscrutable, but also according to human needs, and therefore according to standards of usefulness, which can be defined and explained. This good or usefulness will be of two main kinds, religious and secular; one connected with theology, adapted to the worship and service of God as a person, the other connected with social activity, adapted to the proper ends of human life, which are defined in India as vocation or function (*dharma*), pleasure (*kāma*), and the increasing of wealth (*artha*). Even were it maintained that Asiatic art had never attained to perfection in its kind, it would not be denied that a knowledge of these things could provide an absorbing interest, and must involve a large measure of sympathetic understanding. It is actually a knowledge of these things which alone can be taught; explanation is required, because the mind is idle, and unwilling to recognize beauty in unfamiliar forms, perhaps unable to do so while distracted by anything apparently arbitrary or capricious, or distasteful in the work itself, or by curiosity as to its technique or meaning. All that man can do for man, scholar for public, is to disintegrate those prejudices that stand in the way of the free responses and activity

[11] *Sāhitya Darpana* III.2–3, and Commentary.

of the spirit. It would be impertinent to ask whether or not the scholar himself be in a state of grace, since this lies only in the power of God to bestow; all that is required of him is a humane scholarship in those matters as to which he owes an explanation to the public. Only when we have been convinced that a work originally answered to intelligible and reasonable needs, tastes, interests, or aspirations, whether or not these coincide with our own (a matter of no significance, where censorship is not in view), only when we are in a position to take the work for granted as a creation which could not have been otherwise than it is, are conditions established which make it possible for the mind to acknowledge the splendor of the work itself, to relish its beauty, or even its grace.

If, then, we are to progress from a merely capricious attraction to selected works, possibly by no means the best of their kind, we shall have to concern ourselves to understand the character (*svabhāva*) of the art; more simply expressed, to learn what it is all about, to comprehend it in operation. This is tantamount to an understanding of our neighbor; he alone, for and by whom the art was devised, affords a valid explanation of its existence. To understand him, we require not merely a vague good will, but also real contact: "Wer den Dichter will verstehen, / muss in Dichters Lande gehen." But the homelands of the Poetic Genius are often remote in time as well as space, and in any case mere travel on the part of those who have neither eyes to see nor ears to hear is rather worse than useless. Generally speaking, one who has not been educated *for* travel, will never be educated *by* travel; he who would bring back the wealth of the Indies, must take the wealth of the Indies with him. We are not making too great a demand; in any case the man of today can hardly be called educated who knows no other literature than his own, can hardly be regarded as a "good European" who knows only Europe. The normal man, without proposing to become a professional scholar, or what is essential for research, to control any Oriental language, can obtain what he most needs merely from the reading of Oriental literature in the best translations (despite their inevitable shortcomings), and certain selected works by more specialized scholars. As Mencius said in giving advice to a pupil, "The way of truth is like a great road. It is not difficult to know. Do you go home and search for it and you will have an abundance of teachers."

I am well aware that an art requiring literary interpretation is now discredited; so for that matter is art in any way connected with human

life. However, the comparison is false. We are not suggesting that study should be confined to a search for the literary sources of the themes of particular works, but that literature can provide the most readily available guide to an understanding of the entire background against which the art has flowered, and without which it could be regarded only as a *tour de force*. We must in one way or another acquire a sense of *terre à terre*, if the art is to be a reality in our eyes. We admit and repeat that the art of Asia requires explanation, nor is this a disparagement in any sense. A man can expect to understand without effort and at first sight only the art of his own day and place; it is only the art of today that can be condemned as arbitrary or pathological if it remains impenetrable to the man of average intelligence and education. Everyone does, in fact, understand the lines of motor cars and the subtleties of current fashions, contemporary dance music, and the comic strips; all of which seem difficult, abstract, and mysterious to an Asiatic not versed in these arts. For the rest, it will be only a strictly naturalistic art (to use a contradiction in terms) that can dispense with explanation; we can recognize a horse whenever we see it, in a film from Tibet or one from the Wild West, and if the Chinese language consisted entirely of onomatopoetic words, we should be able to understand a good deal of it without effort. But the more absolute the beauty of an alien work, the more fully it is what it is intended to be, the less intelligible will be its functioning; but to call it, therefore, mysterious would be only to give a name to our ignorance, for such works were never obscure to those for whom they were made. The alien work cannot even be approached as a phenomenon isolated from the life in which it arose; only when it has become for us an inevitable fact, born of human nature, having a given inheritance, and acting in a given environment, and through those very conditions enabled to achieve universal values, can we begin to feel that it belongs to us.

"Who paints a figure, if he cannot be it, cannot draw it." These words of Dante (*Canzone* xvi), utterly alien to the assertions of those who now maintain that art can be successfully divorced from its theme and from experience, are alone sufficient to establish a fundamental identity of European and Asiatic art, transcending all possible stylistic difference, and all possible distinction of themes. But whereas Europe has only rarely and rather unconsciously subscribed to this first truth about art, Asia has consistently and consciously acted in awareness that the goal is only reached when the knower and the known, subject and object are identified in one experience. In European religion, the application of this doctrine

has been a heresy.[12] In India it has been a cardinal principle of devotion that to worship God one must become God (*nadevo devam arcayet: Śivo bhūtvā Śivaṃ yajet*).[13] This is, in fact, a special application of the general method of yoga, which as a mental discipline proceeds from attention concentrated upon the object to an experience of the object by self-identification in consciousness with it. In this condition the mind is no longer distracted by *citta-vṛtti*, perception, curiosity, self-thinking and self-willing; but draws to itself, *ākarṣati*, as though from an infinite distance[14] the very form of that theme to which attention was originally directed. This form *jñāna-sattva-rūpa*, imagined in stronger and better lineaments than the vegetative mortal eye can see, and brought back, as it were, from an inner source to the outer world, may be used directly as an object of worship, or may be externalized in stone or pigment to the same end.

These ideas are expanded in the ritual procedure which we find enjoined upon the images in the mediaeval *Sādhanāmālās*. The details of these rituals are most illuminating, and though they are enunciated with special reference to cult images are of quite general application, since the artist's theme can only be rightly thought of as the object of his devotion, his *devatā* for the time being. The artist, then, purified by a spiritual and physical ritual, working in solitude, and using for his purpose a canonical prescription (*sādhana, mantra*), has to accomplish first of all a complete self-identification with the indicated concept, and this is requisite even though the form to be represented may embody terrible supernatural features or may be of the opposite sex to his own; the desired form then "reveals itself visually against the sky, as if seen in a mirror, or in a dream," and using this vision as his model, he begins to work with his hands.[15] The great Vision of Amida must have revealed itself thus, not-

[12] When Eckhart says, "God and I are one in the act of perceiving Him," this is hardly orthodox doctrine.

[13] Yoga is not merely rapture, but also "dexterity in action," *karmasu kauśalam*, BG II.50. The idea that creative activity (intuition, *citta saññā*) is completed before any physical act is undertaken appears also in the *Atthasālinī*; see Coomaraswamy, "An Early Passage on Indian Painting," 1931.

[14] The remote source may be explained as the infinite focal point between subject and object, knower and known; at which point the only possible experience of reality takes place in an act of nondifferentiation. (Cf. *One Hundred Poems of Kabir* [tr. Rabindranath Tagore, New York, 1961], No. xvi, "Between the poles of the sentient and insentient," etc.).

[15] From a Sanskrit Buddhist text, cited by A. Foucher, *L'Iconographie bouddhique de l'Inde* (Paris, 1900–1905), II, 8–11. Cf. *Śukranītisāra* IV.4.70–71, tr. in Coomaraswamy, *The Transformation of Nature in Art*, 1934, ch. 4, "Aesthetic of

withstanding that the subject had already been similarly treated by other painters; for the virtue of a work is not in novelty of conception, but intensity of realization.

The principle is the same in the case of the painter of scenic, animal, or human subjects. It is true that in this case Nature herself provides the text: but what is Nature—appearance or potential? In the words of Ching Hao, a Chinese artist and author of the T'ang period, the Mysterious Painter "first experiences in imagination the instincts and passions of all things that exist in heaven or earth; then in a style appropriate to the subject, natural forms flow spontaneously from his hand." On the other hand, the Astounding Painter, "though he achieves resemblance in detail, misses universal principles, a result of mechanical dexterity without intelligence . . . when the operation of the spirit is weak, all the forms are defective."[16] In the same way Wang Li, who in the fourteenth century painted the Hua Mountain in Shenshi, declares that if the idea in the mind of the artist be neglected, mere representation will have no value; at the same time, if the natural form be neglected, not only will the likeness be lost, but also everything else—"Until I knew the shape of the Hua mountain, how could I paint a picture of it? But even after I had visited it and drawn it from nature, the 'idea' was still immature. Subsequently I brooded upon it in the quiet of my house, on my walks abroad, in bed and at meals, at concerts, in intervals of conversation and literary composition. One day when I was resting I heard drums and flutes passing the door. I leapt up and cried, 'I have got it.' Then I tore up my old sketches and painted it again. This time my only guide was the Hua mountain itself."[17]

Similarly in literature. When the Buddha attains Enlightenment, in yoga trance (samādhi), the Dharma presents itself to him in entirety and fully articulate, ready to be uttered to the world. When Vālmīki composes the Rāmāyaṇa, though he is already quite familiar with the course of the story, he prepares himself by the practice of yoga until he sees be-

the Śukranītisāra." [See also "The Intellectual Operation in Indian Art," in this volume.—ED.]

[16] A modern teacher in a school of art would say, when the pupil's forms are defective, "look again at the model."

[17] The extracts from Ching Hao and Wang Li are from versions by Arthur Waley. However, the character i, rendered as "idea," does not, as Waley makes it, refer to an essence in the object, but to the "motive" or "form" as conceived by the artist. The reference of "idea" to the object affords a good example of the misapplication of European (ultimately Platonic) modes of thought in an Oriental environment.

fore him the protagonists acting and moving as though in real life. As Chuang-tzu has said, "The mind of the sage, being in repose, becomes the mirror of the Universe, the speculum of all creation": nothing is hidden from it. Though the idea of literal imitation is in no way essential to or even tolerable to Christian art, it has played a large part in popular European views about art, and further, it cannot be denied that European art in decadence has always inclined to make of literal imitation a chief end of art. In Asia, however, views about art are not propounded by popular thinkers; and decadence finds expression, not in a change of principle, but either in loss of vitality, or what amounts to the same thing, excessive elaboration, rococo. It will be useful, then, to consider just what is meant in Asia by words denoting imitation or resemblance, used with reference to art, though the discussion will have a familiar ring for students of Aristotle. Just as in Europe, from the time of Aristotle onwards, "imitation" has had a dual significance, meaning (1) empirically the most literal mimicry attainable, and (2) in aesthetics the imitation of Nature *in sua operatione* (St. Thomas Aquinas), or "imaginative embodiment of the ideal form of reality" (Webster's dictionary); so in Asia, Sanskrit *sādṛśya*, "resemblance," and *loka-vṛtta anukaraṇa*, "making according to the movement of the world," and Chinese *hsing ssŭ*, "shape-likeness," are used both empirically and in aesthetics, but with an essential difference.[18]

As to Chinese *hsing ssŭ*, a multitude of texts could be adduced to show that it is not the outward appearance (*hsing*) which is to be exhibited as such, but rather the idea (*i*) in the mind of the painter, or the immanent divine spirit (*shên*), or breath of life (*ch'i*), that is to be revealed by a use of natural form directed to this end. We have not merely the First Canon of Hsieh Ho, that the work of art must reveal "the operation of the spirit (*ch'i*) in life movement," but also such sayings as "by means of natural shape (*hsing*), represent divine spirit (*shên*)," "the painters of old painted the idea (*i*) and not merely the shape (*hsing*)," "those [painters] who neglect natural shape (*hsing*) and secure the normative idea (*i chih*) are few," and with reference to a degenerate time, "what the age means by pictures is resemblance (*ssŭ*)." Thus none of the terms cited by any means implies a theory of art as illusion: for the East, as for St. Thomas, *ars imitatur naturam in sua operatione*.

The proper connotation of these words as used in aesthetics can be

[18] Sanskrit *loka-vṛtta* and Chinese *hsing* are the equivalents of English "Nature," including human nature; an expression often used is "By means of natural shape (*hsing*) represent divine spirit (*shên*)."

deduced from the actual procedure of artists, already alluded to, from actual works of art, or from their employment in treatises on aesthetics. As to the actual works, we may be deceived at first sight. When Oriental art impresses us by its actuality, as in Japanese paintings of birds or flowers, in Pallava animal sculpture, or at Ajaṇṭā by what seems to be spontaneity of gesture, we are easily led to think that this has involved a study of Nature in our sense, and are too ready to judge the whole stylistic development in terms of degrees of naturalism. Yet, if we analyze such work, we shall find that it is not anatomically correct, that the spontaneous gestures had long since been classified in textbooks of dancing, with reference to moods and passions equally minutely subdivided in works on rhetoric; and that with all these matters the artist had to be familiar, and could not have helped being familiar, because they formed an integral part of the intellectual life of the age. We may say indeed, that whenever, if ever, Oriental art reproduces evanescent appearances, textures, or anatomical construction with literal accuracy, this is merely incidental, and represents the least significant part of the work. When we are stirred, when the work evokes in us a sense of reality akin to that which we feel in the presence of living forms, it is because here the artist has become what he represents, he himself is recreated as beast or flower or deity, he feels in his own body all the tensions appropriate to the passion that animates his subject.

BECAUSE theology was the dominant intellectual passion of the race, Oriental art is largely dominated by theology. We do not refer here only to the production of cult images, for which India was primarily responsible, but to the organization of thought in terms of types of activity. Oriental art is not concerned with Nature, but with the nature of Nature; in this respect it is nearer to science than to our modern ideas about art. Where modern science uses names and algebraic formulae in establishing its hierarchy of forces, the East has attempted to express its understanding of life by means of precise visual symbols. Indian Śiva-Śakti, Chinese Yang and Yin, Heaven and Earth, in all their varied manifestations are the polar opposites whence all phenomenal tensions must arise. In this constant reference to types of activity, Oriental art differs essentially from Greek art and its prolongations in Europe: Greek types are archetypes of being, *ding an sich*, external to experience, and conceived of as though reflected in phenomena; Indian types are acts or modes of action, only valid in a conditioned universe, correct under given circumstances, but

not absolute; not thought of as reflected in phenomena, but as representing to our mentality the informing energies to which phenomena owe their peculiarity. Historically, the latter mode of thought might be described as an improvement of animism.

The corresponding Indian theory of knowledge regards the source of truth as not mere perception (*pratyakṣa*), but an inwardly known criterion (*pramāṇa*),[19] which "at one and the same time gives form to knowledge and is the cause of knowledge" (Dignāga, *kārikā* 6); it being only required that such knowledge shall not contradict experience. We can make this doctrine clearer by the analogy of conscience (Anglo-Saxon "inwit"), still generally regarded as an inward criterion which both gives form to correct conduct, and is its cause. But whereas the Occidental conscience operates only in the field of ethics, the Oriental conscience, *pramāṇa, chih*, etc., orders all forms of activity, mental, aesthetic, and ethical: truth, beauty, and goodness (as activities, and therefore relative) are thus related by analogy, not by likeness, none deriving its sanction from any of the others, but each directly from a common principle of order (*ṛta*, etc.) which represents the pattern of the activity of God, or in Chinese terms, of Heaven and Earth. Just as conscience is externalized in rules of conduct, so aesthetic "conscience" finds expression in rules or canons of proportion (*tāla, tālamāna*) proper to different types, and in the physiognomy (*lakṣaṇas*) of iconography and cultivated taste, prescribed by authority and tradition: the only "good form" is *śāstra-māna*. As to the necessity for such rules, which are contingent by nature, but binding in a given environment, this follows from the imperfection of human nature. Man is, indeed, more than a merely functional and behavioristic animal (the gamboling of lambs is not "dancing"), but he has not yet attained to such an identification of the inner and outer life as should enable him to act at the same time spontaneously and altogether conveniently. Spontaneity (*sahaja*) of action can be attributed to Bodhisattvas "because their discipline is in union with the very essence of all Buddhas" (Aśvaghoṣa); Ching Hao's "Divine Painter," indeed, "makes no effort of his own, his hand moves spontaneously"; but short of this divine perfection, we can only aspire to the condition of the "Mysterious Painter" who "works in a style appropriate to his subject." Or as expressed with reference to the strictly ordered art of the drama, "All the activities of the gods, whether at home or afield, spring from a natural disposition of the mind, but all

[19] English "measure," "mete," "meter," etc. are connected etymologically and in root meaning with *pramāṇa*.

the activities of men result from the conscious working of the will; there-
fore it is that the details of the actions to be done by men must be care-
fully prescribed" (*Nātya Śāstra* II.5). Objection to such rules has often
been made, ostensibly in the interest of the freedom of the spirit, practi-
cally, however, on behalf of the freedom of the affections. But ascertained
rules such as we speak of, having been evolved by the organism for its
own ends, are never arbitrary in their own environment; they may better
be regarded as the form assumed by liberty, than as restrictions.[20]

An admirable illustration of this can be found in Indian music. Here
we have an elaborate system of modes, each employing only certain notes
and progressions, which must be strictly adhered to, and each appropriate
to a given time of the day or particular season: yet where the Western
musician is bound by a score and by a tempered keyboard, the Oriental
music is not written, and no one is recognized as a musician who does not
improvise within the given conditions; we even find two or more mu-
sicians improvising by common consent. In China and Japan, there are
detailed and elaborate treatises solely devoted to the subject of bamboo
painting, and this study forms an indispensable part of an artist's training.
A Japanese painter once said to me, "I have had to concentrate on the
bamboo for many, many years, still a certain technique for the rendering
of the tips of bamboo leaves eludes me." And yet a finished bamboo
painting in monochrome, executed with an incredible economy of means,
seems to be wet with dew and to tremble in the wind. It is only when
rules are conceived of as applied in an alien environment, when one
style, whether of thought, conduct, or art, is judged by another, that
they assume the aspect of regulations; and those modern artists who
affect Primitive, Classical, or Oriental mannerisms, are alone responsible
for their own bondage. What we have said by no means implies that
anybody else's rules will serve to guide our hands, but rather that in any
period of chaos and transition such as the present, we are rather to be
pitied for than congratulated on our so-called freedom. A new condition
of civilization, a new style, cannot be said to have reached a conscious
maturity until it has discovered the criteria proper to itself.

Let us now consider how the doctrine of *pramāṇa* can be recognized in
art itself. We have seen that the virtue of art does not consist in copying
anything, but in what is expressed or evoked. The conception of a nat-
uralistic art, though we know what it means in popular parlance, rep-

[20] "Representations become works of art only when their technique is perfectly
controlled" (Franz Boas, *Primitive Art*, Oslo, 1927, p. 81).

resents a contradiction in terms; art is by definition conventional, and it is only by convention (*saṃketa*) that art is comprehensible at all.[21] Oriental art, all pure art, though it uses inevitably a vocabulary based on experience (God himself, using convenient means, *upāya*, speaks in the language of the world) does not invite a comparison with the unattainable perfection of Nature, but relies exclusively on its own logic and on its own criteria, which logic and criteria cannot be tested by standards of truth or goodness applicable in other fields of action. If, for example, an icon is provided with numerous heads or arms, arithmetic will assist us to determine whether or not the iconography is correct, *āgamārthāvisaṃvādi*, but only our own response to its qualities of energy and characteristic order can determine its value as art. Krishna, seducer of the milkmaids of the Braja-maṇḍala, is not presented to us as a model on the plane of conduct.[22]

Where Western art is largely conceived as seen in a frame or through a window, from a fixed point of view, and so brought toward the spectator, the Oriental image really exists only in our own mind and heart, and is projected thence onto space; this is apparent not merely in "anthropomorphic" icons, but also in landscape, which is typically presented as seen from more than one point of view, or in any case from a conventional, not a "real" point of view.[23] Where Western art depicts a moment of time, an

[21] *Sāhitya Darpaṇa* ii.4. Dogs and some savages cannot understand even photographs; and if bees are reported to have been attracted by painted flowers, why was not honey also provided?

The conventionality of art is inherent, not due either to calculated simplification nor to be explained as a degeneration from representation. Even the drawings of children are not primarily memory images, but "composition of what to the child's mind seems essential"; and "artistic value will always depend on the presence of a formal element that is not identical with the form found in nature" (Boas, *Primitive Art*, pp. 16, 74, 78, 140).

[22] See the *Prema Sāgara*, ch. 34.

[23] See B. March, "Linear Perspective in Chinese Painting," *Eastern Art*, III (1931). Cf. also L. Bachhofer, "Der Raumdarstellung in der chinesischen Malerei," *Münchner Jahrbuch für bildenden Kunst*, VIII (1931).

The two methods of drawing, symbolic and perspective, though often combined, are really based on distinct mental attitudes; it should not be assumed that there really takes place a development from one to the other, or that a progress in art has taken place when some new kind of perspective representation appears. The methods of representing space in art will always correspond more or less to contemporary habits of vision. But perfect comprehensibility is all that is required at any given time, and this is always found; if we do not always understand the language of space employed in an unfamiliar style, that is our misfortune, not the fault of the art.

arrested action, an "effect" of light, Oriental art represents a continuous (though, as we have seen, not eternal) condition. The dance of Śiva takes place not merely as an historical event in the Tāraka Forest, nor even at Cidambaram, but forever in the heart of the worshipper; the loves of Rādhā and Krishna, as Nīlakaṇṭha reminds us, are not an historical narrative, but a constant relation between the soul and God. The Buddha attained Enlightenment countless ages ago, but his manifestation is still accessible, and will so remain. The latter doctrine, expounded in the *Saddharmapuṇḍarīka*, is reflected in the sculptured hierarchies of Boro-buḍūr. It is impossible that the same mentality should not be present equally in thought and art; how could the Mahāyānist, who may deny that any Buddha ever, in fact, existed, or that any doctrine was taught, have been interested in a portrait of Gautama? The image, then, is not the likeness of anything; it is a spatial, but incorporeal, intangible form, complete in itself; its aloofness ignores our presence, for, in fact, it was meant to be used, not to be inspected. We do not know how to use it. Too often we do not ask how it was meant to be used. We judge as an ornament for the mantelpiece what was made as a means of realization, an attitude hardly less naive than that of the Hindu peasants who are said to have converted a disused steam plough to new service as an icon.

The Indian or Far Eastern icon (*pratimā*), carved or painted, is neither a memory image nor an idealization, but ideal in the mathematical sense, of the same kind as a *yantra*;[24] and its peculiarity in our eyes arises as much from this condition as from the unfamiliar detail of the iconography. For example, it fills the whole field of vision at once, all is equally clear and equally essential; the eye is not led to range from one point to another, as in empirical vision or the study of a photographic record. There is no feeling of texture or flesh, but only of stone, metal, or pigment; from a technical point of view this might be thought of as the result of a proper respect for the material, but it is actually a consequence of the psychological approach, which conceives God in stone or paint otherwise than as God in the flesh, or an image otherwise than as an avatāra. The parts are not organically related, for it is not contemplated that they should function biologically; they are ideally related, being the elements of a given type, *Ingrediens einer Versammlung wesensbezeich-nender Anschauungswerte*. This does not mean that the various parts

[24] A *yantra* is a geometrical representation of a deity, composed of straight lines, triangles, curves, circles, and a point.

116

are unrelated, or that the whole is not a unity, but that the relation is mental rather than functional.

All this finds direct expression also in composition. Even in the freer treatment of still definitely religious themes, at Ajaṇṭā, in Vaiṣṇava (Rajput) painting, or in Chinese landscape, the composition may seem at first sight to be lacking in direction; there is no central point, no emphasis, no dramatic crisis, apparently no structure, though we are ready to admit that the space has been wonderfully utilized, and so call the work decorative, meaning, I suppose, that it is not offensively insistent. Similarly in music and dancing, where the effect on an untrained Western observer is usually one of monotony—"we do not know what to make of music which is dilatory without being sentimental, and utters passion without vehemence."[25] The paintings of Ajaṇṭā, certainly lacking in those obvious symmetries which are described in modern text books of composition, have been called incoherent. This is, in fact, a mode of design not thought out as pattern with a view to pictorial effect; yet "one comes in the end to recognize that profound conceptions can dispense with the formulas of calculated surface arrangement and have their own occult means of knitting together forms in apparent diffusion."[26]

Similar phenomena can be observed in the literature. Western critics, who often speak in the same way of pre-Renaissance European writing, express this by saying that in Asiatic literature "there is no desire, and therefore no ability, to portray character."[27] Take one of the supreme achievements of the Far East, the *Genji Monogatari* of Murasaki: Waley, who made an English version by no means satisfactory to Japanese critics, but still embodying some part of the wonderful grace of the original, points out that "the sense of reality with which she (the author) invests her narrative is not the result of realism in the ordinary sense. . . . Still less is it due to solid character building; Murasaki's characters are mere embodiments of some dominant characteristic." The *Genji Monogatari* might be compared with Wolfram von Eschenbach's *Parsifal*. In each of these great works we do sense a kind of psychological modernity, and no doubt the narration is more personal and intimate than that of Homer or the *Mahābhārata*. Yet the effect is not a result of accumulated observation,

[25] A. H. Fox-Strangways, *The Music of Hindostan* (Oxford, 1914).

[26] [AKC's note as first published indicates that the passage is quoted from one of the major works of Laurence Binyon, without further identification.—ED.]

[27] [Similarly, the quotation is ascribed to Arthur Waley, without further information.—ED.]

nor of any emphasis laid on individual temperamental peculiarities. The characters, just as in Oriental paintings, differ more in what they do, than in what they look like. Oriental art rarely depicts or describes emotions for their own spectacular value: it is amply sufficient to put forward the situation itself, unnecessary to emphasize its effects, where you can rely upon the audience to understand what must be taking place behind the actor's mask. Oriental art is not a labor-saving device, where nothing can be left out, lest the spectator should have to exert himself; on the contrary, "it is the spectator's own energy (*utsāha*) that is the cause of aesthetic experience (*āsvādana*), just as in the case of children playing with clay elephants or the like" (*Daśarūpa* IV.47 and 50).

Before leaving the subject of literature it should be observed that what we have called lack of emphasis or of dramatic crisis is expressed also in the actual intonation of Oriental languages. In all these languages there is both accent and tone: but Oriental poetry is always quantitative, and so little is the meaning brought out by stress, even in the spoken languages, that the European student must first learn to avoid *all* stress, before he can rightly employ such stress as is actually correct.

What has been said will also apply to portraiture, little as this might have been expected: here too the conception of types predominates. It is true that in classical Indian literature we frequently read of portraits, which though they are usually painted from memory, are constantly spoken of as recognizable and even admirable likenesses; if not at least recognizable, they could not have fulfilled their function, usually connected with love or marriage. Both in China and in India, from very ancient times onward, we find ancestral portraits, but these were usually prepared after death, and so far as we know have the character of effigies rather than likenesses.[28] In the *Pratimā-nāṭaka* of Bhāsa, the hero, though he marvels at the execution of the figures in an ancestral chapel, does not recognize the effigies of his own parents, and thinks the figures may be those of gods. Similarly in Cambodia and Farther India generally, where a deified ancestor was represented by a statue, this was in the form of the deity of his devotion. It is now only possible from an inscription to tell when a portrait is before us.

The painted portrait functioned primarily as a substitute for the living presence of the original; still one of the oldest treatises on painting, the *Citralakṣaṇa* contained in the Tanjur, though it refers the origin of paint-

[28] True portraiture, as remarked by Baudelaire, is "an ideal reconstruction of the individual." The Chinese term is *ju-shên*, "depicting character."

ing in the world to this requirement, actually treats only of the physiog-
nomical peculiarities (*lakṣaṇas*) of types. Even more instructive is a later
case, occurring in one of the *Vikramacarita* stories: here a king is so
much attached to his queen that he keeps her at his side, even in Council;
this departure from custom and propriety is disapproved of by his cour-
tiers, and the king consents to have a portrait painted, to serve as sub-
stitute for the queen's presence. The court painter is allowed to see the
queen; he recognizes that she is a Padminī (Lotus-lady, one of the four
physical-psychological types under which women are classed by Hindu
rhetoricians) and paints her accordingly *padminī-lakṣaṇa-yuktam*, "with
the characteristic marks of a Lotus-lady," and yet the portrait, spoken of
not merely as *rūpam*, "a figure," but as *svarūpam*, "her very form," is felt
to be a true likeness. Chinese works on portrait painting refer only to
types of features and facial expression, canons of proportion, suitable
accessories, and varieties of brush stroke proper to the draperies; the es-
sence of the subject must be revealed, but there is nothing about anatomi-
cal accuracy.

Life itself reflects the same conditions. At first sight even the most
highy evolved Asiatics look all alike to a Western eye, presenting the
same aspect of monotony to which we have referred above. This effect is
partly a result of unfamiliarity; the Oriental recognizes actual variety
where the European is not yet trained to do so. But it is also in part due
to the fact that Oriental life is modeled on types of conduct sanctioned
by tradition. For India, Rāma and Sītā represent ideals still potent, the
svadharma of each caste is an ascertained *mode* of conduct; and until
recently every Chinese accepted as a matter of course the concept of man-
ners established by Confucius. The Japanese word for "rudeness" means
"acting in an unexpected way." Where large groups of men act and
dress alike, they will not only to some degree look alike, but are alike—
to the eye.

Here then, life is designed like a garden, not allowed to run wild. All
this formality, for a cultured spectator, is far more attractive than can
be the variety of imperfection so freely shown by the plain and blunt, or
as he thinks, "more sincere" European. For the Oriental himself, this
external conformity, whereby the man is lost in the crowd as true archi-
tecture seems to be a part of its native landscape, constitutes a privacy
within which the individual character can flower unhampered. This is
also particularly true in the case of women, whom the East has so long
sheltered from necessities of self-assertion: one may say that for women

of the aristocratic classes in India or Japan, there existed no freedom whatever, in the modern sense. Yet these same women, molded by centuries of stylistic living, achieved an absolute perfection in their kind, and perhaps Asiatic art can boast of no higher achievement than this. In India, where the "tyranny of caste" strictly governs marriage, diet, and every detail of outward conduct, there exists and has always existed unrestricted freedom of belief and thought. It has been well said that civilization is style. An immanent culture in this way endows every individual with an outward grace, a typological perfection, such as only the rarest beings can achieve by their own effort (this kind of perfection does not belong to genius); whereas a democracy, which requires of every man to save his own soul, actually condemns each to an exhibition of his own irregularity and imperfection; and this imperfection only too easily passes over into an exhibitionism which makes a virtue of vanity, and is complacently described as self-expression.

We have, then, to realize that life itself, the different ways in which the difficult problems of human association have been solved, represents the ultimate and highest of the arts of Asia: he who would comprehend and enjoy the arts of Asia, if only as a spectacle, must comprehend them in this highest form, directly at the source from which they proceed. All judgment of the art, all criticism of the life by measurement against Western standards, is an irrelevance that must defeat its own ends.

EVERYONE will be aware that Asiatic art is by no means exclusively theological, in the literal sense of the word. India knows, if not a secular, at least a romantic development in Rajput painting; China possesses the greatest landscape art in the world; Japan has interpreted animals and flowers with unequaled tenderness and sensibility, and developed in Ukiyoye an art that can only be called secular. Broadly speaking, we may say that the romantic and idealistic movements are related to the hieratic art, which is on the whole the older art, as mysticism is related to ritual.[29] Allusion may be made, for example, to the well-known case of the Zen priest, Tan-hsia, who used a wooden image of Buddha to make his fire— not, of course, as an iconoclast, but because he was cold; to the Zen doctrine of the Scripture of the Universe; and to the Vaiṣṇava conception of the world as a theophany. But these developments do not represent an arbitrary break with hieratic modes of thought: as the theology itself

[29] Perhaps it should be added, as relativity to Euclidean geometry.

may be called an improvement of animism, so Zen represents an improvement of yoga achieved through heightened sensibility, Vaiṣṇava painting an improvement of *bhakti* through a perfected sensual experience.

In a "Meditation upon Buddha" translated into Chinese in A.D. 420, the believer is taught to see not merely Gautama the monk, but One endowed with all those spiritual glories that were visible to his disciples; we are still in the realms of theology. A century later, Bodhidharma came to Canton from southern India; he taught, mainly by silence, that the absolute is immanent in man, that this "treasure of the heart" is the only Buddha that exists. His successor, Buddhapriya, codified the stations of meditation: but Zen[30] was to be practiced "in a quiet room, or under a tree, or among tombs, or sitting on the dewy earth," not before a Buddha image. The method of teaching of Zen masters was by means of symbolic acts, apparently arbitrary commands or meaningless questions, or simply by reference to Nature. Zen dicta disturb our complacence, as who should say, "A man may have justice on his side and yet be in the wrong," or "to him that hath shall be given, but from him that hath not shall be taken away even that he hath." Logically inscrutable, Zen may be described as direct action, as immediacy of experience. Still, the idea of Zen is completely universal: "consider the lilies," "a mouse is miracle enough," "when thou seest an eagle, thou seest a portion of Genius," illustrate Zen. There are many Indian analogies: for example, our conduct should be like that of the sun, which shines because it is its nature to shine, not from benevolence; and already in one of the Jātakas (no. 460), the evanescence of the morning dew suffices to enlightenment.

The sources of the tradition are partly Taoist, partly Indian. One might say that the only ritual known to Zen is that of the tea ceremony, in which simplicity is carried to the highest point of elaboration: but Zen is equally demonstrated in the art of flower arrangement; Zen priests lead an active and ordered life, and to say, "this is like a Zen monastery," means that a place is kept in the neatest possible order. After the tenth century it is almost entirely Zen terminology that is used in the discussion of art. Perhaps a majority of artists in the Ashikaga period were Zen priests. Zen art represents either landscape, birds, animals, or flowers, or episodes from the lives of the great Zen teachers, of which last a very familiar

[30] Japanese *Zen*, Chinese *ch'an* = Sanskrit *dhyāna*, a technical term in yoga, denoting the first stage of introspection, in Buddhist usage (Pāli *jhāna*) referring to the whole process of concentration.

aspect may be cited in the innumerable representations of Daruma (Bodhidharma) as a shaggy, beetle-browed recluse.

Zen, seeking realization of the divine nature in man, proceeds by way of opening his eyes to a like spiritual essence in the world of Nature external to himself. The word "romantic" has been applied to the art only for want of a better designation; the romantic movement in Europe was really quite otherwise and more sentimentally motivated, more curiously and less sensually developed. In Europe, Christianity has intensified the naturally anthropomorphic tendencies of Aryan Greece, by asserting that man alone is endowed with a soul: the more remote and dangerous grandeurs of nature, not directly amenable to human exploitation, were not considered without disgust, or as ends in themselves, before the eighteenth century. Even then, the portrayal of nature was deeply colored by the pathetic fallacy; Blake had only too good reason when he "feared that Wordsworth was fond of nature."

But from a Zen point of view, every manifestation of the spirit is perfect in its kind, the categories are indifferent; all nature is equally beautiful, because equally expressive, consequently the painting of a grasshopper may be no less profound than that of a man. The use of plant and animal forms as symbols goes back to very early origins in sympathetic magic: even in Asia the full comprehension of animal life represents the result of a long evolution in which the most ancient ideas survive side by side with the expressions of an ever-heightened sensibility. The two points of view, symbolic and sympathetic, are clearly seen together in a statement on animal painting made by an anonymous Chinese critic in the twelfth century:

> The horse is used as a symbol of the sky, its even pace prefiguring the even motion of the stars; the bull, mildly sustaining its heavy yoke, is fit symbol of earth's submissive tolerance. But tigers, leopards, deer, wild swine, fawns, and hares—creatures that cannot be inured to the will of man—these the painter chooses for the sake of their skittish gambols and swift, shy evasions, loves them as things that seek the desolation of great plains and wintry snows, as creatures that will not be haltered with a bridle nor tethered by the foot. He would commit to brush-work the gallant splendor of their stride; this would he do, *and no more*.[31]

[31] Version by Waley. Italics mine.

The greater part of this exactly corresponds to Zen; the same point of view is clearly presented in India still earlier, in the poetry of Kālidāsa and in Pallava animal sculpture. Centuries before this the sacredness of animal life had been insisted on, but mainly from an ethical point of view.

When at last Zen thought found expression in scepticism—

> Granted this dewdrop world be but a dewdrop world,
> This granted, yet. . . .[32]

there came into being the despised popular and secular Ukiyoye[33] art of Japan. But here an artistic tradition had already been so firmly established, the vision of the world so *approfondi*, that in a sphere corresponding functionally to that of the modern picture-postcard—Ukiyoye illustrates the theater, the Yoshiwara, and the *Aussichtspunkt*—there still survived a charm of conception and a purity of style that sufficed, however slight its essence, to win acceptance in Europe, long before the existence of a more serious and classical pictorial art had been suspected.

In Asia, where at least a partial nudity is too familiar in daily life to attract attention, the human figure has never been regarded as the only or even as the most significant symbol of the spirit. Works, indeed, exist in which the power and dignity of man and woman are sublimely rendered. But even in India, the nude body is seen in art only when and where and to the extent that the subject requires it, never as a study undertaken for its own sake; even the dancer is more, not less, fully clothed than her sisters. On the other hand, India has always made free and direct use of sexual imagery in religious symbolism. The virtue (*vīrya*) of Īśvara as Father of the world retains the connotation of virility, and is expressed in art by the erect lingam; the infinite fecundity of the Great Mother is boldly asserted in litanies and images that emphasize her physical charms in no uncertain terms. The representation of "fertile pairs" (*mithuna*) originally conceived only as general instigations of increase, later more lyrically treated, is characteristic of Indian art from first to last; many mediaeval temples are outwardly adorned with series of reliefs adequate to illustrate the whole art of love, which has never

[32] A Japanese *haiku*: in poems of this kind, the reader is required to complete the thought in his own mind; here, "Gather ye rosebuds while ye may."

[33] *Ukiyoye* means "pictures of the floating world"; the Japanese color print is its typical product.

123

in India been regarded as derogatory to the dignity of man. Already in the Upaniṣads the physical ecstasy (*ānanda*) of union is an image of the delight of the knowledge of Brahman: "As a man united to a darling bride is conscious neither of within nor without, so is it when the mortal self embraced by the all-wise Self knows neither what is within nor what without. That is his very form" (BU iv.3.21). In the later iconography, both Hindu and Buddhist, the two-in-one of manifested Godhead is imitated in the pure ecstasy of physical forms enlinked, enlaced, and enamored.

In Vaiṣṇava mysticism, the Indian analogy of Zen, the miracle of human love reveals itself in poetry and art not merely as symbol, but as felt religious experience; the true relation of the soul to God can now only be expressed in impassioned epithalamia celebrating the nuptials of Rādhā and Krishna, milkmaid and Divine Bridegroom. She who for love renounces her world, honor, and duty alike, is the very type of Devotion. Moreover, the process of thought is reversible: in the truly religious life, all distinction of sacred and profane is lost, one and the same song is sung by lover and by monk. Thus the technical phraseology of yoga, the language of *bhakti*, is used even in speaking of human passion: the bride is lost in the trance (*dhyāna*) of considering the Beloved, love itself is an Office (*pūjā*). In separation, she makes a prayer of the name of her Lord; in union, "each is both." The only sin in this kingdom of love is pride (*māna*).[34] In Rajput painting the life of simple herdsmen and milkmaids is denotation (*abhidhā*), the sports of Krishna connotation (*lakṣaṇā*), the harmony of spirit and flesh the content (*vyañjanā*). These, operating in the media available, have made the paintings what they are. If we ignore these sources of the presented fact, the painting itself "unique in the world's art," how can we expect to find in the fact any more than a pleasant or unpleasant sensation—and can we regard it as worthwhile (*puruṣārtha*) merely to add one more to the abundant sources of sensation already available? Art is not a mere matter of aesthetic surfaces.

If we are to make any approach whatever to an understanding of Asiatic art as something made by men, and not to regard it as a mere curiosity, we must first of all abandon the whole current view of art and artists. We must realize, and perhaps remind ourselves again and again, that that

[34] Not *māna*, "measure," referred to above, but etymologically related to *mens*, "mental," "mind," etc.

condition is *abnormal* in which a distinction is drawn between workmen and artists, and that this distinction has only been drawn during relatively short periods of the world's history.[35] Of the two propositions following, each explains the other: those whom we now call artists, were once artisans; objects that we now preserve in museums were once common objects of the market place.

During the greater part of the world's history, every product of human workmanship, whether icon, platter, or shirt button, has been at once beautiful and useful. This normal condition has persisted longer in Asia than anywhere else. If it no longer exists in Europe and America, this is by no means the fault of invention or machinery as such; man has always been an inventive and tool- or machine-using creature. The art of the potter was not destroyed by the invention of the potter's wheel. How far from reasonable it would be to attribute the present abnormal condition to a baneful influence exerted on man by science and machinery is demonstrated in the fact that beauty and use are now only found together in the work of engineers—in bridges, airplanes, dynamos, and surgical instruments, the forms of which are governed by scientific principles and absolute functional necessity. If beauty and use are not now generally seen together in household utensils and businessmen's costumes, nor generally in factory-made objects, this is not the fault of the machinery employed, but incidental to our lowered conception of human dignity, and consequent insensibility to real values. The exact measure of our indifference to these values is reflected in the current distinction of fine and decorative art, it being required that the first shall have no use, the second no meaning: and in our equivalent distinction of the inspired artist or genius from the trained workman. We have convinced ourselves that art is a thing too good for this world, labor too brutal an activity to be mentioned in the same breath with art; that the artist is one not much less than a prophet, the workman not much more than an animal. Thus a perverted idealism and an amazing insensibility exist side by side; neither condition could, in fact, exist without the other. All that we need insist upon here is that none of these categories can be recognized in Asia. There we shall find nothing useless (fine art) on the one hand,

[35] Cf. G. Groslier, "Notes sur la psychologie de l'artisan cambodgien," *Arts et archéologie khmers*, I (1921–1922), 125, "La différence que nous faisons entre l'artiste et l'ouvrier d'art—toute moderne d'ailleurs—ne semble pas être connue en Cambodge."

nothing meaningless (decorative or servile art) on the other, but only human productions ordered to specific ends; we shall find neither men of genius nor mere laborers, but only human beings, vocationally expert.

Asia has not relied on the vagaries of genius, but on training: she would regard with equal suspicion "stars" and amateurs. She knows diversities of skill among professionals, as apprentice or master, and likewise the products of different ateliers, provincial or courtly: but that anyone should practice an art as an accomplishment, whether skillfully or otherwise, would seem ridiculous.[36] Art is here a function of the social order, not an ambition. The practice of art is typically an hereditary vocation and not a matter of private choice. The themes of art are provided by general necessities inherent in racial mentality, and more specifically by a vast body of scripture and by written canons; method is learned as a living workshop tradition, not in a school of art; style is a function of the period, not of the individual, who could only be made aware of the fact of stylistic change and sequence by historical study. Themes are repeated from generation to generation, and pass from one country to another; neither is originality a virtue, nor "plagiarism" a crime, where all that counts is the necessity inherent in the theme. The artist, as maker, is a personality much greater than that of any conceivable individual: the names of even the greatest artists are unknown.[37]

"What are the paintings even of Michael Angelo compared with the paintings on the walls of the cave temples of Ajaṇṭā? These works are not the work of a man; 'they are the work of ages, of nations.'" Nor would the biographies of individuals, if they could be known, add anything to our understanding of the art. What the East demands of the artist, as individual, is integrity and piety, knowledge and skill—let us say order, rather than peculiar sensibilities or private ideals; for man is a responsible being, not merely as maker, but also as doer and thinker.

In all these ways the freedom and dignity of the individual, as individual, have been protected in a way inconceivable under modern conditions. Where art is not a luxury, the artist is on the one hand preserved from those precarious alternatives of prestige or neglect, affluence or

[36] "That anyone not a *śilpan* (professional architect) should build temples, towns, seaports, tanks or wells, is a sin comparable to murder" (from a *Śilpa Śāstra*, cited by Kearns in *Indian Antiquary*, V, 1876); cf. BG III.35.

[37] This statement is almost literally exact so far as sculpture, architecture, the theater, and sumptuary arts are concerned. The chief exception to the rule appears in Chinese and Japanese painting, where a somewhat fictitious importance has been attached to names, from the collector's point of view.

starvation, which now intimidate "artist" and laborer alike.[38] Where ability is not conceived as an inspiration coming none knows whence, but rather in the same light as skill in surgery or engineering, and where eccentricity of conduct is neither expected of the artist nor tolerated in him, he is enabled to enjoy in privacy the simple privilege of living as a man among men without social ambition, without occasion to pose as a prophet, but self-respecting, and contented with that respect which is normally due from one man to another, when it is taken for granted that every man should be expert in his vocation.

[38] On the status of the craftsman in Asia, see Coomaraswamy, *The Indian Craftsman*, 1909, and *Mediaeval Sinhalese Art*, 1908 (ch. 3); Sir George Birdwood, *The Industrial Arts of India* (London, 1880); Groslier, "Notes sur la psychologie" ("élevé et grandi dans le renoncement, . . . s'il est artiste, c'est pour obéir"); G. Groslier, "La Fin d'un art," *Revue des arts asiatiques*, V (1928); and Lafcadio Hearn, *Japan: An Attempt at an Interpretation* (New York, 1904), esp. pp. 169–171, 440–443.

INDIAN ART AND
AESTHETICS

The Intellectual Operation
in Indian Art

The *Śukranītisāra* iv.70–71,[1] defines the initial procedure of the Indian imager: he is to be expert in contemplative vision (*yoga-dhyāna*), for which the canonical prescriptions provide the basis, and only in this way, and not by direct observation, are the required results to be attained. The whole procedure may be summed up in the words "when the visualization has been realized, set to work" (*dhyātvā kuryāt, ibid.* vii.74), or "when the model has been conceived, set down on the wall what was visualized" (*cintayet pramāṇam; tad-dhyātaṃ bhittau niveśayet, Abhilaṣitārthacintāmaṇi,* 1.3.158).[2] The distinction and sequence of these two acts had long since been recognized in connection with the sacrificial work (*karma*) of the edification of the Fire-Altar, where, whenever the builders are at a loss, they are told to "contemplate" (*cetayadhvam*), i.e., "direct the will towards the structure" (*citim icchata*), and it is "because they saw them contemplatively" (*cetayamānā apaśyan*) that the "structures" (*citayaḥ*) are so called.[3] These two stages in procedure are the same as the *actus primus* and *actus secundus*, the "free" and "servile" parts of the artist's operation, in terms of Scholastic theory.[4] I have shown

[First published in the *Journal of the Indian Society of Oriental Art*, III (1935), this essay was revised for *Figures of Speech or Figures of Thought*. It appears here in the later version, with addenda.—ED.]

[1] Translated in Coomaraswamy, *The Transformation of Nature in Art*, 1934, pp. 113–117.

[2] Cf. also *Atthasālinī* 203 (in the PTS edition, p. 64), "A mental concept (*cittasaññā*) arises in the mind of the painter, 'Such and such forms should be made in such and such ways.' . . . Conceiving (*cincetvā*) 'Above this form, let this be; below, this; on either side, this'—so it is that by mental operation (*cintitena kammena*) the other painted forms come into being."

[3] ŚB vi.2.3.9, etc., with hermeneutic assimilation of √*ci* (edify) and √*cit* (contemplate, visualize).

[4] On the "two operations," see Coomaraswamy, *Why Exhibit Works of Art?* 1943, pp. 33–37. What is meant is admirably stated by Philo in *De vita Mosis* ii.74–76, respecting the "tabernacle . . . the construction of which was set forth

elsewhere[5] that the same procedure is taken for granted as well in secular as in hieratic art. It is, however, in connection with the Buddhist hieratic prescriptions (*sādhana, dhyāna mantram*) that the most detailed expositions of the primary act are to be found; and these are of such interest and significance that it seems desirable to publish a complete and careful rendering of one of the longest available examples of such a text, annotated by citations from others. We proceed accordingly with the *Kiṃcit-Vistara-Tārā Sādhana,*[6] no. 98 in the *Sādhanamālā*, Gaekwad's Oriental Series, no. XXVI, pp. 200–206.

Kiṃcit-Vistara-Tārā Sādhana

Having first of all washed his hands and feet, etc., and being purified, the officiant (*mantrī*) is to be comfortably seated in a solitary place that is strewn with fragrant flowers, pervaded by pleasant scents, and agreeable

to Moses on the mount by divine pronouncements. He saw with the soul's eye the immaterial forms (ἰδέαι) of the material things that were to be made, and these forms were to be reproduced as sensible imitations, as it were, of the archetypal graph and intelligible patterns. . . . So the type of the pattern was secretly impressed upon the mind of the Prophet as a thing secretly painted and moulded in invisible forms without material; and then the finished work was wrought after that type by the artist's imposition of those impressions on the severally appropriate material substances." In mythological terms, the two operations are those of Athena and Hephaistos, who co-operate, and from whom all men derive their knowledge of the arts (*Homeric Hymns* xx; Plato, *Protagoras* 321D and *Statesman* 274C, *Critias* 109C, 112B). Athena, the mind-born daughter of Zeus, "gives grace to work" (*Greek Anthology* VI.205), while Hephaistos is the lame smith; and there can be no doubt that she is that σοφία which (like the corresponding Skr. *kauśalyā* and Hebrew *hochmā*) was originally the "cunning" or knowledge of the skilled craftsman, and only by analogy "wisdom" in any and every sense of the word; she is the *scientia* that makes the work beautiful, he the *ars* that makes it useful—and *ars sine scientia nihil* [cf. *Cratylus* 407, *Philebus* 16c, *Euthyphro* 11E, and the image of Minerva (Athena) jointly with Roma weaving a cloak on no mortal loom in Claudian, *Stilicho* II.330]. But our distinctions of fine from applied art, art from work and meaning from utility, have banished Athena from the factory to the ivory tower and reduced Hephaistos to the status of the "base mechanics" (βαναυσικοί) whose manual dexterity is their only asset, so that we do not think of them as men but call them "hands."

[5] "The Technique and Theory of Indian Painting," 1934, pp. 59–80.

[6] This Sādhana has also been translated, but with some abbreviation, by B. Bhattacharya, *Buddhist Iconography* (London, 1924), pp. 169 ff. Buddhist methods of visualization are discussed by Giuseppe Tucci in *Indo-Tibetica*, III, *Templi del Tibet occidentale e il loro simbolismo artistico* (Rome, 1935); see especially §25, "Metodi e significato dell' evocazione tantrica," p. 97.

to himself. Conceiving in his own heart (*svahṛdaye . . . vicintya*) the moon's orb as developed from the primal sound (*prathama-svarapariṇa-tam*, i.e., "evolved from the letter A"),[7] let him visualize (*paśyet*) therein a beautiful blue lotus, within its filaments the moon's unspotted orb, and thereon the yellow seed-syllable Tāṃ. Then, with the sheaps of lustrous rays, that proceed (*niḥsṛtya*) from that yellow seed-syllable Tāṃ, rays that dispel the world's dark mystery throughout its ten directions and that find out the indefinite limits of the extension of the universe; making all these to shine downwards (*tān sarvān avabhāsya*); and leading forth (*ānīya*)[8] the countless and measureless Buddhas and Bodhisattvas whose abode is there; these (Buddhas and Bodhisattvas) are established (*avasthā-pyante*) on the background of space, or ether (*ākāśadeśe*).[9]

After performing a great office (*mahatīm pūjām kṛtvā*) unto all these vast compassionate Buddhas and Bodhisattvas established on the background of space, by means of celestial flowers, incense, scent, garlands, unguents, powders, ascetic garb, umbrellas, bells, banner, and so forth, he should make a confession of sin, as follows: "Whatever sinful act I may have done in the course of my wandering in this beginningless vor-

[7] For a beginning in this way, cf. Sādhana no. 280 (Yamāntaka), where the operator (*bhāvakaḥ*, "maker to become"), having first performed the purificatory ablutions, "realizes in his own heart the syllable Yam in black, within a moon originating from the letter A" (*ākā-raja-ja-candre kṛṣṇa-yam kāram vibhāvya*).

The syllable seen is always the nasalized initial syllable of the name of the deity to be represented. For a general idea of the form in which the initial visualization is conceived, see Coomaraswamy, *Elements of Buddhist Iconography*, 1935, pl. xiii, fig. 2, or some of the reproductions in Arthur Avalon, tr., *The Serpent Power* (Madras, 1924). For the manner in which the Buddhas and Bodhisattvas are thought of as deduced or led forth from the emanated rays, cf. Bhattacharya, *Buddhist Iconography*, fig. 52.

The whole process, in which the motion of a sound precedes that of any visible form, follows the traditional concept of creation by an uttered Word; cf. *Sum. Theol.* I.45.6, referring to the procedure of the artist *per verbum in intellectu conceptum*.

[8] *Ā-nī*, to "lead hitherward," is commonly used of irrigation, either literally, or metaphorically with respect to a conduction of powers from the *Fons Vitae*. Near equivalents are ἐξηγέομαι (in "exegesis") and *educere*. Perhaps we need a word *eduction* or *adduction* by which to refer to the acquisition of knowledge by intuition or speculation.

[9] Backgrounds of infinite space are highly characteristic of the painted Buddha and Bodhisattva epiphanies, in which the main figure rises up like a sun from behind the distant mountains, or descends on curling clouds, or is surrounded by a golden glory. In Western hieratic art the use of gold backgrounds has a similar significance, gold being the recognized symbol of ether, light, life, and immortality.

133

tex, whether of body or mind, or have caused to be committed or have consented to, all these I confess."

And having thus confessed,[10] and also made admission of the fault that consists in things that have been left undone, he should make an Endorsement of Merit, as follows: "I endorse the proficiency (*kuśalam*) of the Sugatas, Pratyekas, Śrāvakas, and Jinas, and their sons the Bodhisattvas, and that of the spheres of the Angels and of Brahmā, in its entirety." Then comes the Taking of Refuge in the Three Jewels: "I take refuge in the Buddha, for so long as the Bodhi-circle endures; I take refuge in the Norm, for so long as the Bodhi-circle endures; I take refuge in the Congregation, for so long as the Bodhi-circle endures." Then comes the act of Adhesion to the Way: "It is for me to adhere to the Way that was revealed by the Tathāgatas, and to none other." Then the Prayer: "May the blessed Tathāgatas and their children (the Bodhisattvas), who have accomplished the world's purpose since its first beginning, stand by and effect my total despiration" (*mām parinirvāntu*). Then the petition: "May the blessed Tathāgatas indoctrinate me with incomparable expositions of the Norm, of such sort that beings in the world-vortex may be liberated from the bondage of becoming (*bhava-bandhanāt nirmuktāḥ*) full soon." Then he should make an everlasting Assignment of Merit (*puṇya-pariṇāma*): "Whatever root of proficiency (*kuśalam*) has arisen by performance of the seven extraordinary offices (*pūjāḥ*) and by confession of sin, all that I devote to the attainment of Total Awakening (*samyak-sambodhaye*)." Or he recites the verses pertinent to the seven extraordinary offices: "All sins I confess, and I gladly consent to the good deeds of others. I take refuge in the Blessed One, and in the Three Jewels of the True Norm, to the end that I may not linger in the state of birth. I adhere to that way and designate the Holy Discipline (*śubha-vidhīn*) to the attainment of full Awakening." As soon as he has celebrated (*vidhāya*) the sevenfold extraordinary office, he should pronounce the formula of dismissal (*visarjayet*): "Oṃ, Āḥ, Muḥ."

Thereupon he should effect (*bhāvayet*) the Fourfold Brahma-rapture (*catur-brahma-vihāram*) of Love, Compassion, Cheerfulness, and Equa-

[10] [It may appear to the reader at first sight that the religious exercises that are described have little connection with art. They are of real significance in this connection, however, precisely because (1) the immaterial office of personal devotions is actually the same as the imaginative procedure of the artist, with only this distinction, that the latter subsequently proceeds to manufacture, and (2) the nature of the exercises themselves reveals the state of mind in which the formation of images takes place.]

nimity (*maitrī, karunā, muditā, upekṣā*) by stages (*krameṇa*) as follows: "What is Love? Its character is that of the fondness for an only son that is natural to all beings; or its similitude is that of sympathy in the welfare and happiness (of others). And what is Compassion? It is the desire to save from the Triple Ill (*tridukhāt*) and the causes of Ill; or this is Compassion, to say 'I shall remove from the pain of the Triple Ill those born beings whose abode is in the iron dwelling of the world-vortex that is aglow in the great fire of the Triple Ill'; or it is the wish to lift up from the ocean of the world-vortex the beings that are suffering there from the pain of the Triple Ill. Cheerfulness is of this kind: Cheerfulness is a sense of perfect happiness; or Cheerfulness is the confident hope of bringing it to pass that every being in the world-vortex shall attain to the yet unforeseen Buddhahood; or it is the mental attraction felt by all of these beings towards the enjoyment and possession of these virtuosities. What is Equanimity? Equanimity is the accomplishment of a great good for all born beings, whether they be good or evil, by the removal of whatever obstacles stand in the way of their kindly behavior; or Equanimity is a spontaneous affection for all other beings without respect of any personal interest in their friendly conduct; or Equanimity is an indifference to the eight mundane categories of gain and loss, fame and disgrace, blame or praise, pleasure and pain, and so forth, and to all works of supererogation."

Having realized the Fourfold Brahma-rapture, he should effect (*bhāvayet*) the fundamentally Immaterial Nature of all Principles (*sarvadharma-prakṛti-pariśuddhatām*). For all the principles are fundamentally immaterial by nature, and he too should manifest (*āmukhīkuryāt*): "I am fundamentally immaterial, etc. . . ." This fundamental Immateriality of all Principles is to be established by the incantation "Oṃ, the principles are all immaterial by nature, I am by nature immaterial." If now all the principles are naturally immaterial, what can have brought forth the world-vortex (*saṃsāram*)? It arises in the covering up (of the immateriality of the principles) by the dust of the notions of subject and object, and so forth. How this may be removed is by realization of the True Way; thereby it is destroyed. So the fundamental Immateriality of all Principles is perfected.

When the realization of the fundamental Immateriality of all Principles has been effected, he should develop (*vibhāvayet*) the Emptiness of all Principles (*sarva-dharma-śūnyatām*). Emptiness is like this: let one conceive, "Whatever is in motion or at rest (i.e., the whole phenomenal

135

world) is essentially nothing but the manifested order of what is without duality when the mind is stripped of all conceptual extensions such as the notion of subject and object." He should establish this very Emptiness by the incantation: "Oṃ, I am essentially, in my nature of adamantine intelligence, the Emptiness."

Then he should realize the Blessed Āryatārā, as proceeding from the yellow seed-syllable Tāṃ, upon the spotless orb of the moon that is in the filaments of the full-blown lotus within the lunar orb originally established in the heart. He should conceive (*cintayet*) her to be of deep black color, two-armed, with a smiling face, proficient in every virtue, without defect of any kind whatever, adorned with ornaments of heavenly gems, pearls, and jewels, her twin breasts decorated with lovely garlands in hundredfold series, her two arms decked with heavenly bracelets and bangles, her loins beautified with glittering series of girdles of flawless gems, her two ankles beautified by golden anklets set with divers gems, her hair entwined with fragrant wreaths of Pārijāta and such like flowers, her head with a resplendent jeweled full-reclining figure of the Blessed Tathāgata Amoghasiddhi, a radiant and most seductive similitude, extremely youthful, with eyes of the blue of the autumn lotus, her body robed in heavenly garments, seated in Arddhaparyaṅka pose, within a circle of white rays on a white lotus large as any cartwheel, her right hand in the sign of generosity, and holding in her left a full-blown blue lotus. Let him develop (*vibhāvayet*) this likeness of our Blessed Lady as long as he desires.

Thereupon our Blessed Lady is led forth out of space or ether (*ākāśāt āniyate*) in her intelligible aspect (*jñāna-sattva-rūpa*), by means of the countless sheafs of rays, illumining the Three Worlds, that proceed from the yellow seed-syllable Tāṃ within the filaments of the lotus in the moon of which the orb was established in the heart, and from that Blessed Lady (as above described). Leading her forth (*āniya*), and establishing her on the background of space (*ākāśadeśe api avasthāpya*), he is to make an offering at that Blessed Lady's feet, with scented water and fragrant flowers in a jeweled vessel, welcoming her with heavenly flowers, incense, scents, garlands, unguents, powders, cloths, umbrella, bells, banner, and so forth, and should worship (*pūjayet*) her in all manner of wise. Repeating his worship again and again, and with lauds, he should display the finger sign (*mudrāṃ darśayet*) . . . of a full-blown lotus. After he has gratified our Blessed Lady's intelligible aspect with this finger sign, he is to per-

form (*bhāvayet*) the incantation of our Blessed Lady in her contingent aspect (*samaya-sattva-rūpatā*) and is to liberate (*adhimuñcet*) the non-duality of these (two aspects). Thereupon the rays proceeding from the seed-syllable Tāṃ that is upon the spotless orb of the moon within the filaments of the blue lotus in the lunar orb—rays that illumine the ten quarters of the Three Worlds, that are of unlimited range, and proper to Lady Tārā—remove the poverty and other ills of being existent therein, by means of a rain of jewels, and content them with the nectar of the doctrine of the Momentaneous Nonessentiality, and so forth (*kṣaṇika-nairātmādi*), of all things.[11]

When he has thus accomplished the divers need of the world, and has evolved the cosmic aspect of Tārā (*viśvam api tārārūpaṃ niṣpādya*), he should realize again (*punaḥ ... bhāvayet*) for so long as fatigue does not prevail (*yāvat khedo na jāyate tāvat*)[12] whatever has come to be in the yellow seed-syllable Tāṃ, in the stages of expansion and contraction (*sphuraṇa-saṃharaṇa-krameṇa*). If he breaks away from this realization (*bhāvanātaḥ khinno*)[13] he should mutter an incantation (*mantraṃ japet*), in which case the incantation is: *Oṃ tāre tuttāre ture svāhā.* This is the king of incantations, of mighty power; it is honored, worshiped, and endorsed, by all the Tathāgatas.

Breaking off the contemplation (*dhyānāt vyutthito*), and when he has

[11] Momentaneity and Nonessentiality; i.e., that existence (whether that of our own empirical selves or that of any other thing) is not a continuity but a succession of unique instants of consciousness (*anitya*, πάντα ῥεῖ), and that none of these things is a "self" or has selfhood. [Bhattacharya misrenders *kṣaṇika* by "temporary"; the Nonessentiality is not momentary in the temporal sense, but rather the true now or momentaneity of eternity. The Buddha's omniscience is called "momentary" in the same sense.] On the "momentaneousness of all contingent things" see *Abhidharmakośa* IV.2–3, and L. de la Vallée Poussin, "Notes sur le 'moment' ou *kṣaṇa* des bouddhistes," *Rocznik Orjentalistyczny*, VIII (1931).

[12] In the *Divyāvadāna*, p. 547, it is *kheda*, "lassitude" or "weariness," that prevents Rudrāyaṇa's painters from grasping the Buddha's likeness; and this *kheda* is of the same sort as the "laxity of contemplation" (*śithila samādhi*) that accounts for the portrait painter's failure in the *Mālavikāgnimitra* of Kālidās, II.2. The remedy is Sādhana no. 280, "if he is wearied, he should mutter an incantation" (*khede to mantraṃ japet*).

[13] In Sādhana no. 44, *-nyāyena*. These expressions do not mean "eliminating all fluctuation," but imply a repeated operation with alternate development and involution of the forms in accordance with their visual ontology; cf. *Śilparatna* XLVI.39, "repeatedly recalling" (*smṛtvā smṛtvā punaḥ punaḥ*). [All these instructions imply that the image is to be made as definite as possible, it must be firmly adhered to, never allowed to slip or waver.]

seen the mundane aspect of Tārā (*jagat-tārā-rupaṃ dṛṣṭvā*),[14] he should experience at will the consciousness of his own identity with the Blessed Lady (*bhagavaty ahaṃkāreṇa yatheṣṭaṃ viharet*).[15] The longed-for Great Proficiencies fall at the practitioner's feet (*bhāvayataḥ . . . caraṇyoḥ*); what can I say of the other Proficiencies? these come of themselves. Whoever realizes (*bhāvayet*) our Blessed Lady in a solitary mountain cave,

[14] In Sādhana no. 88, *dhyānāt khinno mantraṃ japet*; with the same meaning; *dhyāna* and *bhāvana*, "contemplation" and "making become" being interchangeable. [Whether the *samaya-sattva, viśva*, and *jagat* aspects are to be regarded as the same or as successively developed modes of the likeness of Tārā is not perfectly clear.]

[15] A self-identification with the forms evoked may be assumed throughout. In many cases we find *ātmānaṃ*, "himself," in explicit connection with the injunctive *bhāvayet* or participle *vicintya*. For example, *ātmānaṃ siṃhanāda-lokeśvara-rūpaṃ bhāvayet*, "he should realize himself in the form of the Bodhisattva Siṃhanāda Lokeśvara, the Lord of the World with the Lion's Roar"; *ātmānaṃ . . . mahākālaṃ bhāvayet*, "he should realize himself as Mahākāla"; *trailokya bhaṭṭārakaṃ . . . ātmānaṃ bhāvayet*, "he should realize himself as Trailokyavijaya Bhaṭṭāraka" (Bhattacharya, *Buddhist Iconography*, pp. 36, 121, 146); "for a long time" (*ciram*) in the intelligible aspect of Yamāntaka, Sādhana no. 280; *jambhalaṃ bhāvayet, jambhala eva bhavati*, "he should realize (himself as) Jambhala, and verily becomes Jambhala."

Bhāvayet is the causative form of *bhū*, to "become," and more or less synonymous with *cit*, "think" and *dhyai*, "contemplate," all with a creative sense; cf. Meister Eckhart's "He *thinks* them, and behold, they are." It is far from insignificant, inasmuch as the act of imagination is a conception and a vital operation, that *bhāvayati*, "makes become," in the sense of begetting and bringing forth, can be said of the parents of a child, both before and after birth (AĀ 11.5). For *bhū* as "making become" in Pali texts, see C.A.F. Rhys Davids, *To Become or Not to Become* (London, 1937), ch. 9. *Bhavati*, "becomes," is commonly used as early as the Ṛg *Veda* with reference to the successive assumption of particular forms corresponding to specific functions, e.g. v.3.1, "Thou, Agni, becomest Mitra when kindled"; cf. Exod. 3:14, where the well-known "I am that I am" (so in the Greek text) reads "I become what I become (Heb. *Ehyeh asher Ehyeh*)."

In the present text, *bhagavaty ahaṃkāreṇa* is literally "having the Blessed Lady for his 'I.' " In the same way, in a Sādhana excerpted by A. Foucher (*L'Iconographie bouddhique de l'Inde*, Paris, 1900, II, p. 10, n. 2), we have *tato dṛḍhāhaṃkāraṃ kuryāt; ya bhagavatī prajñāpāramitā so'haṃ; yo'haṃ sa bhagavatī prajñā*—"Let him make a strict identification: 'What the Blessed Lady Prajñāpāramitā is, that am I; what I am, the Blessed Lady Prajñāpāramitā is.' "

These are not merely artistic requirements, but metaphysical. They go back to the formulae of the *Āraṇyakas* and *Upaniṣads*, "That art thou" (*tat tvam asi*), and "I am he" (*so'haṃ asmi*); and moreover, the last end of the work of art is the same as its beginning, for its function as a support of contemplation (*ālambanam, dhiyālambanam*) is to enable the *rasika* to identify himself in the same way with the archetype of which the painting is an image.

he indeed sees her face to face (*pratyakṣata eva tāṃ paśyati*) :[16] the Blessed Lady herself bestows upon him his very respiration and all else. What more can be said? She puts the very Buddhahood, so hard to win, in the very palm of his hand. Such is the whole Sādhana of the Kiṃcit-Vistara-Tārā.

THE Sādhana translated above, differs only from others in the *Sādhanamālā* in its greater than average length and detail. The whole process is primarily one of worship, and need not necessarily be followed by the embodiment of the visualized likeness in physical material; but where the making of an actual image is intended, it is the inevitable preliminary. Even if the artist actually works from a sketch or under verbal instruction, as sometimes happens, this only means that the *actus primus* and *actus secundus* are divided between two persons (cf. note 4); the fundamental nature of the representation, in all the details of its composition and coloring, and as regards the strictly ideal character of its integration, is in any case determined by and can only be understood in the light of the mental operation, the *actus primus* by which the given theme is made to assume a definite form in the mind of the artist, or was originally made to take shape in the mind of some artist; this form being that of the theme itself, and not the likeness of anything seen or known objectively. In other words, what the Sādhana supplies is the detailed sequence according to which the formal cause or pattern of the work to be done is developed from its germ, from the mere hint of what is required; this hint itself corresponding to the requirement of the patron, which is the final cause, while the efficient and material causes are brought into play only if and when the artist proceeds to servile operation, the act of "imitation," "similitude being with respect to the form."

Before we relinquish the present consideration of the *actus primus* in Oriental art, reference must be made to another way in which the derivation of the formal image is commonly accounted for. It is assumed that upon an intellectual or angelic level of reference the forms of things are

[16] In Sādhana no. 44, *pratyakṣam ābhāti*, "appears before his eyes." This appearance becomes the *sādhaka's* model, to be imitated in the first place personally, and in the second place in the work of art. The manner in which such a manifestation appears "before his eyes" is illustrated in the Rajput painting reproduced in figure 2.

Ābhāti (*ā-bhā*, "shine hitherward") corresponds to *ābhāsa* as "painting" discussed in Coomaraswamy, *The Transformation of Nature in Art*, ch. 6.

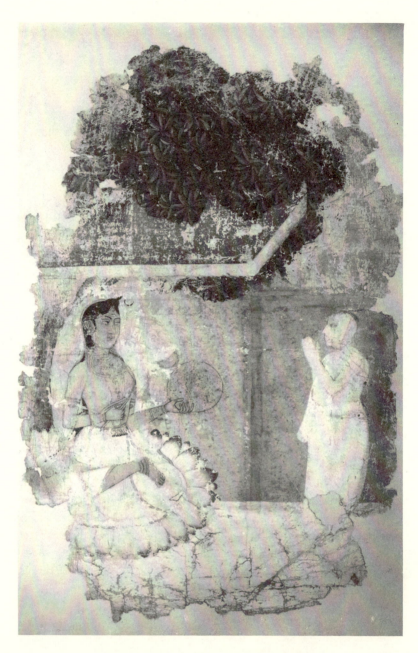

Figure 2. The Gracious Manifestation of Devī

intellectually emanated and have an immediate existence of their own. When this is mythologically formulated, such a level of reference becomes a "heaven" above. Then the artist, commissioned here, is thought of as seeking his model there. When, for example (*Mahāvaṃsa*, ch. xxvii), a palace is to be built, the architect is said to make his way to heaven; and making a sketch of what he sees there, he returns to earth and carries out this design in the materials at his disposal. So "it is in imitation of the angelic works of art that any work of art is accomplished here" (AB vi.27). This is a mythological formula obviously equivalent in significance to the more psychological account in the Sādhanas. And here also it is easy to find extra-Indian parallels; for example, Plotinus, where he says that all music is "an earthly representation of the music that there is in the rhythm of the ideal world," and "the crafts such as building and carpentry which give us matter in wrought forms may be said, in that they draw on pattern, to take their principles from that realm and from the thinking there."[17] And this, indeed, it is that accounts for the essential characteristics of the wrought forms; if the Zohar[18] tells us of the Tabernacle that "all its individual parts were formed in the pattern of that above," this tallies with Tertullian, who says of the cherubim and seraphim figured in the exemplum of the Ark, that because they are not in the likeness of anything on earth, they do not offend against the interdiction of idolatry; "they are not found in that form of similitude in reference to which the prohibition was given."[19]

The emphasis that is laid upon the strict self-identification of the artist with the imagined form should be especially noted. Otherwise stated, this means that he does not understand what he wants to express by means of any idea external to himself. Nor, indeed, can anything be rightly expressed which does not proceed from within, moved by its form. Alike from the Indian and Scholastic point of view, understanding depends upon an assimilation of knower and known; this is indeed the divine manner of understanding, in which the knower is the known. *Per contra*, the distinction of subject from object is the primary condition of ignorance, or imperfect knowledge, for nothing is known essentially except as it exists in consciousness; everything else is supposition. Hence the Scholastic and Indian definitions of perfect understanding as involving

[17] Plotinus, *Enneads* v.9.11.

[18] [Depending upon Exod. 25:40, "Lo, make all things in accordance with the pattern that was shown thee upon the mount."]

[19] *Contra Marcionem* ii.22. In the same way, for all his iconoclasm, Philo takes an iconography of the Cherubim, and that of the Brazen Serpent, for granted.

adaequatio rei et intellectus, or *tad-ākāratā*; cf. Gilson, "Toute connaissance est, en effet, au sens fort du terme, une assimilation. L'acte par lequel une intelligence s'empare d'un objet pour en appréhender la nature suppose que cette intelligence se rend semblable à cet objet, qu'elle en revêt momentanément la forme, et c'est parce qu'elle peut en quelque sorte tout devenir qu'elle peut également tout connaître."[20] It follows that the artist must really have been whatever he is to represent. Dante sums up the whole matter from the mediaeval point of view when he says, "he who would paint a figure, if he cannot be it, cannot paint it," or as he otherwise expresses it, "no painter can portray any figure, if he have not first of all made himself such as the figure ought to be."[21] Given the value that we nowadays attach to observation and experiment as being the only valid grounds of knowledge, it is difficult for us to take these words as literally and simply as they are intended. Yet there is nothing fanciful in them; nor is the point of view an exceptional one.[22] It is rather our own

[20] E. Gilson, *La Philosophie de St. Bonaventure* (Paris, 1924), p. 146. [It would be preferable to say "c'est parce qu'elle est tout qu'elle peut également tout connaître," in accordance with the view that Man—not "this man"—is the exemplar and effectively the demiurge of all things; meaning, of course, by "Man," that human nature which has nothing to do with time, for this is anything but an individually solipsist point of view. It is not that the knower and known are mutually modified by the fact of observation, but that there is nothing knowable apart from the act of knowledge.]

[21] *Convito*, Canzone IV.53–54 and IV.105–106.

[22] [A remarkable approximation to this point of view may be cited from Sir James Jeans' presidential address to the British Association, 1934: "Nature . . . is not the object of the subject-object relation, but the relation itself. There is, in fact, no clear-cut division between the subject and the object; they form an indivisible whole which now becomes nature. This thesis finds its final expression in the wave parable, which tells us that nature consists of waves and that these are of the general quality of waves of knowledge, or of absence of knowledge, in our own minds. . . . If ever we are to know the true nature of waves, these waves must consist of something we already have in our own minds. . . . The external world is essentially of the same nature as mental ideas." These remarks are tantamount to an exposition of the Vedāntic and Buddhist theory of the conceptuality of all phenomena, where nature and art alike are regarded as projections of mental concepts (*citta-saṃjñā*) and as belonging to a strictly mental order of experience (*citta-mātra*) without substantial existence apart from the act (*vṛtti*) of consciousness.]

The artist is from more than one point of view a yogin; and the object of contemplation is to transcend the "dust of the notion of subject and object" in the unified experience of the synthesis of knower and known—"assimilating the knower with the to-be-known, as it was in the original nature, and in that likeness attaining that end that was appointed by the gods for men, as being best both as for this present and for the time to come," Plato, *Timaeus* 90D; cf. Aristotle, *Metaphysics* XII.9.3–5.

empiricism that is, humanly speaking, exceptional, and that may be at fault. Ching Hao, for example, in the tenth century, is expressing the same point of view when he says of the "subtle" painter (the highest type of the human artist) that he "first experiences in imagination the instincts and passions of all things that exist in heaven and earth; then, in a manner appropriate to the subject, the natural forms flow spontaneously from his hand." The closest parallels to our Indian texts occur, however, in Plotinus: "Every mental act is accompanied by an image . . . fixed and like a picture of the thought. . . . The Reason-Principle—the revealer, the bridge between the concept and the image-taking faculty—exhibits the concept as in a mirror," and "in contemplative vision, especially when it is vivid, we are not at the time aware of our own personality; we are in possession of ourselves, but the activity is towards the object of vision with which the thinker becomes identified; he has made himself over as matter to be shaped; he takes ideal form under the action of the vision, while remaining potentially himself."[23]

When we reflect that mediaeval rhetoric, that is to say the preoccupations with which the patron and artist alike approached the activity of making things, stems from Plotinus, through Augustine, Dionysius, and Eriugena to Eckhart, it will not surprise us that mediaeval Christian art should have been so much like Indian in kind; it is only after the thirteenth century that Christian art, though it deals nominally with the same themes, is altogether changed in essence, its properly symbolic language and ideal references being now obscured by statements of observed fact and the intrusion of the artist's personality. On the other hand, in the art that we are considering, the theme is all in all, the artist merely the means to an end; the patron and the artist have a common interest, but it is not in one another. Here, in the words of the *Laṅkāvatāra Sūtra*, the picture is not in the colors, neither has it any concrete existence elsewhere. The picture is like a dream, the aesthetic surfaces merely its vehicle, and anyone who regarded these aesthetic surfaces themselves as constituting the art would have been thought of as an idolater and sybarite. Our modern attitude to art is actually fetishistic; we prefer the symbol

[23] Plotinus IV.3.30 and IV.2. "There is no sense of distance or separation from the thing. . . . All the activities of the self are loosed in enjoyment, unanimous in a single activity which breaks through the framework of aspects enclosing our ordinary rational activity, and which experiences, for a moment or longer, a reality that is really possessed. Now is the mind most alive, and at peace; the thing is present, held and delighted in" (Thomas Gilby, *Poetical Experience*, London, 1934, pp. 78–79, paraphrasing *Sum. Theol.* I-II.4.3 *ad* 1).

to the reality; for us the picture is in the colors, the colors are the picture. To say that the work of art is its own meaning is the same as to say that it has no meaning, and in fact there are many modern aestheticians who assert explicitly that art is unintelligible.

We have thus before us two diametrically opposed conceptions of the function of the work of art: one of the work of art as a thing provided by the artist to serve as the occasion of a pleasurable sensory experience, the other of the work of art as providing the support for an intellectual operation to be performed by the spectator. The former point of view may suffice to explain the origin of the modern work and for its appreciation, but it neither explains nor enables us to make any but a decorative use of the mediaeval or Oriental works, which are not merely surfaces, but have intelligible references. We may elect for our own purposes to adhere to the contemporary point of view and the modern kind of art, and may decide to acquire examples of the other kind in the same way that a magpie collects materials with which to adorn its nest. At the same time in fact, however, we also pretend to study and aspire to understand the works of this other kind that are assembled in our homes and museums. And this we cannot do without taking into account their final and formal causes; how can we judge of anything without first knowing what purpose it was intended to serve, and what was its maker's intention? It is, for example, only the logic of their iconography that can explain the composition of the Oriental works, only the manner in which the model is conceived that can explain the representation that is not in any sense optically plausible or made as if to function biologically.

We must, in fact, begin by approaching these works as if they were not works of art in our sense, and for this purpose it will be a good plan to begin our study without regard to the quality of the works selected for study, even perhaps deliberately choosing poor or provincial examples, wishing to know what kind of art this is before we proceed to eliminate what is not good of its kind; for it is only when we know what is being said that we shall be in a position to know whether it has been well said, or perhaps so poorly expressed as not really to have been said at all.

IT is not altogether without reason that C. G. Jung has drawn a parallel between the "artistic" productions of his pathological patients and the maṇḍalas of Eastern art.[24] He asks his patients "actually to paint what

[24] R. Wilhelm and C. G. Jung, *The Secret of the Golden Flower* (London, 1932); C. G. Jung, *Modern Man in Search of a Soul* (London, 1933), ch. 3. On Jung's interpretation see André Préau, *La Fleur d'or et le taoisme sans Tao* (Paris, 1931).

they have seen in dream or fantasy. . . . To paint what we see before us is a different matter from painting what we see within." Although these productions are sometimes "beautiful" (see the examples reproduced in *The Secret of the Golden Flower*, Pls. 1–10), Jung treats them as "wholly worthless according to the test of serious art. It is even essential that no such value be allowed them for otherwise my patients might imagine themselves to be artists, and this would spoil the good effects of the exercise. It is not a question of art[25]—or rather it should not be a question of art—but of something more, something other than mere art: namely the living effect upon the patient himself—some kind of centering process— a process which brings into being a new center of equilibrium." This corresponds to the Indian conception of the work of art as a "means of reintegration" (*saṃskaraṇa*).[26] It is true, of course, as Jung freely admits, that none of the European maṇḍalas achieves "the conventionally and traditionally established harmony and completeness of the Eastern maṇḍala."

The Eastern diagrams are, in fact, finished products of a sophisticated culture; they are created, not by the disintegrated patient as in Jung's cases, but rather by the psychological specialist himself for his own use or that of others whose state of mental discipline is already above rather than below the average level. We have here to do with an art that has "fixed ends in view and ascertained means of operation." In what is thus a professional and conscious product we naturally find the qualities of beauty highly developed, viz. those of unity, order, and clarity; we can, if we insist upon doing so, regard these products as works of decorative art, and use them accordingly. But if we limit our response in this way, not taking any account of the manner and purpose of their production, we cannot claim to be understanding them; they are not explicable in terms of technique and material, it is rather the art in the artist which determines the development of the technique and the choice of material, and in any case it is the meaning and logical relations of the parts that determines their arrangement, or what we call composition. After the form has once been conceived, the artist performing the servile operation cannot alter it to better please his taste or ours, and never had any intention to do so. It is, therefore, that we maintain that no approach to Oriental art that does not take full account of all its purposes, and of the specific process by which these purposes were achieved, can pretend to

[25] I.e., not of "art for art's sake," but "for good use."
[26] AB vi.27, ŚB vi.1.2.29, etc. *Saṃskaraṇa* is also an integration and a "sacrament"; the operation is a rite.

adequacy. This will apply as much in the case of the minor arts as in that of the major arts of painting, sculpture, and architecture. Oriental art cannot be isolated from life and studied *in vacuo*; we can only be said to have understood it when we have, at least for the time being, so far identified ourselves with its premises as to fully consent to it, taking its kind for granted in just the same way that we take a modern fashion for granted; until we do this, the forms of Oriental art will always seem to us arbitrary or at the least exotic or curious, and this will be the measure of our misunderstanding, for it was none of these things in the eyes of those for whom it was made and who knew how to use it. The man who still worships the Buddhist image in its shrine has in many respects a better understanding of Buddhist art than the man who looks at the same image in a museum, as an object of "fine art."

Just as for Plato the patron is the judge of art in its most important aspect, that of use, so we still say that "the proof of the pudding is in the eating."

The Nature of Buddhist Art

He is not himself brought into being in images presented
through our senses, but He presents all things to us in
such images.

Hermes, *Lib.* v.1b

In order to understand the nature of the Buddha image and its meaning
for a Buddhist we must, to begin with, reconstruct its environment, trace
its ancestry, and remodel our own personality. We must forget that we
are looking at "art" in a museum, and see the image in its place in a
Buddhist church or as part of a sculptured rock wall; and having seen it,
receive it as an image of what we are ourselves potentially. Remember
that we are pilgrims come from some great distance to see God; that
what we see will depend upon ourselves. We are to see, not the likeness
made by hands, but its transcendental archetype; we are to take part in
a communion. We have heard the spoken Word, and remember that
"He who sees the Word, sees Me"; we are to see this Word, not now in
an audible but in a visible and tangible form. In the words of a Chinese
inscription, "When we behold the precious characteristics, it is as though
the whole and very person of the Buddha were present in majesty. . . .
The Vulture Peak is before our eyes; Nāgarahāra is present. There is a
rain of precious flowers that robs the very clouds of color; a celestial
music is heard, enough to silence the sound of ten thousand flutes. When
we consider the perfection of the Body of the Word, the eight perils
are avoided; when we hear the teaching of the Mighty Intellect, the
seventh heaven is reached" (E. Chavannes, *Mission archéologique dans
la Chine septentrionale*, 3 vols., Paris, 1909–1913, I, 340). The image is
of one Awakened: and for our awakening, who are still asleep. The

[This essay was first published as the introduction to a volume by Benjamin Row-
land, Jr., *The Wall-Paintings of India, Central Asia, and Ceylon* (Boston, 1938). It
appears here in the slightly revised version included in *Figures of Speech or Figures
of Thought.*—ED.]

147

objective methods of "science" will not suffice; there can be no under-standing without assimilation; to understand is to have been born again.

The epithet "Awakened" (Buddha) evokes in our minds today the concept of an historical figure, the personal discoverer of an ethical, psy-chological, contemplative, and monastic Way of salvation from the in-fection of death: which Way extends hence toward a last and beatific End, which is variously referred to as a Reversion, Despiration, or Re-lease, indescribable in terms of being or nonbeing considered as incom-patible alternatives, but certainly not an empirical existence nor an an-nihilation. The Buddha "is"; but he "cannot be taken hold of."

In the developed Buddhist art with which we are now mainly con-cerned, we take for granted the predominance of the central figure of a "Founder" in a form that can only be described, although with important reservations, as anthropomorphic. If we take account of the manner in which this usually monastic but sometimes royal figure is sharply dis-tinguished from its human environment, for example, by the nimbus or by the lotus support, or similarly take account of the "mythical" character of the life itself as described in the early texts, we generally say that the man who is spoken of as "Thus-come" (Tathāgata) or as the "Wake" (Buddha) has been "deified," and presume that miraculous elements have been combined with the historical nucleus and introduced into the rep-resentations for edifying purposes. We hardly realize that "Buddhism" has roots that can be traced backward for millennia; and that though the Buddha's doctrines are in the proper sense of the word original, they are scarcely in any sense novel; nor that this applies with equal force to the problems of Buddhist art, which are not in reality those of Buddhist art in particular, but rather those of Indian art in a Buddhist application and, in the last analysis, the problems of art universally. It would be pos-sible, for example, to discuss the whole problem of iconoclasm in purely Indian terms; and we shall in fact have something to say about it, in making the nature and genesis of the anthropomorphic image the main theme of this introduction.

If "Buddhism" (we use quotations because the connotation is so vast) is a heterodox doctrine in the sense that it apparently rejects the imper-sonal authority of the Vedas and substitutes or seems to substitute for this the authority of an historically spoken Word, it is nevertheless becoming more apparent every day that the content of Buddhism and Buddhist art are far more orthodox than was at first imagined, and orthodox not only in a Vedic sense, but even universally. For example, the famous

formula, *anicca, anattā, dukkha,* "Impermanence, Nonspirit, Suffering," does not, as was once believed, involve a denial of the Spirit (*ātman*), but asserts that the soul-and-body or individuality (*nāma-rūpa, atta-bhāva, saviññāna-kāya*) of man are passable, mutable, and above all to be sharply distinguished from the Spirit. *Anattā* does not assert that "there is no Spirit" or "Spiritual-essence," but that "this (empirical self, *Leibseele*) is not my Spirit," *na me so attā,* a formula constantly repeated in the Pali texts. It is in almost the same words that the Upaniṣads assert that "what is other than the Spirit is a misery" (*ato anyad ārtam*) and that "this (its station) is not the Spirit, no indeed: the Spirit is naught that can be taken hold of, naught perishable, etc." (*sa eṣa neti nety ātmā agrihyo . . . aśīryah,* etc., BU iii.4.i and 9.26). This is the greatest of all distinctions, apart from which there can be no intelligence of man's last end; and we find it insisted upon, accordingly, in all orthodox traditions—for example, by St. Paul when he says, "The word of God is quick and powerful, and sharper than any two-edged sword, piercing even to the dividing asunder of soul and spirit" (Heb. 4:12).

We have traced elsewhere[1] the Vedic sources and universal values of Buddhist symbolism, and shall presently discuss the nature of symbolism itself. Here it will suffice to add that the Vedic and Buddhist, or equally Vedic and Vaiṣṇava or Vedic and Jaina scriptures, taken together in continuity, enunciate the dual doctrine, which is also a Christian doctrine, of an eternal and a temporal birth; if the former alone is expounded in the *Ṛg Veda,* the Buddha's historical nativity is in reality the story of the aeonic manifestation of Agni—*Noster Deus ignis consumens est*—compressed "as if" into the span of a single existence. The "going forth" from the household to the homeless life is the ritual transference of Agni from the household to the sacrificial altar; if the Vedic prophets are forever tracking the Hidden Light by the traces of its footsteps, it is literally and iconographically true that the Buddhist also makes the *vestigium pedis* his guide; and if Agni in the Vedic texts, as also in the Old Testament, is a "Pillar of Fire," the Buddha is repeatedly represented as such at Amarāvatī. We need hardly say that, from our point of view, to speak of the "lives" of the Buddha or Christ as "mythical" is but to enhance their timeless significance.[2]

[1] Coomaraswamy, *Elements of Buddhist Iconography,* 1935, and "Some Sources of Buddhist Iconography," 1945.

[2] To speak of an event as *essentially* mythical is by no means to deny the possibility, but rather to assert the necessity of an *accidental*—i.e., historical—eventuation; it is

We very naturally overlook the fact that the central problem of Buddhist art, of which a solution is essential to any real understanding, is not a problem of styles, but of how it came about that the Buddha has been represented at all in an anthropomorphic form: which is almost the same thing as to ask why indeed the Great King of Glory should have veiled his person in mendicant robes—*Cur Deus homo?* The Buddhist answer is, of course, that the assumption of a human nature is motivated by a divine compassion, and is in itself a manifestation of the Buddha's perfect virtuosity (*kosalla, kauśalya*) in the use of convenient means (*upāya*): it is expressly stated of the Buddha that it belongs to his skill to reveal himself in accordance with the nature of those who perceive him. It had indeed already been realized in the Vedas and Brāhmaṇas that "His names are in agreement with his aspect" and that "as He is approached, such He becomes" (*yathopāsate tad eva bhavati*, ŚB x.5.2.20); as St. Augustine, cited with approval by St. Thomas, expresses it, *factus est Deus homo ut homo fieret Deus.*

The notion of a Creator working *per artem*, common to the Christian and all other orthodox ontologies, already implies an artist in possession of his art, the foremeasure (*pramāṇa*) and providence (*prajñā*) according to which all things are to be measured out; there is, in fact, the closest possible analogy between the "factitious body" (*nirmāṇa-kāya*[3]) or "measure" (*nimitta*) of the living Buddha, and the image of the Great Person which the artist literally "measures out" (*nirmāti*) to be a substitute for

in this way that the eternal and temporal nativities are related. To say "that it might be fulfilled which was said by the prophets" is not to render a narrative suspect but only to refer the fact to its principle. Our intention is to point out that the more eminent truth of the myth does not stand or fall by the truth or error of the historical narrative in which the principle is exemplified.

[3] The expression *nirmāṇa-kāya* is evidently derived from JB iii.261-263. Here the Devas have undertaken a sacrificial session, but before doing so propose to discard "whatever is crude in our Spirit (*tad yad eṣāṃ krūram ātmana āsīt*, i.e., whatever are its possibilities of physical manifestation), and to measure it out (*tan nirmimāmahai*—i.e., fashion it)." Accordingly, "they measured it out (*nirmāya*) and put what had thus been wiped off (*sammārjam*) in two bowls (*śarāvayoḥ*, i.e., heaven and earth). . . . Thence was born the mild Deva . . . it was verily Agni that was born. . . . He said, 'Why have ye brought me to birth?' They answered, 'To keep watch' (*aupa-dṛṣtrāya*; cf. ŚB iii.4.2.5, *aupadṛṣṭā*, and Sāyaṇa on RV x.27.13, *āloka karaṇāya*)." Here, then, Agni's embodiment in the worlds is already a *nirmāṇa-kāya*. That Agni is to keep watch corresponds, on the one hand, to the Vedic conception of the Sun as the "Eye of the Devas" and, on the other, to that of the Buddha as the "Eye in the World" (*cakkhum loke*) in the Pali texts, and to Christ as θεοῦ . . . ὄμμα (*Greek Anthology* i.19). Cf. Coomaraswamy, "Nirmāṇa-kāya," 1938.

the actual presence. The Buddha is, in fact, born of a Mother (*mātṛ*) whose name is Māyā (Nature, Art, or "Magic" in Boehme's sense of "Creatrix"), with a derivation in each case from *mā*, to "measure"; cf. *prati-mā* "image," *pra-māṇa*, "criterion," and *tāla-māna*, "iconometry."[4] There is, in other words, a virtual identification of a natural with an intellectual, metrical, and evocative generation.[5] The birth is literally an evocation; the Child is begotten, in accordance with a constantly repeated Brāhmaṇa formula, "by Intellect upon the Voice," which intercourse is symbolized in the rite; the artist works, as St. Thomas expresses it, "by a word *conceived* in intellect." We must not overlook, then, that there is also a third and verbal image, that of the doctrine, coequal in significance with the images in flesh or stone: "He who sees the Word sees Me" (S III.120). These visible and audible images are alike in their information, and differ only in their accidents. Each depicts the same essence in a likeness; neither is an imitation of another—the image in stone, for example, not an imitation of the image in flesh, but each directly an "imitation" (*anukṛti*, mimesis) of the unspoken Word, an image of the "Body of the Word" or "Brahma-body" or "Principle," which cannot be represented as it *is* because of its perfect simplicity.

It was not, however, until the beginning of the Christian era, five centuries after the Great Total-Despiration (*mahā parinibbāna*), that the Buddha was actually represented in a human form. In more general terms, it was not until then (with certain exceptions, some of which date back as far as the third millennium B.C., and despite the fact that the *Ṛg Veda* freely makes use of a verbal imagery in anthropomorphic terms) that any

[4] The origin of the name of the Buddha's mother, Māyā (μαῖα, μῆτις, Sophia), can be followed backward from *Lalita Vistara* XXVII.12 through AV VIII.9.5 to RV III.29.11, "This, O Agni, is thy cosmic womb, whence thou hast shone forth. . . . Metered in the mother (*yad amimīta mātari*)—Mātariśvan"; cf. X.5.3, "Having measured out the Babe (*mitvā śiśum*)," and TS IV.2.10.3, "born as a steed in the midst of the waters."

[5] Observe, in this connection, that in John 1:3–4, the Latin *quod factum est* represents the Greek ὅ γέγονεν (Skr. *jātam*), cf. Philo, *Aet.* 15, ἔργον δὲ καὶ ἔγγονον. "The teaching of our school is that anything known or born is an image. They say that in begetting his only-begotten Son, the Father is producing his own image" (Meister Eckhart, Evans ed., I, 258).

It is from the same point of view, that of the doctrine of ideas, that for St. Thomas, "Art imitates nature [i.e., Natura naturans, Creatrix universalis, Deus] in her manner of operation" (*Sum. Theol.* I.117.1c), and that Augustine "appuie plus nettement [que Plotin] sur la même origine de la nature [Natura naturata] et des oeuvres d'art, *l'origine en Dieu*" (K. Svoboda, *L'Esthétique de saint Augustin et ses sources*, Brno, 1933, p. 115).

widespread development of an anthropomorphic iconography can be recognized at all. The older Indian art is essentially "aniconic," that is, it makes use only of geometrical, vegetable, or theriomorphic symbols as supports of contemplation, just as in early Christian art. An artistic inability to represent the human figure cannot be invoked by way of explanation in either case; not only had human figures already been represented very skillfully in the third millennium B.C., but, as we know, the type of the human figure had been employed with great effect from the third century B.C. onwards (and no doubt much earlier in impermanent material), *except* to represent the Buddha in his last incarnation, where even at birth and before the Great Awakening he is represented only by footprints, or generally by such symbols as the Tree or Wheel.

In order to approach the problem at all we must relegate to an altogether subordinate place our predilection for the human figure, inherited from late classical cultures, and must, to the extent that we are able, identify ourselves with the unanimous mentality of the Indian artist and patron both as it had been before, and as it had come to be when a necessity was actually felt for the representation of what we think of as the "deified" Buddha (although the fact that he cannot be regarded as a man among others, but rather as "the form of humanity that has nothing to do with time," is plainly enough set forth in the Pali texts). Above all, must we refrain from assuming that what was an inevitable step, and one already foreshadowed by the "historicity" of the life, must be interpreted in terms of spiritual progress. We must realize that this step, of which an unforeseen result was the provision for us of such aesthetic pleasures as everyone must derive from Buddhist art, may have been itself much rather a concession to intellectually lower levels of reference than any evidence of an increased profundity of vision. We must remember that an abstract art is adapted to contemplative uses and implies a gnosis; an anthropomorphic art evokes a religious emotion, and corresponds rather to prayer than to contemplation. If the development of an art can be justified as answering to new needs, it must not be overlooked that to speak of a want is to speak of a deficiency in him who wants: the more one is, the less one wants. We ought not, then, to think so much of a deficiency of plastic art in aniconic rituals as of the adequacy of the purely abstract formulae and the proficiency of those who could make use of purely symbolic representations.

The aniconic character of Vedic ritual and early Buddhist art was, then, a matter of choice. Not only is the position iconoclastic in fact, but we

can hardly fail to recognize a far-reaching iconoclastic tendency in such words as those of the *Jaiminīya Upaniṣad Brāhmaṇa*, IV.18.6: "The Brahman is not what one thinks with the mind (*yam manasā na manute*), but, as they say, is that whereby there is a mentation, or concept (*yenāhur manomatam*): know that That alone is Brahman, not what men worship here (*nedaṃ yad idam upāsate*)." At the same time, the Upaniṣads distinguish clearly between the Brahman in a likeness and the Brahman not in any likeness, mortal and immortal (*mūrtaṃ cāmūrtaṃ ca martyaṃ cāmṛtaṃ ca*, BU II.3.1, where it may be noted that one of the regular designations of an image is precisely *mūrti*); and between the concept by which one distinctly remembers and the lightning-flash at which one can only exclaim (Kena Up. IV.4–5). The distinction is that of Eckhart and Ruysbroeck between the knowledge of God *creaturlicher wise, creatuerliķerwijs* and *âne mittel, âne wise, sonder middel, sonder wise*, and involves the universal doctrine of the single essence and two natures. It is clear that these texts and their implied doctrine are tantamount to a justification both of an iconography and of iconoclasm. It is the immediate value of an image to serve as the support of a contemplation leading to an understanding of the exterior operation and proximate Brahman, the Buddhist Sambhogakāya: it is only of the interior operation and ultimate Brahman, Buddhist Dharmakāya, Tattva, Tathatā, or Nirvāṇa, that it can be said that "*This* Brahman is silence."[6]

No one whose life is still an active one, no one still spiritually under the Sun and still perfectible, no one who still proposes to understand in terms of subject and object, no one who still is anyone, can pretend to have outgrown all need of means. It is not a question of the virtually "infinite possibilities of the simple soul" (A. C. Bouquet, *The Real Pres-*

[6] A traditional saying quoted by Śaṅkara on *Brahma Sūtra* III.2.17. Cf. the Hermetic "Then only will you see it, when you cannot speak of it; for the knowledge of it is deep silence, and suppression of all the senses" (Hermes, *Lib.* x.6). Just as for the Upaniṣads the ultimate Brahman is a principle "about which further questions cannot be asked" (BU III.6), so the Buddha consistently refuses to discuss the quiddity of Nibbāna. In the words of Erigena, "God does not know what He Himself is, because He is not any what," and of Maimonides, "by affirming anything of God, you are removed from Him." The Upaniṣads and Buddhism offer no exception to the universal rule of the employment side by side of the *via affirmativa* and *via remotionis*. There is nothing peculiarly Indian, and still less peculiarly Buddhist, in the view that we cannot know what we may become, which "Eye hath not seen, nor ear heard" (1 Cor. 2:9). In the meantime, the function of the image bodily, verbal, or plastic, or in any other way symbolic, is mediatory. See also Coomaraswamy, "The Vedic Doctrine of 'Silence'" [in Vol. 2 of this selection—ED.].

ence, Cambridge, 1928, p. 85), which it would be absurd to deny, but one of *how* these potentialities can be reduced to act. One is astounded at the multitude of those who advocate the "direct" approach to God, as if the end of the road could be reached without a wayfaring, and who forget that an immediate vision can be only theirs in whom "the mind has been de-mented," to employ a significant expression common to Eckhart, the Upaniṣads, and Buddhism.

The *present* problem is not, then, one of the propriety or impropriety of the use of supports of contemplation, but of what sort the most appropriate and efficacious supports of contemplation must be, and of the art of making use of them. For *us*, the work of art both exists and operates on an altogether human, visible, and tangible level of reference; we do not, as Dante requires that we should, "marvel at the doctrine that hides itself behind (*s'asconde sotto*) the veil of the strange verses" (*Inferno* ix.61); the verses are enough for us. It is otherwise in a traditional art, where the object is merely a point of departure and a signpost inviting the spectator to the performance of an act directed toward that form for the sake of which the picture exists at all. The spectator is not so much to be "pleased" as to be "transported": to see as the artist is required to have seen before he took up brush or chisel; to see the Buddha in the image rather than an image of the Buddha. It is a matter of *penetration,* in the most technical senses of the term (cf. Muṇḍ. Up. ii.2.3): the variegated presentation in colors is merely a conceptual exteriorization of what in itself is a perfectly simple brilliance—"Just as it is an effect of the presence or absence of dust in a garment that the color is either clear or motley, so it is the effect of the presence or absence of a penetration into Release (*āvedha-vaśān muktau*) that the Gnosis is either clear or motley. That one alludes to the profundity of the Buddhas on the Unsullied Plane in terms of iconographic characteristics, stances, and acts (*lakṣaṇa-sthāna-karmasu*) is a mere painting in colors on space."[7] Or again, and with ref-

[7] See Sylvain Lévi's edition of the *Mahāyāna Sūtrālamkāra* of Asanga, 2 vols. (Paris, 1907, 1911), I, 39–40; II, 77–78. Lévi has not quite understood *lakṣaṇa-sthāna*; the reference is to the descriptive iconography of narrative and visual art. In *A Survey of Painting in the Deccan* (London, 1937), pp. 27 and 203, n. 31, Stella Kramrisch has mistaken the bearing of the passage: "to paint with colors on space" is a proverbial expression implying "to attempt the impossible" or "effort made in vain," as, for example, in M 1.127, where it is pointed out that a man cannot paint in colors on space, because "space is without form or indication." What Asanga is saying is that to think of any representation of the transcendent Principle as it is in itself is no more than an idle dream; the representation has a merely temporary value, comparable to that of the ethical raft in the well-known parable (M 1.135).

erence equally to verbal and visual imagery, the Buddha is made to say that the metaphorical expression "is adduced by way of illustration . . . because of the great infirmity of babes . . . I teach as does the master painter or his pupil who disposes his colors for the sake of a picture, which picture is not to be found in the colors, nor in the ground, nor in the environment. It is only to make it attractive to[8] creatures that the picture is contrived in color: what is literally taught is impertinent; the Principle eludes the letter.[9] In taking up a stand amongst things,[10] what I really teach is the Principle as understood by the Contemplatives:[11] a spiritual reversion evading every form of thought. What I teach is not a doctrine for babes, but for the Sons of the Conqueror. And just as whatever I may see in a diversified manner has no real being, so is the pictorial doctrine communicated in a manner irrelevant. Whatever is not adapted to such and such persons as are to be taught cannot be called a 'teaching.' . . . The Buddhas indoctrinate beings according to their mental capacity."[12] That is as much as to say with St. Paul, "I have fed you with milk and not with meat: for hitherto ye were not able to bear it, neither yet now are ye able" (1 Cor. 3:2): "Strong meat belongeth to them that are of full age" (Heb. 5:14).

It is only one who *has* attained to an immediate Gnosis that can afford to dispense with theology, ritual, and imagery: the Comprehensor has

It is, nevertheless, as the Sādhanas express it, against a background of "space in the heart" that the picture "not in the colors" must be imagined, just as also Śaṅkarācārya's "world-picture" (the intelligible cosmos seen in the *speculum aeternum*) is "painted by the Spirit on the canvas of the Spirit." And because the picture has been thus imagined as an appearance manifested over against an *infinite* ground, the picture (of Amida, for example) painted in actual colors and on canvas stands out against an analogous background of *indefinite* extent.

[8] *Karṣaṇārthāya*: the notion coincides with the Platonic and Scholastic concept of the *summoning* quality of beauty. Cf. *Mathnawi* 1.2770, "The picture's smiling appearance is for your sake; in order that by means of that picture the reality may be established."

[9] "Eludes" is precisely Dante's "s'asconde sotto." "Speech does not attain to truth; but mind ($\nu o \hat{v}_s = manas$) has mighty power, and when it has been led some distance on its way by speech, it attains to truth" (Hermes 1.185).

[10] I.e., in being born, and consequently in using material figures, speaking parabolically, etc.

[11] *Tattvam yoginām*: cf. RV x.85.4, "Of whom the Brahmans understand as Soma, none ever tastes, none tastes who dwells on earth," and AB vii.31, "It is metaphysically (*parōkṣeṇa*) that he obtains the drinking of Soma, it is not literally (*pratyakṣam*) partaken of by him."

[12] *Laṅkāvatāra Sūtra* ii.112–114.

found what the Wayfarer is still in search of. This has too often been misinterpreted to mean that something is deliberately withheld from those who are to depend on means, or even that means are dispensed to them as if with intent to keep them in ignorance; there are those who ask for a sort of universal compulsory education in the mysteries, supposing that a mystery is nothing but a communicable, although hitherto uncommunicated, secret and nothing different in kind from the themes of profane instruction. So far from this, it is of the essence of a mystery, and above all of the *mysterium magnum*, that it cannot be communicated, but only realized:[13] all that can be communicated are its external supports or symbolic expressions; the Great Work must be done by everyone for himself. The words attributed to the Buddha above are in no way contradictory of the principle of the open hand (*varada mudrā*) or expository hand (*vyākhyāna mudrā*). The Buddha is never ineloquent: the solar gates are not there to exclude, but to admit; no one can be excluded by anyone but himself. The Way has been charted in detail by every Forerunner, who *is* the Way; what lies at the end of the road is not revealed, even by those who have reached it, because it cannot be told and does not appear: the Principle is not in any likeness.

Of what sort are, then, the most appropriate and efficacious supports of contemplation? It would scarcely be possible to cite an authoritative Indian text condemning explicitly the use of anthropomorphic as distinguished from aniconic images. There is, however, one Buddhist source, that of the *Kālinga-bodhi Jātaka*, in which what must have been the early position is still clearly reflected. The Buddha is asked by what kind of hallow, shrine, or symbol (*cetiya*)[14] he can properly be represented in his

[13] "This sort of thing cannot be taught, my son; but God, when he so wills, recalls it to our memory" (Hermes, *Lib.* xiii.2).

[14] *Cetiya, caitya,* are generally derived from *ci,* "to pile up," originally used in particular connection with the building of a fire-altar or funeral pile, and this is not without its significance in connection with the fact to be discussed below that the Buddha image really inherits the values of the Vedic altar. But as the Jātaka itself makes clear, a *caitya* is by no means necessarily a stūpa nor anything constructed, but a symbolic substitute of any sort to be *regarded as* the Buddha in his absence. There must be assumed at least a hermeneutic connection of *ci,* "to edify," with the closely related roots *ci* and *cit,* to regard, consider, know, and think of or contemplate; it is, for example, in this sense that *cetyah* is used in RV vi.1.5, "Thou, O Agni, our means-of-crossing-over, *art-to-be-known-as* man's eternal refuge and father and mother," all of which epithets have, moreover, been applied also to the Buddha. In ŚB vi.2.3.9 it is explicit that *citi* ("platform," \sqrt{ci}) is so called because of having been "seen in meditation" (*cetayamāna,* \sqrt{cit}). The fires "within you," of which the external altar fires are only the supports, are "intellectually piled,"

absence. The answer is that he can properly be represented by a Bodhi tree[15] (a *paribhoga-cetiya*, Mhv 1.69), whether during his lifetime or after the Despiration, or by bodily relics after his Decease; the "indicative" (*uddesika*)[16] iconography of an anthropomorphic image is condemned

or "wisdom-piled" (*manasācitaḥ, vidyācitaḥ,* √*ci,* ŚB x.5.3.3 and 12). Cf. "*Cetiya*" in Coomaraswamy, "Some Pāli Words" [in Vol. 2 of this selection—ED.] with further references; and Coomaraswamy, "*Prāṇa-citi,*" 1943.

The assimilation of *ci* to *cit*, in connection with an operation of which the main purpose is to "build up" the sacrificer himself, whole and complete, has a striking parallel in the semantic development of "edify," the "edifice" having been originally a hearth (*aedes*) and the cognate Greek and Sanskrit roots αἴθω and *idh*, to kindle. The hearth, which is an altar as much as a fireplace, establishes the home (as in ŚB VII.1.1 and 4). So just as *aedes* becomes "house," so "to edify" is in a more general sense "to build," the meaning "to build up spiritually" preserving the originally sacred values of the hearth. Also parallel to "edify" and *idh* is the Pāli *samuttejati,* literally "sets on fire" by means of an "edifying" discourse (D II.109, etc.), no doubt with ultimate reference to the "internal Agnihotra" in which the heart becomes the hearth (ŚB x.5.3.12, ŚA x; S I.169).

[15] This is not, of course, an exclusively Buddhist position. The Vedas already speak of a Great Yakṣa (Brahman) moving on the waters in a fiery flowing at the center of the universe in the likeness of a Tree (AV x.7.32), and this Burning Bush, the Single Fig, is called in the Upaniṣads the "one Awakener" (*eka sambodhayitṛ*) and everlasting support of the contemplation of Brahman (*dhiyālamba,* MU VII.11). In ŚA XI.2 the spirant Brahman is "as it were a great green tree, standing with its roots moistened." [Cf. Mhv 1.69.]

[16] Cf. Coomaraswamy, *Elements of Buddhist Iconography,* pp. 4–6. I now render *uddesika* by "indicative" in view of the discussion by Louis de la Vallée Poussin in HJAS II (1937), 281–282. From the passage which he cites in the *Yogaśāstra* of Asanga it is clear that the *uddiśya* means "indicative of the Buddha"; the examples given of such indicative symbols are "stūpa, building, and ancient or modern shrine." If it was only later that *uddesika cetiya* came also to mean "Buddha image" (*tathāgata paṭimā*), this would mean that the Jātaka takes no account at all of Buddha images; alternatively, Buddha images must be held to have been deprecated with other indicative symbols as "arbitrary." The pejorative sense of *anudissati,* "points at," may be noted in D II.354. The net result, that Buddha images were either ignored, or condemned, suffices for our purposes, the demonstration of the trace of an originally aniconic attitude.

The Buddhist iconoclastic position is curiously like that of Sextus Empiricus (*Adversus dogmaticos* II.146 ff.), who distinguishes "commemorative" (ὑπομνηστικόν) from "indicative" (ἐνδεικτικόν) signs and rejects the latter on the ground that the former are, or have been seen, in intimate association with the things of which they remind us, while for the latter there is no way of demonstrating that they mean what they are said to mean. One may honor the memory of the human teacher that was, but it was and still is only in the Dhamma, his doctrine, that he can really be seen; cf. the story of Vakkali's excessive attachment to the Buddha's visible form, cited in Coomaraswamy, "*Saṃvega*: Aesthetic Shock" [in this volume—ED.]. At the same time, it must not be overlooked that while Sextus Empiricus is a sceptic even in the modern sense, the Buddhist is *not* a "nothing-morist."

as "groundless and conceptual, or conventional" (*avatthukam manamatta-kam*). It will be seen that the wording corresponds to that of the Brāh-maṇa as cited above: *manamattakam = manomatam*.

Before we proceed to ask how it could have been that an anthropo-morphic image was accepted after all, we must eliminate certain con-siderations extraneous to the problem. It must be realized, in the first place, that although an iconoclastic problem is present, it was as a matter of convenience, and without reference to any supposed possibility of a real localization[17] or fetishism that the advent of the image can be said to have been "postponed," and also as a matter of convenience that the image was realized when a need had been felt for it; and in the second place, that the resort to an anthropomorphic imagery by no means im-plies any such humanistic or naturalistic interests as those which led to the subordination of form to figure in European art after the Middle Ages, or in Greek art after the sixth century B.C. The question of locali-zation has been fundamentally misunderstood. If it is practically true that "the omnipresent Spirit *is* where it acts or where we are *attending* to it" (Bouquet, *The Real Presence*, p. 84), it is equally true that this "where" is *wherever* there is posited a center or duly set up an image or other symbol: the symbol can even be carried about from place to place. Not that the Spirit is therefore in one place more than another or can be carried about, but that we and our supports of contemplation (*dhiyā-lamba*) are necessarily in some one place or another. If the use of the symbol is to function mediately as a bridge between the world of local position and a "world" that cannot be traversed or described in terms of

[17] The question is one at the same time of localization and temporality. In modern Indian personal devotions it is typical to make use of an image of clay temporarily consecrated and discarded after use, when the Presence has been dismissed; in the same way the Christian church becomes the house of God specifically only after consecration and, if formally deconsecrated, can be used for any secular purpose without offense. The rite, like the temporal Nativity, is necessarily eventful; the temporal event can take place *anywhere*, just because its reference is to an intem-poral omnipresence. In any case, it is not a question of contradiction as between a "God extended in space" (Bouquet, *The Real Presence*, p. 52) and a special presence at a given point in space; extension in space is already a localization in the same sense that procession is an apparent motion. Of a God "in whom we live and move and have our being" we cannot say that He is in space as we are, but much rather that He *is* the "space" in which we are. But all Scripture employs a language in terms of time and space, adapted to our capacity; it is not only the visual image that must be shattered if this is to be avoided. The iconoclast does not always realize all the implications of his ideal: it cannot be said of anyone who still knows who he is that all his idols have been broken.

size, it is sufficiently evident that the hither end of such a bridge must be somewhere, and in fact wherever our edification begins: procedure is from the known to the unknown; it is the other end of the bridge that has no position.

By fetishism we understand an attribution to the physically tangible symbol of values that really belong to its referent or, in other words, a confusion of actual with essential form. It is a fetishism of this sort that the Buddhist texts deprecate when they employ the metaphor of the finger pointing to the moon, and ridicule the man who either will not or cannot see anything but the finger. The modern aesthetic approach makes fetishes of traditional works of art precisely in this sense. Our own attitude is indeed so naturally and obstinately fetishistic that we are shocked to find and unwilling to believe that it is taken for granted in Buddhism that "those who consider the earthen images, do not honor the clay as such, but without regard to them in this respect, honor the Immortals designated" (*amarasaṃjñā, Divyāvadāna*, ch. 26). Plato in the same way distinguishes "soulless images" from the "ensouled gods" that they represent; "and yet we believe that when we worship the images, the gods are kindly and well-disposed towards us" (*Laws* 931A). So in Christian practice "honor is paid, not to the colors or the art, but to the prototype" (St. Basil, *De spir. sanct.* c. 18, cited in the *Hermeneia* of Athos), and "we make images of the Holy Beings to commemorate and honor *them*" (Epiphanius, Fr. 2), cf. Plotinus, *Enneads* IV.3.11. "How bold it is to embody the bodiless! Nevertheless, the icon conducts us to the intellectual recollection of the Celestials" (*Greek Anthology* 1.33).

As regards the second point, it will suffice to say that "anthropomorphic" in the sense in which this word is appropriate to Indian images does not import "naturalistic"; the Buddha image is not in any sense a portrait, but a symbol; nor indeed are there any Indian images of any deity that do not proclaim by their very constitution that "this is not the likeness of a man"; the image is devoid of any semblance of organic structure; it is not a reflection of anything that has been physically seen, but an intelligible form or formula. Even the canons of proportion differ for gods and men.[18]

[18] The image in pigment or stone, "indicative" of the Buddha, is as much an image of (and as little in the nature of) the god "whose image it is" as is the image in flesh or in words: each is "a sensible god in the likeness of the intelligible god" (εἰκὼν τοῦ νοητοῦ [θεοῦ] θεὸς αἰσθητός, Plato, *Timaeus* 92). We need not shrink from the implied identification of the *aparinibbuto* Tathāgata with ὁ κόσμος οὗτος, in the sense that the universe is his *body*.

Even at the present day there survives in India a widespread use of geometrical devices (*yantra*) or other aniconic symbols as the chosen supports of contemplation. If, in the last analysis, the intellectual has always preferred the use of abstract and algebraical or vegetable or therio-morphic or even natural symbols, one cannot but be reminded of the position of Dionysius, to whom it likewise appeared more fitting that divine truths should be expounded by means of images of a less rather than a more noble type in themselves (the noblest type in itself being that of humanity): "For then," as St. Thomas follows, "it is clear that these things are not literal descriptions of divine truths, which might have been open to doubt had they been expressed under the figure of nobler bodies, especially for those who could think of nothing nobler than bodies" (*Sum. Theol.* 1.1.9). What the Buddha anticipated was not that the figure in stone could ever have been worshiped literally as such, but that he might come to be thought of as a man, who denied of himself that he was "either a man, or a god, or a daimon," as one amongst others, and had not in fact "become anyone." He prognosticated precisely such a humanistic interpretation of the "life" as that which leads the modern scholar to attempt to disengage a "historical nucleus" by the elimination of all "mythical elements," and to repudiate any attribution of omniscience to him to whom the designation "Eye in the World" was appropriate. It is just those "who can think of nothing nobler than bodies"[19] who in modern times have discovered in the incarnate Deity, Christian or Bud-dhist, nothing but the man; and to these we can only say that this "his manhood is a hindrance so long as they cling to it with mortal pleasure" (Eckhart).

The iconolatrous position developed in India from the beginning of the Christian era onward is apparently in contradiction of that which has been inferred in the *Kālinga-bodhi Jātaka*. It is, however, the icono-clastic position, that of Strzygowski's "Mazdaean" and "Northern" art, that still determined the abstract and symbolic nature of the anthropo-morphic image and can be said to account for the fact that a naturalistic development had never taken place in India until the idea of representa-tion was borrowed from Europe in the seventeenth century. The fact that

[19] A remarkable anticipation of the Renaissance point of view. "Coming events cast their *shadows* before." "Through familiarity with bodies one may very easily, though very hurtfully, come to believe that all things are corporeal" (St. Augustine, *Contra academicos* xvii.38); one may, as Plutarch said, being so preoccupied with obvious "fact" as to overlook the "reality," confuse Apollo with Helios (*Moralia* 393D, 400D, 433D), "the sun whom all men see" with "the Sun whom few know with the mind" (AV x.8.14).

the *Śukranītisāra* condemns portraiture at the same time that it extols the making of divine images very well illustrates how the Indian consciousness has been aware of what has been called "the ignominy implicit in representational art"—an ignominy closely related to that of an obsession with the historical point of view, to which in India the mythical has always been preferred. The parallels between the Indian and Christian artistic development are so close that both can be described in the same words. If, as Benjamin Rowland justly remarks, "With the sculptures of Hadda and the contemporary decoration of the monasteries at Jaulian (Taxila), the Gandhāra school properly so-called is at an end. Counter currents of influence from the workshops of Central and Eastern India have almost transformed the Indo-Greek Buddha image into the ideal norm for the representation of Sakyamuni that prevailed at Mathura and Sarnath and Ajanta,"[20] it can only have been because a sense of the unsuitability of any would-be humanistic style had been felt; an idea of the "Buddha type" had already been formed, "but the Hellenistic ideal of representation, the engrained, debased, and commonplace naturalism of a millennium, was incapable of achieving it. Hence the excessive rarity [in India proper] of the Greek type of Christ [Buddha], and the prompt substitution of the Semitic [Indian]."[21] A further parallel can be pointed out in the effects of the European iconoclasm on the nature of Byzantine art: "The chief outcome of the controversy was the formulation of a rigid iconography, which sufficed to prevent, once and for all, any backsliding towards meaningless naturalism. The picture, the human representation, was designed henceforth as an illustration of Reality, and as a vehicle of the deepest human emotions. . . . In this elevation of art to its highest function, though at the price of the artist's freedom, the iconodule defence, raised by the controversy to a high philosophical level, also played a part. . . . This was the chief iconodule contention: that pictures, like statues to Plotinus [iv.3.11], were an effective means of communication with the extra-terrestrial universe.[22] . . . The concern of the artist was to evoke, through his pictures, not this world, but the other . . . that he [the

[20] "A Revised Chronology of Gandhāra Sculpture," *Art Bulletin*, XVIII (1936), 400.

[21] Adapted from Robert Byron and David Talbot Rice, *The Birth of Western Painting* (London, 1930), p. 56, by addition of words in brackets.

[22] "In these outlines, my son, I have drawn a likeness (εἰκών) of God for you, as far as that is possible; and, if you gaze upon this likeness with the eyes of your heart (καρδίας ὀφθαλμοῖς, Islamic 'ayn-i-qalbī), then, my son, believe me, you will find the upward path; or rather, the sight itself will guide you on your way" (Hermes, *Lib.* iv.11b; cf. Hermes, *Asclepius* iii.37 f.).

beholder] might attain, through the reminder of these events, actual communion during life on earth with that firmament of divine arbitration of which the Latin Church taught only the post-human expectation."[23] These distinctions of the Byzantine from the Roman point of view are analogous to the differences between the Mahāyāna and Hīnayāna point of view, and between the more or less didactic art of Sāñcī and the epiphanies of Bamiyān, Ajaṇṭā, and Lung Men.

We do not know whether or not the deprecation of an "indicative" (*uddesika*) likeness which we have cited from the Jātaka is intended to refer to the old lists of *lakkhaṇas*, or thirty-two major and eighty minor iconographic peculiarities of the "Great Person." It must certainly have been in accordance with these prescriptions that a mental image of the Buddha had been entertained before any other image had been made; and equally certain that the validity of the images themselves has always been held to rest upon an accurate rendering of these peculiarities, or such of them as could be realized in any wrought material. For the Buddhist, iconography is art; that art by which he works. The iconography is at once the truth and the beauty of the work: truth, because this is the imitable form of the ideas to be expressed, and beauty because of the coincidence of beauty with accuracy, the Scholastic *integratio sive perfectio*, and in the sense in which a mathematical equation can be "elegant." As a Chinese inscription puts it, "I have sculptured a marvellous beauty . . . all of the iconographic peculiarities have been sublimely displayed" (Chavannes, *Mission archéologique*, 1.i.448). In the traditional view of art there is no beauty that can be divided from intelligibility; no splendor but the *splendor veritatis*.

The authenticity and legitimate heredity of Buddha images are established by reference to what are supposed to have been originals created in the Buddha's own lifetime, and either actually or virtually by the Buddha himself, in accordance with what has been said above with respect to an iconometric manifestation. The capacities of the artist exercised at empirical levels of reference have not sufficed for the dual operation of imagination and execution. The Buddha "cannot be apprehended"; what has been required is not an observation, but a vision. One is reminded of the fact that certain Christian images have been regarded

[23] Byron and Rice, *Birth of Western Painting*, pp. 67, 78. It was, in both cases, a matter of the recognition and endorsement of an older and originally neither Christian nor Buddhist, but universally solar, iconography and symbolism, rather than one of the invention of an iconography *ad hoc*.

in much the same way as "not made by hands" (ἀχειροποίητοι). It is of no importance from the present point of view that the legends of the first images cannot be interpreted as records of historical fact: what is important for us is that the authentication of the images themselves is not historical but ideal. Either the artist is transported to a heaven to take note there of the Buddha's appearance, and afterwards uses this model, or the Buddha himself projects the "shadow" or outlines of his likeness (*nimitta*), which the painters cannot grasp, but must fill in with colors, and animate[24] by the addition of a written "word," so that all is done "as prescribed" (*yathā saṃdiṣṭam, Divyāvadāna*, ch. 27); or finally, the image is made by an artist who, after the work has been done, reveals himself to have been in fact the future Buddha Maitreya.[25]

Interpreted thus, the iconography can no longer be thought of as a groundless product of conventional realization or idealization, but becomes an ascertainment; the form is not of human invention, but revealed and "seen" in the same sense that the Vedic incantations are thought of as having been revealed and "heard." There can be no distinction in principle of vision from audition. And as nothing can be said to have been intelligibly uttered unless in certain terms, so nothing can be said to have been revealed unless in some form.[26] All that can be thought of as prior to formulation is without form and not in any likeness; the meaning and its vehicle can only be thought of as having been concreated. And this implies that whatever validity attaches to the meaning attaches also to the symbols in which it is expressed; if the latter are in any way less inevitable

[24] We deliberately say "animate" because the inscription of an essential text (usually the formula *ye dharmā*, etc.) or the enclosure of a written text within the body of a metal or wooden image implies an eloquence, and it is far more literally than might be supposed that the words of a Chinese inscription, "the artist painted a *speaking* likeness" (Chavannes, *Mission archéologique*, I, 497), are to be understood. We have to alter only very slightly the Buddha's words, "He who sees the Word, sees Me," to make them read, "He who sees my Image, hears my Word."

[25] Samuel Beal, *Hsüan-tsang, Si-yu-ki; Buddhist Records of the Western World* (London, 1884) II, 121.

[26] We must avoid an artificial distinction of "terms" from "forms." The symbol may be verbal, visual, dramatic, or even alimentary; the use of material is inevitable. It is not the kind of material that matters. It is with perfect logic that the Buddhist treats the verbal and the visual imagery alike; "How could the Luminous Personality be demonstrated otherwise than by a representation of colors and iconographic peculiarities? How could the mystery be communicated without a resort to speech and dogma?" The sculptured figures of Buddhas and Bodhisattvas "furnish knowledgeable men with a means of raising themselves to the perfection of truth" (Chinese inscriptions, Chavannes, *Mission archéologique*, I, 501, 393).

than the former, the intended meaning will not have been conveyed, but betrayed.

We need hardly add that all that is said in the preceding paragraph has to do with the art in the artist, which is already an expression in terms, or idea in an imitable form, and holds good irrespective of whether or not any mimetic word has actually been spoken aloud or any image actually made in stone or pigment; if it is not historically true that any tangible image of the Buddha had been made before the beginning of the Christian era, it is equally certain that an essential image not made by hands had been conceived, and even verbally stated, in terms of the thirty-two major and eighty minor peculiarities of the "Great Person"; when the first image was to be made, there already existed the "ascertained means of operation." If, at last, the artist made a corresponding figure in stone or pigment, he was only doing what the Indian imager has always done, and in accordance with such familiar instructions as that of the *Abhilaṣitārthacintāmaṇi*, where the painter is told to "Put down on the wall what has been seen in contemplation (*tad dhyātam bhittau niveśayet*)." Even for Alfred Foucher, who held that the earliest Buddha images are those of the school of Gandhāra and the product of a collaboration between the Hellenistic artist and the Indian Buddhist patron, the prescription or concept of the work to be done was Indian; the Hellenistic artist performing only the servile operation, the Indian patron remaining responsible for the free act of imagination.[27] The sculptors of Mathurā, on the other hand, had at their command not only the visual image of the "Great Person" as defined in the Pāli texts, but also the tradition of the standing types of the colossal Yakṣas of the latter centuries B.C., and for the seated figure also a tradition of which the beginning must have antedated the Śiva types of the Indus Valley culture of the third millennium B.C. The Buddha image came into being because a need had been felt for it, and not because a need had been felt for "art."

THE practice of an art is not traditionally, as it is for us, a secular activity, or even a matter of affective "inspiration," but a metaphysical rite; it is not only the first images that are formally of superhuman origin. No

[27] We are more inclined to agree with Rowland that "the Gandhāra school came into existence only shortly before the accession of Kanishka in the second century of the Christian era" ("A Revised Chronology of Gandhāra Sculpture," p. 399), thus either making the earliest Gandhāran images and those of Mathurā almost contemporary, or giving some priority to the latter.

distinction can be drawn between art and contemplation. The artist is first of all required to remove himself from human to celestial levels of apperception; at this level and in a state of unification, no longer having in view anything external to himself, he sees and realizes, that is to say becomes, what he is afterwards to represent in wrought material. This identification of the artist with the imitable form of the idea to be expressed is repeatedly insisted upon in the Indian books, and answers to the Scholastic assumption as stated in the words of Dante, "no painter can paint a figure if he have not first of all made himself such as the figure ought to be."

The later artist is not, then, imitating the visual aspect or style of the first images, which he may never have seen, but their form; the authenticity of the later images does not depend upon an accidental knowledge (such as that by which our "modern Gothic" is built) but upon a return to the source in quite another sense. It is just this that is so clearly expressed in the legend of Udāyana's Buddha image, which is said to have flown through the air to Khotān (Beal, *Hsüan-tsang*, II, 322) and thus established the legitimacy of the lineage of Central Asian and Chinese iconography.[28] "Flight through the air" is always a technicality implying an independence of local position and ability to attain to whatever desired plane of apperception: a form or idea is "winged" in precisely the sense that, like the Spirit, it is wherever it operates or is entertained and cannot be a private property. What the legend tells is not that an image of stone or wood flew through the air; it tells us, nevertheless, that the Khotanese artist saw what Udāyana's artist had seen, the essential form of the first image: that same form which Udāyana's artist had seen before he returned to earth and took up the chisel or brush.

A distinction must then be very clearly drawn between an archaistic procedure, which involves no more than the servile operation of copying, and the repeated entertainment of one and the same form or idea in a manner determined by the mode or constitution of the knower, which is the free operation of the artist whose style is his own. The distinction is that of an academic from a traditional school of art, the former systematic, the latter consistent. That "Art has fixed ends and ascertained means of operation" asserts an immutability of the idea in its imitable form—that the sun, for example, is *always* an adequate symbol of the

[28] For an image called "Udāyana's" at Lung Men, see Chavannes, *Mission archéologique*, I, 392, and Paul Mus, "Le Buddha paré," BÉFEO, XXVIII (1928), 249.

Light of lights—but is not in any way a contradiction of another Scholastic dictum, that "To be properly expressed, a thing must proceed from within, moved by its form." It is because there is an endless *renewal* of the imaginative act that the artist's interior operation is properly spoken of as "free"; and the evidence of this freedom exists in the fact of a stylistic sequence always observable in a traditional art, followed from generation to generation; it is the academician that repeats the forms of "classic" orders like a parrot. The traditional artist is always expressing, not indeed his superficial "personality," but himself, having made himself that which he is to express, and literally *devoting* himself to the good of the work to be done. What he has to say remains the same. But he speaks in the stylistic language of his own time, and were it otherwise would remain ineloquent, for, to repeat the words of the *Laṅkāvatāra Sūtra* already cited, "Whatever is not adapted to the such and such persons as are to be taught, cannot be called a 'teaching.' "

It is not only the artist, but also the patron who *devotes* himself, not merely by the gift of his "substance" to defray the cost of operation, but also in a ritual, symbolical, and spiritual sense, just as the Christian who is not merely a spectator of the Mass but participates in what is enacted, sacrifices himself. It is the merit of Paul Mus to have recognized for the first time that the essential values of the Vedic sacrifice are inherited and survive in the later iconolatry; the royal patron, for example, donates precisely his own weight of gold to be made into an image, which image is also made at the same time in accordance with an ascertained canon or proportion and employs as modulus a measure taken from his own person; and when the image has been made, offers to it himself and his family, afterwards to be redeemed at a great price. It is in just the same way that the statue of the patron is literally built into the Vedic altar, and that the sacrificer himself is offered up upon the altar—"That sacrificial fire knows that 'He has come to give himself to me' " (*paridāṃ me*, ŚB 11.4.1.11). As Mus expresses it, "It is, in fact, well known that the construction of the fire-altar is a veiled personal sacrifice. The sacrificer *dies*, and it is only upon this condition that he reaches heaven: at the same time, this is only a temporary death, and the altar, identified with the sacrificer, is his substitute. We freely recognize an analogous significance in the identification of the king with the Buddha, and in particular in the manufacture of statues in which the fusion of the personalities is materially effected. It is less a question of apotheosis than of *devotio*. The king gives himself to the Buddha, projects his person into him, at the

same time that his mortal body becomes the earthly 'trace' of its divine model. . . . The artistic activity of India, as we have indicated, has always exhibited the trace of the fact that the first Brahmanical work of art was an altar in which the patron, or in other words the sacrificer, was united with his deity" (Mus, "Le Buddha paré," 1929, pp. *92, *94). If the deity assumes a human form, it is in order that the man, for his part, may put on the likeness of divinity, which he does metaphysically and as if to anticipate his future glorification. The inadequacy of the worship of any principle as other than oneself or proper spiritual essence is strongly emphasized in the Upaniṣads; and it may be called an established principle of Indian thought that "Only by becoming God can one worship Him" (*devo bhūtvā devam yajet*): it is only to one who can say, "I am the Light, Thyself," that the answer is given, "Enter thou, for what thou art I am, and what I am thou art" (JUB III.14).[29] The work of art is a devotional rite.

If the original artist and patron are thus devoted to and literally absorbed in the idea of the work to be done, which the artist executes and for which the patron pays, we have also to consider the nature of the act to be performed by those others for whose sake the work has also been done, among whom may be reckoned ourselves: the donor's inscriptions almost always indicating that the work has been undertaken not only for the donor's benefit or that of his ancestors, but also for that of "all beings." This will be more than a matter of mere aesthetic appreciation: our judgment, if it is to be the "perfection of art," that is, a consummation in use, must involve a reproduction. Or to put it in other words, if it is by their ideas that we judge of what things ought to be like, this holds good as much *post factum* as *a priori*. In order to understand the work we must stand where the patron and artist stood and we must have done as they did; we cannot depend upon the mere reactions of "our own unintelligent nerve ends." The judgment of an image is a contemplation, and as such can only be consummated in an assimilation. A transformation of our nature is required. It is in the same sense that Mencius says that to grasp the true meanings of words requires not so much a dictionary or a knowledge of epistemology as a rectification of personality. The *Amitāyur-Dhyāna Sūtra* is explicit: if you ask *how* is

[29] "If then you do not make yourself equal to God, you cannot apprehend God; for like is known by like" (Hermes, *Lib.* XI.2.20b). "But he that is joined unto the Lord is one spirit" (1 Cor. 6:17). Cf. Coomaraswamy, "The 'E' at Delphi" [in Vol. 2 of this selection—ED.].

one to behold the Buddha, the answer is that you have done so only when the thirty-two major and eighty minor characteristics (i.e., of the iconography) have been assumed in your own heart: it is your own heart that becomes the Buddha and is the Buddha (SBE, XLIX, 178). It is in the same sense that the words of an inscription at Lung Men are to be understood: "It is as if the summit of the mountain has been reached and the river traced to its source: the fruition is accomplished, and one rests upon the Principle" (Chavannes, *Mission archéologique*, p. 514). The aesthetic surfaces are by no means terminal values, but an invitation to a picture of which the visible traces are only a projection, and to a mystery that evades the letter of the spoken word.

The reader may be inclined to protest that we have been speaking of religion rather than of art: we say, on the contrary, of a religious art. One can speak of a "reduction of art to theology" (St. Bonaventura) just because in the traditional synthesis plastic art is as much as any literary form a part of the art of knowing God. The aesthetic experience empathetically realized and cognitive experience intuitively realized can be logically distinguished, but are simultaneous in the whole or holy man who does not merely feel but also understands. It is not at all that the value of beauty is minimized, but that the occasional beauty of the artifact is referred to a formal cause in which it exists more eminently; there is a transubstantiation of the image, in which there is nothing taken away from the participant, but something added.

ALL that has been said above applies as much to the literary narrative of the Buddha's "life" as to the iconographic representation of his "appearance"; just as the latter is not a portrait but a symbol, so the former is not a record of facts but a myth. The supernatural iconography is an integral part of the image, as are the miracles of the life; both are essential elements rather than accidental or adventitious accretions introduced for the sake of "effect."

We have no intention to explain away the miracles by a psychological analysis, any more than we propose to consider the art in its merely affective aspects. As regards the historicity of miracles, there is, of course, a fundamental divergence between the rationalist and traditional positions. The actual demonstration of a magical effect would upset the rationalist's entire philosophy: his "faith" would be destroyed if the sun should stand still at noon or a man walk on the water. For the traditionalist, on the other hand, magic is a science, but an inferior science about which he

feels no curiosity; the possibility of magical procedure is taken for granted, but regarded only as illustrating, and by no means as proving, the principles on which the exercise of powers depends.

It matters very little from the present point of view which of these positions we assume. Rationalist and fundamentalist fall together into the pit of an exclusively literal interpretation. Actually to discuss the historicity or possibility of a given miracle is far beside the main point, that of significance. We can, however, illustrate by a glaring example how the rationalistic, far more than the credulous point of view, can inhibit an understanding of the true intention of the work. The *Sukhāvatī-Vyūha* speaks of Buddhas as "covering with their tongue the world in which they teach"; just as in RV VIII.72.18 Agni's tongue—the priestly *voice*—"touches heaven." What Burnouf has to say in this connection is almost unbelievable: "This is an example of the incredible stupidities that can result from an addiction to the supernatural. . . . To speak of a sticking out of the tongue, and as the climax of the ridiculous also to speak of the vast number of assistant teachers who do the like in the Buddha's presence, is a flight of the imagination scarcely to be paralleled in European superstition. It would seem as though Northern Buddhists had been punished for their taste for the marvellous by the absurdity of their own inventions."[30] *Voilà le crétinisme scientifique dans toute sa béatitude!*[31] Contrast, however, what St. Thomas Aquinas has to say in a similar connection: "The tongue of an angel is called metaphorically the angel's power, whereby he manifests his mental concept. . . . The intellectual operation of an angel abstracts from *here and now*. . . . Hence in the angelic speech, local distance is no impediment" (*Sum. Theol.* 1.107.1 and 4).

We alluded above to a "flight through the air" of Udāyana's Buddha image from India to Khotān, which image became in fact, as Chavannes observes, the prototype of many others fashioned in Central Asia. We repeat, in the first place, that the very existence of an "Udāyana's image" made in the Buddha's lifetime is of the highest improbability. In the second place, what is really meant by "aerial flight" and "disappearance"?

[30] *Le Lotus de la bonne loi* (Paris, 1925), p. 417.

[31] L. Zeigler, *Überlieferung* (1936), p. 183. One cannot wonder that some Indians have referred to European scholarship as a crime. At the same time, the modern Indian scholar is capable of similar banalities. We have in mind Professor K. Chaṭṭopādhyāya, who considers RV x.71.4, where it is a question both of the audition and the vision of the Voice (*vāc*), proof of a knowledge of writing in the Vedic period—an example of intellectual myopia at least as dense as Burnouf's.

The ordinary Sanskrit expression for "to vanish" is *antar-dhānaṃ gam*, literally to "go-interior-position." In the *Kālinga-bodhi Jātaka*, flight through the air depends upon an "investiture of the body in the garment of contemplation" (*jhāna veṭhanena*). As Mus has very aptly remarked in another connection, "Tout le miracle résulte donc d'une disposition intime" ("Le Buddha paré," p. 435). It is not, then, a matter of physical translocation that is involved, but literally one of concentration; the attainment of a center that is omnipresent, and not a local motion. It is altogether a matter of "being in the Spirit," as this expression is used by St. Paul: that Spirit (*ātman*) of whom it is said that "seated, he fares afar, recumbent he goes everywhere" (KU II.21).[32] Of what importance in such a context can be a discussion of the possibility or impossibility of an actual levitation or translocation? What is implied by the designation "mover-at-will" (*kāmācārin*) is the condition of one who, being in the Spirit, no longer needs to move at all in order to be anywhere. Nor can any distinction be made between the possible intellect and the ideas it entertains *in adaequatione rei et intellectus*: to speak of an intellectual omnipresence is to speak of an omnipresence of the forms or ideas which have no objective existence apart from the universal intellect that entertains them. The legend does not refer to the physical transference of a material image, but to the universality of an immutable form that can be seen as well by the Khotanese as by the Indian contemplative; where the historian of art would see what is called the "influence" of Indian on Central Asian art, the legend asserts an independent imagination of the same form. It will be seen that we have not had in view to explain away the miracle, but to point out that the marvel is one of interior disposition, and that the power of aerial flight is nothing like an airplane's, but has to do with the extension of consciousness to other than physical levels of reference and, in fact, to the "summit of contingent being."[33]

[32] Hermes, *Lib.* XI.2.19: "All bodies are subject to movement; but that which is incorporeal is motionless, and the things situated in it have no movement. . . . Bid your soul travel to any land you choose, and sooner than you can bid it go, it will be there . . . it has not moved as one moves from place to place, but it *is* there. Bid it fly up to heaven, and it will have no need of wings." RV VI.9.5: "Mind (*manas*, νοῦς) is the swiftest of birds"; PB XIV.1.13: "The Comprehensor is winged (*yo vai vidvāṃsas te pakṣiṇaḥ*)."

[33] "For man is a being of divine nature . . . and what is more than all besides, he mounts to heaven without quitting the earth; to so vast a distance can he put forth his power" (Hermes, *Lib.* X.24b).

Consider another case, that of "walking on the water,"[34] a power attributed to some, alike in the Hindu, Buddhist, Christian, and Taoist, and very likely many other traditions. We do infer that such a thing can be done, but are not at all curious as to whether it was or was not done upon a given occasion; that we leave to those who suppose that the Vedic Bhujyu was actually picked up from the physical ocean by a passing "tramp." The matter of interest is one of significance. What does it mean that this power has been universally attributed to the deity or others in his likeness? To speak of a motion at will on the face of the waters is to speak of a being all in act, that is, to speak of the operation of a principle wherein all potentiality of manifestation has been reduced to act. In all traditions "the waters" stand for universal possibility.

The direct connection between the symbolic myth and mythical symbol can nowhere be illustrated better than in this context. For if the Buddha is invariably represented iconographically as supported by a lotus, his feet never touching any physical or local earth, it is because it is the idiosyncrasy of the lotus flower or leaf to be at rest upon the waters; the flower or leaf is universally, and not in any local sense, a ground on which the Buddha's feet are firmly planted. In other words, all cosmic, and not merely some or all terrestrial, possibilities are at his command. The ultimate support of the lotus can also be represented as a stem identical with the axis of the universe, rooted in a universal depth and inflorescent at all levels of reference, and if in Brahmanical art this stem springs from the navel of Nārāyaṇa, the central ground of the Godhead recumbent on the face of the waters, and bears in its flower the figure of Brahmā (with whom the Buddha is virtually identified), the universality of this symbolism is sufficiently evident in the Stem of Jesse and in the symbolic representation of the Christian Theotokos by the rose. The expression *rose des vents*, a compass card, and Dante's "quant' è la larghezza di questa rosa nell' estreme foglie" (*Paradiso* xxx.116–117) illustrate the cor-

[34] For the history of the symbol see W. Norman Brown, *Indian and Christian Miracles of Walking on the Water* (Chicago, 1928), and Arthur Waley, *The Way and Its Power* (London, 1934), p. 118. The form of the Hermetic statements, "But from the Light there came forth a holy Word (λόγος = *śabda brahman, uktha*) which took its stand upon the watery substance . . . [earth and water] were kept in motion, by reason of the spiritual (πνευματικός = *ātmanvat*) Word which moved upon the face of the water" (Hermes, *Lib.* 1.8b, 5b), although perhaps dependent on Genesis, is especially significant in its use of the expression "took its stand"; cf. *adhitiṣṭhati*, as predicated of the *ātman* in the Upaniṣads, *passim*.

respondence of rose and lotus in their spatial aspects: cf. MU vi.2, where the petals of the lotus are the points of the compass: directions, that is, of indefinite extension. We need hardly say that the universality and consistent precision of an adequate symbolism do not preclude an adaptability to local conditions and do not depend on the identification of botanical species.[35]

Now this significance of the lotus to which we have referred is inseparably bound up with the problem of Buddhist representation in plastic art. If we take the mythical symbol literally, as the modern Indian artist has sometimes done, we get a picture of what is no longer formally but figuratively a man supported by what is no longer a ground in principle but by what A. Foucher calls "the frail cup of a flower" (in "On the Iconography of the Buddha's Nativity," *Memoirs of the Archaeological Survey of India,* 1934, p. 13); the picture is reduced to absurdity, and we expect the "man" to fall into the "water" at any moment. The correspondence of the aesthetic surfaces to the picture not in the colors has been destroyed; the picture is no longer beautiful, however skilfully executed, precisely because it has been robbed of meaning. It is a case in point of the principle that beauty cannot be divided from truth, but is an aspect of truth.

It has been a fundamental error of modern interpretation to have thought of Buddhist symbolism both as *sui generis* and as conventional, in the sense that Esperanto can be called a conventional language. That is what symbols seem to *us* to be, who are accustomed to the "symbolism," or rather "expressionism," of poets and artists who speak individually in terms of their own choice, which terms are often obscure but are nevertheless sometimes taken over into current usage. It is from these points of view that Foucher can think that he is "able to observe retrospectively the old image-maker's increasingly bold attempts," and opines that elephants "naturally came to take their stand on lotuses . . . a kind of specific detail subsequently added . . . the superstition of precedent alone prevented them from going further" (*ibid.*). Had he remembered that the Vedic Agni is born in and supported by a lotus, he would surely have asked, "How could man have imagined that a fire could have been kindled on the frail cup

[35] For a fuller discussion of the lotus, see Coomaraswamy, *Elements of Buddhist Iconography,* 1935. Cf. the Egyptian representations of Horus on the lotus, of which Plutarch says that "they do not believe that the sun rises as a new-born babe from the lotus, but they portray the rising of the sun in this manner to show darkly (αἰνιττόμενοι) that his birth is a kindling (ἄναψις) from the waters" (*Moralia* 355c), even as Agni is born.

of a flower in the midst of the waters?" He does protest, in fact, that "Had not the lotus filled from the beginning all the available space, no one would ever have dreamt of using the frail cup of a flower as a support for an adult human being" (*ibid.*).[36]

This is to remove the symbols altogether from their traditional context and values and to see in an art of ideas merely an idealizing art. The modern view of symbols is, in fact, bound up with the modern theory of a "natural religion," invoked by some in explanation of the "evolution" of all religions and by others in explanation of all but the Christian religion. But from the point of view of the tradition itself, Brahmanism is a revealed religion, that is to say, a doctrine of supernatural origin; a revelation, then, in terms of an adequate symbolism, whether verbal or visual, in the same sense that Plato speaks of the first Denominator as a "more than human Power" and of the names given in the beginning as necessarily "true names." Whatever we think of this,[37] the fact remains that symbolism is of an immemorial antiquity, an antiquity as great as that of "folklore" itself; many of the Vedic symbols, that of the tracking of the Hidden Light by its footprints, for example, imply a hunting culture antecedent to the beginning of agriculture. The commonest word for "Way," Skr. *mārga*, Pāli Buddhist *magga*, derives from a root *mṛg* "to hunt," and implies a "following in the tracks of." In any case, the Indus Valley peoples, three thousand years B.C., already made use of "symbols, such as the *svastika*, that India has never relinquished. Dare we think that the

[36] That "the lotus filled from the beginning all the available space" is for Foucher merely a fact of iconography and in this sense a "superstitious precedent." The words are true, however, in this far deeper and more original sense—that *in the beginning there was no other space*, and as it was in the beginning it is now and ever shall be because the lotus is the symbol and image of all spatial extension, as stated explicitly in MU VI.2, "What is the lotus and of what sort? What this lotus is is Space, forsooth; the four quarters and four inter-quarters are its constituent petals." The "precedent" is primarily metaphysical and cosmic, and *therefore also* iconographic.

[37] The notions of a "revelation" and Philosophia Perennis (Augustine's "Wisdom uncreate, the same now as it ever was, and the same to be for evermore," *Confessions* IX.10) are, of course, anathema to the modern scholar. He prefers to say that the Vedic hymns "contain the rudiments of a far higher species of thought than these early poets could have dreamt of . . . thought which has become final for all time in India, and even outside of India" (Maurice Bloomfield, *The Religion of the Veda*, New York, 1908, p. 63). It is true that the writer has here in mind an evolution of thought, but just how *does* the Vedic poet formulate "a far higher species of thought than he could have dreamt of"? It is as much as to say that man accomplished what man cannot do. But it is rather unlikely that Bloomfield really meant to support a doctrine of verbal inspiration.

spirituality of Indian art is as ancient as the Indus civilization? If so, we may never hope to penetrate the secret of its origin" (W. Norman Brown, in *Asia*, May 1937, p. 385).

Symbolism is a language and a precise form of thought; a hieratic and a metaphysical language and not a language determined by somatic or psychological categories. Its foundation is in the analogical correspondence of all orders of reality and states of being or levels of reference; it is because "This world is in the image of that, and vice versa" (AB vIII.2, and KU IV.10) that it can be said *Coeli enarrant gloriam Dei.*

The nature of an adequate symbolism could hardly be better stated than in the words "the parabolical (Skr. *parōkṣa*) sense is contained in the literal (Skr. *pratyakṣa*)." On the other hand, "The sensible forms, in which there was at first a polar balance of physical and metaphysical, have been more and more voided of content on their way down to us: so we say, This is an 'ornament'" (W. Andrae, *Die ionische Säule*, Berlin, 1933, p. 65). It becomes, then, a question of the restoration of significance to forms that we have come to think of as merely ornamental. We cannot take up here the problems of symbolic methodology, except to say that what we have most to avoid is a subjective interpretation, and most to desire is a subjective realization. For the meanings of symbols we must rely on the explicit statements of authoritative texts, on comparative usage, and on that of those who still employ the traditional symbols as the customary form of their thought and daily conversation.[38]

Our present concern is not, however, so much with the methodology of symbolic exegesis as with the general nature of a typically symbolic art. We have spoken above of a transubstantiation, and the word has also been properly used by Stella Kramrisch in speaking of art of the Gupta period and that of Ajaṇṭā in particular, with reference to the coincidence in it of sensuous and spiritual values. Our primary error when we consider the Eucharist is to suppose that the notion of a transubstantiation represents any but a normally human point of view. To say that this is not merely bread but also and more eminently the body of God is the same as to say that a word is not merely a sound but also and more eminently a meaning: it is with perfect consistence that a sentimental and materialistic generation not only ridicules the Eucharistic transubstantiation, but also insists that the whole of any work of art subsists in its aesthetic surfaces, poetry consisting, for example, in a conjunction of pleasurable or interesting sounds rather than in a logically ordered sequence

[38] See Coomaraswamy, "The Rape of a Nāgī: An Indian Gupta Seal" [in this volume—ED.].

of sounds with meanings.[39] It is from the same point of view that man is interpreted only as a psychophysical being, and not as a divine image, and for the same reason that we laugh at the "divinity of kings." That we no longer admit an argument by analogy does not represent an intellectual progress; we have merely lost the art of analogical procedure or, in other words, ritual procedure. Symbolism[40] is a calculus in the same sense that an adequate analogy is proof.

In the Eucharistic sacrament, whether Christian, Mexican, or Hindu, bread and wine are "charged with meaning" (Bouquet, *The Real Presence*, p. 77): God is a meaning. The Vedic incantation (*brahman*) is physically a sound but superaudibly *the* Brahman. To the "primitive" man, first and foremost a metaphysician and only later on a philosopher and psychologist, to this man who, like the angels, had fewer ideas and used less means than we, it had been inconceivable that anything, whether natural or artificial, could have a use or value only and not also a meaning; this man literally could not have understood our distinction of sacred from profane or of spiritual from material values; he did not live by bread alone. It had not occurred to him that there could be such a thing as an industry without art, or the practice of any art that was not at the same time a rite, a going on with what had been done by God in the beginning. *Per contra*, the modern man is a disintegrated personality, no longer the child of heaven and earth, but altogether of the earth. It is this that makes it so difficult for us to enter into the spirit of Christian, Hindu or Buddhist art in which the values taken for granted are spiritual and only the means are physical and psychological. The whole purpose of the ritual is to effect a translation, not only of the object, but of the man himself to another and no longer peripheral but central level of reference. Let us consider a very simple case, in which, however, our fictitious distinctions of barbarism from civilization must be discarded. That neolithic man already called his celts and arrowheads "thunderbolts" is preserved in the memory of the folk throughout the world. When Śaṅkarācarya exclaimed, "I have learnt concentration from the maker of arrows," he may well have meant more than to say, "I have learnt from the sight of this man, so completely forgetful of himself in his concern for the good of the work to be done, what it means to 'make the mind one-pointed.'" He may also have had in mind what the initiated artisan and initiated

[39] Sentimentality and materialism, if not in every respect synonymous, coincide in the subject. Man in search of spirit has become Jung's "modern man in search of a soul" who discovers . . . spiritualism and psychology.

[40] Webster, "any process of reasoning by means of symbols."

archer[41] had been made aware of in the Lesser Mysteries, that an arrow made by hands is transubstantially the point of that bolt with which the Solar Hero and Sun of Men first smote the Dragon and pillared apart heaven and earth, creating an environment and dispelling the darkness literally with a *shaft* of light. Not that anybody need have thought that the man-made object had actually "fallen from heaven," but that the "arrow feathered with the solar eagle's feathers and sharpened by incantations" had been made to be not merely a thing of wood and iron, but at the same time, metaphysically, of another sort.[42] It is in the same way that the warrior, also an initiate, conceived himself to be not merely a man, but also in the image of the wielder of the bolt, the Thundersmiter himself. In the same way, the Crusader's sword was not merely a piece of iron or steel, but also a shard detached from the Cross of Light; and for him, *in hoc signo vinces* had neither exclusively a practical nor only a "magical" value; actually to strike the heathen foeman and to bring light into darkness were of the essence of a single act. It belonged to the secret of Chivalry, Asiatic and European, to realize oneself as—that is, metaphysically, to *be*—a kinsman of the Sun, a rider on a winged stallion or in a chariot of fire, and girded with very lightning. This was an imitation of God in the likeness of a "mighty man of war."

We could have illustrated the same principles in connection with any of the other arts than that of war; those, for example, of carpentry or weaving, agriculture, hunting, or medicine, or even in connection with such games as checkers—where the pawn that reaches the "farther shore" becomes a crowned king and is significantly called to this day in the Indian vernacular a "mover-at-will" (*kāmācārin*, already in the Upaniṣads the technical designation of the liberated man in whom the spiritual rebirth has been accomplished). The same holds good for all the activities of life, interpreted as a ritual performed in imitation of what was done in the beginning. This point of view in connection with sexual acts, sacrificially interpreted in the Brāhmaṇas and Upaniṣads, is, for example, essential to any understanding of the Tantric and Lamaistic Buddhist iconographies, or equally of the Krishna myths and their representation in art; the point of view survives in our own expression, "the sacrament of marriage." The bivalence of an image that has been ritually quickened by the invocation of Deity and by the "Gift of Eyes" is of the same kind.

[41] See Coomaraswamy, "The Symbolism of Archery," 1943. It is said that the last company of French archers was dissolved by Clemenceau, who objected to their possession of a "secret."

[42] For the cult and transubstantiation of weapons, cf. RV vi.47 and 75, and ŚB i.2.4.

In the same way relics are deposited in a stūpa and called its "life" (*jīvita*); the stūpa being, like the Christian altar and church, at once an embodiment and the tomb of the dying God. A formal presence of the altogether despirated Buddha, *Deus absconditus*, is thus provided for on earth: the veritable tomb in which the Buddha, himself a Nāga,[43] really lives, is *ab intra*, and guarded by Nāgas; the cult establishes a link between the outward facts and inward reality for the sake of those who are not yet "dead and buried in the Godhead." We indeed speak, although only rhetorically, of the "life" of a work of art; but this is only a folk memory and literally a "superstition" of what was once a deliberate animation metaphysically realized.

From the traditional point of view, the world itself, together with all things done or made in a manner conformable to the cosmic pattern, is a theophany: a valid source of information because itself in-formed. Only those things are ugly and ineloquent which are informal or deformed (*apratirūpa*). Transubstantiation is the rule: symbols, images, myths, relics, and masks are all alike perceptible to sense, but also intelligible when "taken out of their sense." In the dogmatic language of revelation and of ritual procedure this general language is reduced to a formulated science for the purposes of communication and transmission. It is more necessary that the doctrine should be transmitted forever, for the sake of those that have ears to hear—"such souls as are of strength to see"—than possible that everyone who plays a part in the transmission should also be a Comprehensor; and hence there is an adaptation in terms of folklore and fairy tale for popular transmission as well as a formulation in hieratic languages for sacerdotal transmission, and finally also an initiatory transmission in the Mysteries. It is equally true with respect to all of these transmissions that "Whereas in every other science things are signified by words, this science has the property, that the things signified by words have themselves also a signification. . . . The parabolical sense is contained in the literal" (*Sum. Theol.* 1.1.10); that "Scripture, in one and the same sentence, while it describes a fact, reveals a mystery" (St. Gregory, *Moralia* xx.1, in Migne, *Series latina*).

[43] The Buddha is sometimes referred to as a Nāga. In M 1.32, the *arhats* Mogallāna and Sāriputra are called "a pair of Great Serpents" (*mahānāgā*); at 1.144–145, the Nāga found at the bottom of an ant hill (considered as if a *stūpa*) is called a "signification of the monk in whom the foul issues have been eradicated"; in Sn 522, "Nāga" is defined as one "who does not cling to anything and is released" (*sabatta na sajjati vimutto*). Parallels abound on Greek soil, where the dead and deified hero is constantly represented as a snake within a conical tomb, and the chthonic aspect of Zeus Meilichios is similarly ophidian.

It is only in this way that the formality of the whole of traditional art and ritual, Christian, Buddhist, or other, can and must be understood; all of this art has been an applied art, never an art for art's sake; the values of use and meaning are prior to those of ornament. Aesthetic virtues, adequate relations of masses, and so forth, survive in the "art forms" even when their meaning has been forgotten; the "literary" values of Scripture and the "musical" values of the liturgy hold, for example, even for the "nothing-morist" (Skr. *nāstika*).[44] No doubt, our "feelings" about works of art can be psychologically or even chemically explained, and those who wish may rest content with knowing what they like and how they like it. But the serious student of the history of art, whose business it is to explain the genesis of forms and to judge of achievements without respect to preferences of his own, must also know what the artist was trying to do or, in other words, what the patron required.

We may have to admit that it is beyond the competence of the rationalist, as such, to understand Buddhist art. On the other hand, we are far from maintaining that in order to understand one must be a Buddhist in any specific sense; there are plenty of professing Buddhists and professing Christians who have not the least idea what Buddhist or Christian art is all about. What we mean is that in order to understand one must be not merely a sensitive man, but also a spiritual man; and not merely a spiritual, but also a sensitive man. One must have learned that an access to reality cannot be had by making a choice between matter and spirit considered as things unlike in all respects, but rather by seeing in things material and sensible a formal likeness to spiritual prototypes of which the senses can give no direct report.[45] It is not a question of religion versus science, but of a reality on different levels of reference, or better, perhaps, of different orders of reality, not mutually exclusive.

[44] *Nāstika*, one "who thinks 'there is naught beyond this world' *ayam loko nāsti para iti mānī*" (KU II.6), not realizing that "there is not only this much, but another than this *aitāvad enā anyad asti*" (RV x.31.8). If Buddhists themselves have sometimes been regarded as *nāstikas*, this has been because *anattā* has been misunderstood to mean "there is no Spirit"; the true Buddhist position is that it is only of "what is not the Spirit (*anattā; na me so attā*)," only of "life under these conditions," that it can be said that "there is [for the *arahant*] now no more (*nāparam*)," (S III.118). Cf. "Natthika," in "Some Pāli Words" [in Vol. 2 of this selection—ED.].

[45] The nature and use of "images" as supports of contemplation is nowhere more briefly or better stated than in *Republic* 510DE ("he who uses the visible forms and talks about them is not really thinking of them, but of those things of which they are the image"), a passage that may have been the source of St. Basil's well-known formula that "the respect that is paid to the image passes over to its archetype" (*De spiritu sancto* [Migne, *Series graeca*, Vol. 32], c.18; cf. Epiphanius, Fr. 2).

Saṃvega: Aesthetic Shock

The Pāli word *saṃvega* is often used to denote the shock or wonder that may be felt when the perception of a work of art becomes a serious experience. In other contexts the root *vij*, with or without the intensive prefix *sam*, or other prefixes such as *pra*, "forth," implies a swift recoil from or trembling at something feared. For example, the rivers freed from the Dragon, "rush forth" (*pra vivijre*, RV x.111.9), Tvaṣṭṛ "quakes" (*vevijyate*) at Indra's wrath (RV 1.80.14), men "tremble" (*saṃvijante*) at the roar of a lion (AV viii.7.15), birds "are in tremor" at the sight of a falcon (AV v.21.6); a woman "trembles" (*saṃvijjati*) and shows agitation (*saṃvegam āpajjati*) at the sight of her father-in-law, and so does a monk who forgets the Buddha (M 1.186); a good horse aware of the whip is "inflamed and agitated" (*ātāpino saṃvegino*, Dh 144); and as a horse is "cut" by the lash, so may the good man be "troubled" (*saṃvijjati*) and show agitation (*saṃvega*) at the sight of sickness or death, "because of which agitation he pays close heed, and both physically verifies the ultimate truth (*parama-saccam*, the 'moral')[1] and presciently penetrates it" (A ii.116). "I will proclaim," the Buddha says, "the cause of my dismay (*saṃvegam*), wherefore I trembled (*saṃvijitaṃ mayā*): it was when I saw peoples floundering like fish when ponds dry up, when I beheld man's strife with man, that I felt fear" (or "horror"), and so it went "until I saw the evil barb that festers in men's hearts" (Sn 935-938).[2]

The emotional stimulus of painful themes may be evoked deliberately when the will or mind (*citta*) is sluggish, "then he stirs it up (*saṃvejeti*) by a consideration of the Eight Emotional Themes" (*aṭṭha-saṃvega-*

[First published in the *Harvard Journal of Asiatic Studies*, vii (1943), this essay was later included in *Figures of Speech or Figures of Thought.*—ED.]

[1] The ultimate significance (*paramārtha-satyam*) as distinguished (*vijñātam*) from the mere facts in which it is exemplified (see PB x.12.5, xix.6.1; and CU vii.16.17 with Śaṅkarācārya's commentary).

[2] We also feel the horror; but do *we* see the barb when we consider Picasso's *Guernica*, or have we "desired peace, but not the things that make for peace"? For the most part, our "aesthetic" approach stands between us and the content of the work of art, of which only the surface interests us.

vatthūni) (birth, old age, sickness, death, and sufferings arising in four other ways); in the resulting state of distress, he then "gladdens³ (or thrills, *sampahanseti*, Skr. *hrs*, 'rejoice' etc.) it by the recollection of the Buddha, the Eternal Law, and the Communion of Monks, when it is in need of such gladdening" (Vis 135). A poignant realization of the transience of natural beauty may have the same effect: in the *Yuvañjaya Jātaka*, the Crown Prince (*uparājā*) "one day early in the morning mounted his splendid chariot and went out in all his great splendor to disport himself in the park. He saw on the treetops, the tips of the grasses, the ends of the branches, on every spider's web and thread, and on the points of the rushes, dewdrops hanging like so many strings of pearls." He learns from his charioteer that that is what men call "dew." When he returns in the evening the dew has vanished. The charioteer tells him that that is what happens when the sun rises. When the Prince hears this, he is "deeply moved" (*samvegappatto hutvā*), and he realizes that "the living constitution of such as we are is just like these drops of dew;⁴ I must be rid of disease, old age and death; I must take leave of my parents, and turn to the life of a wandering monk." And so it was that "using as support of contemplation simply a dewdrop (*ussāvabindum eva ārammanam katvā*) he realized that the Three Modes of Becoming (Conative, Formal, and Informal) are so many blazing fires. . . . Even as the dewdrop on blades of grass when the sun gets up, such is the life of men" (J IV.120–122).

Here it is a thing lovely in itself that provides the initial stimulus to reflection, but it is not so much the beautiful thing as it is the perception of its evanescence that induces recollection. On the other hand, the "shock" or "thrill" need not involve a recoil, but may be one of supersensual delight. For example, the cultivation of the Seven Factors of Awakening (to Truth), accompanied by the notion of the Arrest (of the vicious causes of all pathological conditions), of which the seventh is an

³ A learned preacher's discourse is said to convince (*samādapeti*), inflame (*samuttejeti*) and gladden (*sampahanseti*) the congregation of monks (S II.280). [*Samvega* is the distressful emotion at failure to attain *upekhā*, M I.186; *dhamma-samvegam* is "thrilled with righteous awe," *Therīgāthā* 211.]

⁴ The dewdrop is here, as are other symbols elsewhere, a "support of contemplation" (*dhiyālamba*). The whole passage, with its keen perception of natural beauty and of its lesson, anticipates the point of view that is characteristic for Zen Buddhism. For the comparison of life to a dewdrop (*ussāva-bindu*), cf. A IV.136–137.

Impartiality (*upekhā*)[5] that issues in Deliverance (*vossagga* = *avasarga*), "conduces to great profit, great ease, a great thrill (*mahā saṃvega*) and great glee" (S v.134).

In it there is "much radical intellection, leading to the full-awakening aspect of delight" (*pīti*) or "contentment (*tuṭṭhi*) with the flavor (*rasa*) of the chosen support of contemplation that has been grasped"; body and mind are flooded or suffused; but this joyous emotion, aftereffect of the shock, is a disturbance proper only to the earlier phases of contemplation, and is superseded by equanimity (Vis 135-145).

We are told that Brother Vakkali spent his days in gazing at the beauty of the Buddha's person. The Buddha, however, would have him understand that not he who sees his body, sees himself, but "only he who sees the Dhamma, sees Me"; he realizes that Vakkali will never wake up (*na . . . bujjhissati*) unless he gets a shock (*saṃvegan ālabhitva*); and so forbids Vakkali to follow him. Vakkali seeks to throw himself down from a mountain peak. To prevent this, the Buddha appears to him in a vision, saying, "Fear not, but come (*ehi*), and I shall lift you up." At this, Vakkali is filled with delight (*pīti*); to reach the Master, he springs into the air[6] and, pondering as he goes, he "discards the joyful emotion" and attains the final goal of Arahatta before he descends to earth at the Buddha's feet (DhA iv.118 f.). It will be seen that the transition from shock (that of the ban) to delight (that of the vision), and from delight to understanding, is clearly presented. Vakkali, at last, is no longer "attached" to the visual and more or less "idolatrous" experience; the aesthetic support of contemplation is not an end in itself, but only an index, and becomes a snare if misused.[7]

[5] The *upekkhaka* (*upa* + √*iks*) corresponds to the *preksaka* (*pra* + √*iks*) of MU ii.7, i.e., the divine and impartial "looker on" at the drama of which all the world, our "selves" included, is the stage.

[6] On levitation (lightness), see Coomaraswamy, *Hinduism and Buddhism*, 1943, n. 269, to which much might be added. Other cases of levitation occasioned by delight in the Buddha as support of contemplation occur in Vis 143-144; the same experience enables the experient to walk on the water (J ii.111). A related association of ideas leads us to speak of being "carried away" or "transported" by joy. In Matthew 14:27-28, the words "Be not afraid . . . Come" are identical with the Pali *ehi, mā bhayi* in the DhA context.

[7] "O take heed, lest thou misconceive me in human shape" (Rūmī, *Dīvān*, Ode xxv). Similarly, Meister Eckhart, "To them his [Christ's] manhood is a hindrance so long as they still cling to it with mortal pleasure"; and "That man never gets to the underlying truth who stops at the enjoyment of its symbol" (Evans ed., I, 186, 187;

So far, then, *saṃvega* is a state of shock, agitation, fear, awe, wonder, or delight induced by some physically or mentally poignant experience. It is a state of feeling, but always more than a merely physical reaction. The "shock" is essentially one of the realization of the implications of what are strictly speaking only the aesthetic surfaces of phenomena that may be liked or disliked as such. The complete experience transcends this condition of "irritability."

It will not, then, surprise us to find that it is not only in connection with natural objects (such as the dewdrop) or events (such as death) but also in connection with works of art, and in fact whenever or wherever perception (αἴσθησις) leads to a serious experience, that we are really shaken. So we read that "the man of learning (*paṇḍito = doctor*) cannot but be deeply stirred (*saṃvijjetheva*, i.e., *saṃvegaṃ kareyya*) by stirring situations (*saṃvejanīyesu ṭhānesu*). So may an ardent master monk, putting all things to the test of prescience, living the life of peace, and not puffed up, but one whose will has been given its quietus, attain to the wearing out of Ill": there are, in fact, two things that conduce to a monk's well-being, contentment, and spiritual continence, viz. his radical premise, and "the thrill that should be felt in thrilling situations" (Itiv 30). We see from this text (and from S v.134, cited above) that the "thrill" (*saṃvega*), experienced under suitable conditions, if it can still in some sense be thought of as an emotion, is by no means merely an interested aesthetic response, but much rather what we so awkwardly term the delight of a "disinterested aesthetic contemplation"—a contradiction in terms, but "you know what I mean."

Now there are, in particular, "four sightly places whereat the believing clansman should be deeply moved (*cattāri kula-puttassa dassanīyāni saṃve-*

cf. p. 194), and St. Augustine, "It seems to me that the disciples were engrossed by the human form of the Lord Christ, and as men were held to the man by a human affection. But he wished them to have a divine affection, and thus to make them, from being carnal, spiritual. . . . Therefore he said to them, I send you a gift by which you will be made spiritual, namely, the gift of the Holy Ghost. . . . You will indeed cease from being carnal, if the form of the flesh be removed from your eyes, so that the form of God may be implanted in your hearts" (*Sermo* CCLXX.2). The "form" of the Buddha that he wished Vakkali to see, rather than that of the flesh, was, of course, that of the Dhamma, "which he who sees, sees Me" (S III.120). St. Augustine's words parallel those of the *Prema Sāgara*, chs. 48 and 49, where Śrī Krishna, having departed, sends Udho with the message to the milkmaids at Brindāban that they are no longer to think of him as a man, but as God, ever immanently present in themselves, and never absent.

janīyāni ṭhānāni); they are those four in which the layman can say 'here the Buddha was born!' 'here he attained to the Total Awakening, and was altogether the Wake!' 'here did he first set agoing the incomparable Wheel of the Law!' and 'here was he despirated, with the despiration (*nibbāna*) that leaves no residuum (of occasion of becoming)!' . . . And there will come to these places believers, monks and sisters, and layfolk, men and women, and so say . . . and those of these who die in the course of their pilgrimage to such monuments (*cetiya*), in serenity of will (*pasanna-cittā*) will be regenerated after death in the happy heaven-world" (D II.141, 142, cf. A 1.136, II.120).

As the words *dassanīya* (*darśanīya*), "sightly," "sight-worthy," commonly applied to visible works of art (as *śravaṇīya*, "worth hearing" is said of audible works), and *cetiya*,[8] "monument," imply, and as we also know from abundant literary and archaeological evidence, these four sacred places or stations were marked by monuments, e.g., the still extant Wheel of the Law set up on a pillar in the Deer Park at Benares on the site of the first preaching. Furthermore, as we also know, these pilgrim stations could be substituted by similar monuments set up elsewhere, or even constructed on such a small scale as to be kept in a private chapel or carried about, to be similarly used as supports of contemplation. The net result is, then, that icons (whether "aniconic," as at first, or "anthropomorphic," somewhat later), serving as reminders of the great moments of the Buddha's life and participating in his essence, are to be regarded as "stations," at the sight of which a "shock" or "thrill" may and should be experienced by monk or layman.

Saṃvega, then, refers to the experience that may be felt in the presence of a work of art when we are struck by it, as a horse may be struck by a whip. It is, however, assumed that, like the good horse, we are more or less trained, and hence that more than a merely physical shock is involved; the blow has a *meaning* for us, and the realization of that meaning, in which nothing of the physical sensation survives, is still a part of the shock. These two phases of the shock are, indeed, normally felt together as parts of an instant experience; but they can be logically distinguished, and since there is nothing peculiarly artistic in the mere sensibility that all men and animals share, it is with the latter aspect of the

[8] On the different kinds of *cetiya*, and their function as substitutes for the visible presence of the *Deus absconditus*, see the *Kālinga-bodhi Jātaka* (J IV.228) and Coomaraswamy, "The Nature of Buddhist Art" [in this volume—ED.].

shock that we are chiefly concerned. In either phase, the external signs of the experience may be emotional, but while the signs may be alike, the conditions they express are unlike. In the first phase, there is really a disturbance, in the second there is the experience of a peace that cannot be described as an emotion in the sense that fear and love or hate are emotions. It is for this reason that Indian rhetoricians have always hesitated to reckon "Peace" (*śānti*) as a "flavor" (*rasa*) in one category with the other "flavors."

In the deepest experience that can be induced by a work of art (or other reminder), our very being is shaken (*saṃvijita*) to its roots. The "Tasting of the Flavor" that is no longer any one flavor is, as the *Sāhitya Darpaṇa* puts it, "the very twin brother of the tasting of God"; it involves, as the word "disinterested" implies, a self-naughting—*a semetipsa liquescere*— and it is for this reason that it can be described as "dreadful," even though we could not wish to avoid it. For example, it is of this experience that Eric Gill writes that "At the first impact I was so moved by the [Gregorian] chant . . . as to be almost frightened. . . . This was something alive . . . I knew infallibly that God existed and was a living God" (*Autobiography*, London, 1940, p. 187). I have myself been completely dissolved and broken up by the same music, and had the same experience when reading aloud Plato's *Phaedo*. That cannot have been an "aesthetic" emotion, such as could have been felt in the presence of some insignificant work of art, but represents the shock of conviction that only an intellectual art can deliver, the body blow that is delivered by any perfect and therefore convincing statement of truth. On the other hand, realism in religious art is only disgusting and not at all moving, and what is commonly called pathos in art generally makes one laugh. The point is that a liability to be overcome by the truth has nothing to do with sentimentality; it is well known that the mathematician can be overcome in this way, when he finds a perfect expression that subsumes innumerable separate observations. But this shock can be felt only if we have learned to recognize truth when we see it. Consider, for example, Plotinus' overwhelming words, "Do you mean to say that they have seen God and do not remember him? Ah no, it is that they see him now and always. *Memory* is for those who have forgotten" (Plotinus, iv.4.6). To feel the full force of this "thunderbolt" (*vajra*)[9] one must have had at least an inkling of what

[9] "The 'thunderbolt' is a hard saying that hits you in the eye (*vajram pratyakṣaniṣṭhuram*)," *Daśarūpa* 1.64; cf. Plutarch, *Pericles* 8, κεραυνὸν ἐν γλώσσῃ φέρειν, and St. Augustine's "O axe, hewing the rock!"

is involved in the Platonic and Indian doctrine of Recollection.[10] In the question, "did He who made the lamb make thee?" there is an incomparably harder blow than there is in "only God can make a tree," which could as well have been said of a flea or a cutworm. With Socrates, "we cannot give the name of 'art' to anything irrational" (*Gorgias* 465A); nor with the Buddhist think of any but significant works of art as "stations where the shock of awe should be felt."

[10] Cf. *Meno* 81c and *Phaedrus* 248c; CU vii.26.1 (*ātmanah smarah*); also Coomaraswamy, "Recollection, Indian and Platonic" [in Vol. 2 of this selection—ED.].

[*Addendum*: "Not all who perceive with the eyes the sensible products of art are affected alike by the same object, but if they know it for the outward portrayal of an archetype subsisting in intuition, *their hearts are shaken* (θορυβοῦνται, literally 'are troubled') and they recapture memory of that Original . . ." Plotinus, ii.9.16].

MEDIAEVAL ART AND
AESTHETICS

The Mediaeval Theory of Beauty

Ex divina pulchritudine esse omnium derivatur.
St. Thomas Aquinas

Each thing receives a μοῖρα τοῦ καλοῦ according
to its capacity.
Plotinus, *Enneads* 1.6.6, lines 32–33

INTRODUCTION

The present article is the first of a series in which it is intended to make
more readily accessible to modern students of mediaeval art the most
important sources for the corresponding aesthetic theory. The mediaeval
artist is, much more than an individual, the channel through which the
unanimous consciousness of an organic and international community
found expression; in the material to be studied will be found the basic
assumptions upon which his operation depended. Without a knowledge
of these assumptions, which embrace the formal and final causes of the
work itself, the student must necessarily be restricted to an investigation
of the efficient and material causes, that is, of technique and material;
and while a knowledge of these is indispensable for a full understanding
of the work in all its accidental aspects, something more is required for
judgment and criticism, judgment within the mediaeval definition de-
pending upon comparison of the actual or accidental form of the work
with its substantial or essential form as it preexisted in the mind of the
artist; because "similitude is said with respect to the form" (*Sum. Theol.*
1.5.4), and not with respect to any other and external object presumed
to have been imitated. It is, however, not merely for the sake of the pro-
fessed student of mediaeval Christian art that these studies have been
undertaken, but also because the Scholastic aesthetic provides for the
European student an admirable introduction to that of the East, and
because of the intrinsic charm of the material itself. No one who has once
appreciated the consistency of the Scholastic theory, the legal finesse of
its arguments, or realized all the advantages proper to its precise technical

189

terminology, can ever wish to ignore the patristic texts. Not only is the mediaeval aesthetic universally applicable and incomparably clear and satisfying, but also, at the same time that it is about the beautiful, it is beautiful in itself.

The modern student of "art" may be at first inclined to resent the combination of aesthetic with theology. This, however, belongs to a point of view which did not divide experience into independently self-subsistent compartments; and the student who realizes that he must somehow or other acquaint himself with mediaeval modes of thought and feeling had better accommodate himself to this from the beginning. Theology is itself an art of the highest order, being concerned with the "arrangement of God," and in relation to the mediaeval works of art stands in the position of formal cause, in ignorance of which a judgment of the art, otherwise than upon a basis of personal taste, remains impossible.

THE TRANSLATIONS

The Scholastic doctrine of Beauty is fundamentally based on the brief treatment by Dionysius the Areopagite[1] in the chapter of the *De divinis nominibus* entitled "De pulchro et bono." We therefore will commence with a translation of this short text made, not from the Greek, but from the Latin version of Johannes Saracenus, which was used by Albertus Magnus in his *Opusculum de pulchro*[2] (sometimes attributed to St. Thomas) and by Ulrich of Strassburg in the chapter of his *Summa de*

[This translation and commentary first appeared in the *Art Bulletin*, XVII (1935) and XX (1938), under the title "Mediaeval Aesthetic." The text given here is Coomaraswamy's revision for *Figures of Speech or Figures of Thought*, but the valuable introduction of the earlier version has been restored to it.—ED.]

[1] On Dionysius, see Darboy, *St. Denys l'aréopagite* (Paris, 1932), and C. E. Rolt, *Dionysius the Areopagite*, 2nd ed. (London, 1940), with bibliography.

[2] This rather inaccessible text can be consulted in (1) P. A. Uccelli, *Notizie storico-critiche circa un commentario inedito di S. Tommaso d'Aquino sopra il libro di S. Dionigi Dei Nomi Divini, la scienza e la fede*, Serie III, Vol. V (Naples, 1869), 338–369, where the authorship is discussed, the discussion being followed by the text "De pulchro et bono, ex commentario anecdoto Sancti Thomae Aquinatis in librum Sancti Dionysii De divinis nominibus, cap. 4, lect. 5" (pp. 389–459), and (2) in Sancti Thomae Aquinatis, *Opuscula selecta*, Vol. IV, opusc. xxxi, "De pulchro et bono," ex comm. S. Th. Aq. in lib. S. Dionysii *De divinis nominibus*, cap. 4, lect. 5 (Paris, n.d.).

The shorter commentary on the same text, also translated below, certainly by St. Thomas, occurs in *Sancti Thomae Aquinatis, Opera omnia* (Parma, 1864), as opusc. vii, cap. 4, lect. 5.

bono entitled "De pulchro," the translation of which forms the second text of the present series. Ulrich Engelberti of Strassburg, who died in 1277, was himself a pupil of Albertus Magnus.[3] Our translation is made from the Latin text edited and published by Grabmann[4] from manuscript sources; it adheres rather more closely to the original than does Grabmann's excellent German rendering. The same editor adds an introduction, one of the best accounts of mediaeval aesthetic that has yet appeared.[5]

Plato's doctrine of the relatively beautiful and of an absolute Beauty is most clearly stated in the *Symposium* 210E–211B:

"To him who has been instructed thus far in the lore of love (τὰ ἐρωτικά),[6] considering beautiful things one after another in their proper order, there will be suddenly revealed the marvel of the nature of Beauty, and it was for this, O Socrates, that all those former labors were undertaken. This Beauty, in the first place, is everlasting, not growing and decaying, or waxing and waning; secondly, it is not fair from one point

[3] Cf. Martin Grabmann, "Studien über Ulrich von Strassburg. Bilderwissenschaftlichen Lebens und Strebens aus der Schule Alberts des Grossen," in *Zeit. für kath. Theologie*, XXIX (1905), or in "Mittelalterliches Geistesleben," in *Abhandlungen zur Geschichte der Scholastik und Mystik*, 3 vols. (Munich, 1926).

[4] Martin Grabmann, "Des Ulrich Engelberti von Strassburg, O.Pr. (†1277) abhandlung De pulchro," in *Sitzb. Bayer. Akad. Wiss., Phil. . . . Klasse* (Munich, 1926), abh. 5.

[5] To the short bibliography in Coomaraswamy, *Why Exhibit Works of Art?*, 1943, p. 59, add: A. Dyroff, "Zur allgemeinen Kunstlehre des hl. Thomas," *Beiträge zur Geschichte der Philosophie des Mittelalters, Supplementband* II (Münster, 1923), 197–219; E. de Bruyne, "Bulletin d'esthétique," *Revue néoscolastique* (August 1933); A. Thiéry, *De la Bonté et de la beauté*, Louvain, 1897; L. Wencélius, "La philosophie de l'art chez les néo-scolastiques de langue française," *Études d'histoire et de philosophie publiées par la Faculté de Théologie Protestante de l'Université de Strasbourg*, No. 27 (Paris, 1932); J. Maritain, *Art and Scholasticism* (New York, 1931); J. Huré, *St. Augustin musicien* (Paris, 1924); W. Hoffmann, *Philosophische Interpretation der Augustinusschrift De arte musica* (Marburg, 1931).

Among these works, that of Dyroff is probably the best. Those of Maritain and de Bruyne are somewhat tendentious, and Maritain's seems to me to be tainted by modernism. Further references will be found in these works, and it is not our present intention to attempt a complete bibliography. It may be added that a sound modern and practical application of Scholastic doctrine as to beauty and workmanship will be found in the writings and works of Eric Gill.

[6] The theory or science of Love, in its social as well as in its spiritual significance and introductory to the higher "rites and mysteries" (*Symposium* 210A; cf. 188B), is represented typically in the Middle Ages (Provence, Dante, *les fidèles de l'amour*, courtly love), in Islam (Rūmī and the Sūfīs generally), and in India (Jayadeva, Vidyāpati, Bihārī, etc.). In this tradition the phenomena of love are the adequate symbols of initiatory teaching, to be distinguished from a merely erotic "mysticism."

of view and foul from another, or in one relation and in one place fair and at another time or in another relation foul, so as to be fair to some and foul to others . . . but Beauty absolute, ever existent in uniformity with itself, and such that while all the multitude of beautiful things participate in it, it is never increased or diminished, but remains impassible, although they come to be and pass away. . . . Beauty itself, entire, pure, unmixed . . . divine, and coessential with itself."

This passage is the source of Dionysius the Areopagite on the beautiful and Beauty in *De divinis nominibus*, cap. 4, lect. 5, which is in turn the subject of the commentaries by Ulrich Engelberti and St. Thomas Aquinas. The three texts are translated below.

1. *Dionysius the Areopagite*

The good is praised by sainted theologians as the beautiful and as Beauty; as delight and the delectable; and by whatever other befitting names are held to imply the beautifying power or the attractive qualities of Beauty. The beautiful and Beauty are indivisible in their cause, which embraces All in One. In existing things these are divided into "participation" and "participants"; for we call "beautiful" what participates in beauty;[7] and "beauty" that participation in the beautifying power which is the cause of all that is beautiful in things.

But the supersubstantial beautiful is rightly called Beauty absolutely, both because the beautiful that is in existing things according to their several natures is derived from it, and because it is the cause of all things being in harmony (*consonantia*) and of illumination (*claritas*); because, moreover, in the likeness of light it sends forth to everything the beautifying distributions of its own fontal raying; and for that it summons all things to itself. Hence, it is called καλόν as gathering all things several into one whole, and *pulchrum* as at the same time most beautiful and superbeautiful; ever existent in one and the same mode, and beautiful in one and the same way; neither created nor destroyed, nor increased nor diminished; nor beautiful in one place or at one time and ugly elsewhere or at another time; nor beautiful in one relation and ugly in another; nor here but not there, as though it might be beautiful for some and not for others; but as being self-accordant with itself and uniform with itself; and always beautiful; and as it were the fount of all beauty; and in itself preeminently possessed of beauty. For in the simple and

[7] Cf. "Imitation, Expression, and Participation" [in this volume—ED.], notes 36, 38.

supernatural nature of all things beautiful, all beauty and all that is beautiful have preexisted uniformly in their cause.

From this [super-] beautiful it is that there are individual beauties in existing things each in its own kind; and because of the beautiful are all alliances and friendships and fellowships, and all are united by the beautiful. And the super-beautiful is the principle of all things as being their efficient cause, and moving all of them, and maintaining all by love of its own Beauty. It is likewise the end of all, as being their final cause, since all things are made for the sake of the beautiful;[8] and likewise

[8] This must not be understood to mean that the artist as such has in view simply to make "something" beautiful, or to "create beauty." The statement of Dionysius refers to the final end from the point of view of the patron (who may be either the artist himself, not as artist but as man, or may be some other man or some organization or society in general), who expects to be pleased as well as served by the object made; for what is the end in one operation may itself be ordained to something else as an end (*Sum. Theol.* I-II.13.4), as, for example, "to give pleasure when seen, or when apprehended" (*ibid.*, 1.5.4 and 1.27.1 *ad* 3); cf. Augustine, *Lib. de ver. rel.* 39, "An iron style is made by the smith on the one hand that we may write with it, and on the other that we may take pleasure in it; and in its kind it is at the same time beautiful and adapted to our use," where "we" refers to man as patron, as in St. Thomas, *Physics* II.4.8, where it is said that "man" is the general end of all things made by art, which are brought into being for his sake. The artist may know that the thing well and truly made (Skr. *sukṛta*) will and must be beautiful, but he cannot be said to be working with this beauty in immediate view, because he is always working to a determinate end, while beauty, as being proper to and inevitable in *whatever* is well and truly made, represents an indeterminate end. The same conclusion follows from the consideration that all beauty is formal, and that form is the same thing as species; things are beautiful *in their kind*, and not indefinitely. Scholastic philosophy is never tired of pointing out that every rational agent, and the artist in particular, is always working for determinate and singular, and not for infinite and vague ends; for example, *Sum. Theol.* 1.25.5c, "the wisdom of the maker is restricted to some definite order"; 1.7.4, "no agent acts aimlessly"; II-I.1.2c, "If the agent were not determinate to some particular effect, it would not do one thing rather than another"; 1.45.6c, "operating by a word conceived in his intellect (*per verbum in intellectu conceptum*) and moved by the direction of his will towards the specific object to be made"; *Phys.* II.1.10, affirming again that art is determined to singular ends and is not infinite, and Aquinas, *De coelo et mundo* II.3.8, that the intellect is conformed to a universal order only in connection with a particular idea. Cf. St. Bonaventura, *I Sent.* d.35, a.unic., q.1, fund.2, "Every agent acting rationally, not at random, nor under compulsion, foreknows the thing before it is, viz. in a likeness, by which likeness, which is the 'idea' of the thing, the thing is both known and brought into being." What is true of *factibilia* is true in the same way of *agibilia*; a man does not perform a *particular* good deed for the sake of its beauty, for *any* good deed will be beautiful in effect, but he does precisely *that* good deed which the occasion requires, in relation to which occasion some other good deed would be inappropriate (*ineptum*), and therefore awkward

the exemplary cause, since all things are determined by it; and therefore the good and the beautiful are the same; for all things desire the beautiful for every reason, nor is there anything existing that does not participate in the Beautiful and the Good. And we make bold to say that the non-existent also participates in the Beautiful and the Good; for then it is at once truly the Beautiful and the Good when it is praised supersubstantially in God by the subtraction of all attributes.

2. Ulrich Engelberti, *De pulchro*[9]

Just as the form of anything whatever is its "goodness,"[10] perfection being desired by whatever is perfectible, so also the beauty of everything is the same as its formal excellence, which, as Dionysius says, is like a light that shines upon the thing that has been formed; which also appears inasmuch as matter subject to privation of form is called vile (*turpis*) by philosophers, and desires form in the same way that the ugly (*turpe*) desires what is good and beautiful. So then the beautiful by another name is the "specific," from species or form.[11] So Augustine

or ugly. In the same way the work of art is always occasional, and if not opportune, is superfluous.

[9] See Grabmann, "Des Ulrich Engelberti von Strassburg."

[10] [This note has been printed as an appendix to this chapter.—ED.]

[11] Cf. *Sum. Theol.* II-I.18.2c, "The primary goodness of a natural thing is derived from its form, which gives it its species," and 1.39.8c, "Species or beauty has a likeness to the property of the Son," viz. as Exemplar. In general, the form, species, beauty, and perfection or goodness or truth of a thing are coincident and indivisible in it, although not in themselves synonymous in the sense of interchangeable terms.

A clear grasp of what is meant by "form" (Lat. *forma* = Gk. εἶδος) is absolutely essential for the student of mediaeval aesthetic. In the first place, form as coincident with idea, image, species, similitude, reason, etc., is the purely intellectual and immaterial cause of the thing being what it is, as well as the means by which it is known; form in this sense is the "art in the artist," to which he conforms his material and which remains in him, and this holds equally for the Divine Architect and for the human artist. This exemplary form is called substantial or essential, not as subsisting apart from the intellect on which it depends, but because it is like a substance (1.45.5 *ad* 4). Scholastic philosophy followed Aristotle (*Metaphysics* IX.8.15) rather than Plato, "who held that ideas existed of themselves, and not in the intellect" (*ibid.*, 1.2.15.1 *ad* 1). Accidents "proper to the form," e.g., that the idea of "man" is that of a biped, are inseparable from the form as it thus subsists in the mind of the artist.

In the second place, over against the essential form or art in the artist as above defined, and constituting the exemplary or formal cause of the becoming of the work of art (*artificiatum, opus,* that which is made *per artem,* by art), is the accidental or actual form of the work itself, which as materially formed (*materialis efficitur*) is determined not only by the idea or art as formal cause, but also by the

(*De Trinitate* vi) says that Hilary predicated species in the image as being the occasion of beauty therein; and calls the ugly "deformed" because of its privation of due form. Just because it is present insofar as the formal light shines upon what is formed or proportioned, material beauty subsists in a harmony of proportion, viz. of perfection to perfectible.[12] And

efficient and material causes; and inasmuch as these introduce factors that are not essential to the idea nor inevitably annexed to it, the actual form or shape of the work of art is called its accidental form. The artist therefore knows the form essentially, the observer only accidentally, to the extent that he can really identify his point of view with that of the artist on whose intellect the thing made immediately depends.

The distinction between the two senses in which the word "form" is used is very clearly drawn by St. Bonaventura, *I Sent.* d.35, a.unic., q.2, opp.1 as follows: "Form is twofold, being either the form that is the perfection of a thing, or the exemplary form. In both cases there is postulated a relation; in the latter case, a relation to the material that is informed, in the former a relation to that [idea] which is actually exemplified."

Scholastic philosophy in general, and when no qualifying adjectives are employed, employs the word "form" in the causal and exemplary sense; modern speech more often in the other sense as equivalent to physical shape, though the older meaning is retained when we speak of a form or mold *to* which a thing is shaped or trued. It is often impossible to understand just what is meant by "form" as the word is used by contemporary aestheticians.

[12] The material beauty, perfection, or goodness of any thing is here defined by the ratio of essential (substantial) form to accidental (actual) form, which becomes in the case of manufacture the ratio of art in the artist to artifact; in other words, anything participates in beauty, or is beautiful, to the extent that the intention of the maker has been realized in it. Similarly, "A thing is said to be perfect if it lacks nothing to the mode of its perfection" (*Sum. Theol.* 1.5.5c); or, as we should express it, if it is altogether good of its kind. Natural objects are always beautiful in their several kinds because their maker, *Deus vel Natura Naturans*, is infallible; artifacts are beautiful to the extent that the artificer has been able to control his material. Questions of taste or value (what we like or dislike, can or cannot use) are equally irrelevant in either case.

The problem of "truth to nature" as a criterion of judgment in our modern sense does not arise in Christian art. "Truth is primarily in the intellect, and secondly in things accordingly as they are related to the intellect which is their principle" (*Sum. Theol.* 1.16.1). Truth in a work of art (*artificiatum*, artifact) is a being well and truly made according to the pattern in the artist's mind, and so "a house is said to be true that expresses the likeness of the form in the artist's mind, and words are said to be true insofar as they are signs of truth in the intellect" (*ibid.*). In the same way, a work of art is called "false" when the form of the art is wanting in it, and an artist is said to produce a "false" work, if it falls short of the proper operation of his art (1.17.1). In other words, the work of art as such is good or bad of its kind, and cannot be judged in any other way; whether or not we like or have any use for the kind being another matter, irrelevant to any judgment of the art itself.

The problem of "truth to nature" in our sense arises only when a confusion is introduced by an intrusion of the scientific, empirical, and rational point of view.

therefore Dionysius defines beauty as harmony (*consonantia*) and illumination (*claritas*).

Now God is the "one true Light that lighteth every man that cometh into the world" (John 1:9), and this is by His Nature; which Light, as being the divine manner of understanding, shines upon the ground of His Nature, which ground is predicated of His Nature when we speak of "God" concretely. For thus He dwells in an inaccessible Light; and this ground of the Divine Nature is not merely in harmony with, but altogether the same as His Nature; which has in itself Three Persons coordinate in a marvellous harmony, the Son being the image of the Father and the Holy Ghost the link between them.

Here he says that God is not only perfectly beautiful in Himself, being the limit of beauty, but more than this, that He is the efficient and exemplary and final cause of all created beauty.[13] Efficient cause: just

Then the work of art, which is properly a symbol, is interpreted as though it had been a sign, and a *resemblance* is demanded as between the sign and the thing presumed to be signified or denoted; and we hear it said of "primitive" art that "that was before they knew anything about anatomy." The Scholastic distinction of sign and symbol is made as follows: "Whereas in every other science things are signified by words, this science has the property that the things signified by the words have themselves also a significance" (*Sum. Theol.* 1.1.10). By "this science" St. Thomas means, of course, theology, and the words referred to are those of scripture; but theology and art in principle are the same, the one employing a verbal, the other a visual imagery to communicate an ideology. The problem of "truth to nature" in our sense, then, arises whenever the habit of attention changes its direction, interest being concentrated upon things as they are in themselves and no longer primarily upon their intelligible aspects; in other words, when there is a shift from the speculative or idealistic to a rational or realistic point of view (the reader should bear in mind that speculative or mirror-knowledge meant originally, and in all traditions, a certain and infallible knowledge, phenomenal things as such being regarded as unintelligible and merely the occasions of sensory reactions such as animals also have). The shift of interest, which may be described as an extroversion, took place in Europe with the Renaissance; and similarly in Greece, at the end of the fifth century B.C. Nothing of the same kind has ever taken place in Asia.

Thus, it is evident that Christian art cannot be judged by any standards of taste or verisimilitude, but solely as to whether and how far it clearly expresses the ideas that are the formal basis of its whole constitution; nor can we make this judgment in ignorance of the ideas themselves. The same will hold good for archaic, primitive, and Oriental art generally.

[13] The fourth of the Aristotelian causes, viz. the material cause, is necessarily omitted here, Christian dogma denying that God operates as the material cause of anything. The Scholastic "primary matter," the "nonexistent" of Dionysius, is not the infinite omnipotence (Skr. *aditi, śakti, mūla-prakṛti*, etc.) of the divine nature, "Natura Naturans, Creatrix, Deus," but a potentiality that extends only to the natural forms or possibilities of manifestation (*Sum. Theol.* 1.7.2 *ad* 3; thus, Dante's "Pura potenza tenne la parte ima," *Paradiso* XXIX.34). It is not the absolute naught

as the light of the sun by pouring out and causing light and colors is the maker of all physical beauty; just so the true and primal Light pours out from itself all the formal light, which is the beauty of all things.[14] Exemplary cause: just as physical light is one in kind, which is nonetheless that of the beauty that is in all colors, which the more light they have the more beautiful they are, and of which the diversity is occasioned by the diversity of the surfaces that receive the light, and the more light lacks, the more are they hideous and formless; even so the divine Light is one nature, that has in itself simply and uniformly whatever beauty is in all created forms, the diversity of which depends on the recipients themselves—from whom also the form is more or less remote in the manner of their unlikeness to the primal intellectual Light, and is obscured; and therefore the beauty of forms does not consist in their

of the Divine Darkness, but the relative naught (*kha, ākāśa* as quintessence) out of which the world was made (*ex nihilo fit*), and in the act of creation takes the place of the "material cause." As such it is remote from God (*Sum. Theol.* 1.14.2 *ad* 3), who is defined as being wholly in act (1.14.2c), though it "retains a certain likeness to the divine being" (1.14.2 *ad* 3), viz. that "nature by which the Father begets" (1.41.5); cf. Augustine, *De Trinitate* xiv.9, "That nature, to wit, which created all others."

If, on the other hand, we consider, not God as distinct from Godhead, but rather the unity of essence and nature in the Supreme Identity of the conjoint principles, it will be proper to say that all causes are present in Deity, for this nature, viz. Natura Naturans, Creatrix (of which the manner of operation is imitated in art, *Sum. Theol.* 1.117.1c), is God. Just as the procession of the Son, the Word, "is from a living conjoint principle (*a principio vivente conjuncto*)" and "is properly called generation and nativity" (1.27.2), and "that by which the Father begets is the divine nature" (1.41.5), so the human artist works through "a word conceived in his intellect" (*per verbum in intellectu conceptum*, 1.45.6c).

It is only when, taking the human analogy too literally, we consider the divine procession and creation as temporal events that the divine nature apparently "recedes from" the divine essence, potentiality becoming "means" (Skr. *māyā*) over against "act"; this is the diremption of BU 1.4.3 ("He divided his Essence in twain," *dvedhā apātayat*), the flight apart of Heaven and Earth in JUB 1.54 (*te vyadravatām*), as in Genesis 1, "God divided the upper from the nether waters." If, then, God be defined as "all act" or "pure act," and as the Divine Architect in operation, the material cause of the things created is not in Him. Just as, in human operation, the material cause is external to the artist, not in him, and inasmuch as the material cause in his case is already to some extent "formed" and not like primary matter altogether informal, tractable, and passive, the material cause both offers a certain resistance to the artist's purpose (Dante's *sorda, Paradiso* 1.129) and in some measure determines the result; at the same time that in its disposition to the recepion of another form it resembles primary matter and lends itself to the intention of the artist, who may be compared to the Divine Architect insofar as he fully controls the material, although never completely.

[14] As in RV v.81.2 where the Supernal Sun *viśvā rūpāṇi prati muñcate*.

diversity, but rather has its cause in the one intellectual Light that is omniform, for the omniform is intelligible by its own nature, and the more purely the form possesses this Light, the more is it beautiful and like the primal Light, so as to be an image of it or imprint of its likeness; and the more it recedes from this nature and is done into matter (*materialis efficitur*) the less it has of beauty and the less like the primal Light. And final cause, for form is desired by whatever is perfectible, as being its perfection,[15] the nature of which perfection is in the form only by way of likeness to the uncreated Light, likeness to which is beauty in created things; as is evident inasmuch as form is desired and tended towards as being good, and also as being beautiful; and so the divine Beauty in itself, or in any likeness of it, is an end attracting every will. And therefore Cicero in his *De officiis* [*De inven. rhet.* II.158] identified the beautiful with the worthy (*honestum*) when he said that "the beautiful is that which draws us by its power and allures by its sweetness."

Beauty is, therefore, really the same as goodness, as Dionysius says, as being the very form of the thing; but beauty and goodness differ logically, form as perfection being the "goodness" of the thing, while form as possessing in itself the formal and intellectual light, and shining on the material, or on anything that being apt to the reception of form is in this sense material, is "beauty." So as John 1:4 says, "All things were in God life, and light." Life, because as being perfections, they bestow fullness of being; and Light, because being diffused in what is formed, they beautify it. So that in this way all that is beautiful is good. Whence if there be anything good that is not beautiful, many sensually delightful things being, for example, ugly (*turpia*),[16] this depends upon the lack of some specific goodness in them; and conversely, when anything beautiful is said to be otherwise than good, as in Proverbs, at the

[15] No "personification" of the thing is implied, "desires" being equivalent to "needs." When we say that a thing "wants" or "needs" something to be perfect, this is as much as to say both that it lacks that something and that it requires that something. A crab, for example, may not be conscious that it has lost a limb, but it is in some sense aware, and it is a kind of will that results in the growth of another limb. Or if we consider an inanimate object, such as a table "wanting" a leg, then the corresponding "will" is attributed to primary matter, "insatiable for form"; *in materia est dispositio ad formam.*

[16] As pointed out by Augustine, *De musica* VI.38, some people take pleasure in *deformia*, and these the Greeks in the vernacular called σαπρόφιλοι, or as we should say, perverts; cf. BG XVII.10. Augustine elsewhere (*Lib. de ver. rel.* 59) points out that while things that please us do so because they are beautiful, the converse, viz. that things are beautiful because they please us, does not hold.

end [31:30], "Favor is deceitful, and beauty vain," this is insofar as it becomes the occasion of sin.[17]

Now because there are both substantial and accidental forms besides the uncreated Beauty, beauty is twofold, as being either essential or accidental. And each of these beauties is again twofold. For essential beauty is either spiritual—the soul, for example, an ethereal beauty—or intellectual, as in the case of the beauty of an angel; or it is physical, the beauty of material being its nature or natural form. In the same way, accidental form is either spiritual—science, grace, and virtues being the beauty of the soul, and ignorance and sins its deformities—or it is physical, as Augustine, *De civitate Dei* XXII, describes it, when he says, "Beauty is the agreement of the parts together with a certain sweetness of color."[18]

[17] The problem of sinister beauty raised by Proverbs 31:30 is rather better dealt with in the *Opusculum de pulchro* (of Albertus Magnus), where it is pointed out that the beautiful is never separated from the good when things of the same kind are considered, "for example, the beauty of the body is never separated from the good of the body nor the beauty of the soul from the good of the soul; so that when beauty is thus called vain, what is meant is the beauty of the body from the point of view of the good of the soul." It is nowhere argued that the beauty of the body can be a bad thing in itself; bodily beauty being rather taken as the outward sign of an inward and constitutional well-being or health. That such a beauty and health, although a great good in itself, may also be called vain from another point of view will be apparent to everyone; for example, if a man be so much attached to the well-being of the body that he will not risk his life in a good cause. How little Christian philosophy conceives of natural beauty as something sinister in itself may be seen in Augustine, who says that the beautiful is to be found everywhere and in everything, "for example in a fighting cock" (*De ordine* 1.25; he selects the fighting cock as something in a manner despicable from his own point of view), and that this beauty in creatures is the voice of God who made them (*confessio ejus in terra et coelo, Enarratio in psalmum*, CXLVIII), a point of view that is inseparable also from the concept of the world as a theophany (as in Erigena) and the doctrine of the *vestigium pedis* (as in Bonaventura). On the other hand, to be attached to the forms as they are in themselves is precisely what is meant by "idolatry," and as Eckhart (Evans ed., I, 259) says, "to find nature herself all her forms must be shattered, and the further in, the nearer the actual thing"; cf. Jāmī, "shouldst thou fear to drink wine from Form's flagon, thou canst not drain the draught of the Ideal. But yet beware! Be not by Form belated: strive rather with all speed the bridge to traverse."

For "many things are beautiful to the eye (of the flesh) which it would be hardly proper to call worthy" (*honestus*, St. Augustine, QQ. LXXXIII.30; cf. Plato, *Laws* 728D, where we are to honor "goodness above beauty"). It is in the same way that we do not choose the most beautiful to work with, but *the best for our purpose* (*Sum. Theol.* 1.91.3).

[18] *Pulchritudo est partium congruentia cum quadam suavitate coloris*; cf. Cicero, *Tusculum disputations* IV.31, *Corporis est quaedam apta figura membrorum cum coloris quadam suavitate.*

Because also all that is made by the divine art has a certain species to which it is formed, as Augustine says, *De Trinitate* VI, it follows that the beautiful, like the good, is synonymous with being in the subject, and considered essentially adds to this the aforesaid character of being formal.[19]

To enlarge upon what was said above, that beauty requires proportion of material to form, this proportion exists in things as a fourfold harmony (*consonantia*),[20] viz. (1) in the harmony of predisposition to receive form; (2) in a harmony of mass to natural form—for as the Philosopher [Aristotle], *De anima* II, expressed it, "the nature of all composites is their last end and the measure of their size and growth"; (3) in the harmony of the number of the parts of the material with the number of the potentialities in the form, which concerns inanimate things; and (4) in the harmony of the parts as measured among themselves and according to the whole. Therefore, in such bodies all these things are necessary to perfect and essential beauty. According to the first, a man is of a good bodily habit whose constitution is most like that of Heaven, and he is essentially more beautiful than a melancholy man or one ill-constituted in some other way. According to the second, the Philosopher [Aristotle], *Nicomachean Ethics* IV, says that beauty resides in things of full stature[21] and that little things, though they may be elegant and

[19] "Formal" is here tantamount to exemplary and imitable; cf. St. Bonaventura, *I Sent.* d.36, a.2, q.2 *ad* 1, "Idea does not denote essence as such, but essence as being imitable," and *Sum. Theol.* 1.15.2, "It is inasmuch as God knows His essence as being imitable by this or that creature, that He knows it as the particular reason and idea of that creature." The "imitable essence" in this sense is the same thing as "nature" ("Natura naturans, Creatrix, Deus") in the very important passage, "ars imitatur naturam in sua operatione," *Sum. Theol.* 1.117.1.

[20] In my *Transformation of Nature in Art*, 1934, I interpreted *consonantia* too narrowly, to mean only "correspondence to pictorial and formal elements in the work of art," or what Ulrich calls the "proportion of material to form." *Consonantia*, however, includes all that we mean by "order," and it is the requirement of this harmony that underlies all the interest that has been felt in "canons of proportion" (Skr. *tālamāna*).

[21] *In magno corpore*, lit. "in a large body." Whatever Aristotle may have intended, Scholastic aesthetic by no means asserts that only large things can be beautiful as such. The point is rather that a due size is essential to beauty; if a thing is undersized, it lacks the element of due stature that is proper to the species; whatever is dwarfed may be elegant (*formosus*), but not truly beautiful (*pulcher*), nor fully in being (*esse habens*), nor altogether good (*bonus*), because the idiosyncrasy of the species is not fully realized in it. In the same way, whatever is oversized in its kind cannot be called beautiful. In other words, a definition of beauty as formal implies also "scale."

Elsewhere St. Thomas Aquinas substitutes *magnitudo* for *integritas* (see *Sum.*

symmetrical, cannot be called beautiful. Whence we see that elegance and beauty differ qualitatively, for beauty adds to elegance an agreement of the mass with the character of the form, which form does not have the perfection of its virtue unless in a due amount of material. According to the third, whatever lacks in any member is not beautiful, but is defective and a deformity, and the more so the nobler is that part as to which there is privation, so that the want of any facial organ is a greater deformity than the want of a hand or finger. According to the fourth, monstrous parts are not perfectly beautiful; if, for example, the head is disproportionate as being too large or too small in relation to the other members and the mass of the whole body.[22] It is rather symmetry (*commensuratio*) that makes things beautiful.

Theol., Turin ed., 1932, p. 266, note 1), the work being imperfect *nisi sit proportionata magnitudo*, unless it have due size [cf. Aristotle, *Nicomachean Ethics* IV.3.5]. Perhaps we ought to think of *magnitudo* as a kind of "magnificence," or even a "monumental" quality. See note 46.

[22] This fourth condition of *consonantia* again asserts the normality of beauty: an excess of any single virtue is a fault in nature or art because it detracts from the unity of the whole. All peculiarity, whether liked or disliked, detracts from beauty; for example, a complexion so marvelous as to outshine all other qualities, or whatever dates or marks the particular style of a work of art. Peculiarity, though it may be a certain kind of good, and is inevitable "under the sun," implies a contraction of beauty simply and absolutely; and we recognize this when we speak of certain works of art as "universal," meaning that they have a value always and for all kinds of men. St. Thomas, in comment on Dionysius, *De div. nom.* IV, remarks that "the second defect of the [relatively] beautiful is that all creatures have a somewhat particularized beauty, even as they have a particularized nature."

It is to be observed that idiosyncrasy in the work of art is of two kinds: (1) essential, as that of the species, which is determined by the formal and final causes, and (2) accidental, depending on the efficient and material causes. The essential idiosyncrasy, which represents the perfect good of the species, is not a "privation as evil," and can be regarded as a defect only as being a minor beauty when compared to that of the universe as a whole. Accidental idiosyncrasy is not a defect when the accident "is proper to the species," as when the portrait of a colored man is colored accordingly, or the portrait in stone differs from the portrait in metal. Accidental idiosyncrasy due to the material will be a defect only when the effects proper to one material are sought for in another, or if there is a resort to some inferior substitute for the material actually required. Accidental idiosyncrasy due to the efficient cause is represented by "style," that which betrays the hand of the given artist, race, or period: it is because, as Leonardo says, *il pittore pinge se stesso* that it is required that the artist be a sane and normal man, for if not, the work will embody something of the artist's own defect; and, in the same way, there will be defect in the product if the tools are in bad condition or wrongly chosen or used, the blunt ax, for example, not producing a clean cut. Essential idiosyncrasy due to the final cause is a matter of the patron's commission to the artist (not forgetting that patron and artist *may* be the same person), or that this

It will also be a true dictum, as Dionysius says, to declare that even the non-existent partakes of beauty, not indeed as being altogether non-existent, for whatever is nothing is not beautiful, but non-existent as being not in act but *in potentia*, as in the case of matter which has the essence of form in itself in a manner of imperfect or non-existent being, which is privation as an evil.[23] For either this is in a good nature sin in act

will involve defect whenever bad taste imposes on the artist some deviation from the *certas vias operandi* of his art (good taste is simply that taste which finds satisfaction in the proper operation of the artist): there will be defect, for example, if the patron demands in the plan of a house something agreeable to himself in particular but contrary to art (a sound popular judgment is often expressed in such cases by calling a building so and so's "folly"), or if he demands an effigy of himself that shall represent him not merely as a functioning type (e.g., as knight, doctor, or engineer), but as an individual and a personality to be flattered.

Individual expression, the trace of good or evil passions, is the same thing as characteristic expression; the psychological novel or painting is concerned with "character" in this sense, the epic only with *types* of character. What affects us in monumental art, whatever its immediate subject, is nothing particular or individual, but only the power of a numinous *presence*. The facts of mediaeval art agree with this thesis. In Byzantine art and before the end of the thirteenth century, as well as in "early" art generally, the peculiarity of the individual artist eludes the student; the work invariably shows "respect for the material," which is used appropriately; and it is not until after the thirteenth century that the effigy assumes an individual character, so as to become a portrait in the modern psychological sense. Cf. "The Traditional Conception of Ideal Portraiture" in Coomaraswamy, *Why Exhibit Works of Art?*, 1943.

[23] Orthodox doctrine maintains that God is wholly in act, and that there is no potentiality in Him. In any case, it will be correct to say that He does not proceed from potentiality to act after the manner of creatures, which, being in time, are necessarily partly in potentiality and partly in act. It will also be correct to say that God is wholly in act, if the name be taken "concretely," i.e., in logical distinction from Godhead. But we think that the exegesis of Dionysius by Albertus Magnus (or St. Thomas) in the *Opusculum de pulchro* and by Ulrich, as above, is incomplete in this matter of the beauty of the nonexistent. Dionysius is really asserting the beauty of the Divine Darkness or Dark Ray as being in no way less than that of the Divine Light; distinguishing the beauty of the Godhead from that of God, although logically and not really. From the metaphysical point of view, the Divine Darkness is as real a darkness as the Divine Light is a light, and ought not to be explained away as merely an excess of light. Cf. Dionysius, *De div. nom.* vii, "not otherwise seeing darkness except through light," which also implies the converse; and it would be reasonable to paraphrase Ulrich's words as follows, "For if there were no Darkness, there would be only the intelligible beauty of the Light," etc. Cf. also Meister Eckhart, Evans ed., I, 369, "the motionless Dark that no one knows but He in whom it reigns. First to arise in it is Light." Cf. also Boehme, "And the deep of the darkness is as great as the habitation of the light; and they stand not one distant from the other, but together in one another, and neither of them hath beginning nor end." The Beauty of the Divine Darkness is asserted also

or in the agent; or it has some good nature of its own, as when a just penalty is actively accepted, or an unjust penalty is passively accepted and patiently endured. In the first way (i.e., as potentiality), then, evil taken in relation to the subject is beautiful; it is indeed a deformity in itself, but is so accidently, as being contrasted with the good; it is the occasion of beauty, goodness, and virtue, not as being these really, but as conducting to their manifestation. Hence, Augustine, *Enchiridion*, c. 11, says, "It is because of the beauty of good things that God allowed evil to be made." For if there were no evil, there would be only the absolute beauty of the good; but when there is evil, then there is annexed a relative beauty of the good, so that by contrast with the opposite evil the nature of the good shines out more clearly. Taking evil in the second and third ways (i.e., as penalty), evil is beautiful in itself as being just and good, though a deformity as being an evil. But since nothing is altogether without a good nature, but evil is rather called an imperfect good, so no

in other traditions, cf. the names Kṛṣṇa and Kālī and the corresponding iconography; and as MU v.2 expresses it, "The part of Him which is characterized by Darkness (*tamas*) . . . is this Rudra"; in RV iii.55.7, where Agni is said to "proceed foremost whilst yet abiding in His ground," this "ground" is also the Darkness, as in x.55.5, "Thou stayest in the Darkness" (*i.e., ab intra*). The conjunction of these "opposites" (*chāyā-tāpau*, "light and shade," KU iii.1 and vi.5; *amṛta* and *mṛtyu*, "life and death," RV x.121.2) in Him as the Supreme Identity no more implies a composition than does the *principium conjunctum* of St. Thomas, *Sum. Theol.* 1.27.2c, as cited above.

All these considerations, which at first sight appear to pertain rather to theology than aesthetics, have an immediate bearing upon the mediaeval representation of God's majesty and wrath, as manifested, for example, on the Judgment Day, to which Ulrich himself refers at the close of his treatise. When we consider actual representations of the Last Judgment, it is needful to be aware that God was thought of here as no less beautiful in His wrath than elsewhere in His love, and that the representations of the damned and of the blessed in art and as representations were regarded as equally beautiful; as St. Thomas says (*Sum. Theol.* 1.39.8), "an image is said to be beautiful if it perfectly represents even an ugly thing," and this accords with the (unstated) converse of St. Augustine's dictum that things are not beautiful merely because they please us. *Sum. Theol.* iii.94.1 *ad* 2 and iii.95.5c, says also, "Although the beauty of the thing seen conduces to the perfection of vision, there may be deformity of the thing seen without imperfection of vision; because the images of things, whereby the soul knows contraries, are not themselves contrary," and, "We delight in knowing evil things, although the evil things themselves delight us not," as in KU v.11: "Even as the Sun, the eye of the universe, is not contaminated by the defects of things outwardly seen, so the Inner Self of all beings is uncontaminated by the evil in the world, which evil is external to it" [cf. *Mathnawī* ii.2535, 2542; iii.1372]. In affirming that the beauty of the work of art does not depend on the beauty of the theme, mediaeval and modern aesthetic meet on common ground.

entity is altogether without the quality of beauty, but what in beauty is imperfectly beautiful is called "ugly" (*turpe*). But this imperfection is either absolute, and this is when there lacks in anything something natural to it, so that whatever is corrupt or foul is "ugly"; or relative, and this is when there lacks in anything the beauty of something nobler than itself to which it is compared, as though it strove to imitate that thing, granted that it has something of the same nature, as when Augustine, *De natura boni contra Manicheos*, c. 22, says that "In the form of a man, beauty is greater, in comparison wherewith the beauty of a monkey is called a deformity."[24]

Augustine, in the Book of Questions [*De diversibus quaestionibus*] LXXXIII [q. 30], also says that the worthy (*honestum*) is an intelligible beauty, or what we properly call a spiritual beauty, and he also says there that visible beauties are also called values, but less properly. Whence it seems that the beautiful and the worthy are the same; and this agrees with Cicero's definition of both (as cited above). But this is so to be understood, that as the ugly (*turpe*) is referred to in two ways, either generally with respect to any deforming defect, or alternatively with respect of a voluntary and culpable defect, so also the worthy is referred to in two ways, either generally with respect to whatever is adorned (*decoratum*) by a participation in anything divine, or particularly with respect to whatever perfects the adornment (*decor*, Skr. *alaṃkāra*) of the rational creature.[25] According to the first way, the worthy is synonymous with the good and the beautiful; but there is a triple distinction, inasmuch as the goodness of a thing is its perfection, the beauty of a thing is the comeliness of its formality, and the worthy belongs to any-

[24] The assumption is implied that monkey and man have something in common, both being animals; and further, that the monkey is a would-be man, man being taken to be the most perfect animal, and all things tending to their ultimate perfection. Psychologically, a certain analogy can be recognized in the modern theory of evolution, which is anthropocentric in the same sense. The comparison of monkey and man (which derives from Plato, *Hippias Major* 289A) cannot be fairly made except, as Augustine makes it, relatively; for things are only beautiful or good in their kind, and if two things are equally beautiful in their kind we cannot say that one is more beautiful or better than another absolutely, all kinds as such being equally good and beautiful, viz. in their eternal reasons, though there is hierarchy *ab extra*, in *ordo per esse*. Things as they are in God, viz. in kind or intelligible species, are all the same, and it is only as being exemplified that they can be ranked.

[25] "Worth" (*honestas*) can be predicated *secundum quod (aliquid) habet spiritualem decorem. . . . Dicitur enim aliquid honestum . . . inquantum habet quemdam decorem ex ordinatione rationis. Delectabile autem propter se appetitur appetitu sensitivo* (*Sum. Theol.* II-II.145.3 and 4).

thing when it is compared to something else, so that it pleases and delights the spectator either intellectually or sensibly. For that is what Cicero's definition, "attracts us by its power, etc.," amounts to. What is to be understood is a matter of propriety (*aptitudo*), for all the terms of a definition bespeak what is proper (to the thing defined). In the second way the worthy is not synonymous with the good, but is a division of the good when the good is divided into the worthy, the useful, and the delightful. And in the same way it is a part of the beautiful and not synonymous with it, but such that what is worthy, viz. grace and virtues, is an accidental beauty in the rational or intellectual creature. Isidorus likewise says in *De summo bono*, "The adornment of things consists in what is beautiful and appropriate (*pulcher et aptus*)," and so these three, adornment, beauty, and propriety are differentiated. For whatever makes a thing comely (*decens*) is called adornment (*decor*), whether it be in the thing or externally adapted to it, as ornaments of clothing and jewels and the like. Hence, adornment is common to the beautiful and appropriate. And these two, according to Isidorus, differ as absolute and relative, because whatever is ordered to the ornamentation of something else is appropriate to it, as clothes or ornaments to bodies, and grace and virtues to spiritual substances; but whatever is its own adornment is called beautiful, as in the case of a man, or angel, or like creature.

So that beauty in creatures is by way of being a formal cause in relation to matter, or to whatever is formed and in this respect corresponds to matter. From these considerations it is plainly evident, as Dionysius says, that light is prior to beauty, being its cause. For as physical light is the cause of the beauty of all colors, so the Formal Light is of the beauty of all forms.[26] But the category of the delightful coincides with both because, besides being made visible, the beautiful is what is desired by everyone, and therewith also beloved, for, as Augustine, *De civitate Dei* [xiv.7], says, desire for a thing not in possession, and love

[26] Ulrich naturally presupposes in the reader a familiarity with the fundamental doctrine of exemplarism, without which it would be impossible to grasp the meaning of "formal light." Those who are not versed in the doctrine of exemplarism may consult J. M. Bissen, *L'Exemplarisme divin selon Saint Bonaventure* (Paris, 1929). The doctrine of the inherence of the many in the one is common to all traditional teaching; it may be briefly summarized in Eckhart's "single form that is the form of very different things" (Skr. *viśvam ekam*) and "image-bearing light" (Skr. *jyotir viśvarūpam*), cf. St. Bonaventura, *I Sent.*, d.35, a.unic. q.2 *ad* 2, "A sort of illustration can be adduced in light, which is one numerically but gives expression to many and various kinds of color."

of a thing possessed are the same,[27] and since desire of this sort necessarily has an object of its own kind, the natural desire for what is good and beautiful is for the good as such and for the beautiful insofar as it is the same as the good, as Dionysius says, who uses this argument to prove that the good and the beautiful are the same.

Dionysius, however, propounds many characteristics of the divine Beauty, saying that beauty and the beautiful are not divided into participant and participated in God, as is the case in creatures, but are altogether the same in Him. Also that it is the efficient cause of all beauty, "in the likeness of light sending forth to everything," together with idiosyncrasy, "the beautifying distributions of its own frontal radiance," and this applies to Him in mode of beauty inasmuch as God is in this way the efficient cause and in causal operation pours out perfections. Thus cometh goodness from Goodness, beauty from Beauty, wisdom from Wisdom, and so forth. Again, it "summons all things to itself," as that which is desirable evokes desire, and the Greek name for beauty shows this. For καλός, meaning "good" and καλός, meaning "beautiful," are taken from καλο, which is to "call" or "cry";[28] not merely that God called all things into being out of nothing when He spake and they were made [Psalm 149.5], but also that as being beautiful and good He is the end that summons all desire unto Himself, and by the calling and desire moves all things to move toward this end in all that they do, and so He holds all things together in participation of Himself by the love of His own Beauty. Again, in all things He assembles all things that are theirs inasmuch as in His mode of Beauty He pours out every form, as light unites all the parts of a composite thing in its own being, and

[27] Ulrich misquotes Augustine (who is cited also by St. Thomas, *Sum. Theol.* II-I.25.2); what Augustine says is that "love yearning to possess the beloved object is desire; but having and enjoying it, is joy," and Meister Eckhart, Evans ed., I, 82, follows when he says, "We desire a thing while as yet we do not possess it. When we have it, we love it, desire then falling away." The greater profundity of Augustine's and Eckhart's understanding is evident. Augustine says too, *De Trinitate* x.10, "We enjoy what we have when the delighted will is at rest therein," and this proposition, like so many in Scholastic philosophy, is equally valid from the theological and the aesthetic points of view, which in the last analysis are inseparable: cf. the Indian view of the "tasting of *rasa*" (i.e., "aesthetic experience") as "connatural with the tasting of Brahman" (*Sāhitya Darpaṇa* III.2–3, where *sahodarah* is equivalent to *ex uno fonte*).

[28] This etymology is ultimately derived from Plato, *Cratylus* 416c: "To have called (τὸ καλέσαν) things useful is one and the same thing as to speak of the beautiful (τὸ καλόν)." Then through Plotinus, Hermes, Proklus, and Dionysius it reaches Ulrich. It is, of course, a hermeneutic rather than a scientific etymology.

Dionysius says the same. Just as ignorance is divisive of those things that wander (*ignorantia divisiva est errantium*),[29] so the presence of the Intelligible Light assembles and unites all things that it illuminates. Moreover, "it is neither created nor destroyed," whether in act or in potentiality, being beautiful essentially and not by participation. For neither are such things made, nor being in such a nature are they subject to corruption. Beauty is neither made to be beautiful, nor can it be made to be otherwise than beautiful. So, again, "there can be neither increase nor decrease of Beauty" whether in act or in potentiality, because as being the limit of beauty it cannot be increased, and because not having any opposite it cannot be diminished. "Nor is it beautiful in some part of its essence and ugly in another" as are all beauties that depend upon a cause; which are beautiful in proportion to their likeness to the primal Beautiful, but in the measure of their imperfection when compared to it, and to the extent that they are like to what is naught, are ugly; which cannot be in Him Whose essence is Beauty, and so it is possible for the beautiful to be ugly, but not indeed for Beauty to be ugly. "Nor is it beautiful in one place and not in another," as is the case with those other and created things which were naturally deformed when the "earth was without form and void" (Genesis 1:2), and afterwords were formed when the Spirit of God moved over the waters warming (*fovens*)[30] and forming all things; and as thus they take their beauty from another, without which other they might not be beautiful, for as Avicenna (*Metaphysics*) says, everything that receives anything from another may also not receive it from that other. But there is nothing of this sort in the First Cause of beauty, which gets its beauty from itself; this is no matter of a possible beauty, but of inevitable and infallible necessity. "Nor is it beautiful in one relation and ugly in another," after the manner of creatures, each of which is comparatively ugly; for the less elegant is ugly when compared to what is more

[29] *Ignorantia* = Skr. *avidyā*, "knowledge-of," objective, empirical, relative knowledge. Cf. BU iv.4.19, "Only by Intellect (*manasā*) can it be seen that 'There is no plurality of Him'"; and KU iv.14, "Just as water rained upon a lofty peak runs here and there (*vidhāvati* = *errat*) amongst the hills, so one who sees the principles in multiplicity (*dharmāny pṛthak paśyam*) pursues after them (*anudhāvati* = *vagatur*)." Ulrich's *errantium* = Skr. *saṃsārasya*.

[30] *Fovere* = Skr. *tap*. Cf. AĀ ii.4.3, "He glowed upon (*abhyatapata*) the Waters, and from the Waters that were set aglow (*abhitaptābhyah*) a form (*mūrtiḥ*) was born"; AĀ ii.2.1, "He who glows (*tapati*) is the Spiritus (*prāṇah*)"; and JUB i.54, where "He who glows yonder" is the Supernal Sun, *Āditya*; also AV x.7.32, "proceeding in a glowing (*tapasi*) on the face (lit. *pṛṣṭhe*, 'back') of the Waters."

beautiful, and the most beautiful is ugly when compared with the un-created Beauty. As in Job 4:18, "Behold, He put no trust in His servants; and His angels He charged with folly," where he is comparing them with God. Whence it is laid down: No man can be justified if he be compared to God. Similarly, Job 15:15, "Behold, He putteth no trust in His saints; yea, the heavens are not clean in His sight." Hence, He alone is the Most Beautiful simply, nor has He any relative deformity. Again, He "is not beautiful in one place and not in another," as is the beautiful that is in some things and not in another, as if He had exemplary Beauty for some things and for some others had it not; but since He is of perfect beauty, He has simply and singly in Himself all of Beauty without any deduction therefrom.

And as besides the goodness in which the goodness of individual things subsists there is a certain goodness of the universe, so also beside the beauty of individual things there is one beauty of the whole universe, which beauty results from the integration of all that is beautiful in any manner to make one most beautiful world, wherein the highest and divine Beauty can be participated in by the creature; and as to these things, it is said in Genesis 2:1, "Thus the heavens and the earth were finished (*perfecti*)," which is to be taken as referring to the goodness of all their adornment (*ornatus*), that is, to their beauty.[31] And since

[31] The doctrine of the beauty of the universe integrally, as being greater than that of any of its parts, is extensively developed in Christian Scholastic as well as in Oriental philosophy; we hope to be able to present subsequently a translation of Hugo of St. Victor, *De tribus diebus* c. 4–13, in which he treats of the beauty of the world as a whole and in its parts, combining the theological and aesthetic points of view [Coomaraswamy seems never to have realized this project.—ED.]. As regards Genesis 2:1, St. Augustine (*Confessions* XIII.28) emphasizes the concept of the greater beauty of the whole when he says, "Thou sawest everything that Thou hadst made, and behold it was not only Good, but also Very Good, as being now all together." This beauty of the whole universe, viz. of all that has been, is, or will be anywhere, is that of the "world-picture" as God sees it, and as it may be seen by others in the eternal mirror of the divine intellect, according to their capacity; as Augustine says (*De civ. Dei* XII.29) with reference to angelic (Skr. *adhidaivata, parokṣa*) understanding, "The eternal mirror leads the minds of those who look in it to a knowledge of all things, and better than in any other way." The divine "satisfaction," expressed in the words of Genesis "saw that it was very good," represents the perfection of "aesthetic" experience, as also in Śaṅkarācārya's *Svātma-nirūpaṇa* 95, "The Ultimate Essence, regarding the world-picture painted by the Essence on the vast canvas of the Essence takes a great delight therein," echoed in the *Siddhāntamuktāvalī*, p. 181, "I behold the world as a picture, I see the Essence"; all this corresponding to the Vedic concept of the Supernal Sun as

there cannot be a more perfect beauty than the universally perfect, unless it be the superperfect Beauty that is in God alone, it is true, as Cicero says, *De natura Deorum* [II:87], that "all the parts of the world are so constituted that they could not be better for use nor more beautiful in their kind." But this must be understood according to the distinction made above,[32] where it was shown in what manner the universe can be either more or less good. For in the same way it can be more or less beautiful. Because since whatever is deformed either has some beauty in it, as in the case of monstrosities or that of penal evil, or alternatively raises the beauty of its opposite to a higher degree, as in the case of natural defect or moral sin, it is clear that deformities themselves have their

the "eye" of Varuṇa wherewith He "surveys the whole universe" (*viśvam abhicaṣṭe*, RV 1.164.44, cf. vii.61.1), and in Buddhism to the designation of the Buddha as "the eye of the world," *cakkhum loke*. All the contempt of the world which has been attributed to Christianity and to the Vedānta is directed not against the world as seen in its perfection, *sub specie aeternitatis*, and in the mirror of the speculative intellect, but against an empirical vision of the world as made up of independently self-subsistent parts to which we attribute an intrinsic goodness or badness based on our own liking or disliking, the "two highwaymen" or "footpaths" of BG iii.34 (cf. v.20, vi.32). "It naught availeth to be wroth at things" (Euripides, *Bell.* fr. 289). "Many are the injustices we commit when we attach an absolute value" to the contraries, pain and pleasure, death and life, over which we have no control, and "he clearly acts impiously who is not himself neutral (ἐπίσης) towards them" (Marcus Aurelius vi.41, ix.1). For "there is no evil in things, but only in the sinner's misuse of them" (St. Augustine, *De doctrina Christiana* iii.12): impartiality, apathy, ataraxia, patience, *upekṣā, sama-dṛṣṭi*, these are the indispensable prerequisites for any true activity; the so-called actions that are "economically" determined by likes and dislikes are not really acts but only a passive, pathetic reaction or behaviorism.

If we ignore the appreciation of the beauty of the world that is a fundamental doctrine in Scholastic philosophy, we shall be in great danger of misinterpreting the whole "spirit" of Gothic art. It is true that Christian art is anything but "naturalistic" in our modern and idolatrous sense (cf. Blake's protest, when he says that he is "afraid that Wordsworth is fond of nature"); but for all its abstraction, or, in other words, its intellectuality, it is saturated with a sense of the formal beauty that is proper to everything in its kind and coincident with its natural life; and unless we recognize that *this* naturalism is altogether consistent with what is explicitly affirmed in the underlying philosophy, we are very likely to commit the romantic error of supposing that whatever in Gothic art seems to be taken directly from nature or to be "true to nature" represents an interpolation of profane experience; in other words, we shall run the risk of seeing in the art an interior conflict that is altogether foreign to it and really belongs only to ourselves.

[32] Viz. in the preceding chapter of the *Summa de bono* which deals with the "Good of the Universe."

source in the beauty of the universe, viz. insofar as they are beautiful essentially or accidentally, or on the contrary do not originate thence, viz. insofar as they are privations of beauty. Whence it follows that the beauty of the universe cannot be increased or diminished; because what is diminished in one part is increased in another, either intensively, when goods are seen to be the more beautiful when contrasted with their opposite evils, or extensively, in that the corruption of one thing is the generation of another, and the deformity of guilt is repaired by the beauty of justice in the penalty.[33] There are also certain other things that do not depend on the natural beauty of the universe, as not being derived from this natural beauty essentially, nor accidents of this natural beauty arising from the essential principles of the universe, but yet pour out abundantly a supernatural beauty in the universe, as in the case of gifts of graces, the incarnation of the Son of God, the renewal of the world, the glorification of the saints, the penalty of the damned, and in general whatever is miraculous. For grace is a supernatural likeness of the divine Beauty. And through the incarnation every creature really participates in the essence of the divine Beauty, by a natural and personal union with it, before which creatures participated in it only by similitude; for as Gregory says [*Hom.* xx *in Evangelia,* n. 7, see Migne, *Series latina*], "Man is in a manner all creatures."[34] Moreover, by the renewal of the world and the glorification of the saints the universe in all its essential parts is adorned with a new glory; and by the punishment of the wicked and the order of divine providence, the further adornment of justice, which is now seen but darkly, is poured out into the

[33] Cf. our "poetic justice." It may be observed that Beauty as an efficient cause of all specific beauties can be compared to the scientific concept of Energy as manifested in a diversity of forces, the notion of a conservation of Beauty corresponding to that of the conservation of Energy. But it must not be overlooked that these are analogies on different levels of reference.

[34] It is in this sense that as Meister Eckhart says (Evans ed., I, 380), "creatures never rest till they have gotten into human nature; therein do they attain to their original form, God namely." Intellect, being conformable to whatever is knowable, "raises up all things into God," so that "I alone take all things out of their sense and make them one in me" (I, 87 and 380). And this is precisely what the artist does, whose first gesture (*actus primus,* Aquinas, *De coelo et mundo* II.4 and 5) is an interior and contemplative act (Skr. *dhyāna*) in which the intellect envisages the thing not as the senses know it, nor with respect to its value, but as intelligible form or species; the likeness of which he afterwards (*actus secundus*) proceeds to embody in the material, "similitude being with respect to the form" (*Sum. Theol.* 1.5.4).

world; and in miracles, all the creature's passive powers are reduced to act—and every act is the "beauty" of its potentiality.

3. St. Thomas Aquinas

"On the Divine Beautiful, and how it is attributed to God"[35]

"This good is praised by the sainted theologians as the beautiful and as beauty; and as love and the lovely." After Dionysius has treated of light, he now treats of the beautiful, for the understanding of which light is prerequisite. In this connection, he first lays down that the beautiful is attributed to God, and secondly, he shows in what manner it is attributed to Him, saying: "The beautiful and beauty are indivisible in their cause, which embraces All in One."

He says first, therefore, that this supersubstantial "good," which is God, "is praised by the sainted theologians" in Holy Writ: "as the beautiful," [as in] the Song of Songs 1:15, "Lo! thou art beautiful, my beloved," and "as beauty," [as in] Psalm 95:6, "Praise and beauty are before Him," and "as love," [as in] John 4:16, "God is love," and "as lovely," according to the text from the Song of Songs, "and by whatever other befitting names" of God are proper to beauty, whether in its causal aspect, and this is with reference to "the beautiful and beauty," or inasmuch as beauty is pleasing, and this is with reference to "love and the lovely." Hence in saying: "The beautiful and beauty are indivisible in their cause, which embraces All in One," he shows how it is attributed to God; and here he does three things. First, he premises that the beautiful and beauty are attributed differently to God and to creatures; second, how beauty is attributed to creatures, saying: "In existing things, the beautiful and beauty are distinguished as participations and participants, for we call beautiful what participates in beauty, and beauty the participation of the beautifying power which is the cause of all that is beautiful in things"[36]; third, how it is attributed to God, saying that "the supersubstantial beautiful is rightly called Beauty absolutely."

Hence he says, first, that in the first cause, that is, in God, the beautiful

[35] Aquinas, *Sancti Thomae Aquinatis, Opera omnia* (Parma, 1864), opusc. VII, c.4, lect. 5.

[36] The beautiful thing is a participant just as "all beings are not their own being apart from God, but beings by participation" (St. Thomas, *Sum. Theol.* 1.44.1), and in the same way that "creation is the emanation of all being from the Universal Being" (*ibid.*, 45.4 *ad* 1).

and beauty are not divided as if in Him the beautiful was one thing, and beauty another. The reason is that the First Cause, because of its simplicity and perfection, embraces by itself "All," that is everything, "in One."[37] Hence, although in creatures the beautiful and beauty differ, nevertheless God in Himself embraces both, in unity, and identity.

Next, when he says "In existing things, the beautiful and beauty are distinguished, . . ." he shows how they are to be attributed to creatures, saying that in existing things the beautiful and beauty are distinguished as "participations" and "participants," for the beautiful is what participates in beauty, and beauty is the participation of the First Cause, which makes all things beautiful. The creature's beauty is naught else but a likeness (*similitudo*) of divine beauty participated in by things.[38]

Next, when he says "But the supersubstantial beautiful is rightly indeed called Beauty, because the beautiful that is in existing things according to their several natures is derived from it," he shows how the aforesaid [beautiful and Beauty] are attributed to God: first how Beauty is attributed to Him, and second, how the beautiful. "Beautiful," as being at the same time most beautiful, and superbeautiful. Therefore he says first that God, who is "the supersubstantial beautiful, is called Beauty," and, for this reason, second, that He bestows on all created beings "according to their idiosyncrasy." For the beauty of the spirit and the beauty of the body are different, and again the beauties of different bodies are different. And in what consists the essence of their beauty he shows when he goes on to say that God transmits beauty to all things inasmuch as He is the "cause of harmony and lucidity" (*causa consonantiae et*

[37] For the convergence of all particular beauties in the divine service, cf. CU IV.15.2; [also Plato, *Phaedo* 100D; *Republic* 476D].

[38] Here the concept of participation is qualified by the statement that the mode of participation is by likeness. That the word "being" (*essentia*) is used of the being of things in themselves and also of their being principally in God, and therefore as God, does not imply that their being in themselves, as realities in nature, is a *fraction* of His being; and in the same way their beauty (which, as *integritas sive perfectio*, is the measure of their being) is not a fraction of the Universal Beauty, but a reflection or likeness (*similitudo*, Skr. *pratibimba, pratimāna*, etc.) of it; [cf. *Sum. Theol.* 1.4.3]. Likeness is of different kinds: (1) of nature, and is called "likeness of univocation or participation" with reference to this nature, as in the case of the Father and the Son; (2) of imitation, or participation by analogy; and (3) exemplary, or expressive. The creature's participation in the divine being and beauty is to some extent of the second, and mainly of the third sort. The distinctions made here are Bonaventura's; for references see Bissen, *L'Exemplarisme divin selon Saint Bonaventure*, pp. 23 ff., and for exemplarism generally, Coomaraswamy, "Vedic Exemplarism" [in Vol. 2 of this selection—ED.].

claritatis). For so it is that we call a man beautiful on account of the suitable proportion of his members in size and placement and when he has a clear and bright color (*propter decentem proportionem membrorum in quantitate et situ, et propter hoc quod habet clarum et nitidum colorem*). Hence, applying the same principle proportionately in other beings, we see that any of them is called beautiful according as it has its own generic lucidity (*claritatem sui generis*), spiritual or bodily as the case may be, and according as it is constituted with due proportion.

How God is the cause of this lucidity he shows, saying that God sends out upon each creature, together with a certain flashing (*quodam fulgore*),[39] a distribution of His luminous "raying" (*radii*) which is the font of all light; which flashing "distributions (*traditiones*) are to be understood as a participation of likeness; and these distributions are beautifying," that is to say, are the makers of the beauty that is in things.

Again, he explains the other part, viz. that God is the cause of the "harmony" (*consonantia*) that is in things. But this harmony in things is of two sorts. The first as regards the order of creatures to God, and he touches upon this when he says that God is the cause of harmony "for that it summons all things to itself," inasmuch as He (or it) turns about all things toward Himself (or itself), as being their end, as was said above; wherefore in the Greek, beauty is called καλός, which is derived from [the verb καλέω, which means] "to summon." And second, harmony is in creatures accordingly as they are ordered to one another; and this he touches upon when he says that it gathers together all in all to be one and same. Which may be understood in the sense of the Platonists, viz. that higher things are in the lower by participation, the lower in the higher eminently (*per excellentiam quandam*),[40] and thus all things are in all. And since all things are thus found in all according to some order, it follows that all are ordered to one and the same last end.[41]

[39] *Fulgor* corresponds to Skr. *tejas*.

[40] Lower and higher things differ in nature, as, for example, an effigy in stone differs from a man in the flesh. The higher are contained in the lower formally, or, as here expressed, "by participation," the "form" of the living man, for example, being in the effigy as its formal cause or pattern; or as the Soul in the body, or "spirit" in the "letter." *Vice versa*, the lower is in the higher "more excellently," the form of the effigy, for example, being alive in the man.

[41] The "end" of anything is that toward which its movement tends, and in which this movement comes to rest, which may be simply illustrated by the case of the arrow and its target; and as we have already seen, all sin, including "artistic sin," consists in a "departure from the order to the end." Here we are told that it is the beauty of God by which we are attracted to Him, as to man's last end; and

Thereafter, when he speaks of "the beautiful as being at the same time most beautiful and superbeautiful, superexistent in one and the same mode," he shows how the beautiful is predicated of God. And first he shows that it is predicated by excess; and second that it is said with respect to causality: "From this beautiful it is that there are individual beauties in existing things each in its own manner." As regards the former proposition he does two things. First, he sets forth the fact of the excess; second, he explains it "as superexistent in one and the same mode." Now there are two sorts of excess: one within a genus, and this is signified by comparative and superlative; the other, outside of genus, and this is signified by the addition of this preposition *super*. For example, if we say that a fire exceeds in heat by an excess within the genus, that is as much as to say that it is very hot; but the sun exceeds by an excess outside the genus, whence we say, not that it is very hot, but that

inasmuch as Dionysius affirms the coincidence of love and beauty, there can be seen here an illustration of Eckhart's dictum to the effect that we desire a thing while as yet we do not possess it, but when we possess it, love it, or as Augustine expresses it, enjoy it; desire and attraction implying pursuit, love and fruition implying rest; see also the following note.

The superiority of contemplation, perfected in *raptus* (Skr. *samādhi*), to action is assumed; which is, indeed, the orthodox point of view, consistently maintained in universal tradition and by no means only (as sometimes assumed) in the Orient, however it may have been obscured by the moralistic tendencies of modern European religious philosophy. The Scholastic treatment of "beauty" as an essential name of God exactly parallels that of the Hindu rhetoric, in which "aesthetic experience" (*rasāsvādana*, lit. "the tasting of flavor") is called the very twin of the "tasting of God" (*brahmāsvādana*). A clear distinction of contemplative experience from aesthetic pleasure is involved; "tasting" is not a "matter of taste" (Skr. *tat lagnam hṛd*, "what sticks to the heart"). Just as "with finding God, all progress ends" (Eckhart), so in perfect contemplative experience the operation of the attracting power of beauty—aesthetic pleasure as distinct from the "rapture" of disinterested contemplation—is at an end. If action ensues, when the contemplative returns to the plane of conduct, as is inevitable, this will neither add to nor detract from the higher "value" of the contemplative experience. On the other hand, the action itself will be really, although not necessarily perceptibly, of another sort than before, as being now a manifestation, rather than motivated; in other words, whereas the individual may previously have acted or striven to act according to a concept of "duty" (or more technically stated, "prudently") and, as it were, against himself, he will now be acting spontaneously (Skr. *sahaja*) and, as it were, of himself (or as St. Thomas so grandly expressed it, "the perfect cause acts for the love of what it has," and Eckhart, "willingly but not from will"); it is in this sense that "Jesus was all virtue, because he acted from impulse and not from rules" (Blake). It scarcely needs to be said that the self-confidence of "genius" is far removed from the "spontaneity" referred to here; our spontaneity is rather that of the workman

it is superhot, because heat is not in it in the same way, but eminently. And granted that this double excess is not found simultaneously in things caused, we say, nevertheless, that God is both most beautiful and superbeautiful; not as if He were in any genus, but because all things that are in any genus are attributed to Him.

Then when he says "and superexistent," he explains what he had said. First, he explains why God is called most beautiful, and second, why He is called superbeautiful, saying "and as it were the fount of all the beautiful, and in itself preeminently possessed of beauty." For, as a thing is called more white the more it is unmixed with black, so likewise a thing is called more beautiful the more it is removed from any defect of beauty. Now there are two sorts of defect of beauty in creatures: first, there are some things that have a changeable beauty, as may be seen in corruptible things. This defect he excludes from God by saying first that God is always beautiful after one and the same mode, and so any alteration of beauty is precluded. And again, there is neither generation nor corruption of beauty in Him, nor any dimming, nor any increase or decrease, such as is seen in corporeal things. The second defect of beauty is that all creatures have a beauty that is in some way a particularized [individual] nature. Now this defect he excludes from God as regards every kind of particularization, saying that God is not beautiful in one

who is "in full possession of his art," which may or may not be the case of "genius."

These considerations should be found of value by the student of T. V. Smith's thoughtful volume, *Beyond Conscience* (New York and London, 1934), in which he speaks of "the richness of the aesthetic pattern furnished by conscience to understanding," and suggests that "the last ought impulse of the imperious conscience would be [i.e., should be] to legislate itself into an abiding object for the contemplative self" (p. 355). It is only from the modern sentimental position (in which the will is exalted at the expense of the intellect) that such an assertion of the superiority of "aesthetic" contemplation could appear "shocking." If we do now shrink from the doctrine of the superiority of contemplation, it is mainly for two reasons, both dependent on the sentimental fallacy: first because, in opposition to the traditional doctrine that beauty has primarily to do with cognition, we now think of aesthetic contemplation as merely a kind of heightened emotion; and second, because of the currency of that monstrous perversion of the truth according to which it is argued that, because of his greater sensibilities, a moral license should be allowed to the artist *as a man*, greater than is allowed to other men. If only because to some extent the painter always paints himself "it is not enough to be a painter, a great and skilful master; I believe that one must further be of blameless life, even if possible a saint, that the Holy Spirit may inspire one's understanding" (Michelangelo, quoted in A. Blunt, *Artistic Theory in Italy*, Oxford, 1940, p. 71 [cf. St. Augustine, *De ordine* 2.xix.50]).

part and ugly in another as sometimes happens in particular things; nor beautiful at one time and not at another, as happens in things of which the beauty is in time: nor again is He beautiful in relation to one and not to another, as happens in all things that are ordered to one determined use or end—for if they are applied to another use or end, their harmony (*consonantia*), and therefore their beauty, is no longer maintained; nor again is He beautiful in one place and not in another, as happens in some things because to some they seem and to others do not seem to be beautiful. But God is beautiful to all and simply.

And for all these premises he gives the reason when he adds that He is beautiful "in Himself," thereby denying that He is beautiful in one part alone, and at one time alone, for that which belongs to a thing in itself and primordially, belongs to it all and always and everywhere. Again, God is beautiful in Himself, not in relation to any determined thing. And hence it cannot be said that He is beautiful in relation to this, but not in relation to that; nor beautiful to these persons, and not to those. Again, He is always and uniformly beautiful; whereby the first defect of beauty is excluded.

Then when he says "and as being in Himself preeminently possessed of beauty," the fount of all the beautiful, he shows for what reason God is called superbeautiful, viz. inasmuch as He possesses in Himself supremely and before all others the fount of all beauty. For in this, the simple and supernatural nature of all things beautiful that derive from it, all of beauty and all the beautiful preexist, not indeed separately, but "uniformally," after the mode in which many effects preexist in one cause. Then when he says: "From this beautiful it is that there is being (*esse*) in all existing things and that individual things are beautiful each in its own way," he shows how the beautiful is predicated of God as cause. First, he posits this causality of the beautiful; second, he explains it, saying, "and it is the principle of all things." He says first, therefore, that from this beautiful proceeds "the being in all existing things." For lucidity (*claritas*) is indispensable for beauty, as was said: and every form whereby anything has being, is a certain participation of the divine lucidity, and this is what he adds, "that individual things are beautiful each in its own way," that is, according to its own form. Hence it is evident that it is from the divine beauty that the being of all things is derived (*ex divina pulchritudine esse omnium derivatur*). Again, likewise, it has been said that harmony is indispensable for beauty, hence, everything that is in any way proper to harmony proceeds from the divine beauty; and this is what he adds, that because of the divine good are all

the "agreements" (*concordiae*) of rational creatures in the realm of intellect—for they are in agreement who consent to the same proposition; and "friendships" (*amicitiae*) in the realm of the affections; and "fellowships" (*communiones*) in the realm of action or with respect to any external matter; and in general, whatever bond of union there may be between all creatures is by virtue of the beautiful.

Then when he says, "and it is the principle of all things beautiful," he explains what he had said about the causality of the beautiful. First, about the nature of causing; and second, about the variety of causes, saying: "This one good and beautiful is the only cause of all and sundry beauties and goods." As regards the first, he does two things. First, he gives the reason why the beautiful is called a cause; second, he draws a corollary from his statements, saying, "therefore the good and the beautiful are the same." Therefore he says first, that the beautiful "is the principle of all things as being their efficient cause," giving them being, and "moving" cause, and "maintaining" cause, that is preserving "all things," for it is evident that these three belong to the category of the efficient cause, the function of which is to give being, to move, and to preserve.

But some efficient causes act by their desire for the end, and this belongs to an imperfect cause that does not yet possess what it desires. On the other hand, the perfect cause acts for the love of what it has; hence he says that the beautiful, which is God, is the efficient, moving, and maintaining cause "by love of its own beauty." For since He possesses His own beauty, he wishes it to be multiplied as much as possible, viz. by the communication of his likeness.[42] Then he says that the beautiful,

[42] All this has a direct bearing upon our notions of "aesthetic" appreciation. All love, delight, satisfaction, and rest in (as distinguished from desire for) anything, implies a possession (*delectatio autem vel amor est complementum appetitus*, Witelo, *Liber de intelligentiis* xviii); it is in another way, "in an imperfect cause that is not yet in possession of what it desires," that love means "desire" (*appetitus naturalis vel amor, Sum. Theol.* 1.60.1). See also Augustine and Eckhart as cited in n. 27.

Delight or satisfaction may be either aesthetic (sensible) or intellectual (rational). Only the latter pertains to "life," the nature of which is to be in act; the satisfactions that are felt by the senses being not an act, but a habit or passion (Witelo, *Liber de intelligentiis* xviii, xix): the work of art then only pertains to our "life" when it has been *understood*, and not when it has only been *felt*.

The delight or satisfaction that pertains to the life of the mind arises "by the union of the active power with the exemplary form to which it is ordered" (Witelo, *Liber de intelligentiis* xviii). The pleasure felt by the artist is of this kind; the exemplary form of the thing to be made being "alive" in him and a part of his "life" (*omnes res . . . in artifice creato dicuntur vivere*, St. Bonaventura, *I Sent.* d.36, a.2, q.1 *ad* 4) as the form of his intellect, therewith identified (Dante, *Convito*, Canzone iv.iii.53 and 54, and iv.10.10–11; Plotinus, iv.4.2; Philo, *De opificio mundi* 20). Cf.

which is God, is "the end of all things, as being their final cause." For all things are made so that they may somewhat imitate the divine Beauty. Third, it is the exemplary [i.e., formal] cause; for it is according to the divine beautiful that all things are distinguished, and the sign of this is that no one takes pains to make an image or a representation except for the sake of the beautiful.[43]

Coomaraswamy, *Why Exhibit Works of Art?* 1943, p. 46. With respect to this intellectual identification with the form of the thing to be made, involved in the *actus primus*, or free act of contemplation, the artist "himself" (spiritually) becomes the formal cause; in the *actus secundus*, or servile act of operation, the artist "himself" (psycho-physically) becomes an instrument, or efficient cause. Under these conditions, "pleasure perfects the operation" (*Sum. Theol.* II-I.33.4c).

Analogous to the artist's providential satisfaction in possession of the exemplary form of the thing to be made is the spectator's subsequent delight in the thing that has been made (as distinguished from his pleasure in the use of it). This second and "reflex delight" (*delectatio reflexa*, Witelo, *Liber de intelligentiis* xx) is what we really mean by that of a "disinterested aesthetic contemplation," though this is an awkward phrase because "disinterested aesthetic" is a contradiction in terms. The reflex delight is no more, in fact, a sensation than was the former delight in a thing that had not yet been made; it is again a "life of the intellect" (*vita cognoscitiva*), depending upon "the union of the active power with the exemplary form to which it is ordered" (*ibid.*, xviii): "ordered," or "occasioned," now by the sight of the thing that has been made, and not, as before, by the need for making.

With this second identification of an intellect with its object, and consequent delight or satisfaction, the artifact, dead matter in itself, comes to be "alive" in the spectator as it was in the artist; and once more it can be said that the love of the thing becomes a love of one's (true) self. It is in this sense, indeed, that "it is not for the sake of things themselves, but for the sake of the Self that all things are dear" (BU iv.5).

Both of these delights or satisfactions (*delectatio et delectatio reflexa*) are proper to God as the Divine Artificer and Spectator, but not in Him as successive acts of being, He being at the same time both artist and patron.

The "love of His own beauty" is explained above as the reason of a multiplication of similitudes, for just as it belongs to the nature of light to reveal itself by a raying, so "the perfection of the active power consists in a multiplication of itself" (Witelo, *Liber de intelligentiis* xxxi); only when light (*lux*) becomes an illumination (*lumen*), effective as *color* (St. Bonaventura, *I Sent.* d.17, p.1, a.unic., q.1), is it "in act." From the possession of an art, in other words, the operation of the artist naturally follows. This operation, given the act of identification as postulated by Dante and others, is a self-expression, i.e., an expression of that which can be regarded either as the exemplary form of the thing to be made, or as the form assumed by the artist's intellect; not, of course, a self-expression in the sense of an exhibit of the artist's personality. In this distinction lies the explanation of the characteristic anonymity of the mediaeval artist as an individual—*Non tamen est multum curandum de causa efficiente* (the artist, So-and-so by name or family), *cum non quis dicat, sed quid dicatur, sit attendendum!*

[43] Statements of this sort cannot be twisted to mean that "Beauty," indefinitely and absolutely, is the final cause of the artist's endeavors. That things are "distin-

Then, in that he says "the good and the beautiful are the same," he draws a corollary from the aforesaid, saying that because the beautiful is in so many ways the cause of being, therefore, "the good and the beautiful are the same," for all things desire the beautiful and the good as a cause in every one of these ways, and because there is "nothing that does not participate in the beautiful and the good," everything being beautiful and good with respect to its proper form.

Moreover, we can boldly say that "the nonexistent," that is to say, primary matter, "participates in the beautiful and the good," since the nonexistent primal being (*ens primum non existens*, Skr. *asat*) has a certain likeness to the divine beautiful and good. For the beautiful and good is praised in God by a certain abstraction; and while in primary matter we consider abstraction by defect, we consider abstraction in God by excess, inasmuch as His existence is supersubstantial.[44]

guished" means each in its kind and from one another; to "take pains" in making anything is to do one's best to embody its "form" in the material, and that is the same as to make it as beautiful as one can. The artist is always working for the good of the work to be done, "intending to give to his work the best disposition," etc. (*Sum. Theol.* 1.91.3c), in other words, with a view to the perfection of the work, perfection implying almost literally "well and truly made." The beauty which, in the words of our text, "adds to the good an ordering to the cognitive faculty" is the appearance of this perfection, by which one is attracted to it. It is not the artist's end to make something beautiful, but something that will be beautiful only because it is perfect. Beauty, in this philosophy, is the attractive power of perfection.

[44] "Primary matter" is that "nothing" (τὸ μὴ ὄν) out of which the world was made. "Existence in nature does not belong to primary matter, which is a potentiality, unless it is reduced to act by form" (*Sum. Theol.* 1.14.2 *ad* 1): "Primary matter does not exist by itself in nature; it is concreated rather than created. Its potentiality is not absolutely infinite because it extends only to natural forms" (1.7.2 *ad* 3). "Creation does not mean the building up of a composite but that something is created so that it is brought into being at the same time with all its principles" (1.45.4 *ad* 2).

But inasmuch as Dionysius is discussing beauty all the time as an essential name of God, and particularly the beautiful as being the Divine Light, following the *via analogica* and ascribing beauty to God by excess, it would seem likely that when he turns to the *via negativa* and, by abstraction, ascribes the beautiful and the good also to the "nonexistent," he is not thinking of "primary matter," as a nature that "recedes from likeness to God" (*Sum. Theol.* 1.14.11 *ad* 3) and as material cause is not in Him, but of the Divine Darkness that "is impervious to all illuminations and hidden from all knowledge" (Dionysius, in *Ep. ad Caium Monach.*), the Godhead, the potentiality of which *is* absolutely infinite, and at the same time (as Eckhart says) "is as though it were not," though it is not remote from God, being that "nature by which the Father begets" (*Sum. Theol.* 1.41.5), "that nature, to wit, which created all others" (Augustine, *De Trinitate* xiv.9). Quite differently expressed, one may say that what Dionysius means is that the Deity in the aspect

219

But although the beautiful and the good are one and the same in their subject, nevertheless, because lucidity and harmony are contained in the idea of the good, they differ logically, since the beautiful adds to the good an ordering to the cognitive faculty by which the good is known as such.

Commentary by Coomaraswamy on the *tria requiruntur*

Beauty is not in any special or exclusive sense a property of works of art, but much rather a quality or value that may be manifested by all things that are, in proportion to the degree of their actual being and perfection. Beauty may be recognized either in spiritual or material substances, and if in the latter, then either in natural objects or in works of art. Its conditions are always the same.

"Three things are necessary to beauty. First indeed, accuracy or perfection; for the more things are impaired, thereby the uglier they are. And due proportion, or harmony. And also clarity; whence things that have a bright color are called beautiful." (*Ad pulchritudinem tria requiruntur. Primo quidem integritas, sive perfectio; quae enim diminuta sunt, hoc ipso turpia sunt. Et debita proportio, sive consonantia. Et iterum claritas; unde quae habent colorem nitidum, pulchra esse dicuntur* [*Sum. Theol.* 1.39.8c].)

It is essential to understand the terms of this definition. *Integritas* in the moral sense is not what is meant, but rather in that of "entire correspondence with an original condition" (Webster). The meaning "accuracy" may be seen in Cicero, *Brutus* XXXV.132, *sermonis integritas*, and in St. Augustine, *De doctrina christiana* IV.10, *locutionis integritas*. *Perfectio* must be taken in the triple sense of *Sum. Theol.* 1.6.3, "first according to the condition of a thing's own being [all it can or ought to be]; second in respect of any accidents being added as necessary to its perfect operation;[45] thirdly, perfection consists in the attaining to something else as the end."[46] So in *Sum. Theol.* 1.48.5c, where evil in anything whatever is

of wrath is no less beautiful and good than under the aspect of mercy; or expressed in Indian terms, that Bhairava and Kālī are no less beautiful and "right" than Śiva and Pārvatī.

[45] Accidents necessary to the perfect operation of anything are its "ornaments" or "decoration"; see "Ornament" [in this volume—ED.]. Hence beauty and decoration are coincident in the subject (*Sum. Theol.* II-II.145.2c, *ratio pulchri sive decori*).

[46] I.e., in the thing's utility or aptitude. In sum, we cannot call a piece of iron a "beautiful knife" unless it is indeed a knife, if it is not sharp, or if it is not so

defined as privation of the good considered as a being "in perfection and in act," the *actus primus* is the thing's *forma et integritas,* and the corresponding evil is "either defect of the form or of some part of it necessary to the thing's *integritas.*" In *Sum. Theol.* Suppl. 80.1.c, both "integrity" and "perfection" imply an "entire correspondence" and "correspondence in full proportion" of the accidental to the substantial form of the natural or artificial object. And since "the first perfection of a thing consists in its very form, from which it derives its species" (*Sum. Theol.* III.29.2c) and that "likeness is with respect to the form" (1.5.4), we see that *integritas* is really "correctness" of the iconography and corresponds to Plato's ὀρθότης; all things being beautiful to the extent that they imitate or participate in the beauty of God, the formal cause of their being at all.

Diminuta does not mean "broken up," but rather "impaired," abated or diminished by defect of anything that should be present, as in *Nicomachean Ethics* IV.3.5, and in Psalm 2:1, *diminutae sunt veritates,* and Rev. 22:19, "if any man shall take away (*diminuerit*)."[47] It must be from this point of view that we should understand "magnitude" as essential to beauty (see n. 21, above): viz. an appropriate, rather than any absolute size. In mediaeval and similar arts the size of a figure is proportionate to its importance (and this is the chief sense of the expression *debita proportio*), and not perspectively determined by its physical relationship to other figures; while in nature, whatever is "undersized" is puny and ugly. *Superfluum et diminutum* (*Nicomachean Ethics* I-II.27.2 *ad* 2) are the extremes to be avoided in whatever is to be "correct"; the Sanskrit equivalents are the *ūnātiriktau,* "too little and too much," to be avoided in ritual operation. "Beautiful" and "ugly" are *pulcher* and *turpis,* like Gk. καλός and αἰσχρός and Skr. *kalyāna* and *pāpa*; "ugly" coinciding with "disgraceful" or "sinful," and beauty with "grace" or "goodness." The terms have a far more than merely aesthetic significance. Skr. √*kal,* present in *kalyāna* and καλός, is recognizable also in "hale," "healthy," "whole," and "holy"; its primary senses are to "be in act," "be effective," "*cal*-culate," "make," and a derivative is *kāla,* "time." This √*kal* is probably identical with √*kṛ* (*kar*) in *kāra,* "creation" and *kratu,* "power," Lat. *creo,* etc., Gk. κραίνω whence κράτος, etc., and in the same way χρόνος,

shaped as to serve the particular end for which it was designed. Things can be beautiful or perfect only in their own way, and only good of their kind, never absolutely. [Cf. Plato, *Hippias Major* 290D, and Philo, *Heres* 157–158.]

[47] Cf. Plato, *Laws* 667D, where correctness (ὀρθότης = *integritas*) is a matter of adequacy (ἰσότης), both as to quality and quantity; also *Republic* 402A and 524C.

"time." The doctrine that "beauty is a formal cause" and that *ex divina pulchritudine esse omnium derivatur* is deeply embedded in language itself.

"Due proportion" and "consonance" (*consonantia* = ἁρμονία) are (1) of the actual to the substantial form and (2) of the parts of a thing among themselves. The former conception, I think, predominates, as in Aquinas, *Summa contra Gentiles* 1.62, "For then an ark is a true ark when it agrees with (*consonat*) the art" (in the mind of the artist), and as suggested above in connection with "magnitude." On the other hand, in the *De pulchro* translated above, St. Thomas by *consonantia* is plainly referring to the due proportion of the parts of a thing in relation to one another. "Due proportion" necessary to beauty is mentioned also in *Sum. Theol.* 1.5.4 *ad* 1 and II-II.45.2c.

Claritas is the radiance, illumination, lucidity, splendor, or glory proper to the object itself, and not the effect of any external illumination. The outstanding examples of clarity are the sun and gold, to which a "glorified" body is therefore commonly compared; so also Transfiguration is a clarification (cf. *Sum. Theol.* Suppl. 85.1 and 2).

Everything has its own "generic lucidity" (Aquinas, *De pulchro*), that of the "shining of the formal light upon what is formed or proportioned" (Ulrich Engelberti, *De pulchro*). An excellent illustration can be cited in CU IV.14.2, where one man says to another, "Your face, my dear, shines like that of one who has known God." Compare Old English, *Hire lure lumes liht, as a launterne a nyht*, William Blake's "Tiger, Tiger, burning bright," and the "flaming kine" of RV II.34.5. In this sense we speak of all beautiful things as "splendid," whether they be natural objects such as tigers or trees, or artifacts such as buildings or poems, in which clarity is the same as intelligibility and the opposite of obscurity. The color of anything beautiful must be bright or pure, since color is determined by the nature of the colored object itself, and if dull or muddy will be a sign of its impurity. So again the color of gold is traditionally the most beautiful color.

Beauty and goodness are identical fundamentally, for they both originate in the form, but they differ logically; goodness relating to the appetite, and beauty to cognition or apprehension; "for beautiful things are those which please when seen (*pulchra enim dicuntur quae visa placent*)." It is because of "due proportion" that they please; for sense (*sensus*) delights in things duly proportioned, as in what is after its own kind (*Sum. Theol.* 1.5.4 *ad* 1). "Those senses chiefly regard the beautiful, viz.

sight and hearing, as ministering to reason. Thus it is evident that beauty adds to goodness a relation to the cognitive power; so that good (*bonum*) means that which simply pleases the appetite, while the beautiful is something pleasing to apprehend." In other words, "that belongs to the nature of the beautiful in which, being seen or known, the appetite is brought to rest" (1-11.27.1 *ad* 3).[48] "Whereas other animals take delight in the objects of the senses only as ordered to food and sex, man alone takes pleasure in the beauty of sensible objects for their own sake" (1.91.3 *ad* 3).

It is clearly recognized that aesthetic pleasures are natural and legitimate, and even essential; for the good cannot be an object of the appetite unless it has been apprehended (*Sum. Theol.* 1-11.27.2c), and "pleasure perfects the operation" (1-11.4.1 *ad* 3, 1-11.33.4c, etc.). Because the beauty of the work is inviting, *delectare* has its due place in the traditional formulae defining the purpose of eloquence.[49] At the same time, to say that its beauty is an invitation to the goodness of anything is also to make it self-evident that *its* beauty is not, like the good, a final end or end in itself. Exactly the same point of view is present for Plato, for whom "learning is accompanied by the pleasure taken in charm" (τῆς χάριτος τὴν ἡδονήν), but the correctness and utility, goodness and beauty of the work are consequences of its truth; the pleasure is not a criterion of the adequacy of the work, and cannot be made the basis of a judgment, which can only be made if we know the work's intention (βούλησις, *Laws* 667–669).[50] It is in making aesthetic pleasures, rather than pleasure in the intelligible good,[51] the end of art, that the modern "aesthetic" differs most profoundly from the traditional doctrine; the current philosophy of art is essentially *sens*ational, i.e., *senti*mental.

[48] "We enjoy what we know when the delighted will is at rest therein," St. Augustine, *De Trinitate* x.10.

[49] See Coomaraswamy, *Why Exhibit Works of Art?*, 1943, p. 104.

[50] As pointed out by St. Augustine, taste cannot be made a criterion of beauty, for there are some who like deformities. Things that please us do so because they are beautiful; it does not follow that they are beautiful because they please us (*De musica* vi.38; *Lib. de ver. rel.* 59).

[51] The current philosophy of manufacture, subservient to industrial interests, distinguishes the fine or useless from the applied or useful arts. The traditional philosophy, on the other hand, asserts that beauty and utility are indivisible in the object, and that nothing useless can properly be called beautiful (Xenophon, *Memorabilia* iii.8.6, iv.6.9; Plato, *Cratylus* 416c; Horace, *Epistula ad Pisones* 334; St. Augustine, *Lib. de ver. rel.* 39; St. Bonaventura, *De reductione artium ad theologiam* 14, etc.). The antitraditional view of life is trivial rather than "realistic" or practical; much of its "culture" is actually useless.

"Art imitates Nature in her manner of operation" (*ars imitatur naturam in sua operatione, Sum. Theol.* 1.117.1c). "Natural things depend on the divine intellect, as do things made by art upon a human intellect" (1.17.1c). In the first citation, the immediate reference is to the art of medicine, in which natural means are employed. But these are not the "nature" that operates, since it is not the tools but the operator that makes the work of art. "Nature herself causes natural things as regards their form, but presupposes matter," and "the work of art is ascribed not to the instrument but to the artist" (1.45.2c and Suppl. 80.1 *ad* 3). Hence the "nature" referred to is Natura naturans, Creatrix universalis, Deus, and not Natura naturata. The truth of art is to Natura naturans.

The net result of the traditional doctrine of beauty, as expounded by St. Thomas Aquinas, is to identify beauty with formality or order, and ugliness with informality or want of order. Ugliness, like other evils, is a privation. The like is expressed in Sanskrit by the terms *pratirūpa*, "formal," and *apratirūpa*, "informal," as equivalents of *kalyāna* and *pāpa*. Beauty, in other words, is always "ideal," in the proper sense of the word; but "our" ideal (in the vulgar sense, that of what we like) may not be beautiful at all.

APPENDIX

With respect to "goodness" (*bonitas*), the reader must bear in mind that good and evil in Scholastic philosophy are not moral categories, except in connection with conduct and when so specified; the worthy or moral good (*bonum honestum* or *bonum moris*) being distinguished from the useful (*bonum utile*) and the enjoyable good (*bonum delectabile*). In general, the good is synonymous with being or act as distinguished from nonbeing or potentiality, and in this universal sense the good is generally defined as that which any creature desires or relishes (*Sum. Theol.* 1.5.1, 1.48.1, and *passim*, Scholastic philosophy following Aristotle, *Nicomachean Ethics* 1.1.1, "The good is that which all desire"). When, for example, it is a matter of the *summum bonum*, which is God, this Good is so called as being man's last end (Skr. *paramārtha*) and the limit of desire; it is "good," not as virtue is opposed to possible vice ("There," as Eckhart says, "neither vice nor virtue ever entered in"), but as being that which draws all things to itself by its Beauty.

It is above all in connection with the arts that goodness is not a moral

quality. As "Prudence is the norm of conduct" (*recta ratio agibilium, Nicomachean Ethics* II-1.56.3), so "Art is the norm of workmanship (*recta ratio factibilium*). . . . The artist (*artifex*) is commendable as such, not for the will with which he does a work, but for the quality of the work" (II-1.57.3); "Art does not presuppose rectitude of the appetite" (II-1.57.4); "Art does not require of the artist that his act be a good act, but that his work be good. . . . Wherefore the artist needs art, not that he may lead a good life, but that he may produce a good work of art, and have it in good care" (II-1.57.5). Those whose interest is in ethics rather than in art should note the converse proposition, "There cannot be a good use without the art" (II-1.57.3 *ad* 1), tantamount to Ruskin's "industry without art is brutality."

The distinction of art from prudence underlies the injunction to "take no thought for the morrow." "Thy mastery is of the work, never of its fruits; so neither work for the fruits, nor be inclined to refrain from working" (BG II.47); similarly, St. Thomas Aquinas, "God ordained that we should not be careful about that which is no affair of ours, viz. the consequences of our acts (*de eventibus nostrarum actionum*), but did *not* forbid us to be careful about that which is our affair, viz. the act itself" (*Summa contra Gentiles* III.35).

As, however, there can be moral sin, so also there can be artistic sin. Sin being defined as "a departure from the order to the end," may be of two kinds, arising either in connection with *factibilia* or in connection with *agibilia*, thus: "Firstly, by a departure from the particular end intended by the artist: and this sin will be proper to the art; for instance, if an artist produce a bad thing, while intending to produce something good; or produce something good, while intending to produce something bad. Secondly, by a departure from the general end of human life (Skr. *puruṣārtha*, in its fourfold division): and then he will be said to sin, if he intend to produce a bad work, and does so actually in order that another may be taken in thereby. But this sin is not proper to the artist as such, but as a man. Consequently, for the former sin that artist is blamed as an artist; while for the latter he is blamed as a man" (*Summa contra Gentiles* II-1.21.1.2). For example, the smith will be sinning as an artist if he fails to make a sharp knife, but as a man if he makes one in order to commit murder, or for someone whom he *knows* to intend to commit murder.

Artistic sin in the first of these senses is recognized in ŚB II.1.4.6 in connection with error in the performance of ritual, to be avoided because "that would be a sin (*aparādhi*, missing the mark), just as if one were

225

to do one thing while intending to do another; or if one were to say one thing while intending to say another; or were to go in one direction while intending to go in another."

It should be added that there can be also a metaphysical sin, as of error, or "heresy," resulting from an infirm act of contemplation (Skr. *śithila samādhi*, or *kheda* in *dhyāna*); see "The Intellectual Operation in Indian Art" [in this volume—ED.]. There can, accordingly, be a departure from the order to the end in three ways: (1) in art, as when a man says "I do not know anything about art, but I know what I like"; (2) in conduct, as when a man says "I do not know what is right, but I know what I like doing"; and (3) in speculation, as when a man says "I do not know what is true, but I know what I like to think."

It is noteworthy that the Scholastic definition of sin as a "departure from the order to the end" is literally identical with that of KU II.2, where he who prefers what he most likes (*preyas*) to what is most beautiful (*śreyas*) is said to "miss the mark" (*hīyate arthāt*). The primary meaning of *śrī* is "radiant light" or "splendor," and the superlative, *śreyas*, without loss of this content, is generally tantamount to "felicity" and *summum bonum*; *śreyas* and *preyas* are thus by no means good and evil simply or in a specifically moralistic sense, but rather the universal as distinguished from any particular good. If, as Dante says, he who would portray a figure cannot do so unless he *be* it, or as we might express it, unless he *lives* it (cf. *Sum. Theol.* 1.27.1 *ad* 2), it is no less certain that he who would (and "Judgment is the perfection of art," II-II.26.3 ff.) appreciate and understand an already completed work, can only do it subject to the same condition, and this means that he must conform his intellect to that of the artist so as to think with his thoughts and see with his eyes. Acts of self-renunciation are required of all those who aspire to "culture," that is, to be other than provincials. It is in this sense that "Wer den Dichter will verstehen, / muss in Dichters Lande gehen."

To judge of Romanesque works of art and to communicate them, the critic or professor in this field must become a Romanesque man, and more is needed for this than a sensitivity to Romanesque works of art or knowledge about them; to assert that a professed "materialist" or "atheist" could in this proper sense become a Doctor in mediaeval art would be a contradiction in terms. Humanly speaking, it is no less absurd to contemplate the teaching of the Bible as "literature." No one can "write a fairy tale" who does not believe in fairies and is not acquainted with the laws of faery.

It may be remarked that the very word "understanding," in application to anything whatever, implies to identify our own consciousness with that upon which the thing itself originally depended for its being. Such an identification, *rei et intellectus*, is implied by the Platonic distinction of σύνεσις (understanding, or literally association) from μάθησις (learning) or, in Sanskrit, that of *artha-jñāna* (gnosis of meaning) from *adhyayana* (study): it is not as a mere Savant (*paṇḍitaḥ*), but as a Comprehensor (*evaṃvit*) that one benefits from what one studies, assimilating what one knows. Understanding implies and demands a kind of repentance ("change of mind"), and so too a recantation of whatever may have been said on the basis of observation alone, without understanding. Only what is correct is comprehensible; hence one cannot understand *and* disagree. All understanding in this sense implies a formal endorsement; he who really understands a work of art would have made it as it is and not in any other likeness. Like the original artist, he may be aware of some defect of skill or of the material, but cannot wish that the art by which, that is to say the form to which, the thing was made had been other than it was, without to the same extent denying the artist's very being. He who would have had the form be other than it was, does so not as a judge of art, but as a patron *post factum*; he is judging, not the formal beauty of the artifact, but only its practical value for himself. So with respect to natural things, no one can be said to have fully understood them, but only to have described them, who would not have made them as they are, had he been their first cause, whether we name that cause "Natura naturans" or "God."

In these respects, the importation of the doctrine of *Einfühlung* or empathy into the theory of criticism marks a step in the right direction; but only a right intention, rather than a perfected gesture, so far as Christian and like arts are concerned. For "infeeling" is subject to the same defect here as the word "aesthetic" itself. Christian and like arts are primarily formal and intellectual, or, as sometimes expressed, "immaterial" and "spiritual"; the relation of beauty is primarily to cognition (*Sum. Theol.* 1.5.4); the artist works "by intellect," which is the same as "by his art" (1.14.8; 1.16.1c; 1.39.8; and 1.45.7c). Note, in this connection, that Scholastic philosophy never speaks of the work (*opus*) as "art"; the "art" always remains in the artist, while the work, as *artificiatum*, is a thing done *by* art, *per artem*. Assuming that the artist is either his own patron working for himself (as typically in the case of the Divine Architect), or freely consents to the final end of the work to be done, con-

ceiving it to be a desirable end, it will be true that he is working both *per artem et per voluntatem*—"The artist works through the word conceived in his mind, and through the love of his will regarding some object" (1.45.6c); that is, as an artist with respect to the formal cause of the thing to be made, as a patron with respect to its final cause. Here we are considering not what things ought to be made, but the part played by art in their making; and as this is a matter of intellect rather than of will, it is evident that "infeeling" and "aesthetic" are hardly satisfactory terms, and that some such words as "conformation" (Skr. *tadākāratā*) and "apprehension" (Skr. *grahaṇa*) would be preferable.

All this has an important bearing on "archaism" in practice. A thing "is said to be true absolutely, insofar as it is related to the intellect from which it depends," but it "may be related to an intellect either essentially or accidentally" (*Sum. Theol.* 1.16.1c). This explains why it is that "modern Gothic" seems to be what it really is, "false" and "insincere." For, evidently, Gothic art can be known to the profane architect only accidentally, viz. through the study and measurement of Gothic buildings; however learned he may be, the work can only be a forgery. For as Eckhart says (Evans ed., I, 108), "to be properly expressed, a thing must proceed from within, moved by its form; it must come, not in from without, but out from within," and in the same way St. Thomas (*Sum. Theol.* 1.14.16c) speaks of the feasible (*operabile*) as depending, not on a resolution of the thing made into its principles, but on the application of form to material. And since the modern architect is not a Gothic man, the form is not in him, and the same will hold for the workmen who carry out his designs. A like defect of proper expression is perceived when the sacrificial music of the Church is performed, not as such but by secular choirs, as "music," or when the Bible or the *Divina Commedia* are taught as "literature." In the same way, whenever the accidents of an alien style are imitated elsewhere, the operation of the artist is vitiated, and we readily detect in this case not so much a forgery as a caricature. It will be easily seen that the study of "influences" should be regarded as one of the least important aspects of the history of art, and hybrid arts as the least important of all arts. We can think one another's thoughts, ideas being independent of time and local position, but we cannot express them for one another, but only in our own way.

Ars sine scientia nihil

Ars sine scientia nihil ("art without science is nothing").[1] These words of the Parisian Master Jean Mignot, enunciated in connection with the building of the Cathedral of Milan in 1398, were his answer to an opinion then beginning to take shape, that *scientia est unum et ars aliud* ("science is one thing and art another"). For Mignot, the rhetoric of building involved a truth to be expressed in the work itself, while others had begun to think, as we now think, of houses, and even of God's house, only in terms of construction and effect. Mignot's *scientia* cannot have meant simply "engineering," for in that case his words would have been a truism, and no one could have questioned them; engineering, in those days, would have been called an art, and not a science, and would have been included in the *recta ratio factibilium* or "art" by which we know how things can and should be made. His *scientia* must therefore have had to do with the reason (*ratio*), theme, content, or burden (*gravitas*) of the work to be done, rather than with its mere functioning. Art alone was not enough, but *sine scientia nihil*.[2]

In connection with poetry we have the homologous statement of Dante with reference to his *Commedia*, that "the whole work was undertaken not for a speculative but a practical end. . . . The purpose of the whole is to remove those who are living in this life from the state of wretchedness and to lead them to the state of blessedness" (*Ep. ad Can. Grand.*, 15 and 16). That is closely paralleled in Aśvaghoṣa's colophon to the *Saundarā-*

[First published in *The Catholic Art Quarterly*, VI (1943), this essay was later included in *Figures of Speech or Figures of Thought*. The Milan archives from which Coomaraswamy drew his theme have since been published and discussed by James Ackerman in "Ars sine scientia nihil est," *Art Bulletin* XXXI (1949).— ED.]

[1] [*Scientia autem artificis est causa artificiatorum; eo quod artifex operatur per suum intellectum, Sum. Theol.* 1.14.8c.]

[2] ["If you take away science, how will you distinguish between the *artifex* and the *inscius*?" Cicero, *Academica* II.7.22; "Architecti jam suo verbo rationem istam vocant," Augustine, *De ordine* II.34; it is the same for all arts, e.g., dance is rational, therefore its gestures are not merely graceful movements but also signs.]

nanda: "This poem, pregnant with the burden of Liberation, has been composed by me in the poetic manner, not for the sake of giving pleasure, but for the sake of giving peace." Giselbertus, sculptor of the Last Judgment at Autun, does not ask us to consider his arrangement of masses, or to admire his skill in the use of tools, but directs us to his theme, of which he says in the inscription, *Terreat hic terror quos terreus alligat error*, "Let this terror affright those whom terrestrial error holds in bondage."

And so, too, for music. Guido d'Arezzo distinguishes accordingly the true musician from the songster who is nothing but an artist:

> Musicorum et cantorum magna est distancia:
> Isti dicunt, illi sciunt quae componit musica.
> Nam qui canit quod non sapit, diffinitur bestia;
> Bestia non, qui non canit arte, sed usu;
> Non verum facit ars cantorem, sed documentum.[3]

That is, "between the true 'musicians' and the mere 'songsters,' the difference is vast: the latter vocalize, the former understand the music's composition. He who sings of what he savors not is termed a 'brute'; not brute is he who sings, not merely artfully, but *usefully*; it is not art alone, but the doctrine that makes the true 'singer.' "

The thought is like St. Augustine's, "not to enjoy what we should use"; pleasure, indeed, perfects the operation, but is not its end. And like Plato's, for whom the Muses are given to us "that we may use them intellectually (μετὰ νοῦ,[4] not as a source of irrational pleasure (ἐφ' ἡδονὴν ἄλογον), but as an aid to the circling of the soul within us, of which the harmony was lost at birth, to help in restoring it to order and consent with itself" (*Timaeus* 47D, cf. 90D). The words *sciunt quae componit musica* are reminiscent of Quintilian's "Docti rationem componendi intelligunt, etiam indocti voluptatem" (IX.4.116); and these are an abbreviation of Plato, *Timaeus* 80B, where it is said that from the composition of sharp and deep sounds there results "pleasure to the unintelligent, but

[3] [Paul Henry Lang, in his *Music and Western Civilization* (New York, 1942), p. 87, accidentally rendered the penultimate line in our verse by "A brute by rote and not by art makes melody"; a version that overlooks the double negative, and misinterprets *usu*, which is not "by habit," but "usefully" or "profitably" ὠφέλιμως.] Professor E. K. Rand has kindly pointed out to me that line 4 is metrically incomplete, and suggests *sapit usu*, i.e., "who, in practice, savors what is sung." [Related material will be found in Plato, *Phaedrus* 245A; Rūmī, *Mathnawī* 1.2770.]

[4] The shifting of our interest from "pleasure" to "significance" involves what is, in fact, a μετάνοια, which can be taken to mean either a "change of mind," or a turning away from mindless sensibility to Mind itself. Cf. Coomaraswamy, "On Being in One's Right Mind," 1942.

to the intelligent that delight that is occasioned by the imitation of the divine harmony realized in mortal motions." Plato's "delight" (εὐφροσύνη), with its festal connotation (cf. *Homeric Hymns* IV.482), corresponds to Guido's verb *sapit*, as in *sapientia*, defined by St. Thomas Aquinas as *scientia cum amore*; this delight is, in fact, the "feast of reason." To one who plays his instrument with art *and* wisdom it will teach him such things as grace the mind; but to one who questions his instrument ignorantly and violently, it will only babble (*Homeric Hymns* IV.483). *Usu* may be compared to *usus* as the *jus et norma loquendi* (Horace, *Ars poetica*, 71, 72), and corresponds, I think, to a Platonic ὠφελίμως = *frui, fruitio* and Thomist *uti* = *frui, fruitio* (*Sum. Theol.* 1.39.8c).

That "art" is not enough recalls the words of Plato in *Phaedrus* 245A, where not merely art, but also inspiration is necessary, if the poetry is to amount to anything. Mignot's *scientia* and Guido's *documentum* are Dante's *dottrina* at which (and not at his art) he asks us to marvel (*Inferno* IX.61); and that *dottrina* is not his own but what "Amor (Sanctus Spiritus) dictates within me" (*Purgatorio* XXIV.52, 53). It is not the poet but "the God (Eros) himself that speaks" (Plato, *Ion* 534, 535); and not fantasy but truth, for "Omne verum, a quocumque dicatur, est a Spiritu Sancto" (St. Ambrose on 1 Cor. 12:3); "Cathedram habet in caelo qui intus corda docet" (St. Augustine, *In epist. Joannis ad parthos*); "O Lord of the Voice, implant in me thy doctrine (*śrutam*), in me may it abide" (AV 1.1.2).

That "to make the primordial truth intelligible, to make the unheard audible, to enunciate the primordial word, such is the task of art, or it is not art"[5]—not art, but *quia sine scientia, nihil*—has been the normal and oecumenical view of art. Mignot's conception of architecture, Guido's of music, and Dante's of poetry underly the art, and notably the "ornament," of all other peoples and ages than our own—whose art is "unintelligible."[6] Our private (ἰδιωτικός) and sentimental (παθητικός) con-

[5] Walter Andrae, "Keramik im Dienste der Weisheit," *Berichte der deutschen keramischen Gesellschaft* XVII (1936), p. 263. Cf. Gerhardt Hauptmann, "Dichten heisst, hinter Worten das Urwort erklingen lassen"; and Sir George Birdwood, "Art, void of its supernatural typology, fails in its inherent artistic essence" (*Sva*, London, 1915, p. 296).

[6] "It is inevitable that the artist should be unintelligible because his sensitive nature inspired by fascination, bewilderment, and excitement, expresses itself in the profound and intuitive terms of ineffable wonder. We live in an age of unintelligibility, as every age must be that is so largely characterized by conflict, maladjustment, and heretogeneity" (E. F. Rothschild); i.e., as Iredell Jenkins has expressed it, in a world of "impoverished reality."

trary heresy (i.e., view that we *prefer* to entertain) which makes of works of art an essentially sensational experience,[7] is stated in the very word "aesthetics," αἴσθησις being nothing but the biological "irritability" that human beings share with plants and animals. The American Indian cannot understand how we "can like his songs and not share their spiritual content."[8] We are, indeed, just what Plato called "lovers of fine colors and sounds and all that art makes of these things that have so little to do with the nature of the beautiful itself" (*Republic* 476B). The truth remains, that "art is an intellectual virtue," "beauty has to do with cognition."[9] "Science renders the work beautiful; the will renders it useful; perseverance makes it lasting."[10] *Ars sine scientia nihil.*

[7] "It was a tremendous discovery, how to excite emotions for their own sake" (Alfred North Whitehead, *Religion in the Making*, quoted with approval by Herbert Read in *Art and Society*, London, 1937, p. 84). Much more truly, Aldous Huxley calls our abuse of art "a form of masturbation" (*Ends and Means*, New York, 1937, p. 237): how otherwise could one describe the stimulation of emotions "for their own sake"?

[8] Mary Austen in H. J. Spinden, *Fine Art and the First Americans* (New York, 1931), p. 5. No more can we understand those for whom the Scriptures are mere "literature."

[9] *Sum. Theol.* 1.5.4 *ad* 1, 1-11.27.1 *ad* 3, and 1-11.57.3 and 4.

[10] St. Bonaventura, *De reductione artium ad theologiam* XIII.

The Meeting of Eyes[1]

In some portraits the eyes of the subject seem to be looking straight at the spectator, whether he faces the picture or moves to right or left of it. There are, for example, many representations of Christ in which his glance seems to hold the spectator wherever he is and to follow him insistently when he moves. Nicholas of Cusa had seen such representations at Nuremberg, Coblentz, and Brussels; a good example is the Head of Christ by Quentin Matsys, in Antwerp (figure 3). The type seems to be of Byzantine origin.[2]

In an article entitled "The Apparent Direction of Eyes in a Portrait,"[3] W. H. Wollaston has discussed and explained the rather subtle conditions on which this phenomenon depends. It is an effect by no means wholly

[First published in the *Art Quarterly*, VI (1943), this essay was later included in *Figures of Speech or Figures of Thought.*—ED.]

[1] In the Indian Rhetoric of Love, the first condition of "Love in Separation," known as "Love's Beginning" (*pūrva rāga*), may be occasioned either by hearsay or by sight, and if by sight, either by seeing in a picture or by "vision eye to eye" (*sākṣāt darśana*) the result is the first of the ten stages of love, that of "Longing" (*abhilāṣa*). So, for example, in the *Sāhitya Darpana*, and the whole of the literature on rhetoric, and in the songs of the Vaiṣṇava Fidèles de l'amour.

I do not know of any explicit Indian reference to the exchange of glances as between a picture and the spectator, but in the *Arabian Nights* (Story of Prince Ahmed and the fairy Peri-Banu, R. F. Burton, *Suppl. Nights* III [1886], 427), it is said that there was in a temple at Besnagar, "a golden image in size and stature like unto a man of wondrous beauty; and so cunning was the workmanship that the face seemed to fix its eyes, two immense rubies of enormous value, upon all beholders no matter where they stood."

That God is all-seeing, or looks in all directions simultaneously, occurs throughout the literature. The Brahma "visibly present and not out of sight" (*sākṣād-aparokṣāt*) is the immanent Breath and true Self (BU III.4); so that (as also in Plato) if the contemplative is to "see" the immanent deity his eye must be "turned round," con- or intro-verted (*āvṛttacakṣus*, KU IV.1).

[2] For the above and further references see E. Vansteenberghe, *Autour de la docte ignorance* (Münster, 1915), p. 37.

[3] *Philosophical Transactions*, Royal Society (London, 1824).

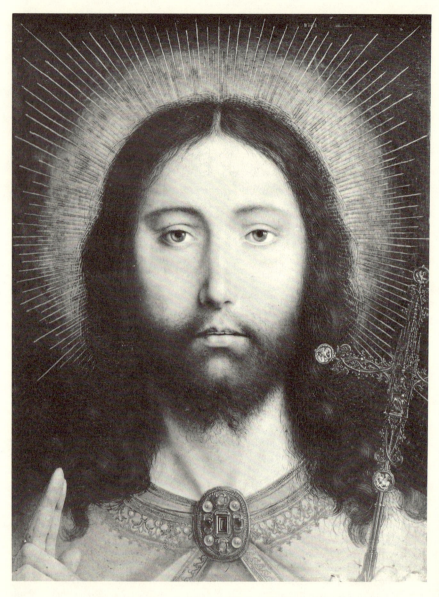

Figure 3. Quentin Matsys: Christus Salvator Mundi

due to the drawing of the eyes themselves,[4] but also and even more depends on the drawing of the nose and other features. Wollaston points out that just as the needle of a compass seen from a little distance, and actually vertical in a perspective drawing, retains its apparently vertical position however much we change our point of view, but seems to move in order to do this, so the eyes of a portrait originally looking at the spectator in one position seem to move in order to regard him in another position. On the other hand, although the eyes themselves may have been drawn as if looking directly at the spectator, if the other features are out of drawing for this position of the eyes, then the effect of the features, and especially the nose, will be to make the picture seem to look in one fixed direction, away from the spectator, whatever his position. The strictly frontal position presents, of course, the simplest case, but it is not at all necessary that the position of the face should be strictly frontal if the eyes are so turned (aside in the subject) as to look directly at the spectator, and there is nothing in the rest of the drawing to contradict this appearance. Thus the essentials for the effect are (1) that the subject must have been originally represented as if looking directly at the artist, and (2) that nothing in the rest of the drawing must conflict with this appearance.

Nicholas of Cusa refers to icons of this kind, and in the *De visione Dei*, or *De icona* (A.D. 1453) he speaks of sending such a picture to the Abbot and the Brethren of Tegernsee. He makes the characteristic of the icon, as referred to above, the starting point of a Contemplatio in Caligine, or Vision of God *in tenebris*, beyond the "wall of the coincidence of contraries."[5] Of such pictures he says:

> Place it anywhere, say on the north wall of your Oratory; stand
> before it in a half-circle, not too close, and look at it. It will seem

[4] In some types of primitive art, for example, the eye of a face in full profile may be drawn as if seen frontally, but this does not make it seem that it is looking at the spectator.

[5] "The wall of the Paradise in which thou dwellest," he says, "is composite of the coincidence of contraries, and remains impenetrable for all who have not overcome the highest Spirit of Reason who keeps the gate" (*De visione Dei*, ch. 9). These "contraries" (past and future, good and evil, etc.), in the traditional symbolism of the Janua Coeli, are the two leaves or sides of the "Active Door," by which, as they "clash," the entrant may be crushed. The highest spirit of Reason must be overcome (cf. John 10:9 and JUB 1.5) because all rational truth (cf. BU 1.6.3 and *Īśā Up.* 15) is necessarily stated in terms of the contraries, of which the coincidence is suprarational. Liberation is from these "pairs" (*dvandvair vimuktaḥ*, BG xv.5).

to each of you, whatever the position from which he looks, that it is as if he, and he alone, were being looked at. . . . So you will marvel, in the first place, how it can be that the icon looks at all of you and at each one of you. . . . Then let a brother, fixing his gaze upon the icon, move towards the west, and he will find that the glance of the icon moves ever with him; nor will it leave him if he returns to the east. He will marvel then at this motion without locomotion. . . . If he asks a brother to walk from east to west, keeping his eyes on the icon, while he himself moves eastwards, he will be told by the latter, when they meet, that the glance of the icon moves with him, and will believe him; and from this evidence will realize that the face follows everyone as he moves, even if the motions are contrary. He will see that the motionless face moves to east and west, north-ward or southward, in one direction and in all directions simultane-ously.

We cannot, in the absence of further literary evidence, be certain that the effect was one that had been deliberately sought by the artist, and the result of a conscious art or rule. But it is an effect pertaining to the formal cause, viz. to the mental image in the artist's mind, and so neces-sarily reflects his implicit intention; if he has not imagined the divine eyes as looking at himself directly, they will not seem to look at any subsequent spectator directly. The effect, in other words, is not an acci-dent, but a necessity of the iconography; if the eyes of an all-seeing God are to be iconostasized *truly* and *correctly*, they must appear to be all-seeing.

Nicholas of Cusa's description of the icon of Christ has a striking parallel in the *Dhammapada Atthakathā*, 1.406: when the Buddha is preaching, to however large an audience, and whether to those standing before or behind him, it seems to each that " 'The Teacher is looking at me alone; he is preaching the Norm to me alone.' For the Teacher ap-pears to be looking at each individual and to be conversing with each. . . . A Buddha seems to stand face to face with every individual, no matter where the individual may stand."

The effect in an icon is an example of the *integritas sive perfectio* that St. Thomas Aquinas makes a condition of beauty, and of the ὀρθότης, ἀλήθεια, and ἰσότης (correctness, truth, and adequacy) with respect to the οἷον, ἰδέα, and δύναμις (suchness, form, and power) of the archetype that Plato insists upon in all iconography and can only be attained when

the artist himself has seen the reality that he is to depict. Only to the extent that an artifact correctly represents its model can it be said to fulfill its purpose. In the present case (as in that of every artifact in proportion to its significance) the purpose of the icon is to be the support of a contemplation (*dhiyālamba*). It may or may not also afford aesthetic pleasures; nor is there any evil in these pleasures as such, unless we think of them as the sole end of the work; in which case we become mere sybarites, lotus-eaters, and passive enjoyers of something that can only be understood from the point of view of its intended use. To adapt the words of Guido d'Arezzo, *Non verum facit ars artificem, sed documentum.*

FURTHER STUDIES

Ornament

As remarked by Clement of Alexandria, the scriptural style is parabolic, but it is not for the sake of elegance of diction that prophecy makes use of figures of speech. On the other hand, "the sensible forms [of artifacts], in which there was at first a polar balance of physical and metaphysical, have been more and more voided of content on their way down to us: so we say, 'this is an ornament' . . . an 'art form.' . . . [Is the symbol] therefore dead, because its living meaning had been lost, because it was denied that it was the image of a spiritual truth? I think not" (W. Andrae, *Die ionische Säule: Bauform oder Symbol?* Berlin, 1933, "Conclusion"). And as I have so often said myself, a divorce of utility and meaning, concepts which are united in the one Sanskrit word *artha*, would have been inconceivable to early man or in any traditional culture.[1]

We know that in traditional philosophy the work of art is a reminder; the summons of its beauty is to a thesis, as to something to be understood, rather than merely enjoyed. Unwilling as we may be to accept such a proposition today, in a world increasingly emptied of meaning, it is even harder for us to believe that "ornament" and "decoration" are, properly speaking, integral factors of the beauty of the work of art, certainly not in-significant parts of it, but rather necessary to its efficacy.

What we have in view, under these circumstances, is to support by the analysis of certain familiar terms and categories the proposition that our modern preoccupation with the "decorative" and "aesthetic" aspects

[First published in the *Art Bulletin*, XXI (1939), this essay was subsequently included in *Figures of Speech or Figures of Thought*.—ED.]

[1] As remarked by T. W. Danzel, in a primitive culture—by "primitive" the anthropologist often means no more than "not quite up to (our) date"—"sind auch die Kulturgebiete Kunst, Religion, Wirtschaft usw. noch nicht als selbständige, gesonderte, geschlossene Betätigungsbereiche vorhanden" (*Kultur und Religion des primitiven Menschen*, Stuttgart, 1924, p. 7). This is, incidentally, a devasting criticism of such societies as are not "primitive," and in which the various functions of life and branches of knowledge are treated as specialities, *gesondert und geschlossen* from any unifying principle.

of art represents an aberration that has little or nothing to do with the original purposes of "ornament"; to demonstrate from the side of semantics the position that has been stated by Maes with special reference to Negro art that "Vouloir séparer l'objet de sa signification sociale, son rôle ethnique, pour n'y voir, n'y admirer et n'y chercher que le côté esthétique, c'est enlever à ces souvenirs de l'art nègre leur sens, leur significance et leur raison d'être! Ne cherchons point à effacer l'idée que l'indigène a incrustée dans l'ensemble comme dans chacun des détails pour n'y voir que la beauté d'exécution de l'objet sans signification, raison d'être, ou vie. Efforçons-nous au contraire de comprendre la psychologie de l'art nègre et nous finirons par en pénétrer toute la beauté et toute la vie" (*IPEK,* 1926, p. 283); and that, as remarked by Karsten, "the ornaments of savage peoples can only be properly studied in connection with a study of their magical and religious beliefs" (*ibid.,* 1925, p. 164). We emphasize, however, that the application of these considerations is not merely to Negro, "savage," and folk art but to all traditional arts, those, for example, of the Middle Ages and of India.

Let us consider now the history of various words that have been used to express the notion of an ornamentation or decoration, and which in modern usage for the most part import an aesthetic value added to things of which the said "decoration" is not an essential or necessary part. It will be found that most of these words, which imply for us the notion of something adventitious and luxurious, added to utilities but not essential to their efficacy, originally implied a completion or fulfillment of the artifact or other object in question; that to "decorate" an object or person originally meant to endow the object or person with its or his "necessary accidents," with a view to proper operation; and that the aesthetic senses of the words are secondary to their practical connotation; whatever was originally necessary to the completion of anything, and thus proper to it, naturally giving pleasure to the user; until still later what had once been essential to the nature of the object came to be regarded as an "ornament" that could be added to it or omitted at will; until, in other words, the art by which the thing itself had been made whole began to mean only a sort of millinery or upholstery that covered over a body that had not been made by "art" but rather by "labor"—a point of view bound up with our peculiar distinction of a fine or useless from an applied or useful art, and of the artist from the workman, and with our substitution of ceremonies for rites. A related example of a degeneration of meaning can be cited in our words "artifice," meaning "trick," but originally *artificium,*

"thing made by art," "work of art," and our "artificial," meaning "false," but originally *artificialis*, "of or for work."

The Sanskrit word *alaṃkāra*[2] is usually rendered by "ornament," with reference either to the rhetorical use of "ornaments" (figures of speech, assonances, kennings, etc.), or to jewelry or trappings. The Indian category of *alaṃkāra-śāstra*, the "science of poetic ornament," corresponds, however, to the mediaeval category of rhetoric or art of oratory, in which eloquence is thought of not as an end in itself or art for art's sake, or to display the artist's skill, but as the art of effective communication. There exists, indeed, a mass of mediaeval Indian poetry that is "sophistic" in Augustine's sense: "A speech seeking verbal ornament beyond the bounds of responsibility to its burden (*gravitas*) is called 'sophistic,'" (*De doctrina Christiana* II.31). At a time when "poetry" (*kāvya*)[3] had to some extent become an end in itself, a discussion arose as to whether or not "ornaments" (*alaṃkāra*) represent the essence of poetry; the consensus being that, far from this, poetry is distinguishable from prose (i.e., the poetic from the prosaic, not verse from prose) by its "sapidity" or "flavor" (*rasa*, corresponding to the *sap-* in Lat. *sapientia*, wisdom, *scientia cum sapore*). Sound and meaning are thought of as indissolubly wedded; just as in all the other arts of whatever kind there was originally a radical and natural connection between form and significance, without divorce of function and meaning.

If we analyze now the word *alaṃkāra*, and consider the many other than merely aesthetic senses in which the verb *alaṃ-kṛ* is employed, we shall find that the word is composed of *alaṃ*, "sufficient," or "enough," and *kṛ*, to "make." It must be mentioned for the sake of what follows that Sanskrit *l* and *r* are often interchangeable, and that *alaṃ* is represented

[2] The present article was suggested by, and makes considerable use of, J. Gonda, "The Meaning of the Word 'alaṃkāra'," in *Volume of Eastern and Indian Studies Presented to F. W. Thomas*, ed. S. M. Katre and P. K. Gode (Bombay, 1939), pp. 97–114; *The Meaning of Vedic* bhūṣati (Wageningen, 1939); and "*Ābharaṇa*," in *New Indian Antiquary*, II (May 1939).

[3] Derivative of *kavi*, "poet." The reference of these words to "poetry" and "poet" in the modern sense is late. In Vedic contexts *kavi* is primarily an epithet of the highest gods with reference to their utterance of words of creative power, *kāvya* and *kavitva* the corresponding quality of wisdom, Vedic *kavi* being therefore rather an "enchanter" than a "charmer" in the later sense of one who merely pleases us by his sweet words.

In much the same way Greek ποίησις originally meant a "making," so that, as Plato says, "The productions of all arts are kinds of poetry and their craftsmen are all poets" (*Symposium* 205c); [cf. RV x.106.1, *vitanvātha dhiyo vastrāpaseva* "Ye weave your songs as men weave garments"].

by *aram* in the older literature. Analogous to the transitive *aram-kr* are the intransitive *arambhū*, "to become able, fit for" and *aram-gam*, "to serve or suffice for." The root of *aram* may be the same as that of Greek ἀραρίσκω, "to fit together, equip, or furnish." *Aram* with *kr* or *bhū* occurs in Vedic texts in phrases meaning preparedness, ability, suitability, fitness, hence also that of "satisfying" (a word that renders *alam-kr* very literally, *satis* corresponding to *aram* and *facere* to *kr*), as in RV VII.29.3, "What satisfaction (*aramkrti*) is there for thee, Indra, by means of our hymns?" *Alam-kr* in the *Atharva Veda* (XVIII.2) and in the *Śatapatha Brāhmaṇa* is employed with reference to the due ordering of the sacrifice, rather than to its adornment, the sacrifice indeed being much less a ceremony than a rite; but already in the *Rāmāyaṇa*, a "poetical" work, the word has usually the meaning to "adorn."

Without going into further detail, it can easily be seen what was once the meaning of an "adornment," viz. the furnishing of anything essential to the validity of whatever is "adorned," or enhances its effect, empowering it. For example, "the mind is adorned (*alamkriyate*) by learning, folly by vice, elephants by mast, rivers by water, night by the moon, resolution by composure, kingship by leading."[4]

In just the same way *bhūṣaṇa* and *bhūṣ*, words that mean in classical Sanskrit "ornament," respectively as noun and as verb, do not have this value in Vedic Sanskrit, where (like *alamkāra*, etc.) they refer to the provision of whatever properties or means increase the efficacy of the thing or person with reference to which or to whom they are employed:[5] the hymns, for example, with which the deity is said to be "adorned," are an affirmation of and therefore a confirmation and magnification of the divine power to act on the singers' behalf. Whatever is in this sense "ornamented" is thereby made more in act, and more in being. That this should be so corresponds to the root meaning of the verb, which is an extension of *bhū*, to "become," but with a causative nuance, so that, as

[4] *Pañcatantra* III.120 (Edgerton ed., p. 391). [*Alam-kr* in the senses "equip" and "ornament" has almost exactly the same senses as *upa-kr*, "to assist, furnish, ornament," and so we find it stated that poetical figures (*alamkāra*) enhance (*upa-kurvanti*) the "flavor" of a poem in the same way that jewels are not ends in themselves but enhance the efficacy of the person that wears them. Ornaments are the necessary accidents of essence, whether artificial or natural.]

[5] The two values of *bhūṣaṇa* are found side by side in *Viṣṇudharmottara* III.41.10, where outline, shading (the representation of), jewelry (*bhūṣaṇam*), and color are collectively "the ornaments (*bhūṣaṇam*) of painting," and it is clear that these "ornaments" are not a needless elaboration of the art but, rather, the essentials or characteristics of painting, by which it is recognized as such.

244

pointed out by Gonda, *bhūṣati dyūn* in RV x.11.7 does not mean "ornaments his days" but "lengthens his life," "makes more his life"; cf. Skr. *bhūyas*, "becoming in a greater degree" (Pāṇini), "abundantly furnished with," and "more." *Bhūṣ* has thus the value of *vṛdh*, "to increase" (trans.), A. A. Macdonell rendering the gerundives *ābhūṣenya* and *vāvṛdhenya* both alike by "to be glorified" (*Vedic Grammar*, Strassburg, 1910, §80, p. 242). An identical connection of ideas survives in England, where to "glorify" is also to "magnify" the Lord, and certain chants are "magnificats." Vedic *bhūṣ* in the sense "increase" or "strengthen," and synonymous with *vṛdh*, corresponds to the later causative *bhāv* (from *bhū*), as can be clearly seen if we compare RV ix.104.1, where Soma is to be "adorned," or rather "magnified" (*pari bhūṣata*) by sacrifices, "as it were a child" (*śiśum na*), with AĀ 11.5, where the mother "nourishes" (*bhāvayati*) the unborn child, and the father is said to "support" (*bhāvayati*) it both before and after birth; bearing also in mind that in RV ix.103.1, the hymns addressed to Soma are actually compared to "food" (*bhṛti*) from *bhṛ*, to "bear," "bring," "support," and that in the *Aitareya Āraṇyaka* context the mother "nourishes . . . and bears the child" (*bhāvayati . . . garbhaṃ bibharti*). And insofar as *ābharaṇa* and *bhūṣaṇa* in other contexts are often "jewelry" or other decoration of the person or thing referred to, it may be observed that the values of jewelry were not originally those of vain adornment in any culture, but rather metaphysical or magical.[6] To some extent this can be recognized even at the present day: if, for example, the judge is only a judge in act when wearing his robes, if the mayor is empowered by his chain, and the king by his crown, if the pope is only infallible and verily pontiff when he speaks *ex cathedra*, "from the throne," none of these things is a mere ornament, but rather equipment by which the man himself is "mored" (*bhūyaskṛta*), just as in AV x.6.6 Bṛhaspati wears a jewel, or let us say a talisman, "in order to have power" (*ojase*). Even today the conferring of an order is a "decoration" in the same sense: and it is only to the extent that we have learned to think of knighthood, for example, as an "empty honor" that the "decoration" takes on the purely aesthetic values that we nowadays associate with the word.[7]

[6] As in AV vi.133, where the girdle is worn "for length of life," and invoked to endow the wearer with insight, understanding, fervor, and virility. "In der Antike noch keine Moden ohne Sinn gab" (B. Segall, *Katalog der Goldschmiede-Arbeiten*, Benaki Museum, Athens, 1938, p. 124).

[7] [The lotus wreath (PB xvi.4.1 ff., and xviii.9.6) worn by Prajāpati for the supremacy (*śreṣṭhyā*), called a *śilpa*, work of art, regarded as his dearest possession

The mention of *bhṛ*, above, leads us to consider also the word *ābharaṇa*, in which the root is combined with a self-referent *ā*, "towards." *Ābharaṇa* is generally rendered by "ornament," but is more literally "assumption" or "attribute." In this sense the characteristic weapons or other objects held by a deity, or worn, are his proper attributes, *ābharaṇam*, by which his mode of operation is denoted inconographically. In what sense a bracelet of conch (*śaṅkha*),[8] worn for long life, etc., is an *ābharaṇam* can be seen in AV iv.10, where the "sea-born" shell is "fetched (*ābhṛtaḥ*) from the waters." In the same way *āhārya*, from *hṛ*, to "bring," with *ā* as before, means in the first place that which is "to be eaten," i.e., nourishment, and second, the costume and jewels of an actor, regarded as one of the four factors of dramatic expression; in the latter sense the sun and moon are called the *āhārya* of Śiva when he manifests himself on the world stage (*Abhinaya Darpaṇa*, invocatory introduction).

Returning now to *alaṃkāra* as "rhetorical ornament," Gonda very properly asks, "Have they always been but embellishments?" and points out that very many of these so-called embellishments appear already in the Vedic texts, which, for all that, are not included in the category of poetry (*kāvya*—cf. note 3), i.e., are not regarded as belonging to *belles lettres*. Yāska, for example, discusses *upamā*, "simile" or "parable" in Vedic contexts, and we may remark that such similes or parables are repeatedly employed in the Pāli Buddhist canon, which is by no means sympathetic to any kind of artistry that can be thought of as an ornamentation for the sake of ornamentation. Gonda goes on to point out, and it is incontrovertibly true, that what we should now call ornaments (when we study "the Bible as literature") are stylistic phenomena in the sense that "the scriptural *style* is parabolic" by an inherent necessity, the burden of scripture being one that can be expressed only by analogies: this style had function in the Vedic contexts likewise other than that of ornament. "Here, as in the literature of several other peoples, we have a sacred or ritual *Sondersprache* . . . different from the colloquial speech."

and given by him to his son and successor Indra, who *thereby* becomes all-conquering, is certainly not "ornament" in the modern sense but equipment; cf. *sambhāra* = equipment (ŚB xiv.1.2.1, "whereinsoever anything of the Sacrifice is inherent, therewith he equips him [*sambharati*]"; "He equips the Mahāvīra with its equipment").]

[8] The commentators here and on RV 1.35.4, 1.126.4, and x.68.11 (where *kṛśana* = *suvarṇa*, golden, or *suvarṇam ābharaṇam*, golden ornament) offer no support whatever for the rendering of *kṛśana* as "pearl." It is, moreover, amulets of conch, and not of pearl oyster shell, that have been worn in India from time immemorial.

At the same time, "These peculiarities of the sacral language may also have an aesthetic side. . . . Then they become figures of speech and when applied in excess they become *Spielerei*."[9] *Alaṃkṛta,* in other words, having meant originally "made adequate," came finally to mean "embellished."

In the case of another Sanskrit word, *śubha,* of which the later meaning is "lovely," there may be cited the expression *śubhaḥ śilpin* from the *Rāmāyaṇa,* where the reference is certainly not to a craftsman personally "handsome," but to a "fine craftsman," and likewise the well-known benediction *śubham astu,* "May it be well," where *śubham* is rather the "good" than the beautiful as such. In the *Ṛg Veda* we have such expressions as "I furnish (*śumbhāmi*) Agni with prayers" (VIII.24.26), where for *śumbhāmi* might just as well have been said *alaṃkaromi* (not "I adorn him," but "I fit him out"); and *śumbhanto* (1.130.6), not "adorning" but "harnessing" a horse; in J V.129, *alaṃkata* is "fully equipped" (in coat of mail and turban, and with bow and arrows and sword). In RV 1.130.6, it is Indra that is "harnessed" like a steed that is to race and win a prize, and it is obvious that in such a case the aptitude rather than the beauty of the gear must have been the primary consideration, and that although the charioteer must have enjoyed at the same time the "pleasure that perfects the operation," this pleasure must have been rather in the thing well made for its purpose, than in its mere appearance; it would be only under the more unreal conditions of a parade that the mere appearance might become an end in itself, and it is thus, in fact, that over-ornamented things are made only for show. This is a development that we are very familiar with in the history of armor (another sort of "harness"), of which the original life-saving purpose was preeminently practical, however elegant the resultant forms may have been in fact, but which in the end served no other purpose than that of display.

To avoid confusion, it must be pointed out that what we have referred to as the "utility" of a harness, or any other artifact, had never been, traditionally, a matter of merely functional adaptation;[10] on the contrary,

9 Gonda, "The Meaning of the Word '*alaṃkāra*,'" p. 110.

10 "Honesty" having been identified with spiritual (or intelligible) beauty, St. Thomas Aquinas remarks that "nothing incompatible with honesty can be simply and truly *useful,* since it follows that it is contrary to man's last end" (*Sum. Theol.* II-II.145.3 *ad* 3). It is the intelligible aspect of the work of art that has to do with man's last end, its unintelligible aspect that serves his immediate needs, the "merely functional" artifact corresponding to "bread alone." In other words, an object devoid of all symbolic ornament, or of which the form itself is

in every work of traditional art we can recognize Andrae's "polar balance of physical and metaphysical," the simultaneous satisfaction (*alaṃkaraṇa*) of practical and spiritual requirements. So the harness is originally provided (rather than "decorated") with solar symbols, as if to say that the racing steed is the Sun (-horse) in a likeness, and the race itself an imitation of "what was done by the gods in the beginning."

A good example of the use of an "ornament" not as "millinery" but for its significance can be cited in ŚB III.5.1.19–20 where, because in the primordial sacrifice the Aṅgirases had accepted from the Ādityas the Sun as their sacrificial fee, so now a white horse is the fee for the performance of the corresponding Sadyaḥkrī Soma-sacrifice. This white horse is made to wear "a gold ornament (*rukma*), whereby it is made to be of the form of, or symbol (*rūpam*) of the Sun." This ornament must have been like the golden disk with twenty-one points or rays which is also worn by the sacrificer himself, and afterwards laid down on the altar to represent the Sun (ŚB VI.7.1.1–2, VII.1.2.10, VII.4.1.10). It is familiar that horses are even now sometimes "decorated" with ornaments of brass (a substitute for gold, the regular symbol of Truth, Sun, Light, Immortality, ŚB VI.7.1.2, etc.) of which the significance is manifestly solar; it is precisely such forms as these solar symbols that, when the contexts of life have been secularized, and meaning has been forgotten, survive as "superstitions"[11] and are regarded only as "art forms" or "ornaments," to be judged as good or bad in accordance, not with their truth, but with our likes or dislikes. If children have always been apt to play with useful things or miniature copies of useful things, for example carts, as toys, we ought perhaps to regard our own aestheticism as symptomatic of a second childhood; *we* do not grow up.

meaningless and therefore unintelligible, is not "simply and truly *useful*" but only physically serviceable, as is the trough to the pig. Perhaps we mean this when we think of mere utilities as "uninteresting" and fly for refuge to the fine or materially useless arts. It is nevertheless the measure of our unawareness that we consent to an environment consisting chiefly of *in*-significant artifacts.

[11] "Superstition . . . a symbol which has continued in use after its original meaning has been forgotten. . . . The best cure for that is not misapplied invective against idolatry, but an exposition of the meaning of the symbol, so that men may again use it intelligently" (Marco Pallis, *Peaks and Lamas*, London, 1939, p. 379). "Every term that becomes an empty slogan as the result of fashion or repetition is born at some time from a definite concept, and its significance must be interpreted from that point of view" (P. O. Kristeller, *The Philosophy of Marsilio Ficino*, New York, 1943, p. 286). Our contemporary culture, from the point of view of these definitions, is preeminently "superstitious" and "unintelligent."

ENOUGH of Sanskrit. The Greek word κόσμος is primarily "order" (Skr. *ṛta*), whether with reference to the due order or arrangement of things, or to the world-order ("the most beautiful order given to things by God," *Sum. Theol.* 1.25.6 *ad* 3);[12] and secondarily "ornament," whether of horses, women, men, or speech. The corresponding verb κοσμέω is to "order or arrange," and secondarily to "equip, adorn, or dress," or, finally, with reference to the embellishment of oratory; and similarly, ἐντύνω. Conversely, καλλύνειν is not only to "beautify," but also to "brush out, sweep," etc. Κόσμημα is an ornament or decoration, usually of dress. Κοσμητικός is "skilled in ordering," κοσμητική the art of dress and ornament (in Plato, *Sophist* 226E, care of the body, a kind of katharsis, or purification), κοσμητικόν "cosmetic,"[13] κοσμητήριον a dressing room. Κοσμοποίησις is architectural ornament; hence our designation of the Doric, etc. "orders." Again we see the connection between an original "order" and a later "ornament." In connection with "cosmetic" it may be remarked that we cannot understand the original intention of bodily ornaments (unguents, tattooing, jewelry, etc.) from our modern and aesthetic point of view. The Hindu woman feels herself undressed and disorderly without her jewels, which, however much she may be fond of them from other and "aesthetic" points of view, she regards as a necessary equipment, without which she cannot function as a woman (from Manu, III.55, "it appears that there existed a connection between the proper adornment of women and the prosperity of their male relatives," Gonda, *Bhūṣati*, p. 7).[14] To be seen without her gear would be more than a mere absence of decoration, it would be inauspicious, indecorous, and disrespectful, as if one should be present at some function in "undress," or have forgotten one's tie: it is only as a widow, and as such "inauspicious," that the woman abandons her ornaments. In ancient India or Egypt, in the same way, the use of cosmetics was assuredly not a matter of mere vanity, but much rather one of propriety. We can see this more easily, perhaps, in connection with hairdressing (κοσμοκόμης

[12] [Cf. Hermes, *Lib.* VIII.3, "works of adornment."]

[13] Cf. Skr. *añj*, to anoint, to shine, to be beautiful; *añjana*, ointment, cosmetic, embellishment.

[14] Cf. such terms as *rakṣābhūṣaṇa*, "apotropaic amulet" (*Suśruta* 1.54.13); *maṅgalālamkṛta*, "wearing auspicious ornaments" (Kālidāsa, *Mālavikāgnimitra* 1.14); and similarly *maṅgalamātrabhūṣaṇā* (*Vikramorvaśī* III.12), cited by Gonda [see n. 2 above—ED.]. The bow and the sword which are Rāma's equipment, and in this sense "ornaments" in the original sense of the word, "are not for the sake of mere ornamentation or only to be worn" (*na . . . bhūṣaṇāya . . . na . . . ābandhanārthāya, Rāmāyaṇa* 11.23.30).

and also one of the senses of *ornare*); the putting of one's hair in order is primarily a matter of decorum, and therefore pleasing, not primarily or merely for the sake of pleasing. Κοσμίζω, "clean," and κόσμητρον, "broom," recall the semantics of Chinese *shih* (9907), primarily to wipe or clean or be suitably dressed (the ideogram is composed of signs for "man" and "clothes"), and more generally to be decorated; Ch. *hsiu* (4661), a combination of *shih* with *san* = "paint brush," and means to put in order, prepare, regulate and cultivate.

THE words "decoration" and "ornament," whether with reference to the embellishment of persons or of things, can be considered simultaneously in Latin and in English. *Ornare* is primarily to "fit out, furnish, provide with necessaries" (Harper) and only secondarily to "embellish," etc. *Ornamentum* is primarily "apparatus, accoutrement, equipment, trappings"[15] and secondarily "embellishment, jewel, trinket,"[16] etc., as well as rhetorical ornament (Skr. *alaṃkāra*); the word is used by Pliny to render κόσμος. God's creation of living beings to occupy the already created world (as decoration "fills space") has always been called "the work of adornment" (cf. "The Mediaeval Theory of Beauty" [in this volume—ED.], n. 31).

"Ornament" is primarily defined by Webster as "any adjunct or accessory (primarily for use . . .)"; so Cooper in the sixteenth century speaks of the "tackling or ornaments of a ship," and Malory of the "ornementys of an aulter."[17] Even now "the term 'ornaments' in Ecclesiastical

[15] "Trappings," from the same root as "drape" and *drapeau*, "flag," was originally a cloth spread over the back or saddle of a horse or other beast of burden but has acquired the inferior meaning of superficial or unnecessary ornament.

[16] "Trinket," by which we always understand some insignificant ornament, was originally a little knife, later carried as a mere ornament and so disparaged. We often refer to a trinket as a "charm," forgetting the connection of this word with *carmen* and "chant." The "charm" implied originally an enchantment; our words "charming" and "enchanting" have acquired their trivial and purely aesthetic values by a development parallel to that which has been discussed throughout the present article. It may be added that an "insignificant" ornament is literally one without a meaning; it is precisely in this sense that ornaments were *not* originally insignificant.

[17] Cf. RV 1.170.4, "Let them furnish the altar" (*aram kṛnvantu vedim*). "Whatever makes a thing befitting (*decentem*) is called 'decoration (*decor*),' whether it be in the thing or externally adapted to it, as ornaments of clothing and jewels and the like. Hence 'decoration' is common to the beautiful and to the apt" (Ulrich of Strassburg, *De pulchro*, quoted in "The Mediaeval Theory of Beauty," in this volume): as in the case of "the iron style that is made by the smith on the one hand that we may write with it, and on the other that we may take pleasure in it; and in its kind at the same time beautiful and adapted to our use" (St. Augustine,

law is not confined, as by modern usage, to articles of decoration or embellishment, but it is used in the larger sense of the word 'ornamentum'" (Privy Council Decision, 1857). Adornment is used by Burke with reference to the furnishing of the mind. *Decor*, "what is seemly . . . ornament . . . personal comeliness" (Harper) is already "ornament" (i.e., embellishment) as well as "adaptation" in the Middle Ages. But observe that "decor" as "that which serves to decorate, ornamental disposition of accessories" (Webster) is the near relative of "decorous" or "decent," meaning "suitable to a character or time, place and occasion" and to "decorum," i.e., "what is befitting . . . propriety" (Webster), just as κόσμημα is of κοσμιότης. And, as Edmond Pottier says, "L'ornement, avant d'être ce qu'il est devenu aujourd'hui, avait été, avant tout, comme la parure même de l'homme, un instrument pratique, un moyen d'action qui procurait des avantages réels au possesseur" (*Délegation en Perse,* XIII, *Céramique peinte de Suse,* Paris, 1912, p. 50).

The law of art in the matter of decoration could hardly have been better stated than by St. Augustine, who says that an ornamentation exceeding the bounds of responsibility to the content of the work is sophistry, i.e., an extravagance or superfluity. If this is an artistic sin, it is also a moral sin: "Even the shoemakers' and clothiers' arts stand in need of restraint, for they have lent their art to luxury, corrupting its necessity and artfully debasing art" (St. Chrysostom, *Homilies on the Gospel of St. Matthew,* tr. George Prevost, Oxford, 1851–1852, 50 a med.). Accordingly, "Since women may lawfully adorn themselves, whether to manifest what becomes (*decentiam*) their estate, or even by adding something thereto, in order to please their husbands, it follows that those who make such ornaments do not sin in the practice of their art, except insofar as they may perhaps contrive what is superfluous and fantastic" (*Sum. Theol.* II-II.169.2 *ad* 4). It need hardly be said that whatever applies to the ornamentation of persons also applies to the ornamentation of things, all of which are decorations, in the original sense of an equipment, of the person to whom they pertain. The condemnation is of an excess, and not of a richness of ornament. That "nothing can be useful unless it be honest" (Tully and St. Ambrose, endorsed by St. Thomas) rules out all pretentious art. The concurrence here of the laws of art with those of morals, despite their logical distinction, is remarkable.

We have said enough to suggest that it may be universally true that

Lib. de ver. rel., 39), between which ends there is no conflict; cf. the style illustrated in Coomaraswamy, *Mediaeval Sinhalese Art*, 1908, fig. 129.

terms which now imply an ornamentation of persons or things for aesthetic reasons alone originally implied their proper equipment in the sense of a completion, without which satis-faction (*alam-karana*) neither persons nor things could have been thought of as efficient or "simply and truly useful," just as, apart from his at-tributes (*ā-bharana*), Deity could not be thought of as functioning. The analogy is far reaching. Whatever is unornamented is said to be "naked." God, "taken naked of all ornament" is "unconditioned" or "unqualified" (*nirguna*): one, but inconceivable. Ornamented, He is endowed with qualities (*saguna*), which are manifold in their relations and intelligible. And however insignificant this qualification and this adaptation to finite effects may be when contrasted with His unity and infinity, the latter would be incomplete without them. In the same way, a person or thing apart from its appropriate ornaments ("in the subject or externally adapted to it") is valid as an idea, but not as species. Ornament is related to its subject as individual nature to essence: to abstract is to denature. Ornament is adjectival; and in the absence of any adjective, nothing referred to by any noun could have an individual *existence*, however it might be in principle. If, on the other hand, the subject is inappropriately or over-ornamented, so far from completing it, this restricts its efficiency,[18] and therefore its beauty, since the extent to which it is in act is the extent of its existence and the measure of its perfection as such-and-such a specified subject. Appropriate ornament is, then, essential to utility and beauty: in saying this, however, it must be remembered that ornament may be "in the subject" itself, or if not, must be something added to the subject in order that it may fulfill a given function.

To have thought of art as an essentially aesthetic value is a very modern development and a provincial view of art, born of a confusion between the (objective) beauty of order and the (subjectively) pleasant, and fathered by a preoccupation with pleasure. We certainly do not mean to say that man may not always have taken a sensitive pleasure in work and the products of work; far from this, "pleasure perfects the operation." We do mean to say that in asserting that "beauty has to do with cognition," Scholastic philosophy is affirming what has always and everywhere been true, however we may have ignored or may wish to ignore

[18] It may be remarked that in the animal world an excessive development of ornament usually preludes extinction ("The wages of sin is death"; sin, as always, being defined as "any departure from the order to the end").

the truth—we, who like other animals know what we like, rather than like what we know. We do say that to explain the nature of primitive or folk art, or, to speak more accurately, of any traditional art, by an assumption of "decorative instincts" or "aesthetic purposes" is a pathetic fallacy, a deceptive projection of our own mentality upon another ground; that the traditional artist no more regarded his work with our romantic eyes than he was "fond of nature" in our sentimental way. We say that we have divorced the "satis-faction" of the artifact from the artifact itself, and made it seem to be the whole of art; that we no longer respect or feel our responsibility towards the burden (*gravitas*) of the work, but prostitute its thesis to an aisthesis; and that this is the sin of luxury. We appeal to the historian of art, and especially to the historian of ornament and the teacher of the "appreciation of art," to approach their material more objectively; and suggest to the "designer" that if all good ornament had in its beginning a necessary sense, it may be rather from a sense to communicate than from an intention to please that he should proceed.

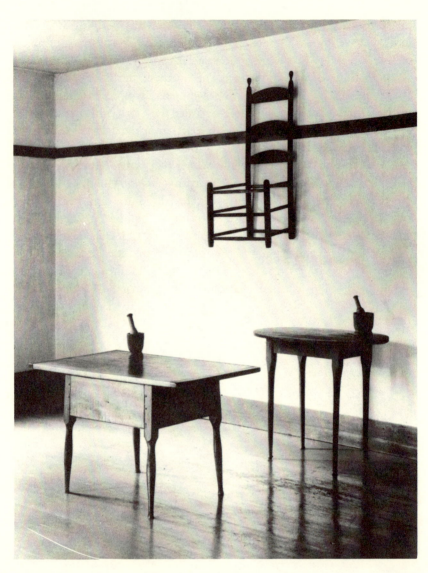

Figure 4. Shaker Furniture

Shaker Furniture

Shaker Furniture[1] emphasizes the spiritual significance of perfect crafts-manship and, as the author remarks, "the relationship between a way of life and a way of work invests the present study with special interest." And truly a humane interest, since here the way of life and way of work (*karma yoga* of the *Bhagavad Gītā*) are one and the same way; and as the *Bhagavad Gītā* likewise tells us in the same connection, "Man attains perfection by the intensity of his devotion to his own proper task," working, that is to say, not for himself or for his own glory, but only "for the good of the work to be done." "It is enough," as Marcus Aurelius says (VI.2), "to get the work done well." The Shaker way of life was one of order; an order or rule that may be compared to that of a monastic community. At the same time, "the idea of worship in work was at once a doctrine and a daily discipline. . . . The ideal was variously expressed that secular achievements should be as 'free from error' as conduct, that manual labour was a type of religious ritual, that godliness should illuminate life at every point."

In this they were better Christians than many others. All tradition has seen in the Master Craftsman of the Universe the exemplar of the human artist or "maker by art," and we are told to be "perfect, *even as* your Father in heaven is perfect." That the Shakers were doctrinally Perfectionists is the final explanation of the perfection of Shaker workmanship; or, as we might have said, of its "beauty." We say "beauty," despite the fact that the Shakers scorned the word in its worldly and luxurious applications, for it is a matter of bare fact that they who ruled that "beadings, mouldings, and cornices, which are merely for fancy, may not be

[First published in the *Art Bulletin*, XXI (1939), this review was later included in *Figures of Speech or Figures of Thought.*—ED.]

[1] Edward Deming Andrews and Faith Andrews, *Shaker Furniture: The Craftsmanship of an American Communal Sect* (New Haven, 1937) [reprinted New York, 1950—ED.]. Cf. Edward Deming Andrews, *The Gift To Be Simple: Songs, Dances and Rituals of the American Shakers* (New York, 1940) [reprinted New York, 1962—ED.].

made by Believers" were consistently better carpenters than are to be found in the world of unbelievers. In the light of mediaeval theory we cannot wonder at this; for in the perfection, order, and illumination which were made the proof of the good life we recognize precisely those qualities (*integritas sive perfectio, consonantia, claritas*) which are for St. Thomas the "requisites of beauty" in things made by art. "The result was the elevation of hitherto uninspired, provincial joiners to the position of fine craftsmen, actuated by worthy traditions and a guildlike pride. . . . The peculiar correspondence between Shaker culture and Shaker artisanship should be seen as the result of the penetration of the spirit into all secular activity. Current in the United Society was the proverb: 'Every force evolves a form.'[2] . . . The eventual result of this penetration of religion into the workshop, as we have noted, was the discarding of all values in design which attach to surface decoration in favor of the values inherent in form, in the harmonious relationship of parts, and the perfected unity of form."

Shaker art is, in fact, far more closely related to the perfection and severity of primitive and "savage" art (of which the Shakers probably knew nothing and which they would not have "understood") than are the "many shrewdly reticent modern creations" in which the outward aspects of primitive and functional art are consciously imitated. Shaker art was not in any sense a "crafty" or "mission style," deliberately "rustic," but one of the greatest refinement, that achieved "an effect of subdued elegance, even of delicacy . . . at once precise and differentiated." One thing that made this possible was the fact that given the context in which the furniture was to be used, "the joiners were not forced to anticipate carelessness and abuse."

The style of Shaker furniture, like that of their costume, was impersonal; it was, indeed, one of the "millennial laws" that "No one should write or print his name on any article of manufacture, that others may hereafter know the work of his hands."[3] And this Shaker style was almost uniform from beginning to end; it is a collective, and not an in-

[2] Expressed more technically, this would read: Every form evolves a figure.

[3] Cf. Dh v.74, " 'May it be known to both religious and profane that *This was my work*' . . . That is a notion befitting an infant." In one of the Shaker hymns occur the lines:

But now from my forehead I'll quickly erase
The stamp of the Devil's great *I*.

This would have been in imitation of Christ's "I do nothing of myself."

dividualistic expression. Originality and invention appear, not as a sequence of fashions or as an "aesthetic" phenomenon, but whenever there were new *uses* to be served; the Shaker system coincided with and did not resist "the historic transference of occupations from the home to the shop or small factory; and new industries were conducted on a scale requiring laborsaving devices and progressive methods. The versatility of the Shaker workmen is well illustrated by the countless tools invented for unprecedented techniques."

We cannot refrain from observing how closely the Shaker position corresponds to the mediaeval Christian in this matter of art. The founders of the Shaker order can hardly have read St. Thomas, yet it might have been one of themselves that had said that if ornament (*decor*) is made the chief end of a work, it is mortal sin, but if a secondary cause may be either quite in order or merely a venial fault; and that the artist is responsible as a man for whatever he undertakes to make, as well as responsible as an artist for making to the best of his ability (*Sum. Theol.* II-II.167.2c and II-II.169.2 *ad* 4): or that "Everything is said to be *good* insofar as it is perfect, for in that way only is it desirable. . . . The perfections of all things are so many similitudes of the divine being" (*ibid.* 1.5.5c, 1.6.1 *ad* 2)—"all things," of course, including even brooms and hoes and other "useful articles" made *secundum rectam rationem artis*. The Shaker would have understood immediately what to the modern aesthetician seems obscure, Bonaventura's "light of a mechanical art."

It would, indeed, be perfectly possible to outline a Shaker theory of beauty in complete agreement with what we have often called the "normal view of art." We find, for example (pp. 20–21, 61–63), in Shaker writings that "God is the great artist or master-builder"; that only when all the parts of a house or a machine have been perfectly *ordered*, "then the beauty of the machinery and the wisdom of the artist are apparent"; that "order is the creation of beauty. It is heaven's first law [cf, Gk. κόσμος, Skr. ṛta] and the protection of souls. . . . Beauty rests on utility"; and conversely, that "the falling away from any spiritual epoch has been marked by the ascendency of the aesthetics [*sic*]." Most remarkable is the statement that that beauty is best which is "peculiar to the flower, or generative period" and not that "which belongs to the ripened fruit and grain."[4] Nor is the matter without an economic bearing. We treat "art"

[4] For the corresponding Indian doctrine of *ummīlana* (= *sphoṭa*, cf. vernacular *phūṭ-phūṭ*) and a fuller analysis of this conception, see Coomaraswamy, "The Technique and Theory of Indian Painting," 1934, n. 16, pp. 74–75.

as a luxury, which the common man can hardly afford, and as something to be found in a museum rather than a home or business office: yet although Shaker furniture is of museum quality, "the New Lebanon trustees reported that the actual cost of furnishing one of our dwellings for the comfortable accommodations of 60 or 70 inmates would fall far short of the sum often expended in furnishing some single parlors in the cities of New York and Albany." One is moved to ask whether our own "high standard of living" is really more than a high standard of paying, and whether any of us are really getting our money's worth. In the case of furniture, for example, we are certainly paying much more for things of inferior quality.

In all this there would appear to be something that has been overlooked by our modern culturalists who are engaged in the teaching of art and of art appreciation, and by our exponents of the doctrine of art as self-expression, in any case as an expression of emotions, or "feelings." The primary challenge put by this splendid book, a perfect example of expertise in the field of art history, may be stated in the form of a question: Is not the "mystic," after all, the only really "practical" man?

Our authors remark that "as compromises were made with principle, the crafts inevitably deteriorated." In spite of their awareness of this, the authors envisage the possibility of a "revival" of Shaker style:[5] the furniture "can be produced again, never as the inevitable expression of time and circumstance, yet still as something to satisfy the mind which is surfeited with over-ornamentation and mere display," produced—shall we say at Grand Rapids?—for "people with limited means but educated taste . . . who will seek a union of practical convenience and quiet charm." In other words, a new outlet is to be provided for the bourgeois fantasy of "cult"-ure when other period furnitures have lost their "charm." The museums will undoubtedly be eager to assist the interior decorator. It does not seem to occur to anyone that things are only beautiful in the environment for which they were designed, or as the Shaker expressed it, when "adapted to condition" (p. 62). Shaker style was not a "fashion" determined by "taste," but a creative activity "adapted to condition."

Innumerable cultures, some of which we have destroyed, have been higher than our own: still, we do not rise to the level of Greek humanity by building imitation Parthenons, nor to that of the Middle Ages by living in pseudo-Gothic châteaux. To imitate Shaker furniture would be

[5] In subsequent correspondence, Mr. Andrews informed me that he did not think such a revival feasible. It would in fact be "artsy-crafty."

no proof of a creative virtue in ourselves: their austerity, imitated for our convenience, economic or aesthetic, becomes a luxury in us: their avoidance of ornament an interior "decoration" for us. We should rather say of the Shaker style *requiescat in pace* than attempt to copy it. It is a frank confession of insignificance to resign oneself to the merely servile activity of reproduction; all archaism is the proof of a deficiency. In "reproduction" nothing but the accidental appearance of a living culture can be evoked. If we were now such as the Shaker was, an art of our own, "adapted to condition," would be indeed essentially like, but assuredly accidentally unlike Shaker art. Unfortunately, we do not desire to be such as the Shaker was; we do not propose to "work as though we had a thousand years to live, and as though we were to die tomorrow" (p. 12). Just as we desire peace but not the things that make for peace, so we desire art but not the things that make for art. We put the cart before the horse. *Il pittore pinge se stesso*; we have the art that we deserve. If the sight of it puts us to shame, it is with ourselves that the re-formation must begin. A drastic transvaluation of accepted values is required. With the re-formation of man, the arts of peace will take care of themselves.

Note on the Philosophy
of Persian Art

What does it profit me to have seen these things,
if I do not know what they mean?
Shepherd of Hermas, Vision III.3.I

In the following note, the problem of meaning in Persian art will be dis-
cussed only in connection with the representations of living things. The
actual existence of such representations makes it needless to refer at any
length to the question of the Islamic iconoclasm, which might have ac-
counted for their absence. We shall do well to remember that this was
a Semitic inheritance, and that even the ancient Hebrews had never
refrained from the representation of supernatural beings, for which there
is ample evidence in the accounts of the "decorations" of the temple of
Solomon, and in the fact of the representation of Cherubim by Sphinxes;
what was objected to was what Plato calls the making of copies of copies.
The instruction to Moses had been to "make all things in accordance
with the pattern that was shown thee on the mount,"[1] "and so it was
with the Tabernacle";[2] hence, as was pointed out by Tertullian, the deco-
rations of the Temple were "not images of the kind to which the pro-
hibition applied."[3]

It is often a supernatural iconography and perhaps always a symbolic
iconography that survives in what we have been so apt to think of as a
merely "decorative" art. For that matter, all the earlier part of the *Shah
Namah* itself is really mythological; and it seems to me that no one who
knew the *Mantik al-Tair* or Rūmī's question, "How are ye hunters of
the sīmurgh of the heart?"[4] or who was familiar with the Sūfī denuncia-

[First published in *Ars Islamica*, XV/XVI (1951), this essay originated in an ad-
dress given at the Near Eastern Culture and Society Bicentennial Conference, held
at Princeton University in the spring of 1947. The epigraph can be found in context
in K. Lake, tr., *The Apostolic Fathers*, II (Cambridge, Mass., 1913, LCL).—ED.]

[1] Exod. 25:40.
[2] *Zohar* IV.61.
[3] *Adversus Marcionem* II.22.
[4] *Mathnawi* III.2712.

tions of the carnal soul as a "dragon" could have seen in the stories of the sīmurgh only a meaningless vestige of the old Saena Muruk, Verethragna, or failed to recognize in the conflicts of heroes with dragons the implications of a psychomachy.

It will be much the same if we consider other Persian books of poetry, of which the content is rarely secular; in the pictures of Lailā and Madjnūn, or those of an illustrated *Haft Paikar*, or a *Kalīla wa-Dimna*, it would be unreasonable to suppose that what was presented to the eye had none of the meaning of what was presented to the ear. In fact, the subjects of book illustrations are often referred to by the metaphysical poets in their symbolic senses. Rūmī, for example, refers to the Story of the Hare and the Elephants, and calls those blind who do not see its hidden meaning,[5] and elsewhere to the story of the Hare and the Lion, in which the hare has quite a different significance. It is with reference to such well-known themes as that of Siyāwush riding the flames that he exclaims, "Blest is the Turkoman whose horse gallops into the midst of the fire! Making his steed so hot that it seeks to mount the zenith of the sky,"[6] the horse in Sūfī symbolism generally meaning the body, ridden and controlled by the spirit.

Representations of polo games are common enough, but for what they might have suggested to a cultivated Persian mind one should consider 'Ārifī's *Gūy u Chawgān*. Alexander's search for the Water of Life in the Land of Darkness, a subject of which there are many pictures, is a Grail Quest. The Seven Sleepers with their dog in the cave are depicted on the pages of manuscripts, and often referred to in connection with the inverted senses of sleeping and waking—"this 'sleep' is the state of the 'ārif even when he is 'awake,'" and the dog as well "is a seeker after God" in this mundane cave.[7]

In all these cases the point is not that the picture can be explained merely by a reference to the literary sources of which they are illustrations, but that both must be understood with reference to a doctrinal meaning that, as Dante said, "eludes the veil of the strange verse." Neither is it only painted pictures that must be understood in this way; the anagogical values can be read in a work of art of any kind. Sa'di, for example, exclaims: "How well the brocader's apprentice said, when he portrayed

[5] *Ibid.*, III.2805. [6] *Ibid.*, III.3613.

[7] *Ibid.*, I.389 ff.; II.1424–1425; III.3553–3554; cf. Nicholson's note on I.389; Koran XVIII.17; see also A. J. Wensinck, "Aṣḥāb al-Kahf," *Encyclopaedia of Islām* (Leiden-London, 1913–1938), I, 478–479.

the 'anḳā,' the elephant, and the giraffe, 'From my hand there came not one form (ṣūrat) the pattern (naḳsh) of which the Teacher from above had not first depicted.' "[8]

It would be, then, only a pathetic fallacy to assume for the Persians the same kind of aesthetic preoccupation that makes ourselves so indifferent to the meaning and utility of the work of art; these are its intelligibility. An axe is unintelligible to a monkey, however fine an axe it may be, because he does not know its intention; and so in the case of the man who does not care what the picture is about and knows only whether or not it pleases his eye. We dare not presume that Persian art was as insignificant as our own; their estate was not yet like ours, a Tom, Dick, and Harryocracy. Rather let us investigate their own conception of the purpose and nature of works of art. "Aesthetics," so-called, being a branch of philosophy, it is to the metaphysicians that we must turn; we cannot expect to learn much from the Mutakallimūn, whose iconoclasm had to do with externals, but may learn something from the Ṣūfīs, whose iconoclasm extended to the very concept of "self," and for whom to say "I" amounted to idolatry and polytheism.

As in Indian, Greek, and Christian theology, so the Persian in his references to works of art has always in mind the analogy of the divine and human artists. The divine Artist is thought of now as an architect, now as a painter, or as a writer, or potter, or embroiderer; and just as none of His works is meaningless or useless, so no one makes pictures, even in a bathhouse, without an intention.[9] "Does any painter," Rūmī asks, "paint a beautiful picture (naḳsh) for the picture's own sake, or with some good end in view? Does any potter make a pot for the sake of the pot, or with a view to the water? Does any calligrapher (khaṭṭāt) write with such skill for the sake of the writing itself, or to be read? The external form (naḳsh) is for the sake of an unseen form, and that for the sake of yet another . . . in proportion to your maturity"—meaning upon meaning, like the rungs of a ladder.[10] "The picture on the wall is a likeness of Adam, indeed, but see from the form (ṣūrat) what is lacking,—the Spirit":[11] "the picture's smiling appearance is for your sake, so that by means of the picture the real theme (ma'nā) may be established."[12]

A fourteenth-century text on pictures in bathhouses, cited by Sir Thomas Arnold, explains that representations of gardens and flowers

[8] Sa'di v.133–135. [9] Mathnawī iv.3000. [10] Ibid., iv.2881 ff.
[11] Ibid., i.1020–1021. [12] Ibid., i.2769.

stimulate the vegetative, those of war and the chase the animal, and erotic paintings the spiritual principles of man's constitution.[13] This may seem strange to modern ears, but it is precisely one of the things that must be understood if the Persian or, indeed, any other traditional art is to be understood: Rūmī, for example, can both ask, "What is love?" and answer, "Thou shalt know when thou becomest me,"[14] and also say that "whether love be from this side or from that [profane or sacred], in the end it leads up yonder."[15]

All this does not apply only to pictures. "One can use a book as a pillow, but the true end of the book is the science it contains,"[16] "or can you pluck a rose from the letters r o s e ?"[17] Similarly for gardens: "This outward springtime and garden are a reflection of the garden spiritual . . . that thou mayest with purer vision behold the garden and cypress plot of the world unseen."[18] Again, there are few, if any, productions of Persian art more beautiful than the mosque lamps; and here we can be sure that every Muslim must have known the interpretation given in the Koran: "Allah is the Light of heaven and earth. The likeness of his Light is a niche in which is a lamp; the lamp is in a glass; and the glass is like a brightly shining star; it is kindled from a blessed tree, neither of the East nor of the West, of which the oil would well-nigh burn untouched by fire. Light upon light! Allah guideth unto his Light whomso He will; and He speaketh to mankind in allegories (amthāl); for He is the knower of all things."[19] Some would have been familiar, also, with the further exegesis according to which, as Dārā Shikūh says, the niche represents the world, the light is the Light of the Essence, the glass through which it shines is the human soul, the tree is the Self of Truth, and the oil is the timeless Spirit.[20]

The artist's procedure involves the two operations, imaginative and operative, intellectual and manual; the work of art itself being the resultant of the four causes, formal, efficient, material, and final. "Behold in the architect the idea of the house (khayāl-ikhāna), hidden in his heart like a seed in the earth; that idea comes forth from him like a sprout from the ground";[21] "behold the house and the mansions; once

[13] *Painting in Islam* (Oxford, 1928), p. 88.

[14] *Mathnawī* II, preface.

[15] *Ibid.*, I.III. [16] *Ibid.*, III.2989. [17] *Ibid.*, I.3456.

[18] Shams-i-Tabrīz, *Dīvān* (Tabriz ed.), 54.10 [cf. Rūmī, *Dīvān*—ED.]; and *Mathnawī* II.1944.

[19] Koran XXIV.35. [20] Dārā Shikūh, *Madjma' 'l-Baḥrain*, ch. 9.

[21] *Mathnawī*, V.1790-1793.

they were spells (*afsān*) in the architect [that is, 'art in the artist']. It was the occasion ('*arẓ*) and the concept (*andīsha*) of the architect that adduced the tools and the beams. What but some idea, occasion, and concept is the source of every craft (*pisha*)? The beginning, which is thought (*fikr*), finds its end in the work ('*aml*); and know that in such wise was the making of the world from eternity. The fruits come first in the thought of the heart, at the last they are actually seen; when you have wrought, and planted the tree, at the end you read the prescription";[22] "the crafts are all the shadows of conceptual forms" (*ẓilli-iṣūrat-iandīsha*).[23] That all amounts to saying that the actual form reveals the essential form, and that the proportion of one to the other is the measure of the artist's success.

Again, "the device on the ring (*naksh-inigīn*) reveals the goldsmith's concept."[24] The whole doctrine is exemplary; the work always the mimesis of an invisible paradigm. "In the time of separation Love ('*ishk*) fashions form (*ṣūrat*); in the time of union the Formless One emerges saying, 'I am the source of the source of intoxication and sobriety both; whatever the form, the beauty is mine. . . .' The form is the vessel, the beauty the wine."[25] It is precisely this creative Love that Dārā Shikūh equates with the principle "called Māyā in the language of the Indian monotheists";[26] and it is Plato's Eros, the master in all makings by art,[27] and Dante's Amor that inspires his *dolce stil nuovo*.[28] But though Rūmī would have agreed that "the invisible things of Him from the creation of the world are clearly seen, being understood by the things that are made,"[29] he knows that the Artist himself is also veiled by his works,[30] and would have endorsed the words of his great contemporary, Meister Eckhart: "Wouldst thou have the kernel, break the shell; and likewise, wouldst thou find out Nature undisguised, must thou shatter all her images."[31] For the Sūfī, this is what the "burning of idols" means.

Unless for a modern, whose interest in works of art begins and ends in their aesthetic surfaces, there will be nothing strange in the concept of art and of its place in a humane culture, as briefly outlined above. The primary sources of this Persian outlook may have been largely Platonic and Neoplatonic, but the position as a whole is quite universal, and

[22] *Ibid.*, II.965–973. [23] *Ibid.*, VI.3728. [24] *Ibid.*, II.1325–1326.
[25] *Ibid.*, V.3727–3728. [26] Dārā Shikūh, *Madjma'*, ch. I.
[27] *Symposium* 197A. [28] *Purgatorio* XXIV.52–54.
[29] *Romans* I:20. [30] *Mathnawī* II.759–762; see also BG VII.25.
[31] Pfeiffer ed., p. 333.

could as well be paralleled from Indian or mediaeval Christian as from Greek sources; it is, in fact, a position on which the whole world has been agreed. I shall only hint at this universality by a citation of two examples, that of St. Thomas Aquinas in comment on Dionysius Areopagiticus, where he says that "the being (*esse*) of all things derives from the Divine Beauty,"[32] and that of the Buddha who, in connection with the art of teaching, said: "The master-painter disposes his colors for the sake of a picture that cannot be seen in the colors themselves."[33]

[32] *Opera omnia* (Parma, 1864), VII.4.5.
[33] *Laṇkāvatāra Sūtra* II.112-114.

Intention

My meaning is what I *intend* to convey, to communicate, to some other person. Now intentions are, of course, intentions of minds, and these intentions *presuppose* values. . . . Meanings and values are inseparable.

> Wilbur M. Urban, *The Intelligible World*
> (New York, 1929), p. 190.

Messrs. Monroe C. Beardsley
and W. K. Wimsatt, Jr.

Gentlemen:

You, Sirs, in the *Dictionary of World Literature*, discussing "Intention," do not deny that an author may or may not succeed in his purpose, but do say that his success or failure, in this respect, are indemonstrable. You proceed to attack the criticism of a work of art in terms of the relation between intention and result; in the course of this attack you say that to pretend "that the author's aim can be detected internally in the work even where it is not realized . . . is merely a self-contradictory proposition"; and you conclude the paragraph as follows: "A work may indeed fall short of what the critic thinks should have been intended, or what the author was in the habit of doing, or what one might expect him to do, but there can be no evidence, internal or external, that the author had conceived something which he did not execute." In our subsequent correspondence you say that even if a criticism could be made in terms of the relation of purpose to result, this would be irrelevant, because the critic's main task is "to evaluate the work itself"; and you make it very clear that this "evaluation" has much more to do with "what the work ought to be" than with "what the author intended it

[First published in *The American Bookman*, I (1944), and reprinted in *Figures of Speech or Figures of Thought*, this essay-letter formulates a principle of criticism central to Coomaraswamy's method. W. K. Wimsatt, Jr., and Monroe C. Beardsley further developed their argument in the well-known essay, "The Intentional Fallacy," in *The Verbal Icon* (Lexington, Ky., 1954).—ED.]

to be." In the same connection you cite the case of a school teacher who proposes to correct a pupil's composition; the pupil maintains that what he wrote is what he "meant to say"; the teacher then says, "Well, if you meant to say so and so, all I can say is that you should not have meant it." You add that there are "good intentions and poor intentions," and that intention *per se* is no criterion of the *worth* of the poem.

I not only dissent from all but the last of these propositions, but also feel that you have not done justice to the principle of criticism that you attack; and, finally, that you confuse "criticism" with "evaluation," overlooking that "values" are present only in the end to which the work is ordered, while "criticism" is supposed to be disinterested. My "intention" is to defend the method of criticism in terms of the ratio $\frac{\text{intention}}{\text{result}}$, which I should also state as that of $\frac{\text{concept}}{\text{product}}$ or $\frac{\text{forma}}{\text{figura}}$ or $\frac{\text{art in the artist}}{\text{artifact}}$. If, in the following paragraphs, I cite some of the older writers, it is not so much as authorities by whom the problem is to be settled for us, as it is to make it clear in what established sense the word "intention" has been used, and to give to the corresponding method of criticism at least its proper historical place.

In the Western world, criticism that takes account of intention begins, I think, with Plato. He says: "If we are to be connoisseurs of poems we must know in each case in what respect they do not miss their mark. For if one does not know the essence of the work, what it intends, and of what it is an image, he will hardly be able to decide whether its intention ($\beta o \acute{v} \lambda \eta \sigma \iota s$) has or has not found its mark. One who does not know what would be correct in it (but only knows what pleases him), will be unable to judge whether the poem is good or bad" (*Laws* 668c, with parenthesis from B). Here "intention" evidently covers "the whole meaning of the work"; both its truth, beauty, or perfection, and its efficacy or utility. The work is to be true to its model (the choice of a model does not arise at this point), and also adapted to its practical purpose—like St. Augustine's writing stylus, *et pulcher et aptus*. These two judgments by the critic (1) as an artist, and (2) as a consumer, can be logically distinguished, but they are of qualities that coincide in the work itself. They will be made as a single judgment in terms of "good" or "bad" by the critic who is not merely an artist or merely a consumer, but has been educated as he ought, and is a whole man. The distinction of meaning from use may, indeed, be considered "sophistic"; at any rate Plato demanded that works of art should provide for soul and body

at one and the same time; and we may observe in passing that Sanskrit, a language that has no lack of precise terms, uses one word, *artha*, to denote both "meaning" and "use"; compare our word "force," which can be used to denote at the same time "meaning" and "cogency."

You, Sirs, say in our correspondence that you are "concerned only with poetic, dramatic, and literary works." Whatever I say is intended to apply to such works, but also to works of art of any kind, since I hold with Plato that "the productions of all arts are kinds of poetry ('making'), and their craftsmen are all poets" (*Symposium* 205c), and that the orator is just like all other craftsmen, since none of them works at random, but with a view to some end (*Gorgias* 503E). I cannot admit that different principles of criticism are applicable to different kinds of art, but only that different kinds of knowledge are required if the common critical method is to be applied to works of art of different kinds.

The most general case possible of the judgment of a work of art in terms of the ratio of intention to result arises in connection with the judgment of the world itself. When God is said to have considered his finished work and found it "good," the judgment was surely made in these terms: what he had *willed,* that he had *done.* The ratio in this case is that of the κόσμος νοητός to the κόσμος αἰσθητικός, invisible pattern to material imitation. In just the same way the human maker "sees within what he has to do without"; and if he finds his product satisfactory (Skr. *alaṃ-kṛta,* "ornamental" in the primary sense of "complemented"),[1] it can be only because it seems to have fulfilled his intention. You, Sirs, in your article and our correspondence have agreed that "in most cases the author understands his own work better than anyone else, and in this sense the more the critic's understanding approximates the author's, the better his criticism will be," and thus essentially with my own assertion that the critic should "so place himself at the original author's standpoint as to see and judge with his eyes."

If, on the other hand, the critic goes about to "evaluate" a work that actually fulfills its author's intention and promise, in terms of what he thinks it "should have been," it is not the work but the intention that he is criticizing. I shall agree with you that, in general, the critic has a right and even a duty to evaluate in this sense; it is, indeed, from just this point of view that Plato sets up his censorship (*Republic* 379, 401, 607, etc.). But this is his right and duty, not as a critic of art, but as a critic

[1] Cf. Coomaraswamy, "Ornament" [in this volume—ED.].

of morals; for the present we are considering only the work of art as such, and must not confuse art with prudence. In criticizing the work of art *as such*, the critic must not go behind it, to wish it had never been undertaken; his business as an art critic is to decide whether or not the artist has made a good job of the work he undertook to do. In any case, such a moral judgment is valid only if the intention is really open to moral objection, the critic being presumed to judge by higher standards than the artist. How impertinent a moral criticism can be when we are considering the work of an artist who is admittedly a nobleman (καλὸς κἀγαθὸς in Plato's and Aristotle's sense) will be apparent if we consider a criticism of the world that is often expressed in the question, Why did not a good God make a world without evil? In this case the critic has completely misunderstood the artist's problem, and ignored the material in which he works; not realizing that a world without alternatives would not have been a world at all, just as a poem made all of sound or wholly of silence would not be a "poem." An equally impertinent criticism of Dante has been made in the following terms: "It is only as the artist has clung fast to his greatness in sensual portrayal, without influence from the content of his work, that he is able to give the content whatever secondary value it possesses. The real significance of the Commedia today is that it is a work of art . . . its meaning shifting steadily with time more and more away from the smallness, the narrowness of special pressures of its dogmatic significance. . . . Does the work of Dante instruct or maim today? He must be split and the artist rescued from the dogmatic first." I will not pillory the author of this effusion by mentioning his name, but only point out that in making such a criticism he is not judging the artist's work at all (his intention being to separate content from form), but only setting himself down as the artist's moral inferior.

At this point it may be helpful to refer to some specific examples of authors' own statements of their "intentions." Avencebrol says, in his *Fons Vitae* (1.9), "Nostra *intentio* fuit speculari de materia universali et forma universali." Again (III.1) he asks, "Quae est *intentio* de qua debemus agere in hoc tractatu?" and answers, "Nostra *intentio* est invenire materiam et formam in substantiis simplicibus." On the other hand, the disciple (here, in effect, the writer's "patron," critic, and reader) says, "Jam *promisisti* quod in hoc secundo tractatu loquereris de materia corporali. . . . Ergo comple hoc et apertissime explana" (II.1). Here the master's "promise" is surely adequate "external evidence" of his inten-

tion; and it is obvious that the master himself might either consider that he had actually fulfilled his promise in the extant work, or otherwise might have said, "I am afraid I come a little short of what I undertook." Or, in answer to some question put by the pupil, he might either say, "I have nothing to add, you must think it out for yourself," or "perhaps I did not make myself quite clear on that point." In the latter case an amended statement would not, as you suggest, imply that "the author has thought of something better to say," but that he has found a better way of expressing what he had originally intended. On his part, the disciple might have justly complained if the master had actually failed to "fulfill his promise and very clearly set forth" the proposed matter. In much the same way, when Witelo, introducing his *Liber de Intelligentiis*, says: "Summa in hoc capitulo nostrae intentionis est, rerum naturalium difficiliora breviter colligere," etc., criticism will naturally be concerned, not with the propriety of the subject matter, but with the degree of the author's success in presenting it. As a matter of fact, Avencebrol goes on to say that the reader's proper business is "to remember what has been well said, and to correct what has been said less well, and so arrive at the truth."

Whenever, in fact, an author provides us with a preface, argument, or preamble, we are given a criterion by which to judge his performance. On the other hand, he may tell us *post factum* what was the intention of the work. When Dante says of the *Commedia* that "the purpose of the whole work is to remove those who are living in this life from the state of wretchedness and to lead them to the state of blessedness," or when Aśvaghoṣa at the end of his *Saundarānanda* tells us in so many words that the poem was "composed, not for the sake of giving pleasure, but for the sake of giving peace," such an advertisement is perfectly good "external evidence" of the author's meaning (unless we assume him to have been a fool or liar), and a fair warning that we are not to expect what Plato calls the "flattering form of rhetoric," but its true form, the sole end of which is "to lay hold upon the truth" (*Gorgias* 517A, *Phaedrus* 260E, etc.). Perhaps our authors in their wisdom foresaw the rise of such critics as Laurence Housman ("Poetry is not the thing said, but a way of saying it") or Gerard Manley Hopkins ("Poetry is speech framed for the contemplation of the mind by way of hearing or speech, framed to be heard for its own sake and interest even over and above the interest of meaning") or Geoffrey Keynes (who regrets that Blake had ideas to express in his otherwise charming compositions) or Evgeniĭ Lampert

(who advocates an "art for art's sake" in the interest of religion!).[2] Our authors, however, warn us to expect not figures of speech but figures of thought; we are not to look for *bons mots*, but for *mots justes*. Aśvagho-ṣa's colophon is addressed to "other-minded hearers." It is quite likely that a modern critic will be "other-minded" than Dante or Aśvaghoṣa; but if such a critic proceeds to discuss the merits of the works merely in terms of his own or current prejudices and tastes, whether moral or aesthetic, this is not, strictly speaking, a *literary* criticism.

You, Sirs, regard it as very difficult or even impossible to distinguish an author's intention from what he actually says. If, indeed, a work is faultless, then form and content will be such a unity that they can be separated only logically and not really. Criticism, however, never presupposes that a work is faultless, and I say that we can never find fault unless we can distinguish what the author meant to say from what he actually said. We can certainly do that in a minor way if we detect a slip of the pen; just as, also, in the case of a misprint we can distinguish what the author meant to say from what he is made to say. Or suppose an Englishman writing in French: the intelligent French reader may see very well what the author meant to say, however awkwardly he says it, and if he cannot, he can very well be called undiscriminating or uncritical.

However, it is not only with such minor faults that we are concerned, but rather with the detection of real internal conflict or inconsistency as between the matter and the form of the work. I assert that the critic cannot know if a thing has been well said if he does not know what was to be said. You, in correspondence, "deny that it is ever possible to prove from external evidence that the author intended the work to mean something that it doesn't actually mean." What then do we mean by "proof"? Outside of the field of pure mathematics, are there any absolute proofs? Do we not know that the "laws of science" on which we rely so implicitly are only statements of statistical probability? We do not *know* that the sun will rise tomorrow, but have sufficient reason to expect that it will; our life is governed by assurances, never by proofs. It is, then, quibbling to assert that there can be no external proof of an author's intention. It is quite true that in our university disciplines of the history of art, the appreciation of art, and comparative literature, aesthetic pre-occupations (matters of taste) stand in the way of an objective criticism; where we are taught to regard aesthetic surfaces as ends in themselves

[2] [Cf. F.S.C. Northrop, *The Meeting of East and West* (New York, 1946), pp. 305, 310.]

we are not being taught to understand their reasons. "Experts understand the logic of the composition, the untrained, on the other hand, what pleasure it affords."[3] Thus the critic's indirection is a consequence of the imperfection of the disciplines in which it is assumed that art is an affair of feelings and personalities, where the traditional criticism had assumed that "art is an intellectual virtue" and that what we now regard as figures of speech or as "ornaments" are really, or were originally, figures of thought.

I say, then, that the critic *can* know what was in the author's mind, if he wants to, and within the limits of what is ordinarily meant by certainty, or "right opinion." But this implies work, and not a mere sensibility. "Wer den Dichter will verstehen, muss in Dichters Lande gehen." What "land" is that? Not necessarily, though often advantageously, a physical territory, but still another world of character and another spiritual environment. To begin with, the critic must both know[4] the author's subject and delight in it—*sine desiderio mens non intelligit*—yes, and believe in it—*crede ut intelligas*. It is laughable if one who is ignorant of and indifferent to, if not scornful of, metaphysics, and unfamiliar with its figures of thought, proceeds to criticize "Dante as literature" or calls the Brāhmaṇas "inane" or "unintelligible." Is it not inconceivable that a "good" translation of Plato could be made by any nominalist, or by anyone not so vitally interested in his doctrine as sometimes to be able even to "read between the lines" of what is actually said? Is it not just this that Dante demands when he says,

> O voi, che avete gl'intelletti sani,
> Mirate la dottrina, che s'asconde
> Sotto il velame degli versi strani?[5]

I assert, from personal experience, that one can so identify oneself with a subject and point of view that one can foresee what will be said next, and even make deductions which one afterwards meets with as explicit

[3] Quintilian IX.4.116. This is directly based on Plato, *Timaeus* 80B, and I have rendered Quintilian's *etiam* by "on the other hand," with reference to Plato's *de* and because the sense demands the contrast. In this case the *Timaeus* context provides us with adequate external evidence of Quintilian's intention. [Cf. P. O. Kristeller, *The Philosophy of Marsilio Ficino* (New York, 1943), p. 119.]

[4] "Are written words of any use except to remind him who knows the matter about which they are written?" (*Phaedrus* 275D).

[5] *Inferno* IX.61–63. Cf. RV I.164.39, "What shall one do with the verse, if he knows not *That*?" [and *Mathnawī* VI.67–80].

statements in some other part of the book or in a work belonging to the same school of thought.[6] If, in fact, one cannot do this, textual emendation would be possible only on grammatical or metrical grounds. I fully agree that interpretation in terms of what an author "must have thought" can be very dangerous. But when? Only if the critic has identified, not himself with the author, but the author with himself, and is really telling us not what the author must have meant but what he would have liked the author to mean, i.e., what in his opinion the author "ought to have meant." This last is a matter about which a literary critic, as such, can hold no views, because he is setting about to criticize an existing work, and not its antecedent causes. If the critic does presume to tell us what an author ought to have meant, this is a condemnation of the author's intentions, which existed before the work was made accessible to anyone. We can, and have a right to, criticize intentions; but we cannot criticize an actual performance *ante factum*.

Finally, in our correspondence you, Sirs, say that your terms "evaluation" and "worth," "should" and "ought" refer "not to moral oughts but to aesthetic oughts." Here, I think, we have a very good example of the case in which a writer's intention is one thing, and the meaning conveyed by what he actually says is another. For consider your own example of the schoolteacher: it is only as a moral instructor that she can tell a pupil that, "You should not have meant what you meant to say." As a literary critic she could only have said, "You have not clearly expressed what you wanted to say." As to that, she can form a sound judgment in terms of intention and result; for if she is a good teacher she not only knows the pupil well, but will be able to understand him when he explains to her just what it was that he meant to say.

On the other hand, if she tells him what he "ought not to mean" ("naughty, naughty!"), that amounts to a criticism of what the Japanese call "dangerous thoughts," and belongs to the same prudential field that would be involved if she had told him what he "ought not to do"; for thinking is a form of action, and not a making until the thought is clothed in a material vehicle, for example of sound if the thought is expressed in a poem, or of pigment if in a painting. Now I fully agree with you that "intention *per se*" is no criterion of the worth of a poem (even if "worth" is to be taken amorally), in the same way that a good intention is no guarantee of actual good conduct; in both cases there must

[6] [Cf. Cicero, *Academica* II.23: *vixisse cum iis equidem videor*—"(Socrates and Plato), I seem to have actually lived with them."]

be not only a will, but also the power to realize the purpose. On the other hand, an evil intention need not result in a poor work of art; if it miscarries, it can be ridiculed or ignored; if it succeeds, the artist (whether a pornographer or a skillful murderer) is liable to punishment. A dictator's strategy or oratory is not necessarily bad as such merely because we disapprove of his aims; it may, in fact, be much better than ours, however excellent our own intentions; and if it is worse, we cannot call him a bad man on that account, but only a bad soldier or poor speaker.

All making or doing has reasons or ends; but in either case there may, for a great variety of reasons, be a failure to hit the mark. It would be absurd to pretend that we do not know what the archer intends,[7] or to say that we must not call him a poor shooter if he misses. The "sin" (properly defined as "any departure from the order to the end") may be either artistic or moral. In the present discussion, I think, our common intention was to consider only artistic virtue or error. It is precisely from this point of view that I cannot understand your terms "what the work of art ought to be," or "should be" as an "ought" to be distinguished from the gerundive—*faciendum*—implied in the author's intention to produce a work that shall be as good as possible *of its kind*. He cannot have in view to produce a work that is simply "beautiful" or "good," because all making by art is occasional and can be directed only to particular and not to universal ends.[8] The only possible literary criticism of an already existing and extant work is one in terms of the ratio of intention to result. No other form of criticism can be called objective, because there are no degrees of perfection, and we cannot say that one work of art, as such, is worth more than another, if both are perfect in their kind. We can, however, go behind the work of art itself, as if it were not yet extant, to inquire whether or not it ought ever to have been

[7] [Cf. *Paradiso* XIII.105.]

[8] "The artist's intention is (*artifex intendit*) to give his work the best possible arrangement, not indefinitely, but with respect to a given end—if the agent were not determinate to some given effect, it would not do one thing rather than another" (*Sum. Theol.* 1.91.3 and II-I.1.2). To say that the artist does not know what it is he wants to do "until he has finally succeeded in doing what he wants to do (W. F. Tomlin in *Purpose*, XI, 1939, p. 46) is an *ahetuvāda* that would stultify all rational effort and that could only be justified by a purely mechanical theory of inspiration or automatism that excludes the possibility of intelligent co-operation on the artist's part. So far from this, it is, as Aristotle says, the end (τέλος) that in all making determines the procedure (*Physics*, II.2.194ab; II.9.22a). [Cf. Leonardo's views in A. Blunt, *Artistic Theory in Italy* (Oxford, 1940), pp. 36–37.]

undertaken at all, and so also decide whether or not it is worth preserving. That may be, and I hold that it is, a very proper inquiry[9]; but it is not literary criticism nor the criticism of any work of art *qua* work of art; it is a criticism of the author's intentions.

[9] S. L. Bethell in the *New English Weekly*, for September 30, 1943, very justly points out that "as literary works express, not 'literary values' but just 'values,' technical criticism must be supplemented by value-judgments, and the latter cannot validly be made without reference to theological or philosophical categories": and I am glad that you, Sirs, really make this point, although you deny your *intention* to do so.

[*Addendum*: "When I say *intendo in hoc* this means a direction towards something as to its last end, in which it 'intends' to rest and with which it desires to be united," St. Bonaventura, *II Sent.*, d.38, a.2, 2.2; concl. II.892b.]

Imitation, Expression,
and Participation

πιστούμεθα δὲ πρὸς τοὺς τεθαυμακότας ἐκ τῶν μετειληφότων
—Plotinus, *Enneads* vi.6.7.

As Iredell Jenkins has pointed out,[1] the modern view that "art is expression" has added nothing to the older and once universal (e.g., Greek and Indian) doctrine that "art is imitation," but only translates the notion of "imitation, born of philosophical realism, into the language and thought of metaphysical nominalism"; and "since nominalism destroys the revelation doctrine, the first tendency of modern theory is to deprive beauty of any cognitive significance."[2] The older view had been that the work of art is the demonstration of the invisible form that remains in the artist, whether human or divine;[3] that beauty has to do with cognition;[4] and that art is an intellectual virtue.[5]

While Jenkins' proposition is very true, so far as expressionism is concerned, it will be our intention to point out that in the catholic (and not only Roman Catholic) view of art, *imitation, expression,* and *participation* are three predications of the essential nature of art; not three

[First published in the *Journal of Aesthetics and Art Criticism*, III (1945), this essay was later included in *Figures of Speech or Figures of Thought.*—ED.]

[1] "Imitation and Expression in Art," in the *Journal of Aesthetics and Art Criticism,* V (1942). Cf. J. C. La Drière, "Expression," in the *Dictionary of World Literature* (New York, 1943), and R. G. Collingwood, *The Idea of Nature* (Oxford, 1944), pp. 61–62 (on participation and imitation).

[2] "Sinnvolle Form, in der Physisches und Metaphysisches ursprünglich polarisch sich die Waage hielten, wird auf dem Wege zu uns her mehr und mehr entleert; wir sagen dann: sie sei 'Ornament.'" (Walter Andrae, *Die ionische Säule: Bauform oder Symbol?* Berlin, 1933, p. 65). See also Coomaraswamy, "Ornament" [in the present volume—ED.].

[3] Rom. 1:20; Meister Eckhart, *Expositio sancti evangelii secundum Johannem,* etc.

[4] *Sum. Theol.* 1.5.4 *ad* 1, I-II.27.1 *ad* 3. [5] *Ibid.,* I-II.57.3 and 4.

different or conflicting, but three interpenetrating and coincident defini-
tions of art, which is these three in one.

The notion of "imitation," ($\mu\acute{\iota}\mu\eta\sigma\iota\varsigma$, anukṛti, pratimā, etc.) will be so
familiar to every student of art as to need only brief documentation. That
in our philosophic context imitation does not mean "counterfeiting"
is brought out in the dictionary definition: imitation is "the relation of
an object of sense to its idea; . . . imaginative embodiment of the ideal
form"; form being "the essential nature of a thing . . . kind or species as
distinguished from matter, which distinguishes it as an individual; forma-
tive principle; formal cause" (Webster). Imagination is the conception
of the idea in an imitable form.[6] Without a pattern ($\pi\alpha\rho\acute{\alpha}\delta\epsilon\iota\gamma\mu\alpha$, ex-
emplar), indeed, nothing could be made except by mere chance. Hence
the instruction given to Moses, "Lo, make all things according to the
pattern which was shewed to thee on the mount."[7] "Assuming that a
beautiful imitation could never be produced unless from a beautiful pat-
tern, and that no sensible object ($\alpha\grave{\iota}\sigma\theta\eta\tau\acute{o}\nu$, 'aesthetic surface') could be
faultless unless it were made in the likeness of an archetype visible only
to the intellect, God, when He willed to create the visible world, first
fully formed the intelligible world, in order that He might have the use
of a pattern wholly divine and incorporeal":[8] "The will of God beheld
that beauteous world and imitated it."[9]

Now unless we are making "copies of copies," which is not what we
mean by "creative art,"[10] the pattern is likewise "within you,"[11] and

[6] "Idea dicitur similitudo rei cognitae," St. Bonaventura, I Sent., d.35, a.unic., q.1c.
We cannot entertain an idea except in a likeness; and therefore cannot think without
words or other images.

[7] Exod. 25:40, Heb. 8:5. "Ascendere in montem, id est, in eminentiam mentis,"
St. Bonaventura, De dec. praeceptis 11.

[8] Philo, De opificio 16, De aeternitate mundi 15; cf. Plato, Timaeus 28AB and
Republic 601. For the "world-picture" (Sumerian gish-ghar, Skr. jagaccitra, Gk.
$\nu\omega\eta\tau\grave{o}\varsigma$ $\kappa\acute{o}\sigma\mu\omega\varsigma$, etc.), innumerable references could be cited. Throughout our litera-
ture the operations of the divine and human demiurges are treated as strictly
analogous, with only this main difference that God gives form to absolutely form-
less, and man to relatively informal matter; and the act of imagination is a vital
operation, as the word "concept" implies.

[9] Hermes, Lib. 1.8B, cf. Plato, Timaeus 29AB. The human artist "imitates nature
(Natura naturans, Creatrix Universalis, Deus) in her manner of operation," but one
who makes only copies of copies (imitating Natura naturata) is unlike God, since
in this case there is no "free" but only the "servile" operation. [Cf. Aristotle, Physics
11.2.194a.20.]

[10] Plato, Republic 601.

[11] Philo, De opificio 17 ff., and St. Augustine, Meister Eckhart, etc., passim.

remains there as the standard by which the "imitation" must be finally judged.[12] For Plato then, and traditionally, all the arts without exception are "imitative";[13] this "all" includes such arts as those of government and hunting no less than those of painting and sculpture. And true "imitation" is not a matter of illusory resemblance (ὁμοιότης) but of proportion, true analogy, or adequacy (αὐτὸ τὸ ἴσον, i.e., κατ' ἀναλογίαν), by which we are reminded[14] of the intended referent;[15] in other words, it is a matter of "adequate symbolism." The work of art and its archetype are different things; but "likeness in different things is with respect to some quality common to both."[16] Such likeness (sādṛśya) is the foundation of painting;[17] the term is defined in logic as the "possession of many common qualities by different things";[18] while in rhetoric, the typical example is "the young man is a lion."

Likeness (similitudo) may be of three kinds, either (1) absolute, and then amounting to sameness, which cannot be either in nature or works of art, because no two things can be alike in all respects and still be two, i.e., perfect likeness would amount to identity, (2) imitative or analogical likeness, mutatis mutandis, and judged by comparison, e.g., the likeness of a man in stone, and (3) expressive likeness, in which the imitation is neither identical with, nor comparable to the original but is an adequate symbol and reminder of that which it represents, and to be judged only by its truth, or accuracy (ὀρθότης, integritas); the best example is that of the words that are "images" of things.[19] But imitative and expressive

[12] Laws 667D ff., etc.　　　　[13] Republic 392C, etc.

[14] Phaedo 74F: Argument by analogy is metaphysically valid proof when, and only when, a true analogy is adduced. The validity of symbolism depends upon the assumption that there are corresponding realities on all levels of reference—"as above, so below." Hence the distinction of le symbolisme qui sait from le symbolisme qui cherche. This is, essentially, the distinction of induction (dialectic) from deduction (syllogism): the latter merely "deducing from the image what it contains," the former "using the image to obtain what the image does not contain" (Alphonse Gratry, Logic [La Salle, Ill., 1944], IV.7; cf. KU II.10, "by means of what is never the same obtaining that which is always the same").

[15] Phaedo 74, Laws 667D ff.

[16] Boethius, De differentiis topicis, III, cited by St. Bonaventura, De scientia Christi, 2.c.

[17] Viṣṇudharmottaram XLII.48.

[18] S. N. Dasgupta, History of Indian Philosophy (Cambridge, 1922), I, 318.

[19] Plato, Sophist 234C. Plato assumes that the significant purpose of the work of art is to remind us of that which, whether itself concrete or abstract, is not presently, or is never, perceptible; and that is part of the doctrine that "what we call learning is really remembering" (Phaedo 72 ff., Meno 81 ff.). The function of reminding does not depend upon visual resemblance, but on the adequacy of the representation: for example, an object or the picture of an object that has been

are not mutually exclusive categories; both are images, and both expressive in that they make known their model.

The preceding analysis is based upon St. Bonaventura's,[20] who makes frequent use of the phrase *similitudo expressiva*. The inseparability of imitation and expression appears again in his observation that while speech is expressive, or communicative, "it never expresses except by means of a likeness" (*nisi mediante specie, De reductione artium ad theologiam* 18), i.e., figuratively. In all serious communication, indeed, the figures of speech are figures of thought (cf. Quintilian ix.4.117); and the same applies in the case of visible iconography, in which accuracy is not subordinated to our tastes, but rather is it we ourselves who should have learned to like only what is true. Etymologically, "heresy" is what we "choose" to think; i.e., private (ἰδιωτικός) opinion.

But in saying with St. Bonaventura that art is expressive at the same time that it imitates, an important reservation must be made, a reservation analogous to that implied in Plato's fundamental question: about *what* would the sophist make us so eloquent?[21] and his repeated condemnation of those who imitate "anything and everything."[22] When St. Bonaventura speaks of the orator as expressing "what he has in him" (*per sermonem exprimere quod habet apud se, De reductione artium ad theologiam* 4), this means giving expression to some idea that he has entertained and made his own, so that it can come forth from within him originally: it does *not* mean what is involved in our expressionism (viz. "in any form of art . . . the theory or practice of expressing one's inner, or subjective, emotions and sensations [Webster]"), hardly to be distinguished from exhibitionism.

Art is, then, both imitative and expressive of its themes, by which it is informed, or else would be informal, and therefore not art. That there is in the work of art something like a real presence of its theme brings

used by someone may suffice to remind us of him. It is precisely from that point of view that representations of the tree under which or throne upon which the Buddha sat can function as adequate representations of himself (*Mahāvaṃsa* 1.69, etc.); the same considerations underlie the cult of bodily or any other "relics." Whereas we think that an object should be represented in art "for its own sake" and regardless of associated ideas, the tradition assumes that the symbol exists for the sake of its referent, i.e., that the meaning of the work is more important than its looks. Our worship of the symbols themselves is, of course, idolatrous.

[20] Citations in J. M. Bissen, *L'Exemplarisme divin selon Saint Bonaventure* (Paris, 1929), ch. i. I have also used St. Thomas Aquinas, *Sum. Theol.* 1.4.3, and *Summa contra gentiles* 1.29. The factors of "likeness" are rarely considered in modern works on the theory of art.

[21] *Protagoras* 312E. [22] *Republic* 396–398, etc.

us to our last step. Lévy-Bruhl[23] and others have attributed to the "primitive mentality" of savages what he calls the notion of a "mystic participation" of the symbol or representation in its referent, tending towards such an identification as we make when we see our own likeness and say, "that's me." On this basis the savage does not like to tell his name or have his portrait taken, because by means of the name or portrait he is accessible, and may therefore be injured by one who can get at him by these means; and it is certainly true that the criminal whose name is known and whose likeness is available can be more easily apprehended than would otherwise be the case. The fact is that "participation" (which need not be called "mystic," by which I suppose that Lévy-Bruhl means "mysterious") is not in any special sense a savage idea or peculiar to the "primitive mentality," but much rather a metaphysical and theological proposition.[24] We find already in Plato[25] the doctrine that if anything

[23] For criticism of Lévy-Bruhl see O. Leroy, *La Raison primitive* (Paris, 1927); J. Przyluski, *La Participation* (Paris, 1940); W. Schmidt, *Origin and Growth of Religion*, 2nd ed. (New York, 1935), pp. 133–134; and Coomaraswamy, "Primitive Mentality" [in this volume—ED.].

[24] "Et Plato posuit quod homo materialis est homo . . . per participationem" (*Sum. Theol.* 1.18.4; cf. 1.44.1), i.e., in the Being of God, in whose "image and likeness" the man was made. St. Thomas is quoting Aristotle, *Physics* IV.2.3, where the latter says that in the *Timaeus* (51A) Plato equated ὕλη (primary matter, void space, chaos) with τὸ μεταληπτικόν (that which can participate, viz. in form).

[25] *Phaedo* 100D; cf. *Republic* 476D. The doctrine was later expounded by Dionysius, *De div. nom.* IV.5, "pulchrum quidem esse dicimus quod participat pulchritudinem." St. Thomas comments: "Pulchritudo enim creaturae nihil est aliud quam similitudo divinae pulchritudinis in rebus participata." In the same way, of course, the human artist's product participates in its formal cause, the pattern in the artist's mind.

The notion of participation appears to be "irrational" and will be resisted only if we suppose that the product participates in its cause materially, and not formally; or, in other words, if we suppose that the form participated in is divided up into parts and distributed in the participants. On the contrary, that which is participated in is always a total presence. Words, for example, are images (Plato, *Sophist* 234c); and if to use homologous words, or synonyms, is called a "participation" (μετάληψις, *Theatetus* 173B, *Republic* 539D), it is because the different words are imitations, expressions, and participations of one and the same idea, apart from which they would not be words, but only sounds.

Participation can be made easier to understand by the analogy of the projection of a lantern slide on screens of various materials. It would be ridiculous to say that the form of the transparency, conveyed by the "image-bearing light," is not *in* the picture seen by the audience, or even to deny that "this" picture *is* "that" picture; for we see "the same picture" in the slide and on the screen; but equally ridiculous to suppose that any of the material of the transparency is in what the audience sees.

When Christ said "this is my body," body and bread were manifestly and materially distinct; but it was "not bread alone" of which the disciples partook. Conversely, those who find in Dante's "strange verses" only "literature," letting their

is beautiful in its kind, this is not because of its color or shape, but because it participates (μετέχει) in "that," viz. the absolute, Beauty, which is a presence (παρουσία) to it and with which it has something in common (κοινωνία). So also creatures, while they are alive, "participate" in immortality.[26] So that even an imperfect likeness (as all must be) "participates" in that which it resembles.[27] These propositions are combined in the words "the being of all things is derived from the Divine Beauty."[28] In the language of exemplarism, that Beauty is "the single form that is the form of very different things."[29] In this sense every "form" is protean, in that it can enter into innumerable natures.

Some notion of the manner in which a form, or idea, can be said to be *in* a representation of it may be had if we consider a straight line: we cannot say truly that the straight line itself "is" the shortest distance between two points, but only that it is a picture, imitation or expression of that shortest distance; yet it is evident that the line coincides with the shortest distance between its extremities, and that by this presence the line "participates" in its referent.[30] Even if we think of space as curved, and the shortest distance therefore actually an arc, the straight line, a reality in the field of plane geometry, is still an adequate symbol of its idea, which it need not resemble, but must express. Symbols are projections of their referents, which are in them in the same sense that our three dimensional face is reflected in the plane mirror.

So also in the painted portrait, my form is there, *in* the actual shape, but not my nature, which is of flesh and not of pigment. The portrait is also "like" the artist ("Il pittore pinge se stesso,")[31] so that in making an attribution we say that "That looks like, or smacks of, Donatello," the model having been my form, indeed, but as the artist conceived it.[32]

theory escape them, are actually living by sound alone, and are of the sort that Plato ridicules as "lovers of fine sounds."

[26] RV 1.164.21. [27] *Sum. Theol.* 1.4.3.

[28] Aquinas, *De pulchro et bono*, in *Opera omnia*, Op. vii.4, 1.5 (Parma, 1864).

[29] Meister Eckhart, Evans ed., I, 211.

[30] [All discourse consists in "calling something by the name of another, because of its participation in the effect of this other (κοινωνία παθήματος)," Plato, *Sophist* 252B.]

[31] Leonardo da Vinci; for Indian parallels see Coomaraswamy, *The Transformation of Nature in Art*, 2nd ed., 1935, n. 7.

[32] From this consideration it follows that imitation, expression, and participation are always and can be only of an invisible form, however realistic the artist's intention may be; for he can never know or see things as they "are," because of their inconstancy, but only as he imagines them, and it is of this phantasm and not of any *thing* that his work is a copy. Icons, as Plato points out (*Laws* 931A) are rep-

For nothing can be known, except in the mode of the knower. Even the straight line bears the imprint of the draughtsman, but this is less apparent, because the actual form is simpler. In any case, the more perfect the artist becomes, the less will his work be recognizable as "his"; only when he is no longer anyone, can he see the shortest distance, or my real form, directly and as it is.

Symbols are projections or shadows of their forms (cf. n. 19), in the same way that the body is an image of the soul, which is called its form, and as words are images (εἰκόνας, *Cratylus* 439A; εἴδωλα, *Sophist* 234C) of things. The form is in the work of art as its "content," but we shall miss it if we consider only the aesthetic surfaces and our own sensitive reactions to them, just as we may miss the soul when we dissect the body and cannot lay our hands upon it. And so, assuming that we are not merely playboys, Dante and Aśvaghoṣa ask us to admire, not their art, but the *doctrine* of which their "strange" or "poetic" verses are only the vehicle. Our exaggerated valuation of "literature" is as much a symptom of our sentimentality as is our tendency to substitute ethics for religion. "For he who sings what he does not understand is defined as a beast.[33] . . . Skill does not truly make a singer, but the pattern does."[34]

resentations not of the "visible gods" (Helios, etc.), but of those invisible (Apollo, Zeus, etc.) [Cf. *Republic* 510DE; *Timaeus* 51E, 92; *Philebus* 62B].

[33] Skr. *paśu*, an animal or animal man whose behavior is guided, not by reason, but only by "estimative knowledge," i.e., pleasure-pain motives, likes and dislikes, or, in other words, "aesthetic reactions."

In connection with our divorce of art from human values, and our insistence upon *aesthetic* appreciation and denial of the *significance* of beauty, Emmanuel Chapman has very pertinently asked: "On what philosophical grounds can we oppose Vittorio Mussolini's 'exceptionally good fun' at the sight of torn human and animal flesh exfoliating like roses in the Ethiopian sunlight? Does not this 'good fun' follow with an implacable logic, as implacable as a bomb following the law of gravity, if beauty is regarded only as a name for the pleasure we feel, as merely subjective, a quality projected or imputed by the mind, and having no reference to things, no foundation whatsoever in existence? Is it not further the logical consequence of the fatal separation of beauty from reason? . . . The bitter failures in the history of aesthetics are there to show that the starting-point can never be any subjective, *a priori* principle from which a closed system is induced" ("Beauty and the War," *Journal of Philosophy*, XXXIX, 1942, 495).

It is true that there are no timeless, but only everlasting, values; but unless and until our contingent life has been reduced to the eternal now (of which we can have no sensible experience), every attempt to isolate knowing from valuation (as in the love of art "for art's sake") must have destructive, and even murderous or suicidal consequences; "vile curiosity" and the "love of fine colors and sounds" are the basic motives of the sadist.

[34] Guido d'Arezzo, ca. A.D. 1000; cf. Plato, *Phaedrus* 265A.

As soon as we begin to operate with the straight line, referred to above, we transubstantiate it; that is, we treat it, and it becomes for us, *as if*[35] it were nothing actually concrete or tangible, but simply the shortest distance between two points, a form that really exists only in the intellect; we could not use it *intellectually* in any other way, however handsome it may be;[36] the line itself, like any other symbol, is only the support of contemplation, and if we merely see its elegance, we are not using it, but making a fetish of it. That is what the "aesthetic approach" to works of art involves.

We are still familiar with the notion of a transubstantiation only in the case of the Eucharistic meal in its Christian form; here, by ritual acts, i.e., by the sacerdotal art, with the priest as officiating artist, the bread is made to be the body of the God; yet no one maintains that the carbohydrates are turned into proteins, or denies that they are digested like any other carbohydrates, for that would mean that we thought of the mystical body as a thing actually cut up into pieces of flesh; and yet the bread is changed in that it is no longer mere bread, but now bread with a meaning, with which meaning or quality we can therefore communicate by assimilation, the bread now feeding both body and soul at one and the same time. That works of art thus nourish, or should nourish, body and soul at one and the same time has been, as we have often pointed out, the normal position from the Stone Age onwards; the utility, as such, being endowed with meaning either ritually or as well by its ornamentation, i.e., "equipment."[37] Insofar as our environment, both natural and artificial, is still significant to us, we are still "primitive

[35] *The Philosophy of "As If,"* about which H. Vaihinger wrote a book with the subtitle *A System of the Theoretical, Practical and Religious Fictions of Mankind*, (English ed., London, 1942), is really of immemorial antiquity. We meet with it in Plato's distinction of probable truth or opinion from truth itself, and in the Indian distinction of relative knowledge (*avidyā*, ignorance) from knowledge (*vidyā*) itself. It is taken for granted in the doctrine of multiple meaning and in the *via negativa* in which all relative truths are ultimately denied because of their limited validity. The "philosophy of 'as if'" is markedly developed in Meister Eckhart, who says that "that man never gets to the underlying truth who stops at the enjoyment of its symbol," and that he himself has "always before my mind this little word *quasi*, 'like'" (Evans ed., I, 186, 213). The "philosophy of 'as if'" is implicit in many uses of ὥσπερ (e.g., Hermes, *Lib.* x.7), and Skr. *iva*.

[36] Cf. Plato, *Republic* 510DE.

[37] Cf. Coomaraswamy, "Ornament" [in this volume—ED.]. We say above "either ritually or by ornamentation" only because these operations are now, and according to our way of thinking, unrelated: but the artist was once a priest, "chaque occupation est un sacerdoce" (A. M. Hocart, *Les Castes*, Paris, 1938); and in the Christian Sacrifice the use of the "ornaments of the altar" is still a part of the rite, of which their making was the beginning.

mentalities"; but insofar as life has lost its meaning for us, it is pretended that we have "progressed." From this "advanced" position those whose thinking is done for them by such scholars as Lévy-Bruhl or Sir James Frazer, the behaviorists whose nourishment is "bread alone"—"the husks that the swine did eat"—are able to look down with unbecoming pride on the minority whose world is still a world of meanings.[38]

We have tried to show above that there is nothing extraordinary, but rather something normal and proper to human nature, in the notion that a symbol participates in its referent or archetype. And this brings us to the words of Aristotle, which seem to have been overlooked by our anthropologists and theorists of art: he maintains, with reference to the Platonic conception of art as imitation, and with particular reference to the view that things exist in their plurality by participation in ($\mu\acute{\epsilon}\theta\epsilon\xi\iota\varsigma$) the forms after which they are named,[39] that to say that they exist "by imitation," or exist "by participation," is no more than a use of different words to say the same thing.[40]

[38] The distinction of meaning from art, so that what were originally symbols become "art forms," and what were figures of thought, merely figures of speech (e.g., "self-control," no longer based on an awareness that *duo sunt in homine*, viz. the driver and the team) is merely a special case of the aimlessness asserted by the behavioristic interpretation of life. On the modern "philosophy of meaninglessness . . . accepted only at the suggestion of the passions" see Aldous Huxley, *Ends and Means* (New York, 1937), pp. 273-277, and I. Jenkins, "The Postulate of an Impoverished Reality" in *Journal of Philosophy*, XXXIX (1942), 533. For the opposition of the linguistic (i.e., intellectual) and the *aesthetic* (i.e., sentimental) conceptions of art, see W. Deonna, *"Primitivisme et classicisme, les deux faces de l'histoire de l'art,"* BAHA, IV (1937); like so many of our contemporaries, for whom the life of the instincts is all-sufficient, Deonna sees in the "progress" from an art of ideas to an art of sensations a favorable "evolution." Just as for Whitehead "it was a tremendous discovery—how to excite emotions for their own sake!"

[39] That things can be called after the names of the things impressed upon them is rather well illustrated by the reference of J. Gregory to "coins called by the name of their Expresses, as . . . saith Pollux καὶ ἐκαλεῖτο βοῦς ὅτι βοῦς εἰκών εντετυρόμενον, from the figure of an ox imprinted," *Notes and Observations upon Several Passages in Scripture* (London, 1684). Any absolute distinction of the symbol from its referent implies that the symbol is not what Plato means by a "true name," but arbitrarily and conventionally chosen. But symbols are not regarded thus, traditionally; one says that the house *is* the universe in a likeness, rather than that it is a likeness *of* the universe. So in the ritual drama, the performer becomes the deity whose actions he imitates, and only returns to himself when the rite is relinquished: "enthusiasm" meaning that the deity is in him, that he is ἔνθεος (this is not an etymology).

All that may be nonsense to the rationalist, who lives in a meaningless world; but the end is not yet.

[40] *Metaphysics* 1.6.4. There can be little doubt that Aristotle had in mind *Timaeus* 51A, where Plato connects ἀφομοιόω with μεταλαμβάνω. That the one implies the

Hence we say, and in so doing say nothing new, that "art is imitation, expression, and participation." At the same time we cannot help asking: What, if anything, has been added to our understanding of art in modern times? We rather presume that something has been deducted. Our term "aesthetics" and conviction that art is essentially an affair of the sensibilities and emotions rank us with the ignorant, if we admit Quintilian's "Docti rationem componendi intelligunt, etiam indocti voluptatem!"[41]

other is also the opinion to which Socrates assents in *Parmenides* 132E, "That by participation in which ($\mu\epsilon\tau\acute{\epsilon}\chi o\nu\tau a$) 'like' things are like ($\ddot{o}\mu o\iota a$), will be their real 'form,' I suppose? Most assuredly." It is not, however, by their "likeness" that things participate in their form, but (as we learn elsewhere) by their proportion or adequacy ($\iota\sigma\acute{o}\tau\eta s$), i.e., truth of the analogy; a visual likeness of anything to its form or archetype being impossible because the model is invisible; so that, for example, in theology, while it can be said that man is "like" God, it cannot be said that God is "like" man.

Aristotle also says that "thought thinks itself through participation ($\mu\epsilon\tau\acute{a}\lambda\eta\psi\iota s$) in its object" (*Metaphysics* XII.7.8). "For participation is only a special case of the problem of communion, of the symbolizing of one thing with another, of mimicry" (R. C. Taliaferro, foreword to Thomas Taylor, *Timaeus and Critias*, New York, 1944, p. 14).

For the sake of Indian readers it may be added that "imitation" is Skr. *anukaraṇa* ("making according to"), and "participation" (*pratilabha* or *bhakti*); and that like Greek in the time of Plato and Aristotle, Sanskrit has no exact equivalent for "expression"; for Greek and Sanskrit both, an idea is rather "manifested" ($\delta\eta\lambda\acute{o}\omega$, *pra-kāś, vy-añj, vy-ā-khyā*) than "expressed"; in both languages words that mean to "speak" and to "shine" have common roots (cf. our "shining wit," "illustration," "clarify," "declare," and "argument"). Form ($\epsilon\tilde{\iota}\delta os$ as $\iota\delta\acute{\epsilon}a$) and presentation ($\phi a\iota\nu\acute{o}\mu\epsilon\nu o\nu$) are *nāma* (name, quiddity) and *rūpa* (shape, appearance, body); or in the special case of verbal expressions, *artha* (meaning, value), *prayojana* (use), and *śabda* (sound); the former being the intellectual (*mānasa*, $\nu o\eta\tau\acute{o}s$) and the latter the tangible or aesthetic (*spṛśya, dṛśya*, $a\iota\sigma\theta\eta\tau\iota\kappa\acute{o}s$, $\dot{o}\rho a\tau\acute{o}s$) apprehensions.

[41] Quintilian IX.4.117, based on Plato, *Timaeus* 80B, where the "composition" is of shrill and deep sound, and this "furnishes pleasure to the unintelligent, and to the intelligent that intellectual delight which is caused by the imitation of the divine harmony manifested in mortal motions" (R. G. Bury's translation, LCL).

Primitive Mentality

The myth is not my own, I had it from my mother.
Euripides, fr. 488

There is, perhaps, no subject that has been more extensively investigated and more prejudicially misunderstood by the modern scientist than that of folklore. By "folklore" we mean that whole and consistent body of culture which has been handed down, not in books but by word of mouth and in practice, from time beyond the reach of historical research, in the form of legends, fairy tales, ballads, games, toys, crafts, medicine, agriculture, and other rites, and forms of social organization, especially those that we call "tribal." This is a cultural complex independent of national and even racial boundaries, and of remarkable similarity throughout the world;[1] in other words, a culture of extraordinary vitality. The material of folklore differs from that of exoteric "religion," to which it may be in a kind of opposition—as it is in a quite different way to "science"[2]—by

[First published in French by *Études traditionelles*, XLVI (1939), this essay appeared in English in the *Quarterly Journal of the Mythic Society*, XX (1940), and was later included in *Figures of Speech or Figures of Thought*.—ED.]

[1] "The metaphysical notions of man may be reduced to a few types which are of universal distribution" (Franz Boas, *The Mind of Primitive Man*, New York, 1927, p. 156); "The great myths of mankind are almost monotonously alike in their fundamental aspects" (D. C. Holtom, *The National Faith of Japan*, London, 1938, p. 90). The pattern of the lives of heroes is universal (Lord Raglan, *The Hero*, London, 1936). From all over the world more than three hundred versions of a single tale had already been collected fifty years ago (M. R. Cox, *Cinderella*, London, 1893). All peoples have legends of the original unity of Sky and Earth, their separation, and their marriage. "Clapping Rocks" are Navajo and Eskimo as well as Greek. The patterns of *Himmelfahrten* and the types of the active *Wunderthor* are everywhere alike.

[2] The opposition of religion to folklore is often a kind of rivalry set up as between a new dispensation and an older tradition, the gods of the older cult becoming the evil spirits of the newer. The opposition of science to the content of both folklore and religion is based upon the view that "such knowledge as is not empirical is meaningless." The most ludicrous, and pathetic, situation appears when, as happened not long ago in England, the Church joins hands with science in proposing to withhold fairy tales from children as being untrue; it might have

its more intellectual and less moralistic content, and more obviously and essentially by its adaptation to vernacular transmission:[3] on the one hand, as cited above, "the myth is not my own, *I had it from my mother*," and on the other, "the passage from a traditional mythology to 'religion' is a humanistic decadence."[4]

The content of folklore is metaphysical. Our failure to recognize this is primarily due to our own abysmal ignorance of metaphysics and of its technical terms. We observe, for example, that the primitive craftsman leaves in his work something unfinished, and that the primitive mother dislikes to hear the beauty of her child unduly praised; it is "tempting Providence," and may lead to disaster. That seems like nonsense to us. And yet there survives in our vernacular the explanation of the principle involved: the craftsman leaves something undone in his work for the same reason that the words "to be finished" may mean either to be perfected or to die.[5] Perfection is death: when a thing has been altogether

reflected that those who can make of mythology and fairy lore nothing but literature will do the same with scripture. "Men live by myths . . . they are no mere poetic invention" (Fritz Marti, "Religion, Philosophy, and the College," in *Review of Religion*, VII, 1942, 41). "La mémoire collective conserve . . . des symboles archaïques d'essence purement métaphysique" (M. Eliade in *Zalmoxis*, II, 1939, 78). "Religious philosophy is always bound up with myths and cannot break free from them without destroying itself and abandoning its task" (N. Berdyaev, *Freedom and the Spirit*, London, 1935, p. 69). Cf. E. Dacqué, *Das verlorene Paradies* (Munich, 1940).

[3] The words "adaptation to vernacular transmission" should be noted. Scripture recorded in a sacred language is not thus adapted; and a totally different result is obtained when scriptures originally written in such a sacred language are made accessible to the "untaught manyfolk" by translation, and subjected to an incompetent "free examination." In the first case, there is a faithful transmission of material that is always intelligible, although not necessarily always completely understood; in the second, misunderstandings are inevitable. In this connection it may be remarked that "literacy," nowadays thought of as almost synonymous with "education," is actually of far greater importance from an industrial than from a cultural point of view. What an illiterate Indian or American Indian peasant knows and understands would be entirely beyond the comprehension of the compulsorily educated product of the American public schools.

[4] J. Evola, *Rivolta contra il mondo moderno*, Milan, 1934, p. 374, n. 12. "For the primitives, the mythical world really existed. Or rather it still exists" (Lucien Lévy-Bruhl, *L'Expérience mystique et les symboles chez les primitifs*, Paris, 1938, p. 295). One might add that it will exist forever in the eternal now of the Truth, unaffected by the truth or error of history. A myth is true now, or was never true at all.

[5] Just as Sanskrit *parinirvāṇa* is both "to be completely despirated" and "to be perfected" (cf. Coomaraswamy, "Some Pāli Words" [in Vol. 2 of this selection—ED.]). The Buddha's *parinibbāna* is a "finish" in both senses.

fulfilled, when all has been done that was to be done, potentiality altogether reduced to act (*kṛtakṛtyaḥ*), that is the end: those whom the gods love die young. This is not what the workman desired for his work, nor the mother for her child. It can very well be that the workman or the peasant mother is no longer conscious of the meaning of a precaution that may have become a mere superstition; but assuredly we, who call ourselves anthropologists, should have been able to understand what was the idea which alone could have given rise to such a superstition, and ought to have asked ourselves whether or not the peasant by his actual observance of the precaution is not defending himself from a dangerous suggestion to which we, who have made of our existence a more tightly closed system, may be immune.

As a matter of fact, the destruction of superstitions invariably involves, in one sense or another, the premature death of the folk, or in any case the impoverishment of their lives.[6] To take a typical case, that of the Australian aborigines, D. F. Thompson, who has recently studied their remarkable initiatory symbols, observes that their "mythology supports the belief in a ritual or supernatural visitation that comes upon those who disregard or disobey the law of the old men. When this belief in the old men and their power—which, under tribal conditions, I have never known to be abused—dies, or declines, as it does with 'civilization,' chaos and racial death follow immediately."[7] The world's museums are filled

[6] The life of "civilized" people has already been impoverished; its influence can only tend to impoverish those whom it reaches. The "white man's burden," of which he speaks with so much unction, is the burden of death. For the poverty of "civilized" peoples, cf. I. Jenkins, "The Postulate of an Impoverished Reality," *Journal of Philosophy*, XXXIX, 1942, 533 ff.; Eric Meissner, *Germany in Peril* (London, 1942), pp. 41, 42; Floryan Znaniecki, as quoted by A. J. Krzesinski, *Is Modern Culture Doomed?* (New York, 1942), p. 54, n. 8; W. Andrae, *Die ionische Säule: Bauform oder Symbol?* (Berlin, 1933), p. 65—"*mehr und mehr entleert.*" [The text from which this citation is taken is reviewed, with a translation of key passages, in the present volume; cf. "Walter Andrae's *Die ionische Säule: Bauform oder Symbol?*: A Review."—ED.]

[7] *Illustrated London News*, February 25, 1939. A traditional civilization presupposes a correspondence of the man's most intimate nature with his particular vocation (see René Guénon, "Initiation and the Crafts," JISOA, VI, 1938, 163–168). The forcible disruption of this harmony poisons the very springs of life and creates innumerable maladjustments and sufferings. The representative of "civilization" cannot realize this, because the very idea of vocation has lost its meaning and become for him a "superstition"; the "civilized" man, being himself a kind of economic slave, can be put, or puts himself, to any kind of work that material advantage seems to demand or that social ambition suggests, in total disregard for his individual character, and cannot understand that to rob a man of his hereditary

with the traditional arts of innumerable peoples whose culture has been destroyed by the sinister power of our industrial civilization: peoples who have been forced to abandon their own highly developed and beautiful techniques and significant designs in order to preserve their very lives by working as hired laborers at the production of raw materials.[8] At the same time, modern scholars, with some honorable exceptions,[9] have as little understood the content of folklore as did the early missionaries understand what they thought of only as the "beastly devices of the heathen"; Sir J. G. Frazer, for example, whose life has been devoted to the study of all the ramifications of folk belief and popular rites, has only to say at the end of it all, in a tone of lofty superiority, that he was "led on, step by step, into surveying, as from some spectacular height, some Pisgah of the mind, a great part of the human race; I was beguiled, as by some subtle enchanter, into indicting what I cannot but regard as a dark, a tragic chronicle of human error and folly, of fruitless endeavor, wasted time and blighted hopes"[10]—words that sound much more like an indict-

vocation is precisely to take away his "living" in a far more profound than merely economic sense.

[8] See Coomaraswamy, "Notes on Savage Art," 1946, and "Symptom, Diagnosis, and Regimen" [in this volume—ED.]; cf. Thomas Harrisson, *Savage Civilization* (New York, 1937).

[9] E.g., Paul Radin, *Primitive Man as Philosopher* (New York, 1927); Wilhelm Schmidt, *Origin and Growth of Religion*, 2nd ed. (New York, 1935), and *High Gods in North America* (Oxford, 1933); Karl von Spiess, *Marksteine der Volkskunst* (1937), and *Vom Wesen der Volkskunst* (1926); Konrad Th. Preuss, *Lehrbuch der Völkerkunde* (Stuttgart, 1939), to mention only those best known to me. C. G. Jung is put out of court by his interpretation of symbols as psychological phenomena, an avowed and deliberate exclusion of all metaphysical significance.

[10] *Aftermath* (London, 1936), preface. Olivier Leroy, *La Raison primitive, essai de réfutation de la théorie de prélogisme* (Paris, 1927), n. 18, remarks that Lévy-Bruhl "fut aiguillé sur les recherches ethnologiques par la lecture du *Golden Bough*. Aucun ethnologue, aucun historien des religions, me contredira si je dis que c'était un périlleux début." Again, "la notion que Lévy-Bruhl se fait du 'primitif' a été écartée par tous les ethnographes . . . son peu de curiosité des sauvages a scandalisé les ethnographes" (J. Monneret, *La Poésie moderne et le sacré*, Paris, 1945, pp. 193, 195). The very title of his book, *How Natives Think*, betrays him. If he had known *what* "natives" think (i.e., about Europeans), he might have been surprised. Another exhibition of the superiority complex will be found in the concluding pages of Sidney Hartland, *Primitive Paternity* (London, 1909–1910); his view that when "the relics of primeval ignorance and archaic speculation" have been discarded, the world's "great stories" will survive, is both absurd and sentimental, and rests on the assumption that beauty can be divorced from the truth in which it originates, and a notion that the only end of "literature" is to amuse. *The Golden Bough* is a glorified doctor's thesis. Frazer's only survival value will be documentary; his lucubrations will be forgotten.

ment of modern European civilization than a criticism of any savage society!

The distinctive characteristic of a traditional society is order.[11] The life of the community as a whole and that of the individual, whatever his special function may be, conforms to recognized patterns, of which no one questions the validity: the criminal is the man who does not *know* how to behave, rather than a man who is unwilling to behave.[12] But such an unwillingness is very rare, where education and public opinion tend to make whatever ought not to be done simply ridiculous, and where, also, the concept of vocation involves a corresponding professional honor. Belief is an aristocratic virtue: "unbelief is for the mob." In other words, the traditional society is a unanimous society, and as such unlike a proletarian and individualistic society, in which the major problems of conduct are decided by the tyranny of a majority and the minor problems by each individual for himself, and there is no real agreement, but only conformity or nonconformity.

It is often supposed that in a traditional society, or under tribal or clan conditions, which are those in which a culture of the folk flourished most, the individual is arbitrarily compelled to conform to the patterns of life that he actually follows. It would be truer to say that under these conditions the individual is devoid of social ambition. It is very far from true that in traditional societies the individual is regimented: it is only in democracies, soviets, and dictatorships that a way of life is imposed

[11] "What we mean by a normal civilization is one that rests on principles, in the true sense of this word, and one in which all is ordered and in a hierarchy consistent with these principles, so that everything is seen to be the application and extension of a purely and essentially intellectual or metaphysical doctrine: that is what we mean when we speak of a 'traditional civilization'" (René Guénon, *Orient et occident*, Paris, 1930, p. 235).

[12] Sin, Skr. *aparāddha*, "missing the mark," any departure from "the order to the end," is a sort of clumsiness due to want of skill. There is a ritual of life, and what matters in the performance of a rite is that whatever is done should be done correctly, in "good form." What is not important is how one *feels* about the work to be done or life to be lived: all such feelings being tendentious and self-referent. But if, over and above the *correct* performance of the rite or any action, one also understands its form, if all one's actions are conscious and not merely instinctive reactions provoked by pleasure or pain, whether anticipated or felt, this awareness of the underlying principles is immediately dispositive to spiritual freedom. In other words, wherever the action itself is correct, the action itself is symbolic and provides a discipline, or path, by following which the final goal must be reached; on the other hand, whoever acts informally has opinions of his own and, "knowing what he likes," is limiting his person to the measure of his individuality.

upon the individual from without.[13] In the unanimous society the way of
life is self-imposed in the sense that "fate lies in the created causes them-
selves," and this is one of the many ways in which the order of the tradi-
tional society conforms to the order of nature: it is in the unanimous
societies that the possibility of self-realization—that is, the possibility of
transcending the limitations of individuality—is best provided for. It is,
in fact, for the sake of such a self-realization that the tradition itself is
perpetuated. It is here, as Jules Romains has said, that we find "the
richest possible variety of individual states of consciousness, in a harmony
made valuable by its richness and density,"[14] words that are peculiarly
applicable, for example, to Hindu society. In the various kinds of prole-
tarian government, on the other hand, we meet always with the intention
to achieve a rigid and inflexible uniformity; all the forces of "educa-
tion,"[15] for example, are directed to this end. It is a national, rather than
a cultural type that is constructed, and to this one type everyone is ex-
pected to conform, at the price of being considered a peculiar person or
even a traitor. It is of England that the Earl of Portsmouth remarks, "it

[13] A democracy is a government of all by a majority of proletarians; a soviet, a
government by a small group of proletarians; and a dictatorship, a government by
a single proletarian. In the traditional and unanimous society there is a government
by a hereditary aristocracy, the function of which is to maintain an existing order,
based on eternal principles, rather than to impose the views or arbitrary will (in the
most technical sense of the words, a *tyrannical* will) of any "party" or "interest."
The "liberal" theory of class warfare takes it for granted that there can be no
common interest of different classes, which must oppress or be oppressed by one
another; the classical theories of government are based on a concept of impartial
justice. What majority rule means in practice is a government in terms of an un-
stable "balance of power"; and this involves a kind of internal warfare that cor-
responds exactly to the international wars that result from the effort to maintain
balances of power on a still larger scale.

[14] "The stronger and more intense the social is, the less it is oppressive and ex-
ternal" (G. Gurvitch, "Mass, Community, Communion," *Journal of Philosophy*,
XXXVIII, 1941, 488). "In a mediaeval feudalism and imperialism, or any other
civilization of the traditional type, unity and hierarchy can co-exist with a maximum
of individual independence, liberty, affirmation, and constitution" (Evola, *Rivolta*,
p. 112). But: "Hereditary service is quite incompatible with the industrialism of
today, and that is why the system of caste is always painted in such dark colors"
(A. M. Hocart, *Les Castes*, Paris, 1938, p. 238).

[15] "Compulsory education, whatever its practical use may be, cannot be ranked
among the civilizing forces of this world" (Meissner, *Germany in Peril*, p. 73).
Education in a primitive society is not compulsory, but inevitable; just because the
past is there "present, experienced and felt as an effective part of daily life, not
just taught by schoolmasters" (*idem*). For the typically modern man, to have
"broken with the past" is an end in itself; any change is a meliorative "progress,"
and education is typically iconoclastic.

is the wealth and genius of variety amongst our people, both in character and hand, that needs to be rescued now":[16] what could not be said of the United States! The explanation of this difference is to be found in the fact that the order that is imposed on the individual from without in any form of proletarian government is a *systematic* order, not a "form" but a cut and dried "formula," and generally speaking a pattern of life that has been conceived by a single individual or some school of academic thinkers ("Marxists," for example); while the pattern to which the traditional society is conformed by its own nature, being a meta-physical pattern, is a consistent but not a systematic form, and can there-fore provide for the realization of many more possibilities and for the functioning of many more kinds of individual character than can be included within the limits of any system.

The actual unity of folklore represents on the popular level precisely what the orthodoxy of an elite represents in a relatively learned environ-ment. The relation between the popular and the learned metaphysics is, moreover, analogous to and partly identical with that of the lesser to the greater mysteries. To a very large extent both employ one and the same symbols, which are taken more literally in the one case, and in the other understood parabolically; for example, the "giants" and "heroes" of popu-lar legend are the titans and gods of the more learned mythology, the seven-league boots of the hero correspond to the strides of an Agni or a Buddha, and "Tom Thumb" is no other than the Son whom Eckhart describes as "small, but so puissant." *So long as the material of folklore is transmitted, so long is the ground available on which the superstructure of full initiatory understanding can be built.*

Let us now consider the "primitive mentality" that so many anthropol-ogists have studied: the mentality, that is, which manifests itself in such normal types of society as we have been considering, and to which we have referred as "traditional." Two closely connected questions must first be disposed of. In the first place, is there such a thing as a "primitive" or "alogical" mentality distinct from that of civilized and scientific man? It has been taken for granted by the older "animists" that human nature is a constant, so that "if we were in the position of the primitives, our mind being what it is now, we should think and act as they do."[17] On

[16] G.V.W. Portsmouth, *Alternative to Death* (London, 1943), p. 30.
[17] G. Davy, "Psychologie des primitifs d'après Lévy-Bruhl," *Journal de psychologie normale et pathologique*, XXVII (1931), 112.

the other hand, for anthropologists and psychologists of the type of Lévy-Bruhl, there can be recognized an almost specific distinction between the primitive mentality and ours.[18] The explanation of the possibility of disagreement in such a matter has much to do with the belief in progress, by which, in fact, all our conceptions of the history of civilization are distorted.[19] It is too readily taken for granted that we have progressed, and that any contemporary savage society in all respects fairly represents the so-called primitive mentality, and overlooked that many characteristics of this mentality can be studied at home as well as or better than in any African jungle: the point of view of the Christian or Hindu, for example, is in many ways nearer to that of the "savage" than to that of the modern bourgeoisie. What real distinction of two mentalities can be made is, in fact, the distinction of a modern from a mediaeval or oriental mentality; and this is not a specific distinction, but one of sickness from

[18] For a general refutation of "prélogisme," see Leroy, *La Raison primitive*, and W. Schmidt, *The Origin and Growth of Religion*, pp. 133, 134. Leroy, for example, in discussing the "participation" of kingship in divinity, remarks that all that Lévy-Bruhl and Frazer have done is to call this notion "primitive" because it occurs in primitive societies, and these societies "primitive" because they entertain this primitive idea. Lévy-Bruhl's theories are now quite generally discredited, and most anthropologists and psychologists hold that the mental equipment of primitive man was exactly the same as our own. Cf. Radin, *Primitive Man as Philosopher*, p. 373, "in capacity for logical and symbolical thought, there is no difference between civilized and primitive man," and as cited by Schmidt, *Origin and Growth of Religion*, pp. 202, 203; and Boas, *The Mind of Primitive Man*, p. 156.

[19] Cf. D. B. Zema on "Progress," in the *Dictionary of World Literature* (New York, 1943); and René Guénon, *East and West* (London, 1941), ch. 1, "Civilization and Progress." The latter remarks: "The civilization of the modern West appears in history as a veritable anomaly: among all those which are known to us more or less completely, this civilization is the only one which has developed along purely material lines, and this monstrous development, whose beginning coincides with the so-called Renaissance, has been accompanied, as indeed it was fated to be, by a corresponding intellectual *regress*." Cf. Meissner, *Germany in Peril*, pp. 10–11: "The shortest way of stating the case is this: during the last centuries a vast majority of Christian men have lost their homes in every sense of the word. The number of those cast out into the wilderness of a dehumanized society is steadily increasing . . . the time might come and be nearer than we think, when the ant-heap of society, worked out to full perfection, deserves only one verdict: *unfit for men*." Cf. Gerald Heard, *Man the Master* (New York, 1941), p. 25, "By civilized men we now mean industrialized men, mechanical societies. . . . Any other conduct . . . is the behavior of an ignorant, simple savage. To have arrived at this picture of reality is to be truly advanced, progressive, civilized." "In our present generation of primary and almost exclusive emphasis on mechanics and engineering or economics, understanding of people no longer exists, or at best only in very rare cases. In fact we do not want to know each other as men. . . . That is just what got us into this monstrous war" (W. F. Sands in *Commonweal*, April 20, 1945).

health. It has been said of Lévy-Bruhl that he is a past master in opening up what is to us "an almost inconceivable" world: as if there were none amongst us to whom the mentality reflected in our own immediate environment were not equally "inconceivable."

We shall consider, then, the "primitive mentality" as described, very often accurately enough, by Lévy-Bruhl and other psychologist-anthropologists. It is characterized in the first place by a "collective ideation";[20] ideas are held in common, whereas in a civilized group, everyone entertains ideas of his own.[21] Infinitely varied as it may be in detail, the folk literature, for example, has to do with the lives of heroes, all of whom meet with essentially the same adventures and exhibit the same qualities. It is not for one moment realized that a possession of ideas in common does not necessarily imply the "collective origination" of these ideas. It is argued that what is true for the primitive mentality is unrelated to experience, i.e., to such "logical" experience as ours. Yet it is "true" to what the primitive "experiences." The criticism implied, for such it is, is exactly parallel to the art historian's who criticizes primitive art as not being "true to nature"; and to that of the historian of literature who

[20] The anthropologist's "collective ideation" is nothing but the unanimism of traditional societies that has been discussed above; but with this important distinction, that the anthropologist means to imply by his "collective ideation" not merely the common possession of ideas, but also the "collective origination" of these ideas: the assumption being that there really are such things as popular creations and spontaneous inventions of the masses (and as René Guénon has remarked, "the connection of this point of view with the democratic prejudice is obvious"). Actually, "the literature of the folk is not their own production, but comes down to them from above . . . the folktale is never of popular origin" (Lord Raglan, *The Hero*, p. 145).

[21] In a normal society one no more "thinks for oneself" than one has a private arithmetic [cf. Augustine, *De ordine* II.48]. In a proletarian culture one does not think at all, but only entertains a variety of prejudices, for the most part of journalistic and propagandistic origin, though treasured as one's "own opinions." A traditional culture presumes an entertainment of ideas, in which a private property is impossible. "Where the God (*sc.* Eros) is our teacher, we all come to think alike" (Xenophon, *Oeconomicus* XVII.3); "What really binds men together is their culture—the ideas and standards they have in common" (Ruth Benedict, *Patterns of Culture*, Boston, 1934, p. 16). In other words, religion and culture are normally indivisible: and where everyone thinks for himself, there is no society (*sāhitya*) but only an aggregate. The *common* and divine Reason is the criterion of truth, "but most men live as though they possessed a private intelligence of their own" (Heraclitus, *Fragment* 92). "Insofar as we participate in the memory of that [common and divine] Reason, we speak truth, but whenever we are thinking for ourselves (ἰδιάσωμεν) we lie" (Sextus Empiricus, on Heraclitus, in *Adversus dogmaticos* I.131-134).

demands from literature a psychoanalysis of individual character. The primitive was not interested in such trivialities, but thought in types. This, moreover, was his means of "education"; for the type can be imitated, whereas the individual can only be mimicked.

The next and most famous characteristic of the primitive mentality has been called "participation," or more specifically, "mystical participation." A thing is not only what it is visibly, but also what it represents. Natural or artificial objects are not for the primitive, as they can be for us, arbitrary symbols of some other and higher reality, but actual manifestations of this reality:[22] the eagle or the lion, for example, is not so much a symbol or image *of* the Sun as it *is* the Sun in a likeness (the form being more important than the nature in which it may be manifested); and in the same way every house *is* the world in a likeness, and every altar situated at the center of the earth; it is only because we are more interested in what things are than in what they mean, more interested in particular facts than in universal ideas, that this is inconceivable to us. Descent from a totem animal is not, then, what it appears to the anthropologist, a literal absurdity, but a descent from the Sun, the Progenitor and Prajāpati of all, in that form in which he revealed himself, whether in vision or in dream, to the founder of the clan. The same reasoning validates the Eucharistic meal; the Father-Progenitor is sacrificed and partaken of by his descendants, in the flesh of the sacred animal: "This is my body, take and eat."[23] So that, as Lévy-Bruhl says of

[22] Cf. "The lust of the goat is the bounty of God. . . . When thou seest an Eagle, thou seest a portion of Genius" (William Blake). "The sacrificial horse is a symbol (*rūpa*) of Prajāpati, and consubstantial with Prajāpati (*prājāpatya*)," so that what is said to the horse is said to Prajāpati "face to face" (*sākṣāt*), and so "verily he wins Him visibly" (*sākṣāt*, TS v.7.1.2). "One day I witnessed a Rāmlilā performance. I saw the performers to be actual Sītā, Rāma, Lakṣmaṇa, Hanumān, and Bibhiṣana. Then I worshiped the actors and actresses, who played those parts" (Śrī Rāmakrishna). "The child lives in the reality of his imagery, as did the men of early prehistoric time" (R. R. Schmidt, *Dawn of the Human Mind*, London, 1936, p. 7), but the aesthete in the actuality of the fetish!

[23] In the statement, "in some cases we cannot easily tell whether the native thinks that he is in the actual presence of some (usually invisible) being, or that of a symbol" (Lévy-Bruhl, *L'Expérience mystique*, p. 206), "we" can only refer to such profane mentalities as are intended by our authors when they speak of "civilized" or "emancipated" man or of themselves. It would not be true for a learned Catholic or Hindu to say that "this peculiarity of the symbols of the primitives creates a great difficulty for us," and one wonders why our authors are so much puzzled by the "savage," and not by the contemporary metaphysician. More truly, one does not wonder: it is because it is assumed that wisdom was born with *us*, and that the savage does not distinguish between appearance and reality; it is because we choose

such symbols, "very often it is not their purpose to 'represent' their proto-
type to the eye, but to facilitate a participation," and that "if it is their
essential function to 'represent,' in the full sense of the word, invisible
beings or objects, and to make their presence effective, it follows that
they are not necessarily reproductions or likenesses of these beings or
objects."[24] The purpose of primitive art, being entirely different from
the aesthetic or decorative intentions of the modern "artist" (for whom
the ancient motifs survive only as meaningless "art forms"), explains
its abstract character. "We civilized men have lost the Paradise of the
'Soul of primitive imagery [*Urbildseele*].' We no longer live among the
shapes which we had fashioned within: we have become mere spectators,
reflecting them from without."[25]

The superior intellectuality of primitive and "folk" art is often con-
fessed, even by those who regard the "emancipation" of art from its lin-
guistic and communicative functions as a desirable progress. Thus W. De-
onna writes, "Le primitivisme exprime par l'art les idées," but "l'art évolue
. . . vers un naturalisme progressif," no longer representing things "telles
qu'on les conçoit" [I would rather say, "telles qu'on les comprend"], but
"telles qu'on les voit"; thus substituting "la réalité" for "l'abstraction"; and
that evolution, "de l'idéalisme vers un naturalisme" in which "la forme [*sc.*
la figure] tend à prédominer sur l'idée," is what the Greek genius, "plus
artiste que tous les autres," finally accomplished.[26]

To have lost the art of thinking in images is precisely to have lost the
proper linguistic of metaphysics and to have descended to the verbal logic

to describe the primitive religious cults as a "worship of nature"—we who are
nature worshipers indeed, and to whom the words of Plutarch are preeminently
applicable, viz. that men have been so blinded by their powers of observation that
they can no longer distinguish between Apollo and the Sun, the reality and the
phenomenon.

[24] Lévy-Bruhl, *L'Expérience mystique*, pp. 174, 180. Lévy-Bruhl appears to have
been quite ignorant of the Platonic-Aristotelian-Christian doctrine of the "participa-
tion" of things in their formal causes. His own words, "not necessarily . . . like-
nesses," are notably illogical, since he is speaking of "invisible" prototypes, and it is
evident that these invisibles have no appearance that could be visually imitated,
but only a character of which there can be a representation by means of adequate
(ἴσος) symbols; cf. Rom. 1:20, "invisible things . . . being understood by the
things that are made."

[25] Schmidt, *Dawn of the Human Mind*, p. 7.

[26] W. Deonna, "Primitivisme et classicisme," BAHA, IV, no. 10 (1937). For
the same facts but a contrary conclusion see A. Gleizes, *Vers une Conscience
plastique; la forme et l'histoire* (Paris, 1932).

of "philosophy." The truth is that the content of such an "abstract," or rather "principial," form as the Neolithic sun-wheel (in which *we* see only an evidence of the "worship of natural forces," or at most a "personification" of these forces), or that of the corresponding circle with center and radii or rays, is so rich that it could only be fully expounded in many volumes, and embodies implications which can only with difficulty if at all be expressed in words; the very nature of primitive and folk art is the immediate proof of its essentially intellectual content. Nor does this only apply to the diagrammatic representations: there was actually nothing made for use that had not a meaning as well as an application: "The needs of the body and the spirit are satisfied together";[27] "le physique et le spirituel ne sont pas encore séparés,"[28] "meaningful form, in which the physical and metaphysical originally formed a counterbalancing polarity, is increasingly depleted in its transmission to us; we say then that it is 'ornament.' "[29] What we call "inventions" are nothing but the application of known metaphysical principles to practical ends; and that is why tradition always refers the fundamental inventions to an ancestral culture hero (always, in the last analysis, a descent of the Sun), that is to say, to a primordial revelation.

In these applications, however utilitarian their purpose, there was no need whatever to sacrifice the clarity of the original significance of the symbolic form: on the contrary, the aptitude and beauty of the artifact at the same time express and depend upon the form that underlies it. We can see this very clearly, for example, in the case of such an ancient invention as that of the "safety pin," which is simply an adaptation of a still older invention, that of the straight pin or needle having at one end a head, ring, or eye and at the other a point; a form that as a "pin" directly penetrates and fastens materials together, and as a "needle" fastens them together by leaving behind it as its "trace" a thread that originates from its eye. In the safety pin, the originally straight stem of the pin or

[27] Schmidt, *Dawn of the Human Mind*, p. 167. Was "primitive man" already a Platonist, or was Plato a primitive man when he spoke of those arts as legitimate "that will at the same time care for the bodies and the souls of your citizens" (*Republic* 409E–410A), and said that "the one means of salvation from these evils is neither to exercise the soul without the body nor the body without the soul" (*Timaeus* 88BC)?

[28] Hocart, *Les Castes*, p. 63. Under these conditions, "Chaque occupation était un sacerdoce" (p. 27).

[29] Andrae, *Die ionische Säule*, p. 65.

needle is bent upon itself so that its point passes back again through the "eye" and is held there securely, at the same time that it fastens whatever material it has penetrated.[30]

Whoever is acquainted with the technical language of initiatory symbolism (in the present case, the language of the "lesser mysteries" of the crafts) will recognize at once that the straight pin or needle is a symbol of generation, and the safety pin a symbol of regeneration. The safety pin is, moreover, the equivalent of the button, which fastens things together and is attached to them by means of a thread which passes through and again returns to its perforations, which correspond to the eye of the needle. The significance of the metal pin, and that of the thread left behind by the needle (whether or not secured to a button that corresponds to the eye of the needle) is the same: it is that of the "thread-spirit" (*sūtrātman*) by which the Sun connects all things to himself and fastens them; he is the primordial embroiderer and tailor, by whom the tissue of the universe, to which our garments are analogous, is woven on a living thread.[31]

For the metaphysician it is inconceivable that forms such as this, which express a given doctrine with mathematical precision, could have been "invented" without a knowledge of their significance. The anthropologist, it is true, will believe that such meanings are merely "read into" the forms by the sophisticated symbolist (one might as well pretend that a mathematical formula could have been discovered by chance). But that a safety pin or button is meaningless, and merely a convenience for us, is simply the evidence of our profane ignorance and of the fact that such forms have been "more and more voided of content [*entleert*] on their way down to us" (Andrae); the scholar of art is not "reading into" these intelligible forms an arbitrary meaning, but simply reading their mean-

[30] It is noteworthy that the word *fibule* (fibula) in French surgical language means *suture*.

[31] "The Sun is the fastening (*āsañjanam*, one might even say "button") to whom these worlds are linked by means of the quarters. . . . He strings these worlds to Himself by a thread; the thread is the Gale of the Spirit" (ŚB VI.1.1.17 and VIII.7.3.10). Cf. AV IX.8.38, and BG VII.7, "All 'this' is strung on Me like a row of gems on a thread." For the "thread-spirit" doctrine, cf. also Homer, *Iliad* VIII.18 ff.; Plato, *Theatetus* 153 and *Laws* 644; Plutarch, *Moralia* 393 ff.; Hermes, *Libellus* XVI.5.7; John 12:32; Dante, *Paradiso* I.116; Rūmī, *Dīvān*, Ode XXVIII, "He gave me the end of a thread . . ."; Blake, "I give you the end of a golden string. . . ." We still speak of living substances as "tissues." See also Coomaraswamy, "The Iconography of Dürer's 'Knoten' and Leonardo's 'Concatenation,'" 1944, and "Spiritual Paternity and the Puppet-Complex," 1945.

ing, for this is their "form" or "life," and present in them regardless of whether or not the individual artists of a given period, or we, have known it or not. In the present case the proof that the meaning of the safety pin had been understood can be pointed to in the fact that the heads or eyes of prehistoric fibulae are regularly decorated with a repertoire of distinctly solar symbols.[32]

Inasmuch as the symbolic arts of the folk do not propose to tell us what things are like but, by their allusions, intend to refer to the ideas implied by these things, we may describe them as having an algebraic (rather than "abstract") quality, and in this respect as differing essentially from the veridical and realistic purposes of a profane and arithmetical art, of which the intentions are to tell us what things are like, to express the artist's personality, and to evoke an emotional reaction. We do not call folk art "abstract" because the forms are not arrived at by a process of omission; nor do we call it "conventional," since its forms have not been arrived at by experiment and agreement; nor do we call it "decorative" in the modern sense of the word, since it is not meaningless;[33] it is properly speaking a principial art, and supernatural rather than naturalistic. The nature of folk art is, then, itself the sufficient demonstration of its intellectuality: it is, indeed, a "divine inheritance." We illustrate in Figures 5 and 6 two examples of folk art and one of bourgeois art. The characteristic informality, insignificance, and ugliness of the latter will be obvious. Figure 5 is a Sarmatian "ornament,"[34] probably a horse trapping. There is a central six-spoked wheel, around which revolve four equine protomas, also wheel-marked, forming a whorl or *svastika*; and it is abundantly clear that this is a representation of the divine "procession," the revolution of the Supernal Sun in a four-horsed and four-wheeled chariot; a representation such as this has a content evidently far exceeding that of later pictorial representations of an anthropomorphic "Sun," or human athlete, riding in a chariot actually drawn by four prancing horses. The two other illustrations are of modern Indian wooden toys: in the first case we recognize a metaphysical and formal art, and a type that can be paralleled throughout a millennial tradition, while in the latter the effect of European influence has led

[32] See Christopher Blinkenberg, *Fibules grècques et orientales*, Copenhagen, 1926. The ornamentation of these fibulae forms a veritable encyclopedia of solar symbols.

[33] See Coomaraswamy, "Ornament" [in this volume—ED.].

[34] Reproduced by permission of the Trustees of the British Museum.

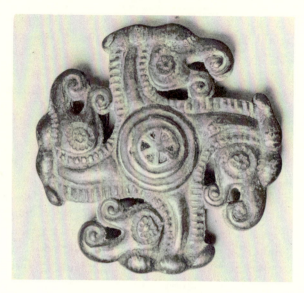

Figure 5. Sarmatian (?) Ornament

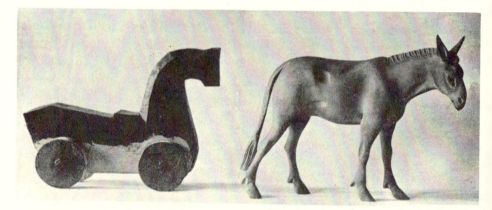

Figure 6. Horse and Donkey: Folk Art and Bourgeois Art

the artist not to "imitate nature in her manner of operation," but simply to imitate nature in her appearances; if either of these kinds of art can be called "naïve," it is certainly not the traditional art of the folk!

The characteristic pronouncements of anthropologists on the "primitive mentality," of which a few may be cited, are often very remarkable, and may be said to represent not what the writers have intended, the description of an inferior type of consciousness and experience, but one intrinsically superior to that of "civilized" man, and approximating to that which we are accustomed to think of as "primordial." For example, "The primitive mind experienced life as a whole. . . . Art was not for the delectation of the senses."[35] Dr. Macalister actually compares what he calls the "Ascent of Man" to Wordsworth's *Ode on the Intimations of Immortality,* not realizing that the poem is the description of the descent or materialization of consciousness.[36] Schmidt remarks that "In 'heathenish' popular customs, in the 'superstitions' of our folk, the spiritual adventures of prehistoric times, the imagery of primitive insight are living still; *a divine inheritance.* . . . Originally every type of soul and mind corresponds to the physiological organism proper to it. . . . The world is conceived as being partner with the living being, which is unconscious of its individuality; as being an essential portion of the Ego; and it is represented as being affected by human exertion and sufferings. . . . Nature-man lives his life in images. He grasps it in his conception as a series of realities. His visions are therefore not only real; they form his objective insight into a higher world. . . . The talent, in the man of understanding, is only obstructed, more or less. Artistic natures, poets, painters, sculptors, musicians, seers, who see God face to face, remain all their lives eidetically rooted in their creations. In them there

[35] Earl Baldwin Smith, *Egyptian Architecture* (New York, 1938), p. 27. "It was a tremendous discovery—how to excite emotions for their own sake" (A. N. Whitehead). Was it really? "No, not even if all the oxen and horses in the world, by their pursuit of pleasure, proclaim that such is the criterion" (Plato, *Philebus* 67)!

[36] Preface to Schmidt, *Dawn of the Human Mind.* The customary virtual identification of the "childhood of humanity" with the childhood of the individual, that of the mind of Cro-Magnon man with his "fully developed forehead" (Schmidt, p. 209), with that of the still subhuman child, is illogical. "Since we are forced to believe that the race of man is of one species, it follows that man everywhere has an equally long history behind him" (Benedict, *Patterns of Culture*, p. 18). That the child can in certain respects be used as an adequate symbol of the primordial state, in the sense that "of such is the Kingdom of Heaven," is quite another matter.

lives the folk-soul of dissolving images in their most perfect creative form. . . . Natural man, to whom vision and thought are identical. . . . The man of magic . . . is still standing in a present world which includes the whole of primeval time. . . . [On the other hand] the emancipated man, vehicle of a soul . . . differentiates the original magical somatopsychic unity. . . . Outward and Inward, World and Ego, become a duality in the consciousness."[37] Could one say more in support of the late John Lodge's proposition, "From the Stone Age until now, *quelle dégringolade*"?

If it is difficult for us to understand the primitive belief in the efficacy of symbolic rites, it is largely because of our limited knowledge of the prolongations of the personality, which forces us to think in terms of a purely physical causality. We overlook that while we may believe that the anticipatory rite has no physical effect in the desired direction, the rite itself is the formal expression of a will directed to this end, and that this will, released by the performance of the rite, is also an effective force, by which the environment in its totality must be to some extent affected. In any case, the preliminary rite of "mimetic magic" is an enactment of the "formal cause" of the subsequent operation, whether it be the art of agriculture or that of war that is in question, and the artist has a right to expect that the actual operation, if carried out on this plan, will be successful. What seems strange to us, however, is that for the primitive mentality the rite is a "prefiguration," not merely in the sense of a pattern of action to be followed, but in the sense of an anticipation in which the future becomes a virtually already existent reality, so that "the primi-

[37] Schmidt, *Dawn of the Human Mind*, pp. 1, 13, 89, 126, 212 ff.; italics mine. The final sentence contrasts poignantly with Plato's famous prayer, "grant to me that I may become beautiful within, and that my outward and my inner man may be in fond accord" (*Phaedrus* 278c); cf. BG VI.5 and 6, on friendship or enmity between the empirical and the essential "self." Schmidt is referring, of course, to the clear distinction of subject from object which ordinary "knowledge" presupposes; it is precisely this kind of "knowing" that is, from the standpoint of traditional metaphysics, an *ignorance*, and morally an "original sin" of which the wages are death (Gen. 3); cf. Coomaraswamy, "The Intellectual Operation in Indian Art" [in this volume—ED.], n. 20.

The remarkable expressions of Schmidt are tantamount to the definition of the modern, civilized "man of understanding" as an atrophied personality, out of touch with his environment. That he also envisages this as an *ascent* of man can only mean that he regards the "seers, who see God face to face" and in whom the folk soul survives, as belonging to a strictly atavistic and inferior type of humanity, and thinks of the "divine inheritance" as something to be gotten rid of as soon as possible.

302

tives feel that the future event is actually present": the action of the force released is immediate, "and if its effects appear after some time it is nevertheless imagined—or, rather, in their case, felt—as immediately produced."[38] Lévy-Bruhl goes on to point out very justly that all this implies a conception of time and space that is not in our sense of the word "rational": one in which both past and future, cause and effect, coincide in a present experience. If we choose to call this an "unpractical" position, we must not forget that at the same time "the primitives constantly make use of the real connection between cause and effect . . . they often display an ingenuity that implies a very accurate observation of this connection."[39]

Now it is impossible not to be struck by the fact that it is precisely a state of being in which "everywhere and every when is focused" (Dante), that is for the theologian and the metaphysician "divine": that at this level of reference "all states of being, seen in principle, *are* simultaneous in the eternal now," and that "he who cannot escape from the standpoint of temporal succession so as to see all things in their simultaneity is incapable of the least conception of the metaphysical order."[40] We say that what seems to "us" irrational in the life of "savages," and may be unpractical, since it unfits them to compete with our material force, represents the vestiges of a primordial state of metaphysical understanding, and that if the savage himself is, generally speaking, no longer a comprehensor of his own "divine inheritance," this ignorance on his part is no more shameful than ours who do not recognize the intrinsic nature of his "lore," and understand it no better than he does. We do not say that the modern savage exemplifies the "primordial state" itself, but that his beliefs, and the whole content of folklore, bear witness to such a state. We say that the truly primitive man—"before the Fall"— was not by any means a philosopher or scientist but, by all means, a metaphysical being, in full possession of the *forma humanitatis* (as we are only very partially); that, in the excellent phrase of Baldwin Smith, he "experienced life as a whole."

Nor can it be said that the "primitives" are always unconscious of the sources of their heritage. For example, "Dr. Malinowski has insisted on

[38] Lucien Lévy-Bruhl, *La Mentalité primitive* (Paris, 1922), pp. 88, 290. The problem of the use of apparently ineffectual rites for the attainment of purely practical ends is reasonably discussed by Radin, *Primitive Man as Philosopher*, pp. 15–18.

[39] Lévy-Bruhl, *La Mentalité primitive*, p. 92.

[40] René Guénon, *La Métaphysique orientale* (Paris, 1939), pp. 15, 17.

the fact that, in the native Trobriand way of thinking, magic, agrarian or other, is not a human invention. From time immemorial, it forms a part of the inheritance which is handed down from generation to generation. Like the social institutions proper, it was created in the age of the myth, by the heroes who were the founders of civilization. Hence its sacred character. Hence also its efficacy."[41] Far more rarely, an archaeologist such as Andrae has the courage to express as his own belief that "when we sound the archetype, the ultimate origin of the form, then we find that it is anchored in the highest, not the lowest," and to affirm that "the sensible forms [of art], in which there was at first a polar balance of physical and metaphysical, have been more and more voided of content on their way down to us."[42]

The mention of the Trobriand Islanders above leads us to refer to one more type of what appears at first sight to imply an almost incredible want of observation. The Trobriand Islanders, and some Australians, are reported to be unaware of the causal connection between sexual intercourse and procreation; they are said to believe that spirit-children enter the wombs of women on appropriate occasions, and that sexual intercourse alone is not a determinant of birth.[43] It is, indeed, implausible that the natives, "whose aboriginal endowment is quite as good as any European's, if not better,"[44] are unaware of any connection whatever between sexual intercourse and pregnancy. On the other hand, it is clear that their interest is not in what may be called the mediate causes of pregnancy, but in its first cause.[45] Their position is essentially identical with that of the universal tradition for which reproduction depends on the activating presence of what the mythologist calls a "fertility spirit" or "progenitive deity," and is in fact the Divine Eros, the Indian Kāmadeva and Gandharva, the spiritual Sun of RV 1.115.1, the life of all and source of

[41] Lévy-Bruhl, *L'Expérience mystique*, p. 295.

[42] Andrae, *Die ionische Säule*, "Schlusswort" [cf. n. 6, *supra*—ED.].

[43] M. F. Ashley Montagu, *Coming into Being among the Australian Aborigines* (London, 1937); B. Malinowski, *The Sexual Life of Savages* (London, 1929). Cf. Coomaraswamy, "Spiritual Paternity and the Puppet-Complex," 1945.

[44] Montagu, *Coming into Being*.

[45] "God, the master of all generative power" (Hermes, *Asclepius* III.21); "the power of generation belongs to God" (*Sum. Theol.* 1.45.5); "ex quo omnis paternitas in coelis et terra nominatur" (Eph. 3:14). In Gaelic incantations (see A. Carmichael, *Carmina gadelica*, Edinburgh, 1928), Christ and the Virgin Mary are continually invoked as progenitive deities, givers of increase in cattle or man; the phrasings are almost verbally identical with those of RV VII.102.2, "Who puts the seed in the plants, the cows, the mares, the women, Parjanya." "Call no man your father upon the earth: for one is your father, which is in heaven" (Matt. 23:9).

all being; it is upon *his* "connection with the field"[46] that life is transmitted, as it is by the human "sower" that the elements of the corporeal vehicle of life are planted in *his* "field." So that as the *Majjhima Nikāya*, 1.265–266, expresses it, three things are required for conception, viz. conjunction of father and mother, the mother's period, and the presence of the Gandharva:[47] of which the two first may be called dispositive and the third an essential cause. We see now the meaning of the words of BU III.9.28.5, "Say not 'from semen,' but 'from what is alive [in the semen]'": "It is the Provident Spirit [*prajñātman*, i.e., the Sun] that grasps and erects the flesh" (Kauṣ. Up. III.3); "The power of the soul, which is in the semen through the spirit enclosed therein, fashions the body" (*Sum. Theol.* III.32.11). Thus, in believing with Schiller that "it is the Spirit that fashions the body for itself" (*Wallenstein*, III.13), the "primitive" is in agreement with a unanimous tradition and with Christian doctrine: "Spiritus est qui vivificat: caro non prodest quicquam" ("it is the spirit that quickeneth; the flesh profiteth nothing," John 6:63).[48]

[46] "The Sun is the *ātman* of all that is motionless or mobile," RV 1.115.1. "Whatsoever living thing is born, whether motionless or mobile, know that it is from the union of the Knower of the Field and the Field itself," BG XIII.26. "It is inasmuch as He 'kisses' (breathes on) all his children that each can say 'I am,'" ŚB VII.3.2.12; "Light is the progenitive power" TS VII.1.1.1; cf. John 1:4, "the life was the light of men"; "when the father thus actually emits him as seed into the womb, it is really the sun that emits him as seed into the womb," JUB III.10.4. Further references to solar paternity will be found in ŚB 1.7.2.11 (Sun and Earth parents of all born beings); Dante, *Paradiso* XXII.116 (Sun "the father of each mortal life"); St. Bonaventura, *De reductione artium ad theologiam*, 21; *Mathnawī* 1.3775; Plutarch, *Moralia* 368c, φῶς . . . γόνιμον.

In connection with the "Knower of the Field" it may be remarked that his "conjunction" (*samyoga*) with the "Field" is not merely cognitive but erotic: Skr. *jñā* in its sense of "to recognize as one's own," or "possess," corresponding to Latin *gnoscere* and English "know" in the Biblical expression "Jacob knew his wife." Now the solar manner of "knowing" (in any sense) is by means of his rays, which are emitted by the "Eye"; and hence in the ritual in which the priest represents Prajāpati (the Sun as Father-Progenitor), he formally "looked at" the sacrificer's wife, "for insemination"; a metaphysical rite that the anthropologist would call a piece of "fertility magic." See also Coomaraswamy, "The Sunkiss," 1940.

[47] For "to be present," the Pāli equivalent of Skr. *praty-upasthā*, "to stand upon," is employed; and this is the traditional expression, in accordance with which the Spirit is said to "take its stand upon" the bodily vehicle, which is accordingly referred to as its *adhiṣṭhānam*, "standing ground" or "platform." Gandharva, originally the Divine Eros, and Sun.

[48] That St. John is speaking with reference to a regeneration by no means excludes application to any generation; for as exegetical theory insists, the literal sense of the words of scripture is also always true, and is the vehicle of the transcendental significance.

It will be seen that the Trobriander view that sexual intercourse alone is not a determinant of conception but only its occasion, and that "spirit-children" enter the womb, is essentially identical with the metaphysical doctrine of the philosophers and theologians. The notion that "old folk-lore ideas" are taken over into scriptural contexts, which are thus contaminated by the popular superstitions, reverses the order of events; the reality is that the folklore ideas are the form in which metaphysical doctrines are received by the people and transmitted by them. In its popular form, a given doctrine may not always have been understood, but for so long as the formula is faithfully transmitted it remains understandable; "superstitions," for the most part, are no mere delusions, but formulae of which the meaning has been forgotten and are therefore called meaningless—often, indeed, because the doctrine itself has been forgotten.

Aristotle's doctrine that "Man and the Sun generate man" (*Physics* II.2),[49] that of JUB III.10.4 and that of the *Majjhima Nikāya*, may be said to combine the scientific and the metaphysical theories of the origin of life: and this very well illustrates the fact that the scientific and metaphysical points of view are by no means contradictory, but rather complementary. The weakness of the scientific position is not that the empirical facts are devoid of interest or utility, but that these facts are thought of as a refutation of the intellectual doctrine. Actually, our discovery of chromosomes does not in any way account for the origin of life, but only tells us more about its mechanism. The metaphysician may, like the primitive, be incurious about the scientific facts; he cannot be disconcerted by them, for they can at the most show that God moves "in an even more mysterious way than we had hitherto supposed."

We have touched upon only a very few of the "motifs" of folklore. The main point that we have wished to bring out is that the whole body of these motifs represent a consistent tissue of interrelated intellectual doctrines belonging to a primordial wisdom rather than to a primitive science; and that for this wisdom it would be almost impossible to conceive a popular, or even in any common sense of the term, a human

[49] To which correspond also the words of a Gaelic incantation, "from the bosom of the God of life, and the courses together," (Carmichael, *Carmina gadelica*, II, 119). In Egypt, similarly, "Life was an emanation of progenitive light and the creative word. . . . The Sun, Râ, was the creator above all others, and the means of his creative power were his eye, the 'Eye of Horus,' and his voice, the 'voice of heaven, the bolt' "; the Pharaoh was regarded as having been born, quite literally, of the Sun and a human mother (Alexandre Moret, *Du Caractère religieux de la royauté pharaonique*, Paris, 1902, pp. 40, 41).

origin. The life of the popular wisdom extends backward to a point at which it becomes indistinguishable from the primordial tradition itself, the traces of which we are more familiar with in the sacerdotal and royal arts; and it is in this sense, and by no means with any "democratic" implications, that the lore of the people, expressed in their culture, is really the word of God—*Vox populi vox Dei.*[50]

[50] The misunderstanding of the folk is accidental rather than essential; because they are not sceptical, nor moralistic, "by faith they understand." On the other hand, the literary artist (Andersen, Tennyson, etc.) who does not scruple to modify his narrative for aesthetic or moral reasons, often distorts it (cf. Plutarch, *Moralia* 358F, on "the unestablished first thoughts of poets and littérateurs"); and so, in the transition "from ritual to romance" we often have to ask, "how far did such and such an author really understand his material?"

Chinese Painting at Boston

This is a monumental art, informed by utilitarian, political, moral, and religious ways of thinking—ways which in the civilization of China are not (as they are for us) independent patterns, but parts of a whole that is a total presence to all its parts. These works of art are the charts of a Way that men have followed. But our current training in the "appreciation" of works of art will not enable us to trace it; for our "aesthetic" approach can be compared only to that of a traveler who, when he sees a signpost, proceeds to admire its elegance, then asks who made it, and finally cuts it down and takes it home to be used as a mantelpiece ornament.

In this exhibition we are not looking at a collection of curiosities, but at the evidence of a people's inner life. Products in the first place of contemplation, these works of art were "theories," i.e., visions, before they were made; and having been made, are not mere utilities or ornaments, but "supports of contemplation." In other words, the traditional Chinese work of art is a signification; of what, we shall presently see.

Many are the stories of artists' previsions. The carpenter, for example, explains what "mystery" there is in his art: "I first reduce my mind to absolute quiescence. . . . I enter some mountain forest, I search for a suitable tree. It contains the form required, which is afterwards elaborated. I see the thing in my mind's eye, and then set to work." The Chinese would have agreed with Socrates that "we cannot give the name of 'art' to anything irrational." What we might call spontaneity in Chinese painting, the Chinese artist attributes to an understanding of "tears and laughter and of the shapes of things" as they reveal themselves to one whose heart is "natural, sincere, gentle, and honest." It is not the accident of genius, but a pure humanity that is essential. One is reminded of the saying of Mencius, that the right use of words is more a matter of up-

[This essay was published in *The Magazine of Art*, XXXVII (1944), as a commentary on an exhibition at the Museum of Fine Arts, Boston.—ED.]

rightness than of the use of the dictionary; and of Plato's saying, conversely, that the misuse of words is the symptom of a sickness in the soul.

These are paintings, but it must not be supposed that we are thinking only of paintings. We shall not have really seen, but only "looked" at the paintings, if we have been so trained that we cannot also *see* the design of a garden or that of a peasant embroidery. By "art," as a Chinese critic says, "is meant ritual, music, archery, charioteering, calligraphy, and numbers. . . . Learning to paint is no different from learning to write." No different, at any rate, in China, where both are means of communication by brushwork, and both are more or less pictorial.

The painter studies nature, wild or human, with infinite patience. This is not in order to be able to tell us what nature looks like, but what she *is* like. He "watches" the landscape until its meaning, or idea, is clear to him; if he merely paints the mountains as they are, the result will be only a piece of topography. He does not draw his bamboo from "life," but studies the "true outlines" of its shadows cast on a white wall by moonlight. An artist once painted a bamboo forest in red; when the patron complained that this was "unnatural," the painter asked, "Did you ever see a *black* bamboo?"

The Chinese artist does not merely observe but *identifies* himself with the landscape or whatever it may be that he will represent. The story is told of a famous painter of horses who was found one day in his studio rolling on his back like a horse; reminded that he might really become a horse, he ever afterwards painted only Buddhas. An icon is made to be imitated, not admired. In just the same way in India the imager is required to identify himself in detail with the form to be represented. Such an identification, indeed, is the final goal of any contemplation—reached only when the original distinction of subject from object breaks down and there remains only the knowing, in which the knower and the known are merged. If this seems at all strange to us, whose concept of knowledge is always objective, let us at least remember that an "identification" was also presupposed in mediaeval European procedure; in Dante's words, "He who would paint a figure, if he cannot be it, cannot draw it."

All this involves a concentration, on which the vitality of the finished work will depend—"when the artist is lazily forcing himself to work and is failing to draw from the very depths of his resources, then his painting is weak and soft and lacking in decision." Just as in India, the imager must be a contemplative expert, and if he somehow misses the mark, it

is attributed not to want of skill but to the "laxity" of his contemplation. When a Chinese swordsmith was asked if it was his skill, or some particular method, which gave him eminence, he replied, "It was concentration. If a thing was not a sword, I did not notice it. I availed myself of whatever energy I did not use in other directions in order to secure greater efficiency in the needed direction." And as one judges a sword by its cutting power, so in a good Chinese painting the incisiveness of the brush strokes impresses us. The painter's brush is his sword; if we are not *touché*, it is either the fault of the painter's stroke, or our own insensibility and lack of intelligence. But the mere reaction to aesthetic stimuli, a merely animal "irritability," is not enough. The blow must have meaning for us.

We read in a Jātaka of a prince who drives out in the morning and sees "on the ends of branches, on every spider's web and thread, and on the points of the rushes, dewdrops hanging like so many strings of pearls." These are responsive words that might have been written by a Chinese poet. But later on the dew has vanished. The realization of transience, that nothing lasts, applied to one's own self, the shock of conviction that "such is the life of men," that, and not the mere admiration of an array more exquisite than Solomon's in all his glory, is the real experience. So for the Chinese painter, nature, of which our human nature is but a part, is charged with meaning—*Ligna et lapides docebunt te, quod a magistris audire non posse*; and from the work of art the critic expects no less than from nature herself.

Of what Chinese painters put into their work one can learn a great deal from the innumerable anecdotes, which form a kind of treasury of Chinese "aesthetic." None is more famous than Ku K'ai-chi (of whom the British Museum "Admonitions" may be an authentic trace). Of a poem by Chi K'ang he said that "the line 'My hand sweeps the five strings' is quite easy to illustrate; but the line 'My eye follows the wild geese on their homeward flight' is difficult." Curiously enough, the subject of the second line has often been rather successfully treated in India. It is said that Ku K'ai-chi made his studio at the top of a high pavilion, and was both literally and metaphorically a "man of wide vision"; which reminds us of the values implied in the Pāli Buddhist word *pāsādika*, the adjectival form of the word for "high temple" or "palace," and meaning "sublime." That the man was a knower in the higher sense is clear from his comment on his escape from shipwreck near the island of "Break-

tomb." "Truly," he says, "I escaped from death by breaking the hulk that entombed me." These are the accents of a Socrates.

The connection of perfection with death, implied in the word *nirvāna* itself, is brought out in the significant story of Wu Tao-tze's "escape": we are told that he had painted on a wall a veritable "world picture," for a princely patron, and that when it was done, and had been duly admired, Wu Tao-tze invited the prince to follow him, for there were wonders within greater than those without (cf. Rom. 1:20). He opened a door in the smooth wall and entered; but the door closed on his heels, and the prince could not even discover where it had been. That is, of course, a piece of folklore; but folklore motives are metaphysical formulae, and it will be, or should be, easy for the reader to see what is meant.

In what sense is Chinese painting religious? We must use the word here, of course, in a general way, not differentiating between metaphysics (referred to by many writers as "mysticism"), religion, and philosophy. The social pattern of Chinese life, dominated by the concept of "good form," is in the main Confucian, and might be called secular but for the essential element of "ancestor worship," through which the individual is to a large degree liberated from himself and transformed by his sense of connection and unity with invisible powers. However, we are hardly concerned in the present exhibition with the strictly Confucian art of funeral portraiture. In Chinese culture, or any traditional culture as a whole, we cannot really distinguish between the culture and the religion; they are as inseparably interwoven as is the shape of a work of art with its significance. The oldest religion of China was a sacrificial cult of Sky and Earth, the universal progenitors; its traces survive in the ritual bronzes and archaic jades, in the agricultural rites in which the last emperors still participated, and in some of the motifs of folk art. But in connection with painting, and for present purposes, we need to consider only Taoism and Buddhism, the former of native, the latter of Indian origin.

The Buddhist paintings are easily recognizable. The oldest, and perhaps the most important of those exhibited, is a representation of the Buddha enthroned in glory on the summit of the Vulture Peak, preaching the Law, or Transcendent Norm, to the assembled Bodhisattvas and guardian deities of the entire universe. The earlier Buddhist sculpture had been more intense; here the prevailing mood is one of grandeur

and serenity; in much later Buddhist works the iconography becomes a habit and loses much of its life, but here the aesthetic and religious experiences are still indivisible, and the spectator's heart is "broadened with a mighty understanding," to quote a slightly earlier inscription.

In the sixth century, when Buddhism had already become an institutional and court religion, there came to China an Indian Buddhist master who taught the futility of external practices and founded a school of "abstract contemplation." For Bodhidharma the Buddha is not a person but a principle, immanent within you, where alone it can be found. Bodhidharma's Way is that of the old Indian yoga, and from the Sanskrit *dhyāna* (contemplation) are derived Chinese Ch'an and Japanese Zen, as the designations of a way that was to exercise a transforming influence not only upon Buddhism in China as a religion, but also on art and literature. It was as if the *Cloud of Unknowing* had become the dominant force in the giving of a new direction to life, and in the creation of a new conception of art, of which William Blake might be considered the typical Western representative. Some idea of this direction can be gathered from the saying of the Ch'an master Hsueng-Feng, who, seeing baby monkeys at play, remarked that "even those tiny creatures have their little Buddha-mirrors in their hearts." Had not the Bodhisattva Avalokiteśvara (the Chinese Kwanyin) vowed that he—or she—would not abscond until the last blade of grass had been liberated? Can we then wonder at the painting of a blade of grass with understanding? Was it in vain that St. Francis of Assisi preached to a congregation of birds?

The Ch'an movement in China has been called "romantic." In a European context, this might seem to imply a romanticism, a way of "escape." The concept of "freedom," indeed, necessarily involves the idea of an "escape"; the literal sense being that of "casting off a garment." In metaphysics the escape is from one's self, the cloak in which our self is hidden and by which it is confined; but this is in order to find one's real Self, and it demands an *askesis* rather than a life of greater comfort or ease. The distinction of what might be called the classical romanticism of the East and the sentimental romanticism of nineteenth century Europe could hardly be better expressed than in the words of a Tibetan Lama: "The only stirring adventure on which the heroes admired by the crowd embark are those of a spiritual order."

The modern concept of a "conquest of nature" (H. M. Kallen's "conquest of fate and defeat of God" by the emancipated artist) could never have been formulated in Asia. There man has always felt the kinship

of all life, and sought to establish not so much a government of other lives as a harmonious symbiosis. This does not connote the sentimentality of the modern "nature lover," but rather that of one who makes himself at home with nature; he sympathizes with the lives of animals, trees, mountains, and rivers for what they are in themselves, rather than for him. No more does his attitude reflect the supposedly Buddhist consideration that what is now the soul of the grasshopper may once have inhabited the body of a king; in this literal sense the notion of a "reincarnation" is a mistaken conception. For Buddhism as for Hinduism (aside from parabolic expressions and popular misunderstanding), just as for Plato or Plutarch, there is no individually constant "soul," the same from one moment to the next, but only a "becoming" that consists in a succession of experiences; still less could there be thought of a constant individuality that could be reborn on this earth in self-identity after death. The conception of kinship is far more profound than this: it is the "soul of the soul," or "spirit," that is one and the same undivided life or light in all living things "down to the ants." It is this, and not "my" life that reincarnates—*ma non distingue l'un dall' altro ostello*. The whole creation is, then, a family; and whoever is unresponsive to the innermost nature of an animal or tree is unresponsive to his own Inner Man. Whoever despises another, despises himself. In the words of John Donne: "No man is an Iland, intire of it selfe; every man is a peece of the Continent, a part of the maine; if a Clod bee washed away by the Sea, Europe is the lesse, as well as if a Promontorie were, as well as if a Mannor of thy friends or of thine owne were; any mans death diminishes me, because I am involved in Mankinde."

But we must not suppose that the Ch'an movement, with all its consequences, was of an exclusively Buddhist origin. China could absorb Indian ideas because she already possessed them. Ch'an is at least as deeply rooted in the Taoism of Lao-tzu and Chuang-tzu as it is in Indian yoga. China could assimilate Indian "influence," as our own Middle Ages could assimilate Islamic thought, because she already had its essence in herself. If we ourselves cannot do so, or only with great difficulty, finding it "exotic" or "mysterious," it is not because of *its* inhumanity, but because our own traditions have been cut off at the roots, leaving *us* adrift.

The Taoist Immortals (*hsien*) are literally "men of the mountains," as the old Indian rishis, to whom they correspond, were men of the forest; to both, it seemed "impossible for one to obtain salvation, who lives in a

city covered with dust," and that (in Blake's words) "great things are done when men and mountains meet." "Dust," in traditional contexts, both denotes and connotes; the "city" and the "dust" have both a *double entendre*; our eyes are blinded by "dust." Let us not imagine that the Chinese "world" was so much better than our own; there too were "passion, ill-will and delusion." Their world may not have differed morally from ours; but still it was a different world, just because all men in it, whatever their own character might be, accepted the validity of an other-worldly ideal which we deny.

The spirit of Ch'an painting, poles apart from the sentimental romanticism of the European nineteenth century, is essentially Taoist in its avoidance of pathetic fallacies. Chuang-tzu had said, "Horses have hoofs to carry them over frost and snow; hair to protect them from the wind and cold. They eat grass and drink water and fling up their heels in the meadows. Such is the real nature of horses. Thus far only do their natural dispositions carry them. Palatial stables are of no use to them." A millennium later the author of a treatise on animal painting wrote:

> The horse is used as a symbol of the sky, its even pace prefiguring the even motion of the stars; the bull, mildly sustaining its heavy yoke, is fit symbol of the earth's submissive tolerance. But tigers, leopards, deer, wild swine, fawns, and hares—creatures that cannot be inured to the will of man—these the painter chooses for the sake of their skittish gambols and swift, shy evasions, loves them as things that seek the desolation of great plains and wintry snows, as creatures that will not be haltered with a bridle nor tethered by the foot. He would commit to brushwork the gallant splendour of their stride; this he would do, and no more.

The "Six Canons of Hsieh Ho" (ca. 500), (Hsieh Ho was himself a painter), have since their formulation remained the foundation of Chinese criticism and appreciation. Of these the first and most essential, *ch'i-yün shēng-tung*, translated as literally as possible by "spirit-reverberation (or operation), (in) life-motion," implies that it is not the mere appearance that a true painter seeks to represent, but its animating form that he reveals. We are told accordingly that the great painters of old "painted the idea (*i*) and not merely the shape (*hsing*) of things," while in adverse criticism it is said that "the appearance (*hsing*) was like, but the reverberation weak." The intention is to "depict what is divine (*shēn*)

in things by means of the appearance" and "if you concentrate your own (*shēn*), then it perfects the work."

The word *ch'i* we rendered above by "spirit." Asked in what did he excel, the Chinese philosopher Mencius replied, "I know words, I am an expert in cultivating my vast *ch'i*." To the question, "What is that?" he answered, "Hard to say; its nature is, that being cultivated with sincerity and without violence, it is then most great, most adamant, and fills all this twixt heaven and earth." *Ch'i* corresponds to the Indian *prāṇa*, immanent Breath—"Verily, it is the Breath that shines forth in all things"—"This Brahma that shines forth when we see or hear or think, and is then 'alive' in us," being "the only seer, hearer, thinker, etc., itself unseen, unheard, unthought within you."

The world is a theophany, an epiphany of things themselves unseen: and so ought to be every work of art, an imitation of nature in her manner of operation, "wherein are united the earthly and the heavenly, the human and divine," as the missal expresses it. In the words of the Assyrian archaeologist Walter Andrae, "to make the primordial truth intelligible, to make the unheard audible, to enunciate the primordial word, such is the task of art, or it is not art." It is by such standards as these that the visitor to an exhibition of Chinese paintings should be guided; he should ask himself not so much, "how do I like this or that work?" or "is the attribution correct?" but "what is the painter saying? have I heard him?"

Symptom, Diagnosis, and Regimen

Outstanding characteristics of our world in a state of chaos are disorder, uncertainty, sentimentality, and despair. Our comfortable faith in progress has been shaken, and we are no longer quite sure that man can live by bread alone. It is a world of "impoverished reality," one in which we go on living as if life were an end in itself and had no meaning. As artists and students of art, and as museum curators, we are a part of this world and partly responsible for it. Our point of view is one of its symptoms—a sinister word, for symptoms imply disease. Nevertheless, they provide a basis for diagnosis, our only resort when prognosis has been neglected. Let us describe the symptoms, ask of what morbid condition they are an index, and prescribe a remedy.

Symptomatic abnormalities in our collegiate point of view include the assumption that art is essentially an aesthetic, that is, sensational and emotional, behavior, a passion suffered rather than an act performed; our dominating interest in style, and indifference to the truth and meaning of works of art; the importance we attach to the artist's personality; the notion that the artist is a special kind of man, rather than that every man is a special kind of artist; the distinction we make between fine art and applied art; and the idea that the nature to which art must be true is not Creative Nature, but our own immediate environment, and more especially, ourselves.

Within and outside the classrooms, we misuse terms, such as "form," "ornament," "inspiration," and even "art." Our naturalistic preoccupations and historical prejudice make it impossible for us to penetrate the arts of the folk and of primitive man, whose designs we admire but whose meanings we ignore because the abstract terms of the myth are enigmatic to our empirical approach. Our artists are "emancipated" from any obligation to the eternal verities, and have abandoned to tradesmen the satisfaction of present needs. Our abstract art is not an iconography

[This essay was first published in the *College Art Journal,* II (1943), and reprinted in *Figures of Speech or Figures of Thought.*—ED.]

of transcendental forms, but the realistic picture of a disintegrated mentality. Our boasted standard of living is qualitatively beneath contempt, however quantitatively magnificent. And what is, perhaps, the most significant symptom and evidence of our malady is the fact that we have destroyed the vocational and artistic foundations of whatever traditional cultures our touch has infected.

We call these symptoms abnormal because, when seen in their historical and worldwide perspective, the assumptions of which they are a consequence are actually peculiar, and in almost every detail opposed to those of other cultures, and notably those whose works we most admire. That we can admire Romanesque building—an "architecture without drainage"—at the same time that we despise the mind of the "Dark Ages" is anomalous; we do not see that it may be the fault of our mentality that ours is a "drainage without architecture."

All these symptoms point to a deep-seated sickness: primarily, the diagnosis must be that of ignorance. By that, of course, we do not mean an ignorance of the facts, with which our minds are cluttered, but an ignorance of the principles to which all operations can be reduced, and must be reduced if they are to be understood. Ours is a nominalist culture; nothing is "real" for us that we cannot grasp with our hands or otherwise "observe." We train the artist, not to think, but to observe; ours is "a rancour contemptuous of immortality." In the train of this fundamental ignorance follow egotism (*cogito ergo sum, ahaṃkāra, οἴησις*), greed, irresponsibility, and the notion that work is an evil and culture a fruit of idleness, miscalled "leisure." The Greeks very properly distinguished "leisure" (σχολή) from a "cessation" (παῦσις); but we, who confuse these two, and find the notion of a "work of leisure," i.e., one requiring our undivided attention (Plato, *Republic* 370B), very strange, are also right in calling our holidays "vacations," *vacances*, i.e., times of emptiness.

Our malady, moreover, is one of schizophrenia. We are apt to ask about a work of art two *separate* questions, "What is it for?" and "What does it mean?" That is to divide shape from form, symbol from reference, and agriculture from culture. Primitive man, whose handiwork displays a "polar balance of physical and metaphysical," could not have asked these separate questions. Even today the American Indian cannot understand why his songs and ritual should interest us, if we cannot use their spiritual content. Plato considered unworthy of free men, and would have excluded from his ideal state, the practice of any art that served only the needs of

the body. And until we demand of the artist and the manufacturer, who are naturally one and the same man, products designed to serve the needs of the body and the soul at one and the same time, the artist will remain a playboy, the manufacturer a caterer, and the workman a snob wanting nothing better than a larger share of the crumbs that fall from the rich man's table.

Now for the regimen. To administer a medicine may take courage when the doctor's business depends on the patient's good will. To question the validity of the distinction of fine from applied art, or of the artist from the craftsman, is to question the validity of "that monster of modern growth, the financial-commercial state" on which both artist and teacher now depend for their livelihood. Nevertheless, in addressing a body of educators and curators, one must insist upon their responsibility for the teaching of truth about the nature of art and the social function of the artist.

This will involve, among other things, a repudiation of the view that art is in any special sense an aesthetic experience. Aesthetic reactions are nothing more than the biologist's "irritability," which we share with the amoeba. For so long as we make of art a merely aesthetic experience or can speak seriously of a "disinterested aesthetic contemplation," it will be absurd to think of art as pertaining to the "higher things of life." The artist's function is not simply to please, but to present an ought-to-be-known in such a manner as to please when seen or heard, and so expressed as to be convincing. We must make it clear that it is not the artist, but the man, who has both the right and the duty to choose the theme; that the artist has no license to say anything not in itself worth saying, however eloquently; that it is only by his wisdom as a man that he can know what is worth saying or making. Art is a kind of knowledge by which we know *how* to do our work (*Sum. Theol.* 1.2.57.3), but it does not tell us *what* we need, and therefore ought, to make. So there must be a censorship of manufacture; and if we repudiate a censorship by "guardians" it remains for us to teach our pupils, whether manufacturers or consumers, that it is their responsibility to exercise a collective censorship, not only of qualities, but of kinds of manufacture as well.[1]

[1] "The crucial error is that of holding that nothing is any more important than anything else, that there can be no order of goods, and no order in the intellectual realm," R. M. Hutchins, *Education for Freedom* (Baton Rouge, La., 1943), p. 26.

Our obligation demands at the same time a radical change of method in our interpretation of the language of art. No one will deny that art is a means of communication by signs or symbols. Our current methods of analysis are interpretations of these signs in their inverted sense, that is, as psychological expressions, as if the artist had nothing better to do than to make an exhibition of himself to his neighbor or of his neighbor to himself. But personalities are interesting only to their owners, or, at most, to a narrow circle of friends; and it is not the voice of the artist but the voice of the monument, the demonstration of a *quod erat demonstrandum*, that we want to hear.[2]

The art historian is less of a whole man than the anthropologist. The former is all too often indifferent to themes, while the latter is looking for something that is neither in the work of art as if in a place, nor in the artist as a private property, but to which the work of art is a pointer. For him, the signs, constituting the language of a significant art, are full of meanings; in the first place, injunctive, moving us to do this or that, and in the second place, speculative, that is, referent of the activity to its principle. To expect any less than this of the artist is to build him an ivory tower. Such a habitation may suit him for the moment; but in times of stress we may no longer be able to afford such luxuries; and if he stays in his tower, enjoying his irresponsibility, and should even die of neglect, he may be unlamented and unsung. For if the artist cannot be interested in something greater than himself or his art, if the patron does not demand of him products well and truly made for the good use of the whole man, there is little prospect that art will ever again affect the lives of more than that infinitesimal fraction of the population that cares about the sort of art we have, and no doubt, deserve. There can be no restoration of art to its rightful position as the principle of order governing the production of utilities short of a change of mind on the part of both artist and consumer, sufficient to bring about a reorganization of society on the basis of vocation, that form in which, as Plato said, "more will be done, and better done, and more easily than in any other way."

[2] "Une pensée a guidé la main de l'artisan ou de l'artiste: pensée d'utilité . . . pensée religieuse . . . ce que l'archéologue cherche dans le monument, c'est l'expression d'une pensée." G. de Jerphanion, *La Voix des monuments* (Paris, 1930), pp. 10–16.

TRADITIONAL SYMBOLISM:
METHODOLOGY

Literary Symbolism

Lo! Allah disdaineth not to coin the similitude even of a gnat.
Koran ii.26.

Words are never meaningless by nature, though they can be used irrationally for merely aesthetic and nonartistic purposes: all words are by first intention signs or symbols of specific referents. However, in any analysis of meaning, we must distinguish the literal and categorical or historical significance of words from the allegorical meaning that inheres in their primary referents: for while words are signs of things, they can also be heard or read as symbols of what these things themselves imply. For what are called "practical" (shopkeeping) purposes the primary reference suffices; but when we are dealing with theory, the second reference becomes the important one. Thus, we all know what is meant when we are ordered, "raise your hand"; but when Dante writes "and therefore doth the scripture condescend to your capacity, assigning hand and foot to God, with other meaning . . ." (*Paradiso* iv.43, cf. Philo, *De somniis* i.235), we perceive that in certain contexts "hand" means "power." In this way language becomes not merely indicative, but also expressive, and we realize that, as St. Bonaventura says, "it never expresses except by means of a likeness (*nisi mediante specie, De reductione artium ad theologiam* 18). So Aristotle, "even when one thinks speculatively, one must have some mental picture with which to think" (*De anima* iii.8). Such pictures are not themselves the objects of contemplation, but "supports of contemplation."

"Likeness," however, need not imply any visual resemblance; for in representing abstract ideas, the symbol is "imitating," in the sense that all art is "mimetic," something invisible. Just as when we say "the young man is a lion," so in all figures of thought, the validity of the image is one of true analogy, rather than verisimilitude; it is, as Plato says, not a mere

[First published in the *Dictionary of World Literature* (New York, 1943), this exposition was later included in *Figures of Speech or Figures of Thought*.—ED.]

resemblance (ὁμοιότης) but a real rightness or adequacy (αὐτὸ τὸ ἴσον) that effectively reminds us of the intended referent (*Phaedo* 74 ff.): the Pythagorean position being that truth, rightness (κατόρθωσις, *recta ratio*) in a work of art is a matter of proportion (ἀναλογία, Sextus Empiricus, *Adversus dogmaticos* 1.106); in other words, true "imitation" is not an arithmetical reproduction, "on the contrary, an image, if it is to be in fact an 'image' of its model, must not be altogether 'like' it" (*Cratylus* 432B).

Adequate symbolism may be defined as the representation of a reality on a certain level of reference by a corresponding reality on another: as, for example, in Dante, "No object of sense in the whole world is more worthy to be made a type of God than the sun" (*Convito* III.12). No one will suppose that Dante was the first to regard the sun as an adequate symbol of God. But there is no more common error than to attribute to an individual "poetic imagination" the use of what are really the traditional symbols and technical terms of a spiritual language that transcends all confusion of tongues and is not peculiar to any one time or place. For example, "a rose by any name (e.g., English or Chinese) will smell as sweet," or considered as a symbol may have a constant sense; but that it should be so depends upon the assumption that there are really analogous realities on different levels of reference, i.e., that the world is an explicit theophany, "as above, so below."[1] The traditional symbols, in other words, are not "conventional" but "given" with the ideas to which they correspond; one makes, accordingly, a distinction between *le symbolisme qui sait* and *le symbolisme qui cherche*, the former being the universal language of tradition, and the latter that of the individual and self-expressive poets who are sometimes called "Symbolists."[2] Hence also the primary necessity of accuracy (ὀρθότης, *integritas*) in our iconography, whether in verbal or visual imagery.

It follows that if we are to understand what the expressive writing intends to communicate, we cannot take it only literally or historically, but

[1] [Cf. *Mathnawī* 1.3454 ff.]

[2] A distinction "of the subjective symbol of psychological association from the objective symbol of precise meaning . . . implies some understanding of the doctrine of analogy" (Walter Shewring in the *Weekly Review*, August 17, 1944). What is implied by "the doctrine of analogy" (or, in the Platonic sense, "adequacy," ἰσότης) is that "une réalité d'un certain ordre peut être représentée par une réalité d'un autre ordre, et celle-ci est alors un *symbole* de celle-là," René Guénon, "Mythes, mystères et symboles," *Le Voile d'Isis*, XL (1935), 386. In this sense a symbol is a "mystery," i.e., something to be understood (Clement of Alexandria, *Miscellanies* II.6.15). "Ohne Symbole und Symbolik gibt es keine Religion" (H. Prinz, *Altorientalische Symbolik*, Berlin, 1915, p. 1).

must be ready to interpret it "hermeneutically." How often it happens that in some sequence of traditional books one reaches the point at which one questions whether such and such an author, whose account of a given episode is confused, has understood his material or is merely playing with it, somewhat as modern literary men play with their material when they write what are called "fairy tales," and to whom may be applied the words of Guido d'Arezzo, "Nam qui canit quod non sapit, diffinitur bestia." For as Plato long ago asked, "About what does the Sophist make one so eloquent?" (*Protagoras* 312E).

The problem presents itself to the historian of literature in connection with the stylistic sequences of myth, epic, romance, and modern novel and poetry whenever, as so often happens, he meets with recurring episodes or phrases, and similarly in connection with folklore. An all-too-common error is to suppose that the "true" or "original" form of a given story can be reconstructed by an elimination of its miraculous and supposedly "fanciful" or "poetic" elements. It is, however, precisely in these "marvels," for example in the miracles of Scripture, that the deepest truths of the legend inhere; philosophy, as Plato—whom Aristotle followed in this respect—affirms, beginning in wonder. The reader who has learned to think in terms of the traditional symbolisms will find himself furnished with unsuspected means of understanding, criticism, and delight, and with a standard by which he can distinguish the individual fancy of a littérateur from the knowing use of traditional formulae by a learned singer. He may come to realize that there is no connection of novelty with profundity; that when an author has made an idea his own he can employ it quite originally and inevitably, and with the same right as the man to whom it first presented itself, perhaps before the dawn of history.

Thus when Blake writes, "I give you the end of a golden string, Only wind it into a ball; It will lead you in at heaven's gate Built in Jerusalem's wall," he is using not a private terminology but one that can be traced back in Europe through Dante (*questi la terra in sè stringe, Paradiso* 1.116), the Gospels ("No man can come to me, except the Father . . . draw him," John 6:44, cf. 12:32), Philo, and Plato (with his "one golden cord" that we human puppets should hold on to and be guided by, *Laws* 644) to Homer, where it is Zeus that can draw all things to himself by means of a golden cord (*Iliad* VIII.18 ff., cf. Plato, *Theatetus* 153). And it is not merely in Europe that the symbol of the "thread" has been current for more than two millennia; it is to be found in Islamic, Hindu,

and Chinese contexts. Thus we read in Shams-i-Tabrīz, "He gave me
the end of a thread. . . . 'Pull,' he said 'that I may pull: and break it not
in the pulling,'" and in Hāfiz, "Keep thy end of the thread, that he
may keep his end"; in the *Śatapatha Brāhmaṇa*, that the Sun is the fasten-
ing to which all things are attached by the thread of the spirit, while in
the *Maitri Upaniṣad* the exaltation of the contemplative is compared to
the ascent of a spider on its thread; Chuang-tzu tells us that our life is
suspended from God as if by a thread, cut off when we die. All this is
bound up with the symbolism of weaving and embroidery, the "rope
trick," rope walking, fishing with a line and lassoing; and that of the
rosary and the necklace, for, as the *Bhagavad Gītā* reminds us, "all things
are strung on Him like rows of gems upon a thread."[3]

We can say with Blake, too, that "if the spectator could enter into these
images, approaching them on the fiery chariot of contemplative thought
. . . then he would be happy." No one will suppose that Blake invented
the "fiery chariot" or found it anywhere else than in the Old Testament;
but some may not have remembered that the symbolism of the chariot
is also used by Plato, and in the Indian and Chinese books. The horses
are the sensitive powers of the soul, the body of the chariot our bodily
vehicle, the rider the spirit. The symbol can therefore be regarded from
two points of view; if the untamed horses are allowed to go where they
will, no one can say where this will be; but if they are curbed by the
driver, his intended destination will be reached. Thus, just as there are
two "minds," divine and human, so there is a fiery chariot of the gods,
and a human vehicle, one bound for heaven, the other for the attain-
ment of human ends, "whatever these may be" (TS v.4.10.1). In other
words, from one point of view, embodiment is a humiliation, and from
another a royal procession. Let us consider only the first case here. Tradi-
tional punishments (e.g., crucifixion, impalement, flaying) are based on
cosmic analogies. One of these punishments is that of the tumbril: who-
ever is, as a criminal, carted about the streets of a city loses his honor and
all legal rights; the "cart" is a moving prison, the "carted man" (*rathita*,
MU iv.4) a prisoner. That is why, in Chrétien's *Lancelot*, the Chevalier
de la Charette shrinks from and delays to step into the cart, although it
is to take him on the way to the fulfilment of his quest. In other words,
the Solar Hero shrinks from his task, which is that of the liberation of

[3] For a summary account of the "thread-spirit" (*sūtrātman*) doctrine and some of
its implications, see Coomaraswamy, "The Iconography of Dürer's 'Knoten' and
Leonardo's 'Concatenation,'" 1944.

the Psyche (Guénévere), who is imprisoned by a magician in a castle that lies beyond a river that can only be crossed by the "sword bridge." This bridge itself is another traditional symbol, by no means an invention of the storyteller, but the "Brig of Dread" and "razor-edged way" of Western folklore and Eastern scripture.[4] The "hesitation" corresponds to that of Agni to become the charioteer of the gods (RV x.51), the Buddha's well-known hesitation to set in motion the Wheel of the Law, and Christ's "may this cup be taken from me"; it is every man's hesitation, who will not take up his cross. And *that* is why Guénévere, even when Lancelot has crossed the sword bridge barefoot and has set her free, bitterly reproaches him for his short and seemingly trivial delay to mount the cart.

Such is the "understanding" of a traditional episode, which a knowing author has retold, not primarily to amuse but originally to instruct; the telling of stories only to amuse belongs to later ages in which the life of pleasure is preferred to that of activity or contemplation. In the same way, every genuine folk and fairy tale can be "understood," for the references are always metaphysical; the type of "The Two Magicians," for example, is a creation myth (cf. BU 1.4.4, "she became a cow, he became a bull," etc.); John Barleycorn is the "dying god"; Snow-white's apple is "the fruit of the tree"; it is only with seven-league boots that one can traverse the seven worlds (like Agni and the Buddha); it is Psyche that the Hero rescues from the Dragon, and so forth. Later on, all these motifs fall into the hands of the writers of "romances," littérateurs, and in the end historians, and are no longer understood. That these formulae have been employed in the same way all over the world in the telling of what are really only variants and fragments of the one Urmythos of humanity implies the presence in certain kinds of literature of imaginative (iconographic) values far exceeding those of the belle-lettrist's fantasies, or the kinds of literature that are based on "observation"; if only because the myth is always true (or else is no true myth), while the "facts" are only true eventfully.[5]

[4] See D. L. Coomaraswamy, "The Perilous Bridge of Welfare," HJAS, VIII (1944).

[5] On the understanding of myths, cf. Coomaraswamy, "Sir Gawain and the Green Knight: Indra and Namuci," 1944. See also Edgar Dacqué, *Das verlorene Paradies* (Munich, 1938), arguing that myths represent the deepest knowledge that man has; and Murray Fowler, s.v. "Myth," in the *Dictionary of World Literature* (New York, 1943).

"Plato . . . follows the light of reason in myth and figure when the dialectic stumbles" (W. M. Urban, *The Intelligible World*, New York, 1929, p. 171).

We have pointed out that words have meaning simultaneously on more than one level of reference. All interpretation of scripture (in Europe notably from Philo to St. Thomas Aquinas) has rested upon this assumption: our mistake in the study of literature is to have overlooked that far more of this literature and these *contes* are really scriptural, and can only be criticized as such, than we supposed; an oversight that implies what is really an incorrect stylistic diagnosis. The twofold significance of words, literal and spiritual, can be cited in the word "Jerusalem" as used by Blake, above: "Jerusalem" being (1) an actual city in Palestine and (2) in its spiritual sense, Jerusalem the "golden," a heavenly city of the "imagination." And in this connection, too, as in the case of the "golden" thread, it must be remembered that the traditional language is precise: "gold" is not merely the element *Au* but the recognized symbol of light, life, immortality, and truth.

Many of the terms of traditional thinking survive as clichés in our everyday speech and contemporary literature, where, like other "superstitions," they have no longer any real meaning for us. Thus we speak of a "brilliant saying" or "shining wit," without awareness that such phrases rest upon an original conception of the coincidence of light and sound, and of an "intellectual light" that shines in all adequate imagery; we can hardly grasp what St. Bonaventura meant by "the light of a mechanical art." We ignore what is still the "dictionary meaning" of the word "inspired," and say "inspired by" when we mean "stimulated by" some concrete object. We use the one word "beam" in its two senses of "ray" and "timber" without realizing that these are related senses, coincident in the expression *rubus igneus*, and that we are here "on the track of" (this itself is another expression which, like "hitting the mark," is of prehistoric antiquity) an original conception of the immanence of Fire in the "wood" of which the world is made. We say that "a little bird told me" not reflecting that the "language of birds" is a reference to "angelic communications." We say "self-possessed" and speak of "self-government,"

"Myth . . . is an essential element of Plato's philosophical style; and his philosophy cannot be understood apart from it" (John A. Stewart, *The Myths of Plato*, New York, 1905, p. 3). "Behind the myth are concealed the greatest realities, the original phenomena of the spiritual life. . . . It is high time that we stopped identifying myth with invention" (N. Berdyaev, *Freedom and the Spirit*, London, 1935, p. 70). "Men live by myths . . . they are no mere poetic invention" (F. Marti in *Review of Religion*, VII, 1942). It is unfortunate that nowadays we employ the word "myth" almost exclusively in the pejorative sense, which should properly be reserved for such pseudo-myths as those of "race."

without realizing that (as was long ago pointed out by Plato) all such expressions imply that "there are two in us" and that in such cases the question still arises, which self shall be possessed or governed by which, the better by the worse, or vice versa. In order to comprehend the older literatures we must not overlook the precision with which all such expressions are employed; or, if we write ourselves, may learn to do so more clearly (again we find ourselves confronted by the coincidence of "light" with "meaning"—to "argue" being etymologically to "clarify") and intelligibly.

It is sometimes objected that the attribution of abstract meanings is only a later and subjective reading of meanings into symbols that were originally employed either only for purposes of factual communication or only for decorative and aesthetic reasons. Those who take up such a position may first of all be asked to prove that the "primitives," from whom we inherit so many of the forms of our highest thought (the symbolism of the Eucharist, for example, being cannibalistic), were really interested only in factual meanings or ever influenced only by aesthetic considerations. The anthropologists tell us otherwise, that in their lives "needs of the soul and body were satisfied together." They may be asked to consider such surviving cultures as that of the Amerindians, whose myths and art are certainly far more abstract than any form of story telling or painting of modern Europeans. They may be asked, Why was "primitive" or "geometric" art formally abstract, if not because it was required to express an abstract sense? They may be asked, Why, if not because it is speaking of something other than mere facts, is the scriptural style always (as Clement of Alexandria remarks) "parabolic"?

We agree, indeed, that nothing can be more dangerous than a subjective interpretation of the traditional symbols, whether verbal or visual. But it is no more suggested that the interpretation of symbols should be left to guesswork than that we should try to read Minoan script by guesswork. The study of the traditional language of symbols is not an easy discipline, primarily because we are no longer familiar with, or even interested in, the metaphysical content they are used to express; again, because the symbolic phrases, like individual words, can have more than one meaning, according to the context in which they are employed, though this does not imply that they can be given any meaning at random or arbitrarily. Negative symbols in particular bear contrasted values, one "bad," the other "good"; "nonbeing," for example, may represent the state of privation of that which has not yet attained to being, or, on the

other hand, the freedom from limiting affirmations of that which transcends being. Whoever wishes to understand the real meaning of these figures of thought that are not merely figures of speech must have studied the very extensive literatures of many countries in which the meanings of symbols are explained, and must himself have learned to think in these terms. Only when it is found that a given symbol—for instance, the number "seven" (seas, heavens, worlds, motions, gifts, rays, breaths, etc.), or the notions "dust," "husk," "knot," "eye," "mirror," "bridge," ship," "rope," "needle," "ladder," etc.—has a generically consistent series of values in a series of intelligible contexts widely distributed in time and space, can one safely "read" its meaning elsewhere, and recognize the stratification of literary sequences by means of the figures used in them. It is in this universal, and universally intelligible, language that the highest truths have been expressed.[6] But apart from this interest, alien to a majority of modern writers and critics, without this kind of knowledge, the historian and critic of literature and literary styles can only by guesswork distinguish between what, in a given author's work, is individual, and what is inherited and universal.

[6] "The metaphysical language of the Great Tradition is the only language that is really intelligible" (Urban, *The Intelligible World*, p. 471). [Jacob Boehme, *Signatura rerum*, Preface: "a parabolical or magical phrase or dialect is the best and plainest habit or dress that mysteries can have to travel in up and down this wicked world."]

The Rape of a Nāgī:
An Indian Gupta Seal

The Museum has recently acquired an Indian clay sealing of considerable interest (Figure 7). Impressions of seals bearing personal names (*nāma-mudrā*) were used in India either as tokens by which the bearer could be identified, or were affixed to letters or parcels; in the former case the sealing was fired, in the latter allowed to harden naturally, or only heated so far as this could be done without injuring the sealed package. The present example is of the latter type, and clearly shows at the back grooves corresponding to the overlapping strings with which the letter or parcel had been tied. The sealing has in its right field an inscription of four letters in northern Gupta characters of about the fifth century A.D., and in the left field an unrecognizable symbol superficially suggesting a perched bird. The inscription ends with the letter *s,* forming the genitive case of the owner's name, which I read with some hesitation as *Jambhara.*

The principal interest of the seal, however, is provided by the device of an eagle carrying off a woman, which occupies the central field; or to speak more precisely, that of a Suparṇa or Garuḍa carrying off a Nāgī, or again in other words, of the rape or rapture by the Sunbird of a feminine serpent in human form. In purely Indian representations of this motif the Garuḍa is usually represented as bearing off an actual serpent held in its beak (Figure 8); and the motif illustrates what may be termed the fundamental opposition of Sun and Serpent, according to which the serpents are represented as the natural prey of the solar eagle. On the other hand, the present example exactly reproduces the iconographic peculiarities of several sculptured representations that occur in the Greco-Buddhist art of Gandhāra.[1] Here the type at first sight suggests that of the well-known Greek formula of the Rape of Ganymede,

[First published in the *Bulletin of the Museum of Fine Arts* (Boston), XXXV (1937).—ED.]

[1] See A. Foucher, *L'Art gréco-bouddhique de Gandhāra*, II (Paris, 1918), 32–40.

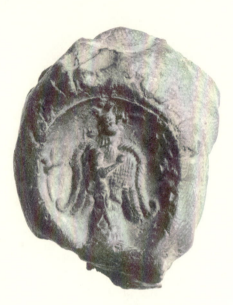

Figure 7. Eagle Carrying Youth

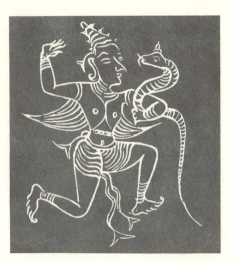

Figure 9. Garuḍa and Nāga

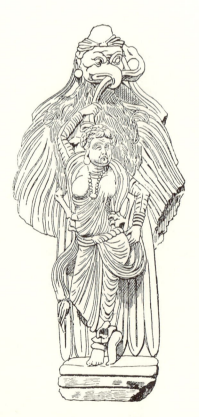

Figure 8. Rape of a Nāgī

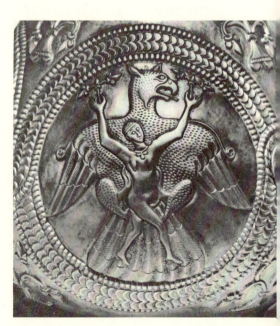

Figure 10. Garuḍa and Nāgī

as represented, for example, by Leochares (ca. 350 B.C.); and in fact a distant relationship, not necessarily one of derivation, is far from impossible, although in this Indian type the iconography is specifically and minutely Indian, and has a strictly Indian mythological reference.

The iconography may be better understood by reference to the accompanying cut representing a sculptured treatment of the same subject from Sanghao (Figure 9). In our example the royal eagle is crowned instead of turbaned, but otherwise similar, except that the claws that grasp the woman's waist can hardly be distinguished. The woman's pose is slightly different, her left arm being raised to grasp the eagle's breast, her right arm resting on her waist; except for a girdle (*mekhala*) she is apparently nude. An important feature in the sealing, which could easily be overlooked at first sight, is the line that extends from the woman's head to the Garuḍa's beak, beyond which it expands into some rather shapeless elevations: this is in fact precisely the serpentine element in the character of the Nāgī. Whenever a Nāga or Nāgī is represented in human form, the ophidian nature is always indicated in just this way, by the form of a serpent which rises from the spine and appears above the head and shoulders of the human form;[2] and it is this serpentine element that the eagle holds in his beak, while he embraces the human form in his claws. It would not be too much to say that it is really the serpentine, and not the human form of the Nāgī that the eagle is rending; and this is supported by the fact that the Nāgī herself, in her human aspect, seems rather to cling to than to shrink from her raptor, who supports her in his grasp. In these respects the motif presents a certain and by no means altogether accidental resemblance to that of certain modern and very sentimental Christian representations of the "soul's ascent," in which the "soul" is represented by a feminine figure borne aloft by a winged angel.

Another striking example (Figure 10) of our motif occurs in one of the four medallions of the famous golden treasure of Nagyszentmiklós, now in the Kunsthistorisches Museum, Vienna, in which, as justly remarked by Zoltán de Takács, who assumes an Indian derivation, "Nous retrouvons le Garuḍa . . . où il est figuré enlevant une Nāgī dans ses serres."[3] In this example it may be observed that on the one hand the ophidian quality of the Nāgī is not in any way indicated, and on the other that the expression of the human form is manifestly ecstatic.

[2] See, for example, *Bulletin of the Museum of Fine Arts* (April 1929), p. 21, three lower figures to right.

[3] "L'Art des grandes migrations," *Revue des arts asiatiques*, VII, 35, and Pl. xv, fig. 15.

In order to understand the actual content and raison d'être of the iconography it will be needful as usual to go back to much older and pre-Buddhist literary sources, in which the antithesis of the winged (angelic) and ophidian (titanic) powers of light and powers of darkness is developed at length. We shall find that in the same sense that we speak of the "old man" or the "cloven hoof," so in the older Indian ontology whatever is evil is represented by the "snake skin" or other reptilian integument; and that the procession of any individual principle, whether that of a human or divine "person," is thought of as a "casting of the snake-skin," from which the purified being emerges, "just as a blade of grass is pulled from its sheath." A familiar equivalent of this transformation in European folklore (which here, as invariably, represents something much more than merely the "lore of the folk") may be cited in the case of the mermaid (equivalent of the Indian Nāgī, sometimes represented accordingly)[4] who exchanges her scaly tail for human feet and acquires a "soul" when she emerges from the waters onto the dry land and weds a mortal.

The primordial serpent or dragon—really the Godhead, as distinguished from the proceeding God—is described as "omniform," or "protean," in accordance with the exemplarist doctrine of the first principle as being of a single form that is the form of very different things. There is accordingly something more than a simple opposition of the solar-angelic and lunar-titanic powers of light and darkness. Beyond the concept of an alternate procession and recession, beyond the contrast of exterior and interior operations, there lies the "Supreme Identity" (*tad ekam*) of both divine natures, of mortal Love and deathless Death, of Mitrāvaruṇau, *apara* and *para brahman*; as well-known texts express it, "I and my Father *are* one," "the Serpents *are* the Suns"; "now Soma *was* Vṛtra"; Agni *is* outwardly the household altar Fire, and inwardly the Chthonic Serpent. Because of the temporal form of our understanding, we think and speak of the one as proceeding *from* the other, and of an eventful division of "the light *from* the darkness" (Genesis), or of Heaven *from* Earth (Vedas, *passim*); and thus regarding the Supernal Sun, Eternal Avatār, or Messiah, as having most effectively cast off all adherent potentiality and as wholly in act, it is inferred by analogy that it lies within the competence of every separated creature to effect in the same way a riddance of evil, "just as the serpent sheds its skin."[5]

[4] See, for example, Coomaraswamy, *Rajput Painting*, 1916, Pl. LIII.

[5] [Cf. *śyena*, etc. as psychopomp in TS III.2.I.]

We are now in a position to consider what may be called *the* type of the separated creature or private principle, individually proceeding from potentiality to act, darkness to light. The act of "creation," as we have seen, implies a separation of Nature from Essence. Nature or Earth, thus "receding from likeness to God"[6] is then, as it were, "fallen" into a state of passive potentiality (*prakṛti, kṛtyā*),[7] complementary to the formative actuality of the solar Creator (*kartṛ*);[8] or in the technical terms of the symbolism explained above, Mother Nature or Mother Earth, although the destined bride of the Sun, as merely bride-elect is literally "in the coils of" evil, and clothed in the filthy reptilian integument of nonentity,[9] whence her designation as Sasarparī, nowadays represented in the serpentine form of the goddess Manasā Devī.[10] The purification of the Bride of the Sun is described in RV x.85.28 f., where she is divested of "adherent potentiality" and robed in other and "sunny" garments, becoming literally "the woman clothed with the sun" (*śukravāsaḥ*, RV I.113.7); and more explicitly in RV VIII.91 and related Brāhmaṇa texts, where Apālā (the "Unwed"),[11] being thrice drawn through the hub of the solar wheel, or in other words, by means of three successive "deaths" and "births," is stripped of her reptilian aspects, and acquiring thus a "sun-skin," becomes the fitting bride of the solar Indra. The in-

[6] In this phrase from St. Thomas Aquinas, "from likeness" is said with reference to the identity of nature and essence *in divinis*, which is replaced by their separation *ab extra*.

[7] *Prakṛti*, p.p.f. of *prakṛ*, to do, make, or form, also to marry; *kṛtyā* fut.pass.p. (gerundive) of *kṛ*, with the same meanings. Contrasted with these expressions we find in the Upaniṣads *kṛtakṛtyaḥ*, "One who has done what was to be done," i.e., "One who is all in act," descriptive of a perfect being, in whom all potentiality has been reduced to act.

[8] Creation involving the differentiation of the "Three Worlds," *sāttvik, rājasik*, and *tāmasik*; as in Dante, *Paradiso* XXIX. 32 ff., "cima nel mondo in che puro atto fu produtto; pura potenza tenne la parte ima; nel mezzo strinse potenza con atto tal vime," etc.

[9] *Ens et bonum convertuntur*, and vice versa. Cf. BU 1.3.28, "Lead us from nonentity to being, darkness to light."

[10] For these identifications and the following matter, see Coomaraswamy, "The Darker Side of Dawn," 1935.

[11] Apālā, described as "hating her husband" (*patidviṣaḥ*, RV VIII.91.4), and being in fact identical with Sūrya, previously wedded to Soma, is in effect the woman to whom Christ says, "Thou hast well said 'I have no husband'; for thou hast had five husbands; and he whom thou now hast is not thy husband: in that saidst thou truly" (John 4:17-18, cf. Eckhart's commentary, Evans ed., I, 405). With the strong expression "hating her husband" cf. Luke 14:26, "If any man come unto me, and hate not his father, and mother, and wife, and children, and sisters, yea, and his own life also, he cannot be my disciple."

335

evitable coincidence of a regeneration unto light with a death unto darkness (i.e., a death to all selfhood, a rejection of all private essence) is very clearly brought out in RV x.189.2, where it is said of Sasarparī, Mother Earth, and Dawn, united to the risen Sun, that "with his spiration, she expires" (*asya prāṇad apānatī*), cf. Eckhart, Evans ed., I, 292, "The soul, in hot pursuit of God, becomes absorbed in Him, just as the sun will swallow up and put out the dawn";[12] and in the same sense numerous Vedic texts describe the solar Indra as both the destroyer and the bridegroom of the Dawn. It may be called a law of metaphysics that a divinely inflicted "death" is also an "assumption."[13]

We see, then, in what sense a death at the hands of God is also a felicity and consummation most to be desired. If the Eagle, *noster Deus consumens*, really "devours" the Nāgī ("ne l'enlève que pour la manger," as Foucher expresses it, *L'Art gréco-bouddhique*, p. 37), this is not merely a consumption, but also an assimilation and incorporation; if the act of solar violence is a rape, it is also a "rapture" and a "transport" in both possible senses of both words. And inasmuch as it is Mother Earth, the Vedic "Eve" (who was also beguiled by the serpent) that is the type of whoever becomes a bride of the Sun (we need hardly say that in Hinduism and Christianity alike, "all creation is feminine to God"), it may be added (1) that Cunningham, quoted by Foucher (who does not supply a reference) was by no means altogether wrong in identifying the Nāgī with Māyā Devī, the Mother of Buddha, and (2) that our Nāgī by the same token answers to the Virgin, both as the Theotokos whose Dormition (death) and Assumption are followed by her Coronation as the Queen of Heaven (the Magna Mater), and to the Virgin as the type of the Church (Ecclesia), the betrothed (*electa mea*) of the Sun of Men and Light of the World,[14] whom Christ "having loved in her baseness

[12] Cf. Song of Songs 1:6, "black but comely," and conversely Dante, *Paradiso* XXVII.136, "So blackeneth the skin, white at the first aspect, of his fair daughter, who (the Sun) bringeth morn and leaveth evening,"—these oppositions of contrary qualities corresponding to the contrary characteristics of the Vedic sister Dawns—black Night and radiant Morn—who are at once the mothers of the twy-born Fire and brides of the Sun, himself the risen Fire. For the detailed references see "The Darker Side of Dawn," 1935, and "Two Passages in Dante's *Paradiso*" [in Vol. 2 of this selection—ED.]. [Cf.. John of Ruysbroeck, *The Adornment of the Spiritual Marriage*, trans. C. A. Wynschenk (London, 1916), Prologue, p. 4: "He was married to this bride, our nature, . . . the glorious Virgin."]

[13] [Cf. St. John of the Cross, *Llama de amor viva*, "And, slaying, dost from death to life translate."]

[14] The expressions "Sun of men" and "Light of lights" are common to the Christian and Sanskrit scriptures. Song of Songs 6:10, "Who is she that riseth as

and all her foulness, will present as his Bride, glorious with his own glory, without spot or wrinkle," in the words of St. Bernard. Further equivalents and parallels could be developed at great length.

THE analysis and explanation of the iconography of our sealing raises a problem familiar enough in aesthetic discussions, although often neglected because of the aesthetician's preoccupation with stylistic rather than iconographic interpretation. We conceive, on the contrary, that the most significant element in a given work is precisely that aspect of it that may and often does persist throughout millennia, and the least significant, those accidental variations of style by which we are enabled to date a given work, or even in some cases to attribute it to a given artist. No explanation of a work of art can be called complete which does not account for its actual composition, which we may call its "constant," as distinguished from its "variable." In other words, no art history can be called complete which merely considers the decorative usage of a given motif, and ignores the *raisons d'être* of the elements of which it is built up and the logic of the relationship of its parts. It is begging the question to attribute the precise and minute particulars of a traditional iconography merely to the operation of an "aesthetic instinct"; we have still to explain why the formal cause has been imagined as it was, and for this we cannot supply the answer until we have understood the final cause in response to which the formal image arose in a given mentality.

The expert iconographer and symbolist has often been accused of "read-

the morning" (*quasi aurora* = Skr. *uṣar iva*), has been read as applying to the Assumption of the Virgin. There is a representation (Museum of Fine Arts, photo 36561) of the risen Virgin as the Bride of Christ in S. Maria in Trastevere (Rome), where the Virgin is seated with the Son on one and the same throne, "altogether as his equal . . . and embraced, not crowned, by him" (A. Jameson, *Legends of the Madonna*, London, 1902, pp. 15–16); Christ holding the text *Veni, electa mea, et ponam te in thronum meum*, and the Virgin the text (Song of Songs 2:6) *Leva ejus sub capite meo, et dextera illius amplesabitur me*. [*Amplesabitur me*: cf. *strīpumānsau samparisvaktau* in BU 1.4.3, *samparisvaktaḥ* in BU iv.3.21, *dyāvāpṛthivī samslisyataḥ* in JUB 1.5.5, *Apālā samśliṣṭikā* in ŚB, quoted by Sāyaṇa on RV viii.91; Dante, *Convito* iii.12, "She [Sophia] exists in Him in true and perfect fashion, as if eternally wedded to Him"; Eckhart, Evans ed., I, 371, "In this embrace is consummated . . . beatitude," and many similar texts.

The earlier Christian nativities clearly show the Virgin as the Earth, and it is with perfect accuracy that Wolfram (*Parzival* ix.549 ff.) says that "the Earth was Adam's mother . . . yet still was the Earth a maid. . . . Two men have been born of maidens, and God hath the likeness ta'en of the son of the first Earth-Maiden . . . since He willed to be Son of Adam."]

ing meanings into" given emblems. It would be truer to say that the pure aesthetician and anthropologist "read meanings out of" them and thus denature them. It is perfectly true that at any given moment any given patron or artist or both may in fact be unaware of the significant content of a motif, which is then for one or both no longer the visible formula of a traditionally transmitted doctrine, but merely an art form; and perfectly true that in the course of the "history of art" innumerable symbols have thus been secularized.[15] For the sake of argument we shall assume (what is not by any means necessarily true) that the Gupta artist and patron had no understanding of the intrinsic significance of the motif employed on our seal as a personal device, but only recognized its decorative values. We have still to enquire how the particular symbol, which the Gupta artist *inherited*, actually originated.

We have proved by repeated analyses that what may be called "prescriptions" for, and are in fact explanations of, the later iconography can be found in the antecedent literature belonging to the same tradition, or often also, as has been shown above, in other analogous literatures farther removed in space or time. It must be understood that, as Mâle remarked in the case of Christian art, symbolism is a calculus; we may say that the semantics of visual symbols is at least as much an exact science as the semantics of verbal symbols, or words. And admitting the possibility and the actual frequency of a degeneration from a significant to a merely decorative and ornamental use of symbols, we must point out that simply to state the problem in these terms is to confirm the dictum of a great Assyriologist, that "when we sound the archetype, the ultimate origin of the form, then we find that it is anchored in the highest, not the lowest."[16]

[15] The question of how far an author has "understood his material" can always arise. In many cases, however, the supposedly "secular" character of a given "ornament" is the product of a modern rather than a contemporary ignorance. The technicalities, for example, of such authors as Homer, Dante, or Wolfram are sometimes thought of as "literary ornaments," to be accredited to an individual "poetic imagination," laudable or otherwise in the measure of their "appeal." From the point of view of an older and more learned aesthetic, however, "Beauty has to do with cognition," that of these ornaments depending directly upon their truth (in the same sense that a mathematician speaks of an equation as "elegant"); their "appeal" being not to the senses, but through the senses to the intellect.

However unintelligently a symbol may have been used, it can never, so long as it remains recognizable, be called unintelligible; intelligibility is essential in the symbol, by definition, while intelligence in the observer is accidental.

[16] W. Andrae, *Die ionische Säule*, p. 65 [see Coomaraswamy's review of his work in the next essay—ED.]. Cf. Luc Benoist, *La Cuisine des Anges* (Paris, 1932), pp. 74–75, "L'intérêt profond de toutes les traditions dites populaires réside sur-

Our own infatuation with the idea of "progress" and conception of ourselves as civilized and of former ages or other cultures as barbarous has made it exceedingly difficult for the historian of art—despite his recognition of the fact that all "art cycles" are in fact descents from the levels attained by the "primitives"—to accept the proposition that an "art form" is already a defunct and derelict form, and strictly speaking a "superstition," i.e., literally a stand-over from a more "primitive" humanity than ours; it is, in other words, exceedingly difficult for him to accept the proposition that an "art form" or "decorative motif" is the vestige of a more abstract and more trenchant mentality than our own, a mentality that used less means to mean more, and that made use of symbols primarily for their intellectual values, and not as we do, sentimentally.[17]

Archaeologists are nowadays beginning to recognize the truth of what has been indicated above. Strzygowski, for example, discussing the conservation of ancient motifs in Chinese peasant embroidery, endorses the dictum that "the thought of many so-called primitive peoples is far more spiritualized than that of many so-called civilized peoples," adding that "in any case it is clear that in matters of religion we shall have to drop the distinction between primitive and civilized peoples."[18] The art historian is being left behind by the archaeologist, who is nowadays in a fair way to offer a far more complete explanation of the work of art than the aesthetician, who, far more than the archaeologist, judges all things by his own standards. If a given form has a "merely decorative" value for ourselves, it is far easier, and more comfortable, to assume that its value must always have been of this sensitive kind than it is to admit our ignorance of its original necessity or to undertake the *self-denying* task of entering into and consenting to the mentality in which the form was first conceived.

The aesthetician will object that we are ignoring both the question of

tout dans le fait qu'elles ne sont pas populaires d'origine. . . . Aristote y voyait avec raison les restes de l'ancienne philosophie. Il faudrait dire les formes anciennes de l'éternelle philosophie."

[17] In the literal meaning of their etymology, "sentimental" and "aesthetic" are identical, and both equivalent to "materialistic"; aesthetic being feeling, sense the means of feeling, and matter what is felt. To speak of aesthetic experience as "disinterested" properly involves an antinomy: it is rather a noetic or cognitive experience that can be disinterested. Cf. A. Gleizes, *La Forme et l'histoire* (Paris, 1932), p. 62.

[18] J. Strzygowski, *Spüren indogermanischen Glaubens in der bildenden Kunst* (Heidelberg, 1936), p. 344.

artistic quality and that of the distinction of a noble from a decadent style. By no means. We merely take it for granted that every serious student is equipped by temperament and training to distinguish good from bad workmanship. And if there are noble and decadent periods of art, despite the fact that workmanship may be as skilful or even more skilful in the decadent than in the noble period, we say that the decadence is by no means the fault of the artist as such, the maker by art, but of the man who in the decadent period has so much more to say and means so much less. More to say and less to mean—this is a matter, not of formal, but of final causes, implying defect not in the artist, but in the patron. We say then that the art historian, whose standards of explanation are altogether too facile and too merely psychological, need feel no qualms about the "reading of meanings into" given formulae. When meanings, which are also *raisons d'être*, have been forgotten, it is indispensable that those who can remember them, and can demonstrate by reference to chapter and verse the validity of their "memory," should reread meanings into forms from which the meaning has been ignorantly read out. For in no other way can the art historian be said to have fulfilled his task of fully accounting for and explaining the form which he has not invented himself and only knows of as an inherited "superstition." It is not as such that the reading of meanings into works of art can be criticized, but only as regards the precision with which the work is done; the scholar being always, of course, subject to the possibility of a subsequent self-correction or of correction by his peers, in matters of detail. For the rest, with such "aesthetic" mentalities as ours, we are in little danger of proposing over-intellectual interpretations of ancient works of art.

Walter Andrae's

Die ionische Säule: Bauform oder Symbol?:

A Review

Indications of a new orientation in archaeological research have appeared in recent years in widely separated fields of investigation. In connection with the *Ṛg Veda*, for example, it has been realized that nearly all that can be expected from a purely philological or anthropological analysis has already been accomplished, and yet that we are still very far from understanding what the Vedas *are*. Again, in the picture-puzzle game (the history of art in terms of personal style and attribution) it is beginning to be realized that something like an end is in sight, that it may not be long before we may be in a position to label all our museum specimens with as much accuracy as is attainable, and yet that when all is said and done, very little progress has been made towards the humane end of assisting the student to relive for himself the intuitions expressed in ancient art. The study of mediaeval art is still almost entirely a problem of unraveling "influences"; nevertheless, it has occurred to a few minds that it might be enlightening to inquire what values were actually attached to the art by those by and for whom it was made. And as regards contemporary art, it has been recognized again and again that its private character and the indifference of its subject matter have so effectually separated the art from real living, the artist from the man, that we hardly nowadays expect to meet with the workman who is both an artist *and* a man.[1] Because of its fundamental unreality, the study of art has begun to be a bore.

[This review was first published in the *Art Bulletin*, XVII (1935). Coomaraswamy's translation of the conclusion of Andrae's study was later published as the final chapter of *Figures of Thought or Figures of Speech*; he often quoted it in writings after 1935. The Andrae volume appeared in Berlin, 1933.—ED.]

[1] Cf. Otto Rank, *Art and Artist* (New York, 1932), p. 428, "Since Renaissance days, there can be no doubt that the great works of art were bought at the cost

Here and there within the last few years a disconcerting wind has stirred the dry bones, to the alarm of orthodox scholarship, which fears nothing so much as a stirring up of life amongst the relics that have been so neatly catalogued and put away in our archaeological mortuaries. It has begun to be realized that whatever may be the case with contemporary art, art in the world by and large has been thought of not as a spectacle for tired businessmen, but as a language for the communication of ideas; and that the shape and color of an icon, the relationships of masses in a biting aphorism, the how of what has been said, have depended not on vague and indefinable "aesthetic urges," but directly upon what was to be said. This was the mediaeval point of view, which judged the "truth" of a work of art solely according to the degree of correspondence between the work itself and its essential form as it existed in the mirror of the artist's intellect. Over against our demand for novelty stands again the mediaeval point of view, which asserts that the notion of a property in ideas represents a contradiction in terms; and we ourselves have begun to see that while there cannot be and never has been a private property in ideas, it is only when the individual has fully possessed an idea that he can express it well and truly, that "to be properly expressed, a thing must proceed from within, moved by its form," and that, as follows, we cannot judge of any work unless we too possess its form and *raison d'être*. And although amongst us today, it is no longer true that the "play's the thing," but rather the "star," so that we buy names rather than pictures, we are forced to admit that the farther we go back towards the "primitives" (whom we affect to admire the most), the less significance can be attached to the "name," if names, indeed, can be found at all. We suspect that our proposal to study the *Divina commedia* as "literature," notwithstanding that the author (who should know best) so plainly asserted the purely practical purpose of his work, may be a little ridiculous.

In other words, it has begun to be realized that problems of composition and color cannot be understood if we abstract them from their determining reasons, viz. the meanings or content to be expressed. To study the forms of art in and for themselves alone, and not in connection with the determining ends in relation to which they functioned as means, is simply to indulge in a parlor game of arranging mental

of ordinary living. Whatever our attitude toward this fact and interpretation of this fact, it is at least certain that the modern individualist must give up this kind of artistic creation if he is to live as vigorously as is apparently necessary."

bric-a-brac. The "history of design," for example, remains an absolutely sterile exercise when abstracted from the intellectual life that can alone explain and account for the facts of design. If we are satisfied only with the facts, and our "reactions" to them, it is because we have come to think of art solely in terms of upholstery ("decoration"); but it is, to say the least, a naïve and unscientific procedure to carry over any such bias into a discipline that deals with the arts of other and less sentimental ages than our own. If anyone doubts the sentimentality of our modern approach to works of art, it will suffice to cite the recent dictum of a professor of the history of art in the University of Chicago, "It is inevitable that the artist should be unintelligible because his sensitive nature, inspired by fascination, bewilderment, and excitement, expresses itself in the profound and intuitive terms of ineffable wonder."[2] The mediaeval or Asiatic patron of art would have regarded the workman who thus "babbled of green fields" as a simple idiot.

The new tendency of which we spoke above finds a clear and definite expression in Andrae's work, which treats of the Ionic capital and the development of the volute form. Much of the book is occupied with a strictly archaeological investigation of the prototypes, the Western Asiatic origin of which, before the motif is adopted into Greek art as an "architectural form," is definitely established.[3] The whole *life* of the motif belongs to this prehistory, the form itself as it occurs in Greek art being, however elegant, already dead; and as it occurs in modern pseudo-Greek, viz. in contemporary public building, not merely dead but actually offensive. We ourselves have often shown that the same applies to classical "egg and dart," which is really a lotus petal form (standing for the

[2] E. F. Rothschild, *The Meaning of Unintelligibility in Modern Art* (Chicago, 1934), p. 98.

[3] It is now realized that the origins of Greek science, the heroic age of which was up to the middle of the fifth century B.C., are likewise of Western Asiatic origin; see Abel Ray, *La Jeunesse de la science grecque* (Paris, 1933), and review by George Sarton in *Isis*. The Western Asiatic sources of Greek mythology are also becoming more and more apparent; Henri Frankfort, for example, regarding the oriental origins of Heracles as beyond possibility of doubt (*Iraq Excavations of the Oriental Institute, 1932/33*, Chicago, 1934, p. 55); cf. Clark Hopkins, "Assyrian Elements in the Perseus-Gorgon Story," *American Journal of Archaeology*, XXXVIII (1934), 341–358. If the same is not admitted for philosophy (see T. Hopfner, *Orient und griechische Philosophie*, Leipzig, 1925) it is mainly because the nature of early Oriental "philosophy" has been misunderstood; a different conclusion may be expected when the problem is posed not with respect to *systematic philosophy* in the modern sense, but with reference to the beginnings of Greek *metaphysics*.

chthonic basis of existence, and retaining this significance in Indian art until the present day) which, entering into the Greek repertoire (probably by the same route as the Ionic capital itself) became there a mere ornament, and has survived as such in European architectural upholstery until now.

More specifically, Andrae traces the prehistory of the volute capital in its two parallel courses: on the one hand, in use as a constructive element in architecture, and on the other, in its hieroglyphic aspect. In architecture we meet first with a simple reed bundle, the top of which is soon bent over to form a spiral "head," and then to this there is added a "sheaf"; two such forms function as gate-posts, a joining up of the "sheaves" forming a lintel or architrave; a repetition of the form then establishing the use of the proto-Ionic column in colonnades, alike in Greek and Achaemenid art. Side by side with this development runs the use of the motif as a symbol in script and iconography; first of all, the paired uprights of the gateway are united so as to represent "a combination of the polar, viz. male and female, elements of human nature" (corresponding to the *principium conjunctivum* whence the generation and nativity of the Exemplar, *Sum. Theol.* 1.27.2c, and to the Indian *ardhanārī* concept in all its ramifications); then the volutes are doubled or trebled, and finally surmounted by a single terminal circle, four distinct levels of reference being thus represented; then this terminal circle breaks into a flower ("palmette") which opens below and towards the winged image of the Supernal Sun that is shown as poised in the zenith above it; and in this last form, it is clearly seen that the volute pillar and the Assyrian Tree of Life, with its symbols of Heaven above and Earth below, are cognate in form and coincident in reference. It is very certain that developments such as this are not to be explained away by the artist's "sensitive nature" or any blind "aesthetic urge," but rather that, as the Scholastic aesthetic expresses it, it is by the power of his intellect and will that the artist becomes the cause of the becoming of things made by art; the artist (whether individual or race) "operating by a word conceived in his intellect (*per verbum in intellectu conceptum*) and moved by the direction of his will towards the specific object to be made" (*Sum. Theol.* 1.45.6c).

Thus, as indicated in the preface, the intention of the book is not so much to assemble the facts (which is done with all requisite learning, as might be expected from so accomplished an archaeologist as Andrae, already well known for his work in the Assyrian field) as to find a clue

to their significance, without which they must remain no more than a collection of data, connected only by an observed time sequence, rather than by any inherent logic. It is in the conclusion that Andrae expounds more fully the requisite approach, and it is indeed remarkable with what insight he has there set forth the idea of the symbol as a living thing, having a power in itself that can survive no matter what vicissitudes; the notion is, indeed, familiar enough in metaphysical exegesis, but never before, so far as we know, has it been so uncompromisingly set down by a professional archaeologist. As case in point, we might take that of the Stem of Jesse, a motif already found and used intelligibly in the *Ṛg Veda*, and surviving in Indian ornament and iconography up till now, but first appearing in Christian art only in the eleventh century, where we need not necessarily assume an Indian origin, but may rather regard it as spontaneous; the fact being in such cases that the actual connections by which a motif may be transmitted across great intervals of time or space can never become the subject of historical demonstration, for the simple reason that the transmission is accomplished by oral and not by published means. Let us cite the author's thesis in his own words:

> Humanity . . . attempts to embody in a tangible or otherwise perceptible form, we may say to materialize, what is in itself intangible and imperceptible. It makes symbols, written characters, and cult images of earthly substance, and sees in and through them the spiritual and divine substance that has no likeness and could not otherwise be seen. It is only when one has acquired the habit of this way of looking at things that symbols and images can be understood; not when we are habituated to the narrower way which always brings us back to an investigation of the outward and formal aspects of symbols and images and makes us value them the more, the more complicated or fully evolved they are. This formalistic method leads always into a vacuum. Here we are dealing only with the end, not with the beginning, and what we find in this end is always something hard and opaque, which throws no further light on the path. And it is only by such a glimpse of the spiritual that the ultimate goal can be reached, whatever means or methods of research may be resorted to. When we sound the archetype, then we find that it is anchored in the highest, not the lowest.[4] This does not mean that

[4] Cf. René Guénon, "Du Prétendu 'Empirisme' des anciens," *Le Voile d'Isis*, CLXXV (1934).

we moderns must needs lose ourselves in irrelevant speculation, for everyone of us can experience microcosmically in his own life and body the fact that he has wandered from the highest and that the *longer* he learns to feel a hunger and thirst for symbol and likeness, the more *deeply* he feels it; that is, if he only retains the power to guard himself against the inner hardening and petrifaction, in which we all, alas, are in danger of being lost.

The formalistic method can indeed only be justified in proportion as we move away from the archetypes to the present day. The sensible forms, in which there was once a polar balance of physical and metaphysical, have been more and more emptied of content on their way down to us. So we say, this is an "ornament"; and as such it can indeed be treated and investigated in the formalistic manner. And this is what has constantly happened as regards all traditional ornament, not excepting the "ornament" so-called that is represented in the beautiful pattern of the Ionic capital. . . . He for whom this concept of the origin of ornament seems strange, should study for once the representations of the whole fourth and third millennia B.C. in Egypt and Mesopotamia, contrasting them with such "ornaments" as are properly so called in our modern sense. It will be found that scarcely even a single example can be given there. Whatever may seem to be such, is a drastically indispensable technical form, or it is an expressive form, the picture of a spiritual truth. Even the so-called ornament of the pottery painting and engraving that ranges back to the neolithic period in Mesopotamia and elsewhere is for the most part controlled by technical and symbolic necessity. . . .[5]

He who marvels that a formal symbol can remain alive, not only for millennia, but that, as we shall yet learn, that it can spring into life again after an interruption of thousands of years, should remind himself that the power from the spiritual world, which forms one part of the symbol, is eternal; [and that only] the other part is material, earthly, and impermanent. . . . It becomes then, an indifferent problem whether the ancients, in our case the early Ionians, were

[5] Cf. C. G. Jung, *Modern Man in Search of a Soul* (London, 1933), p. 189, "the so-called sun-wheel . . . as it dates from a time when no one had thought of wheels as a mechanical device . . . cannot have had its source in any experience of the external world. It is rather a symbol that stands for a psychic happening; it covers an experience of the inner world, and is no doubt as lifelike a representation as the famous rhinoceros with the tick-birds on its back."

aware of the whole content of the ancient symbol of humanity which the East had bestowed upon them, or whether or not they wanted to carry over only some part of that content into their formula. . . .

From that moment when the deep symbolic meaning of the Ionic column was forgotten, when it was changed into architecture and art, its truthfulness was at an end. . . . Was the Ionic column therefore dead, because its living meaning had been lost, because it was denied that it was the image of a spiritual truth? I think not. . . . Someday humanity, hungry for a concise and integral expression of itself, will again take hold of this inviolate and holy form, and therewith attain to those powers of which it is in need, to the biunity and its own superstructure, to the perfecting of the all-too-earthly in the freedom of the spiritual worlds. . . .

What is the significance for our day of all the investigations of the noble forms of antiquity and of all their identification in our museums, if not as guides, indispensable to life, on the road through ourselves and onward into the future? . . . Again the call is uttered to formative men in general and the creative artist in particular: maintain the transparency of the material, that it may be saturated with the spirit. He can obey this command only if he maintains his own transparency—and this is the rock on which most of us are apt to break. Each and every one reaches a point in his life when he begins to stiffen, and—either congeals in fact, or must by a superhuman effort recover for himself what he possessed undiminished in his childhood but has been more and more taken away from him in youth: so that the doors of the spiritual world may open to him, and the spirit find its way into body and soul.[6]

As we have spoken of a tendency in archaeology, we may be permitted to allude in conclusion to some other recent works in which the meaning or inner life of formal motifs has been studied as affording the effective clue to their "history." Mus, for example, in discussing the origin of the "Crowned Buddha" type, found it necessary to make an intensive study of Mahāyāna ontology, and in a magisterial treatment of the scheme of

[6] [At this point a discussion of A. Roes, *Greek Geometric Art, Its Symbolism and Its Origin* (Oxford, 1933), is deleted from our version of the text. AKC much appreciated that study, but his discussion of it is largely concerned with art-historical detail and adds little to the argument derived from Andrae.—ED.]

the Barabuḍur, to discuss at length the traditional metaphysic of space and the doctrine of the axis of the universe.[7] Carl Hentze, *Mythes et symboles lunaires* (Anvers, 1932), discusses the origins of script from a similar point of view, remarking with respect to the earliest symbols that "their meaning is always to be found in one and the same ambient of ideas, that of a cult, and that is the distant source of writing"; and when he proceeds to say "the sign may be regarded as a rendition of the idea 'to evoke the species and ensure its multiplication,'" this is of the greatest interest because of the analogy presented with the later, neo-Platonic and Scholastic, notion of the form, species, or idea as equally in nature and art the efficient cause of the becoming of the thing itself; the prehistoric symbol being in fact the picture, not immediately of the thing inferred, but rather of the idea of the thing which is its form or *raison d'être*. Or consider the *Tripiṭaka in Chinese, Picture Section*, ed. Takakusu and Ono (Tokyo, 1933); how little could we speak of a history of the art that is here so richly represented, in the sense of explanation (and is it not the function of history to "explain" events?), were not the reproductions "documented" by very lengthy extracts from the Shingon and other Buddhist texts that are their transcendent context. We ourselves have followed the same course in our *Elements of Buddhist Iconography*.

Those who, indeed, attempt to deal with the unsolved problems of archaeology by an analysis and exegesis of meanings and contexts may expect to be accused of "reading into" their material meanings that are not in it. They will reply that the archaeologist or philologist who is not also a metaphysician must inevitably, sooner or later, find himself before a blank wall, which he cannot penetrate; and as Ogden and Richards

[7] Cf. Paul Mus, "Le Buddha Paré: son origine indienne," BÉFEO XXVIII (1928), and "Barabuḍur, les origines du stūpa et la transmigration, essai d'archéologie religieuse comparée," BÉFEO XXXII (1932). Regarding the latter title, the author remarks in a footnote, "It goes without saying that the bearing of the present work is strictly archaeological. . . . Architecturally, the Barabuḍur is simple enough to be grasped at a first glance. . . . The whole difficulty, far from depending on subtle principles of construction, depends, on the contrary, upon the fact that there is no way of making use of these principles in interpretation. *The ordering of the parts is determined by abstract ideas* and has magical ends in view, and these, which are the essential theme of our investigation, are foreign to the actual technique of building. We ought rather to say that these ideas and ends are the context of (*contournent*) and surpass it (*l'eludent*), and this is no exaggeration, for the design remains unintelligible to whomever has not studied the Mahāyāna texts where the explanations of its peculiarities can be found." *L'eludent* in the foregoing passage corresponds exactly to *s'asconde* in Dante, *Inferno* IX.62, and *varjitam* in *Laṅkāvatāra Sūtra* II.118.

have so well expressed it, that "symbols cannot be studied apart from the references which they symbolize." A word of warning may be given here: the study of symbolism has been discredited, precisely because working from a profane point of view, the interpretation of symbols by guesswork has become a métier of the pseudoarchaeologist. Let us rather recognize that, as Mâle so well expressed it in connection with Christian art, symbolism is a *calculus*; the scholar in this field needs be rather a mathematician than an aesthete, nor can his equations be expounded without the most exact and far-reaching documentations, for which an acquaintance with the most widely diversified forms of the common symbolic tradition may be required.

If now archaeology has been regarded as a dry-as-dust science, and the museum as a mausoleum (and these are feelings widely diffused amongst the younger students of the history of art, the interest of which is often only kept alive by a substitution of the histories of artists for the history of art, or by masses of verbiage in which it is given them to understand that the appreciation of art must be rather a functional reaction than an intellectual act), what else could have been expected? What is required is an intellectual reanimation of our discipline, so that those academic courses on the history of art which are now closed systems of rhetoric may be informed with a human value and significance, and that the student may be given, over and above the mechanical tasks that are prerequisite to scholarship, but are not the last end of scholarship, a sense of living forces operating in the materials before him, and may realize that the true end of scholarship is not attained with information, but must be accomplished within himself, in a reintegration of himself in modes of rhythm. This was precisely the purpose of those ancient initiations and mysteries with which there originated all those symbolic forms of art which still survive in "design" and "ornament," but are no longer for us supports of contemplation and means of regeneration, but only the frills and furbelows of comfortable living.

349

TRADITIONAL SYMBOLISM:
FOUR STUDIES

On the Loathly Bride

*Nigra sum, sed formosa . . . nolite me considerare quod
fusca sum* Song of Songs 1:3

The episode of the Marriage of Sir Gawain, and more generally that of
the Loathly Lady Transformed, well known to all students of Arthurian
Romance, has often been discussed.[1] The correct interpretation is, no
doubt, the one that is given by R. S. Loomis,[2] who identifies her with the
Earth Goddess and therefore with the Sovereignty—the kingdom, the
power, and the glory which he who possesses the Earth enjoys—which,
in the Celtic sources is, of course, the Sovereignty of Ireland (Eriu).
Most of all is Loomis right in recognizing that the archetypal pattern is
the mythological theme of the marriage of the Sun god (Lug) with the
Earth (Eriu, Ire-land); and in the fine passage in which he puts forward
the metaphysical basis of Gawain's (and other solar heroes') multiple
marriages—his many loves being but "different manifestations, different
names for the same primeval divinity" who is also "Isis,[3] Europa, Arte-

[First published in *Speculum*, XX (1945).—ED.]

[1] E.g., G. L. Maynadier, *The Wife of Bath's Tale* (London, 1901; Grimm
Library XIII); Laura Sumner, *The Weddynge of Sir Gawen and Dame Ragnell*
(Northampton, Mass., 1924; Smith College Studies in Modern Languages, V, no.
4); Margaret Schlauch, "The Marital Dilemma in the 'Wife of Bath's Tale,'"
PMLA, XLI (1946), 416–430; G. B. Saul, *The Wedding of Sir Gawain and Dame
Ragnell* (New York, 1934); A.C.L. Brown, *The Origin of the Grail Legend* (Cam-
bridge, Mass., 1943; ch. 7, "The Hateful *Fée* Who Represents the Sovereignty");
J. W. Beach, "The Loathly Lady" (Ph.D. dissertation, Harvard, 1907).

[2] R. S. Loomis, *Celtic Myth and Arthurian Romance* (New York, 1927), esp.
pp. 221–222 and ch. 29.

[3] Who "is adored throughout the world in divers manners, in variable customs
and by many names" (Apuleius, *Golden Ass*, Bk. XI). Cf. A. Jeremias, *"Die eine
Madonna,"* Der Alte Orient, XXXII (1932), 12, 13; M. Durand-Lefebure, *Étude
sur l'origine des vierges noires* (Paris, 1937). The identity of the Virgin with the
Earth Goddess is asserted iconographically in the older Christian Nativities (e.g.,
at Palermo, and in many Russian icons), where the more familiar "ruined stable"
is represented by an opened mountain, or "grotto"; cf. B. Rowland, in *Bulletin
of the Fogg Art Museum*, VIII (1939), 63: "The original reason for the 'choice'

mis, Rhea, Demeter, Hecate, Persephone, Diana; one might go on indefinitely." Accordingly, "Gawain was no light of love, for in spite of his many marriages, it was the same goddess he loved." In almost the same words A. B. Cook justifies the many loves of Zeus—Dion of Prousa's "common Father and Saviour and Keeper of Mankind."[4] In the same connection there might have been cited Indra, Krishna—and Christ, for as the "Platonist and Puritan" Peter Sterry said, "the Lord Jesus hath his concubines, his Queenes, his Virgines; Saints . . . who kept themselves single for the immediate imbraces of their Love." The Solar Spirit, Divine Eros, Amor, is inevitably and necessarily "polygamous," both in himself and in all his descents, because all creation is feminine to God, and every soul is his destined bride.[5]

The tale of the Loathly Lady occurs in several Irish contexts, amongst which that of the Five Sons of Eochaidh related in the *Temair Breg* and *Echtra mac Echdach Mugmedóin* may be regarded as typical.[6] The

of the mountain cave—or rather the 'necessity' for it—lies dead and buried in the minds of the creators of the Christian legend who had the memories of the cosmological foundations of all the great religions of the Semitic world dating from Sumer behind them."

[4] Arthur Bernard Cook, *Zeus; A Study in Ancient Religion*, 3 vols. (Cambridge, 1914-1940), I, 779: "Zeus as sky-father is in essential relation to an earth-mother. Her name varies from place to place and from time to time . . . everywhere and always either patent or latent, the earth-mother is there as the necessary correlative and consort of the sky-father." For Dion, see *ibid.*, III, 961. [Cf. Hera, sister of Zeus, *Iliad*, XVIII.356.]

[5] For so long as men still understood the true nature of their myths, they were not shocked by their "immorality." The myths are never, in fact, immoral, but like every other form of theory (vision), amoral. In this respect also they must be distinguished from invented allegories; their pattern may be "imitated" ritually, where many things are done which might be, humanly speaking, improper. The content of the myths is intellectual, rather than moral; they must be understood— "Without such a consciousness it would have been evil and impious for later generations to invent such baseness about their highest god and the father of their ideal hero. The old nature myths are not inventions, however, but the articulated acknowledgment of events which were perceived and therefore not to be denied" (E. Siecke, *Drachenkämpfe*, Leipzig, 1907, p. 64). Just as the injunction to "hate" father and mother, brother and sister (Luke 14:26) was never meant to be a rule for the active life, so when King Parikṣit cannot understand Śrī Krishna's behavior Śrī Śukadeva says, "Listen, King! you do not understand the distinction, but are judging the Lord as though he were a man" (*Prema Sāgara*, ch. 34). Myths and fairy tales are not moral treatises, but supports of contemplation; and whoever deprecates the hero's "morals" has already misconceived the genre.

[6] For the stories referred to in this paragraph see A.C.L. Brown, *Origin of the Grail Legend*, ch. 7, and other references cited in n. 1; S. H. O'Grady, *Silva Gadelica* (Edinburgh, 1892), I, 327-330, and II, 369-373 and 489-548.

five brothers in turn go to a fountain to obtain a drink of its "water of virtues," but it is guarded by a most hideous hag who demands a kiss as the price of a drink.[7] Only the youngest brother, Niall, who like many another hero has been reared in exile, throws his arms about her "as if she were forever his wife"; thereupon she becomes a beautiful maiden and foretells Niall's rule in Tara. "As at first thou hast seen me ugly," she says, "but in the end beautiful, even so is royal rule. Without battles it may not be won, but in the end, to anyone, it is comely and handsome." Similarly, in the story of Lughaid Laighe, only he who dares and consents to sleep with the Loathly Lady is the destined king; asked who she is, she says that High Kings sleep with her, and that she *is* "the kingship of Alba and Eriu."

In just the same way the Indian goddess Śrī (-Lakṣmī) is "the personification of the right to rule . . . (the) Spirit of Sovereignty . . . and certainly so when the relationship is . . . a marital one."[8] But this is to anticipate; my intention in the present article is to call attention to certain aspects of the story of the transformation of the "Loathly Lady" that have hitherto been overlooked, and, in particular, (1) to adduce a number of Oriental parallels, (2) to point out that the Loathly Lady must be identified with the Dragon or Snake whom the hero disenchants by the Fier Baiser, and (3) to point out that the Loathly Lady or Dragon-Woman is the Undine, mermaid soul, the Psyche, whose disenchantment and transformation are brought about by her marriage with the Hero.

To begin with the marriage of Indra, the "Great Hero" of the *Ṛg Veda*, to Apālā, the "Unprotected."[9] Apālā is the wooer: thinking, "What if we

[7] I fully agree with A.C.L. Brown's suggested equation of the fairy guardian of a "marvellous water" with a damsel guardian of the Grail. I would add that all these are, so to speak, "Hesperides." I also fully agree with Brown's observation that "it is not incredible that all these personages [Perceval's sister, and cousin, and wife, and the Grail messenger, as equated by Miss Mallon] were originally different manifestations of one supernatural earth-mother who controlled the plot"; and so with the suggestion that Cundrîe, the hideous Grail-messenger, who in Wauchier "transforms herself into a beauty" is "a fée who took an ugly shape in order to test the greatest of all knights" (*Origin of the Grail Legend*, pp. 211, 217, nn. 6 and 24).

[8] J. C. De, "On the Hindu Conception of Sovereignty," *The Cultural Heritage of India* (Calcutta, n.d. [1937]), III, 258. See also G. Hartmann, *Beiträge zur Geschichte der Göttin Lakṣmī* (Wertheim, 1933).

[9] RV VIII.91: see full details and references in H. Oertel, "Brāhmaṇa Literature, II: Indra cures Apālā," JAOS XVIII (1897), 26–31, and Coomaraswamy, "*The Darker Side of Dawn*," 1935, p. 1. Apālā is a *pati-dviṣ*, "who hates her [former] lord and master," like the "all-generating" Earth who in AV XII.1.37, "shaking off the snake, chooses not Vṛtra but Indra."

go and wed with Indra? Will he not further, yea, and work for us, enrich us?" Bringing Soma, which she prepares by chewing, as her sacrificial offering, she addresses Indra as "Thou that movest yonder, little hero, looking round about upon one house after another,"[10] and asks him to "replant her father's [bald] head, [barren] field, and 'this below my belly.' "[11] Indra drinks the Soma from her lips; in the words of the Brāhmaṇa, "He, verily, drank the Soma from her mouth: and whoever, being a Comprehensor of this [myth, or doctrine], kisses a woman's mouth, that becomes for him a Soma-draught," that is to say, of the Water of Life, of which this was the "first drinking." It is not explicit in the brief Ṛg Veda text that Apālā was loathsome, but this is implied by the statement that Indra purifies her thrice by drawing her through the

[10] Viraka, cf. RV VIII.69.15 where Indra is "a little boy" (kumāraka); the theme of the hero's precocity and strength out of all proportion to his size (cf. "Tom Thumb") recurs throughout the traditional literature: cf. Cuchullain as "boy-hero." The designation "mannikin" has further reference to the very usual identification of Indra, as immanent deity, with the "Person in the Right Eye," analogue of the greater Person in the Sun; the left eye pertaining to Indrāni, and their beatific union being consummated in the "heart," where also the draught of Soma is really imbibed. The "houses" of the text are, of course, the bodies of the living beings in which the solar Indra is the vivifying and conscious principle—"Thee, O Indra, we discern in every birth" (BD IV.73). Cf. Jacob Boehme, "Of the Supersensual Life," Dialogue II, p. 249, in The Signature of All Things.

[11] These are, at least in one sense, the "waste lands" that Indra "fills" or "peoples" (RV IV.19.7); Indra is the typical "Grail-winner" of the Vedas. Apālā's father is Atri; in his case, the "hair" to be restored is probably rays of light. The "field" (urvarā, fertile ground, earth) is, no doubt, Apālā's (Earth's) own womb: cf. AV XIV.2.14, where the Bride is referred to as "an animate field" (ātmanvī urvarā); RV VIII.21.3, where Indra is "Lord of the Field" (urvarāpati) as in IV.57.7 (kṣetrapati, in connection with Sītā, the Furrow, "whose Lord is Indra," PGS II.17.9); BD IV.40 where Prāṇa (often = Indra) is "the only 'Knower-of-the-Field,' " (kṣetra-jña), i.e., of the body with its powers. For "hair" = vegetation, cf. TS VII.4.3.1, "This [earth] was bare and hairless; she desired, let me be propagated with plants and trees"; ŚB IX.3.1.4 (beard on chin analogous to plants on earth); and VS XIX.81, where "hair" is represented by sprouts of grass and barley [see also BU III.2.13 and Ovid, Metamorphoses IV.660]. Apālā's lack of hair is a result of her "skin-disease": a parallel can be cited in Perlesvaus, where the Grail Messenger has lost her hair at the time of the Dolorous Stroke, and foretells that it will grow again when the Grail Hero asks the fateful question; and there can be no doubt but that, as Loomis says (Celtic Myth and Arthurian Romance, p. 282) by "hair" she means "the bursting buds and shooting stalks of reawakened earth." Similarly, the "Damsel of the Car," whose head is bald and will be so "until such time as the Grail be achieved"; see H. Muchnic, "The Coward Knight and the Damsel of the Car," PMLA XLIII (1928), 323–343. [See also J. J. Bachofen, Mutterrecht und Urreligion (Leipzig, 1926), pp. 76, 251.]

356

naves of his (evidently three-wheeled, cf. RV 1.164.2, *trinābhi*) solar chariot, making her "sunskinned" at last. The longer versions of the Brāhmaṇas make it clear that Apālā was originally "of evil hue" and that the purifications are removals of her scaly reptilian skins, so that from the third lustration she emerges in the fairest of all forms and as one to be embraced. The same story is paraphrased in *Jātaka* No. 31, where the story of Indra's marriage with Sujātā ("Eugenie") is essentially the same, but the successive purifications are spoken of as "births." Beyond all question, Indra's drinking of Soma involves a Fier Baiser.

As in the Celtic and Greek traditions Eriu-Europa, so in the Indian Apālā-Sujātā bears many different names, and the story is told or implied in many contexts. So we have as names of Indra's consort, Indrāṇī: Śacī, Śrī, Virāj, Umā, Sītā,[12] and many others, and all these in the last analysis are forms of the Earth Goddess, and of one and the same Māyā-Śakti, and as such represent Dominion; not the Ruler himself, but the Power, the Glory and the Fortune with which he operates. In the great hymn to the Earth Mother (AV XII.1) she is described as "whose Bull is Indra," "whose Lord is Parjanya" (Indra as Rain god); she is the Mother, Parjanya the Father, "I her son"; "adorning herself, shaking off the Serpent, choosing [in marriage] not Vṛtra but Indra, she keeps herself for Śakra [Indra], the virile Bull"; she is invoked to "establish us in the first drinking" (of Soma),[13] and to bestow upon us "force and strength, in utmost royalty (*rāṣṭram*) . . . and fortune (*śrī*)." The expression, "shaking off the serpent,"[14] i.e., casting her slough, is in itself a proof of Mother Earth's originally ophidian nature; this is, however, explicit in RV x.22.14, cf. 1.185.2, where she is "footless" (*apadī*), i.e., like Ahi-Vṛtra, a "serpent," while on the other hand in III.55.14 as Agni's Mother, "she stands erect, with feet (*padyā*), adorned with many beauties"; and again ex-

[12] Sītā, the "Furrow," and wife of Rāma. Cf. in this connection J. J. Bachofen, *Urreligion und antike Symbole,* II (Leipzig, 1926), 305 ("Was aus dem *spurium* geboren wird, hat nur eine Mutter, sei es die Erde, sei es das Weib").

[13] An allusion to the "Ford of Acquisition" and "that pathway whereby they drink of the pressed juice" (RV x.114.7), and so the archetypal draught offered by Apālā, beside the river (RV VIII.91.7).

[14] The "casting of the slough" is the ever-recurring Indian equivalent for the "putting off of the old man" from whom the new emerges; and the "shaking off of bodies" (physical, mental, etc.) is essential to the ascent, because "no one becomes immortal with a body." [Cf. P. Radin, *Road of Life and Death,* New York, 1945, p. 112, "From . . . here have we obtained this Rite. He alone know how to secure the power of shedding our skins for us."]

plicit, in that Earth is the "Serpent Queen" (*sarparājñī*, ŚB IV.6.9.17) who is now represented by the Bengali "Snake goddess," Manasā Devī.[15]

Śrī ("Splendor")-Lakṣmī ("Insigne") is the well-known Indian Goddess of Fortune (Tyche), Prosperity (the personified "Luck" of western folklore) and Beauty: she is the principle and source of all nourishment, kingship, empire, royalty, strength, sacerdotal luster, dominion, wealth, and species, which are appropriated from her by the gods whose distinctive properties they are, when she abandons Prajāpati, weakened by the act of creation (ŚB XI.4.3.1 ff.). She is identified with Virāj,[16] that maternal Nature (Natura Naturans) from whom all beings "milk" their characteristic qualities (AV VIII.9): and "the Virāj, they say, is This [Earth], and he who possesses the most thereof becomes the most fortunate" (*śreṣṭhaḥ*, superlative of *śrī*), ŚB XII.6.1.40. Śrī-Lakṣmī (in Pali, Sirī, Lakkhī) has a contrary Alakṣmī (in Pali, Alakkhī), Kali (Mil. 191) or Kālakaṇṇī ("Black-ear"), the Goddess of Misfortune or Ill-luck. These contrasted powers, as distinguished from one another, can be thought of either as sisters, of whom Alakṣmī is the "Elder" (Jyeṣṭhā), or as the daughters respectively of the (originally ophidian) Regents of the North and West; but like Durgā (with whom Alakṣmī is sometimes identified) and Umā, and Night and Day, they are also to be regarded as the polar forms of a single principle.[17] It is explicit, accordingly, that either can assume the other's form; Lakṣmī assumes the form of Alakṣmī for the overcoming of the Titans (*lakṣmīr alakṣmī-rūpeṇa dānavān vadhāya, Harivaṃśa* 3279); that under other circumstances a converse transformation takes place is, of course, implied. The *Mārkaṇḍeya Purāṇa* LXXXIV.4, says that the Goddess (Caṇḍikā, Durgā, etc., who is also the Earth and Magna Mater) "is Śrī herself in the homes of well-doers, but Alakṣmī in those of evil-doers."

In other words, the form in which the Luck appears, whether that of Good Luck or Bad Luck (the word itself is indeterminate) is that which is appropriate to the given situation; the person of Dominion appears in her form of beauty only to those who deserve her; the expression "none

[15] All of the above material is much more fully treated in Coomaraswamy, "The Darker Side of Dawn" (see n. 9 above), where the references will be found. Manasā Devī is so called because the hymns of the Serpent Queen are *orationes secretae*, mentally (*manasā*), i.e., silently, recited.

[16] "Shining about" or "Wide-ruling"; √*raj*, to "shine" or "rule," in *rājā, rex*, "royal," "realm," etc.

[17] In this connection cf. Gerda Hartmann, *Beiträge zur Geschichte*, pp. 13–15 and 35–42.

but the brave (or good) deserve the fair" takes on a fuller meaning, and could never have been better said than of the hero of a Fier Baiser. It is precisely in respect of her fundamental polarity and changeability or fickleness that we can so clearly recognize the principle that underlies the transformations of the Lady of the Land in Celtic contexts, and realize that even in stories that speak of Fortune and Misfortune as relatives, this still means that they are interchangeable aspects of one and the same "fée" or Fata. We see, accordingly, a parallel to the story of Eochaidh's Five Sons in *Jātaka* No. 382; here the Bodhisatta hero is a wealthy and generous merchant; Kālakaṇṇi (Alakṣmī) and Sirī (Śrī), still in heaven above, have each of them laid claim to precedence, and it is adjudged that they shall descend and appear to the Bodhisatta, whose decision shall determine their dispute. Kālakaṇṇī appears first in a blue-black robe (the color of darkness and death), and explains that she wanders about the world, misleading men to their undoing; the Bodhisatta refuses her. Sirī then appears in golden radiance and, in answer to the question who she is, explains that she presides over such conduct as gives Lordship (*issariya*). The Bodhisatta makes her welcome, and she spends the night with him, sharing his couch.

We have seen that Śrī is the "personification of the right to rule . . . [the] Spirit of Sovereignty . . . and certainly so when such relationship is . . . a marital one."[18] This marital relation of the Ruler to the Earth is directly expressed in the word Bhūpati, "Lord of the Earth," i.e., a king. The notion that a king is "espoused unto his Kingdom" survives at least as late as the seventeenth century in Europe.[19] In this connection there

[18] See n. 11. I have shown in *Spiritual Authority and Temporal Power in the Indian Theory of Government*, 1942 (see esp. nn. 26, 45), that the Ruling (as distinct from the Sacerdotal) function is essentially feminine. This is of interest in connection with the transformation motive in The Wedding of Sir Gawain, where Dame Ragnell tells us that what women "desyren of men aboue alle manner thyng [is] To haue the souereynte, withoute lesyng, Of alle, bothe hyghe and lowe" (ll. 422-424). So in India likewise; for we have seen above that Sirī (Śrī) is the presiding genius of lordship (*issariya*), and in A iii.363, where the ruling passions or functions of human beings are listed, that of lordship (*issariya*) is assigned to kṣatriyas (the ruling class) and to women. Alike in government and marriage, the woman's is the power, and the man's the authority. By a tyrant or virago the feminine "power" is abused; by legitimate king or true wife, exercised in accordance with justice. On Sarah as the "sovereignty" see Philo, references in the Loeb Library edition, I, xxvii.

[19] Peter Heylin, *Cyprianus Angelicus* (London, 1668), p. 145. It might seem, at first sight, that some contradiction is involved in the fact that in the *Wedding of Sir Gawain and Dame Ragnell* the latter's disenchantment and transformation take

can be cited the legends of the founders of Cambodia. Without going into great detail, it will suffice to cite the Champā inscription of A.D. 658, which records that the great brāhman Kauṇḍinya,[20] who came overseas from India, "planted his spear" in the capital (Bhavapura), where there lived a daughter of the King of the Nāgas, whom he married. Nāgas, of course, are Snakes or Dragons, connected with the Waters, and to say that the Lady of the Land was of this race is as much as to call her a mermaid; more than one Indian dynasty traces its descent from the union of a human prince with such an Undine.[21] As Aymonier[22] remarks, "In all the legends, the leading role is the woman's. She is the foundress of the royal race. She, and not the immigrant prince, is the protectress of the realm." The memory of the mythical founders long survived in Cambodian folklore and ritual, and notably in the requirement, binding on the king, to sleep with the Lady of the Land every night, before approaching any of his human brides. A Chinese author records, in the thirteenth century, that there was a golden tower in the palace at Angkor Thom at the top of which the king sleeps—"all the people say that in this tower there dwells the spirit of a nine-headed Serpent, the Lord of the Whole Land, and that every night he appears there in the form of a woman. It is with him that the king first sleeps and cohabits. . . . If ever the spirit of the Serpent does not appear, the time has come for the king to die; if ever the king fails to come, some disaster follows."[23]

place as a consequence not only of Gawain's embrace but inasmuch as he gives her "the *sovereignty* of all his body and goods." Similarly in AV 11.36.3, we find that a married woman is to rule (*vi rājatu*); and in A 111.363 that "lordship" is proper to both the ruling class and to women [cf. Aristotle, *Oeconomica* 111.1]. This does not mean that the reins of all government are handed over to her, but that hers is the executive power in a joint government. Dame Ragnell, in fact, undertakes "never to anger, disobey, or contend with" Sir Gawain, while in the *Atharva Veda*, in the same way, the wife will "never thwart" (*vi-rādh*) him. She is the source of his Sovereignty in that without her he would not be a Sovereign; the King without a Realm is no King in the same sense that as Meister Eckhart says, "Before creatures were, God was not 'God'" [cf. RV x.85].

[20] Matronymic from Kuṇḍinī, perhaps "Son of the Well." Kuṇḍina and Kauṇḍinya are well-attested old Indian names.

[21] Nāginīs are still represented in Indian art as womanly from the waist up, but with a scaly fishtail below. For Nāgas generally see J. Ph. Vogel, *Indian Serpent-Lore* (London, 1925); also G. Coedes, "La Légende de la Nagi," BÉFEO XI (1911). R. Guénon informs me that there are European families, e.g. the French Lurignan, whose descent is traced from a mermaid.

[22] E. Aymonier, *Histoire de l'ancien Cambodge* (Strasbourg, n.d. [1924?]).

[23] P. Pelliot, "Memoires sur les coûtumes du Cambodge," BÉFEO II (1902), 145.

There may be some confusion in this Chinese account, which should be taken to mean that the Lady of the Land is the daughter of a nine-headed Serpent or Dragon, but appears to the king in the form of a beautiful woman. The connection of Nāginīs with the Waters is more significant in the present context than might appear at first sight. For, in the first place, Śrī-Lakṣmī is the Indian "Aphrodite," born of the foam at the Churning of the Ocean in the beginning;[24] she is otherwise known as Padmā, the "Lotus," or "Lotus Lady," and is represented iconographically seated or standing in the flower of a lotus; while, at the same time, the Earth is thought of as an island floating on the surface of the primordial sea and is regularly symbolized, accordingly, by the lotus leaf or flower.[25] All that is as much as to say that Śrī is "Flora," and by the same token "Rosa Mundi";[26] in *Paradiso* XXIII.88, *bel fior* = Virgin Mary; and this is not without its bearing for us here, for as Loomis (*Celtic Myth and Arthurian Romance*, p. 222) says, "we shall do well to remember the conception of a damsel, called the Sovereignty of Ireland, who by her embraces confers immortality, who gives her cup to the hero, and whose floral names have some significance"; in the same connection Loomis cites the names of other daughters of the gods, Blathnat ("Little Flower") and Scothniamh ("Flower-luster"), and we meet with other significant names such as Blanchefleur, Flore de la lunel, and Rosa Espania.

[24] *Rāmāyaṇa* 1.45.40–43. In this connection it may be observed that just as in classical sources Cupid is the son of Venus, so in Indian contexts Kāmadeva (Eros) is the son of Lakṣmī (*Harivaṃśa* 11535, 12483; cf. Mbh XIII.11.1 f.).

[25] On the lotus symbolism see Coomaraswamy, *Elements of Buddhist Iconography*, 1935, pp. 17–22 and nn. 28–44. On "Floating Islands" see A. B. Cook, *Zeus*, III, 975–1015; and Coomaraswamy, "Symplegades" [in this volume—ED.]. It is emphasized, e.g., in the *Śrī Sūkta*, that the beginnings of the lotus are in the slime of the depths; its development and blossoming are in response to the light of the Sun (Mbh XII.228.21 *et passim*), that of "the one lotus of the sky," the Sun or Brahma (BU II.3.6, VI.3.6)—a transformation into the same image. That the lotus represents equally the Earth and Śrī-Lakṣmī reflects their essential identity.

[26] Just as the Earth-lotus in the Vedic tradition blooms on the surface of the primordial Ocean in response to the down-shining of the lights of heaven above, so in the Greek tradition the Sun perceives a fertile land, Rhodos, the Rose, rising from the depths of the Sea, "and there it was that Helios mingled with the Rose, and begat seven sons who inherited from him yet wiser minds than any of those of the heroes of old" (Pindar, *Olympian Odes*, VII.54 ff.). On Rose and Lotus as symbols of the Magna Mater see also Coomaraswamy, "The Tree of Jesse and Indian Parallels or Sources," 1929. I do not attach here any importance to the possibility of Indian influence; all that concerns us is the universality of doctrines and of the formulae in which they are expressed. The Mother of God is always a "Flower."

The whole motif of the transformation of the Loathly Lady or Serpent into the Perfect Bride is reflected in the lunar periodicity of a woman's life, and it is, perhaps, only from this point of view that the traditional menstrual taboos can be rightly interpreted. The menstruating woman is regarded as dangerous and baleful, alike to men and crops, and she is often secluded where the light of sun or moon cannot reach her (light is the progenitive power, and she must not beget at this time). What this seclusion implies is a temporary return to her primordial state, which is not, so to speak, human, but uncanny. Menstruation has often been regarded as a kind of infection or possession; the subsequent purification followed by intercourse is the regeneration of her humanity, and a repetition of the nuptial *rite*[27] by which she was first "made a woman" who had been a "nymph."

Accordingly: "She is, assuredly, the very Śrī of women [Fortuna incarnate] when she removes the soiled garment; therefore, let the man approach this Glorious woman (*yaśasvī*) then, uttering a blessing; or, if she does not yield, strike her with a rod or his hand, uttering the curse, 'I, by my power and by my glory, take thy glory to myself'—and she becomes inglorious. But if she yields, the blessing, 'I, by my power and by my glory, bestow upon thee'—and both are glorified" (BU vi.4.7-8). All this reflects the archetypal marriage of Sūryā, the Daughter of the Sun and paradigm of the human bride. At her wedding: "Discarded is the Potentiality (*kṛtyā*, evil, spell, enchantment)[28] that clung about her; her

[27] Rite, sacrifice, reenactment of cosmic relationships; cf. ŚB xi.6.2.10, BU vi.4.2, 3, CU iii.17.5, and the marriage formula, "I am Sky, thou art Earth, I the Chant, thou the Verses, let us be one, and bring forth offspring," AV xiv.2.71. *Facere = sacra facere* when, and only when, the act of kind is referred to its paradigm *in divinis*— "the act of fecundation latent in eternity."

[28] *Kṛtyā*, personified gerundive (*faciendum*), as "potentiality" is Evil, contrasted with the highest Good characterized by a "being all in act" (*kṛtakṛtya*). So *kṛtyā*, abstractly, is often "witchcraft, enchantment, necromancy," etc. *Kṛtyā* in RV corresponds to *mala* (defilement) in BU: clinging, i.e., at once like the coils of a snake and the folds of a garment. It is to be borne in mind that in the traditional doctrine about transformation or shape-shifting all changes of appearance are thought of in terms of the putting on or taking off of a skin or cloak, by which acts a proper essence is concealed or revealed, as the case may be. A werewolf, for example, is not a species, but a man who knows how to wear a wolfskin as though it were his own [cf. *Mathnawī* iii.4681]. This conception underlies the well-known motif of disenchantment by flaying (*Abhautungsmotiv*, cf. C. G. Jung, *Einige Bemerkungen zu den Visionen des Zosimos*, Zurich, 1938, p. 30, and G. L. Kittredge, *Sir Gawain and the Green Knight*, Cambridge, Mass., 1916, pp. 214 ff.). Our real Self, accordingly, appears only when all its disguises have been shed; the bride is unveiled before her husband; and in the same way, "across Thy [Love's] threshold

[new] kinsmen prosper; her husband is secured by obligations. 'Cast away the soiled garment, give largesse unto brāhmans!' Now hath Potentiality gotten her feet (*padvatī bhūtvī*), and as a wife associates with a husband" (RV x.85.28, 29). From this "gotten feet" it is clear that the wife's original form, that clung to her, was ophidian, and, if we collate the two contexts, that the monthly purification, after which the woman is no longer dangerous but most acceptable, is a regeneration thought of as the casting of the slough and a glorious emergence, analogous on the one hand to Apālā's and on the other to that of every one who "puts off" the old man and is renewed.

We have so far seen that the heroic motif of the transformation of a hideous and uncanny bride into a beautiful woman cannot be regarded as peculiarly Celtic, but rather represents a universal mythical pattern, underlying all marriage, and one that is, in fact, the "mystery" of marriage. In more than one case it is emphasized that the disenchantment is effected by a kiss; so, for example, in the story of Eochaidh's sons, and again in the Wedding of Sir Gawain and Dame Ragnell where, when he is backward, she begs him: "For Arthur's sake, at least kiss me." Surely these are "Fiers Baisers"! In a typical version of the Fier Baiser, the hero reaches the Otherworld, Underwave. The population is enchanted. He enters a castle. A great snake enters, and begs him, "kiss me," but he refuses. The next evening he dreams of what would have followed had he given the kiss, and he resolves to do so. The snake comes again, this time in a more terrible form, with two heads, and begs him, "kiss me," but he refuses. He dreams again, and hears a voice, "Thou wouldst, nevertheless, have only done rightly hadst thou kissed the snake." He makes up his mind to do so; and this time, when the snake enters, now in a still more awful form, with three heads, it coils about him and begs, "kiss me." He kisses it, and "as soon as he had kissed it, the snake turned into a beautiful maiden, as beautiful as a maiden could be. The snake was the enchanted daughter of the lord of the castle. After the kiss, all belonging

naked all must pass," cf. Philo, *Legum allegoriae* ii.55 ff. Every "property" (in the theatrical and other senses of the word) must be dispensed with; and only the *thread* of our existence, as Rūmī says, is suitable for the eye of the needle. In the last analysis even our own bodies (personalities) are disguises, from which only a (the) Prince Charming can extract us: and, as JUB iii.30.4 expresses it, "these same gods above have shaken off their bodies." Even "to disappear" is thought of as a "putting on" of invisibility; so we find an adept escaping from his enemies by "investing his body in the tarn-cloak of contemplation" (J v.127) [i.e., "wearing nothing." Cf. Vis 390, 392–393].

to the castle, and the whole town, were disenchanted." In this case the actual marriage is postponed by the hero's human desire to revisit his parents in this world, but when he recollects himself, it is to return to his bride and the kingdom that awaits him.[29] Exactly the same principles are involved in what may be called the Fier Baiser *manqué*, of which an example will be found in William Morris's "Lady of the Land" (the second story for June in *The Earthly Paradise*); the hero reaches an un-populated island, enters a deserted castle, and finds a beautiful woman, who tells him that in her enchanted form, from which she is released on only one day of each year, she is a Dragon, and that if he would win both her and the kingdom, he must kiss her in the dragon form, in which she will appear to him on the morrow. The hero's courage fails him, and he flees, leaving the Dragon wailing.[30]

The motif of the Fier Baiser is too well known for it to be necessary to cite any other examples.[31] Our main object has been to point out that the Loathly Lady and the Snake or Dragon, Mermaid or Undine or Nā-ginī, are one and the same "Lady of the Land." We must, however, point out that the motif appears in the story of Apālā; for it is beyond question that she was a reptile[32] when Indra drank the Water of Life from her lips; the purification takes place afterwards. The words of the Brāhmaṇa

[29] A. H. Wratislaw, *Sixty Folk-Tales, Exclusively from Slavonic Sources* (London, 1889), no. 58. As E. Siecke remarks in a more general context, "der Drache und die Jungfrau sind natürlich identisch" (*Drachenkämpfe*, Leipzig, 1907, p. 15).

[30] The barren island is evidently a Waste Land, which would have been repopulated had the hero achieved the quest. Morris's use of mythical or magical motivations in his romances is always accurate. In the present case I do not know his immediate source [but cf. Sir John Mandeville, *Voiage and Travaile* (New York, 1928)]; see also Brown, *The Origin of the Grail Legend*, p. 211, n. 7 ("Only a persistently brave hero wins the ugly-appearing *fée*," etc.).

[31] References will be found in W. H. Schofield, *Studies on the Libeaus Desconus* (Boston, 1895) ("Disenchantment by Means of a Kiss," pp. 51, 199–208). Cf. Axel Olrik, *A Book of Danish Ballads* (Princeton, 1939), p. 271, "The Serpent Bride," The wording of the *Carduino* (*I Cantari di Carduino* in Rajna, *Poemetti Cavallereschi*, Bologna, 1873, pp. 1–44, cited by Schofield, p. 51) is significant:

> Chè come quella serpe fu basciata
> Ella sì deventò una donzella
> Legiadra e adorna e tutta angielicata.

In several other versions of the story the *donzella* is explicitly Gaia Donzella, Pulzella Gaia, the daughter of Morgan le Fay, and the hero is Gawain (E. G. Gardner, *The Arthurian Legend in Italian Literature*, Garden City, N.Y., 1930, pp. 167–241, 308, 309). See also Coomaraswamy, "The Sunkiss," 1940.

[32] Cf. also PB ix.2.14 where, as Akūpārā (fem. of Akūpāra, "Infinite," "Ocean," primordial "Tortoise"), Indra's bride is described as having a "skin like a lizard's."

364

are well worth repeating: "He, verily, drank the Soma from her mouth: and whoever, being a Comprehensor of this [myth, or doctrine], kisses a woman's mouth, that becomes for him a Soma-draught." The Bride is always in some sense a servant of the Living Waters, of which the Hero robs her, whether by force or favor: and the principle remains the same when (as in the story of Eochaidh's Sons) it is a draught from the Well (of Life) that the Hag gives only to him who kisses her, or when (as in many other versions of the story, and as reflected in custom) she offers him the bridal cup. We have shown elsewhere[33] that the true Soma Sacrifice ("Interior Agnihotra," the offering of "what the Brahmans understand by Soma, of which none tastes who dwells on earth")[34] is one of the life-blood of the draconian Psyche—macrocosmically "the Sovereignty of Erin, who by her embraces confers immortality, *who gives her cup to the hero.*"[35]

It is by *this* draught that the "mortal" hero, Dying God, Divine Eros, child of a supernatural Father and an earthly Mother, who has assumed a mortal and passible body in order to rescue his destined Bride—and in so doing "fetters himself by himself, like a bird in the net"[36]—is restored to his otherworldly kingdom in which the Lover and Beloved live together happily "ever afterwards." On the other hand, this is a consummation that may be postponed; and in this case the bridal cup is rather to be regarded as a pledge than as a fulfilment. For it happens all too often that the Hero is not yet altogether liberated from the ties that bind him to this world. He would, for example, return to earth to visit, console, and say farewell to his parents or companions. It is a dangerous undertaking, to which his Fairy Bride consents unwillingly. She provides him with a talisman, or sound advice; but the talisman is stolen, or the advice ignored, with the result that the Fairy Bride is forgotten and the Hero tricked into marriage with an evil bride, the antithesis of the immortal Beloved by whom he is only rescued at the last moment. She, for her part, undergoes innumerable trials and lives *in disguise* until, by some ingenious device, or by means of a token, she succeeds in reminding the Hero of his forgotten adventure;[37] a *lethe* and an *anamnesis* that

[33] "Ātmayajña" [in Vol. 2 of this edition—ED.].

[34] RV x.85.3, 4, cf. AV xiv.1.5.

[35] Loomis, *Celtic Myth and Arthurian Romance*, p. 222.

[36] MU iii.2.

[37] For instance, in the Polish story of "Prince Unexpected" (Wratislaw, *Sixty Folk-Tales*, no. 17), when the Prince and the youngest Princess have eluded pursuit, the former sees a beautiful town, and desires to visit it; the Princess tells him that

are not without relation to the Platonic and Indian doctrine of Recollection. Or again, if the Hero has not forgotten but loses his immortal Bride by the infringement of a taboo (whether this infringement be the result of his own thoughtlessness, or human weakness, or brought about by an adversary), then it remains for him to seek her out in that Otherworld or unknown City whence she first came, and of which the very name and place are strange to all those of whom he asks the way, for who knows "where" is Overseas or Underwave, or east of the sun or west of the moon, or "when" was once upon a time? The theme is infinitely varied, but always the same story of the *Liebesgeschichte Himmels*, the story of a separation and a reunion, enchantment and disenchantment, fall and redemption.[38]

Hero and Heroine are our two selves—*duo sunt in homine*—immanent Spirit ("Soul of the soul," "this self's immortal Self") and individual soul or self: Eros and Psyche. These two, cohabitant Inner and Outer Man, are at war with one another, and there can be no peace between them until the victory has been won and the soul, our self, this "I," submits. It is not without reason that the Heroine is so often described as haughty, disdainful, "Orgelleuse."[39] Philo and Rūmī repeatedly equate this soul, our

if he must go, he must beware of a beautiful child whom he must not kiss. But the beautiful child runs into his arms, and he kisses him impulsively, and "that moment his memory was darkened, and he utterly forgot the Princess, Bony's daughter." Before long, the Prince is to be married to the King's daughter, but the Princess takes service in the royal kitchen, and obtains leave to make the wedding cake; when it is cut, a pair of pigeons appears; the female pursues the male, her cooing restores the Prince's memory, he finds the true Princess, and again they make their escape, and in this case safely reach the Prince's (heavenly) Father's kingdom. The essential motif in this familiar pattern (cf., for example, the King's forgetfulness in the Epic and Kālidāsa's versions of the story of Śakuntalā, and in MU III.2 the deluded soul's forgetfulness of "its immortal Soul") is that of the loss and recovery of *memory*. This is the mythical formulation of the well known Indian and Platonic doctrine of *lethe* and *anamnesis*; and every such story has been told, at least in the beginning (however it may have been "voided of content on its way down to us"), not merely for the amusement of "children," whether young or old, but also to expound a doctrine for the sake of those who have ears to hear and to whom it is given to understand the mysteries of the kingdom of God. Plato and Aristotle were profoundly right in calling the marvelous "the only beginning of philosophy," and in equating "the lover of myths" with "the lover of wisdom!"

[38] Cf. E. Siecke, *Die Liebesgeschichte des Himmels* (Strasbourg, 1892), and note the equation of Indra and Vṛtra with Sun and Moon (normally Groom and Bride) in ŚB 1.6.4.18, 19. See also Coomaraswamy, "Ātmayajña," and "Two Passages from Dante's *Paradiso*" [in Vol. 2 of this edition—ED.].

[39] Typically, for example, in the well known story of Enid and Geraint; and in the Lay of Graelent (W. H. Schofield, "The Lays of Graelent and Lanval," PMLA

self, with the Dragon,[40] and it is this soul that we are told to "hate" if we would be disciples of the Sun of Men.

The myth of the Loathly Bride survives in St. Bonaventura's prediction of Christ's Marriage to his Church: "Christ will present his Bride, whom he loved in her baseness and all her foulness, glorious with his own glory, without spot or wrinkle."[41] "Nor ever chast, except *thou* ravish mee"— and it is by a true analogy that a woman "ravished" is said to be *in gloria*. We can see no other and no less meanings than these in even the oldest forms of the story of the Loathly Lady's or Dragon-woman's transformation. To suppose that "old folklore motifs" (of which the origin is left unexplained) are taken up into scriptural contexts, in which they survive as foreign bodies, is to invert the order of nature: the fact is that scriptural formulae survive in folklore, it may even be long after the

XV [1900], 131; E. M. Grimes, *The Lays of Desiré, Graelent and Melion*, New York, 1928, p. 23). The maiden of the fountain is extremely scornful, but as soon as Graelent has had his way with her, submissive and devoted. There can be no doubt that the contrast of pride and humility parallels that of reptilian hideousness and the height of womanly beauty; and one may say that the motif survives in secular contexts as a "Taming of the Shrew."

[40] In slightly different ways, corresponding respectively to RV x.85.28, where *Kṛtyā* is described as *clinging about* Sūryā, and 29, where Sūryā is spoken of as *having been* Kṛtyā—just as "Soma *was* Vṛtra!" Thus for Philo (*De opificio mundi* 44, *Legum allegoriae* 1.21 ff., 11.50 ff., 111.221 ff.), νοῦς is the "Man" (rational, heavenly, superior, artist), αἴσθησις is the "Woman" (irrational, earthly, inferior, material); the latter, carnal "soul" (ψυχή = *nefesh*), bringing to the former the realm of things perceived, the former, "soul of the soul," imposing order upon them; and Pleasure (ἡδονή) is the "Serpent" that coils about the sensitive soul like an evil garment. Hence Philo's *Drachenkampf* (ὀφιομαχία) is the conflict of Reason with Pleasure (cf. HJAS, VI, 1942, 397); and the Victory implies a transformation, for when the Soul submits herself to Mind, her lawful husband, "there will be flesh no more, but both of them will be Mind" (cf. Hermes *Lib.* x.19a). Similarly for Plutarch (*Moralia* 371BC), "Typhon (Seth) is that part of the soul which is passible and titanic." For Rūmī (*Mathnawi* 1.1375, 2617-2619; 111.1053, 2548, etc.), Reason ('*aql*) is the Man, and the Soul (*nafs*) the Woman, and these are at war; she is the Dragon, whom only the God, or Moses within you, can overcome.

[41] *Dominica prima post octavum epiphaniae* 11.2: "without wrinkle" (*sine ruga*) might well describe such a transformation as Apālā's, whose skin was originally "rough." Cf. St. Bernard, *De gradibus humilitatis* 21, "unites this soul to himself as a glorious bride"; *Misc. Serm.* 45.4, "from the slime of the abyss"; *Grace and Free Choice* x.35, "changed into the same image, from glory to glory" (*Opera* 1388). Transformations from hideous hag to beautiful spirit, differently motivated, may be noted here as occurring in the Buddhist *Petavatthu* (SBB XII, 1942, 158 ff. and 167 ff.). ["The Son proceeded out of the Most High to go and fetch his lady whom his Father had eternally given him to wife and restore her to her former high estate," Meister Eckhart (Evans ed., I, 224).]

"scripture" itself has been romanticized or rationalized in more sophisticated circles. In whichever context they are preserved correctly, the motifs retain their intelligibility, whether or not they are actually understood by any given audience. These motifs are not primarily "figures of speech," but *figures of thought*, and whoever still understands them is not reading meanings *into* them, but only reading *in* them the significance that was originally concreated with them (cf. Rom. 1:20).

Myths are significant, it will be conceded: but of what? If we do not ask the right questions, with the Grail before our eyes, our experience of the mythical material will be as ineffectual as that of the hero who reaches the Grail castle and fails to speak, or that of the hero who will not kiss the Dragon: our science will amount to no more than the accumulation of data, which can be classified, but cannot be brought to life.[42] Myths are not distorted records of historical events.[43] They are not periphrastic descriptions of natural phenomena, or "explanations" of them; so far from that, events are demonstrations of the myths. The aetiological myth, for example, was not invented to explain an oddity, as might be supposed if we took account only of some isolated case. On the contrary,

[42] Add to this, that even the data will be only imperfectly assembled if the folklore sources alone are investigated. For this reason, no doubt, the Symplegades motif in RV vi.49.3, AV xiv.1.63, ŚB 1.9.3.2, and ŚA iv.13 (= Kauṣ. Up. ii.13) has been overlooked, as has that of Decapitation in numerous Islamic contexts, for example in Rūmī, *Divān*, Ode ii, "When thou seest in the pathway a severed head, which is rolling . . . ask of it, ask of it the secrets of the heart," and *Mathnawī*, Tabrīz ed., 206.6, "The more he plied his sword, the more my head became." It is not a deification of human heroes, but the humanization of gods that "literary history" demonstrates. On Decapitation see further Coomaraswamy, "Sir Gawain and the Green Knight: Indra and Namuci," 1944, where I have also discussed the nature of myth and folklore.

[43] Cf. Lord Raglan, *The Hero* (London, 1936); Siecke, *Drachenkämpfe*, p. 61; N. P. Nilsson, *Mycenean Origin of Greek Mythology* (Berkeley, Calif., 1932), (p. 31, Mythology can never be converted into history); [S. Reinach, *Orpheus* (New York, 1909), ch. 8, §28, "It is contrary to every sound method to compose, as Renan did, a life of Jesus, eliminating the marvelous elements of the Gospel story. It is no more possible to make real history with myths than to make bread with the pollen of flowers."] It may be observed here that wherever it is asserted that a given event, such as the temporal birth of Christ, is at once *unique* and *historically* true we recognize an antinomy; because, as Aristotle perceived (*Metaphysics* vi.2.12, xi.8.3), "knowledge (ἐπιστήμη) is of that which is always or usually so, not of exceptions," whence it follows that the birth in Bethlehem can only be thought of as *historical* if it is granted that there have also been *other* such "descents"; if, for example, we accept the statement that "for the establishment of Justice, I am born in age after age" (BG iv.7, 8).

the phenomena are *exempla* of the myth: for instance, if we are told "Why the Hare has no Tail," investigation will show that the Symplegades motif by which this is "explained," explains too much. It also explains how the good ship Argo lost her stern-ornament, how the end of Giviok's canoe was crushed, and how the spurs were cut from the feet of a Celtic hero by the Active Door of an Otherworld castle. It is only in a later than the "myth-making age," and when nothing but the symbol survives as a "motif" or "art form," that anyone could have imagined that the whole and complex pattern of the Otherworld Quest or *Himmelfahrt* could have been invented to explain a minor fact of natural history![44] "Docking" is a figure; and if the function of a figure is to be understood, it is not alone of the figure itself, but also of its configuration (*Gestalt*), that we must take account. It is only when we realize that the arts and philosophies of our remote ancestors were "fully developed," and that we are dealing with the relics of an ancient *wisdom*, as valid now as it ever was, that the thought of the earliest thinkers will become intelligible to *us*.[45] We shall only be able to understand the astounding uniformity of the folklore motifs all over the world, and the devoted care that has everywhere been taken to ensure their correct transmission, if we approach these *mysteries* (for they are nothing less) in the spirit in which they have been transmitted "from the Stone Age until now"—

[44] On the hare and hounds see Karl von Spiess, "Die Hasenjagd," *Jahrb. f. historische Volkskunde*, V, VI (1937), 243 ff. Also E. Pottier, "L'Histoire d'une bête," *Revue de l'art ancien et moderne*, XXVII (1910), 419–436, and *Bulletin de correspondance hellénique* (1893), p. 227; L. von Schroeder, *Arische Religion*, II (Leipzig, 1923), p. 664; and John Layard, *The Lady of the Hare* (London, 1945).

[45] Aristotle, *Metaphysics* XII.8.21. Cf. W. Andrae, *Die ionische Säule* (Berlin, 1933), p. 65; E. Dacqué, *Das verlorene Paradies* (Munich, 1940); F. Marti, "Religion, Philosophy, and the College," *Review of Religion* VII (1942) ("Men live by myths ... they are no mere poetic invention"); N. Berdyaev, *Freedom and the Spirit* (New York, 1935) ("Behind the myth are concealed the greatest realities, the original phenomena of the spiritual life. ... Christianity is entirely mythological, as indeed all religion is"); M. Eliade in *Zalmoxis* II (1939), 78 ("La mémoire collective conserve quelquefois certains détails précis d'une 'théorie' devenue depuis longtemps inintelligible ... des symboles archaïques d'essence purement métaphysique"), and in *Revista fundatiilor regale* (April, 1939), p. 16 ("O buna parte din ornamentatia populara este de origine metafizica"); J. Strzygowski, *Spüren indogermanischen Glaubens in der bildenden Kunst* (Heidelberg, 1936), p. 344 ("Wir müssten wohl überhaupt in der Religion die Unterscheidung zwischen Natur- und Kulturvölkern fallen lassen"); Franz Boas, *The Mind of Primitive Man* (New York, 1938), p. 156 ("This led us to a consideration of whether the hereditary mental faculty was improved by civilization, an opinion that did not seem plausible to us"). Similar views could be cited *ad lib.*

with the confidence of little children, indeed, but not the childish self-confidence of those who hold that wisdom was born with themselves. The true folklorist must be not so much a psychologist as a theologian and a metaphysician, if he is to "understand his material."[46] Many or most of our fairies and heroes were originally gods;[47] in this connection, the special value of the early Indian parallels lies in the fact that here the "deeds of love and high emprise" are still those of the gods themselves.

[46] On this subject see Coomaraswamy, " 'Spiritual Paternity' and the 'Puppet Complex'; a Study in Anthropological Methodology," 1945.

[47] *Diu Krone* (L. 29622) still refers to the Grail Bearer as "die gotinne Wolgetân" (Loomis, *Celtic Myth and Arthurian Romance*, p. 284).

Le Corps parsemé d'yeux

Professor Raffaele Pettazzoni's informative discussion of certain divinities as many-eyed or covered with eyes shows that this symbolism is of almost universal distribution, "et même très ancienne."[1] He rightly recognizes that the symbolism is connected with "l'idée 'de l'omniprésence et de l'omniscience de Dieu.'" Our understanding of the symbolism can nevertheless be carried much farther and explained in connection with the whole doctrine of the Spirit and of Light.

In the first place, let us remark that all of the divine forms under discussion are solar. This is sufficiently evident in the cases of Argos, Puruṣa, Indra, Mitra, Horus, and Christ. That Argos functions as "cowherd" recalls the designation of Indra and of the Sun as *gopati* in the *Ṛg Veda* and *Mahābhārata*, and the more so if we remember that the Earth in Vedic tradition is a "cow." The Tetramorphs or Cherubim of Ezekiel 1:5 ff. and 10:12 ff., with their many eyes, are connected with the Spirit and with Light and are evidently four aspects, reflexes, or powers of the "glory of the God of Israel above them" (Ezekiel 10:19). They are represented in Christian art in the form of a man with many wings and three accessory heads—those of an ox, a lion, and an eagle, represented by protomas in an arrangement closely resembling that of the nimbus of the solar deity at Dokhtar-i-Nōshirwān, where, however, the eagle occupies the center and the number of the animal protomas is doubled.[2] As regards Satan, it is more than doubtful whether it is Satan as such and not rather Lucifer in the proper sense of this name that is intended by the "Angel of Death"

[This essay was first published in *Zalmoxis*, II (1939).—ED.]

[1] "Le Corps parsemé d'yeux," *Zalmoxis*, I (1938), 1–12.

[2] The Tetramorph as a type of Christ is an aspect of the Sun. Cherubs, however, as such, are not God but, rather, gales of the spirit on which God rides (Maruts) (cf. Psalms 18:10); they are distinguished by their "excess of knowledge" of God (*Sum. Theol.* I.108.5), being in this respect superior even to the Thrones, and from this point of view their many eyes may be said to imply their "immediate knowledge of the types of things in God"; they see what He sees (in the "eternal mirror") and in this respect as He sees.

For the nimbus at Dokhtar-i-Nōshirwān, see A. Godard and J. Hackin, *Les Antiquités bouddhiques de Bāmiyān* (Brussels, 1928), p. 70.

in the Babylonian Talmud; for "Death" is one of the highest names of the God that both quickens and slays, separates and unifies, and is always identified in Vedic tradition with the Sun and Spirit (ŚB x.5.2.3, 13–15; xi.2.2.5; KU 1.16, etc.). As regards Christ, it may be observed that the seven eyes of the Apocalyptic lamb, "which are the seven spirits of God sent forth into all the earth" (Rev. 5:6), correspond to the "seven gifts of the Spirit" as well as to the "seven rays of the Sun," so often referred to in the Vedic tradition.[3] The seven eyes of the Lamb are represented in Christian art in the head and not on the body, for example in the dome of the church of St. Climent de Tahulla (Spain);[4] here the Lamb is found in the circle that corresponds to the solar "eye" of the dome, where the Pantakrator is more often seen (Figure 11).

The connection of the eyes with the Spirit and with Light provides us the key to the meaning of the symbolism elsewhere. Once we have recognized that the eyes are those of the "Sun of men" (*sūryo nṛn*, RV 1.146.4), the "Light of lights" (RV 1.113.1; BG xiii.16, etc.), that the Sun is the spiritual essence (*ātman*) of all that is (RV 1.115.1); once we have understood that light is progenitive (TS vii.1.1.1; ŚB viii.7.1.16),[5] that the Sun's

[3] See Coomaraswamy, "The Symbolism of the Dome" [in this volume—ED.], and René Guénon, "La Porte étroite," *Études traditionelles*, XLIII (1938), 447–448. The seven rays of the Sun are represented by the six spokes and the center of a six-spoked wheel or six-rayed "star," or more rarely by a seventh ray differing in form from the rest.

[4] In the Catalan painting the Lamb has three eyes on one side of the nose and four on the other. The Irish solar hero Cuchullain had either seven pupils in each eye (W.O.E. Windisch, ed., *Die altirische Heldensage Táin Bó Cúalnge*, Leipzig, 1905, p. 169) or, according to another version, four pupils in one eye and three in the other (*Zeitschrift für Celtische Philologie*, III, 1901, 230). St. Columcille's pupil, Baithin, is said to have had seven pupils in each eye (Manus O'Donnell, *Life of Columcille*, ed. and tr. Andrew O'Kelleher, Urbana, Ill., 1918, p. 362). The latter references are taken from R.A.S. Macalister, "The Goddess of Death in the Bronze-age Art and the Traditions of Ireland," IPEK (1926), p. 257.

[5] For this reason the highest deities are also "gods of fertility." In Navaho mythology virgins are referred to as "non-sunstruck girls." And this is another aspect of the divine omniscience, for the erotic significance of the verb "to know" is a very old one. "God is the master of all generative power" (Hermes, *Asclepius* iii.21; cf. 17A).

The solar deity being "thousand-eyed," each eye implying a "ray," and because "light is the progenitive power," "thousand-eyed," "thousand-rayed," and "thousand-membered" (*sahasra-muṣka, sahasra-retas*, RV) are equivalent concepts, and Sāyaṇa rightly interprets RV viii.19.32 *muṣkāni*, by *tejāṅsi*. These considerations explain the traditional connection of the phallus with flame ("The 'flamboyant' character of the linga is also quite evident in public worship . . . the solar flame, the fiery essence, the 'tejas,' the 'tejas' being the sex organ," F.D.K. Bosch, "Het Linga-heiligdom van Dinaja," *Madjalah untuk ilmu buhasa, ilmu bumi dan kebudajaan Indonesia*, LXIV (1924), 232, 257.

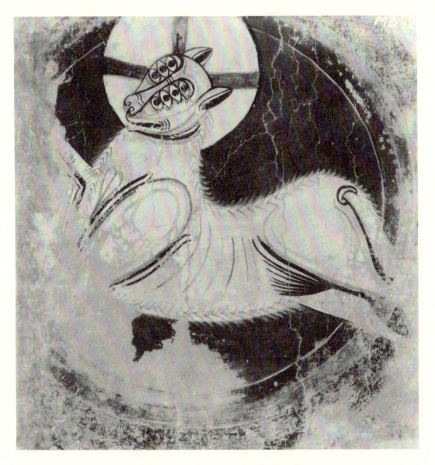

Figure 11. The Apocalyptic Lamb

many rays are his sons (JUB II.9.10), that he fills these worlds by a division of his essence (*ātmanaṃ vibhajya*, MU vi.26), although remaining undivided, i.e., a total presence, amongst divided things (BG xiii.16 and xviii.20), being thus one in himself and many in his children (ŚB x.5.2.16), and that he is connected to each of these children by the ray or thread of pneumatic light (*sūtrātman* doctrine, *passim*) on which their life depends, it will not be difficult to understand how it is that the Light of lights who is himself the one eye of all the gods, Varuṇa's eye, must also appear to our iconographic faculty to be many-eyed. For while the divine omniscience is not derived from objects external to itself, but from their ideas, composing the "world picture painted by the Spirit on the canvas of the Spirit" (Śaṅkarācārya, *Svātmanirūpaṇa* 95), so that the vision of all that is in time or space as if in a mirror constitutes a single act of being, apart from time, we cannot thus represent it to ourselves. From the standpoint of our multiplicity, the Sun is central to a cosmic sphere, to the boundaries of which its innumerable rays[6] extend in every direction, so that the darkness is filled with light; and if these rays are spoken of as a "thousand," it is because "a thousand means everything" (ŚB, *passim*), and it is by means of these rays that he knows the expressed forms to which they extend. If we recall the traditional theory of vision, we shall understand that every one of these rays implies an "eye" or "pupil" from which it proceeds and an eye to which it extends and through which it passes: for in this theory, vision is by means of a ray of light projected from the eye, and it is rather He that sees in us than "we" that see.[7] God, in terms of human concept, verbal or visual, is therefore Argos-eyed, because He sees all things. Indra is preeminently the "thousand-eyed," and "Indra art Thou to the mortal worshipper" (RV v.3.2), that is, conceptually, but in

[6] Each of which, for the individual to whom it extends, corresponds to the "seventh and best" ray referred to above.

[7] JUB 1.28.8: "That ray of His, becoming sight is present in all his children; whoever sees, it is by means of His ray that he sees"; He, whose outlook is through beings (*yo bhūtebhir vyapaśyata*, KU iv.6) and thus appropriates the objects of perception (*viṣayān atti*, MU ii.6; *viṣayān upasevate*, BG xv.9). Cf. Plato, *Timaeus* 47B, and Rūmī, *Mathnawi* ii.1297. *Mirṣād* 65.7 ff. and 69.2 ff. (cited by Nicholson on *Mathnawi* ii.1293 with reference to the Koran, xxiv.35) correspond almost verbally to MU ii.6. Also cf. Plutarch, *Moralia* 355A, Osiris "many eyed"; Hesiod, *Works and Days* 265, "Eye of Zeus, seeing all"; Heb. 4:13, "all seeing"; MU vi.8, *sahasrākṣeṇa*, thousand-eyed; *Mihir Yast* xxxiii.141 (SBE Vol. 23, Oxford, 1883, 119–58), xxiv.145, Mithra "of a thousand eyes . . . a thousand spies . . . all knowing"; AV iv.16.4 and 5, Varuṇa: "thousand-eyed . . . his spies look over the earth"; ŚB ix.2.3.32 ff., "O Agni, thousand-eyed, *suparṇa* . . ."; RV x.81.3, "the Sole God, who has eyes on all sides"; cf. TS iv.6.2.1 and KB vi.1, "he of a thousand eyes."

reality "not what men worship here" (*ne'daṃ yad idam upāsate*, JUB iv.18). We are reminded of this by the fact that it is one being that has many eyes, the number depending upon our point of view and not upon the being itself, who is *the* "Eye" (RV x.8.5 *bhuvaś cakṣus*, x.102.12 *viśvasya cakṣus*; Buddhist *cakkhum loke*, Jaina *cakkhu logassa*).

The Inverted Tree

The expression *brahma-vṛkṣa*, "Brahma-tree," in the *Mahābhārata* (*Aśva-medha Parva* XLVII.14), points backward to MU VI.4, where the One Aś-vattha is identified with Brahman; ŚA XI.2, where the Brahman stands up as a great green Tree; and finally to the question asked in RV x.31.7 and x.81.4, "What was the Wood, and what the Tree, of which they fashioned Heaven and Earth," with its answer in TB II.8.9.6, "The Wood was Brah-man, Brahman the Tree, of which they fashioned Heaven and Earth: it is my deliberate word, ye knowledgeable men, that there stands Brahman, world-supporting."[1] Bearing in mind the equivalence of Mitrāvaruṇau and *apara* and *para* Brahman, and the designation of Varuṇa in the *Ṛg Veda* and of Brahman in the Brāhmaṇas and Upaniṣads as yakṣa, it can readily be seen in what sense Brahman is thought of both as root and branch of one and the same Tree. The Brahman being a single essence with two natures (*dvaidhībhāvaḥ*, MU VII.11.8), "in a likeness and not in any likeness (*mūrtaṃ cāmūrtam ca*), mortal and immortal, local and per-vasive (*sthitam, yat*), existent and beyond (*sat, tyat*), solar (*ya eṣa tapati*) and intrasolar" (*ya eṣa etasmin maṇḍale puruṣaḥ*, BU II.3.1–3, cf. MU

[This study was first published in the *Quarterly Journal of the Mythic Society* (Bangalore), XXIX (1938).—ED.]

[1] This does not, as might at first sight be supposed, make of Brahman a material cause of the world, but an apparitional cause. Skr. *vana*, "wood," like Gk. ὕλη, is neither "matter" nor "nature" in the modern sense of these words. In the Indian tradition, the world is a theophany, and "that which fills space" and by which the Brahman enters into the world is "form and phenomenon" (*nāma-rūpa*, as in ŚB XI.2.3.4 and 5): it is by these powers of denomination and appearance that the divine possibilities of manifestation are expressed and can be apprehended in the dimensioned cosmos. In other words, the process of "creation" is a "measuring out" (root *mā*) of these possibilities; in this sense the divine procession is *per artem*. The word *mātrā*, "measure," corresponds etymologically to "matter," but not to the modern concept of matter, which concept is altogether foreign to the Philosophia Perennis. *Mātrā* (explained by Sāyaṇa as *svarūpam*, "own appearance," in his Introduction to RV) corresponds almost exactly to "number" as characteris-tic of "species" in Scholastic philosophy.

VI.3,15,36, etc.), Brahma-tree is necessarily to be considered from the same point of view; in other words, either as rooted in the dark ground of the Godhead and as standing up and branching out in the manifested Cosmos, and therefore inverted, or as consisting of a continuous stem having two parts, of which one extends as the Axis of the Universe from Earth to Heaven, while the other branches above the roof of the world in Paradise.[2] In accordance with RV x.121.2 "His shadow is both of death and of immortality," we can identify these "parts" of the Tree with the Tree of Death and Tree of Life of other traditions.

A twofold division, cosmic and supracosmic, of the Axial Column is clearly enunciated in AV x.7.3, where the *skambha* (in which the Devas inhere "like branches of a tree about its trunk," the solar Tree in which the Brahman-Yakṣa moves on the face of the waters, *ibid.*, 38) is fourfold, three of its members (*aṇga*) corresponding to earth, air, and sky (the three worlds of the cosmos), while the fourth "stands beyond the sky" (*tiṣṭhaty uttaraṃ divaḥ*). This division is already explicit in RV x.90.3–4, where the Person's "one foot is all beings,[3] and three feet immortality in heaven (*amṛtaṃ divi*); with three feet he is up above (*ūrdhvaḥ*), one foot of him is that which is born repeatedly (*abhavat punaḥ*)," and repeated in MU VII.11.8, where the Brahman "moves (*carati*) with one foot in the three (stations), and with three in the higher (*uttare*)," of which the "fourth" station, "beyond that of sleep" (*suptāt paraḥ*), is the "greatest" (*mahattaram*).[4] This involves, of course, the usual trinitarian arrangement

[2] This is, of course, the situation depicted in hypaethral tree-shrines; see Coomaraswamy, "Early Indian Architecture: I. Cities and City Gates, II. Bodhi-gharas," 1930. In the same way, "King Volsung let build a noble hall in such wise, that a big oak tree stood therein, and that the limbs of the tree blossomed far out over the roof of the hall, while below stood the trunk within it, and the said tree did men call Branstock" (*Völsunga Saga*, trans. Magnusson and Morris, ch. 2; observe that "Branstock" = "Burning Bush"). In the same way, in the Shaman tree-shrines, the top of the Tree projects through an opening in the roof, through which it is possible to pass from one world to another (Uno Holmberg, "Der Baum des Lebens," *Annales Academiae Scientiarum Fennicae*, XVI, 1922–23, 28, 30, 142), which "luffer" is the same as the "Sundoor" of the Vedic tradition.

[3] The "one foot" of the Sun as Aja Ekapad, e.g., in RV VIII.41.8, where Varuṇa "with his bright foot ascends the vault, with the Pillar holds apart the paired spheres, upholds the sky" (*arcinā padā nākam ā aruhat skambhena vi rodasī ajo na dyām adhārayat*). The Ātman thus by means of its rays, "proceeds multifariously born" (*carati bahudhā jāyamānaḥ*, Muṇḍ. Up. II.2.6); and it is thus "with the Eye (Sun) that the Person ranges (*carati*) all measured things" (*mātrāḥ*, MU VI.6).

[4] Or better, "beyond the Great," i.e., beyond the Sun, cf. KU III.11, *mahat-param avyaktam*, and VI.7, *mahato 'vyaktam uttatam*.

of the Brahman, which makes of the proceeding deity Three Persons (Agni, Indra-Vāyu, Āditya) and of the transcendent deity One Principle in whom the distinction of these Persons is lost.[5]

Thought of, then, as Pillar or Tree, the Person, Brahman, Prajāpati, stands in part within the cosmos and in what is a greater part also out beyond the sky. AV x.7.10 asks where in the Pillar are these parts, "the Existent and the Nonexistent" (*asac ca yatra sac cānta skambham, tam brūhi*).[6] The answer follows in verse 21, "The (higher)[7] kindreds know

[5] The fourfold arrangement is made in two different ways. The All-whole, That One, is triple within the cosmos and single beyond. On the other hand, it is only with one foot or part, a fraction (*aṃśa*, BG xv.7) as it were of the whole of the Divine Being, that he moves in the Three Worlds, and with three feet or parts, that is to say the major part, that he transcends these worlds. That infinite "part" of the Divine Being which is insusceptible of manifestation includes, but also exceeds that finite "part" which can be manifested: the Whole consisting therefore both of a known and an unknown, shown and unshown, *vyaktāvyaktam.* [Cf. JUB 1.33.9, with reference to the fourfold sun.]

[6] In the beginning, when there is as yet no differentiation of cosmic space (*rajas*) from the Empyrean (*vyoma*), or day from night ("Mitra is the day, Varuṇa the night," PB xxv.10.10), there is in the same way no distinction of an Existent from a Nonexistent, but only That One (*nāsad āsīn no sad āsīt . . . āsīt . . . tad ekam,* RV x.129, 2–3) "not to be spoken of as either the Existent or the Non-existent" (*na sai tan nāsad ucyate,* BG xiii.12), because It is beyond all alternatives. In the same way RV x.5.7, where Agni (Vanaspati, "Lord of Trees," RV *passim*) is *sadasat* in the Empyrean; Brahman, *sadasat* in Muṇḍ. Up. ii.2.1, and Prāṇa in Praśna Up. ii.5–6.

On the other hand, when the Universe comes into existence, and a logical distinction of the Existent from the Nonexistent supervenes, this "Existent is born of the Nonexistent" (RV x.72.2, *asataḥ sad ajāyata,* echoed in TU ii.7, *asat . . . tato vai sad ajāyata*); or as St. Thomas Aquinas expresses it, *Sum. Theol.* i.45.1c, "*oportet considerare . . . emanationem . . . totius entis a causa universali, quae est Deus . . . ita creatio, quae est emanatio totius esse, est ex non ente, quod est nihil.*" Cf. also Charlotte Baynes, *Coptic Gnostic Treatise* (Cambridge, 1933), p. 51, "The seventh Deep is the Door of Nonbeing, from out of it came forth all Being"; and the teaching of Basilides, reported by Hippolytus, "Thus the Nonexistent God made the cosmos out of the Nonexistent" [*Philosophumena; or, the Refutation of All Heresies,* tr. F. Legge (London and New York, 1921), vii.21; cf. *Mathnawī* v.1026].

[7] "Higher" we take from verse 25, *paro janāḥ,* whereas in Sāyaṇa's comment on RV x.129.1, *paras = parastād uparideśe.* The intended contrast of (*paro*) *janā viduh* in the first line with *manyante 'vare janāḥ* in the second line is conspicuous: it is the usual distinction of what is *parokṣa* from what is *pratyakṣa*—what the gods know in principle, men know only in fact. The distinction thus drawn is emphasized in JUB iv.18.6, where the Brahman is "not that which men worship here" (*nedaṃ yad idam upāsate*), though "even as men worship him, so he becometh" (*yathopāsate tad eva bhavati,* ŚB x.5.2.20, cf. RV v.44.6). Cf. MU iv.5, "These [Agni, Vāyu, Āditya, etc.] are the preeminent forms of the immortal, unembodied Brahman. . . . These one should meditate upon and praise, but then deny. For

the steadfast Nonexistent bough as the supernal; those below who worship this thy bough are aware of it as the Existent" (*asac-chākhām pratiṣṭhantim paramam iva janā viduḥ; uto san manyante'vare ye te śākhām upāsate*),[8] and verse 25, "The higher kindreds call that One limb of the Pillar the Nonexistent" (*ekaṃ tad aṇgaṃ skambhasyāsad āhuḥ paro janāḥ*);[9] verse 26 substitutes "Ancient" (*purāṇam*) for "Nonexistent" (*asat*). We defer the question of whether the lower part of the Pillar must be thought of as inverted with respect to the higher, but call attention to the fact that the Pillar, in its lower and cosmic extension, may properly be called a "Tree of the knowledge of good and evil," for as MU vii.11.8 (cited above) continues, "The twofold nature (*dvaitībhāva*) of the Great Spirit (*mahātmanaḥ*, the Sun) is for the sake of experiencing both the true and the false (*satyānṛtōpabhogārthaḥ*)," by which "true and false" are clearly denoted the two worlds, respectively celestial and infrasolar, immortal and mortal, designated in ŚB 1.9.3.23 as superhuman (*amānuṣa*

by these one moves higher and higher in the worlds. But in the universal dissolution he attains the unity of the Person, yea, of the Person"; and *Sum. Theol.* iii.92.1 and 3, "Our most perfect knowledge of Him as wayfarers is to know that He is above all that our intellect can conceive, and thus we are united to Him as to something unknown."

Those to whom the designation *naicaśākha* is applied in RV iii.53.14 are probably the same as the *avare ye te śākhām upāsate* of AV x.7.21, i.e., "mortals here below" as contrasted with the (*paro*) *janāḥ* and *devā . . . paro panāḥ* of AV x.7.21 and 25.

[8] For Whitney, AV x.7.21 is a "highly obscure verse," chiefly because, as usual, he makes no effort whatever to understand it; he does not even take the trouble to consider it in connection with other verses of the hymn in which it occurs, much less to refer to such texts as RV viii.41.8. It would have been too much, perhaps, to expect of Whitney, whose knowledge of metaphysics seems to have been nil, to equate Vedic *skambha* with Greek *stauros*, or Germanic *irminsūl*, or to refer to the universal doctrine of the Axis of the Universe, which is so fully illustrated in the Vedic tradition. He has at least the grace to call his version "only mechanical."

With AV x.7.21 may be compared Chuang-tzu, ch. 1, "Now if you have a big tree and are at a loss what to do with it, why not plant it in the domain of nonexistence, whither you might betake yourself to inaction by its side, to blissful repose beneath its shade?"

[9] Evidently related to AV x.7 as cited, with its distinction of two "branches" and two kindreds (*paro janāḥ* and *avare ye*), is TS 1.3.5, "I have found thee [the Tree to be felled as sacrificial post] hitherward with respect to the yonder kindreds, but yonder with respect to those here below" (*arvāk tvā parair avindan, paro 'varais tvā*, understanding *janaiḥ* after *paraiḥ* and *avaraiḥ*), the sense being that although it is an "existent" tree that is actually felled, it represents the "nonexistent branch" to those of the *avare ye te śākhām upāsate* who understand. [Cf. *Mathnawi* v.1026.]

= *daivya*) and human (*mānuṣa*), true (*satyam*) and false (*anṛtam*); cf. the distinction in CU viii.3.1 of true desires (*satyāḥ kāmāḥ*) and these same desires "falsified" (*anṛtāpidhānāḥ*), the former to be found by going "there," the latter those that men pursue "here." Indeed, it follows inevitably from the doctrine of "one essence and two natures" attributed to Varuṇa, Agni, or Brahman throughout the Vedic tradition, that insofar as the Deity is represented by a Tree, this can only be thought of either as a single Tree to which the contrasted aspects of the Deity are, as in RV 1.164.20, differently related, or as two different Trees, respectively cosmic and supracosmic, manifested and unmanifested, but indwelt throughout by the single Brahman-Yakṣa.

This duality is explicit in connection with the *palāśa* (tree or leaf),[10] expressly identified with the Brahman in ŚB 1.3.3.9, vi.6.3.7, and vii.1.1.5. In JUB 1.20.3, we find that just as heaven and earth are represented by the two wheels of the solar chariot, separated and connected by their common axle-tree (*akṣa*; the "separating breath," *vyāna* of RV x.85.12 and ŚB vii.1.2.21), so they are represented by "two *palāśas*," pillared apart by their common stem or trunk (*yathā kāṣṭhena palāśe viṣkabdhe syātām*,[11] *akṣeṇa vā cakrāv, evam etena [antarikṣeṇa*][12] *imau lokau viṣkabdhau*); and this is quite in accordance with RV x.135.1, where Yama's suprasolar Paradise is "in a fair *palāśa* tree" (*vṛkṣe supalāśe*), evidently the same as the *aśvattha* of AV v.4.3. Yama's *supalāśa* is the higher of the "two *palāśas*" of the *Jaiminīya Upaniṣad Brāhmaṇa*. The memory of these two *palāśas*, or twofold *palāśa*, seems to be preserved in the name of the *Dūipalāsa cēiya*, a famous *yakṣa* shrine referred to in the *Uvāsaga Dasāo* 3.[13]

The problem presents itself again in connection with the Soma as Tree of Life. For of "the immortal nectar hid in heaven" (*divi . . . amṛtaṃ*

[10] *Palāśa* may mean either "tree" or "leaf"; if the latter, we should render in RV x.135.1 "in a fair-leaved tree," and understand in JUB "two leafy [trees]."

[11] It is no doubt from the same point of view that in TS vi.2.8.3, the enclosing sticks are made of *palāśa* "for the holding apart of these worlds." For *kāṣṭhā* as "goal post" see TS 1.7.8.2, PB ix.1.35, and KU iii.11.

[12] Heaven and Earth, originally together, are separated in the beginning by that which intervenes, viz. the cosmic space, equally a fiery, pneumatic, and luminous principle. JUB explains *antarikṣa* by *antary-akṣa* ("inter-axle," or "inter-eye"), ŚB vii.1.2.23 by *antarā īkṣa* ("inter-sight"). "Inter-eye," of course, because Sun is the "Eye" (of the "needle") whose spiritual rays, pillars, or feet, are axes at the same time separating and connecting Heaven and Earth, Knower and Known.

[13] *Dūipalāse* corresponding to the (*dve*) *palāśe* of JUB. *Dūipalāsa* also occurs in the alternative form *Dūtipalāsa*, where we assume a connection with Skr. *dvita* or Pali *dutiya* rather than with *dūti* as "messenger"; cf. Hermann Jacobi, "Kalpa Sūtra," in *Abh. für die Kunde des Morgenlandes*, VII (1879), 124, n. 47.

nigūḷham, RV vi.44.23–24), "that which the Brahmans know as Soma, nonesoever drinks on earth" (RV x.85.3–4), but on the contrary, of various substitutes, notably the *nyagrodha* (pippal): in AB vii.31, "The *nyagrodha* is metaphysically (*parokṣam*) king Soma; metaphysically [transubstantially] the Temporal power (*kṣatriya*) attains to the form of the Spiritual power (*brahmaṇo rūpam upanigacchati*) by means of the priest, the initiation, and the invitation"; similarly KB xii.5, where the Sacrificer (if himself a priest) partakes of Soma "mentally, visually, aurally," etc., and "thus by him yonder Soma, the king, the discerning, the moon, the food is eaten, that food yonder that the Devas eat." We have thus to do with a Soma up above, and another "Soma" here below; the former is partaken of only transubstantially.

The Avestan tradition also knows of two Haoma trees, a white and a yellow, heavenly and earthly; the relevant texts are collected in W. H. Ward, *Seal Cylinders of Western Asia* (Washington, D.C., 1910), pp. 232–236. The Gokart or Gaokarena, the White Haoma risen from the midst of the sea Vouro-kash,[14] where it sprang up on the first day, is the Tree of the solar Eagle (*soena* or *sīmurgh*, corresponding to the Indian *śyena*, *garuḍa*, *suparṇa*); it is sometimes confused with and sometimes distinguished from the "Tree of All Seeds" which grows beside it (there is no hint of an inversion), of which the seeds, sent down with the rain, are the germs of all living things. The notion of a "Tree of All Seeds"[15] corresponds to the Indian conception of the Tree or Pillar as a single form in which all other principles inhere (RV x.82.6; AV x.7.38, etc.). In the old Semitic tradition, likewise, viz., in Genesis 3, a distinction is made between two Trees, respectively of the "Knowledge of Good and Evil," and of "Life"; man, having eaten of the former, is driven out of the Garden of Eden, the gate of which is defended against him by Cherubim and a "flaming sword which turned every way, to keep the way of the Tree of Life." Both of these Trees are "in the midst of the garden" (Gen. 2:9), which is as much as to say "at the navel of the earth." One is tempted to ask if these Trees are not in reality one, a Tree of Life for those who do not eat of its fruits and a tree of life-and-death for those who do; just as in RV 1.164.20, the Tree is one (*samānaṃ vṛkṣam*), and of the Eagles there is one that is all-seeing, and another who "eats of the fruit" (*pippa-*

[14] The Indian Tree grows likewise in the midst of ocean (RV 1.182.7, *vṛkṣo niṣṭhito madhye arṇasaḥ*).

[15] In *Purgatorio* xxvii.118–19, the Earthly Paradise is described as "full of every seed" (*d'ogni semenza è piena*), the origin of such plants as can grow here below.

lam atti). The words of verse 22, "upon its top, they say, the fig is sweet; none getteth it who knoweth not the Father," imply (what is explicit elsewhere in connection with the rites of climbing)[16] that all the difference between life-and-death on the one hand and Eternal Life on the other can be expressed in terms of eating of the fruits of the lower branches, and of the fruit that is only for the Comprehensor who reaches the "top of the tree."[17]

The *Zohar* (Shelah Lecha) distinguishes the Trees as higher and lower: "Observe that there are two Trees,[18] one higher and one lower, in the one of which is life and in the other death, and he who confuses them brings death upon himself in this world and has no portion in the world to come." These Trees are nevertheless so closely related that a transmutation can be effected: "This verse (Prov. 11:24) testifies that whoever gives

[16] AB IV.20–21; JUB III.13; PB XVIII.10.10; on climbing, see ŚB V.2.1.5 ff. We propose to deal with the climbing rites (Vedic and Shamanistic) on another occasion: cf. Coomaraswamy, "Pilgrim's Way," 1937, and "*Svayamātṛṇṇā*: Janua Coeli" [in this volume—ED.].

[17] These are also the implications of KU III.1, *ṛtam pibantau . . . parame parārdhe*, considered in connection with RV x.135.1, *vṛkṣe supalāśe devaiḥ sampibate yamuḥ*; RV I.164.12 *pitaram . . . diva āhuḥ pare ardhe puriṣinam*; and ŚB XI.2.3.3, where the Brahman, having completed his creative activity, *parārdham agacchat* = "rested on the seventh day."

[18] The vertical trunk or axis of the Kabbalistic Tree of the "Ten Splendors" directly connects the highest (Kether) with the lowest (Malkuth). The latter corresponds to all that is implied by "Field" (*kṣetra*) and "Lotus" in the Vedic tradition, and is "in a sense external to the system of which it is the last member"; it is its reflection. When we represent the Sephirotic system as the Man, Malkuth is "under his feet" (*Le Voile d'Isis*, XXXV, 1930, 852). The sixth Splendor (Tifereth) occupies a position on the vertical axis corresponding to the "heart" of the Man (and to the "nail of the Cross" in the Acts of Peter); it is from this point and level that the "branches" (the contrasted fourth and fifth, and seventh and eighth Splendors) are extended. This sixth Splendor (Tifereth, "Beauty") thus corresponds to the Sun, what is above it being supracosmic, and what below infrasolar and cosmic. The ninth Splendor is represented by that lower part of the vertical axis which is in immediate contact with Malkuth (it answers there to the point of Indra's *vajra* and of the Grail "lance"); "[elle] correspond, en effet, à l'organe générateur mâle, qui projette dans la réalisation effective les germes de toute chose" (*ibid.*, p. 851; cf. the Avestan "Tree of all seeds"). For a representation of this "Tree" see *Le Voile d'Isis*, XXXVIII (1933), 230. From this summary description it may be inferred that the upper part of the Tree (above Tifereth) being erect, the lower part (extending downwards from Tifereth to Malkuth, i.e., Sun to Moon = Earth) is inverted or "reflected," and understood very clearly just how it is that whoever confuses the higher with the lower part "brings death upon himself in this world" (all that is under the Sun being in the power of Death, ŚB II.3.3.7, etc.). For some further details see *Zohar*, V, 401–404. As remarked by A. E. Crawley (*The Tree of Life*, London, 1905, p. viii) "Later ages . . . have, in more senses than one, made an error of identification, and have taken the Tree of Knowledge for the Tree of Life."

to the poor induces the Tree of Life to add of itself to the Tree of Death, so that life and joy prevail on high, and so that that man, whenever in need, has the Tree of Life to stand by him and the Tree of Death to shield him" (*Zohar*, Beha 'Alotheka).[19] The two Trees are also contrasted as follows: "All over-souls emanate from a high and mighty Tree . . . and all spirits from another and smaller Tree . . . when these unite, they shine with a celestial light. . . . For the feminine is in the image of the small Tree . . . the lower, feminine Tree, and had to receive life from another Tree. . . . When the Holy One grants the sinner grace and strength to accomplish his return to righteousness . . . the man himself (who as a sinner had been 'dead') is truly and perfectly alive, being joined to the Tree of Life. And, being united with the Tree of Life, he is called 'a man of repentance' for he is become a member of the Community of Israel"[20] (*Zohar*, Mishpatim, III, 303–324).[21]

[19] Again it is implied that the two Trees are really one, that is to say of one essence and two natures, like His "whose shadow is both of death and of immortality" (RV x.121.2), who "both separates and unifies" (AĀ iii.2.3), "gathers together and divides" (RV ii.24.9), "kills and makes alive" (Deut. 32:9). If "he who confuses them [i.e., the two natures] brings death upon himself and has no portion in the world to come," the same will apply to the dualist who makes of "evil" an essence independent of the "good"; and the converse will apply to one who recognizes in both natures a single essence, that of the "simplex Yakṣa" of AV viii.9.26.

The *Sanatsujātīya* (*Udyoga Parva* 45.1762), combining the thought of RV x.27.24, x.121.2, x.129.2, and AV xi.4.21, reads "The Gander, ascending, does not withdraw his one foot from the sea, and were he to lift that outstretched [ray], there would be neither death nor immortality" (*ekam padam notkṣipati saliladd-hamsa uccaran, tān cet satatam ūrddhvāya na mṛtyur nāmṛtam bhavet*): it would be as it was in the beginning, when *na mṛtyur āsīd amṛtam na tarhi na rātryā ahu āsīd praketah* (x.129.2). This makes it clear that the *praketa* of death and immortality, of night and day in x.129.2, is the same thing as the one foot of the Gander, Sūrya Ekapad, and as that Sun-pillar or Sun-tree which is implied by the *sa dādhāra pṛthivīṃ dyām vtêmām* of x.121.1 (cf. AV 41.8), and of which the "shadow" is of immortality and death, *yasya chāyāmṛtam yasya mṛtyuh*, in x.121.2. All these are forms of the Axis of the Universe, thought of as a Tree by which the very existence of the cosmos is maintained. This at the same time throws a further light on the value of *chāyā* as "shelter" (especially from scorching heat) in RV *passim* (see Coomaraswamy, "*Chāyā*," 1935, and cf. ŚB viii.7.3.13, "for in His shadow is all this universe"). Finally, let us not forget that "shadow" (*chāyā*) also means "reflected image," as in *Gopatha Brāhmana* 1.3, where the Brahman-Yakṣa looks down into the waters and sees his own reflection (*chāyām*) in them, and that a reflected image is, strictly speaking, an inverted image.

[20] In Christian terms, a member of the Mystical Body of Christ, σταυρός, *ipso summo angulari lapide . . . in quo et vos coedificamini*, Eph. 11:20; *skambha* as in AV x.7.

[21] In conclusion of what has been said regarding the tradition of two Trees in Western Asia, attention may be called to at least one apparently quite clear representation of superimposed Trees, on an Assyrian seal; this is No. 589 in Léon

Before proceeding to a more detailed account of the Inverted Tree as described in the Indian texts (and elsewhere), a few words may be said on the two names by which the Tree is commonly referred to: *aśvattha* (*ficus religiosa, pippala*) and *nyagrodha* (*ficus indica, vaṭa*, banyan).[22] The word *Aśvattha* is understood to mean the "Station of the Horse" (*aśva-stha*), the Horse being Agni and/or the Sun; that this is the proper interpretation is placed almost beyond doubt by the repeated expression "as unto the standing horse" (*aśvayeva tiṣṭhante*), with reference to offerings made to Agni kindled at the navel of the earth[23]—e.g., in TS iv.1.10,

Legrain, *Culture of the Babylonians* (Philadelphia, 1925), pl. 30, and is described by him as "a tree of life, in form of a double palm tree," p. 303. Something of the same kind is suggested by the Phoenician Tree in G. Ward, *Seal Cylinders of Western Asia* (1910), fig. 708. An excellent example can also be cited in Phyllis Ackerman, *Three Early Sixteenth Century Tapestries, with a Discussion of the History of the Tree of Life* (New York, 1923), pl. 40b; cf. pl. 37c and the types on pl. 38. Cf. also the inverted tree supported by two lions, represented on an Islamic slab, now in the Byzantine Museum at Athens [illustrated in D. T. Rice, "Iranian Elements in Byzantine Art," *III Congrès international d'art et d'archéologie iraniens, Mémoirs* (Leningrad, 1935), pl. XCIII].

[22] We are considering here only the principal designations of the Tree of Life, which can also be thought of as *palāśa, udumbara, plakṣa*, or even as a "plant" (*oṣadhi*) or "reed" (*vetasa*, notably in RV iv.58.5, "A golden reed in the midst of the streams of ghee," TS iv.2.9.6 adding, "Therein an eagle sitteth, a bee, nested, apportioning honey," etc. In TS v.4.4.2, this reed is "the flower of the waters," *etar puṣpam yai vetaso'pām*: evidently, then, that "flower of the waters" wherein gods and men inhere like spokes in a nave (AV x.8.34) and the trunk of the Tree of AV x.7.38. Closely related to these references is the phallic *vaitasena* of RV x.95.5 = *śūcyā* of ii.32.4. (In *Elements of Buddhist Iconography*, 1935, p. 33, I misunderstood the "flower of the waters" to be the lotus.)

As remarked by E. W. Hopkins (*Epic Mythology*, Strasbourg, 1915, p. 7), "The *Aśvattha* is the chief of trees (it represents the life-tree) and typifies that tree of life which is rooted in God above (Mbh vi.34.26; 39.1 ff.)." The *Aśvattha* is represented already on seals of the Indus Valley culture, cf. Sir John Marshall, *Mohenjodaro and the Indus Civilization* (London, 1931), I, 63–66. On one seal the tree is guarded by dragons which emerge from the stem; another is an epiphany, the deity being seen within the body of the tree itself.

[23] The steed (Agni as racer, TS ii.2.4.6) or steeds (Indra's in TS i.7.8.2) is or are probably thought of as standing and at rest when the race has been run and the Navel of the Earth and Axis of the Universe have been reached. Numerous texts speak of the "unyoking" of the horses of the chariot of the deities when the altar has been reached. In TS v.5.10.6, "If one yokes Agni and does not unloose him, then just as a horse that is yoked and not loosed, being hungry, is overcome, so is fire overcome . . . he loosens him and gives him fodder"; iv.2.5.3, "being loosed, eat" (*addhi pramuktah*); and iv.1.10.1, "For him as fodder to a stalled horse (*aśvāyeva tiṣṭhante ghāmam asmai*) . . . kindled on earth's navel, Agni." Cf. also ŚB iii.6.2.5,

"bearing for him as fodder to a stalled horse . . . kindled on earth's navel, Agni we invoke" (*asvāyèva tiṣṭhante ghāmam asmai . . . nābhā pṛthivyā samidhānam agnim . . . havāmahe*), and similarly AV III.15.8, VS XI.75, ŚB VI.6.3.8—and from the fact that *aśvattha* is a designation of the solar Viṣṇu in the *Mahābhārata* (E. W. Hopkins, *Epic Mythology*, Strasbourg, 1915, pp. 6–7 and 208–209). *Nyagrodha* means "downward growing" not merely insofar as this is actually represented by the growth of aerial roots, but because the Tree itself is thought of as inverted, as is clear from AB VII.30, where the bowls which the Devas "tilted over (*nyubjan*); they became the *nyagrodha* trees. Even today in Kurukṣetra men call these [trees] '*nyubjas*.' They were the first-born of *nyagrodhas*; from them are the others born. In that they grew downwards, and accordingly the *nyagrodha* 'grows downwards,' and its name is '*nyagrodha*' being *nyagroha* ['growing downwards'], the Devas call it *nyagrodha* parabolically." This explanation recurs in ŚB XIII.2.7.3.

" 'A white horse (*aśvaḥ*) stands by a stake (*sthānau*)': the white horse is Agni, the stake the sacrificial post."

In TS 1.7.8.2, the racing steeds are urged (*kāṣṭhām gacchatu*) to reach the goal post (*kāṣṭhā*; cf. KU III.11, *puruṣān na param kiñcit, sā kāṣṭhā sā parā gatiḥ*, with VI.1, *aśvatthaḥ sanātanaḥ . . . tad u nātyeti kaścana, etat vai tat*, implying an equation of the Tree with the Person), which goal post (*kāṣṭhā*) as the trunk of the "two *palāśas*" is synonymous with the Axis of the Universe (JUB 1.20.3); in PB IX.1.35, "They made the Sun their goal (*kāṣṭhām*)." In all these expressions *kāṣṭhā* is "goal post" in the same sense that Jupiter (*dyaus-pitṛ*) is "Terminus."

It may be noted, too, that it is likewise at the Navel of the Earth and foot of the World Tree that the Buddha attains his goal. Jesus is born in a stable (or, rather, cave), and laid on straw in a manger, which correspond to the strewn altar of the Vedic tradition. The identity of "stable" (as place where horses are unsaddled and fed) and "stable" (= firm), of "crib" (as manger) and "crib" (as cradle), and common derivation of "stallion," "stall" (as loose-box), "installation," and "stele" (as pillar and turning-post) are significant for the associations of ideas involved in "*aśvattha*." In the Horse sacrifice the stable put up for the horse near the offering place is made of *aśvattha* wood (see ŚB XIII.4.3.5 and n. 2).

Cf. also TB III.8.12.2, where the *Aśvattha* is described as the abiding place of (Agni) Prajāpati: "The stable is made of *aśvattha*-wood (*aśvattho vrajo bhavati*); [for when] Prajāpati vanished from the Devas, he assumed the form of a horse and stood for a year in (or at) the *Aśvattha*, and that is why its name is *aśva-ttha*."

With "*aśvattha*" explained as above, cf. "Rosspfahl des Obergottes Ürün-ai-tojon" ("horse-post of the High-god Ürün-ai-Tojon") as a designation of the Tree of which the roots strike deep into the Earth and summit pierces the seven heavens, in the Yakut saga cited by Holmberg, "Der Baum des Lebens," p. 58. For the association of horse with tree in China, see Carl Hentze, *Frühchinesische Bronzen- und Kulturdarstellungen* (Antwerp, 1937), pp. 123–130 (*Lebensbaum, Himmelsbaum, Sonnenbaum; Pferd und Pferdegottheit*).

In every country the World-tree is of a species proper to the country in which the tradition has been localized—for example, in Scandinavia an oak, and for Dante an apple. In Siberia the Tree is a birch: this birch is set up in hypaethral shrines comparable to the Buddhist *bodhi-gharas*, it is called significantly the "Door god," and there are climbing rites analogous to those of the Brāhmaṇas and Saṃhitās.[24] The idea of an erect and of an inverted Tree is met with over a range of time and space extending from Plato to Dante and Siberia to India and Melanesia. Most likely the proto-Vedic tradition already knew of both. In this case it might be supposed that in India the *aśvattha* was taken to be the type of the erect, and the *nyagrodha*, because of its downward-striking aerial roots, as the type of the inverted Tree. The *akṣaya-vaṭa* at Bodhgayā is, however, not an *aśvattha*, but a *nyagrodha*; the Pāli texts refer to the Bodhi-tree now as *asattha*, and now as *nigrodha*; the Tree in Buddhist art and existing shrines is an *aśvattha*; and the Inverted Tree of KU VI.1 and similar texts is specifically spoken of as the "One *Aśvattha*." In other words, the Trees are not clearly distinguished in practice; and if the distinction of meaning so admirably made in the two names *aśvattha* and *nyagrodha* continued to be felt, it must have been rather within an esoteric doctrine than publicly. That the doctrine of the Inverted Tree has always been an esoteric doctrine is far from unlikely; this is, indeed, suggested by AB VII.30, where the meaning of the ritual is evidently a "mystery," and also by what has been said of Soma above, cf. RV 1.139.2, where it is a matter of "seeing the golden," i.e., the immortal, "with these our eyes, the eyes of Soma," which "eyes" are those of "contemplation and intellect" (*dhī* and *manas*) and, in AB II.32, "silent praise."

We turn now to a consideration of the texts in which the Inverted Tree, of whatever species, is described as such. RV 1.24.7 is explicit: "In the unground [air] King Varuṇa, Pure power, upholds the Tree's crest (*vanasya stūpaṃ*); its ground is up above; [its branches] are below;[25] may their banners [or oriflammes] be planted deep in us" (*abudhne rājā varuṇo vanasyōrdhvaṃ stūpaṃ dadate pūtadakṣaḥ; nīcīnāḥ sthur upari budhna eṣām asme antar nihitāḥ ketavaḥ syuḥ*). For the word *stūpa*, cf. RV VII.2.1, where we have, addressed to Agni, "touch heaven's summit with thy crests (*stūpaiḥ*), overspread it with the rays of the sun," and the epithets *hiraṇya-*

[24] See Holmberg, "Der Baum des Lebens."

[25] We infer from RV III.53.14, *naicāśākham*, and AV x.7.21, *avare ye te śākhām upāsate*, that by *nīcīnāḥ* are to be understood *nīcīnāḥ śākhāḥ*.

stūpa and *aruṣa-stūpa* applied to Agni in x.149.5 and iii.29.3. In VS ii.2, *viṣṇo stūpaḥ* is certainly "Viṣṇu's crest" (*śikhā*); see TS 1.1.11.1 and ŚB 1.3.3.5. The Tree, then, hangs from overhead downwards. At the same time, a distinction of crown from trunk is not essential: the Tree is a fiery pillar as seen from below, a solar pillar as from above, and a pneumatic pillar throughout; it is a Tree of Light,[26] most like that of the Zohar to be cited presently.

Sāyaṇa rightly understands that the Tree is a "Burning Bush":[27] the *ketavaḥ* are "rays" (*raśmayaḥ*) and "breaths of life" (*prāṇaḥ*), the *stūpa* an "aggregate of fiery energy" (*tejasaḥ saṃgham*). That the rays tend downwards is in accordance with the often emphasized fact that the rays of the Sun strike downwards; cf. ŚB vii.4.1.18, where the gold plate representing the solar Orb is laid down "so as to look hitherwards" (*arvāñcam*). In other words, the rays, thought of as the branches of a Tree of which the root is up above, spread downwards; while if we think of the flames as the branches of a Tree rising from a root below (Agni as Vanaspati), then all these flames rise upward (RV iii.8.11, "Arise, Vanaspati, a hundred branched," *vanaspate śatavalśo vi roha*), their axial flame reaching and lighting up the Sun himself. In the same way, if we consider the "breaths," which are the "rays" in their pneumatic aspect: the Sun, or solar Fire is the "Breath" (*prāṇa*), and it is because he "kisses" (breathes upon) all his children that each can say "I am,"[28] being thus inspired, while Agni

[26] For the Sun as itself the Pillar that holds apart these worlds, cf. RV vi.86.1; viii.41.10; x.17.11; x.121.1, etc., and JUB 1.10.9, *sthūnaṃ divastambhanīṃ sūryam āhuḥ*. For the pillar as of Fire or Smoke, RV 1.59.1, *sthūnā iva*; iv.13.5, *divaḥ skambha samṛtaḥ pāti nākam*; iv.6.2, *metā iva dhumaṃ stabhāyad upa dyām*, etc.

[27] With this aspect of the Tree, so conspicuous in the Vedic (as also in the Christian) tradition, we propose to deal more fully upon another occasion, only remarking here that, in RV, Agni is typically Vanaspati.

[28] This very beautiful passage involves the *sūtrātman* doctrine (RV 1.115.1; AV x.8.38; ŚB viii.7.3.10; BU iii.7.2; BG vii.7, etc.), according to which all worlds and all beings are connected with the Sun, literally in one vast conspiracy. It is in the same way that the Sun horse is made to kiss the Self-perforated bricks, thereby endowing them with life (*aśvam upaghrapayati, prāṇam evasya dadhāti*, TS v.2.8.1; 3.2.2, and 3.7.4). The sniff-kiss (see E. W. Hopkins in JAOS, XXVIII, 1907, 120–134), a breathing on rather than a "smelling of," is undoubtedly an "imitation" of the Sun-kiss, and in the same way a communication. It is, finally, from the same point of view that we have to understand the apparently strange *apānena hi gandhān jighrati* of JUB 1.60.5 and BU iii.2.2: it is the Spirit within us that smells in us, rather than the nose itself that smells, just as it is the Spirit, and not the retina, that really sees in us; the sense powers (*indriyāṇi*), often spoken of as breaths (*prāṇaḥ*) moving outwards from within to objects, which are only cognizable because foreknown (*nahi prajñāpetā . . . prajñatavyaṃ prajñāyeta*, Kauṣ. Up. iii.7).

is the "breathing up" (*udāna*) or aspiration, and these two are separated and connected by the "separating breath" (*vyāna*); these three breathings together make up the whole of what is called "spiration" (*prāṇa*), the "whole Spirit" (*sarva ātmā*) of Prajāpati (ŚB VII.1.2.21 and VII.3.2.12–13). The World-tree thus inevitably burns or lightens at the same time upwards or downwards according to *our* point of view, which may be either as from below or as from above. The same can be expressed in another way in connection with the rites of climbing: where, just as "the Devas then traversed these worlds by means of the 'Universal lights' (*viśvajyotibhiḥ*, i.e., by means of Agni, Vāyu and Āditya,[29] as 'stepping-stones' or 'rungs,' *samyānyaḥ*),[30] both from hence upwards and from above downwards (*cordhavānaṃ cārvācaḥ*), even so does the Sacrificer now. . . ." (ŚB VIII.7.1.23; cf. TS V.3.10); for example, "Even as one would keep ascending a tree by steps (*ākramaṇair ākramāṇaḥ*; cf. TS VI.6.4.1), even so . . . he keeps ascending these worlds" (*imān lokān rohan eti*, JUB I.3.2); "he mounts the difficult mounting (*dūrohaṇaṃ rohati*)," reaching Heaven, and again "descends as one holding onto a branch" (*pratyavarohati yathā śākhāṃ dhāramāṇayaḥ*) until he is reestablished on earth (AB IV.21),[31] or, to express this in terms of AV X.7.21 (cited above), returns from Non-existence to Existence, or using those of ŚB I.9.3.23, from the superhuman and true to the human and false plane of being.

The important text AV X.7.38 (cf. also RV X.82.6) describes the procession of the (Brahman-) Yakṣa: "A great Yakṣa at the center of the world, proceeding in a glowing (i.e., as the Sun) on the back (i.e., surface) of the ocean, therein are set the Deities, as it were branches round about the Tree's trunk" (*vṛkṣasya skandhaḥ parita iva śākhāḥ*); nothing in the text itself is explicit as to erection or inversion; only if we rely on the equation of "Yakṣa" with "Varuṇa" in RV VII.88.6 and X.88.13 and correlate the text with RV I.24.7 can it be assumed that the Tree is inverted.

AV II.7.3, "From the sky is the root stretched down (*divo mūlam avata-*

[29] These three being the "Light form" of the Spirit (*ātman*), corresponding to earth, air, sky as the "Cosmic form"; past, present, and future as the "Time form"; and *a, u, m*, as the "Sound form" of the OM, which is both the *apara* and *para* Brahman, MU VI.4.5.

[30] The reader will not fail to recognize "Jacob's ladder." Cf. PB XVIII.10.10, JUB I.3.2.

[31] Thus, too, in the myth of Jack and the Beanstalk. AB adds, with reference to the rite, that "those whose desire is for the one world only, viz. the world of heaven, should mount in the forward direction only (*parāñcam eva rohet*); they will win the world of heaven, but will not have long to live in this world"; cf. TS VII.3.10.4 and VII.4.4.3.

tam), on the earth stretched out, with this, the thousand-jointed, do thou protect us about on all sides," concerning an unnamed "plant," is apparently contradicted by AV xix.32.3, where the thousand-jointed *darbha*, invoked for long life, and evidently assimilated to the Axis of the Universe, since in 4 and 7 it is said to have pierced the three skies and three earths (three worlds) and is called "god-born" (*deva-jāta*) and "sky-prop" (*divi-skambha*), is described as planted on earth with its tuft in heaven (*divi te tūlam oṣadhe pṛthivyām asi niṣṭhitaḥ*).

We find ourselves, however, on sure ground in KU vi.1, MU vi.4, and BG xv.1-3, where the Tree is described as inverted and called an *Aśvattha*. In KU: "With roots above and branches down (*ūrdhva-mūlo'rvāk-śakhaḥ*) is this everlasting *Aśvattha*: that is the Bright Sun (*śukram*),[32] that is Brahman, that is called the Immortal, therein all worlds are set, beyond it nonesoever goeth, This indeed is That." "Beyond it nonesoever goes" corresponds to KU iii.11, "beyond the Person there is naught, that is the end, the final goal (*kāṣṭhā*)," and AV x.7.31, "beyond it [the *skambha*] there is no more any being."

In MU vi.4, "The three-quarter Brahman [i.e., Tree as extended within the cosmos from earth to sky] has his roots above. Its branches are the ether, air, fire, water, earth, etc. This Brahman has the name the 'One *Aśvattha*.' Pertaining to it is the fiery energy (*tejas*) that is yonder Sun, and the fiery energy of the imperishable logos (OM); wherefore one should worship it (*upāsita*; cf. AV x.7.21, *avare ye te śākham upāsate*) with this same 'OM' incessantly; it is his 'One Awakener' (*eko'sya sambodhayitṛ*)." MU vii.11, on the other hand, describes the Burning Bush, Agni as Vanaspati, as it branches forth in space: "This, indeed, is the intrinsic form of space (*svarūpaṃ nabhasaḥ*) in the hollow of the inner being (*khe antarbhūtasya*), that which is the supreme fiery energy (*tejas*) is threefold in Agni, in the Sun, and in the Breath ... that the imperishable logos (OM), whereby, indeed, it awakens, ascends, aspires, a perpetual support for the contemplation of Brahman (*ajasraṃ brahma-dhiyālambam*). In the draught, that is stationed in the heat, that casts forth light; branching forth and rising up, as of smoke when there is a draught, it moveth on, stem upon stem (*skandhāt-skandham*)." In these two passages the contrast of the Inverted Tree as which the Brahman descends into the cosmos and erected Tree as which he ascends from it is clearly drawn; both of these aspects of the one and only Tree being one and the same

[32] "The Śukra (= cup) is yonder Sun," TS vii.2.7.2.

Logos, in the one case as proceeding from the Silence and Nonbeing, and in the other as returning to it.

BG xv.1–3 describes the Tree with equal fervor, but finally as one to be cut off at the root: "With root above and branches downward, the *Aśvattha* is proclaimed unwasting: its leaves are the meters, he who knoweth it a knower of the Vedas.[33] Downwards and upwards both its branches are outspread, the outgrowths of the qualities; its shoots the objects of the senses, and its downward-stretching roots the bonds of action in the world of men. Nor here can be grasped its form, nor can its end or its beginning or its ultimate support: it is [only] when this firmly rooted *Aśvattha* has been felled by the axe of nonattachment that the step beyond it can be taken, whereby going there is no return." Here the Tree is plainly described as rooted both above and below, and as branching both upwards and downwards. We have already seen that the Axis of the Universe is, as it were, a ladder on which there is a perpetual going up and down. To have felled the Tree is to have reached its top, and taken wing; to have become the Light itself which shines, and not merely one of its reflections.

In the *Mahābhārata* (*Aśvamedha Parva* 47.12–15),[34] we have "sprung from the Unmanifested (*avyakta* = *asat* of AV x.7.21), arising from it as only support, its trunk is *buddhi*, its inward cavities, the channels of the senses, the great elements its branches, the objects of the senses its leaves, its fair flowers good and evil (*dharmādharmav*), pleasure and pain the consequent fruits. This eternal Brahma-tree (*brahma-vrkṣa*) is the source of life (*ājīvyaḥ*) for all beings. This is the Brahma-wood, and of this Brahma-tree That [Brahman] is.[35] Having cut asunder and broken the Tree with the weapon of Gnosis (*jñānena*), and thenceforth taking pleasure in the Spirit, none returneth thence again."

The very fine description of the Inverted Tree as a Tree of Light in the

[33] This identification of the Tree with Scripture is paralleled in the *Zohar* V (Balak), "Just as a tree (the Tree of Psalms 1:3) has roots, bark, sap, branches, leaves, flowers and fruit, seven kinds in all, so the Torah has the literal meaning, the homilectical meaning, the mystery of wisdom, numerical values, hidden mysteries, still deeper mysteries, and the laws of fit and unfit, forbidden and permitted and clean and unclean. From this point [Tifereth?] branches spread out in all directions, and to one who knows it in this way it is indeed like a tree and, if not, he is not truely wise." Similarly in *Paradiso* xxiv.115–117, "who so from branch to branch [of Scripture] examining, had drawn me now, that we were nigh unto the utmost leaves."

[34] As quoted by Śaṅkarācārya on BG xv.1.

[35] Reminiscent of RV x.31.7 and the answer in TB ii.8.9.6.

Zohar (Beha 'Alotheka, with reference to Psalms 19:6) accords with texts already cited, especially RV 1.24.7 as interpreted by Śaṅkara: we find, "Now the Tree of Life extends from above downward, and it is the Sun which illumines all. Its radiance commences at the top and extends through the whole trunk in a straight line. It is composed of two sides, one to the north, one to the south, one to the right, and one to the left. When the trunk shines, first the right arm of the Tree is illuminated and from its intensity the left side catches the light. The 'chamber' from which he goes forth is the starting point of light, referred also in the next verse, 'from the end of the heaven,' which is, indeed, the starting point of all. From that point he goes forth veritably as a bridegroom to meet his bride, the beloved of his soul, whom he receives with outstretched arm. The Sun proceeds and makes his way towards the west; when the west is approached, the north side bestirs itself to meet it, and joins it. Then 'he rejoices as a strong man to run his course' so as to shed his light upon the Moon.[36] Now the words 'When thou lightest the lamps' contain an allusion to the celestial lamps, all of which are lit up together from the radiance of the Sun," i.e., as the Light of lights.

In the *Zohar* (Bemidbar), the Tree of Life and Tree of Death are distinguished: "For as soon as the night falls the Tree of Death dominates the world and the Tree of Life ascends[37] to the height of heights. And since the Tree of Death has sole rule of the world (cf. TS v.2.3.1; ŚB xi.3.37, and x.5.1, 4), all people in it have foretaste of death ... when dawn breaks, then the Tree of Death departs and people come to life again by reason of the Tree of Life. This happens in accordance with what is written, 'to see if there were any man of understanding that did seek after God.'" It is clear from the last sentence that Day and Night are to be taken as symbols, as well as literally: the Tree of Life pertains to those who are verily awake, and that of Death to those who are still unawakened; cf. BG ii.61.

We must next consider the two Inverted Trees described in Dante's *Purgatorio*, Cantos xxii–xxv. These are met with near to the summit of the "mountain" and immediately below the plain of the Earthly Paradise, which is protected by a wall of flames (by which we understand the "flaming sword which turned every way, to keep the way of the Tree of Life"

[36] I.e., to consummate the marriage of Heaven and Earth, the reunion of the right and the left, etc. "To shed light" is evidently to inseminate, as in the Vedic tradition; cf. ŚB viii.7.1.16 and TS vii.1.1.1, *jyotiḥ prajananam*.

[37] Cf. in the Shelah Lecha section, cited above, the Tree of Life as higher and Tree of Death as lower. Here also we assume that the lower tree is inverted.

of Gen. 3:24, rather than the Keeper of the Sundoor of JUB 1.3, etc.) from which flames both Trees, met with in succession, seem to hang, and are represented in Botticelli's illustrations as thus dependent. If we are to understand these Trees at all, we must take careful note of all that is said of them. The first "has a fruit sweet and pleasant to smell." A spring falls from above and moistens its leaves.[38] It seems to Dante that the inversion of the Tree is "so that none may go up" (cred'io perchè persona su non vada). The voice of the Virgin Mary "from within the foliage cried: 'Of this Tree shall ye have lack'" (Canto xxii). The emaciated shade of Forese adds: "From the eternal counsel virtue descends into the water, and into the Tree left behind (cade virtù nell'acqua e nella pianta rimasa retro), whereby I thus waste away. All this people, who weeping sing, sanctify themselves again in hunger and thirst, for having followed appetite to excess. The scent which issues from the fruit, and from the spray that is diffused over the green, kindles within us a desire to eat and drink. And not once only, while circling this road, is our pain renewed: I do say 'pain,' but should say 'solace,' for that desire leads us to the Tree which led glad Christ to say: 'Eli,' when as he freed us with his blood" (Canto xxiii). We infer from the wording that this is a reflected and inverted image of the Tree of Life, for which the souls in the (cosmic) Purgatory hunger and thirst, but of which they can neither partake nor can they climb it.

Not much farther on, or higher, "the laden and green boughs of another Tree appeared to me. . . . I saw people beneath it lifting up their hands, and crying out something towards the foliage, like spoilt and greedy children who beg, and he of whom they beg, answers not, but to make their longing full keen, holds what they desire on high, and hides it not. Then they departed as though undeceived; and now we came to the great Tree which mocks so many prayers and tears. 'Pass onward without drawing nigh to it; higher up[39] is a Tree which was eaten of by Eve, and this plant was raised from it.' Thus amid the branches some one spake" (Canto xxiv). The voice then cites examples of gluttony; it is evident that this inverted image of the Tree of the Knowledge of Good and Evil serves for the disillusionment of those in whom desire is not yet overcome.

[38] The Tree of Life itself in the Brahma world is described as "soma-dripping" (aśvatthah soma savanah), only to be attained by leading the Brahma-life (brahma-cariyena), CU viii.5.3-4. Yggdrasil, too, is "sprent with dews i' the dales that fall" (cf. Volüspa, tr. Coomaraswamy, 1905).

[39] The Earthly Paradise, although withdrawn and elevated, is still actually a part of the cosmos and, like the three lower Heavens above it, still under the Sun.

Dante is now about to emerge from the steep side[40] of the Mountain onto the plain of the Earthly Paradise at its summit. It must be realized that the "world" from which Dante has climbed thus far, and to which he will return (*Purgatorio* II.91–92) lies far below at the foot of the mountain, and that the Earthly Paradise has since the Fall been withdrawn to the summit of the Mountain; Dante speaks of it as "one of the peaks of Parnassus" (*Paradiso* I.16). It is no longer on a level with the inhabited world, neither is it a part of the purgatorial slope; its position is virtually supracosmic, it represents the "summit of contingent being" (*bhavāgra*). The way to it leads through flames which are, as it were, a "wall" (*muro*, *Purgatorio* XXVII.35) and through the rock (*per entro il sasso*, XXVII.64), which "*entro*" must have been such a cleft or tunnel and strait gate as Dante has previously called a "needle's eye" (*cruna*, X.16).

Virgil's guidance and leadership are of no further avail: "Son," he says, "the temporal fire and the eternal hast thou seen, and art come to a plane where I, of myself, can discern no further. Here have I brought thee with wit and with art; now take thy pleasure for guide;[41] forth art thou from the steep ways, forth art from the narrow. . . . No more expect my word, nor my sign" (*Purgatorio* XXVII.127–39). Virgil, being still of human nature, can go no further; henceforth Dante's guide is Beatrice, "risen from flesh to spirit" (XXX.127) and, as Sophia rather than as the individual for whom he longed on earth, a being no longer "human." And were it not that Dante himself divests himself of his humanity, he could have gone no further: "gazing on her, such (as she was) I became within. . . . To pass beyond humanity may not be told in words" (*Paradiso* I.67–71).[42]

[40] The "scarp" (*pravat*) of the Vedic tradition; cf. RV I.10.2, *yat sānoḥ sānum āruhai.*

[41] *Lo tuo piacere omai prendi per duce. Piacere* here is precisely Skr. *kāma*: Dante is now a *kāmacārin*, "a mover at will." Such a motion at will is spoken of already in connection with the Solar Paradise, RV IX.113.8 ff., "There where dwells King Sun, where heaven's fence is, where are those running streams, make me immortal there where motion is at will (*yatrānukāmaṁ caraṇam*), the third celestial firmament of heaven, where are the realms of Light," etc., and again and again in the Upaniṣads, e.g., CU VIII.1.6, "He who goes hence having already found the Spirit [or, his own spiritual essence] becomes a 'mover at will' (*kāmacārin*) in every world." Such an independence of local motion as is implied is often denoted by "wings"; in PB XIV.1.12–13, JUB III.13.9, and *Sanatsujātīya*, ch. VI, for example, it is said that of those who climb the Tree, those who are Comprehensors are winged (*pakṣin*) and fly away, but others, unfledged, fall down; in *Purgatorio* XXI.51, Beatrice makes use of the same symbolism when she reproaches Dante, suggesting that long since he should have been "full-fledged" (*pennuto* = Skr. *pakṣin*).

[42] As in CU IV.15.5–6, "There there is a Person who is not-human. He leads them on to Brahman. That is the way of the gods, the way of Brahman. Those who go

Even before this change has taken place, he has drunk of the Fountain of Life, Eunoe (*fontana salda e certa, Purgatorio* XXVIII.124), and has been "born again, even as new trees renewed with new foliage, pure and ready to mount to the stars" (XXIII.142–145).

From the point of view of conduct (prudence), the situation is summarized by Hermann Oelsner in *The Purgatorio of Dante Alighiere* (London, 1933), as follows: "The keynote of the Purgatory is primarily ethical.... But the Church, as a regimen, is not to be confused with Revelation (Beatrice) herself.[43] The proper office of the Church, as a regimen, ends when the proper office of Beatrice begins": and accordingly, whatever sin Dante may have committed, "he will remember again, but as an external thing that does not now belong to his own personality."[44] The effort henceforth is no longer moral, but intellectual and spiritual.

It will be seen that the Great Transition (*sāmpāraya*, KU 1.29, etc.), which for the Indian tradition depends upon a qualification to pass

by it return not again to the human path"; cf. CU v.10.2 and BU vi.2.15 (read *puruṣo' mānavaḥ*). "Return not again" does not, of course, apply to those whose experience of the suprasolar realm is by way of vision or ritual; the symbolic ascents of the sacrificial ritual make careful provision for a corresponding descent, and if such provision is not made, it is understood that the sacrificer will either go mad or not have long to live (TS vii.3.10.3–4; AB iv.21). The ritual ascent of the initiated sacrificer, whose sacrifice is of himself, prefigures and forecasts an actual ascent to be made at death; and though he returns to the world and to himself (ŚB 1.9.3.23), he has assuredly set foot upon "that stairway which, save to reascend, no one descendeth" (*Paradiso* x.86–87). In the same way, "Richard [of St. Victor] who, in contemplation (*a considerar*) was more than man" (*Paradiso* x.130–131). It may be remarked that in this context a reference rather to *raptus* or *excesses* (= *samādhi*) than to *consideratio* (= *dharaṇa*) might have been expected; it must be understood that the initial stage of contemplation stands for its consummation.

That Dante himself has now become an "eagle" (*suparṇa*) is further implied by *Paradiso* 1.53–54, "I fixed mine eyes upon the Sun, transcending our wont," in this respect also resembling Beatrice (*Paradiso* 1.46).

[43] The Islamic distinction of *shari'at* (Law) from *qiyāmat* (Resurrection).

[44] "Such a one, verily, the thought does not torment: 'Why have I not done the right? Why have I done wrong? He who is a Comprehensor thereof, redeems his spiritual essence from both these thoughts'" (TU ii.9); "He comes to the River of Incorruptibility (*vijarā*). This he crosses by intellect (*manasā*). There he shakes off his good deeds and his ill deeds. . . . Parted from both, a knower of Brahman, he goes on to Brahman" (Kauṣ. Up. 1.4); "The Brahman is without forms or characteristics. . . . The means by which he can be apprehended is an understanding already purified by conduct. . . . It is not enjoined in the Rule of Liberation that 'This should be done' or 'That should not be done'; in this Rule, knowledge of the Spirit depends alone on vision and audition" (*Anugītā* 34); "Whoever is born of God, cannot sin" (John 3:9); "If ye be led of the Spirit, ye are not under the law" (Gal. 5:18).

through the midst of the Sun (JUB 1.3 ff., III.13–14; Īśā Up. 15–16, etc.) takes place for Dante in terms of the reentry to the Earthly Paradise, where at the end of the spiral ascent he sees erect that Tree of which Eve ate, thereby (as we seem to understand) reverting it; he stands now for the first time at the Navel of the Earth (within the *Bodhi-maṇḍala*), from which point[45] the trunk of the arborescent Axis of the Universe,[46] of which the summit is "*il punto dello stelo al cui la prima rota va dintorno*" (*Paradiso* XIII.12–13), patterns an ascent no longer spiral but direct. In other words, for Dante the critical passage from the human to the angelic level of reference separates the *kāmaloka* which he has left from the *rūpaloka* into which he enters at the summit of contingent being (*bhavāgra*), rather than the *rūpaloka* from the *arūpaloka* in which he will not enter until the four lowest of the planetary heavens (of which the fourth is that of the Sun) have been past. The gist of the whole matter for us is that the Trees, which seem to be different aspects of the only Tree, are inverted only below that point at which the rectification and regeneration of man takes place.

Plato has also said, "Man is a heavenly plant; and what this means is that man is like an inverted tree, of which the roots tend heavenward and branches downwards to earth."[47] Furthermore, the symbol of the inverted

[45] "The nail which holdeth the crosstree unto the upright in the midst thereof is the repentance and conversion of men" (Acts of Peter 38). We take it that the plane of the "crosstree" is the ground of the elevated Earthly Paradise, and that in the cosmic symbolism of the Cross all below this plane is inverted, all above it erect. We can perhaps present a clearer image of this: suppose that we are standing at the foot of the Cross and that the space between ourselves and the crosstree is a water, of which the plane of the crosstree is the "farther shore," and the upper part of the upright above this plane is the trunk of the Tree of Life as it was planted by God in the Garden: what we see near at hand is an inverted image with roots above and branches down, and beyond this is the source of this image, the real tree standing erect; and only when we reach the farther shore do we no longer see the inverted tree, which is now as it were underfoot. The tree is always the same tree, only our relation to it changes. We may observe, at the same time, that the reflected tree is always of variable aspect because of the motion of the water by which it may be entirely hidden from our sight, and that both trees may be hidden by mist; in any case, one whose eyes are bent on what lies underfoot, and who has no other shore in mind, will naturally see the inverted tree before he sees its prototype, to see which requires a more elevated glance.

[46] The *kāṣṭhā*, as final goal in the sense of TS 1.7.8.2 and KU III.11; cf. JUB 1.20.3.

[47] I am obliged to take this at second (or rather third) hand from Holmberg, "Der Baum des Lebens," p. 56. The quotations immediately following are from the same source, where the original references can be found. Holmberg's work contains also a vast amount of comparative material on the upright Tree of Life,

tree is widely distributed in "folklore." An Icelandic riddle asks, "Hast heard, O Heidrik, where that tree grows, of which the crown is on the earth, and of which the roots arises in heaven?" A Finnish lay speaks of an oak that grows in the floods, "upward its roots, downward its crown." The Lapps sacrificed every year an ox to the god of vegetation, represented by an uprooted tree so placed on the altar that its crown was downward and roots upward. It is quite possible that the symbol of the Inverted Tree may have a distribution and antiquity as great as that of the Upright Tree. What has been cited already will suffice for present purposes. We shall attempt in conclusion to deduce from the scattered fragments of what must have been a consistent doctrine, its ultimate significance.

Now just as the Ātman, Brahman, is the Yakṣa in the Tree of Life, which is the manifested aspect of the supracosmic Person, so also is Everyman an *Ātmanvat Yakṣa* (AV x.8.43), and, as it were, a tree (Job 18:16): "As is a tree, just such as is the Lord of Trees, so indeed is man" (BU III.9.8); and thus, as for Plato, "by nature a heavenly plant" (*Timaeus*). He comes into being in the world because of the descent of a solar "ray" or "breath," which is the sowing of a seed in the field; and when he dies, the dust returns to the earth as it was, and the ray, on which his life depended, ascends to its source. We are not for the moment concerned with the ensuing judgment at the Sundoor which, if he is not qualified for admission, will permit the continued operation of those mediate causes by which the nature of a given birth is determined, and if he is qualified for admission will mean a final release from all individual causal order. What we are concerned with is that the coming into being of the man presupposes a descent, and that the return to the source of being is an ascent; in this sense, the man, *qua* tree, is inverted at birth and erected at death. And this holds good as much for the Universal Man as for the microcosmic

of which we shall make further use on another occasion.

All that I have been able to find in Plato about the inverted tree is that, while "it is by suspending our head and root from that region whence the substance of our soul first came that the Divine Power keeps upright our whole body," insofar as man declines from his proper nature, he is, as it were, an animal whose head approaches the earth, a condition most fully realized in creeping things (*Timaeus* 90 ff.).

The sentence ending with "keeps upright" may be compared with AB vII.4, where Aditi, the Earth (goddess), discerns the zenith, and "therefore it is that on this earth plants grow upright, trees upright, men upright, Agni is kindled upright, whatever there is on this earth that stretches upright, for this was the quarter discerned by her." Cf. ŚB III.2.3.19.

man, insofar as these are thought of as entering into and again departing from the cosmos, and hence as much to the "Person in the Sun" as to the "Person in the right eye" of the man, when both are thought of as the immanent principles of the vehicles on which they take their stand. For when the transcendental Person, who is one eternally as he is yonder, enters into the world, he divides himself (*ātmānaṃ vibhajya*, MU vi.26, etc.), becoming many in his children in whom the spirit takes birth. This taking on of a passible mortal nature and "eating of the Tree of the Knowledge of Good and Evil" (RV 1.164; MU ii.6d, etc.) is a descent, a dying, and a "fall," and even though we think of the Eternal Avatar's descent (*avataraṇa*, "coming down" or "inverse crossing") as a willing sacrifice undertaken for the sake of Everyman's crossing over and ascent, the Solar Hero cannot evade the inevitable death of all those "who come eating and drinking," and must ascend again to the Father, entering thus into himself, who is himself the Way and the Sundoor through which he passes; stooping to conquer, still he stoops. The descent of the Spirit is headlong; witness, for example, the descending Dove (equivalent of the Indian Haṃsa) in the Christian iconography of the Baptism. Therefore we find in BU v.3-4 that "The head of the Person there in that solar orb is Earth (*bhūr*). . . . His arms are Space (*bhuvar*). . . . His feet the Heavenly-light-world (*svar*)"; in the same way for his microcosmic counterpart, "the head of the Person who is here in the right eye is Earth,"[48] etc. This is in complementary contrast to the normal formulation, typically in MU vi.6, where Prajāpati's cosmic body (*prajāpateḥ sthaviṣṭā tanūr yā lokāvatī*) is erect, "its head is the Heavenly-light-world," etc.[49]

[48] The Person in the Sun (also called Death) and Person in the right eye or in the heart (where the conjunction of the Persons in the right and left eyes takes place, ŚB x.5.2.11–12) are often identified and correlated (e.g., MU vi.1, etc.). In BU v.5.2, "these two Persons [in the Sun, and right eye] are supported each upon the other [cf. AĀ ii.3.7]: by the rays that one on this, and by the breaths this one on that. When one is about to die, he sees that orb quite plainly; those rays [by which he was supported] come to him no more." The interdependence of the macrocosmic and microcosmic Persons corresponds to Eckhart's "Before creatures were, God was not, albeit he was Godhead" (Evans ed., I, 410).

[49] It may be noted that in this formulation the navel and not the arms represent Space, implying, evidently, that the arms are not extended. As MU vi.6 continues, "This is the all-supporting form of Prajāpati. This whole world is hidden in it, and it in this whole world" (for, as need hardly be said, this Pillar is omnipresent, and passes through the center of every being). And as this text also remarks, the Eye of this cosmic embodiment is the Sun, this Eye is the Person's "great unit of measure" (*mātrā*) and his means of motionless locomotion, "his range is visual" (*cakṣuṣā carati*). Finally, it may be observed that this solar Eye at the top of the

He descends, in other words, as Light, and ascends as Fire; and these are the pneumatic countercurrents that pass up and down the Axis Mundi. Again in other words, this means that as undivided (macrocosmically), he is erect; as many (microcosmically), inverted.

It is, accordingly, the express intention of the sacrificial ritual that the Sacrificer should not only imitate the First Sacrifice, but at one and the same time reintegrate and erect (in both senses of the word, to build up and set upright) the immanent and, as it were, divided and inverted Agni-Prajāpati, and himself. For Prajāpati, "having emanated his children,[50] and won the race,[51] was unstrung (vyasraṃsata)[52] and fell down (apadyata)." The Devas, performing the First Sacrifice, reintegrated and erected him; and so now the Sacrificer, "reintegrating Father Prajāpati

Pillar, the Sun-door through which only the arhat and vidu can pass (JUB 1.6 and III.14; CU VIII.6.5; etc.), is the "eye of the needle" through which it is so hard for the "rich man" to pass (Matt. 19:24, cf. BU II.4.2, amṛtasya tu nāśāsti vittena), as is explicit in Mathnawī 1.3055–3066.

[50] That is, sent forth his rays; the antarātman being a "ray" of the Sun. As Plotinus expresses it, "Under the theory of procession by powers, souls are described as 'rays'" (Plotinus VI.4.3). For the solar rays as the children of the Sun, cf. JUB II.9.10; ŚB III.9.2.6; VII.3.2.12 (with Sāyaṇa's comment), VIII.7.1.16–17 (jyotiḥ prajananam, also TS VII.1.1.1), and x.2.6.5. Also St. Bonaventura, De scientia Christi 3c: "Ipsa divina veritas est lux, et ipsius expressiones respectu rerum sunt quasi luminosae irradiationes, licet intrinsecae, quae determinate ducunt in id quod exprimitur"; and Witelo, Liber de intelligentiis VI ff.: "Prima substantiarum est lux. Ex quo sequitur naturam lucis participare alia. . . . Unumquodque quantum habet de luce, tantum retinet esse divini."

[51] That is, reached the sacrificial altar; cf. TS 1.7.8.2 and II.2.4.6. See n. 22 above.

[52] For the full significance of vyasraṃsata, "was untied," "let loose," "analyzed," etc., see TS V.1.6.1, "Agni's form as Varuṇa [cf. RV V.3.1] is tied up (naddhaḥ). Saying 'With extended blaze,' he unloosens (visraṃsati) him; impelled by Savitṛ, indeed, he lets loose (visṛjati) on all sides the angry glitter (menim) of Varuṇa that pertains to him. He pours down water . . . appeases Agni's burning heat (śucam) throughout his whole extent. . . . Mitra is the kindly one (Śiva) of the Devas, he connects him, indeed, with Mitra, for pacification." Cf. AB III.4, "Inasmuch as they worship him, the dreadful to be touched [cf. JUB II.14], as 'friend' (mitrakṛtropāsan), that is his [Agni's] form as Mitra. . . . Again, in that him being one they bear apart in many places, that is his form as the Universal Deities." Keith makes menim "wrath" and śucam "pain": certainly what is intended corresponds to Boehme's "anguishing or scorching fire" and "fierce and sudden flash," which is "all together" in its eternal origin, but springs up "into the meekness and light" so as to be freed from the darkness, and "in the appearing of the plurality . . . sparkleth or discovereth itself in infinitum" (Three Principles of Divine Essence XIV.69–77). Vyasraṃsata thus implies "was divided up, became the sacrifice," "was undone" or "done for," as indeed the word "appeases" (śamayati) in the TS context also shows; Agni-Prajāpati is the victim, and is "given his quietus." For "to 'quiet' a victim is to kill it" (TS VI.6.9.2, VI.6.7; ŚB XIII.2.8.2, etc.).

so as to be all whole, erects him" (*sarvaṃ kṛtsnaṃ saṃskṛtyordhvam ucchrayati*, ŚB VII.1.2.1 and 11, with many analogous passages). To this can also be applied the last words of BU v.5.4, cited above: "He who realizes this, smites off evil, leaves it behind." Realization will mean to have understood that this is a topsy-turvy world;[53] that the Person in the right eye, man as he is in himself (*aham*, BU v.5.4), is an inverted or refracted principle, seen as if in a mirror, whether of water or the retina (CU VIII.7.4; BU v.5.4);[54] it is for him to rectify himself, in such a manner as to be able to ascend these worlds (JUB 1.3), which cannot be done so long as the Tree is inverted.[55]

A remarkable illustration and confirmation of these conclusions can be cited in the Acts of Peter 37–39, where Peter beseeches his executioners, "Crucify me thus, with the head downwards, and not otherwise. . . . For the first man, whose race I bear in mine appearance, fell head downwards. . . . He, then, being pulled down . . . established this whole disposition of all things, being hanged up an image of the creation wherein he made the things of the right hand into left hand and the left hand into right hand, and changed about all the marks of their nature, so that he thought those things that were not fair to be fair, and those that were in truth evil, to be good. Concerning which the Lord saith in a mystery: Unless ye make the things of the right hand as those of the left, and those of the left as those of the right, and those that are above as those below, and those that are behind as those that are before, ye shall not

[53] This is the constant assumption: for example, RV 1.164.19, "Those whom [mortals] speak of as 'present' (*arvāñcaḥ*), they [the immortals] speak of as 'far off' (*parāñcaḥ*), and those whom [mortals] call 'far off,' they [the immortals] call 'those present'" (cf. the wording of AV x.7.10, 21, 25 cited above); and BG II.61, "What is for all beings night is for the Collected Man the time of waking; and when beings are awake, that is night for the seeing Sage." The same idea is expressed in the opposition of *pravṛtti* and *nivṛtti* (procession and recession), and in the often repeated "The way to the World of Heavenly Light is countercurrent" (TS VII.5.7.4, cf. Buddhist *uddhaṃsoto* and *paṭisotagāmin*).

Cf. also in Chinese script, in connection with the Moon as *Magna Mater*, the representation of beginning and birth by an inverted human figure (meaning also "opposite" or "counter-"), and representation of the end by an erect figure (meaning also "great"), Hentze, *Frühchinesische Bronzen- und Kulturdarstellungen*, pp. 72, 73.

[54] The fact must have been known that the retinal image is actually inverted and erected only by the mind, which sees through rather than with the eye.

[55] Dante, *Purgatorio* XXII.134–135, *cosi quello in giuso, cred'io perche persona su non vada*. The ascent is barred to those for whom the Tree is an inverted Tree ("to keep the way of the Tree of Life," Gen. 3:24).

have knowledge of the kingdom.[56] This thought, therefore, have I declared unto you; and the figure wherein ye see me now hanging is the representation of that man that first came unto birth. Ye therefore, my beloved, and ye that hear me and shall hear, ought to cease from your former error and return back again."[57]

We have attempted to bring together some of the *disjecta membra* of an evidently consistent and intelligible symbolism, and are now perhaps in a better position to understand why it is that the Tree of Life, extending from earth to heaven or heaven to earth and filling with its branches all the interspace, can be thought of both as the "One Awakener" (*eka sambodhayitṛ*) and "everlasting basis of the contemplation of Brahman" (*ajasram brahma-dhiyālambam*)—being, indeed, the Brahman (*eko'śvattha nāmaitad brahma*, MU iv.6 and vii.11) and the "uttermost full awakening" (*anuttarā samyak-sambodhi*, in *Sukhāvatī Vyūha* 32), but can also and with perfect consistency be called a tree that must be felled at the root: "When this *Aśvattha*, so nobly rooted, has been cut down with the axe of nonattachment, then is that Station (*padam*) to be reached, whither having gone they return no more," BG xv.3-4. "That is," as Śaṅkara comments, "uprooting the Tree of the World vortex together with its seed, he is to seek out and to know that way of the stride of Viṣṇu, taking refuge with that Primordial Person from whom the Tree sprang up, as phantasmagoria from a juggler."[58] Śaṅkara's explanation of the Inverted Tree of

[56] That "the nail which holdeth the crosstree unto the upright in the midst thereof [of the Cross] is the conversion and repentance of men" shows that what is implied is not merely a sunwise transposition, but an attainment of the Center in which there is no distinction of directions, where "the Sun shall no more rise nor set, but stand in the Center single" (CU iii.11.1). This is to have reached the Brahman, who is "endless in all directions, though for him assuredly directions such as 'East,' etc., cannot be predicated" (MU vi.17), that "Night" in which "the directions are submerged" (*muhyanti diśaḥ*, JUB iii.1.9). In other words, it is just inasmuch as men see a plurality and in terms of the "pairs of opposites" (such as right and left, up and down, good and evil) that they "crucify Him daily."

[57] Cf. Plato, *Timaeus* 90D, "rectifying the revolutions within our head, which were distorted at our birth." Cf. TS I, cxiii, where the initiate "does everything as nearly as may be topsy-turvy, exactly opposite to the usages of men."

[58] Rawson's characteristic difficulty at this point arises from his confusion of essence with nature: "one would expect the root to be of the same essential nature as the tree" (KU, p. 185). It is incorrect to use such an expression as "essential nature" when we are considering an already existent manifestation. Essence and nature are one and the same only in the unity of the transcendental Person: an epiphany implies already that this essence and this nature have been distinguished (RV x.27.23; BV i.4.3); then we have still to do with a single essence, but with a dual nature, the *dvaitībhāva* of MU vii.11.8, the Brahman being now both in-a-

KU vi.1 and BG xv.1–3 may be summarized as follows: This is the "Tree of the World vortex" (*saṃsāra-vṛkṣa*), compact of all desires and activities: its downward branches are the worlds in which all creatures have their several beings. It is rooted in the pure Light of the Spirit, in Brahman, immortal and immutable; as a Tree, resounding with the cries of all those, whether gods or men or animals or ghosts, whose nests are in its branches, it is a growth without beginning or end in time, but of an ever-changing aspect. The Tree has all to do with actions, whether ordinate or inordinate (*karma dharmādharma-lakṣaṇam*), and their rewards (*phalāni*), the "fruits of the tree." In this respect it is like the Vedas, which are another manifestation of the Brahman: "He who knows the Tree of the World vortex and its Root as they are described in the cited texts is a Knower-of-the-Vedas (*vedavit*); there is nothing more than this Tree of the World vortex and its Root that remains over to be known; whoever knows it, is omniscient."[59]

The felling of the Tree, or taking flight from its summit, involves, in other words, the usual substitution of the *via remotionis* for the *via affirmativa*; the great transition involves a passing over from the Taught (*śaikṣa*) to the Untaught Way (*aśaikṣa mārga*), the Spoken to the Unspoken Word. The Brahma-tree (*brahma-vṛkṣa*), the Brahman in-a-likeness, as *saṃsāra-vṛkṣa*, is an indispensable means to the knowledge of Brahman, but of no more use than any other means once the end of the road has been reached; it is a Tree to be used and also to be felled, because whoever clings to any means as if they were the end can never hope to

likeness and not-in-any-likeness, mortal and immortal, vocal and silent, explicit and inexplicit, many and one (BU ii.3; MU vi.3, etc.), both the *apara* and the *para, imago imaginata* and *imago imaginans*. To reach that Person in whom essence and nature are one, the mortal and manifested nature must be broken through: "understanding has to break through the image of the Son" (Meister Eckhart, Evans ed., I, 175), entering in by the Door (John 10:9 and Brāhmaṇas and Upaniṣads, *passim*). In other words, he who is fully fledged and has climbed to the top of the Tree "flies away" (PB xiv.1.12), and this departure is the same as to fell the Tree of the World vortex, since whoever thus "breaks out of the cosmos" (Hermes), leaves behind him the manifestation and enters into that which is manifested. He who thus "becomes Brahman" has no further need of any "support of contemplation of Brahman." As Plotinus expresses it, "in other words, they have seen God, and they do not remember? Ah, no: it is that they see God still and always, and that as long as they see, they cannot tell themselves that they have had the vision; such reminiscence is for souls that have lost it" (Plotinus, iv.4.6).

[59] "Not till she knows all that there is to know does she cross over to the unknown good" (Meister Eckhart, Evans ed., I, 385).

reach the end.[60] The way of affirmation and denial applies then to the cosmic theophany, just as it applies to scripture. The Tree, as we have seen, is a manifestation of Agni, Vāyu, and Āditya; and "These are the preeminent forms[61] of the immortal, unembodied Brahman. . . . These one should contemplate and praise, but then deny (*tā abhidhyāyed arcayen nihnuyāc cātas*). For with these, indeed, one moves higher and higher in the worlds, and then when the whole comes to its end, reaches the Unity of the Person, yea the Person" (*ekatvam eti puruṣasya*, MU iv.6).

The conclusions thus reached are confirmed by the very significant text of AB ii.1–2. Here the Devas, by means of the sacrifice, have ascended to heaven; and lest men and prophets (*ṛṣayaḥ*) should follow after them, they "posted" (barred) the way by means of the sacrificial "post" (*yūpa*) set point downwards (*avācināgram*).[62] Men and prophets, reaching the sacrificial site, realized what had been done. They dug out the post and "dug it in again upright" (*ūrddhva-nyaminvan*), using the words, "Rise erect, O Lord of the Forest" (*śrayasva vanaspate*, RV 1.36.13), "Aloft to our aid do thou stand like Savitṛ the God" (the Sun), and "Erect us[63] for motion (*carathāya*), for life." Then they discerned the world of heaven. "In that the post is fixed upright (it avails) to the foreknowledge of the sacrifice and for the vision of the world of heaven"[64] (*svargasya lokasy-*

[60] Exactly of the same nature as the *brahma-vṛkṣa* = *saṃsāra vṛkṣa* is the *brahma-cakra* = *saṃsāra-cakra* (described at length in the *Anugītā*). And just as the Tree is one to be felled, so is the Wheel to be arrested. It is in just the same way that the Vedas themselves are of no further use to one who has reached their "end." As the iconoclast expresses it, "An idol is only fit to be used as a threshold upon which travellers may tread."

[61] In MU vi.5, the "Light form": and in the Fire altar, represented accordingly by the Viśvajyotis bricks.

[62] Cf. Dante, *Purgatorio* xxii.135, *perchè persona su non vada*. In the parallel passage, ŚB iii.2.2.2, Eggeling misunderstands the value of *yopaya* (= "posted" in the sense of "blocked" or "barred" the way). Whitney in *American Journal of Philology* III (1882), 402, translates correctly but fails to understand how the setting up of a post could be thought of thus; an illustration of the evident fact that Whitney's mind was always securely "posted" against the comprehension of any metaphysical notion.

[63] The Sacrificer identifying himself with the Post, as is explicit in KB x.2 (cf. ŚB xiii.2.6.9).

[64] The Post, or Bolt, wielded point downwards, pierced (and fertilized) the earth; now withdrawn and set up erect, it points upwards to and virtually penetrates the sky, literally pointing the way by which the smoke of the sacrificial fire, bearing with it the spirit of the Sacrificer identified with that of the victim, ascends to pass out through the cosmic luffer, the eye of the domed roof of the world, and "eye of the needle." "Agni arose aloft touching the sky: he opened the door of the world of heaven . . . him he lets pass who is a Comprehensor thereof" (AB iii.42);

ānukhyātyai; cf. TS v.2.8.1, vi.3.4.8, etc.: *svayamātṛṇṇā bhavati prāṇānām utsṛṣṭyai atho svargasya lokasyānukhyātyai*). Being set up on the surface of the earth (*varṣma pṛthvyai*), " 'banning mindlessness far from us' (*āre asmad amatiṃ badhamāna iti*), namely privation, evil (*aśanāyā vai pāpmānam*)," "The Post is the Bolt (*vajro vai yūpaḥ*), it stands erect as a weapon against him whom we hate (*dviṣato badha udyatiṣṭhati*)."[65]

and, "Were the sacrificer not to ascend after him, he would be shut out from the world of heaven" (TS v.6.8.1). Cf. Micah 2:13, *Ascendet enim pandens iter ante eos: dividet, et transibunt portam, et ingredientur per eam* (like Muṇḍ. Up. 1.2.11, *sūrya-dvāreṇa prayānti*), and St. Thomas, *Sum. Theol.* iii.49.5c *ad 2, Et ideo per passionem Christi aperta est nobis janua regni coelestis* (i.e., of the *coelum empyreum* and not merely of the *coelum aureum*).

[65] *Quo se potest tueri contra hostis impugnationes, Sum. Theol.* iii.49.2 *ad 2.* The wording of the text (*amatim . . . aśanāyā vai pāpmānam*) makes it abundantly clear that it is not primarily any private "adversary" that is intended by the "hateful kinsman" (*dviṣataḥ bhrātṛvyaḥ*) against whom the Post is set up and in this sense "hurled" (*praharati*, AB ii.1), but rather *the* Enemy of gods and men. Similarly as regards *bhrātṛvyaḥ* in RV vii.18.18, *Yaḥ Kṛṇotī tigmam, tasmin ni jāhi vajram, indra,* and AV, etc., where the very possibility of applying an incantation (*mantra*) against "so and so" depends upon its primary efficacy as an exorcism of the Fiend, the *anyavrataḥ* of VS xxxviii.20. Cf. TS vii.4.2, "Smiting off misery, evil, death (*arttim pāpmānam mṛtyum*), let us reach the divine assembly." It is in the same spirit that so many incantations have as their end to secure a liberation from Varuṇa. Who then is the Enemy, the Mindless One, Privation, Evil, that is smitten by the erection of the Post? Evidently Death (*mṛtyu*), and in the present connection more specifically that form of Agni that is often identified with Death, the Agni whose connection is with Varuṇa, from whom the Sacrificer is ever seeking to escape: Agni as Ahir Budhnya, the "Chthonic Serpent" (who is invisibly what the Gārhapatya Agni is visibly, AB iii.36); the Agni "that was before" as distinguished from the kindled Agni worshipped as a Friend (*mitrakṛtyopāsan*, AB iii.4, etc.), with reference to which pair, whose relation is assuredly "brotherly," it is said that "the Agni that is in the fire pan and the Agni that was before hate (*dviṣāte*) one another" (TS v.2.4.1). The Serpent's head is "bruised" (cf. Gen. 3:15) by the Post.

The Sacrificer repeats what had been done by Indra in the beginning (*vajreṇābodhayāhim*, RV 1.103.7, etc.), when the Sacrificial site (*yajña-vāstu* of AB ii.1) was first taken possession of. The rite is repeated to this day when a new house is to be built: "Before a single stone can be laid . . . the astrologer shows what spot in the foundation is exactly above the head of the snake that supports the world. The mason fashions a little wooden peg from the wood of the *khadira* tree [cf. the use of *khadira* for the Post in AB ii.1], and with a coconut drives the peg into the ground at this particular spot, in such a way as to peg the head of the snake securely down" (Margaret Stevenson, *Rites of the Twice-born*, London, 1920, p. 354). For the full significance of this rite see further Paul Mus, *Barabudur*, pp. 207, 347, 348, and my note in JAOS, LVII (1937), 341; and A. Bergaigne, *La Religion védique d'après les hymnes du Rig-Veda* (Paris, 1878–1897), I, 124, n. 1, remarking on the use of RV v.62.7, *bhadre kṣetre nimitā*, etc., in this connection. It is from

403

There are three kinds of wood of which the post can be made, *khadira*, *bilva*, and *palāśa*. The latter is "the fiery energy and brahma glory of the Lords of the Forest" (*tejo vai brahma-varcasam vanaspatīnāṃ*) and "the birth place of all Lords of the Forest" (*sarveṣāṃ vanaspatīnāṃ yoniḥ*). In TS ii.4, the Lord of the Forest (elsewhere the common epithet of Agni) is identified with the Breath (*prāṇo vai vanaspatiḥ*). It is perfectly clear from all this that the sacrificial "tree," *yūpa* (and σταυρός), is thought of as inverted and unclimbable until it is erected by the setting *upright* of the symbolic post of the rite: wherewith erected, the Sacrificer is himself erected and regenerated.

the same point of view that the setting up of a lance is a taking possession of the realm (see JAOS, LVII, 1937, 342, n. 4).

On the other hand, the setting *upright* of the Post or Bolt implies a regeneration, and at the same time fully explains why, in a *lingam-yoni*, the *lingam* is supported by the *yoni* and stands erect, head upward, in what is strictly speaking an unnatural position. First, let us observe that Agni's birth place is always a *yoni*; *vīryeṇa* in RV ii.11.2 is the equivalent of *vajreṇa* in i.103.7; and the equivalence of *vajra* and *lingam* as stabilizing Axis is fully brought out in the Dāruvana legend (see Bosch, "Het Linga-Heiligdom van Dinaja," *Madjalah untuk ilmu buhasa, ilmu bumi dan kebudajaan Indonesia*, LXIV (1924), and further references in Coomaraswamy, *Yakṣas*, Pt. II, 1931, p. 43, n. 2). These relations could be demonstrated at much greater length, both from the Indian and from other (e.g., the Grail and the Greek) traditions. In the second place, we have to bear in mind the distinction of the Gārhapatya from the Āhavanīya Fires as respectively natural and supernatural places of birth (*yoni*) into which the Sacrificer inseminates himself (*ātmanāṃ siñcati*), and from which he is reborn accordingly (JB 1.17 and 18; see Oertel in JAOS, XIX, 1898, 116, a text which should not fail to be consulted in the present connection; and cf. AB 1.22). Thirdly must be borne in mind the frequent identification in our texts of the Āhavanīya Fire with the Sky. The setting upright of the Post, Bolt, or Lingam, with these assumptions, implies then a withdrawal from the lower and natural *yoni* and a reversal by means of which the lingam is pointed towards the Sundoor above, which is precisely the birth place through which the Sacrificer, whether by the initiation and the sacrifice, or finally at death, is reborn for the last time, obtaining a "body of light" and "sunskin," in accordance with the universal doctrine that "all resurrection is from ashes."

The Sea

For Plato, the Divine Life is an "ever-flowing Essence" (ἀέναον οὐσίαν, *Laws* 966ε). For Meister Eckhart, who called Plato "that great priest," the Soul is "an outflowing river of the eternal Godhead" (Pfeiffer ed., p. 581, cf. 394); and he says also, "while I was standing in the ground, the bottom, in the river and fountain of the Godhead, there was none to ask me where I was going or what I would be doing. . . . And when I return into the ground, the bottom, the river and fountain of the Godhead, none will ask me whence I came or whither I went" (p. 181). In the same way Shamsi-i-Tabrīz: "None has knowledge of each who enters that he is so-and-so or so-and-so. . . . Whoever enters, saying, 'Tis I,' I smite him on the brow."[1]

An incessant river of life implies an inexhaustible source, or *fons*—the Pythagorean "fountain, or spring, of the ever-flowing Nature" (πηγὴ ἀενάου φύσεως *Golden Verses* 48). "Imagine," says Plotinus, "a fountain (πηγή) that has no origin beside itself; it gives itself to all the rivers, yet is never exhausted by what they take, but always remains integrally what it was . . . the fountain of life, the fountain of intellect, beginning of being, cause of the good, and root of the Soul" (Plotinus III.8.10 and VI.9.9). This, as Philo says in comment on Jer. 2:13, πηγὴ ζωῆς, is God, as being the elder source not only of life but of all knowledge (*De fuga et inventione* 137, 197, 198; *De Providentia* 1.336); cf. John 4:10 and Rev. 14:7, 21:6. It is Jan van Ruysbroeck's "Fountain-head from which the rills flow forth. . . . There Grace dwells essentially; abiding as a brimming fountain, and actively flowing forth into all the powers of the soul" (*Adornment of the Spiritual Marriage*, ch. 35). And in the same way,

[This essay was first published in *India Antiqua: Essays in Honor of Jean Philippe Vogel* (Leiden, 1947).—ED.]

[1] Rūmī, *Dīvān*, Odes xv, xxviii; cf. *Mathnawī* vi.3644, "Whoever is not a Lover sees in the water his own image . . . (but) since the Lover's image has disappeared in Him, whom now should *he* behold in the water? Tell me that." Similarly in CU viii.8, with respect to one's reflection in water.

Shams-i-Tabrīz: "Conceive Soul as a fountain, and these created beings as rivers. . . . Do not think of the water failing; for this water is without end" (Rūmī, *Dīvān*, Ode XII). Meister Eckhart speaks of the Divine Life as both "fontal and inflowing." The concept of the return of the Soul to its source, when its cycle is completed and, as Blake says, "the Eternal Man reassumes his ancient bliss," is, indeed, universal; so that, in its present sense, the Sea, as the source of all existences, is equally the symbol of their last end or entelechy. Such an end may appear at first sight to involve a loss of self-consciousness, and a kind of death; but it should not be forgotten that in any case the man of yesterday is dead, that every ascent implies a rising on "stepping stones of our dead selves," or that the content of the Now-without-duration (Skr. *kṣaṇa*, Aristotle's ἄτομος νῦν), i.e., of Eternity, is infinite compared with that of any conceivable extent of time past or future. The final goal is not a destruction, but one of liberation from all the *limitations* of individuality as it functions in time and space.

From the Buddhist point of view, life is infinitely short; we are what we are only for so long as it takes one thought or sensation to succeed another. Life, in time, "is like a dewdrop, or a bubble on the water . . . or as it might be a mountain torrent flowing swiftly from afar and carrying everything along with it, and there is no moment, pause, or minute in which it comes to rest . . . or it is like the mark made by a stick on water" (A IV.137). The "individual," a process rather than an entity, ever *becoming* one thing after another and never stopping to *be* any one of its transient aspects, is like Heracleitus' river into which you can never step a second time—πάντα ρεῖ. But over against this perpetual flux of the *Saṃsāra* there stands the concept of the silent Sea, from which the waters of the rivers are derived and into which they must return at last. In speaking of this Sea, the symbol of *nirvāṇa*, the Buddhist is thinking primarily of its still depths: "As in the mighty ocean's midmost depth no wave is born, but all is still, so in his case who's still, immovable (*ṭhito anejo*), let never monk give rise to any swell" (Sn 290). The Sea is the symbol of *nirvāṇa*, and just as Meister Eckhart can speak of the "Drowning," so the Buddhist speaks of "Immersion" (*ogadha*) as the final goal.

"The dewdrop slips into the shining sea." The reader of these concluding words of Sir Edwin Arnold's *Light of Asia* may very likely have thought of them as the expression of a uniquely Buddhist aspiration, and may have connected them with the altogether erroneous interpretation of *nirvāṇa* as "annihilation"; for, indeed, he may never have heard

of the "annihilationist heresy" against which the Buddha so often fulmi-
nated, or may not have reflected that an annihilation of anything real,
anything that *is*, is a metaphysical impossibility. Actually, however, for
man to be plunged into the infinite abyss of the Godhead as his last and
beatific end, and the expression of this in terms of the dewdrop or rivers
that reach the sea towards which they naturally tend, so far from being
an exclusively Buddhist doctrine, has been stated in almost identical words
in the Brahmanical and Taoist, and Islamic and Christian traditions,
wherever, in fact, *der Weg zum Selbst* has been sought.

To begin with the Buddhist formulation, we find: "Just as the great
rivers, entering the mighty ocean, lose their former names and semblances,
and one only speaks of 'the sea,' even so these four kinds, the warriors,
priests, merchants, and workmen, when they go forth from the house-
hold into the homeless life, into the rule established by the Truth-finder,
lose their former names and lineages, and are only called 'ascetics' and
'sons of the Buddha' " (A IV.202; M I.489; Ud 55.IV). The figure, no doubt,
derives from and represents an adaptation of the Vedic idea of the oceanic
origin and end of the Living Waters as stated, for example, in RV VII.49.1
and 2: "forth from the Sea the sleepless waters flow . . . their goal the
Sea (*samudrārthāḥ*)." But the words as they stand are more directly an
echo of several passages in the *Upaniṣads*, notably *Praśna Up.* VI.5: "Even
as these flowing (*syandamānāḥ*, ῥέοντες) rivers that move towards the sea,
when they reach it, are come home, and one speaks only of 'the sea,' so
of this 'Witness' or 'Looker-on' (*paridraṣṭṛ*)[2] these sixteen parts that move

[2] The Witness, or Looker-on, is primarily that one of the two birds or selves that
does not eat of the fruit of the Tree of Life, but only looks on (*abhi cakṣīti*, RV
I.164.20, cf. Muṇḍ. Up. III.1.1 and 2 and Philo, *Heres* 126); "the Self alive and
close at hand, the Lord of what hath been and shall be . . . who stands indwelling
(*pra-viśya* = ἐνοικῶν) the cave (of the heart), who looked forth in the powers-of-
the-soul (*bhūtebhir vyapaśyat*, KU IV.5 and 6); "the sole Seer, himself unseen" (BU
III.7.23, III.8.11); "onlooker (*upadraṣṭṛ*), approver, groom, experient, High Lord
and Self Supreme, these are designations of the Supreme Person in the body" (BG
XIII.22).
The term *upadraṣṭṛ*, hardly to be distinguished in meaning from *paridraṣṭṛ*, has
a further particular history and interest of its own, with specific reference to Agni,
the Sacerdotium *in divinis* and within you, whom the gods "measured out . . . to
keep watch" (*aupadraṣṭryāya*, JB III.261-263); Agni is the Onlooker or Watchman,
Vāyu the Overhearer, Āditya the Announcer (TS III.3.5); and it is from Agni that
the Buddha derives his epithet of "the Eye in the World." Krishna's relationship
to Arjuna is that of Agni to Indra, Sacerdotium to Regnum, and corresponds to that
of an older text in which we also find the Purohita acting as the King's charioteer,
to advise him and "to see to it that he does no wrong" (*aupadraṣṭryāya ned ayaṃ
pāpam karavat* JB III.94, see in JAOS, XVIII, 1897, 21). In ourselves, this is the re-

407

towards the Person, when they reach the Person, are come home, their name-and-shape are broken down, and one speaks only of 'the Person' (*puruṣa*).[3] He then becomes without parts, the Immortal." Similarly in CU vi.10.i and 2: "As these rivers flow first eastward to and after backwards from the sea,[4] and when they enter into the sea there is nothing but 'the Sea,' and there they know not 'I am this' or 'I am that'—just so, my friend, all these children,[5] though they have come forth from that-

lationship that the Chinese call that of the Inner Priest to the Outer King; the Onlooker's functions are those of the Socratic Daimon, Immanent Spirit, Synteresis, and Conscience.

[3] There are two "forms" of Brahma, temporal and timeless, with and without parts (MU vi.15). In his temporal form Prajāpati (the Progenitor), the Year, is thought of as having sixteen parts, of which fifteen are his "possessions" and the sixteenth, constant (*dhruva*) part Himself; with this sixteenth part he is entered into (*anupraviśya* = ἐποικίζων) everything that breathes here (BU 1.5.14 and 15); and it is precisely with this sixteenth, left over (*pariśiṣṭa*) when the fire of life is checked by fasting ("just as there might remain from a blazing fire only a gleed no bigger than a firefly, and that blazes up again when the fast is over"), that "you now understand the Vedas" (CU vi.7.1–5). In other words, the constant sixteenth part is the "Spark," Jacob Boehme's "God in me that knows these things" and who, as St. Augustine says, both has his throne in heaven and teaches from within the heart—"And it is established, according to Augustine and the other saints, that 'Christ, having his throne in heaven, teaches from within'; nor can any truth be known in any way except through that truth. For the same one [i.e., Christ] is the source of being and understanding." (St. Bernard, *In hexaëm.* 1.13, Migne, *Series latina*, v.331).

[4] This can be understood in two ways, either with Śaṅkara as referring to the general circulation of the waters, which are drawn up from the sea by the sun and return to it in the rivers; or, as seems to me more plausible, as referring to the tides that flow alternately far up such a river as the Ganges, and back again into the sea, being "river" as they ebb and flow, but only "sea" when the tide is out. In any case the reference is to the "fontal and inflowing" circulation of the Rivers of Life, cf. RV 1.164.51, *samānam etad udakam uc caity ava*, and JUB 1.2.7, *āpaḥ parācir . . . prasṛtās syanderan . . . niveṣṭamānā . . . yanti.*

[5] *Prajā*, "children," all living things regarded as the offspring of Prajāpati, and usually to be distinguished from *bhūtāni*, "beings," in the sense of the "Breaths," i.e., "faculties" or "powers of the soul" (Pythagorean ψυχῆς ἄνεμοι, Philo's τῆς ψυχῆς δυνάμεις, etc.), of which the names, vision, etc., are those of the immanent Person's acts rather than of our own (BU 1.4.7, CU v.1.15, JUB 1.28–29).

As regards the reference of *prajā* to all living things, whether or not human, cf. BU 1.4.3 and 4: "Thence were born human beings. . . . Thus, indeed, He (*puruṣa*, the Person) emanated all (*sarvam asṛjata*), down to the ants"—a context that makes it clear that *sṛṣṭi*, too often rendered by "creation," ought rather to be rendered by "emanation" or "expression." It is one and the same universal Self that quickens all things, but It is more clearly manifested in animals than in plants, and still more clearly in man than in animals (AĀ ii.3.2). In Meister Eckhart's words, "God is

which-is (*sat*, τὸ ὄν), know not that 'We have come forth from That-which-is,' but here in the world become whatever they become, whether tiger, lion . . . or gnat," i.e., believe that they *are* this or that; whereas MU vi.22: "those who pass beyond this diversely variegated [sonorosity of rivers, bells, or falling rain] go home again into the supreme, silent, unmanifested Brahma, and reaching That are there no longer severally characterized or severally distinguished."[6]

So, again, in China, *Tao Te Ching*, 32: "Unto Tao all under heaven will come, as streams or torrents fall into a great river or sea" [see n. 9 below]; which reminds us both of Dante's "nostra pace: ella è quel mare, al qual tutto si move" (*Paradiso* iii.85 and 86), and of the Vedic "When shall we come to be again in Varuṇa?" (RV vii.86.2), i.e. in that Brahma "whose world is the Waters" (Kauṣ. Up. 1.7), or that Agni who "is Varuṇa at birth" (RV iii.5.4, v.3.1) and is "the single Sea, the keeper of all treasures" (RV x.5.1). In the words of Jalālu'd Dīn Rūmī, "the final end of every torrent is the Sea. . . . Opposites and likes pertain to the waves, and not to the Sea" (*Mathnawī* iv.3164 and vi.1622, cf. Philo, *Immut.* 164).

Parallels abound in Islamic contexts. Thus, Shams-i-Tabrīz: "Enter that ocean, that your drop may become a sea that is a hundred 'seas of Omān'. . . . When my heart beheld Love's sea, of a sudden it left me and leapt in" (Rūmī, *Dīvān*, Odes xii and vii)—contemporary with Meister Eckhart's "Plunge in, this is the drowning." More than once his great disciple, Jalālu'd Dīn Rūmī, asks us, "What is Love? Love is 'the Sea of Non-existence,'"[7] he says; and again, "What is Love? Thou shalt know

in the least of creatures, even in a fly"; and conversely, "any flea, as it is in God [ideally], is higher than the highest of the angels as he is in himself."

For the term "emanation," often avoided for fear of a narrow "pantheistic" interpretation, cf. St. Thomas Aquinas, *Sum. Theol.* 1.45.1: *"It is appropriate* to contemplate . . . the emanation of all being from the universal cause which is God. . . . Creation, which is the emanation of all being, is out of nonbeing, which is nothing."

God is the supreme identity of "Being and Nonbeing," Essence and Nature; from Nonbeing there arises Being as a first assumption, and from Being come forth all existences.

[6] "He who aims at actual gnosis . . . will pin his faith to the One devoid of any sort of number or variety, the One wherein is lost, is blotted out, every property and all distinctions, which are there the same" (Meister Eckhart, Evans ed., II, 64).

[7] I.e., of superessential Being, unlimited by any of the conditions of ex-istence (*ex alio sistens*), those of being "thus" or "otherwise." "There is no crime worse than thy ex-istence" (Rūmī, *Dīvān*, Ode xiii, commentary, p. 233): "Most specially he feeleth matter of sorrow who knows and feels that he is. All other sorrows are unto this in comparison but as game to earnest. For he may make sorrow earnestly

when thou becomest Me" (*Mathnawī* iii.4723, and ii, Introduction). Man is like a drop of water that the wind dries up, or that sinks into the earth, but "if it leaps into the Sea, which was its source, the drop is delivered . . . its outward form disappears, but its essence is inviolate. . . . Surrender thy drop and take in exchange the Sea . . . of God's Grace"; "Spill thy jug[8] . . . for when its water falls into the river-water, therein it disappears, and it becomes 'the River' " (*Mathnawī* iv.2616 ff., and iii.3912–3913)—the River, that is to say, of Plato's "ever-flowing Nature."[9]

All this pertains to the common universe of metaphysical discourse; none of these ways of speaking is foreign to specifically Christian aspiration. For God "is an infinite and indeterminate Sea of substance" (Damascene, *De fide orthodoxa* i) : and deification, or theosis, man's last end, demands an "ablatio omnis alteritatis et diversitatis" (Nicholas of Cusa, *De filiatione Dei*). "All things," Meister Eckhart says, "are as little unto God as the drop is to the wild sea; and so the soul, indrinking God, is deified, losing her name and her own powers, but not her essence" (Pfeiffer ed., p. 314). And Ruysbroeck: "For as we possess God in the immersion of Love— that is, if we are lost to ourselves—God is our own and we are His own; and we sink ourselves eternally and irretrievably in our one possession, which is God. . . . And this down-sinking is like a river, which without pause or turning back pours ever into the sea; since this is its proper resting place. . . . And this befalls beyond Time; that is, without before or after, in an Eternal Now . . . the home and the beginning of all life and all becoming. And so all creatures are therein, beyond themselves, one Being and one Life with God, as in their Eternal Origin" (Jan van Ruysbroeck, *The Sparkling Stone*, ch. 9, and *The Book of Supreme Truth*, ch. 10).

who knows and feels not only what he is, but that he is" (*Cloud of Unknowing*, ch. 44). The Supreme Identity, indeed, is of "Being and Nonbeing" (*sadasat*), beyond both affirmation and negation; but to attain to this last end, it will not suffice to have stopped short at Being existentially.

[8] For the "jug," the psycho-physical "personality," see *Mathnawī* i.2710–2715; cf. the Vedantic symbol of the jar, of which the space contained and space that contains are seen to be the same as soon as the jar is broken; and the Buddhist comparison of the body to a jar, Dh 40, *kumbhūpamam kāyam imam viditvā*.

[9] It will be noticed that the terms of the symbolism are not always literally the same. The eternal source may be called the Sea, or the River, while temporal existences are either waves of the Sea, or rivers that reenter it or that are tributaries of the Rivers. The eternal source is at the same time motionless and flowing, never "stagnant"; so that, as Meister Eckhart says, there is "a fountain in the godhead, which flows out upon all things in eternity and in time" (Pfeiffer ed., p. 530); as is also implied by the "enigma" of RV v.47.5, where "though the rivers flow, the Waters do not move."

So, also, Angelus Silesius in *Der Cherubinische Wandersmann*, VI.172:

> If you would speak of the tiny droplet in the great sea,
> Then you would understand my soul in the great divinity;

and to the same tradition there belongs Labadie's beautiful last testament: "I surrender my soul heartily to God, giving it back like a drop of water to its source, and rest confident in Him, praying God, my origin and Ocean, that He will take me into himself and engulf me eternally in the abyss of His being."[10] When, indeed, shall we come "to be again in Varuṇa?"

In conclusion: we are not much concerned here with the literary history of these striking agreements; it matters little that the Indian sources are the oldest, since it can almost always be assumed that any given doctrine is older than the oldest record of it that we happen to have found. The point is, rather, that such collations as have been made above illustrate a single case of the general proposition that there are scarcely any, if any, of the fundamental doctrines of any orthodox tradition that cannot as well be supported by the authority of many or all of the other orthodox traditions, or, in other words, by the unanimous tradition of the Philosophia Perennis et Universalis.

[10] Cited by Dean Inge, *The Philosophy of Plotinus* (London, 1918), I, 121.

TRADITIONAL SYMBOLISM: THE SUNDOOR AND RELATED MOTIFS

The Symbolism of the Dome

PART I

The origin of any structural form can be considered either from an archaeological and technical or from a logical and aesthetic, or rather cognitive, point of view; in other words, either as fulfilling a function or as expressing a meaning. We hasten to add that these are logical, not real distinctions: function and significance coincide in the form of the work; however, we may ignore the one or the other in making use of the work as a thing essential to the active life of the body or dispositive to the contemplative life of the spirit.

Inasmuch as we are here mainly concerned with significance, we need not emphasize the importance in architectural history of the problem presented by the superposition of a domed (or barrel-vaulted) roof upon a rectangular base, nor go into the question of how, where homogeneous materials such as mud or wattle were in use, this was originally very simply solved (and even more easily in the case of a tent of skins or woven material) by a gradual obliteration of the angles as the walls were built up; and how subsequently where stone or brick was employed, the same problem was solved structurally in two ways, either by spanning (trabeation, squinches) or by building forward from the angles (corbelling, pendentives). We propose to ask rather *why* than *how* "the square chamber is *obliged* to forsake its plan and strain forward to meet the round dome in which it must terminate,"[1] and whether it is altogether accidentally,

[First published in *The Indian Historical Quarterly*, XIV (1938), this essay includes in Part II the text of a shorter essay, "Le Symbolisme de l'épée," which appeared in *Études traditionelles*, XLIII (1938).—ED.]

[1] E. Schroeder, in *A Survey of Persian Art*, ed. Arthur Upham Pope and Phyllis Ackerman (Oxford, 1938–1939 [2nd ed., 1964–1965]), Vol. VI, s.v. "The Seljuq Period," pp. 1005–1006 (italics mine). In a consideration of the successive courses of the elevation, Schroeder also remarks that "the four zones suggest in their succession a series of metaphysical concepts whose progression has been the concern of contemplatives from Pythagoras to St. Thomas: first individuality or multiplicity, secondly conflict and pain, next unanimity, consent and peace, and finally unification, loss of individuality, beatitude."

so to speak, that our domes "appear to have been *destined* to symbolize the passage from unity to quadrature through the mediation of the triangle of the squinches";[2] and why in the north porch of the Erechtheion "immediately above the trident-mark [of Poseidon] an opening in the roof had been *purposely* left."[3] We might have expressed the problem otherwise by asking, "Why should the walls of a tepee or sides of a pyramid contract towards a common point in which their independent existence ceases?" or again, in the case of a dome supported by pillars, by asking, "Why should these pillars either actually (as in the case of certain bamboo constructions) or virtually (as is evident if we consider the arch as a dome in cross-section) converge towards the common apex of their separated being, which apex is in fact their '*key*'?"

In this matter of procedure from unity to quadrature there is something analogous to the work of the three Ṛbhus in making four cups out of Tvaṣṭṛ's one. These Ṛbhus compose a triad of "artists,"[4] who are described as "Men of the interspace, or air" (*antarikṣasya narāḥ*), and are said to have quartered the Titan's cup (*camasam, pātram*), "as it were measuring out a field" (*kṣetram iva vi mamuḥ*, RV 1.130.3-5). The reference is undoubtedly to the primordial act of creation by which a "place" is prepared for those who are eager to emerge from the antenatal tomb, to escape the bonds of Varuṇa. Attention may be called to the expression *vi mamuḥ*, from *vi mā*, to "measure out" or "lay out," and hence to "plan" or even "construct." The root with its prefix occurs notably in the word *vimāna*, which often coincides with *ratha* (chariot) as the designation of what is at once the "palace" and the "vehicle" of the gods (i.e., the revolving universe),[5] and which occurs in the *Ṛg Veda* chiefly in con-

[2] J. H. Probst-Biraben, "Symbolisme des arts plastiques de l'Occident et du Proche-Orient," *Le Voile d'Isis*, XL (1935), 16.

[3] Jane Ellen Harrison, *Themis* (Cambridge, 1927), p. 92.

[4] Rbhu, from *rabh* (cf. *labh*), as in *ārabh*, to "undertake," "fashion," and *rambha*, a "prop," "post," "support." In RV x.125.8 *ārambhamāṇā bhuvanāni viśvā*, "fashioning all the worlds, the universe," embodies the meaning also of "setting up all the houses."

[5] Hence it is that actual temples, as at Konāraka, may be provided with wheels and represented as drawn by horses; and it is from the same point of view that their movable images are carried in procession on chariots, drawn by men or horses, of which the most familiar example is that of the annual procession of the "Lord of the World" (Jagannātha) at Puri. That the universe is thought of as a house, not only in a spatial but also in a temporal sense, is seen in ŚB 1.66.1.19, "He alone wins the Year who knows its doors, for what were he to do with a house who cannot find his way inside?"

nection with the creative determination of "space" (*antarikṣa, rajas*), for example in v.41.3, where Somāpūṣaṇā, described as the Poles of the Universe, are besought to "urge your chariot hitherward, the seven-wheeled chariot that measures out the region" (*rajaso vimānaṃ . . . ratham*), that is to say, are asked to bring into being an inhabitable space. In countless texts we find *vi mā* employed in this way with respect to the delimitation of space, the laying out of "abodes of cosmic order" (*ṛtasya dhāma*), and the determination of the "measure of the sacrifice" (*yajñasya mātram*), which is again an aspect of the act of creation. In v.81.3 it is the Sun himself that "measures out the chthonic regions" (*pārthivāni vi mame . . . rajāṃsi deva savitā*), i.e., the "grounds" of the seven worlds; or, otherwise expressed, it is Varuṇa who, "employing the Sun as his rule, measures out the earth" (*māneneva . . . vi . . . mame pṛthivīm sūryeṇa*, v.85.5);[6] and we may say in the words of Genesis 2:1, "thus the heavens and the earth were finished, and all the host of them."

Our citations above have been chosen in part to bring out the connection of the Sun with the act of creative delimitation by which the Three (or Seven, or Thrice Seven) Worlds are made actual. For we must assume from RV 1.110.3 and 5 that the "Asura's cup" made fourfold by the Ṛbhus is really the "platter" or disc (*pātra = maṇḍala*) of the Sun (or rather, *ante principium*, that of the united Sun and Moon, Heaven and Earth, coincident in the beginning as they are at the end of time): we remark not merely the appositional sequence "Savitṛ (the Sun) . . . him-that-may-not-be-hidden . . . this only feeding vessel of the Titan (Father)"

[6] Similarly MU vi.6, "The eye of Prajāpati's crudest form, his cosmic body, is the Sun: for the Person's great dimensioned world (*mātrāḥ*) depends upon the eye, since it is with the eye that he moves about amongst dimensioned things," *mātrāḥ* meaning literally "measured things," and hence the material world of measurable things, or whatever occupies space.

It may be remarked that although we began with the case of the dome on a square base, the spatial principles involved are the same in the case of a circular base, since any "field" is determined in two dimensions. Heaven and Earth are generally thought of as wheels or circles (*cakra*); but in ŚB xiv.3.1.17, the Sun is "four-cornered, for the quarters are his corners," and ŚB vi.1.2.29, the Earth is similarly "four-cornered, and that is why the bricks (of the altar) are likewise four-cornered."

The Axis of the Universe, according to the texts or as represented, is usually cylindrical or four- or eight-angled; early Indian pillars are usually either cylindrical or eight-angled. We might also have discussed the symbolism of these pillars, and similarly that of the palace supported by a single pillar (*ekathambhaka-pāsāda*), but will merely cite as parallel, "Every column in those Achaemenid palaces was an emblem of the sun-god to which the king of kings might look up" (Anna Roes, *Greek Geometric Art*, London, 1933).

(*savitā . . . agohyaṃ . . . camasam asurasya bhakṣaṇam ekaṃ santam,* 1.110.3, with *pātram* for *camasam,* in verse 5),[7] and similarly in AV x.8.9, "bowl wherein is set the glory omniform" (*camasa . . . yasmin yaśo nihi- taṃ viśvarūpam*), but also the later designation of the Sundoor as an "entrance covered over by the golden platter of truth" (*hiraṇyamayena pātreṇa satyasyāpihitaṃ mukham,*[8] Īśā Up. 15, cf. JUB 1.3.6).

It is, then, by means of the Sun, often described as the Titan's "eye," that He surveys, experiences, and "feeds upon" the worlds of contingent being under the Sun, which are in the power of Death, and properly His food; by means of the Sun that these worlds are in the first place "measured out," or "created." It is just this that is implied in the work of the Ṛbhus, who make of the single solar "platter" four of like sort, by which we can only

[7] *Camasam* (= *pātram*) *bhakṣaṇam,* the solar "Grail" as an all-wish-fulfilling feeding vessel; regarded either as himself the "enjoyer" or as the Titan's (Varuṇa's) "means of enjoyment," just as we speak of the eye as "seeing" or as the "means of vision." The Titan Father's bowl, which is also his "eye" (RV 1.50.5-7, x.82.1, x.88.13; AV x.7.33, etc.) provides whatever "food" may be desired, precisely inasmuch as it is the solar orb, paten, or platter which envisages and thus partakes of all things at once; in which sense it is that "the Sun with his five rays feeds upon the objects of sense perception" (*viṣayān atti,* MU vi.31, cf. *pippalam . . . atti,* RV 1.164.20), i.e., "When as the Lord of Immortality he rises up by food" (*amṛtatvasy- êśāno yad annena atirohati,* RV x.90.2 = "comes eating and drinking"); which rays are "the far-seeing rays of Varuṇa," RV x.41.9, "five" if we consider the four quarters and central orb, "seven" if we also consider the zenith and nadir, or more indefinitely "a hundred and one," of which the hundred and first is again the central orb. The bowl is not, as some have suggested, the Moon—"The Person in the orb is the eater, the Moon his food. . . . The Moon is the food of the gods" (ŚB x.5.2.18 and 1.6.4.5); "The Sun is the eater, the Moon his dues. When this pair unites, it is termed the eater, not the food" (ŚB x.6.2.3 and 4). It is, of course, as "world" or "universe," all that is "under the sun," that the Moon is his "meat." The very "life" of Varuṇa, the Fisher King, the deity *ab intra,* otherwise inert and impotent, depends upon this Grail as the eternal means of his rejuvenation and procession. And this solar Grail is the prototype of every sacrificial paten. For the Grail motif in the Indian tradition, and the Buddha's bowl as a Grail, see Coomaraswamy, *Yakṣas,* Pt. II, 1932, pp. 37-42.

[8] *Mukha,* "entrance," "gateway," as in JUB iii.33.8, "The comprehensor thereof, frequenting in the spirit both these classes of divinities (Gale, Fire, Moon, Sun as transcendent and as immanent), the Gate receives him" (*vidvān . . . etā ubhayīr devatā ātmany etya, mukha ādatte*); JUB iv.11.5, "I (Agni) am the Gate of the Gods" (*aham devānām mukham asmi*); AB iii.42, "Agni ascended, reaching the sky, he opened the door of the world of heaven" (*svargasya lokasya dvāram*). For *mukha* as the gateway of a city or fort see *Arthaśāstra,* ii, ch. 21, and the plan in *Eastern Art,* II (1930), Pl. CXXII: the "mouth" of the gateway is approached by a bridge or "concourse" (*saṃkrama*) which spans the moat, so that whoever enters may be said to have reached the "farther shore." There is accordingly a solar symbolism of gateways and of bridges and bridge builders (cf. "pontiff").

understand four solar stations, representing the limits of the solar motion in the four directions (motion daily from east to west and back again, and annually from south to north and back again). It will then be a matter of obtaining "food from all four quarters" (PB xv.3.25): this may seem from a human point of view a great thing, but it can be easily seen that it is far more in accordance with the dignity of the divine unity to obtain all possible kinds of "nourishment" from a single source, a veritable cup of plenty, than to obtain these varied foods from widely extended sources: what Tvaṣṭṛ resents is in effect the partition of his central unity involved by an extension in the four directions. If all this is attributed in the *Ṛg Veda* either to the Deity in person, or alternatively to a subsequently deified triad of "artists," this can only be understood to mean that the latter are collectively the three dimensions of space, and in this sense "powers" whose operation is indispensable to the extension of any horizontal "field" in terms of the four quarters: it is, in fact, only by means of the three dimensions that an original "one" can be made "four," "like a field" (*kṣetram iva*), and it is in this sense that we proceed from unity to quadrature by means of a triangle.[9] The converse procedure is given in the well-known miracle of the Buddha's begging bowl (*patta = pātra*, *Jātaka* I.80); that the Buddha receives four bowls from the kings of the Four Quarters, and making of these four one bowl eats from it, implies an involution of space, and what is evidently and literally an atonement of

[9] This holds good also in the analogous case of the four-fold partition of the *vajra* (made by Tvaṣṭṛ, given to Indra, and with which he smites the Dragon, RV I.85.9, etc.), inasmuch as the four parts are to be wielded, or otherwise moved, ŚB I.2.4.

The coronate and royal Buddha types of the Mahāyāna iconography characteristically hold the begging bowl, and represent (1) the Buddha as Cakravartin, or King of the World, and (2) the Sambhogakāya or Body of Beatitude (Paul Mus, "Le Buddha paré," BÉFEO XXVIII, 1928, 274, 277). Now we suggest that *sam* in *sambhoga* has the value "completely" or "absolutely," rather than that of "in company with"; *sambhoga* is not (in these contexts) an eating "together with others," but an "all-eating," in a sense analogous to that of "all-knowing," cf. *sam-bodhi*, *sam-vid*, *sam-s-kṛ*, etc. The bowl is more than the simple *patta* in which a wandering monk collects his food from here or there; it is a *puṇṇa patta*, a "full bowl," furnished with all kinds of food; and the story seems to assert unmistakably that His body who eats from it is no mere *kāya*, but the Sambhogakāya or Body of Omnifruition. Approaching the problem from another angle, Mus has reached the same conclusion, that the term *sambhoga* implies a perfect, universal, and effortless fruition; pointing out at the same time that *anābhoga*, meaning "not relying upon any external source of nourishment," naturally coincides with *sambhoga* in one and the same subject, and implies a self-subsistence of which the Sun is an evident image (*Barabuḍur*, Paris, 1935, p. 659). My own interpretation of the atonement of the four bowls merely confirms these deductions.

what had been done by the Ṛbhus. For the Buddha, now a unified being, the Grail is once more as it had been in the beginning and for Tvaṣṭṛ, single.

Thus considered, the "myth" of the Ṛbhus may be called a paraphrase of a more usual formula according to which the Sun is described as seven-rayed;[10] of which seven, six represent the arms of the three-dimensional Cross of spiritual Light (*trivṛd vajra*) by which the universe is at once created and supported.[11] Of the six rays, those which correspond to the zenith

[10] From other points of view, of course, the Sun can be regarded as having one, four, five, eight, nine, or a "thousand" rays; eight, for example, with respect to the four quarters and four half-quarters on a given plane of being.

[11] A fuller discussion of the Vedic "Cross of Light," of which the arms are the pathways of the Spirit, must be undertaken elsewhere. In the meantime, for the expression *trivṛd vajra*, see JB 1.247, "The procession of the threefold spear perpetually coincides with that of these worlds" (*trivṛd vajro'harahar imān lokān anuvartata*); for the "best ray" (*param bhās, jyeṣṭha raśmi*, cf. *jyotiṣām jyotis*, "Light of lights"), see ŚB 1.9.3.10 with Mahidhara's commentary, together with JUB 1.30.4, *yat param atibhati . . . tam abhyatimucyate*; and for the *sūtrātman* doctrine, RV 1.115.1, AV x.8.37–38, ŚB vi.7.1.17 and viii.7.3.10, where the Sun is said to "string these worlds to Himself by the thread of the Gale of the Spirit" and to be the "point of attachment" (*āsañjanam*) to which these worlds are bound by means of the six directions; cf. in AV x.7.42 the concept of the universal warp of being as fastened by six pegs or rays of light (*tantram . . . ṣaṇmayūkham*); and BG vii.7 and x.20. It may be added that similar ideas are clearly expressed in the apocryphal Acts of John, 98–99, and Acts of Peter 38.

To avoid all possibility of confusion, it must be emphasized that the position of the Sun in the universe is in the Vedic tradition always at the center, and not at the top of the universe, although always above and at the "Top of the Tree," when considered from any point within the universe. How this is will be readily understood if we consider the universe as symbolized by the wheel, of which the center is the Sun and the felly any ground of being. From any one position on the felly it will be seen that the Axis of the Universe, which pillars apart heaven and earth, is a radius of the circle and a ray of the Sun, occupying what is from our point of view the zenith, but from the solar point of view the nadir; while from an exactly opposite position on the felly, the same will hold good. The Axis of the Universe is represented, then, by what in the diagram is actually a diameter, made up of what is from any one point of view a nadir and a zenith; in other words, the axis passes geometrically through the Sun. It is in quite another than this geometric sense that the "seventh ray" passes through the Sun, viz. into an undimensioned beyond, which is not contained within the dimensioned circle of the universe. The prolongation of this seventh ray beyond the Sun is accordingly incapable of any geometric representation; from our point of view it ends in the Sun, and is the disc of the Sun, through which we cannot gaze, otherwise than in the spirit, and not by any means either physically or psychically. To this "ineffable" quality of the prolongation of the "Way" beyond the Sun correspond the Upaniṣad and Buddhist designations of the continuing *brahma-patha* as "nonhuman" (*amānava*) and as "uncommunicable" or "untaught" (*aśaikṣa*), and the whole doctrine of "Silence" (see Coomaraswamy, "The Vedic Doctrine of Silence" [in volume 2 of this selection—ED.]). The essential dis-

and nadir coincide with our Axis of the Universe (*skambha, divo dharuṇa,* etc.), Islamic *quṭb,* and Gnostic σταυρός, while those which correspond to north and south, east and west, determine the extension of any horizontal plane or "world" (*loka,* precisely as the *locus* of a specific ensemble of possibilities), for example, that of each of the seven worlds considered as a given plane of being. The seventh ray alone passes *through* the Sun to the suprasolar Brahma worlds, "where no sun shines" (all that is under the Sun being in the power of Death, and all beyond "immortal"); and is represented accordingly in any diagram by the point at which the arms of the three-dimensional cross intersect, or as Mahidhara expresses it, "the seventh ray is the solar orb itself." It is by this "best ray," the "one foot" of the Sun, that the "heart" of each and every separated essence is directly connected with the Sun; and it will prove to be significant in our interpretation of the summit of the dome that when the separated essence can be thought of as returned to the center of its own being, on whatever plane of being this seventh ray will evidently coincide with the Axis of the Universe. In the case of the Buddha's "First Meditation,"[12] it is evidently just because he is for the time being completely reverted and thus analogically situated at the "navel of the earth," the nether pole of the Axis, that the Sun above him casts an unmoving shadow while the shadows of trees other than the one under which he is seated change their place. We need hardly say that the position of the Axis of the Universe is a universal and not a local position: the "navel of the earth" is "within you," else it were

tinction of this seventh ray from the other spatial rays (which also corresponds to the distinction of transcendent from immanent and of infinite from finite) is clearly marked in symbolic representations, of which we give two illustrations, respectively Hindu and Christian [Figure 12].

Figure 12. The Seven-Rayed Sun
In B. the long shaft of the seventh ray extends downward
from the Sun to the Bambino in the cradle.

[12] J 1.58; cf. CU III.8.10, where for the Sādhya deities the Sun rises always in the zenith and sets in the nadir—and can therefore, so far as they are concerned, cast only a fixed shadow.

impossible to "build up Agni intellectually," as the *Śatapatha Brāhmaṇa* expresses what is formulated in Christianity as the "bringing to birth of Christ in the soul." In the same way the center of every habitation is analogically *the* center, an hypostasized center, of the world, and immediately underlies the similarly hypostasized center of the sky at what is the other pole of the Axis at once of the edifice and of the universe it represents.

Every house is therefore the universe in a likeness, and provided with an analogous content: as Mus expresses it, "the house and the world are two equivalent sums. . . . The family living in it is the image of the countless crowd of creatures dwelling in the shelter of the cosmic house, of which the ceiling or roof is heaven, light, and sun." The work of the architect is really an "imitation of nature in her manner of operation": the several houses reflect in their accidents the peculiarity of as many builders, but are essentially "so many hypostases of one and the same world and all together possess but one and the same reality, that of this universal world."[13]

What we have said with respect to the house applies with equal force to many other constructions, of which we may cite the chariot as a notable example. No less precisely than the house, the chariot reproduces the constitution of the universe in luminous detail. The human vehicle is an exemplary likeness of the cosmic vehicle or body in which the course is run from darkness to light, from endless end to endless end of the universe, conceived at once in terms of space (and in this sense as stable) and in terms of time (as the Year, and in this sense revolving).[14] The paired wheels of this cosmic vehicle or universal incarnation of the Spirit, its driver, are respectively heaven and earth, at once divided and united by the axle tree, on which the revolution of the wheels takes place (RV x.89.4). This axle tree is the same thing as our Axis of the Universe, and trunk of the Tree, and the informing principle of the whole construction.

[13] P. Mus, "Barabuḍur: esquisse d'une histoire du Bouddhisme fondée sur la critique archéologique des textes," BÉFEO, 1932 f. [published in 1935 in 2 vols. (Paris: Geunther)]. Passages quoted above are from Part V, pp. 125, 207, 208.

Cf. H. Kern, *Histoire du Bouddhisme dans l'Inde* (Paris, 1903), II, 154, "The true Dhātugarbha of the Ādi-Buddha, in other words the Creator, Brahmā, is the Brahmāṇḍa, the world-egg, container of all the elements (*dhātu*) and which is divided into two halves by the horizon. This is the real Dhātugarbha (receptacle of the elements): the constructions are only an imitation of it."

[14] See the excellent discussion of the cosmic chariot and its microcosmic replicas, and the demonstration of the analogy of cosmic and human *processions* in Mus, "Barabuḍur," p. *229.

The division of the wheels, which is the act of creation, brings into being a space within which the individually proceeding principles are borne on their way; while their reunion, realized by the charioteer when he returns from the circumference to the center of his own being, is the rolling up of time and space, leaving in principle only a single wheel (Dante's *prima rota*), of which the hub is that solar gate "through the midst of which one escapes altogether" (*atimucyate*, JUB 1.3.5) from the revolving cosmos into an uncontained empyrean. Nothing will be changed in principle if we take account in the same way of the exemplary likeness of ships to the cosmic Ship of Life in which the Great Voyage is undertaken; the deck corresponding to the surface of the earth, the mast coinciding with the vertical axis of the house and axle tree of the chariot, while the "crow's nest" corresponds to the seat of the all-seeing Sun above.

All that we have implied, here and elsewhere, with respect to the imitation of heavenly prototypes in human works of art, and the conception of the arts themselves as a body of transmitted knowledge of ultimately superhuman origin, can be applied equally to the case of the artificer himself, just as also in Christian philosophy there is taken for granted an exemplary likeness of the human architect to the Architect of the World, and as indeed the consistency of the doctrine requires. If we consider such an architectural treatise as the *Mānasāra*, we find in the first place clear evidence of a direct dependence upon Vedic sources, for example, in the statement that the master architect (*sthapati*) and also his three companions or assistants, the surveyor (*sūtra-grāhī*), the builder and painter (*vardhakī*), and carpenter (*takṣaka*), are required, by way of professional qualification, to be acquainted both with the Vedas and with their accessory sciences (*sthapatiḥ . . . vedavic-chāstra-pāragaḥ, Mānasāra*, II.13 ff.), and in such verses as "It is through the Sun that the Earth becomes the support of all beings" (*ibid*. III.7), evidently an echo of RV v.85.5 cited above.[15] Furthermore, "It has been said by the Lord Himself that He is the All-fashioner (Viśvakarmā)" (*ibid*. II.2); and it is from His four "faces" that are descended the quartet of architects mentioned above, who are moreover called "all-fashioners" after Him (*ibid*. II.5). It may be added that evidently the "four architects" correspond to the four ritual priests of the sacrifice, the *sthapati* in particular to that one who is styled preeminently *the* Brāhmaṇa, as distinguished from the others by his greater knowledge, without which their operation would be defective. In

[15] Cf. VIII.25.18, "He (Sun) hath measured out with his ray the boundaries of heaven and earth."

Coomaraswamy, *Mediaeval Sinhalese Art* [1908—ED.], we have called attention to the sacerdotal and regal functions performed even by the modern *sthapati* in Ceylon. A similar analogy could be drawn between the "four architects" on the one hand, and the Sun or solar Indra with his particular associates, the Ṛbhus. And finally, the designation of the master architect as *sthapati* immediately suggests *vi . . . atiṣṭhipaḥ* in RV 1.56.5–6, where it is a matter of the architectural construction of the universe, with its axial "Pillar of Heaven" (*divo dharuṇam*, cf. IX.73.7, where Soma as the Tree of Life is *aharuṇaḥ mahaḥ divaḥ*, "the great σταυρός of the sky"), and rigid crossbeam (*tiro dharuṇam acyutam*): *sthapati* and *atiṣṭhipaḥ* being equally causative forms of *sthā* in the sense "to set up." RV 1.56 at the same time makes a direct connection between the construction of the universe and the smiting of the Serpent, Ahi-Vṛtra, the significance of which will appear later. We may say that just as much as the sacrifice itself (a synthesis of all the arts), every artistic operation as such operation is envisaged by tradition is an imitation of what was done by the gods in the beginning.

The questions of the Ṛbhus and of the Cross of Light have been introduced into our discussion of the principles of sacred architecture (from the traditional point of view, there is nothing that can be defined as essentially or wholly secular) primarily in order to provide a background illustrative of the manner in which the problems of spatial extension and construction have been traditionally approached. Our method of approach is based upon the fact that the technical problem as such only presents itself when there has already been imagined a form to be realized in the material. Whether we have in view a spatial universe or a human construction, the idea of a space to be enclosed between a vault above and a plane below must be assumed in the mind of the architect logically prior to any actual becoming of the work to be done; which priority will be merely logical in the case of the Divine Architect, but must be also temporal in the case of the human builder who proceeds from potentiality to act. And prior to this formal cause, with the same reservations, there must be assumed a final cause or purpose of the construction to be undertaken, the artist always working both *per artem et ex voluntate*. The same will hold good whether we take account of the house of the body, a constructed dwelling, or the universe as a whole. Just as formally considered there is a correspondence between the human body,[16] human building,

[16] With its interior cell, the "lotus of the heart, indwelt by the Golden Person of the Sun" (MU VI.2), "ever seated in the heart of creatures" (KU VI.17), the "all-

and whole world, so there is also a teleological correspondence: all these constructions have as their practical function to shelter individual principles on their way from one state of being to another—to provide, in other words, a field of experience in which they can "become what they are." The concepts of creation (means) and of redemption (end) are complementary and inseparable: the Sun is not merely the architect of space, but also the liberator of all things thereinto (which would otherwise remain in an obscurity of mere potentiality), and finally of all things therefrom.

It can be said with respect to any of these houses to which we have referred that one enters into the provided environment at its lowest level (at birth) and departs from it at its highest level (at death); or in other words that ingress is horizontal, egress vertical (these are the two directions of motion on the wheel of life, respectively peripheral and centripetal). If this is not empirically evident in all respects,[17] this is nevertheless an accurate presentation of the traditional concept of the passage of any individual consciousness through any "space"; and this is a matter of importance, because it is precisely in the notion of a vertical egress that we shall find an explanation of the symbolism of our domes.

We are not then disposed to inquire whether or not, or whether to some extent, the form of a stūpa may or may not have been derived from that of a tumulus or domed hut (we agree in fact with Mus in rejecting

containing city of Brahman" (CU VIII.1.6), "constance of Indra and Indrāṇī" (Heaven and Earth) (BU IV.2.3, MU VII.11). We shall see later that it is from the apex of this house of the body or heart that the indwelling Spirit emerges when its connection (samyoga) with the individual body and soul is severed.

For a corresponding analogy of the inward and outward "cells," see *The Golden Epistle of Abbot William of St. Thierry to the Carthusians of Mont Dieu,* tr. Walter Shewring (London, 1930), p. 51: "Thou hast one cell without, another within. The outward cell is the house wherein thy soul and thy body dwell together; the inward is thy conscience (*conscientia,* "consciousness," "inward controller," *antaryāmin*), which ought to be dwelt in by God (who is more inward than all thy inward parts) and by thy spirit" (sc. *antarātman*).

[17] Our allusion is, in fact, to the metaphysical identification of woman with the household fire (*gārhapatya*) and of the act of insemination with that of a ritual offering in this fire; for which see JB 1.17 (JAOS, XIX, 1898, 115–116), and BU VI.4.1–3. Considered from this point of view all birth is from fire. Man's first birth is his liberation from an antenatal hell; he enters at birth into a purgatorial space; and being laid in the sacrificial fire at death, is regenerated through the Sun; his earthly motions are horizontal, his spiritual ascent vertical, by way of the σταυρός, under whatever aspect this pillar may be represented.

such a theory of origins), but rather to seek for what may be called the common formal principle that finds expression equally in all of these and in other related constructions. We propose to consider the architectural form primarily as an imagined (*dhyātam*)[18] form, referring its "origin" rather to "Man" universally, in whom the artist and the patron are one essence, than to this or that man individually. It need hardly be said that the traditional theory of art, and the Indian tradition in particular, invariably assume an "intellectual operation" (*actus primus*) preceding the artist's manual operation. We have discussed this elsewhere in connection with the later sources,[19] but may remark that the principle is clearly expressed in Indian texts from the beginning by the constant employment of the roots *dhī* or *dhyai*[20] and *cit* or *cint* in connection with all kinds of constructive operation, such as the fashioning of an incantation or that of a chariot or altar. For example, in RV III.2.1 the priests are said to bring Agni nigh "by contemplation" (*dhiyā*), "even as it is by contemplation that the tool gives form to the chariot"; in AV x.1.8, where we find the image "even as by a Ṛbhu the parts of a chariot are put together, by means of a contemplation" (*dhiyā*); and in ŚB vi.2.3.1 (and *passim*) where in connection with the building of the Fire Altar, whenever the builders are at a loss, not knowing how to build up the next course of the structure, we find a sequence of words in which they are enjoined to "contemplate" (*cetayadhvam*) and are then described as "seeing" (*apaśyan*) the required form. It is thus not by means of the empirical faculties, nor, so to say, experimentally, but intellectually that the formal cause is apprehended in an imitable form. We are considering the dome, accordingly, primarily as a work of the imagination, and only secondarily as a technical achievement.

Man has always, in a manner that we have tried to indicate above, correlated his own constructions with cosmic or supramundane prototypes. As Plotinus expresses it, "The crafts such as building and carpentry

[18] Just as in connection with painting we find the instruction *tad dhyātam bhittau niveśayet*, "put down on the wall what has been imagined" (*Abhilaṣitārtha-cintāmaṇi* 1.3.158).

[19] "The Intellectual Operation in Indian Art" [in this volume—ED.]; "The Technique and Theory of Indian Painting," 1934; *The Transformation of Nature in Art*, 1934.

[20] *Dhī* as noun is not so much merely "thought," but specifically *contemplatio, theoria, ars, prognosis*; and *dhira* not merely "wise" but specifically "contemplative," and tantamount to *yogi*, especially in the sense in which the latter term is sometimes applied to artists.

which give us matter in wrought forms may be said, in that they draw on pattern, to take their principles from *that* realm and from the thinking *there*" (Plotinus, v.9.11). For example, the Indian seven-storied palace (*prāsāda*) with its various floors or "earths" (*bhūmi*) has always been thought of as analogous to the universe of seven worlds; and one mounts to the top story as if to the summit of contingent being (*bhavāgra*), just as the Sun ascends the sky and from his station in the zenith surveys the universe. It has been pointed out by Mus, in his magnificent monograph on Barabuḍur, from which we have quoted above, that the stūpa, particularly when monolithic, is essentially a domed *form* rather than a domed construction, and therefore, necessarily to be understood rather from a symbolic than from a practically functional point of view; it represents a universe *in parvo*, the abode of a person who has passed away, analogous to the universe itself considered as the body or abode of an active "Person." In the same way the Christian church, functionally adapted to the uses of liturgy, which are themselves entirely a matter of symbolic significance, derives its form from an authority higher than that of the individual builder who is its responsible architect: just as also in the case of the painted icons. "The art alone belongs to the painter; the ordering and the composition belong to the Fathers" (Second Council of Nicaea). In the same way the Indian architect "should reject what has not been prescribed (*anuktam*), and in every respect perform what has been prescribed" (*Mānasāra*); just as it is stated in connection with images that "the beautiful is not what pleases the fancy, but what is in agreement with the canon" (*Śukranītisāra*, iv.4.75 and 106), the function of which canon is to provide the support for the contemplative act in which an imitable form is visualized (*Śukranītisāra*, iv.4.70–71).[21]

Before proceeding to a more detailed consideration of the ideology expressed in Indian domed constructions, and in what may be termed the archetypal form of any edifice, we must point out that what has been said by Mus for the stūpa and for the palace, "this Buddhist monument is comprehensible primarily with respect to its axis," and "we say of the *prāsāda*, as of the *stūpa*, that it is to be understood with respect to its

[21] Needless to say that the doctrines of the "freedom of the artist" and of artistic "self-expression" could only have arisen, in logical apposition to that of the "free examination" of the Scriptures, in such an antitraditional environment as that which had been provided by the Protestant Reformation (*sic*), with its altogether unChristian evaluation of "personality."

axis, and that all the rest is only accessory decoration,"[22] is of universal application.[23] This is sufficiently evident in the case of a domed hut of which the roof is actually supported by a king post, thought of not merely as connecting the apex of the roof with a tie beam, but as extending from the apex to the ground. We wish to point out, however, that while huts of this type have certainly existed and that similarly, at least in some cases (e.g., at Ghaṇṭasālā), the axis of the stūpa was actually and structurally represented within it, the importance of the axis in principle is no more necessarily represented by an actual pillar within the building than it would be possible to demonstrate the empirical existence of an Axis of the Universe, which axis is, indeed, always spoken of as a purely spiritual or pneumatic essence. On the other hand, we do find that the prolongations of the axis above the roof and below the ground are materially represented in actual construction; above, that is, by a finial, which may be relatively inconspicuous, but in many stūpas extends upwards in the form of a veritably "sky-scraping" mast (*yaṣṭi*) or "sacrificial post" (*yūpa*) far beyond the dome; and below the floor of the contained space by the peg of khadira wood driven into the ground,

[22] Mus, "Barabuḍur," pp. 121, 360.

[23] We say "universal" advisedly, and not merely with reference to each and every human construction. The universe itself can be understood only with reference to its axis. The creation is continually described as a "pillaring apart" (*viskambhana*) of heaven and earth; and that "Pillar" (*skambha* = σταυρός) by which this is done is itself the exemplar of the universe. "It is pillared apart by this Pillar that heaven and earth stand fast; the Pillar is all this enspirited (*ātmanvat*) world, whatever breathes or winks" (AV x.8.2); "therein the future and the past and all the worlds are stayed" (AV x.7.22); "therein inheres all this" (AV x.8.6); "trunk of the Tree wherein abide whatever gods there be" (AV x.7.38).

Two illustrations may be cited. The Deopārā inscription of Vijayasena says that this king erected (*vyadhita*, lit, "struck," in the sense in which one "sticks up" a post) a temple of Pradyumna, which was the "Mount (Meru) whereupon the Sun at midday rests the Tree whose branches are the quarters of space (*dik-śākhā-mūla kāṇḍam*), and only sustaining pillar of the house of the Three Worlds" (*ālamba-stambham ekam tribhuvana-bhavanasya*) (*Ep. Ind.*, 1.310, 314, cited by Mus, "Barabuḍur," Part IV, p . 144; cf. BÉFEO, 1932, p. 412).

In the *Volsunga Saga*, "King Volsung let build a noble hall in such a wise that a big oak tree stood therein, and that the limbs of the tree blossomed far out over the roof of the hall, while below stood the trunk within it, and the said trunk did men call Branstock" (i.e., burning bush); it is moreover from this trunk that Sigmund draws the sword Gram, with which Sigurd subsequently slays Fafnir; cf. the Indian myth of the origin of the sacrificial sword, discussed in Part II of this article.

It will be observed that in Volsung's hall the roof is penetrated by the stem of the World-Tree. The hall is virtually a hypaethral temple, like the Indian *bodhi-ghara,* fully described in Coomaraswamy, "Early Indian Architecture: I. Cities and City Gates; II. Bodhi-gharas," 1930, pp. 225–235.

by which the head of the all-supporting Serpent is fixed.[24] In any traditional society, every operation is in the strictest sense of the word a rite, and typically a metaphysical rather than a religious (devotional) rite; and it is of the very nature of the rite that it is a mimesis of what was done "in the beginning." The erection of a house is in just this sense an imitation of the creation of the world; and it is in this connection that the transfixation of the head of the Serpent, alluded to above, and regarded as an indispensable operation, acquires an intelligible meaning. In modern practice, "the astrologer shows what spot in the foundation is exactly above the head of the snake that supports the world. The mason fashions a little wooden peg from the wood of the khadira tree, and with a coconut drives the peg into the ground at this particular spot, in such a way as to peg the head of the snake securely down . . . if this snake should ever shake the world to pieces." A foundation stone (padma-śilā), with an eight-petaled lotus carved upon it, is set in mortar above the peg. A Brahman priest assists at all these rites, reciting appropriate incantations (mantras).[25] As Mus very justly adds to this citation, "If one

[24] These penetrations of the roof and floor correspond to what in the case of the cosmic chariot are the insertions of the axle-tree in the hubs of the wheels. The Serpent underground, an Endless Residuum (ananta, śeṣa), is the nonproceeding Godhead, Death, overcome by the proceeding Energy with whom the Axis of the Universe, its exemplary support, is identified, and Who "occupies" the whole universe in the same way that the σταυρός, as the first principle of space, is said to "occupy" the six extents, for example in AV x.7.35: "The Pillar (skambha) hath given their place to both heaven and earth and to the space between them, hath given a place to the six extents (i.e., the three dimensions of space considered as proceeding from a common center in opposite directions), and taken up its residence (vi viveśa) in this whole universe," for all of which we have in practice the direct analogy of the builder's gnomon, set up in the beginning, and employed as the first principle of the whole layout (Mānasara, ch. vi).

[25] Margaret Stevenson, The Rites of the Twice Born (London, 1920), p. 354. Cf. extracts from the Māyāmataya, verses 56–60, in Coomaraswamy, Mediaeval Sinhalese Art, 1908, p. 207. Mrs. Stevenson remarks that a fire altar is subsequently made "in the very center of the principal room of the house" (p. 358). Such a "principal room" may be said to represent what was once the whole house, in its prototypal form of a circular hut, with its central hearth. At least in the case of this prototype, it will be safe to assume that this central hearth has been constructed immediately above the transfixed head of the chthonic Serpent; and it will be remarked that the smoke of the fire will rise vertically upwards to the eye or luffer in the roof, from which it escapes. These relations correspond exactly with the doctrine that the household fire is ab extra and manifestly what the chthonic Serpent is ab intra and invisibly (AB iii.36), and with such texts as RV iii.55.7, where Agni is said to remain within his ground, even while he goes forth (anv agraṃ carati kṣeti budhnah)— proceeds, that is, when he has been "awakened" by Indra's lance (sasantam vajrena abodhyo'him, RV i.103.7) which "awakening" is a "kindling," as in RV v.14.1,

performs in this way what is apparently a sacrilege, it is with a view to avoiding such quakings of the earth as might be caused if the Serpent should move its head."[26] A very striking example of the rite is to be found in the "Ballad of the Iron Pillar" at Delhi: "All above a polished shaft, all a piercing spike below. Where they marked the Nāga's head [Śeṣa's in a subsequent verse], deep the point was driven down. . . . Soon a castle clothed with might round the iron pillar clomb; soon a city . . . "; but when at the instigation of an enemy of the royal "house," the bloody point is afterwards withdrawn,[27] "sudden earthquakes shook the plain."[28]

"Awaken Agni, ye that kindle him," *agnim . . . abodhya samidhanah*. Cf. also the identification of Agni with the "Head of Being," RV x.88.6 and AB III.43; and the discussion in Coomaraswamy, "Angel and Titan," 1935, p. 413. Furthermore, were it not that the smoke passes through the roof and into the beyond, the analogy would be defective, since in this case (i.e., if the smoke of the burnt offering were confined), Agni could not be thought of as the missal priest by whom the oblation is conveyed to the immortal deities whose abiding place is beyond the solar portal.

[26] Mus, "Barabuḍur," p. 207. It will not be overlooked that even in modern Western practice there still survives the laying of a foundation stone, accompanied by what are strictly speaking metaphysical rites; nor that such survivals are strictly speaking superstitions, or "stand-overs" of observances of which the meaning is no longer understood.

[27] In connection with this "bloody point" and the cosmic instability that follows upon its withdrawal, there could be developed an exposition of the phallic and fertilizing properties of the Axis of the Universe, of which the Bleeding Lance of the Grail tradition, the Indian Śiva-liṅgam, and the planting stick or ploughshare are other aspects. But this would be to wander too far away from the present architectural theme.

[28] Waterfield and Grierson, *The Lay of Alha* (Oxford, 1923), pp. 276 ff. The Brahman's question in the ballad, "How should mortal dare deal the Nāga king a mortal blow?" exactly corresponds to that of Mus, "Barabuḍur," "How is it that each house could be made out to stand just above the head of the mythical Serpent, the supporter of the world?" The answer is, of course, that the very center of the world, the "navel of the earth" (*nābhiḥ pṛthivyāḥ*), beneath which lies the all-supporting serpent Śeṣa, Ananta (Ahir Budhnya, Ahi-Vṛtra), is not a topographically situated place but a place in principle, of which every established and duly consecrated "center" can be regarded as an hypostasis. In this sense, and just as the *forma humanitatis* is present in every man, the form of the unique Serpent is an actual presence wherever a "center" has been ritually determined. In the same way the transfixing peg is the nether point of Indra's *vajra*, wherewith the Serpent was transfixed in the beginning. It is an illustration of the customary precision of Blake's iconography that in his Prophecy of the Crucifixion, the nail that pierces the Saviour's feet pierces also the head of the Serpent.

For the general principle involved in the consecration of a holystead, see ŚB III.1.1.4, "Verily this whole earth is the goddess (Earth); on whatsoever part thereof one may propose to offer sacrifice, when that part has been taken hold of by means of a sacred formula (*yajuṣā parigṛhya*), there let him perform the sacrificial rite,"

The earth was originally insecure, "quaking like a lotus leaf; for the gale was tossing it hither and thither. . . . The gods said, 'Come, let us make steady this support'" (ŚB 11.1.1.8–9).[29] The architect who drives down his peg into the head of the Serpent is doing what was done by the gods in the beginning, what was done, for example, by Soma when he "fixed the miser" (*paṇim astabhāyat*, RV vi.44.22), and "made fast the quaking Earth" (*pṛthivīṃ vyathamānām adṛṃhat*, RV ii.12.2), and by Indra when he "smote the Serpent in his lair" (*ahiṃ . . . śayathe jaghāna*, RV vi.17.9); and what has been done, and is done, by every solar hero and Messiah when he transfixes the Dragon and treads him underfoot.

In conclusion of the present introduction, a word may be said on the principle involved in the symbolic interpretation of artifacts. The modern critic is apt to maintain that symbolic meanings are "read into" the "facts" which "must" originally have had no meaning, but only a physical efficiency. Nor could any objection be made to this if it were a matter of such absurdities of "interpretation" as are involved in an explanation of Gothic arches as imitated from the interlacing branches of forest trees, or implied in the designation of certain well-known classical ornaments as "acanthus" and "egg and dart" motifs. Far from such sentimental fancies, a correct symbolic exegesis must be founded on a real knowledge of the principles involved, and supported by cited texts, which are just as much facts as the monuments themselves. The modern critic is apt, however, to go further, and to argue that even the oldest citable texts are already "meanings read into" still older forms, which perhaps had originally no intellectual significance whatever, but only a physical function.

The truth is, however, that it is precisely in adopting *this* point of view

the rite, of course, involving the erection of an altar "at the center of the earth." For the establishment of fires as a legal taking possession of a tract of land, see PB xxv.10.4 and 13.2; here the site of the new altar is determined by casting a yoke pin (*śamyā*) eastward and forward; where this peg falls and, as is evidently to be understood, sticks into the ground so as to stand upright, marks the position of the new center. There is reference, apparently, to how this was in the beginning, in RV x.31.10b, where "When the First Son (Agni) was born of Sire-and-Mother [Heaven and Earth, and/or two fire-sticks, of which the upper is like the yoke pin made of *śami* wood], the Cow (Earth) engulfed (*jagāra*) the yoke pin (*śamyām*) for which they had been seeking," "seeking," probably, because it had been "flung." The expression *samāpāsam*, "peg-thrown site," survives in S 1.76.

[29] "He spread her out (cf. Skr. *pṛthivī*), and when He saw that she had come to rest on the waters, He fastened upon her the mountain" (ibn Hishām, quoted by Lyall, JRAS, 1930, p. 783).

that we are reading our own mentality into that of the primitive artificer. *Our* division of artifacts into "industrial" and "decorative," "applied" and "fine" art, would have been unintelligible to the primitive and normal man, who could no more have separated use from meaning than meaning from use; as Mus remarks, "the true fact, the only fact of which the builders were aware, was a combination of both";[30] in primitive and traditional art the whole man finds expression, and therefore there is always in the artifact "a polar balance of physical and metaphysical," and it is only on their way down to us that the traditional forms "have been more and more emptied of content."[31] The primitive artifact can no more be fully explained by our economic determinism than it can be by our aestheticism; the man who did by thinking, and thought by doing, was not as we are solely concerned about physical safety and comfort, but far more self-sufficient; he was as profoundly interested in himself as we are nowadays in our bodies.

Part II

Let us for a moment abandon the consideration of architecture for that of another craft, the smith's, and that of his ancestor, the maker of stone weapons.

Tangible symbols, no less than words, have their etymons: in this sense, a "derivation" of the sword, and similarly of the celt, from a "root" or archetype in lightning is universal and worldwide.

[30] Mus, "Barabuḍur," p. 361.

[31] W. Andrae, *Die ionische Säule* (Berlin, 1933), Schlusswort. "He for whom this concept of the origin of ornament seems strange, should study for once the representations of the whole third and fourth millennia B.C. in Egypt and Mesopotamia, contrasting them with such 'ornaments' as are properly so called in our modern sense. It will be found that scarcely even a single example can be found there. Whatever may seem to be such, is a drastically indispensable technical form, or it is an expressive form, the picture of a spiritual truth": for "or" in the last sentence we could wish to substitute "and at the same time" [cf. Coomaraswamy, review of Andrae in this volume—ED.].

Similarly Herbert Spinden, in the *Brooklyn Museum Quarterly* (1935), pp. 168 and 171: "Then came the Renaissance. . . . Man ceased to be a part of the universe, and came down to earth. So it would seem that there are only two categories of art, one a primitive or spiritual category, one a category of disillusioned realism based on material experiments. . . . [The primitive artist] wrought and fought for ideals which hardly come within the scope of immediate comprehension. Our first reaction is one of wonder, but our second should be an effort to understand. Nor should we accept a pleasurable effect upon our unintelligent nerve ends as an index of understanding."

In *Śatapatha Brāhmaṇa* I.2.4, there is described the origin of the sacrificial sword, sacrificial post, chariot (of which the axle-tree is evidently the principle), and arrow from Indra's *vajra* (thunderbolt, lightning, adamantine lance, and σταυρός). "When Indra hurled the thunderbolt at Vṛtra, that one thus hurled became fourfold. Thereof the wooden sword (*sphya*) represents a third or thereabouts, the sacrificial post about a third or thereabouts, and the chariot (*sc.* axle tree) one third or thereabouts. That (fourth and shortest) piece moreover, with which he struck him, was broken away, and flying off (*patitvā*)[32] became an arrow; whence the designation 'arrow' (*śara*) inasmuch as it was 'broken away' (*āśīryata*). In this way the thunderbolt became fourfold. Priests make use of two of these in sacrifice, while men of royal blood make use of two in battle. . . . Now when he [the priest] brandishes the wooden sword, it is the thunderbolt (*vajra*) that he raises against the wicked, spiteful enemy, even as Indra in that day raised the thunderbolt against the Dragon (Vṛtra). . . . He takes it with the incantation 'At the instigation of divine Savitṛ (the Sun), I take thee with the arms of the Aśvins, with the hands of Pūṣan (the Sun).' . . . With His hands therefore he takes it, not with his own; for it is the thunderbolt, and no man can hold that. . . . He murmurs, and thereby makes it sharp, 'Thou art Indra's right arm,' for Indra's right arm is no doubt the strongest, and therefore he says 'Thou art Indra's right arm.' 'The thousand-spiked, the hundred-edged,' he adds, for a thousand spikes and a hundred edges had that thunderbolt that Indra hurled at Vṛtra; he thereby makes the wooden sword to be that thunderbolt. 'The keen-edged Gale (Vāyu) art thou,'[33] he adds; for he who blows here is indeed the keenest edge; for he cuts across these worlds; he thereby makes it sharp. When he further says: 'The killer of the foe,' let him, whether he wishes to exercise or

[32] *Patitvā* is also "fallen." The *double entendre* is, let us not say calculated, but inevitable. Inasmuch as the arrow is winged (*patatrin, patrin*) it is virtually a "bird" (*patatrin*), that is to say, in terms of Vedic symbolism, an intellectual substance (cf. RV VI.9.5) by the same token of divine origin and heavenly descent. The embodiment of the "form" of an arrow in an actual artifact is precisely such a "descent" (*avatarana*), and a decadence from a higher to a lower level of reference or plane of being; conversely, the actual weapon can always be referred to its principle, and is thus at the same time a tool and a symbol. *Patitvā*, finally, also implies subtraction, as of a part from a whole; and it is in this sense that our text provides us with a hermeneia of the word *śara*, "arrow."

[33] That is, of course, and also in Christian phraseology, the "Gale of the Spirit": "The Gale that is thy-Self thunders through the firmament, as it were an untamed beast taking its pleasure in the cultivated fields," RV VII.87.2.

not, say: 'The killer of so-and-so.'[34] When it has been sharpened, he must not touch either himself or the earth with it: 'Lest I should hurt, etc.'" Later he brandishes the sword thrice, driving away the Asuras from the three worlds, and a fourth to repel the Asuras from "what fourth world there may or may not be beyond these three"; the first three strokes being made with chanted formulae, the fourth stroke silently. The third verse of the *Śatapatha Brāhmaṇa* text, cited above, in effect affirms *in hoc signo vinces*. The wooden sword is described as straight (Kāty. Śr. 1.3.33 and 39), and the usual word for sword, *khaḍga*, is used in connection with it, and as it must accordingly have had a guard, it is clear that this must have been cruciform. The European parallel is sufficiently obvious; sword and cross are virtually identified in Christian knightly usage; the sword, at least, can be used as a substitute for a wooden cross, and in the same way as a hallowed or apotropaic weapon, in the banning of evil spirits.

In Japan the sword is similarly "derived" from an archetypal lightning. The Japanese sword, Shinto, royal, or samurai, is in fact the descendant or hypostasis (*tsugi*, as this word occurs in the imperial title Hitsugi, "Scion of the Sun," Skr. *āditya-bandhu*) of the sword of lightning found by Susa-no-Wo-no-Mikoto, whom we may call the "Shinto Indra," in the tail of the Dragon of the Clouds whom he slays and dissevers, receiving in return the last of the daughters of the Earth, whose seven predecessors have been consumed by the Dragon.[35] The solar hero, in other words,

[34] RV vi.75.15–16, "Be such great honor paid unto the arrow, celestial, of Parjanya's seed; fly forth, thou arrow, sharpened by incantation, from the bow-string, go reach our enemies, let there not any one of them be left." Similarly for the chariot, compared to and addressed directly as "Indra's thunderbolt, edged of the Gales, germ of Mitra and navel of Varuna" (*indrasya vajro marutām anīkam mitrasya garbho varuṇasya nābhih*, RV vi.47.28). The whole complex of ideas expressed in our Brāhmaṇa text is thus already present in *Ṛg Veda*, where the warrior very clearly sees himself in the likeness of Indra at war with the powers of darkness, and his weapons in the likeness of Indra's. The warrior *is* virtually Indra, his weapons virtually Indra's.

For the similar "deification," or as we should express it, "transubstantiation" of other implements, see also A. B. Keith, *Religion and Philosophy of the Veda and Upanishads* (London, 1925), p. 188. The modern craftsman's annual "worship" of his tools is of the same sort.

[35] D. C. Holtom, *Japanese Enthronement Ceremonies* (Tokyo, 1928, ch. 3, "The Sword"). It may be remarked that these ceremonies are essentially rites, and only accidentally, however appropriately, attended with an imposing pomp. The most solemn of all these "ceremonies" is that of the Great New Food Festival, of which Holtom says, "Herein are carried out the most extraordinary procedures to be found anywhere on earth today in connection with the enthronement of any monarch. In the dead of night, alone, except for the service of two female attendants, the Em-

possesses himself of the Dragon (Father's) *sting*, which "sword" he indeed returns to the gods, but which in a likeness made by hands and empowered by appropriate rites becomes a veritable palladium, a talisman "fallen from the sky" (διοπετεῖς = *divo-patita*), whether as a cult object in a Shinto shrine or "symbolizing the soul of the samurai, and as such the object of his worship." Dr. Holtom's "worship" is, however, scarcely the right word here. The sword of a samurai is thought of both as himself or own soul (*tamashii*) or alter ego, and also as the embodiment of a guardian principle (*mamori*), and thus as a protector, spiritually as well as physically. The first conception, that of the sword as an extension of one's own essence, bears a close likeness to the doctrine of *Bṛhad-devatā* 1.74, where the weapon of a Deva "is precisely his fiery energy" (*tejas tv evāyudham . . . yasya yat*), and iv.143, where conversely the Deva "is its inspiration" (*tasyātmā bahudhā saḥ*, better perhaps "is hypostasized in it"). The Templar's sword is in the same way a "power" and extension of his own being, and not a "mere tool"; but only an outsider (*pro-fanus*) would speak of the crusader as "worshipping" his sword. Dr. Holtom is, of course, a "good" anthropologist, and satisfied with naturalistic and sociological explanations of the weapon as a *palladium*, of celestial derivation; we, who see in traditional art an incarnation of ideas rather than the idealization of facts, should prefer to speak of an *adequate symbolism* and an adaptation of superior principles to human necessities.

The same idea can be recognized in the fact that in the mysteries of the Idaean Daktyls, Pythagoras was purified by a "thunder stone" which, as Miss Harrison says, was "in all probability nothing but a . . . black stone celt, the simplest form of stone-age axe"; and in the fact that the designation of stone axes and arrowheads as "thunderbolts" and the attribution to them of a magical efficacy has been "almost world-wide." We agree with Miss Harrison that this idea was not of popular origin; but not therefore that it must have been of late origin, for we see no force or sense in her view that "the wide-spread delusion that these celts were thunderbolts cannot have taken hold of men's minds till a time when their real use as ordinary axes was forgotten . . . cannot therefore have been very primitive" (*Themis*, pp. 89, 90). "Delusion . . . cannot"—

peror, as the High Priest of the nation, performs solemn rites that carry us back to the very beginnings of Japanese history, rites which are so old that the very reasons for their performance have been forgotten. Concealed in this remarkable midnight service we can find the original Japanese enthronement ceremony" (p. 59).

a *non sequitur* from any point of view, for if the Hindu and the Japanese can call a wooden or a metal sword a thunderbolt at a time when these weapons were in "real use," it is hard to see why primitive man, who was also in some sense a shamanist, should not have done the same. In the first place there can be little doubt that primitive man enspirited his weapons by appropriate incantations (as did the Hindu and the Japanese, and as the Christian church even to this day consecrates a variety of objects made by hands, notably in the case of "transubstantiation"), and thereby endowed them with a more than human efficiency; and in the second place, if we assume from the worldwide and "superstitious" ("stand-overish") prevalence of the notion, and also on more general grounds, that he already called his weapons thunderbolts, though perfectly aware of their actual artificiality, can we possibly suppose that he meant this to be taken in any more literal (or any less real) sense than the Brahman who likewise calls his sword a *vajra*—thunderbolt, lightning, or adamant?[36] Primitive man, as every schoolboy knows, recognized a will in all things—"Iron of itself draws a man on"—and has therefore been called an "animist." The term is only inappropriate because it was not an independent *anima* ("soul") that he saw in everything, but *mana*, a spiritual rather than a psychic power, undifferentiated in itself, but in which all things participated according to their own nature. In other words, he explained the being-in-act or efficacy of any contingent thing by thinking of it as informed by an omnipresent, inexhaustible, informal, and unparticularized Being and source of all power: which is precisely the Christian and Hindu doctrine.[37] We say, then, that primitive man already spoke

[36] A mass of data on "thunder stones" has been brought together by Émile Nourry [Pierre Saintyves] (*Pierres magiques: bétyles, haches-amulettes et pierres de foudre; traditions savantes et traditions populaires*, Paris, 1936), who, however, has not really understood his material; for, as René Guénon remarks (in a review in *Études traditionelles*, XLII, 81), "In the matter of prehistoric weapons, it is not enough to say with the author that they have been called 'thunder-bolts' only because their real origin and use has been forgotten, for if that were all, we should expect to find as well all sorts of other explanations whereas in fact, in evry country without exception they are always 'thunder-bolts' and never anything else; the symbolic reason is obvious, while the 'rational explanation' is disturbingly puerile"!

[37] It is not at all without ground that J. Strzygowski remarks that the Eskimos "have a much more abstract conception of the human soul than the Christians. . . . The thought of many so-called primitive peoples is far more spiritualized than that of many so-called civilized peoples," adding that "in any case it is clear that in matters of religion we shall have to drop the distinction between primitive and civilized peoples" (*Spuren indogermanischen Glaubens in der bildenden Kunst*, Heidelberg, 1936, p. 344).

of his weapons as "thunderbolts," and more, that he knew what he meant when he called them such; that the same is true of the more sophisticated Hindu and Japanese, with only this difference, that he can prove by chapter and verse that he calls his weapons thunderborn without being unaware of their artificiality and practical use; that the Christian in the same way "worships idols made by hands" (as the iconoclast or anthropologist might say), while able to show that it is not as a fetish that he "worships" the icon; and finally, that if there are to be found ignorant peasants who speak of celts as thunderbolts without knowing them for weapons, in this case only we have to do with a veritable superstition or "stand-over"—a superstition which it should have been the business of the anthropologist rather to elucidate than merely to record.

All of these considerations apply, *mutatis mutandis*, to the problem of architectural symbolism. How then can we propose to explain the genesis of the forms embodied in works of art only by an enumeration of the material facts and functions of the artifact? To take a case in point, it is certainly not by purely "practical" considerations that one can explain the position of the *harmikā* or "little dwelling," or *deva koṭuwā* or "citadel of the gods" immediately above and outside the apex of the stūpa; whereas the *raison d'être* of this emplacement becomes immediately evident if we understand that "immediately above the apex of the dome" is as much as to say "beyond the Sun"; all that is mortal being contained within, and all that is immortal exceeding the structure.

But let us also consider the matter from a physically practical point of view. We have agreed that the symbols, on their way down to us, tend more and more to become merely decorative "art forms," a sort of upholstery, to which we cling either from habit or for "aesthetic" reasons; and that the corresponding rites, with which, for example, the work of construction is "blessed" at various stages, become mere superstitions. In this case we ask what practical value was originally served by these now apparently useless institutions and survivals. In a purely material sense, what have we gained or lost by an implicit decision to "live by bread alone"? Was the actual stability of buildings in any way secured by the recognition of such meanings and the performance of such rites as we have described above? We mention bread, because all that we have to say will apply as much to agricultural as to architectural rites. Not to take up too much space, we shall only ask whether or not it is by chance that the neglect of agriculture as a sacred art, and denial of a spiritual significance

to bread, have coincided with a decline in the quality of the product, so conspicuous that only a people altogether forgetful of the realities of life, and drugged by the phraseology of advertisers, could have failed to remark it.

For the answer to this question we refer the reader to Albert Gleizes, *Vie et mort de l'Occident chrétien* (Sablons, 1930), of which the latter part is devoted to "le mystère du pain et du vin." Here we shall only attempt to show that in spite of all our scientific knowledge (which is in reality not so much at the consumer's disposal as it is at the disposal of the consumer's exploiter, the commercial builder and real estate agent), there can be traced a significant parallel between the neglect of architecture as a sacred and symbolic art and an actual instability of buildings; that it is not without its consequences for the householder that the builder and mason can no longer conceive what it may have meant to be "initiated into the mystery of their craft," nor in what sense an architect could ever have played the part of priest and king. Let us grant that rites as such, envisaged, that is, simply as a mechanical going-through with habitual and required motions, cannot be supposed to affect in any way the stability of a structure, and that the stability of an actual building depends essentially on the proper adjustment of materials and stresses, and not on what has been said or done in connection with the building. It remains that in considering only materials and stresses, of which an admirable knowledge may exist in theory, we are leaving out the builder. Does nothing depend upon him—upon his honesty, for example? Is it of no consequence whatever if he mixes too much sand with his mortar? as he will surely do, whatever the textbook says, if he is building only for profit, and not for use? Arguing not merely on principle, but also from personal contact with hereditary craftsmen in whom a tradition of workmanship has been transmitted through countless generations, we affirm that, as long as faith remains, the attribution of superhuman origins and symbolic significance to architecture, and the participation of the architect in metaphysical rites in which a direct connection is made of macrocosmic with microcosmic proportions, confer upon the architect a human dignity and a responsibility far other than that of the "contractor," who at best may calculate that "honesty is the best policy."[38] We say further that it is not merely a

[38] "The cost approach is the primary trouble with all housing in this country, private as well as public. . . . This has resulted not only in the tenements of the slums but also in the fantastic apartments of the well-to-do, sixteen stories or more in height, with a density per acre and a lack of natural light and ventilation which are shock-

question of ethics, but that the recognition of the possibility of an "artistic sin," as a thing distinct in kind from "moral sin,"[39] even in Europe (where occasional workmen are still to be found whose first concern is with the good of the work to be done) long delayed the appearance of what is now called "jerry-building." We are not here, however, primarily concerned with these practical and technical considerations but more with meanings, and with the artifact considered as a symbol and as a possible support of a contemplation dispositive to gnosis. We say that just as it is beyond the capacity of man to make anything whatever so purely spiritual and intellectual as to afford no sensuous satisfaction, so it is beneath the dignity of man to make anything whatever with a view to an exclusively material good, and devoid of any higher reference. We who have consented to this subhuman standard of living cannot postulate in primitive man such limitations as our own. Even at the present day peoples survive, uncontaminated by civilization, to whom it has never occurred that it might be either possible or desirable to live by bread alone, or in any manufacture to separate function from significance. It is not by any means only for political reasons that Western civilization is feared and hated by the Orient, but also because "it is impossible for one to obtain liberation who lives in a town covered with dust" (*Baudhāyana Dh. Sū.* ɪɪ.3.6.33). We are not, then, "reading meanings into" primitive works of art when we discuss their formal principles and final causes, treating them as symbols and supports of contemplation rather than as objects of a purely material

ing. It is literally true that the most important part of an architect's work in our cities has been to produce maximum floor space with minimum expense. . . . Design for comfort, health, and safety is always secondary" (L. W. Post, in *The Nation*, March 27, 1937). No "metaphysical" architecture has ever been as inefficient as this; we may say that a neglect of first principles inevitably leads to discomfort, and point out that the secularization of the arts has resulted in the sort of art we have—a sort of art that is either the plaything of an idle class or if not that, then a means of making money at the cost of human well-being, and for which in either case we have only to thank our own antitraditional individualism.

[39] Sin, defined as "a departure from the order to the end" may be either artistic or moral: "Firstly, by a departure from the particular end intended by the artist: and this sin will be proper to the art; for instance, if an artist produce a bad thing, while intending to produce something good; or produce something good, while intending to produce something bad. Secondly, by a departure from the general end of human life: and then he will be said to sin, if he intend to produce a bad work, and does so actually in order that another may be taken in thereby. But this sin is not proper to the artist as such, but as a man. Consequently, for the former sin the artist is blamed as an artist; while for the latter he is blamed as a man" (*Sum. Theol.* ɪ-ɪɪ.21.2 *ad* 2). Indian text books, at least, require of the hereditary artist to be both a good artist and a good man.

utility, but simply *reading their meaning*.[40] For to say "traditional art" is to say "the art of peoples who took for granted the superiority of the contemplative to the active life, and regarded the life of pleasure as we regard the life of animals, determined only by affective reactions." "A *person* knows what is and is not mundane, and is so endowed that by the mortal he pursues the immortal. But as for the *herd*, theirs is an acute discrimination merely according to hunger and thirst" (AB II.3.2); cf. Boethius, *Contra Evtychen* II, "There is no person of a horse or ox or any other of the animals which, dumb and unreasoning, live a life of sense alone, but we say there is a person of a man, or God."

Part III

We shall take it for granted that the reader is familiar with our "Pali *kaṇṇikā*: Circular Roof-Plate" [see appendix to this essay—ED.]. To what has been said there, we wish to add in the first place that it can hardly be doubted that the *kaṇṇikā* or roof-plate of a domed structure, the meeting place of its converging rafters, had almost certainly, as the term itself suggests, the form of a lotus, and that this lotus was in effect the Sun, "the one lotus of the zenith" (BU VI.3.6), to be correlated with the "lotus of the earth" and womb of Agni below; and, secondly, that the expression *vijjhitvā* (Skr. root *vyadh*), J I.201, implies a central perforation of the *kaṇṇikā-maṇḍalam*, which was itself an image of the disk of the Sun (*sūrya-maṇḍalam*) and at the same time constituted what may have been called the "eye" of the dome, although for this we have no Indian literary evidence beyond the use of "eye" for "window" in the word (*gavākṣa*, literally "bull's eye"), and the expression "eye of a lotus" (*puṣkarākṣa*) occurring in *Pāṇini* v.4.76. We need hardly say that "Sun" and "Eye" are constantly assimilated notions in Vedic mythology, and that it is from the same point of view that the Buddha is frequently called the "Eye in the World" (*cakkhumāloke*).[41]

[40] That is, seeing things, whether natural or artificial, not merely as individual and in this sense unintelligible essence, but also as symbolic referents, that which is symbolized being the archetype and *raison d'être* of the thing itself, and in this sense its only final explanation.

[41] RV *passim*; AV III.22.5; BU I.3.8.14; III.1.4; KU v.11; S I.138; *Atthasālinī* 38; Sn I.599; etc. *Oculus mundi* is the sun in Ovid, *Metamorphoses* 4.228, whence "eye of the world" = "sun" in English. Other meanings of English "eye" include "center of revolution," "socket" (for insertion of another object), "place of exit or ingress," "fountain" (well-eye), "brightest spot or center." Arabic *'ayn* and Persian *chashm*, *chashma* are "eye, sun, and well-spring," *'ayn* also "exemplar." None of these meanings is without significance in the present connection.

A majority of existing domes are in fact provided with an apical aperture, called the "eye of the dome" (J. Gwilt, *Encyclopedia of Architecture*, London, 1867, defines "eye" as "a general term signifying the center of any part. The eye of a dome is the horizontal aperture in its summit. The eye of a volute[42] is the circle in its centre").

"On the Acropolis of Athens . . . in the north porch of the Erechtheion are the marks of a trident. In examining the roof of this north porch it has been found that immediately above the trident-mark an opening in the roof had been purposely left: the architectural traces are clear."[43] The Roman Pantheon was lighted by an enormous eye, open to the sky, making the structure in fact hypaethral. More often the eye of a dome is comparatively small, and opens into a "lantern" above the dome, which lantern admits light but excludes rain. In the case of the stūpa there is likewise an opening at the summit of the dome, the purpose of which is to serve as a place of insertion or socket for the mast that overstands the dome, and which is therefore also an "eye."

In any case, and whether an opening or a socket, the aperture can be regarded as at the same time functional (source of illumination, mortice, etc.) and as symbolic (means of passage from the interior to the exterior of the dome). It may be further observed that the eye in a roof is also a louver or luffer permitting the escape of smoke from the central fire beneath it.[44] That the eye or luffer thus functions as a chimney (as well as

[42] The two eyes of the double volute correspond in fact to the sun and moon, which are the eyes of the sky, RV 1.70.10. It is not inconceivable that in apsidal buildings having an apse and therefore also a roof-plate at each end, the two *kaṇṇi-kās* were thought of as respectively the sun and moon of the house.

[43] J. Harrison, *Themis*, pp. 91–92. Miss Harrison adds, "But what does Poseidon want with a hole in the roof?" and answers correctly enough that "before Poseidon took to the sea he was Erectheus the Smiter, the Earth-shaker." Poseidon is no more than Ouranos or Varuṇa, in an essentially limited sense a sea god. These are, like the God of Genesis, the gods of the primordial waters (both the upper and the nether), representative of "all possibility"; if he bears a trident, iconographically indistinguishable from Śiva's *triśūla* and Indra's *vajra*, and in fact a solar shaft, it is because he is not merely a "sea god" in the later and literary sense, but the protean deity of all that is, whether above or below. Vitruvius (1.2.5) says that Fulgur, Coelum, Sol, and Luna were worshipped in hypaethral temples. Even the domes of such modern structures as St. Paul's may be called, with respect to their "eyes," vestigially hypaethral shrines of the sky god. In cathedrals, of which the vault is generally closed, the opening is replaced by a representation of an evidently solar type; as Robert Byron and David Talbot Rice express it, "The central dome was *reft* by the stupendous frown of Christ pantocrator, the sovereign judge" (*Birth of Western Painting*, London, 1930, p. 81, italics mine).

[44] "It was the abode of a blacksmith. . . . We were ushered into the hall of dais, into the sanctum of the edifice. The 'riggin' was above our heads. . . . Chimney,

a source of light) by no means reduces, but rather reinforces the macrocosmic symbolism, for it is both as an ascending flame and as a pillar of smoke that Agni props up the sky, as in RV IV.6.2–3, where "Agni, even as it were a builder, hath lifted up on high his splendor, even as it were a builder his smoke, yea, holdeth up the sky (*stabhāyat upadyām*) . . . a standard, as it were the pillar of sacrifice (*svaru = yūpa*), firmly planted and duly chrismed," cf. RV III.5.10, IV.5.1, VI.17.7.

It is certainly not without significance that *vijjhitvā*, "perforating" or "penetrating," is also employed in connection with the piercing of a mark or bull's eye by an arrow, e.g., in J v.129 ff., where there is an account of the feats of archery performed by the Bodhisattva Jotipāla ("Keeper of Light"), a superlative marksman (*akkhaṇa-vedhin*)[45] whose

of course, there was none, an opening in the center of the roof immediately above the fire, allowed of the egress of the smoke and admitted light enough to see one's way in the apartment. . . . Around the fire were arranged soft seats of turf for the family" (E. Charlton, "Journal of an Expedition to Shetland in 1834," in *Saga-book of the Viking Society*, 1936, p. 62). This description of the main room of a house, still surviving in the nineteenth century, is applicable in every detail to what we understand to have been the typical form of a dwelling already in the Stone Age, and generally as the prototype of the house, itself mimetic of a macrocosmic archetype.

[45] The etymology of the word *akkhana* has been disputed: as PTS remarks, "We should expect either an etym. bearing on the meaning 'hitting the center of the target' [i.e., its 'eye'; cf. Eng. bull's eye] . . . or an etym. like 'hitting without mishap.'" It is evident, in fact, that the connection of *akkhana* is with Skr. *aks*, to "reach" or "penetrate," the source of *aksa* and *aksam*, "eye" and *ākhana*, "butt" or "target" and in fact "bull's eye." We digress to cite the latter word from JUB 1.60.8, "The breath of life is this stone as a target" (*sa eso'smākhanam yat prānaḥ*, where it may be noted that *prāna* and *asman* can both be taken as references to the Sun; cf. RV VII.104.19, *divo asmānam*), which target the Asuras cannot affect.

Aksa is also "axis" and "axle-tree" (distinguished only by accent from *aksa*, "eye"), and Benfey was evidently near the mark when he suggested that *aksa* as axle tree was so-called as forming the "eye" in the hub of the wheel which it penetrates. Eng. *eye* (Ger. *Auge*) and Eng. *axis* and *auger* present some curious analogies with Skr. *aksa* and *aksi*. Auger is stated to represent O.E. *nafu-gār*, "that which perforates the nave of a wheel"; had it been related to Ger. *Auge*, it would be "that which makes an 'eye' in anything." It may be added that Skr. *aksāgra* is the "axle point," and the hub its "door," *aksa-dvāra*.

Akkhana-vedhin is then "one who pierces the 'eye,'" or "one whose arrow penetrates the bull's eye": in the present context it would scarcely be too much to say "pierces the center of the disk of the Sun" or "hits the solar and macrocosmic bull's eye," cf. Mund. Up. cited below [cf. note 54—ED.]. Probably the best short English equivalent for *akkhana-vedhin* would be "infallible marksman."

We find the epithet again in Jātaka No. 181 (J II.88 ff.), where it is applied to the Bodhisattva Asadisa ("Nonpareil"), who performs two feats. In the first, a king under whom the Bodhisattva has taken service, is seated at the foot of a

shaft is "tipped with adamant" (*vajiraggaṃ nārācam*),[46] and who is, furthermore, possessed of the power of aerial flight, to be subsequently discussed. One of the feats of the "Keeper of Light," whom we can only regard as a "solar hero" and like the Buddha a "kinsman of the Sun" (*ādicca-bandhu*), is called "the threading of the circle" (*cakka-viddham*). In the execution of this feat, his arrow, to which a scarlet thread (*ratta-suttakaṃ*) has been attached, penetrates in succession four marks placed at the four corners of the arena, returning through the first of these marks to his hand, thus describing a circle which proceeds from and ends in himself as its center. Thus the Bodhisattva, standing within a four-cornered field (*caturassa-paricchedabbhantare*), connects its corners (the four quarters, cf. ŚB VI.I.2.29) to himself by means of a thread (*suttakaṃ = sūtram*): and this is unmistakably a "folklore" version of the *sūtrātman* doctrine, according to which the Sun connects these worlds and all things to himself by means of a thread of spiritual light.[47]

mango tree (*ambarukkhamūle*) on a great couch close beside a "ceremonial stone slab" (*mangalasilā-paṭṭa*, probably an altar of Kāmadeva, cf. *Daśakumāracarita*, ch. 5, as cited in Coomaraswamy, *Yakṣas*, Pt. II, 1932, p. 12); the king desires his archers to bring down a bunch of mangoes from the top of the tree (*rukkhagge = vṛkṣāgre*). Nonpareil undertakes to do so, but must first stand just where the king is sitting, which he is allowed to do (we see here a close analogy to the Māra-dharṣaṇa scene, and to that of the First Meditation, with the implication that the king has been seated precisely at the navel of the earth, or a least a "center" analogically identified with that center); standing then at the foot of the tree, he shoots an arrow vertically upwards, which pierces the mango stalk but does not sever it; and following this a second arrow, which touches and overturns the first, and continues into the heaven of the Thirty-three, where it is retained; finally the original arrow in its fall severs the mango stalk, and Nonpareil catches the bunch of mangoes in one hand and the arrow in the other. In the second feat, the Bodhisattva's brother, Brahmadatta ("Theodore"), king of Benares, is beleaguered by seven other kings. Nonpareil terrifies these and raises the siege by letting fly an arrow which strikes the "knop of the golden dish from which the seven kings are eating" (*sattannaṃ rājūnaṃ bhuñjantānaṃ kañcanapāti-makule*, where *pāti = pātra*), i.e., the center of this dish, which can hardly be regarded otherwise than as a likeness of the Sun which we have identified with the "Titan's feeding bowl," *camasan asurasya bhakṣanam . . . pātram* in RV I.110.3 and 5, cited above.

[46] *Vajiraggaṃ*, applied to the weapon of a solar hero, is significant. For the arrow, in origin, is said to have been the broken tip of the primordial *vajra* with which Indra smote the Dragon; which part "having flown (*patitvā*), is called an arrow (*śara*) because it was broken off" (*aśīryata*, ŚB I.2.4.1). For further data on *vajira*, *vajra* see Coomaraswamy, *Elements of Buddhist Iconography*, 1935, pp. 43–46. We might say that *vajiraggaṃ = vajrāgram* implies "which was the point of the *vajra*" as much as "tipped with adamant."

[47] As pointed out in a subsequent note on the "turn-cap" motif, the question of "truth" in folklore, fairy tale, and myth, is not a simple matter of correlation with observed fact, but one of intelligibility. The "threading of a circle" as described above

We cannot, indeed, agree with M. Foucher that the well-known bow and arrow symbol met with on early Indian coins primarily represents a stūpa. On the other hand, as pointed out by Mus, "Does not the stūpa, considered as constructed wholly round about the axis of the universe,

can only be called a "miracle" (and for present purposes we assume that "miraculous" and "impossible" are much the same): nevertheless we have seen that the narrative has a true meaning. It is no more necessary that a truth should be expressed in terms of fact, than that an equation should resemble its locus. The symbolism must be consistent; it does not have to be historically factual.

Scripture is written in a hieratic language and a parabolic style, often requiring a learned commentary. The oral literature of the folk, which may be called the Bible of the unlearned, is by no means of popular origin, but designed to secure the transmission of the same doctrines by and amongst an unlearned folk. For such a purpose the ideas had necessarily to be imagined and expressed in readily imitable forms. The same, of course, applies to the visual art of the people, often misconceived as an essentially "decorative" art, but which is really an essentially metaphysical and only accidentally decorative art. The necessity and final cause of folk art is not that it should be fully understood by every transmitter, but that it should remain intelligible, and it is precisely for this reason that its actual forms must have been such as would lend themselves to faithful and conservative transmission.

"Conservative transmission" can easily be misunderstood from our modern point of view, in which the emphasis on individuality has led to a confusion of *originality* with *novelty*. Herbert Spinden proposes a false alternative when he asks, "Does man, at large, think or merely remember?" (*Culture: The Diffusion Controversy*, London, 1928, p. 43.) "Transmission" may be either from one generation to another, *or* from one to another contemporary culture. We cannot draw a logical distinction between "transmission" and "memory": for even if we set ourselves to copy an object before us, it is only memory, visual or verbal, that enables us to bridge the temporal gap that separates the model from its repetition. If there can be no property in ideas, it is also true that nothing can be known or stated except in some way: and it is precisely in this "way" that the liberty of the individual subsists, apart from which there could be no such thing as a sequence of styles in a given cycle, nor any such thing as a distinction of styles in a national or geographical sense. It is of the essence of "tradition" that something is *kept alive*; and as long as this is the case, it is as erroneous to speak of a "mechanical" transmission from generation to generation as it is to suppose that the elements of culture can be mechanically borrowed from one people by another. It is only because our academic science acquaints us for the most part only with dead or dying traditions (often, indeed, traditions that have been deliberately killed by the representatives of a supposedly higher culture), and because of our own individualistic insistence upon *novelty* that we are so little conscious of the absolute *originality* of even the most conservative peasant art. No one who has ever lived and worked with the traditional artist, whether craftsman or storyteller, has failed to recognize that in repeating what has been repeated for countless generations, the man is always completely himself, and giving out what proceeds from within, moved by its form, which giving out from within is precisely what we mean by the word originality. As J. H. Benson, himself a "traditional artist," has recently admirably expressed it, "If a work of art *originates* in a clear mental image, we call it an *original* work of art. It has a true mental *origin*.

look strangely like a bow to which an arrow has been set?"[48] and, we may add, like other domed structures, if thought of in cross section. Remembering the actual perforation (*vijjhitvā*) of our roof plate, and what has been said above about the "eye of a dome," we cannot but be struck by the fact that in this symbol of a bow and arrow suggesting the cross section of a stūpa (or any like domed structure), the arrow actually penetrates the apex of the "dome"; in other words, breaks through the summit of contingent being (*bhavāgra*), through the station of the Sun in the zenith, into a beyond.

It is at this point that our symbolic archery becomes most significant. For, as will now be seen, that goal which lies beyond the Sun, and which is usually described as reached by a passing through the midst of the Sun, is also very strikingly described in Muṇḍ. Up. II.2.2–4 (which we cite in a slightly condensed form) as to be attained by means of a spiritual marksmanship: "Resplendent Sun (*arcinam*), imperishable Brahman, Breath of Life (*prṇāḥ*), Truth (*satyam*), Immortal—That is the mark (*lakṣyam*) to be penetrated (*veddhavyam*).[49] Taking for bow the mighty

Original work has nothing to do with the novelty or newness of the subject or its treatment. The subject and the technique may be as old as the hills, but if they are created in an original mental image, the work will be original" (Museum of Fine Arts, Boston, Third Radio Series, sixth address, February 11, 1936).

There is something just a little too precious and condescending in the attitude of the modern intellectual who, for his part, is naive enough to believe that even the more technical language of scripture has none but literal and naturalistic meanings, and at the same time proposes to protect the child at its mother's knee and the peasant by the fireside from the possibility of a like belief in the literal significance of a transmitted legend, which indeed he may not have fully understood but which at least has been handed down to him reverently, and will be handed on by him in the same spirit. We need hardly say that the amoral character of the fairy tale, to which exception is similarly taken, is only a further evidence of its strictly metaphysical and purely intellectual content.

The *Jātakas*, of course, have been adapted to edifying uses, but it is impossible that the original shapers of the stories should not have understood their analogic significance, and improbable that none of those who heard or read them "had ears to hear."

A "symbolische Schiessen nach den vier Himmelsrichtungen" occurs in late Egyptian art; see H. Schäfer, *Aegyptische und heutige Kunst* (Berlin, 1928), p. 46, Abh. 54, after Prisse d'Avennes, *Mon. Eg.*, Pl. 33. No "thread" is represented, but it can scarcely be doubted that the arrows are shafts of light. There occur also in late Egyptian art admirable representations of the Sundoor both open and closed; see Schäfer, p. 101, Abh. 22–24.

[48] Mus, "Barabuḍur," p. 118.

[49] Cf. BG XI.54, "I can verily be penetrated" (*śakyo hy aham viddhaḥ*). If That (Spirit, *ātman*, immanent as "body-dweller" and transcendent in itself discarnate) is

weapon of the Upaniṣad, set thereunto an arrow pointed by reverent service, and bending it by the thought of the nature of That, penetrate (*viddhi*)[50] that mark, my friend. Oṃ is the bow, the Spirit (*ātman*) the arrow, Brahman the mark to be penetrated by one abstracted from sensuous infatuation: as is the arrow, so should he become of that same nature (*śaravat tanmayo bhavet*)," i.e., of the nature of That, the mark to be attained. It is only as no man to whom soul and body are "himself," no man who still conceives "himself" to be So-and-so, but as one who recog-

also described as "ever impenetrable (*nityam avedhyaḥ*, BG 11.30)," this means, of course, by whatever is not of Its own nature; the Asuras, for example, being themselves shattered on that Stone that is the Breath of Life, JUB 1.60.8, as quoted in a previous note.

[50] With the injunction *tal lakṣyaṃ viddhi*, "Hit that mark," cf. the expressions *lakṣa-vedhin, lakṣya-vedha, lakṣya-bheda*, and the previously cited *akkhana-vedhin*, all denoting one who hits the mark, the target, the "bull's eye." *Viddhi* is the imperative both of *vyadh* to "pierce" and of *vid* to "know"; the "penetration" is here in fact a Gnosis. In JUB iv.18.6, *tad eva brahma tvam viddhi*, "*viddhi*" is perhaps primarily "know" and secondarily "penetrate." *Nirvedhya*, from *vyadh*, may be noted in the *Divyāvadāna* as "intuition" or "intellectual penetration." We think that in the same way Vedic *vedhas* is "penetrating" in this sense, and to be derived from *vyadh* rather than from *vid*; and hence primarily equivalent to *vedhin*, "marksman" in the sense of Muṇḍ. Up., and secondarily "wise" or "gnostic." Consider for example RV x.177.7 (cf. JUB iii.35.1) *Pataṅgam ... hṛdā paśyanti manasā vipaścitaḥ, marīcīnām padam icchanti vedhasaḥ.* An interpretation in terms of archery is, if not indeed inevitable, at least quite possible. For *vipaścitaḥ* is not simply "wise," but rather "vibrant" (cf. "Shaker" = Quaker), and *vip* may mean an arrow, as in RV x.99.6, "He smote the boar with bronze-tipped shaft" (*vipā varāham ayas-agrayā han*—incidentally *ayas-agra* does not invalidate the mythical origin of the arrow previously cited, inasmuch as the one foot of the Sun, which is also the Axis of the Universe and lance wherewith the Dragon was smitten, is itself "a golden shaft at dawn and one of bronze [*ayas*] at dusk," RV v.62.8). *Icchanti* is from to "desire" or "seek" or "have as one's aim" (Grassmann, "Die ursprüngliche Bedeutung ist sich nach etwas in Bewegung setzen"), a root distinguished in conjugation but originally identical (Grassmann, "ursprünglich gleich") with *is* to "propel" (Grassmann, "in schnelle Bewegung setzen"), whence *iṣu*, "arrow." We translate accordingly, that is, with specific reference to the imagery of Muṇḍ. Up. 11.2, as follows: "Intellectually, within their heart, the vibrant (prophets) descry the winged (Sun = Spirit)—marksmen (*vedhasaḥ*) whose aim pursues the pathway of his rays."

When in the Mahāvrata, "They cause a skin to be pierced (*vyādhayanti*) by a man of the princely caste," by the best available archer (AĀ v.1.5, cf. A. B. Keith, *Śāṅkhāyana Āraṇyaka* [ŚA], pp. 80 ff.), which skin is the Sun himself in a likeness (*Kāṭaka Saṃhitā* xxxiv.5), this is evidently a symbolic penetration of the sense of the Muṇḍaka text, of which the very words *tad veddhavyaṃ somya viddhi ... lakṣyam tad evakṣaram somya viddhi* might suitably have been addressed to the archer in the ritual, as he stood before his solar target. According to Keith (AĀ, p. 277, n. 13, and v.1.5), "The idea is clearly a rain-spell." Something of this kind may indeed have been involved, not in the penetration of the Sun, but in the ritual "intercourse

nizes in "himself (*ātman*)" only the immanent Spirit (*śarīrātman, dehin*), and moving in the Spirit (*ātmany etya*), or as our text expresses it, making of himself a purely spiritual arrow, that any man can hit That mark so as to be confused with It, as like in like: just as, in more familiar imagery, when rivers reach the sea, their individuality is undone, and one can only speak of "sea" (Praśna Up. vi.5).

The flight of our spiritual arrow is a flight and an emergence from a total darkness underground and the chiaroscuro of space under the Sun into realms of spiritual Light where no Sun shines, nor Moon, but only the Light of the Spirit, which is Its own illumination.[51] Now, as we know

of creatures" (*bhūtānaṃ ca maithunam*), the fall of rain being a consequence of the marriage of Heaven and Earth (PB vii.10.1–4, viii.2.10, and more especially JB 1.145, "Yonder world thence gave rain to this world as a marriage gift"). But the modern scholar is far too ready to resort to naturalistic and rationalistic explanations even when, as in the present case, the most obvious metaphysical interpretations are available. The whole context has to do with the attainment of Heaven; and even the "intercourse of creatures" is not primarily a "magical" (fertility) rite, but an imitation of the conjunction of the Sun and Moon "at the end of the sky, at the Top of the Tree, where Heaven and Earth embrace" (*dyāvāpṛthivī saṃśliṣyathah*), and whence "one is altogether liberated through the midst of the Sun" (JUB 1.3.2 and 1.5.5, cf. Coomaraswamy, "Note on the Aśvamedha," 1936, p. 315).

When we assert the priority of the metaphysical significance of a rite, we are not denying that there may have been, then as now, *avidvānsaḥ* for whom the given rite had a merely magical character: we are deducing from the form of the rite itself that it could only have been thus correctly ordered by those who fully understood its ultimate significance, and that this metaphysical significance must have been understood in the same way by the *evamvit*; just as a mathematical equation presupposes a mathematician, and also other mathematicians able to riddle it. That the modern scholar trained in a school of naturalistic interpretation is not a "mathematician" in this sense proves nothing; "For the Scriptures crave to be read in that spirit wherein they were made; and in the same spirit they are to be understood" (William of Thierry, *Golden Epistle*, x.31).

[51] None of this runs counter to the indefeasible principle that "the first beginning is the same as the last end." If the "long ascent" (AB iv.20–21) is apparently a departure from the chthonic Serpent, a release from the bonds of Varuṇa, it is also a return to Varuṇa, to the Brahman, who is no less above than He is below the Serpent in His ground: which "ground" is that of nature below, and of essence above, which nature and which essence are the same *in divinis*, and omnipresent; Ananta girdles these worlds. For the ophidian nature of the Godhead see Coomaraswamy, "Angel and Titan," 1935, and "The Darker Side of Dawn," 1935, to which may be added the explicit formulation of Muṇḍ. Up. 1.2.6, where the Brahman is described as a "blind [worm] and deaf [adder], without hands or feet" (*acakṣuhśrotram tad apāny apādam*), as is Vṛtra in RV 1.32.7, Kunāru-Vṛtra in iii.30.8 (*budhne rajasaḥ*) and in iv.1.11, and Ahi in ŚB 1.6.3.9; cf. AV x.8.21, *apād agre sama-bhavat*, etc., with this "footless he first came into being" compare Rūmī, *Dīvān*, Ode xxv, "the last step to fare without feet." Ahi is understood to mean "residue" (JB iii.77),

from texts too many to be cited here at length, it is through the Sun, and only through the Sun, as Truth (*satyam*), and by the way of the Well at the World's End, that there runs the road leading from this defined Order (*rta*, κόσμος) to an undefined *Empyrean*. It is "through the hub of the wheel, the midst of the Sun, the cleft in heaven, that is all covered over by rays, that one is altogether liberated" (JUB 1.3.5–6). "The Sun is

and this is, of course, the evident meaning of "Śeṣa," as being "that which is left," *śiṣyate*. It is from this Endless Residuum (*ananta, śeṣa*) that one escapes *at* birth, and as and into the same Endless Residuum that one escapes *from* birth. There is no need to cite texts to show in what way the Brahman-Ātman is Endless (*ananta*), but we shall quote two in which the Brahman-Ātman is defined as the Residuum from which one departs at birth, and as the Residuum as and into which one reenters at last: BU v.1, where the ancient Brahman is called a "plenum that is left behind (*avaśiṣyate*) as a plenum, no matter what has been deducted from it," and CU viii.1.4–5, where, when the soul-and-body vehicle perishes, "what is left over (*atiśiṣyata*) therefrom . . . is the Spirit" (*ātman*).

Let us remark at this point that the well-known symbol of the Serpent biting its own tail is evidently a representation of the Godhead, the Father, and of Eternity: as Alfred Jeremias has expressed it, "Das grossartige Symbol der Schlange, die sich in den eigenen Schwanz beisst, stellt den Aëon dar" (*Der Antichrist in Geschichte und Gegenwart*, Leipzig, 1930, p. 4).

We speak advisedly of a reentry "as and into" the Ophidian Godhead: the "return to God" can only be in likeness of nature. It can be only as a snake that one can be united to the "Snake without End," as a circle superimposed on a circle coincides with it. This does not, however, mean that the way from snakehood to snakehood which passes through the Sun is meaningless for the snake that proceeds (*atisarpati*); on the contrary, it is by means of the sacrifice, the incantation, and by reduction of potentiality to act, that the livid scaly snake skin must be cast, and a sunny skin revealed; it is as a streak of serpentine lightning that the Wayfarer returns to the source from which he came forth, for which source and now goal no other symbol than that of lightning is adequate, "The Person seen in the Lightning—I am He, I indeed am He" (CU iv.13.1, cf. Kena Up. 29–30). It will not be overlooked that in Indian iconography, lightnings are commonly represented in the form of golden snakes.

The foregoing is based on the references cited and on materials collected for a discussion of the symbolism of lightning. In addition there can be cited some Buddhist texts in which the *arhat* is called a "serpent" in a laudatory sense. In M 1.32, for example, the *arhats* Mogallāna and Sāriputra are Mahānāgā, "a pair of Great Snakes." This is explained, M 1.144–145, where an anthill is excavated (anthills are, in fact, often the homes of snakes, and in the *Rg Veda* are evidently symbols of the primordial mount or cave from which the Hidden Light is released): when there is found a snake at the very base of the mound (which is called a "signification of the corruptible flesh"), it is explained that this Serpent or *Nāga* is a "signification of the Mendicant in whom the foul issues have been eradicated," i.e., of an *arhat*; cf. Sn 512, where *Nāga* is defined as "one who does not cling to anything and is released" (*sabattha na sajjati vimutto*). From the first of these two passages it is evident, of course, that the "Nāga" in question is a snake and not an elephant. To these instances may be added the case of the death of Balarāma related in the

the world-gate (*loka-dvāra*) which admits the Comprehensor into Paradise, but is a barrier (*nirodha*) to the ignorant" (CU VIII.6.15, cf. JUB I.5 and III.14). The question is asked accordingly, "Who is qualified (*arhati*) to pass through the midst of the Sun?" (JUB 1.6.1, cf. KU II.21 *kas tam ... devam jñātum arhati*).[52] The *arhati* immediately reminds us of those

Mausala Parvan of the *Mahābhārata*, where Balarāma, being seated alone and lost in contemplation, leaves his body in the shape of a mighty Snake, a white Nāga, having a thousand hoods and of mountainous size, and in this form makes his way into the Sea.

The formulations outlined above may be said to offer an intelligible explanation not merely of many aspects of Indian iconography, but also certain aspects of that of Greek mythology, where Zeus is not only represented as a solar Bull, etc., but also in his chthonic aspect of Zeus Meilichios as a bearded Serpent, and where also the Hero, entombed and deified, is constantly depicted in the same manner.

[52] It is, of course, the Pathfinder, Agni, *arhat* in RV 1.127.6, II.3.1 and x.10.2, who first "ascended, reaching the sky; opened the door of the world of heavenly light (*svargasya lokasya dvāram apāvrnot*); and is the ruler of the heavenly realm" (AB III.42); it is "by qualification" (*arhaṇā*) that the Suns partake of immortality (RV x.63.4). In the same way the Buddha (who is none other than *the* Man Agni) opened the doors of immortality for such as have ears (*apārutā tesam amatassa dvārā ye sotavanto*, Mv 1.7), and as Mus expresses it, "having passed on for ever, the way remains open behind Him" ("Barabuḍur," p. *277).

The Christian parallel is evident, since Christ also prepared the way, ascended into heaven, and sits at the right hand of God. The opening of the gate is discussed by St. Thomas, *Sum. Theol.* III.49.5, "The shutting of the gate is the obstacle which hinders men from entering in . . . on account of sin. . . . Christ by His Passion merited for us the opening of the kingdom of heaven, and removed the obstacle, but by His Ascension, as it were, He brought us to the possession of the heavenly kingdom. And consequently it is said that by ascending He *opened the way before them*." And just as Agni, whether as Fire or Sun, is himself the door (*aham devānārn mukha*, JUB IV.11.5), so "I am the door: by Me if any man shall enter in, he shall be saved, and shall go in and out, and shall find pasture" (John 10:9), i.e., shall be a "mover-at-will" (*kāmācārin*). In this connection Meister Eckhart comments (Evans ed., I, 275) "Now Christ says, 'No man cometh to the Father but through Me.' Though the soul's abiding place is not in Him, yet she must, as He says, go through Him. This breaking through is the second death of the soul, and far more momentous than the first." With the expression "breaking through" may be compared both "breaking through the solar gate" (*sauram dvāram bhitvā*, MU VI.30) and "breaking through the round of the roof-plate" (*kannikā-mandalam bhnditvā*, DhA III.66, to be cited again below).

To *hrdayasyāgra*, "apex of the heart," corresponds the Islamic *'ayn-i-qalb*, "eye of the heart"; which apex or eye is "the Sun-door within you." Cf. Frithjof Schuon, "L'Oeil du coeur," in *Le Voile d'Isis*, XXXVIII (1933), citing Mansūr al-Hallāj, "I have seen my Lord with the eye of my heart (*bi-ayn-i-qalbī*); I said, Who art thou? He answered, Thyself"; and JUB III.14.5, where the Comprehensor, having reached the Sun, is similarly welcomed, "Who thou art, that am I; who am I, that one art thou; proceed."

arhats who ascend in the air, pass through the roof-plate (*kaṇṇikā-maṇḍa-lam*) and are "movers-at-will."

Before proceeding to consider these, however, we shall cite the account of the Comprehensor's passage of the Sun from MU vi.30, the wording of which is closely paralleled in texts already cited and in the Buddhist texts to follow. Here, then, it is said that the "Marut" (i.e., the King Bṛhadratha, the "Lord of the Mighty Chariot" and disciple of Śākāyanya, MU ii.1), "having done what had to be done (*kṛtakṛtyaḥ*, i.e., as one 'all in act'), departed by the northern solar course, than which there is, indeed, no other path. That is the path to Brahman (whence, as may be inter-jected from CU iv.15.5–6, 'there is no return'); breaking through the Solar Gate, he made his way aloft" (*sauraṃ dvāram bhītvordhvena vinirgatā*). At this point the text makes a direct transition from the preceding nar-rative of what is apparently an outwardly manifested miracle to a formu-lation of this ascension in terms of the "vectors of the heart" (*hṛdayasya nāḍyaḥ*, CU viii.6.1, q.v.), which "vectors" are the channels of the solar rays and breaths of life "within you." All but one of these vectors "are for procedure hither or thither"; only that one which passes vertically upward and emerges from the crown of the head "extends to immortality," i.e., the Brahma worlds beyond the Sun. At death, "the apex of the heart is illuminated (*hṛdayasyāgram pradyotate*); by way of that illumined point the spirit departs (*ātmā niṣkrāmati*), either by way of the eye, or head,[53]

[53] It is generally understood that the spirit of the Comprehensor, having left the heart, departs through the suture called *brahmarandhra* in the dome of the skull, that suture, viz., which is still open at birth, but closed throughout life. *Brahma-randhra* is lacking in P. K. Acharya's *Dictionary of Hindu Architecture* (New York, 1927), but there is good evidence in the (quite modern) *Bṛhadīśvara Māhātmya*, ch. xv, that the opening in the top of a tower (the "eye" of the tower, as explained above) has been called by this name. The story (which closely parallels that of Sudhammā related in J 1.200–201 and DhA 1.269—see "Pali *kaṇṇikā*" [appendix to this article], p. 460) runs that a pious woman besought the builders of the great *gopura* of the Tanjore temple (ca. A.D. 1000) to make use of a stone provided by herself, "and accordingly it was used for closing the *brahmarandhra*" (J. M. Soma-sundaram, *The Great Temple at Tanjore*, Madras, 1935, pp. 40–41).

The *brahmarandhra* is precisely what is called in medical language the *foramen*. This *foramen* is the very word employed by Ovid (and no doubt as a technicality) to denote the hole intentionally left in the roof of the temple of Jupiter, immedi-ately above "old Terminus, the boundary stone" to whom "it is not allowed to sacrifice save in the open air" (Harrison, *Themis*, p. 92, with a further reference to Vergil *ad Aen.* iv.48, as commented by Servius): "Even today, lest he (Terminus) see aught above him but the stars, have temple roofs their little aperture" (*exiguum ... foramen*, Ovid, *Fasti* ii.667).

Terminus, whose place in the Capitoline temple of Jupiter was in the central

or other part of the body; and as it goes, the breath of life follows" (BU
IV.4.2). For "the rays of Him (the Sun) are endless, Who as its lamp in-
dwells the heart. . . . Of which one standeth upward, breaking through
the solar orb (*bhitvā sūrya-maṇḍalam*) and overpassing (*atikramya*) into
the Brahma-world; thereby men attain their final goal" (MU VI.30). It is
thus that one "wins beyond the Sun" (*param ādityāj jayati*), CU II.10.5.

We proceed to an analysis of the significance of the dome and roof-plate,
using as key the various accounts of the miraculous powers of the Bud-
dhist *arhats*, "spiritual adepts," by which powers (*iddhi*) they are able to
rise in the air, and, if within a roofed structure, to emerge from it by
"breaking through" the roof-plate and subsequently moving at will in the
beyond.

We shall first consider the case in which this power is exercised out of

shrine, and evidently in the center of this shrine, was represented by a column,
which is not really the symbol of an independent deity, but the lower part of the
column which stood for Jupiter Terminus, on a coin struck in honor of Terentius
Varro (for which, and other data, see C. V. Daremberg, *Dictionnaire des antiquités
grecques et romaines*, 5 vols., Paris, 1873–1919, s.v. *Terminus*). Thus whereas
termini, as boundary posts in the plural, are placed at the edges of a delimited
area, the *Terminus* of all things occupies a central position, and is in fact a form
of our cosmic axis, *skambha*, σταυρός. It may be added in the present connection
that Skr. *sīman* (from *sī*, to draw a straight line, cf. *sītā*, "furrow") is not only in
the same way *a* boundary mark and in other contexts *the* utmost limit of all
things, but also a synonym of *brahmarandhra*.

It will be observed that our *foramen*, identifiable with the solar doorway, is
ideally situated at the summit of the cosmic σταυρός, and is quite literally an "eye."
We can hardly doubt, accordingly, that no mere figure of speech, but a traditional
symbolism is involved in the saying, "It is easier for a camel to go through the
eye of a needle (*foramen acus* in the Vulgate) than for a rich man to enter into
the kingdom of God" (Matt. 19:24), where, indeed, "eye of *the* needle" might
have been a better rendering. *Brahmarandhra* and foramen, it may be added, imply
by their physiological reference that the temple has been thought of not merely
as in the likeness of the cosmic *house* of God, but at the same time as an image of
the cosmic *body* of God (into which He enters and from which He departs by an
opening above, the solar door, of which Eckhart speaks as "the gateway of His
emanation, by which He invites us to return").

It may be further remarked that a comparison of the human head with the
spherical cosmos occurs in Plato (*Timaeus* 44D ff.; for further references see *Her-
mes*, II, 249). Incidentally, the saying that in man "there is nothing material above
the head, and nothing immaterial below the feet" is far from unintelligible; the
"Man" is cosmic; what is above his head is supracosmic and immaterial; what be-
low his feet is a chthonic basis which is his "support" at the nether pole of being;
the intervening space is occupied by the cosmic "body," in which there is a mixture
of immaterial and material.

doors, and where there is therefore no reference to an artificial roof-plate; and it will be necessary to consider the nature of the miracle itself, which as we have already seen can also be thought of as an interior operation, before we make use of it in explaining the symbolism of the dome itself. In Mil 85, the power (*iddhi*) of travelling through the sky is explained as consisting in an intellectual virtue analogous to that sort of mental resolution by means of which, in ordinary jumping, "one's body seems to be light" when the moment for taking off arrives. In J v.125–127, we have the case of the Elder Moggallāna, an *arhat*, who by means of his miraculous power (*iddhi-balena*) is able to visit heaven or hell at will. This Elder, being in danger of death at the hands of certain evilly disposed persons, "flew up and made off" (*uppatitvā pakkāmi*). Upon a subsequent occasion, because of a former sin of which the trace remained in him, he "could not fly up in the air" (*ākāse uppatitum nāsakkhi*). Left for dead by his enemies, he nevertheless recovered consciousness, and "investing his body in the cloak of contemplation" (*jhāna-veṭhanena sarīram veṭhetvā*), he "flew off into the Buddha's presence" and obtained permission to end his life. At the close of the subsequent "Story of the Past" related by the Buddha, we are told that the assembled Prophets (*isiyo*) also "flew up into the air and went to their own places."

We hardly need to go beyond these texts for an adequate indication of the true nature of the "power" (*iddhi*) of flying through the air. In the first place it may be observed that *uppatitvā*, "flying," implies wings, as of a bird;[54] and that wings, in all traditions, are the characteristic of angels, as being intellectual substances independent of local motion; an intellectual substance, as such, being immediately present at the point to which its attention is directed. It is in this sense that the "intellect is the swiftest of birds" (*manaḥ javiṣṭam patayatsv antaḥ*, RV vi.9.5); that the sacrificer, endowed by the singing priest with wings of sound by means of the Syllable (OM) is supported by these wings, and "sits without fear in the world of heavenly light, and likewise goeth about" (*ācarati*, JUB iii.14.9–10), i.e., as a "mover-at-will" (*kāmacārin*), cf. PB xxv.3.4, "for wherever a winged thing would go, thereunto it comes"; and that "of such as ascend to the top of the Tree, those that are winged fly away, the wingless fall

[54] Or those of an arrow, cf. the discussion of Muṇḍ. Up. ii.2, above. The Sun, identified with the Spirit (RV i.115.1, etc.), being typically winged (*suparṇa, pataṇga, garuḍa,* etc.), can be entered into as like unites with like only by a similarly winged principle: in the present context, by the arrow of the Spirit, soaring on wings of sound or light, coincident at this level of reference.

down: it is the comprehensors that are winged, the ignorant wingless"
(PB xiv.1.12–13).[55]

In the second place, it will be observed that the power of motion at will
presupposes a state of perfection, that of one who can be thought of as
arhat, or in other terms *kṛtakṛtyaḥ, sukṛtaḥ, kṛtātmā*: it is inhibited by
even a trace of defect. And finally, the very striking expressions "flew up
into the air" and "investing his body in the cloak of contemplation" im-
ply at the same time an "ascension" and a "disappearance." The meanings
of *veṭhetvā = veṣṭitvā* include those of "wrapping up," "enveloping," and
"veiling," and hence of "concealing" that which is enveloped, which in the
present case is the body (*śarīram*) or appearance (*rūpam*) of the person
concerned.[56] The primary senses of *pakkāmi = prākramīt* are "went

[55] Similarly Rūmī, *Dīvān* xxix and xliv, "Fly, fly O bird, to thy native home,
for thou hast escaped from the cage, and thy pinions are outspread. . . . Fly forth
from this enclosure since thou art a bird of the spiritual world."

[56] Cf. the use of *veṣṭ* in Manu 1.49, where creatures are described as "enveloped
by darkness" (*tamasā . . . veṣṭitāḥ*); and Śvet. Up. vi.20, "Not until men shall be
able to roll up space like a skin" (*carmavat ākāśaṃ veṣṭayiṣyanti*)—impossible for
man as such.

It may be added that *veṭhana = veṣṭana* is very often employed to denote not
merely a wrapping of any sort but more specifically a head cover or turban. We
might accordingly, and with reference to the familiar folklore motif of the cap of
darkness (of which the possession signifies an *iddhi* of the sort that we are now
considering), have rendered *jhāna-veṭhanena sarīram veṭhetvā pakkāmi* by "con-
cealing his person by means of the turn-cap of contemplation, disappeared."

This provides a further illustration of the fact, alluded to in a previous note,
that what is called the "marvelous" in folk and epic literature, and thought of as
something "added to" a historical nucleus by the irregular fantasy of the people
or that of some individual littérateur, is in reality the technical formulation of a
metaphysical idea, an adequate and precise symbolism by no means of popular
origin, however well adapted to popular transmission. Whether or not we believe
in the possible veridity of the miracles attributed to a given solar hero or Messiah,
the fact remains that these marvels have always an exact and spiritually intelligible
significance: they cannot be abstracted from the "legend" without completely
denaturing it; this will apply, for example, to all the "mythical" elements in the
nativity of the Buddha, which, moreover, are repetitions of those connected with
the nativities of Agni and Indra in the *Ṛg Veda*.

In the present connection we may point out further that the phraseology of our
text throws some light on the nature of the power of shape shifting and of imposing
a disguise on others, which powers are so often attributed, for good or evil, to the
heroes of folklore. If to disappear altogether is really to have perfected a contem-
plative act wherewith the person concerned in a spiritual sense escapes from him-
self, so that he no longer knows "who" he is, but only that he "is," and analogi-
cally vanishes from the sight of others who may be present in the flesh, one may
perhaps say of the lesser marvel of magical transformation involved in the imposi-
tion of an altered appearance upon oneself or others that this is in a similar man-

forth," "made his exit," or as in our rendering, "made off," or "disappeared," as in Cowell and Francis (J v.65).

What is really involved and implied by an "investiture of the body in the cloak of contemplation" is a disappearance into one's spiritual essence, or "being in the spirit" (*ātmany antarhita, guhā nihita, ātmany etya*);[57] just as in Manu 1.51, where the manifested Deity, having completed his creative operation, is described as having "vanished into his own spiritual essence (*ātmany antar dadhe*, being accordingly *ātmany hita, antarhita, guhā nihita, adṛśya*),[58] superenclosing time within time" (*bhūyaḥ kālaṃ kālena pīḍayan*),[59] that is to say, in the language of Genesis 2:2, "rested on the seventh day from all his work which he had made."

ner an investiture (*veṣṭana*) of the body in a form that has been similarly realized in contemplation (*dhyāna*), and thereafter projected and wrapped about one's own or another's person, so that only this disguise can be seen, and not the person within it.

Finally, it must not be supposed that the actual exhibition of marvels has any spiritual significance: on the contrary, the exhibition of "powers" is traditionally deprecated; it is only that state of being of which the powers may be a symptom that can be called "spiritual." It is, moreover, taken for granted that any such powers can be more or less successfully imitated by the "black magician," in whom they prove a certain skill, but not enlightenment. There is this great difference in the "traditional" and "scientific" points of view, that in the former one would not be astonished, nor one's philosophy upset, by the occurrence of an actual miracle; while in the latter, while the possibility is denied, yet if the event took place, the whole position would be undermined.

[57] As in Rev. 4:2, "I was in the spirit," and 1 Cor. 14:2, "in the spirit he speaketh mysteries." A great deal more than metaphor is intended in Col. 2:5, "For though I be absent in the flesh, yet am I with you in the spirit, joying, and beholding your order."

In Rev. 17:3, "He carried me away in the spirit" (*abstulit me in spiritu*); cf. the Saṃgāmāvacara Jātaka (J II.92), where the Buddha "taking Nanda [not yet an *arhat* having the power of aerial flight] by the hand, went off in the air" to visit the heaven of Indra. *Abstulit* corresponds to being *raptus*, which is the consummation of *contemplatio*. In these two cases the state of *samādhi* is rather induced than innate.

[58] Cf. Mv 1.21 *antaradhāyi*, "disappeared," and M 1.329 *antaradhāyitum*, "to vanish," and *antarhito*, "vanished."

[59] That is, compressing past and present into the now of eternity; just as in Śvet. Up. VI.20, it is a question of the "rolling up of space." Being thus returned into Himself, He is "the hard to behold, abider in secret, set in the cave (of the heart), the Ancient whose station is the abyss" (KU II.12); He can be known only by the contemplative, as the immanent Spirit, "abiding in the vacancy of innermost being" or "within you," *antarbhūtasya khe*, MU VII.11.

Expressed in the narrative terms of the myth, creation (in which He might have been seen at work), being a past event, is concealed from us because we cannot pursue it at a greater speed than that of light, or in other words are "not in the spirit," which if we were, the whole operation would be presently apparent.

To have entered thus into one's own spiritual essence, *ātmany antarhito bhūtvā*, is to have realized that state of unification (*samādhi*) which is, in fact, the consummation of *dhyāna* in Indian, as *excessus* or *raptus* is that of *contemplatio* in Christian yoga. Nor could we understand the supernatural power of ascension and motion at will otherwise than as a going out of oneself, which is more truly an entering into one's very Self. One cannot think of the power as an independent skill or trick, but only as a function of the ability to enter into *samādhi* at will and as a manifestation of that perfect recollectedness which is, in fact, attributed to the *arhat*. To have thus returned to the center of one's own being is to have reached that center at which the spiritual Axis of the Universe intersects the plane on which the empirical consciousness had previously been extended; to have become if not in the fullest sense a *sādhu*, at any rate *sādhya*, one whose consciousness of being, on whatever plane of being, has been concentrated at the "navel" of that "earth," and in that pillar (*skambha, stauros*) of which the poles are chthonic Fire and celestial Sun.

We have seen that the *Breath of Life* (*prāṇaḥ*), often identified with the Spirit, and with Brahman, but more strictly speaking the vital manifestation of the Spirit, the Gale of the Spirit insofar as this can be distinguished from the Spirit at rest, departs from the heart by its apex; and we know also that all the breaths of life (*prāṇāḥ*) are, as it were, the subjects of the Breath (Praśna Up. III.4) and diverge into their vectors at birth, and are unified in the Breath, or Gale, when it departs, and hence it is that one says of the dying man that "He is becoming one" (Upaniṣads, *passim*). This supremacy of the Breath of Life lends itself to a striking architectural illustration, which we find first in the *Aitareya Āraṇyaka*, III.2.1 (ŚA VIII), as follows: "The Breath of Life is a pillar (*prāṇo vaṃśa*). And just as [in a house] all the other beams are met together (*samāhitaḥ*) in the king-post (*śālā-vaṃśa*, 'hall-beam'),[60] so it is that in

[60] *Vaṃśa* is literally "bamboo," and architecturally either a post or a cross beam such as a wall plate. We assume that the *śālā-vaṃśa* is here a king post (either supported by tie beams, or even extending to the ground, and in either case coincident with the main axis of the house) rather than a ridge pole, because it is only in such a post that all the other beams, i.e. rafters, can be said to meet *together*. And similarly in the *Milindapañha* passage below [cf. note 63—ED.] we assume that *kūṭa* is synonymous with *kaṇṇikā* (as we know that it can be) and means roof-plate rather than ridge pole. If the meaning were "ridge pole" in either or both cases, the force of the metaphor would not, indeed, be destroyed, but somewhat lessened.

In this connection it may be noted that in J I.146, a "great blazing *kūṭa* of bronze, as big as a roof-plate" is used as a weapon by a Yakṣa (so *kaṇṇika-mattaṃ mahantam ādittam ayakūṭam gahetvā*). This seems to throw some light on the obscure passages

this Breath [the functions of] the eye, the ear, the intellect, the tongue, the senses, and the whole self are unified" (*samāhitaḥ*). In order to grasp the connection of this simile with the later Buddhist variant, it is needful to observe that to be *samāhita* is literally the same as to be "in *samādhi*."[61] In the Buddhist variant we have, Mil 38 (ii.1.3): "Just as every one of the rafters of a building with a domed roof (*kūṭāgāra*) go up its roof-plate (*kūṭaṅgamā honti*), incline towards its roof-plate (*kūṭaninnā*),[62] and are

JB 1.49.2, where the sacrificial victim "is to be struck on the *kūṭa*" (*kūṭe hanyāt*), by which we should understand "on the crown of the head"; and JB 1.49.9, where a Season, described as "having a *kūṭa* in his hand" (*kūṭa-hastaḥ*), descends on a "ray of light" (*raśminā pṛtyavetya*): since the Season descends from the Sun and is the messenger of the solar Judge, we suppose again that this means that he has in hand as his weapon a *discus*, analogous to the solar disc, which is the roof-plate of the universe. Cf. H. Oertel in JAOS, XIX (1898), 111–112.

In the same way the discus (*cakra*) is the characteristic weapon (*āyudha*) of the solar Viṣṇu. Another use of the Sun in a likeness as a weapon can be cited in the Mahāvrata, where an Aryan and a Śūdra struggle for a white round skin which represents the Sun, and the former uses the skin to strike down the latter. *Kūṭa-hasta* then is tantamount to "armed with the Sun."

Just as the sacrificial victim is to be struck "on the *kūṭa*," so also we find that the deceased yogi's cranium may be broken, in order to permit the ascension of the breath of life; and in this connection Mircea Eliade (*Yoga*, Paris and Bucharest, 1936, p. 306) remarks that "Yoga has had an influence also upon architecture. The origin of certain temple types, together with their architectonic conception, must be explained by the funeral rites of ascetics." Eliade gives references, and adds that "the fracture of the skull (in the region of the *brahmarandhra*, the foramen of Monro) is a custom found in the funeral rites of many races. It is widespread too, in the Pacific, India, and Tibet." That it was also an American Indian practice is known from the discovery in Michigan and elsewhere of perforated skulls; the circular perforation of the foramen met with here can only have had a ritual significance. It is distinct from ordinary trepanning in that the operation was performed post mortem. It would be perfectly natural to describe the perforation as an "eye" in the dome of the skull.

[61] *Samādhi* (n.) and *samāhita* (pp.) are from *sam-ā-dhā*, to "put together," "make to meet," "con-centrate," "resolve," and hence reduce to a common principle: *samādhi* is "composition," "consent," and in yoga, the "consummation" of *dhyāna*, in which consummation or unification or at-one-ment, the distinction of knower and known is transcended and knowledge alone remains.

[62] As remarked in a previous note, we assume that *kūṭa* is here a synonym for *kaṇṇikā*. Had a ridge pole been meant, one could hardly have spoken of every one of the rafters as "converging" to it. *Kūṭāgāra* may indeed also mean a "gabled house." But in the present context we have evidence that the house envisaged had really a domed rather than a ridged or even a pointed roof. This is indicated by *ninnā*, which implies that the rafters (*gopānasiyo*) are curved, and the roof therefore rounded; cf. the expression *gopānasī-bhogga*, *gopānasīvaṅka*, "bent like a rafter," used of women and old people ("bent," i.e., curved, not bent double as implied by the ∧ in PTS).

assembled at its roof-plate (*kūṭasamosaraṇā*), and the roof-plate is called the apex (*agga = agra*) of all, even so, your Majesty, every one of these skilful habits (*kusala dhammā*)[63] has the state of unification as its forefront (*samādhi-pamukhā honti*), inclines towards the state of unification (*samādhi-ninnā*), leans towards the state of unification (*samādhi-poṇā*), and bears upon the state of unification (*samādhi-pabbhārā*)."[64] It will be seen that *samādhi* here replaces the previous *prāṇe . . . samāhita*, affecting the emphasis, rather than the essence of the meaning.

We are now in a position to consider the texts in which a breaking through the roof-plate of a house, and even a breaking down of the house itself, is spoken of. In J iii.472, the *arhat* "flies up in the air, cleaving the roof-plate of the palace (*ākāse uppatitvā pāsādakaṇṇikam dvidhā katvā*)." In DhA i.63, an *arhat* "flying up by his 'power,' breaks through the roof-plate of the peaked [or probably domed] house, and goes off in the air." DhA iii.66, the *arhat* Moggallāna (cf. J iv.228-229) "breaking through the round of the roof-plate, springs into the air (*kaṇṇika-maṇḍalam bhinditvā ākāsan pakkhandi*)," is incidentally good evidence also for the circular form of the plate. Finally, in J i.76, we have the Buddha's song of triumph on the occasion of the Full Awakening (*mahāsambodhi*), in which he glories in the fact that the house of life, the tabernacle of the flesh, has once and for all been broken down (*gahakūṭam visaṇkhitam*).[65]

If we have not by any means exhausted the subject of the symbolic

[63] Defined in Mil 33, etc., as *sīlam* (conduct), *saddhā* (faith), *viriyam* (energy), *samādhi* (unification, or "one-pointedness of the attention"), with the *indriyā-balāni* (sense powers) and *paññā* (insight, or more strictly speaking, foreknowledge). It will be seen that while the application in the Brāhmaṇa is strictly metaphysical, that of the Buddhist text is rather more "edifying." The *Milindapañha* passage is repeated elsewhere; see Coomaraswamy, "Early Indian Architecture: III. Palaces," 1931, p. 193.

[64] Cf. M 1.322–323, "Just as the roof-plate (*kūṭa*) of a domed mansion (*kūṭāgarassa*) is the peak (*aggam*) that ties together (*samghā-tanikam*) and holds together (*samgānikam*), just so the sheltering roof of the [skillful] habits (*channam-dhammānam*) [is the peak that ties together and holds together the six laudable states of consciousness]."

[65] The house of life, the spatial world of experience, is above all a half-way house: a place of procedure from potentiality to act, but of no further use to one whose purposes have all been accomplished and is now altogether in act. We have already seen the same idea (that of no further validity of space) expressed in another way by the miracle of the atonement of the four bowls. The cycle symbolized by the building and destruction of the house, or division and unification of the bowls, proceeds from unity to multiplicity, and returns from multiplicity to unity, in agreement with the Buddha's word, "I being one become many, and being many become one" (S ii.212).

values of Indian architecture, we may perhaps claim to have shown that during a period of millennia this architecture must be thought as having been not merely one of "material facts" but also an iconography: that the form of the house conceived in the artist's mind as the pattern of the work to be done, and in response to the needs of the householder (whether human or divine), actually served the double requirements of a man who can be spoken of as a whole man, to whom it had not yet occurred that it might be possible to live "by bricks and mortar only," and not also in the light of eternity, "by every word that proceedeth out of the mouth of God"; by which we mean in India precisely "what was heard (*śruti* = *veda*)," together with the accessory sciences (*śāstra*), of which the basic principle is to imitate what was done by the gods in the beginning, or in other words to imitate Nature, Natura naturans, Creatrix, Deus, in her manner of operation.[66] By touching on the subject of other things than buildings made by art, and that of other than Indian architecture, we have implied that the metaphysical tradition, or Philosophia Perennis, of which the specifically Indian form is Vedic, is the heritage and birthright of all mankind, and not merely of this or that chosen people; and hence that it can be said of all humane artistic operation that its ends have always been at the same time physical and spiritual good. This is merely to re-state the Aristotelian and Scholastic doctrine that the general end of art is the good of man, that the good is that for which a need is felt and to which we are attracted by its beauty (by which we recognize it, as though it said, "Here am I"), and that the whole or holy man has always been conscious at the same time of physical and spiritual needs; and therefore not in any capacity merely a doer or merely contemplative, but a doer by contemplation and a contemplative in act.

Finally we contend that nothing has been gained, but very much lost, both spiritually and practically, by our modern ignorance of the meanings of superstitions, which are in fact "stand-overs" that are only meaningless to us because we have forgotten what they mean. If the thunderstorm is no longer for us the marriage of heaven and earth, but only a discharge of electricity, all that we have really done is to substitute a physical for a metaphysical level of reference; the man is far more a man who can realize the perfect validity of both explanations, each on its own level of reference. Of the man who could look up to the roof of his house, or temple, and say "there hangs the Supernal Sun," or down at his hearth and say "there is

[66] For the Vedas as a "map of life," cf. ŚB xi.5.13.

the navel of the earth," we maintain not only that his house and temple were the more serviceable to him and the more beautiful in fact, but in every sense much more such homes as the dignity of man demands than are our own "machines to live in."

Appendix: Pāli *kaṇṇikā*: Circular Roof-Plate[67]

The renderings of this word, in its architectural sense, in published translations of Pāli texts are so obviously unsatisfactory that it will be needless to cite them here. I have therefore consulted afresh practically all the original texts in which the word can be found.

The literal meaning of the word is, of course, "ear-thing," probably with reference to the idea of something standing out or projecting. The only example of the meaning "earring" (cf. Hindi *karnphūl*) is DA 1.94, *pilandhana-kaṇṇikā*; cf. Skr. *karṇaka*, *karṇikā*, "projection, handle, earring, pericarp of a lotus, central point," etc. Very often the word is used to denote a part, namely the inner part, the seed vessel, of a lotus. In J 1.183, we have *patta*, *kiñjakkha*, *kaṇṇikā*, i.e., petals, stamens, pericarp of a lotus (*paduma*); the two first fall away, leaving the last "standing." The same words occur in the same sense in Mil 361, except that *kesara* replaces *kiñjakkha*. As is well known, the *paduma* (Skr. *padma*) seed vessel has a flat circular top marked with smaller circles. In iconography it is precisely this top which forms the actual support of a deity seated or standing on a seat or pedestal (*pīṭha*); accordingly, we find the upper part of a pedestal (*vedi*, *pīṭhaka*) designated in Sanskrit as *karṇikā* (*Mānasāra*, XXXII.111, 112, and 117 with v. l. *kari-karṇa*).

The *paduma-kaṇṇikā* disk forms the top of a cylindrical body which narrows downwards towards the stalk of the flower. Probably because of their resemblance in shape to this form, shocks of rice standing in a field are called *kaṇṇikā-baddhā* (DhA 1.81); they are tied in at the waist, so to speak.

In J 1.152, a fawn is said to be as beautiful as a *puppha-kaṇṇikā*, which may mean here no more than the "heart of a lotus flower."

We come now to the more difficult problem of *kaṇṇikā* and *kaṇṇikā-maṇḍala* as an architectural term. We find it as part of the roof of a

[67] [At the beginning of Part III of "The Symbolism of the Dome," Coomaraswamy takes for granted the reader's knowledge of this article, originally published in the *Journal of the American Oriental Society*, L (1930).—ED.]

kūtāgāra, DA 1.309, DhA 1.77; of a *sālā*, J 1.201 (= DhA 1.269, *vissamana-sāla*); of a *pāsāda*, J III.431 and 472; of a king's *vāsāgāra*, J III.317-319; of a *geha* generally, DhA IV.178; and D 1.94, where divination by the *lakkhaṇa*, lucky marks, of a *kaṇṇikā* is alluded to, the Commentary (DA 1.94) explaining that the *kaṇṇikā* may be either an ornament, or the *kaṇṇikā* of a house, *geha*. *Kaṇṇikā-maṇḍala* seems to mean the same as *kaṇṇikā*, as will appear from the texts (DhA III.66, IV.178; J III.317) and from the fact that the *kaṇṇikā* is in any case round, just as a plate and the circle of a plate are practically the same thing.

In three places we have an account of arhats rising in the air and making their exit from the house by breaking through the *kaṇṇikā*. Thus, *pāsāda-kaṇṇikaṃ dvidhā katvā*, J III.472; *kūtāgāra-kaṇṇikaṃ bhinditvā*, DhA 1.77; *kaṇṇikā-maṇḍalaṃ bhinditvā*, DhA III.66. In DhA IV.178, several novices make a miraculous exit: one breaks through the *kaṇṇikā-maṇḍala*, another through the front part of the roof (*chadana*), another through the back of the roof.

In J 1.200–201 and DhA 1.269, we have the story of a woman (Sudhammā) who contrives, against the will of the original donors, to share in the meritorious work of building a public hall (*sālā, vissamana-sālā*). She conspires with the carpenter (*vaḍḍhakī*) to become the most important person in connection with the hall, and it appears that the person who provides the *kaṇṇikā* is so regarded. A *kaṇṇikā* cannot be made of green wood, so the carpenter dries, shapes (*tacchetvā*), and perforates (*vijjhitvā*) a piece of *kaṇṇikā*-timber (*kaṇṇikā-rukkham*), and the woman takes it, wraps it in a cloth, and puts it away. Presently the hall is nearly finished and it is time to put up the *kaṇṇikā*; as hers is the only one ready for use that can be found, it has to be used. In the DhA version we are further told that an inscription was carved on the *kaṇṇikā*: *Sudhammā nāma ayaṃ sālā*, "this hall hight Sudhammā," after the principal donor.

In J III.431, the king is told that a weevil has eaten up all the soft wood (*pheggu*) of the *kaṇṇikā* of the *pāsāda*, but as the hard wood (*sāra*) is still intact, there is no danger.

The most instructive text is that of the *Kukku-Jātaka* (J III.317-319). Here the king's *vāsāgāra* is unfinished; the rafters (*gopānasiyo*) are supporting the *kaṇṇikā*, but have only just been put up. The king enters the house (*geha*) and, looking up, sees the *kaṇṇikā-maṇḍala*; he is afraid it will fall on him, and goes out again. He wonders how the *kaṇṇikā* and rafters are held up. Two verses follow; in the first, the size of the *kaṇṇikā* is given: it is one and a half *kukku* in diameter, eight *vidathi*

in circumference,[68] and made of *siṃsapa*[69] and *sāra* wood; why does it stand fast? In the second verse the Bodhisattva replies that it stands fast because the thirty rafters (*gopānasiyo*) of *sāra* wood "curved[70] and regularly arranged, compass it round, grip it tightly." The Bodhisattva goes on to expound a parable; the *kaṇṇikā* and rafters are like the king and his ministers and friends. If there is no *kaṇṇikā*, the rafters will not stand, if there are no rafters, there is nothing to support the *kaṇṇikā*; if the rafters break, the *kaṇṇikā* falls; just so in the case of a king and his ministers.

In DA 1.309, gloss on *kūṭāgāra-sāla*, we have *kaṇṇikaṃ yojetvā thambānaṃ upari kūṭāgāra-sālā-saṃkhpena deva-vimāna-sadisaṃ pāsādaṃ akaṃsu.* I now venture to render this passage not quite as in C.A.F. Rhys Davids' translation quoted in JAOS, XLVIII, 269, but "putting in the *kaṇṇikā*, they completed the mansion in the shape of a gabled hall (resting) on pillars, like to a palace of the gods." This is quite in accord with the architectural forms represented in the old reliefs, where the commonest type of more pretentious building is that of a pinnacled hall resting on pillars: *saṃkhepena* is "in the shape of," just as in DA 1.260, *bhūmi-ghara-saṃkhepena pokkharaṇiṃ.* In DA 1.43, gloss on *maṇḍala-māla* (a building in which the brethren assemble), we have "Wherever two *kaṇṇikās* are employed, and the thatching (*channa*) is done in goose or quail (-feather style), it is a *maṇḍala-māla*, 'a circle hall,' and so also where one *kaṇṇikā* is employed and a row of pillars is set around about (the building) it is called *upaṭ-ṭhāna-sālā* (attendance hall) or *maṇḍala-māla*." Here then, *maṇḍala-māla* must mean "assembly hall."[71] It is clear that when the size of a building required it, two circular roof-plates might be employed instead of one; presumably the building would then

[68] Incidentally, we observe that a *kukku* must = 26/11 *vidatthi*: Vin III.149 informs us that a *vidatthi* = twelve *aṅgulas*, or "inches."

The only other indication of the size is the vague reference in J III.146, to a mass of iron "as big as a *kaṇṇika.*"

[69] *Dalbergia sisu.*

[70] The *gopānasiyo* of a domed or barrel-vaulted roof are of course curved, as we see them reproduced in the interiors of *sela-cetiya-gharas*, but the curve (often used figuratively with reference to old people) is a single rounded curve, not like an inverted V as stated in the PTS Dictionary. The rafters are bent, but not bent double.

[71] The word occurs also at DA 1.48; and Mil 23, where it is a monastery hall in which an innumerable company of brethren is seated. VbhA 366, explains it as a "rectangular *pāsāda* with one pinnacle (*kūṭa*), like a refectory (*bhojana-sālā*)." See also PTS Dictionary, s.v. *māla*: SnA 477 explains *māla* as *savitānaṃ maṇḍapaṃ*, "pavilion with an awning (or overhanging eaves)."

be apsidal at both ends. The reference to thatch patterns is interesting. It is to be noted that *maṇḍala* refers not to the circular shape of the building, but to the "circle" of those assembled in it.

It will now be obvious that the *kaṇṇikā* is made of wood, is connected with the rafters, and is to be seen from within the house by looking up (hence it cannot possibly be a "pinnacle," as hitherto commonly translated); it is the most honorable part of the house, and may bear a donor's inscription; it is probably always ornamented, very likely representing an inverted lotus. It is distinct from the rest of the roof. It is not obviously firmly fastened to the rafters, but they and it are interdependent, and support each other.

Only one possible architectural unit answers to these conditions, that is, a roof-plate or patera. The perforating of J 1.201 probably alludes to the cutting of slots in the margin of the *kaṇṇikā* to receive the ends of the rafters; once set in place, the rafters pressing inwards grip the *kaṇṇikā* tightly and, on the other hand, the *kaṇṇikā* itself keeps the rafters in place. Where a building is not simply circular, square, or octagonal, but barrel-vaulted with two apsidal ends,[72] there must be two (half-) *kaṇṇikās*; on the other hand, in the case of a barrel-vaulted building with gable ends, the rafters would rest directly against a ridge-pole (*kūṭa*), as at Ajaṇṭā, Cave XIX, or would simply meet above (as at Aurangābād, Cave IV), and no *kaṇṇikā* would be needed. In any case the meaning "circular roof-plate" or patera must be regarded as definitely established for *kaṇṇikā* as an architectural term in Pāli literature; taken collectively, the various allusions are singularly explicit.

The present discovery of the roof-plate as a typical architectural device in the construction of early domed or half-domed (apsidal) roofs is of considerable interest for the history of the dome in India. Like other wooden methods of construction, it would naturally have been copied in stone; only in making a solid dome, we should expect to find the stone "rafters" thinned and broadened out; and this is just what we see in the case of the little domed temple of the Amarāvatī relief illustrated in my *History of Indian and Indonesian Art*, fig. 145, where it is evident that there must be a roof-plate (beneath the finial) against which the stone rafters rest.[73] It will be observed that the principle is that of the true arch, and that the roof-plate is effectively a keystone. Domed construction of this type has survived in India down to modern times.

[72] E.g., in the case of the larger *maṇḍala-māḷa* described above.

[73] [A. K. Coomaraswamy, *History of Indian and Indonesian Art* (Leipzig, New York, and London, 1927; reprinted New York, 1965).—ED.]

Actual representations of the interiors of secular buildings are, of course, very rare or unknown in the early reliefs. But it is well known that the early rock-cut caitya halls exactly reproduce wooden forms; and actually I have been able to find two or three examples in which a *kaṇṇikā* can be clearly seen. One of these, Ajaṇṭā, Cave XIX, reproduced in Martin Hürliman, *India* (New York, 1928), pl. 110, shows a small circular roof-plate which receives the upper ends of the rafters of the half-dome of the apse, while a long straight plate in similar fashion receives the ends of the rafters of the barrel-vaulted part of the roof. Another is Cave IV at Aurangābād, where in a photograph, so far unpublished, a semicircular roof-plate, or half-*kaṇṇikā*, receives the apsidal rafters, while those of the barrel-vaulting meet above without a plate of any kind; similarly at Kārlī. A majority of photographs of early caves do not show any of the roof details clearly, but it is almost a certainty that an examination *in situ* would reveal a circular or semicircular roof-plate wherever we have a dome or apsidal half-dome.

As an architectural unit our *kaṇṇikā* obviously corresponds to the central pendant so characteristic of later *Cāḷukyan* and *Solaṇkī* architecture, but I am not able to say whether the term *karṇikā* is actually used in this connection.

It is also obvious that the word may have other and related meanings; in the *Kāmikāgama* LIV.37, 40, cited by Prasanna Kumar Acharya, *Dictionary of Hindu Architecture* (New York, 1927), s.v. *karṇikā*, it is explained as meaning a swinging lotus pendant attached to the edge of the cornice (*kapota*).

It is necessary also to discuss briefly the meaning of *kūṭa*, which occurs so commonly in the combination *kūṭāgāra*. As the top, peak, or roof-ridge of a building, the meeting place of the rafters, *kūṭa* is partially synonymous with *kaṇṇikā*; and this is exemplified in *Jātaka* no. 347, entitled the *Ayakūṭa Jātaka* because in it there is mentioned a piece of iron "as big as a *kaṇṇikā*." Usually it is more specifically the horizontal ridge-pole or roof-plate against which rest the rafters of a building with a peaked or barrel-vaulted roof. This is just what is to be understood in Mil 38 (II.1.3) where we have, "As the rafters (*gopānasiyo*) of a *kūṭāgāra* go up to the *kūṭa*, and are gathered together at the *kūṭa*, and the *kūṭa* is acknowledged to be the peak (*agga*) of all, so. . . ."[74] *Kūṭa* does not, as I formerly sup-

[74] An analogous simile occurs already in ŚA VIII (= AĀ III.2.1): "Just as all the other beams (*vaṃśa*) rest on the main beam (*śālā-vaṃśa*), so the whole self rests on this breath." This enables us to translate *śālā-vaṃśa* more precisely as ridge-pole or roof-plate.

posed (JAOS XLVIII, 262), mean finial, but roof-ridge, etc. For finial we have (*puṇṇa-*)*ghaṭa*, *kalasa*, etc.; in DhA 1.414, a *pāsāda* has a golden *kūṭa* designed to carry sixty *udaka-ghaṭa*. Hence *kūṭāgāra* is not primarily a pinnacled hall, though this is also implied, but a building with a ridged or rounded, but not domed, roof, and the established translation "gabled hall" is probably the best that can be found; in any case a mansion, rather than a mere house, is to be understood. The PTS Dictionary equation *gaha-kūṭa* = *thūnirā* = *kaṇṇikā* is not actually incorrect, but it should be remembered that the two first are horizontal beams, the last a circular roof-plate. When, as in DA 1.309, cited above, a *kūṭāgāra* has a *kaṇṇikā*, it must be assumed that a building with apsidal end or ends is meant, each such end requiring its (half-) *kaṇṇikā*; but it is just possible that here *kaṇṇikā* stands for *kūṭa* since, after all, the two are alike in function although different in form.

Svayamātṛṇṇā: Janua Coeli

'Αμὴν ἀμὴν λέγω ὑμῖν, ὅτι ἐγώ εἰμι
ἡ θύρα τῶν προβάτων.

John 10:7

*Eine grosse Weltlinie der Metaphysik zieht sich durch aller
Völker hindurch.* J. Sauter

The coincidences of tradition are beyond the scope of
accident. Sir Arthur Evans

The "second building" (*punaściti*) of the Fire Altar consists essentially
in the laying down of three "Self-perforated 'bricks' " (*svayamātṛṇṇā*),
representing these worlds, Earth, Air, and Sky; the seasonal bricks,
representing the Year; and the Universal-Light bricks representing
Agni, Vāyu, Āditya (ŚB ix.5.1.58–61). As a part of the construction
of the regular Fire Altar, this "second building" or rather "super-struc-
ture" of the Altar is described in detail in ŚB vii.4.2 ff. and TS v.2.8 ff.
Here we propose to discuss only the nature of the three "Self-perforates"
(*svayamātṛṇṇā*) which represent Earth, Air, and Sky, and with the
three intervening "Universal Lights" representing Agni, Vāyu, Āditya
(Fire, Gale of the Spirit, and Sun) compose the vertical Axis of the
Universe, the passageway from one world to another, whether up-
wards or downwards. The three Self-perforates, of which the lowest
is a hearth and the uppermost[1] the cosmic luffer, form in effect a chimney,
disons cheminée, à la fois caminus *et* chemin ("hearth" and "way")
*par laquelle Agni s'achemine et nous-mêmes devons nous acheminer
vers le ciel.*[2]

The Self-perforates are referred to as "stones" or "dry stones" (*śarkare,
śuṣkāḥ śarkarāḥ*)[3] in ŚB viii.7.3.20 and viii.7.4.1, and J. Eggeling rightly

[This study was first published in *Zalmoxis*, II (1939). The last two epigraphs are
drawn respectively from the *Archiv für Rechts- und Sozialphilosophie*, XXVIII
(1934), 90; and the *Journal of Hellenic Studies* (1901), p. 130. Because of their
length, the notes for this study are printed at the end of the essay.—ED.]

465

thinks of them as "natural stones," which may have been larger than the ordinary bricks (SBE, XLIII, 128, n. 2). It is evident that "perforated" does not mean "porous,"[4] but rather annular or like a bead, since the Self-perforates are not only "for the upward passage of the breaths" (*prāṇānām utsṛṣṭyai*)[5] but "also for vision of the world of heaven" (*atho suvargasya,*[6] *lokasyānukhyātyai,*[7] TS v.2.8.1, 3.2.2, and 3.7.4). They are, moreover, the Way by which the Devas first strode up and down these worlds, using the "Universal Lights" (*viśvajotis* "bricks," Agni, Vāyu, Āditya) as their stepping stones (*samyānayah,* ŚB viii.7.1.23),[8] and the Way for the Sacrificer now to do likewise (ŚB viii.7.2.23 and vii.4.2.16), who as a Comprehensor (*evaṃvit*) "having ascended to the Beatific Spirit (*ānandamayam-ātmānam upasaṃkramya*), traverses these worlds, 'eating' what he will, and in what shape he will" (*imān lokān kāmānī kāmarūpy anusaṃcaran,* TU iii.10.5; cf. JUB 1.45.2 and iii.28.4), as in John 10:9, "shall be saved, and shall go in and out, and find pasture," and *Pistis Sophia.*[9] From all this it follows that the Self-perforates of the Fire Altar must have been "ring-stones," like the well-known example at Śatruñjava, called a "Door of Liberation (*mukti-dvāra*)," through which people are still passed, and like the many ring-stones of all sizes that have been found on Indus Valley sites.[10]

The Self-perforates are these worlds (ŚB ix.5.1.58, etc.) in a likeness. What is common to them is the "whole Breath (*sarvah prāṇah*)," of which the three aspects are that of the aspiration (*udāna*) proper to Agni, transspiration (*vyāna*) proper to Vāyu, and spiration (*prāṇa*) proper to the Sun (ŚB vii.1.2.21).[11]

We have here to do with the *sūtrātman* doctrine, according to which all things are connected with the sun in what is literally a common con-spiracy. The Self-perforates, then, are quickened with the Breath of life by the Sunhorse, which is made to kiss them (*aśvam upaghrāpayati, prāṇam evāsya dadhāti,* TS v.2.8.1, 3.2.2, and 3.7.4);[12] for "That 'horse' is yonder Sun, and those 'bricks' are the same as all these offspring (*prajā*); thus, even as he makes it kiss [snuffle at] them, so yonder Sun kisses these offspring.[13] And hence, by the power of [that solar] Prajāpati,[14] each one thinks 'I am' (*aham asmi*)[15] . . . and again, why he makes it kiss [snuffle at]: that horse is yonder Sun,[16] and those Self-perforates these worlds; and even as he makes it kiss [snuffle at], so yonder Sun strings these worlds to himself on a thread (*sūtre samāvayate*). . . . Now that thread is the same as the Gale (*vāyu*)," ŚB vii.3.2.12–13 and viii.7.3.10; "Verily, he bestows the Breath upon it" (TS v.2.8.1, etc.).

This, indeed, is the middle term of a large group of texts beginning with RV I.115.I, "The Sun is the Spirit (*ātman*) of all that is in motion or at rest"; and continuing, AV x.8.38, "I know the extended thread (*sūtram*) wherein these offspring are inwoven: the thread of the thread I know; what else but the 'Great' (*mahat*, the Sun), of the nature of Brahman?"; BU III.7.1–2, "He who knows that thread and the 'Inward Ruler' (*antaryāminam iti*),[17] knows the Brahman, knows the worlds, knows the Devas, knows the Vedas, knows himself, knows All. . . . By the Gale, indeed, O Gautama, as by a thread, are this and yonder world and all beings strung together";[18] JUB III.4.13–III.5.1, "Even as the thread of a gem (*maṇisūtram*) might be threaded through a gem, even so is all this strung thereupon [upon the Sun, Vāyu, Prāṇa, Brahman], to wit, Gandharvas, Apsarases, beasts, and men"; BG VII.7, "All this is strung on Me, like rows of gems upon a thread."[19]

It can hardly be doubted that the well-known "cotton-bale" (Figure 13A) symbol of the Indian punch-marked coins (with which may be compared a number of similar forms to be met with on Babylonian seals, e.g., Figure 13B) is a representation of the Three Worlds in the shape of the Self-perforates, connected by a common thread, which is that of the Breath, Sunpillar, and Axis of the Universe.[20] The three Self-perforates are, furthermore, manifestly comparable to the naves of wheels; they are, indeed, the navel-centers (*nābhi*) of the worlds (*cakra*) which they represent. It is upon their axis that the three-wheeled cosmic chariot of the Aśvins turns. These are the three holes (*khāni*) in the naves of the chariot wheels through which Indra draws Apālā, so that her scaly skins are shed, and she is made to be "Sunskinned" (RV VIII.91, JB I.220, etc.);[21] the Moon, the Gale, and the Sun, "opened up like the hole of a chariot wheel or a drum" for the ascent of the deceased Comprehensor (BU v.10–11), who, "when he departs thus from this body, ascends with these very rays of the Sun. . . . As quickly as one could thither direct his mind, he comes to the Sun.[22] That is verily and indeed the world-door, a progression for the wise, but a barrier for the foolish" (*lokadvāraṃ prapadanaṃ viduṣāṃ nirodho'viduṣam*, CU VIII.6.5).[23] Each of these holes is a birthplace (*yoni*), whoever passes through such a hole dying to a former and inferior state of being and being regenerated in another and higher; in this the openings answer to the three birthplaces of JUB III.8.9–III.9.6, AĀ II.5, and Manu II.169. Whoever has thus not only been born but born again after repeated deaths and is duly "qualified to pass through the midst of the Sun" (*ādityam arhati samaya-*

467

A B C D E F

G H I J

Figure 13A. The So-Called "Cotton-Bale" Symbol
 As it appears on early Indian punch-marked coins:
 three "Self-perforates" or "beads" are strung on a "pole."

Figures 13B–I. Related Motifs from Western Asiatic Seals

Figure 13J. Symbol on a Coin from Hierapolis
 Recalls Figure 13A. "The Assyrians themselves speak
 of a symbol, but they have assigned to it no
 definite name" (Lucian, *De Syria Dea*, 33).

itum, JUB 1.6.1) has either virtually broken out of the cosmos while still in the flesh[24] or will for the last time be reborn at death, so as to be "altogether liberated through the midst of the Sun" (*ādityaṃ samay-ātimucyate,* JUB 1.3.5); [see also *Garuḍa Purāṇa* x.56–59, on rebirth from the pyre].

We shall now consider more especially the uppermost Self-perforate, which is at once the roof of the cosmic house, the crown of the cosmic tree, and the skull of the cosmic Man. It is the hole in this firmament of the sky that chiefly concerns us; this opening is variously referred to as a hole, chine, foramen, mouth, or door (*kha,*[25] *chidra, randhra, mukha, dvāra*). To have ascended these worlds as one might a ladder or a tree and to have escaped the jaws of Death is to have passed through this strait gate. JUB 1.3.5–1.7.5 continues, "That is heaven's chine (*divaś chidram*); as might be the hole in the nave of a cart or chariot (*yathā khaṃ vānasas syād rathasya*),[26] even so is this 'heaven's chine.' It is seen all covered over by rays (*raśmibhis saṃchannam*). . . .[27] Thus 'through the midst of Him,' who knows that? If verily when these waters are all about him, he indeed invokes the Gale,[28] He verily disperses the rays (*raśmīn . . . vyūhati*) for him. . . .[29] Thereupon he separates himself from death, from evil. Who knows what is beyond the Sun (*yat pareṇādityam*), what beneath this homeless atmosphere (*idam anālayam antarikṣam avareṇa*)?[30] That is just immortality!"

In the light of all this it is easy to understand the prayer of Īśā Up. 15–16 (and parallel texts, BU v.15.1 and MU vi.35), "The Gate of Truth (*satyasya . . . mukham*) do thou, O Pūṣan, uncover, that I, who am of the quality of Truth[31] (*satyadharmāya*), may see [thy fairest form]. . . . The rays dispel (*raśmīm vyūha*), unify the fiery energy (*samūha tejas*), that I may see thy fairest form"; and possible, too, to understand statements to the effect that it is a sign of death "when sun and moon are opened up (*vihīyete*),[32] when the sun looks like the moon, when its rays are not seen (*dṛśyate na raśmayaḥ*)[33] . . . when the sun is seen as if it were a chine (*chidra ivādityo dṛśyate*), and looks like the nave of a chariot wheel" (*ratha-nābhir iva,* AĀ iii.2.4; cf. ŚA viii.6.7 and xi.3.4).

All that is under the Sun is in the power of Death (ŚB x.5.1.4),[34] the Sun (ŚB x.5.2.3, xi.2.2.5, etc.) "whose shadow is both immortality and death" (RV x.121.2); and, "inasmuch as the Sun is Death, his offspring here below are mortal,[35] but the Devas are beyond and therefore undying" (ŚB ii.3.3.7); "Whatever is embodied is in the power of Death,

but whatever incorporeal, immortal" (JUB III.38.10, cf. ŚB x.4.3.9). The whole intention of the Vedic tradition and of the sacrifice is to define the Way (*mārga*) by which the aspirant (here in the literal sense of "up-breather" rather than the psychological sense of one who has mere ambition) can ascend these worlds and escape altogether through the midst of the Sun, thus crossing over from mortality to immortality. Like all other "passages," this passing over is at the same time a death and a re-birth (regeneration), and equally so whether the "death" be sacrificial and initiatory (in which case a return to "life" is provided for in the ritual) or that real death following which the man is laid on the funeral pyre and "reaches the Sun, the world door, as quickly as one could direct the mind to Him" (CU VIII.6.5).

We find accordingly in the literature a conception of the World-tree in which the trunk, which is also the Sunpillar, sacrificial post, and *axis mundi*, rising from the altar at the navel of the earth, penetrates the World-door and branches out above the roof of the world (*tiṣṭhaty utta-raṃ divaḥ*, AV x.7.3) as the "nonexistent [unmanifested] branch that yonder kindreds know as the supernal" (AV x.7.21), i.e., Yama's *supa-lāśa* of RV x.135.1, the *aśvattha* of AV v.4.3. This conception is directly reflected in the form of the hypaethral tree-temples which in India were originally Yakṣa holysteads and subsequently Buddhist temples;[36] in all of these *rukkha-cetiyas* and *bodhi-gharas* the sacred tree rises through the open temple roof and branches above it, an arrangement that is not in any way uniquely Indian.[37]

Connected with these conceptions we find in the literature that the ascent of the spirit is often described in terms of tree climbing, and in the ritual we meet with a variety of explicit climbing rites. Thus in JUB 1.3.2, "As one would keep climbing up a tree[38] by steps (*yathā vṛkṣam*

Figure 14. Han Hypaethral Tree Shrines

ākramaṇair ākramāṇaḥ iyād) . . . he keeps ascending these worlds (*imāṇ lokān rohann eti)*"; cf. ŚB 1.9.3.10, "ascending (*samāruhya*) these worlds, he reaches that goal, that support" (*etāṃ gatim etāṃ pratiṣṭhāṃ gacchati)*, even as the Sun himself climbed: "I know that of thine, O Immortal, namely thy climb (*ākramaṇam*) in the sky, thy station in the uttermost empyrean" (AV XIII.1.44). Further references to the ascent and descent of the Tree will be found in PB IV.7.10, XIV.1.12–13, XVIII.10.10; JUB III.1.3.9; Mbh, *Udyoga Parvan* 45: those who reach the summit, if still callow, fall down, if fully fledged fly away (cf. *pennuto* in Dante, *Purgatorio* XXXI.61).

Climbing rites are enacted in connection with the sacrificial post (*yūpa*), one of the most characteristic aspects of the *skambha* or *axis mundi*, and coincident with the "Bridge": "Verily the Sacrificer makes it a ladder and a bridge to attain the world of heaven (*ākramaṇam eva tat setuṃ yajamāna kurute suvargasya lokasya samaṣṭyai*, TS VI.6.4.2)."[39] The rites themselves are described in TS 1.7.9, where the Sacrificer mounts on behalf of himself and his wife; he climbs by means of steps (*ākramaṇa*) and on reaching the summit stretches out his arms and says, "We have come to heaven, to the Devas: we have become immortal": similarly ŚB V.2.1.5, where the Sacrificer climbs and "rises by a head above the post, saying, 'We have become immortal,' and thereby wins the world of the Devas." In TS V.6.8, the "mounting after Agni (*agner anvārohaḥ*)"[40] is a part of the construction of the altar itself, in other words, it is by means of the aforesaid "stepping stones"; and "were he [the Sacrificer] not to mount after Him [Agni], he would be excluded from the world of heaven"; cf. CU VIII.6.5, *nirodho'vidūṣām*. AB IV.20–22 (cf. KB XXV.7) describes the "difficult mounting (*dūrohaṇa*)": "Verily thus he mounts the world of heaven, who is in this matter a Comprehensor. . . . He mounts with the verse in which are the words 'The Gander. . . .'[41] 'Like a ship let us mount';[42] verily thus he mounts it for the attainment of heaven, the winning, the reaching the world of heaven. . . . He mounts by 'feet'[43] . . . and descends like one holding on to a branch. . . .[44] Thus having obtained the world of heaven, the sacrificer finds support [again] in this world. For those who desire only the one, viz. heaven, he [the priest] should mount in the forward direction only; they will win the world of heaven, but they will not have long to live in [this] world." In ŚB V.1.5.1 and TS 1.7.8, the priest on behalf of the Sacrificer mounts a wheel set up on a post, navel high, and mimes the driving of horses; he makes the wheel revolve three times. The whole of

a race is enacted, while the priest, still seated on the nave of the wheel, chants verses in which are the words, "Hasten, ye steeds, for the prize . . . attain the goal (*kāṣṭhām*, the Sunpillar, or Sun)."[45] All this belongs to a regular ritual sequence, consisting first of an actual race by which this earth is won, then of the mounting of the wheel by which the air-world is won, and finally the mounting of the sacrificial post, as in TS 1.7.9 cited above, whereby heaven is won.

The citation from AB iv.21 shows us that the rite, involving as it does an initiation and symbolic death, is a dangerous one. The initiated Sacrificer is ritually dead, no longer a man but a Deva; "if he did not descend again to this world, he would either have gone to the suprahuman world, or he would go mad"[46] (PB xviii.10.10), "would either go mad or perish" (TS vii.3.10.4); "if he did not relinquish the operation, the sacrificial fire [in which he has symbolically immolated himself] would be apt to consume him" (TS 1.7.6.6).[47] Supremely important as the ritual death may be, in which the Sacrificer's final attainment of his immortal goal is prefigured, it is still of utmost importance (as explained in ŚB x.2.6.7–8, where also suicide is expressly condemned) that he should live out his full term of life on earth, for the "hundred years" of his earthly life corresponds to the "thousand years" of his heavenly life (the "thousand years" is a round number: "a thousand means everything," ŚB *passim*).[48] He therefore "relinquishes the rite," either by means of the formal "descents" and the use of inverted chants, or, as in ŚB 1.9.3.23, with the words, "Now I am he whom I actually am" (taken from VS 11.28b). For in undertaking the operation he becomes as if nonhuman (a Deva): and as it would be inconvenient for him to say, "I enter into untruth from the Truth," which is how the matter really stands, and as, in fact, he now again becomes a human being, he therefore relinquishes the operation with the text, "Now am I he that actually am," i.e., So-and-so by name and family. By means of such reversals the sacrificer, having virtually left the body[49] and virtually broken out of the cosmos, nevertheless "secures whatever full measure of life remains for him here" (VS 11.18). The logic of the whole procedure is superb.

It will have been remarked that a qualification is a necessary condition of admission by the Sundoor: "Who is qualified (*arhati*) to pass through the midst of the Sun?" (JUB 1.6.1), "Who is able (*arhati*) to know that God?" (KU 11.21). It was by their qualification (*arhaṇā*) that the Ādityas in the beginning partook of immortality (*amṛtattvam ānaśuh*, RV x.63.4). In order to complete our understanding of the Vedic tradition

of the Sundoor, we must ask in what such a qualification consists. The qualification is primarily one of likeness, and consequently of anonymity; anonymity, because whoever still is anyone cannot be thought of as entering in, as like to like, to Him "who has not come from anywhere nor become anyone" (KU ii.18). "One should stand aloof from intention, from concepts, and from the conceit of 'self.' This is the mark of liberation (*mokṣa*). This is the track,[50] here and now, that leads to Brahman. This is the 'opening of the door'[51] here and now. By it one reaches the farther shore of this darkness. Here, indeed, is the 'consummation of all desires.' . . . There is no attainment of the goal by a bypath here in the world. This is the road to Brahman here and now. Breaking through the Sundoor (*sauraṃ dvāraṃ bhitvā*),[52] the Marut (Bṛhadratha) made his exit, having done what was to be done.[53] In which connection they cite: 'Endless are the rays of Him . . . and by that[54] of these that breaks through the solar Orb (*sūrya-maṇḍalaṃ bhitvā*),' overstriding into the Brahma-world, one reaches the supreme goal" (MU vi.30). At world's end[55] the way is barred by the Sun, the Truth, the Janitor of Heaven (*apaṣedhantī*, JUB i.5.1; *viṣṇur vai devānāṃ dvārapaḥ*, AB 1.30; *nirodho'vidūṣām*, CU viii.6.5; *yatra avarodhanaṃ divaḥ*, RV ix.113.8; "and the door was shut," Matt. 25:10; Agni, *nāstuto'tisrakṣya*, AB iii.42). But whoever comes to Him as like to like, as very Truth to very Truth, worshipping him as Spirit, cannot be rejected[56] (JUB i.5.3, *neśe yad enam apaṣedhet*; AB iii.42, *stuto atyasarjata, satyena labhyas . . . ātmā*; Muṇḍ. Up. iii.1.5). "Open unto me in whom the Truth abides" (Īśā Up. 15, *apāvṛnu satyadharmāya*; cf. BU v.15.1 and MU vi.35) is the password; "disconnected with both well done and ill done (*viṣukṛto viduṣkṛtaḥ*),[57] the Comprehensor of Brahman goes on to Brahman" (Kauṣ. Up. 1.4); "they pass over by way of the Sundoor" (*sūryadvāreṇa prayānti*, Muṇḍ. Up. 1.2.11); "The Janitor opens that door for him" (*dvārapaḥ, sa evāsmā etad dvāraṃ vivṛṇoti*, AB 1.30).

What is really involved when we speak of "passing through the midst of the Sun" is already apparent in the cited texts to the effect that this is not a matter of salvation by works or merit. It is stated, more plainly perhaps than anywhere else, in JUB iii.14.1–5, "him that has reached [the Sundoor] He asks 'Who art thou?' In case he announces himself by his own or by a family name, He says to him, 'This self of thine that hath been in Me, be that now thine.'[58] Him arrived in that self, forsooth, caught by the foot on the threshold of success, the Seasons drag away.[59] Day and Night take possession of his 'world.' But to Him he should an-

swer thus, 'Who I am is the Heaven thou art. As such unto Thee, heaven-ward, am I come unto Heaven.' ... He says to him, 'Who thou art, that am I; and who I am, that art thou (*yo'ham asmi sa tvam asi*).[60] Come.' " Of the many parallels to this great passage, the most literal occurs in Rūmī's *Mathnawī* 1.3055: "Whosoever is uttering 'I' and 'we' at the door, he is turned back from the door and is continuing in *not*. A certain man came and knocked at the friend's[61] door: his friend asked him, 'Who art thou, O trusty one?' He answered, 'I.' The friend said 'Begone.' Save the fire of absence and separation, who will cook that raw one?[62] The wretched man went away, and for a year in travel and separation he was burned with sparks of fire. That burned one was cooked. ... He knocked at the door. ... His friend called to him, 'Who is at the door?' He answered, 'Tis thou art at the door, O charmer of hearts.' 'Now,' said the friend, 'since thou art I, come in, O myself:[63] there is not room in the house for two "I"s. The double end of the thread is not for the needle: inasmuch as thou art single, come into (the eye of) this needle. ... Tis the thread that is connected with the needle: the eye of the needle is not suitable for the camel.' "[64]

We have now before us a fairly complete account of the Indian doctrine of the Sundoor at World's End, and of how it may be passed. Attention has already been called to the universality of the doctrine, of which the Christian and Islamic forms have been noted. We shall conclude with some account of the doctrine as it is similarly developed in the Chinese, Siberian, Egyptian, and Hebrew traditions.

In China we shall be concerned with only two rather than three stone objects, which we can speak of, for the sake of uniformity, as "Perforates": these objects of jade are symbols of Earth and of Heaven, and are employed as such in the Imperial worship of Heaven and Earth.[65] Of these two "Perforates," the *ts'ung*, or Earth symbol, is internally tubular and externally square (Figure 15), while the *pi*, or Heaven symbol, is a perforated circular disk or ringstone (Figure 16). The Way (the most essential meaning of *tao*) is thus open from below upwards and from above downwards. The *ts'ung* is not a disk, but rather a cylinder of some height, and can readily be assimilated to the first *and* second of the Indian Self-perforates by regarding it as consisting of two disks, a lower and an upper, connected by a continuous passage. It is of great interest that these *ts'ung* are regularly thought of as "cart wheels" or "wheel hubs": for example, in the *Ku yü t'u p'u*, where the illustrated examples

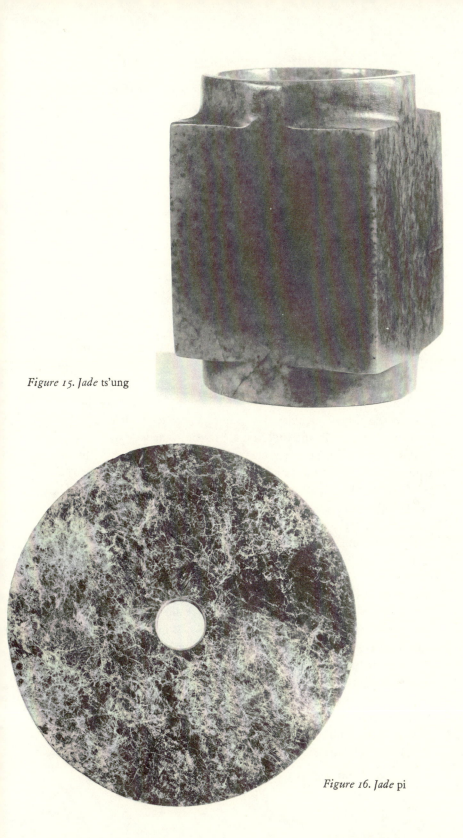

Figure 15. Jade ts'ung

Figure 16. Jade pi

are all described as "wheel hubs of the ancient jade chariot." The interior is, in fact, "uniformly hollowed out into a cylindrical cavity, into which the end of the axle would be run" (B. Laufer, *Jade*, Chicago, 1912, p. 125). Archaeologists have been disturbed by the fact that jade *ts'ung* are nevertheless by no means very like the actual bronze wheel naves (or rather axle ends, Skr. *āni*) which have come down to us from the Chou period. But "ancient jade chariot" no more implies an actual chariot used by human rulers than do the Vedic chariot of light or Biblical chariot of fire refer to vehicles that might be unearthed by the excavator's spade. Jade in China (cf. "adamant") stands for immortality: "to eat in the perfection of jade" is "to obtain immortal life" (Laufer, *Jade*, p. 297); just as gold in India means light and immortality (ŚB III.2.4.9, v.4.1.12, etc.). A chariot of jade (*yü lu*) is hardly more conceivable as an actuality than one of gold (*kin lu*), and if "great vehicles (*ta lu*)" called by these names were reserved for "the Emperor, the Son of Heaven" (Laufer, *Jade*, pp. 125, 126; Hentze, "Le Jade 'pi,'" p. 208), one may well inquire, Who is the Emperor, the Son of Heaven, in principle?[66] The "ancient jade chariot" is rather the archetype of the earthly vehicle than vice versa.[67] The *ts'ung*, as a hollow cylinder, is indeed intended to receive an axle tree, but an axle of purely spiritual (pneumatic) substance, not made by hands, and in fact the Axis Mundi.[68] In the funerary use of the six jades (*pi, ts'ung, chang, hu, huang, kuei*, respectively blue, yellow, green, red, white, black, and representing heaven, earth and the quarters E., S., W., and N.), the *ts'ung* is laid on the abdomen (note the association of "earth" with "navel" here), the *pi* under the back, and the images of the quarters so that N. and S. are head and feet and E. and W. the left and right hands (the body therefore facing south), so that the whole body is enclosed in what is called the "brilliant cube" (*Chou Li*, ch. xviii, cited by Laufer, *Jade*, p. 120).[69] The evident intention is to provide the deceased with a new and adamantine cosmic body of light. In later Taoist tradition, the "new man" born of initiation (*ju shé*, Skr. *dīkṣā*) is actually called the "Diamond Body" (*ging gan shen*, cf. Skr. Buddhist *vajra-kāya*), initiation prefiguring the transformation to be actually and forever realized at death.[70] A jade cicada placed in the mouth of the corpse of the deceased is the symbol of his resurrection in this state of transformed being,[71] in which he is set free from the limitations of human individualization.

The Siberian Shaman symbolism corresponds even more closely with the Indian, as U. Holmberg ("Der Baum des Lebens," Helsinki, 1922–1923, p. 31) has not failed to observe. We meet again with a pair of annular

476

symbols, of which the one is a perforated disk representing the Earth (Holmberg, "Der Baum des Lebens," fig. 13), and the other the luffer above the central hearth of the *yurt*, which is also the opening in the roof of a hypaethral temple, through which passes the stem of the World-tree to branch above. We shall quote the most pertinent passages from Casanowicz and Holmberg.[72] The Dolgans and Yenisei-Ostiaks erect World-pillars surmounted by a horizontal transom representing the sky and a double-headed "Bird lord" described as "all-seeing."[73] Sacrifices are offered by the Lapps to the "World-man," represented by a tree set up in a roofed shrine. In the Shaman rites of Altai races, a green birch tree is set up in a *yurt*, its crown rising above the smoke-hole;[74] within the *yurt* the stem is made to slope so as to leave space for a hearth situated beneath the smoke-hole or luffer, and "this birch symbolizes the Door-god (*udeśi-burchan*) which opens for the Shaman the way into heaven";[75] the Shaman climbs this birch, and so out on to the roof of the *yurt*, and there invokes the gods. As Holmberg comments (p. 30), "The reference of the luffer in the roof of the yurt, amongst the Altai races and the Buriats, is evidently to a heavenly prototype. The Ostiaks speak of the house of heaven as provided with a golden luffer." The opening is identified with the Pole Star, or takes its place; it is a "hole through which it is possible to pass from one world to another": Shamans and spirits, and the heroes of folktales who ride on eagles or thunder-birds, are said to slip through the series of similar holes situated under the Pole Star, and thus (as our Indian texts would express it) pass up and down these worlds.[76] There is a corresponding hole in the earth, which leads down into the nether world.[77]

The climbing rites referred to above are especially striking, constituting as they do a ritual *Himmelfahrt* of just such a sort as is described in the Brāhmaṇas. The essentials of the rite may be summarized as follows (Casanowicz, "Shamanism of the Natives of Siberia," *Smithsonian Report for 1924*, pp. 427 ff.): "In the yurta a young birch tree with the lower branches lopped is set up. . . . At the bottom of the tree nine steps [*tapty* = Skr. *ākramaṇa*] are cut with an axe. Round the yurta a penfold[78] is made . . . a birch pole with a noose of horsehair is set up. Then a horse agreeable to the deity is chosen. . . . The Shaman waves a birch twig over the horse's back, thus driving its soul to Ulgan [Bai Ulgan, who dwells in the sixteenth heaven, and is next in rank to Kaira Kan, the highest god], accompanied by the holder's soul. . . . The Shaman goes outside the yurta, sits down on a scarecrow in form of a goose [Skr.

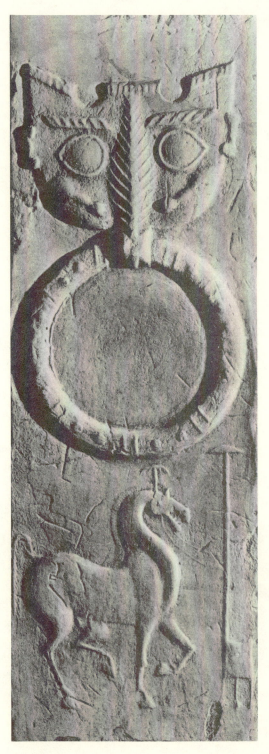

Figure 17. Han Grave Slab
Sacrificial horse, *t'ao t'ieh* mask
and ring, the mask and ring like
a door knocker.

haṃsa!] stuffed with hay and covered with cloth, and moving both arms rapidly like wings, sing in a loud voice:

> Below the white sky,
> Above the white cloud
> Below the blue sky,
> Above the blue cloud—
> Mount a bird to the sky.[79]

"The goose replies by quacking. . . . On this feathered steed the Shaman pursues the soul [*pura* = Skr. *ātman*] of the horse,[80] imitating the horse's neighing. . . . He drives to the birch pole . . . after much straining and drawing . . . the Shaman incenses the animal with juniper, blesses it . . . and kills it. The dead animal is skinned and cut up in a very elaborate manner[81] so that the bones are not broken. . . . On the second evening . . . the Shaman's journey to Bai Ulgan in heaven is enacted. . . . He circles several times the birch tree in the yurta, then he kneels in front of the door and asks the imaginary porter spirit to grant him a guide. . . . At last begins the ascent to heaven . . . the Shaman passes into ecstasy. Then he suddenly places himself on the first step cut in the trunk of the birch tree. . . . He is rising to the sky. From heaven to heaven he passes, riding on the goose. . . . At each stage he tells the audience what he has seen and heard. And finally having reached the ninth or even the twelfth heaven, he addresses a humble prayer to Bai Ulgan. . . . After this interview with Ulgan the ecstasy or delirium of the Shaman reaches its climax, he collapses and lies motionless. After a while he gradually rouses himself, rubs his eyes and greets those present as if after a long absence." A closer correspondence with the Indian rites could scarcely be imagined.

The old Egyptian doctrine of the Sundoor and its passage is essentially the same as the Indian, except that the door is thought of as rectangular. Citations following are from E.A.T. Wallis Budge, *Book of the Dead* (London, 1895), pp. cxvii–cxviii and 12–14.[82] The sky is thought of as a metallic "ceiling of the earth and floor of heaven," to reach which "a ladder was thought to be necessary."[83] This is the "ladder of Horus . . . who is the Lord of the Ladder," and the deceased, entering "in *His* name of 'Ladder' . . . the ceiling of the heavens unbolteth its gates" to him when the welcoming word is uttered, "Come forth then, to heaven, and enter therein in *thy* name of 'Ladder.'"[84] Admission depends upon the result

of a psychostasis[85] in which the "heart" is weighed against the feather Maat, the symbol of Right and Truth. The deceased "is sponsored by Horus who says, 'His heart is righteous; it hath not sinned against any God or Goddess. Thoth hath weighed it . . . it is most true and righteous. Grant that cakes and ale[86] may be given unto him, and let him appear in the presence of the God Osiris; and let him be like unto the followers of Horus for ever and ever." And in turn he says,[87] "I have not knowingly spoken that which is not true,[88] nor have I done aught with a false heart. Grant thou that I may be like unto those favored ones who are in thy following, and that I may be an Osiris, greatly favored of the beautiful God and beloved Lord of the World." Illustration to the Book of the Dead show us the World door with the Sun-god seated within it, or represented by a disk above it (Figure 18), in either case as if to say

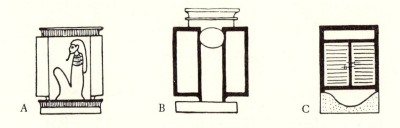

Figure 18. Egyptian World Door and Sundoor
A. The open door, guarded by the Sun God in anthropomorphic form; B. the open door, with the Sundisk above (cf. T. Dombart, "Der zweitürmige Tempel-Pylon" in *Egyptian Religion* I [1933], 93, abb. 7, the closed door surmounted by the winged disk); C. the closed door, also a representation of sunset (the Sun has "gone home," *aṣṭam yatra ca gacchati*, KU IV.9).

again, "I am the door, by me if any man enter in, he shall be saved," a formula expressed or implied in every branch of the universal tradition that we have studied; and again the door, shut and bolted, as in Matt. 25:10, "and the door was shut."[89] We have only to add that for those who fail to pass the test of the psychostasis there lies in wait the crocodile-headed monster called Āmām, the Devourer, or Āmmit, the Eater of the Dead.[90] We cannot enter here into a more general comparison of Egyptian with Indian mythology, and shall only remark that both Horus and Osiris are "falcon gods," like Agni (and Gawain, *Gwalchmai*), and point out the equivalence of the concepts of the Egyptian Amon-Rā' and Indian

Indra-Vāyu, or Sūrya = Ātman, with the Christian "God is a Spirit: and they that worship him must worship him in spirit and in truth. . . . Even the Spirit of Truth" (John 4:24, 14:17).

In conclusion, we cite from the *Zohar* (Vayaqhel, pp. 211–216): "There is, besides, in the center of the whole of the heavens, a door called G'bilon. . . . From that door again there is a path mounting ever higher and higher until it reaches the Divine Throne. . . ."[91] In the center of that firmament there is an opening (G'bilon) facing the opening of the supernal Palace on high and forming the gateway through which the souls soar up from the Lower Paradise unto the Higher Paradise by way of a pillar that is fixed in the Lower Paradise reaching up to the door on high. . . . The garments of the Lower Paradise are made of men's actions; those of the Celestial Paradise of the devotion and earnestness of his spirit."[92]

Not only is the symbolism with which we are already familiar clearly recognizable here, but we also meet with it in a remarkable work of the fifteenth-century Christian painter Hieronymus Bosch (Figure 19), for which the words "gateway through which the souls soar up from the Lower Paradise unto the Higher Paradise by way of a pillar that is fixed in the Lower Paradise" might have served as the prescription (*dhyāna mantram*). We are already familiar in many contexts with the ascent "by way of a pillar": more remarkable is the manner in which the "Ascent to the Celestial Paradise" is depicted by Bosch, which might as well have been based upon BU v.12.10, "He reaches the Sun; it opens out there for him like the hole of a drum. Through it he mounts higher."

It is one of the most distinctive traits of the "primitive mentality" that objects, beings, phenomena in general, can be for it at one and the same time what they "are" and something other than themselves.[93] *We* see only the aesthetic surfaces, or facts, of phenomena, whether natural or artificial: but for primitive metaphysics the words of St. Thomas hold good, that "this science has the property, that the things signified by the words have also a signification" (*Sum. Theol.*, 1.1.10). Primitive art depicts not what the artist sees, but what he knows; it is algebraic rather than arithmetical. It is not a question of abilities; we know very well that the primitive artist, old Egyptian or Aurignacian, for example, could be wonderfully realistic when he had this intention, just as we know that it was not an artistic inability that can be evoked to explain the absence of an anthropomorphic imagery in early Christian or early Buddhist art.

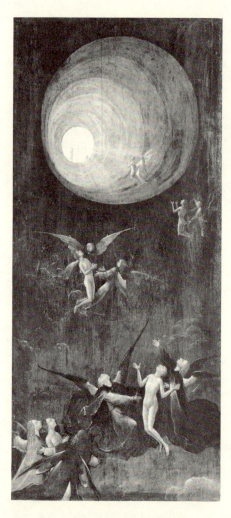

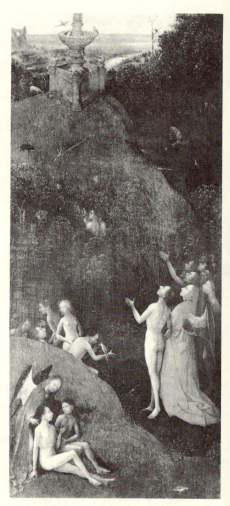

Figure 19A. Hieronymus Bosch:
Entrance to the Celestial Paradise
"He reaches the Sun, it opens out for him like
a hole in a drum," BU v.10.

Figure 19B. Hieronymus Bosch:
The Earthly Paradise

If our children also draw what they know and mean, rather than what they see, it does not follow that the primitive artist (who held, like Augustine, that it is by their ideas that we judge of what things ought to be like and "really" are like) was a child by comparison with us, who very soon demand of our children to "correct" their drawing by the "model." To draw what one means, just as to make noises that embody meanings and are not merely onomatopoetic, may be simply human: and our endeavor to subtract meaning from representation, our "subtract" rather than "abstract" art, may be less than human, and even devilish, implying as it does a will to live by bread alone.

We have collated above what may be called a symbolic text, preserved in many recensions, both visual and verbal, in all of which a definite pattern can be clearly recognized. Where formulations are thus precise and perfectly intelligible, it can only be presumed that an understanding of their meaning coexisted with their promulgation and use. One does not first discover a mathematical equation and afterwards read a meaning into it; if a diagram of the fifth proposition of Euclid should appear on the surface of Mars, we should infer the existence there of beings already acquainted with geometry. If we assume that a language is understood by those who speak it,[94] we must assume that a doctrine is coeval with the symbolic formulae in which it is expressed. If now we examine the symbols, verbal or visual (we often overlook that no distinction in principle can be made between aural and visible or tangible symbols), in which our text and the Urmythos to which it is intrinsic is stated, it will be seen at once that none of these imply a "civilization" in any literal sense of the word, but only a culture of such a sort as the American Indian or Eskimo possessed (we must be careful not to prejudice our judgment of "primitive man" by an exclusive study only of what are evidently degenerate races, such as the Veddas). Of all our symbols, the chariot with its axle and wheels, etc., and harnessed horses, is the most complex. But even this form was already a widely distributed actuality as early as the beginning of the fourth millennium B.C. and among peoples who still made use of stone implements, although acquainted with metal. Of the others, few or none could not have been naturally used by Paleolithic man, who, as we now know, already possessed his circular hut with central hearth and a hole in the roof for the escape of smoke, and could therefore perfectly well have said that "like a builder hath Agni upheld his pillar of smoke, upheld the sky" (RV iv.6.2), and thought of Him accordingly as the missal priest by whom man's sacrifice

is conveyed to the gods beyond. Primitive man already possessed his needle and thread of sinew, and just because his thread was of sinew could have felt in a designation of the act of kind as a sewing (cf. RV 11.32.4 cited above, and *syūti* as both "sewing" and "offspring"), and in the expression "unstrung" applied to the body at death—and hence analogically to that of the cosmos at the end of the world—an image even more vivid than at a later time, when thread was of cotton.[95] The principal word for "Way" in the theological sense is *mārga*, a derivative of *mṛg*, to "hunt" by following in the track of the pursued, as in Eckhart's "following the spoor of her quarry, Christ." The Vedic and Christian Eucharist alike preserve the values of cannibalism. If, in fact, we should subtract from the most spiritual and intellectual forms of religious doctrine all that is in the last analysis of prehistoric origin, if we decide to reject "participation," and to think not really but only logically (to reverse the Scholastic "logically but not really"), very little will be left of what we are accustomed to think of as spiritual values. If we entertain such values still, it is because we have inherited them, not because we have created them. Whoever will study the Urmythos dispassionately and apart from wishful thinking in terms of "progress," will be convinced that we cannot separate the content of the myth from the fact of its first enunciation, and will realize that it is only with difficulty that we, from our narrower point of view,[96] can raise ourselves to the level of reference of the prehistoric "myth-making age."[97]

NOTES

[1] *Uttara*, cf. English "utter," is not only "uppermost," "highest," "superior," "last," but means also "northern," and in this connection it may be remarked that the *devayāna* is constantly described as a "northern" way. We are primarily concerned with a solar symbolism in the present article. But it must not be overlooked that the polar and solar symbolisms are almost inseparably combined in the Vedic tradition, and that this is inevitable in any universal tradition, not exclusively polar. The Axis Mundi is naturally thought of as vertical. This is only literally a north and south axis for an observer at the north pole, while for one at or near the equator, it is evidently the sun that is overhead. "Ce qu'il importe essentiellement de remarquer à cet égard est ceci: l'axe vertical, en tant que joignant les deux pôles, est évidemment un axe Nord-Sud; dans le passage du symbolisme polaire au symbolisme solaire, cet axe devra être en quelque sorte projeté sur le plan zodiacal, mais de façon de conserver une certaine correspondance, on pourrait même dire une

équivalence aussi exacte qu'il est possible, avec l'axe polaire primitif. . . . Les solstices sont véritablement ce qu'on peut appeler les pôles de l'année; et ces pôles du monde temporel, s'il est permis de s'exprimer ainsi, se substituent ici, en vertu d'une correspondance réelle et nullement arbitraire, aux pôles du monde spatial . . . et ainsi se trouvent reliées l'une à l'autre, aussi clairement que possible, les deux modalités, symboliques dont nous avons parlé" (René Guénon, "*La Sortie de la caverne,*" *Études traditionnelles*, XLIII, 1938, 149–150). In the same way our "polarity," although implying originally a north-south orientation, has a more general application to the correlation of any two opposite states, and "pole" is not merely "north pole" but also any upright "post." Ontologically there are, of course, three distinguishable polarities, (1) east-west, (2) north-south (these two with reference to the daily and yearly motion of the sun), and (3) axial (polar, in the primary sense, and as at the north pole). Of these three polarities, the connection of the first is with birth (hence in the *Agnicayana*, the Golden Person is laid down with his head to the East; cf. VS XIII.3, "The Brahman firstborn in the East, from the limit [*sīmatas*]"; see ŚB VII.4.114–18, and the corresponding Ait. Up. III.11–12, *sa etam eva sīmānaṃ vidāryaitayā dvārā prapadyata, saiṣā vidṛtir nāma dvāḥ,* "Cleaving that 'limit,' he proceeded by that door; the name of that door is the 'cleft' "). The connection of the second is with life (standing up, erection, *utthāna*; and motion, *caraṇā*), and that of the third is with sleep and death (one sleeps with the head to the north, the *devayāna* is a Northern Path, the Buddha's death bed is "headed north [*uttara-sīso*]," D II.137).

[2] It is not without significance in this connection that it is by the chimney that Santa Claus ascends and descends. I try to bring out a hermeneutic association of ideas by means of a play on words. The actual relations of *chemin* and *cheminée* are not quite so simple. Latin *caminus*, of Greek origin, is "hearth," as was also "chimney," when as yet no chimneys in our sense existed; at the same time Spanish and Italian *camino* are "way."

[3] *Śarkara* is, broadly speaking, "gravel," i.e., water-worn stones mixed with sand, but when the word is used in the dual or plural, or as a proper name, only "stone" can be meant. The occurrence of natural "ring-stones," of concretionary origin and with decayed centers, is not unknown, but it is quite likely that in practice holes were artificially bored, and only in theory "self-bored."

A baetylic origin of *śarkarāḥ*, of which a ritual use is made, is predicated in TS v.2.6.2 (perhaps the oldest text extant in which such stones are thought of as "thunder-bolts"); the variant in ŚB 1.2.4.1 assigns the same origin to arrows (*śara*), cf. Part II of Coomaraswamy, "The Symbolism of the Dome" [in this volume—ED.].

Ṣaḍviṃśa Brāhmaṇa 1.7.2 derives *śarkarā* (= *sikatā*) from the eyes of the Sādhya deities; *sattram āsīnānāṃ sādhyānāṃ devānām akṣasu śarkarā jajñire.* If these eyes are understood to be the sun and moon, this would not be inconsistent with the connection of Śarkara with Agnīṣomau as developed below, nor with that of perforated stones.

"Śarkara" can also be connected with the Self-perforates, and particularly the uppermost *svayamātṛṇṇā*, in another way. Śarkara is the name of the Ṛṣi

Śiśumāra (*śiśumāra,* "crocodile," and literally "killer of children" = *jhaṣa, makara, graha, grāha*) in a version of the Flood Legend referred to in PB VIII.6.8–9 and XIV.5.14–15; JB I.174, 175 and III.193; and AB II.19.3: "He ascended to heaven; he is that Śarkara who rises (*udeti*) there . . . whoever is a Comprehensor thereof, attains to heaven." Cf. TS IV.6.3.4, where the sun is a "spangled stone set in the midst of the sky" (*madhye divo nihitaṃ pṛṣṇir aśmā*), and ŚB IV.6.5.1, "The *graha,* indeed, is he who glows yonder," i.e., the sun. The Siṃsumārī (probably m. from -*mārin*) is identified with the Yajñayajñīya Sāman (in *Ṣaḍviṃsa Brāhmaṇa* 1.3.16, "the head of the sacrifice") and with Agni Vaiśvānara, and is described as lying in wait "on the sacrificer's path" or as "lurking with yawning jaws in the one-way, countercurrent" (*ekāyane śiṃsumārī pratīpaṃ vyādāya tiṣṭhati*), in which connection it should be remembered that "the way to heaven is countercurrent" (*pratīpam, pratikūlam,* Pali *paṭisoto, uddhaṃsoto;* cf. RV X.28.4, TS VII.5.7.4, PB and JB *passim,* S 1.136 f., etc., and especially TS VI.6.5.4, "If he should offer that to Varuṇa along the stream of the waters, Varuṇa would seize his offspring; he offers facing north on the south side against the stream of the waters, to prevent Varuṇa seizing his offspring"). [In ŚA III.5 the head bar (*śīrṣaṇya*) of the throne of Brahma, the Breath, is identified with the Sāmans Bhadra and Yajñayajñīya, while in actual construction the two ends of this bar are *makara* heads, presumably the auspicious and inauspicious aspects of the solar *śiṃsumāra* (*śiṃśumāra,* the "devourer of babes": the initiate and the deceased on their way to rebirth are "babes").

Varuṇa's "maw (*kākuda*)" into which the Seven Rivers flow (RV VIII.69.12) is the Sea as man's last "home (*astam*)," wherein the individual's "name and likeness" are dissolved (*bhidyate*), and it is called only the Sea (Praśna Up. VI.5 = Ud 55). For Varuṇa as Viśvāyus and Graha, cf. JUB IV.1.7; for Agnīṣomau as the jaws of death, see ŚB III.6.3.19.] So the Brahmans of yore used to wonder, "Who will today be delivered from (*atiproṣyata*) the Siṃsumārī's open jaws," the answer being that he who places the properly worded chant as a sop in his mouth, comes safely through (*tasyānnādyam eva mukhato'pidhāya svasty atyeti,* JB 1.174, where *tasya . . . mukhato . . . atyeti* = KU 1.11, *mṛtyu-mukhāt pramuktam*); cf. VS X.10, *avasta dandaśūkāḥ,* and ŚB V.4.1.1, *sarvān . . . mṛtyūn atimucyate . . . tasya jaraiva mṛtyur bhāvati*—the Sacrificer's ritual death and liberation prefiguring his ascent from the pyre when he literally "dies." The Yajñayajñīya as "head of the sacrifice" can be identified with Makha-Soma (-Vṛtra, etc.): cf. ŚB XIV.1.1 and XIV.1.2.17, etc., and also Coomaraswamy, "Angel and Titan," 1935, p. 318; for the "mouths" of Sóma-Prajāpati, cf. Kauṣ. Up. 11.9.6. The intention is, then, the same as in ŚB III.3.4.21, where "Agni and Soma (-Viṣṇu) have seized him who is initiated (and therefore an 'infant,' *garbha, śiśu*) . . . and is himself the offering: thus they have seized him between their jaws; and by the victim he now redeems himself"; "in it he sees himself" (TS VI.6.7.2), and "thus ransoming self by self, having become free of debt, he sacrifices" (KB XIII.3; cf. TS III.3.8). The sacrifice of self is represented by that of the victim, King Soma, who is always "slain" (TS VI.6.9.2, ŚB XIII.2.8.2, etc.), and thus the rite is performed as it was

in the beginning when the Devas "sacrificed with the sacrifice (*yajñena yaj-ñam ayajanta*, RV x.90.16)," and as in the Christian sacrifice (the Mass) where Christ is the victim, with whom the participant identifies himself (cf. Bede Frost, *The Meaning of Mass*, London, 1934, pp. 66–67).

It will not be overlooked that it is as a solar station that *śarkara* is translated to heaven (JB III.193), becoming in fact the constellation Capricorn. The contrasted aspects of the Janua Coeli (opened or shut, to admit or exclude, as in CU VIII.6.5 and Matt. 25:10–12) are in the Pythagorean tradition (see Guénon, "Le Symbolisme du zodiaque chez les Pythagoriciens," *Études tradition-nelles,* XLIII, 1938) the two separate gates of Capricorn and Cancer, of which the former corresponds to the Hindu *devayāna*, in which the passage of the Sun is achieved, and the latter to the *pitṛyāna*, by which there is no breaking out of the cosmos. These *yānas* or courses are, respectively, northern and southern, inasmuch as the apparent motion of the sun, which the sacrificer follows, is an ascent northward starting from Capricorn, and a descent southward starting from Cancer.

Thus *śarkara* appropriately designates the uppermost *svayamātṛnnā*, not only in its sense of "stone," but also in that of *graha*: the Sundoor is either the Gate of Life or the Jaws of Death, all depending on the Sacrificer's understanding, who if he thinks of himself as So-and-so, "thinking 'He is one, and I another,' is not a Comprehensor, but as it were a beast to be sacrificed to the gods" (BU 1.4.10). All "passages" (from one state of being to another) are in this sense "dangerous"; and there can be no doubt that the *makara* (= *śiṃśu-māra*) placed over doorways, and known in Java as *kāla-makara* (*kāla*, "Time," being one of the well-known names of Death) has a like significance; cf. J. Scheftelowitz, *Die Zeit als Schicksalsgottheit in der indischen und iranischen Religion*, Stuttgart, 1929. The *kāla-makara* head is called in India and Ceylon both "makara face (*makara vaktra*)" and the "lion's jaws (*siṃha-mukha*)," and it is noteworthy that in what is perhaps the earliest reference to this motif, KhA 172, the *sīha-mukha* is an "ornament at the side of the nave of the king's chariot," evidently as in the Chinese example, B. Laufer, *Jade* (Chicago, 1912), pl. XVI, fig. 1.

An author (I have mislaid the reference) describing a Phrygian gravestone of the second century A.D., remarks that the lion represented on it "als Hüter der Todestür im Bogen über der Tür erscheint," and that "als Sinnbild der Macht ist der Löwe wohl auch an Toren aufzufassen." It will not be overlooked that Christ, who says of himself that "I am the door," is the "Lion of Judah" as well as the "Sun of Men."

The Indian and universal theory of art assumes a mimesis of angelic prototypes. The king's palace, for example, reproduces the forms of the celestial city. A remarkable illustration of this is afforded by the palace-fortress of Sīhagiri in Ceylon, described as "hard of ascent for human beings (*durārohan ma-nussehi*, Mhv XXXIX.2; cf. the *dūrohana* of AB IV.21)." Here Kassapa constructed a "stairway in the form of a lion (*sīhākārena . . . nisseṇi-gehāni*) . . . and built a sightly and delightful royal palace like a second Alakamaṇda (Celestial City, D II.147, 170) and dwelt there like Kuvera" (*ibid.*, 3–5). The

main ascent must have led, in fact, through the jaws of the colossal brick and stucco lion, from which the fortress takes its name and of which portions are still extant (*Archaeological Survey of Ceylon, Annual Report*, 1898, p. 9, and *Cūḷavaṃsa*, tr. Wilhelm Geiger and C. M. Rickmers, 2 vols., Oxford, 1929, 1930, p. 42, n. 2). An assimilation of the palace-fortress to a divine prototype and of the ascent to a *Himmelfahrt* was manifestly intended.

The place and the nature of the crowning mask of a *makara toraṇa* (e.g., Coomaraswamy, *History of Indian and Indonesian Art*, 1927, fig. 225) are the same: the *toraṇa* functions, indeed, as the niche of an image, but it is *toraṇa* by name because the niche is essentially a portal and to be understood as part of the frontal aspect of the deity whose image fills the gateway. The back of the image is concealed, and generally left unfinished and relatively formless, not without sound metaphysical reasons. There can be no doubt of the similarity between this kind of figure and the radiate figures of Christ in Majesty (a complex conception, often connected with the psychostasis and Last Judgment) set over the portals of Romanesque cathedrals as if to say, "no man cometh to the Father but by me," and, "except ye be born again"; such are figures of the Sun of Men, who divides the sheep from the goats at the "parting of the ways." The figure above the portal prefigures that of the Pantakrator (Figure 20) which fills the circle of what is really the "eye" of the dome ("The central dome was reft by the stupendous frown of Christ Pantakrator, the sovereign judge," Robert Byron and David Talbot Rice, in *The Birth of Western Painting*, London, 1930, p. 81; Vincent of Beauvais speaks of Christ's *ferocitas*). The Way to the "eye" of the dome is horizontal (*tiryak*) until the altar, the navel of the earth, has been reached, and thereafter it is vertical (*ūrddhvam*); or to say the same in other words, the way into the Church prefigures the entrance into Heaven. In Muslim architecture the same principles are implied by the circular opening which, in very many cases, surmounts a niche or doorway.

The well-known Chinese "ogre mask," which appears in so many characteristic ways on the earliest Chinese bronzes, is certainly formally related to the "*makara* face" of the Indian tradition. It cannot but be recognized that the relation is one not only of form but also of significance, and that the designation *t'ao t'ieh*, meaning "glutton" (cf. Agni as *grasiṣṇu, kravyāt*, etc., and such texts as BU 1.2.1, *taṃ jātam abhivyādadāt*), although given by Chinese scholars to the "ogre mask" very long afterwards, was appropriately given (see also n. 78). A similar interpretation can be given of the devouring monsters of the Indonesian sword grips, which have been so brilliantly studied by R. Heine-Geldern; these, however, we should not so much attach to a particular legend, but rather see in them an illustration of the general principle that is reflected in such legends. In JISOA, V (1937) and in IPEK (1925), Heine-Geldern connects the forms of these sword grips, where a monster is devouring a human being, often a child, with the *Sutasoma Jātaka*, no. 537, in which a king Brahmadatta (alias Kalmāṣapāda) of Benares is the incarnation of a cannibal *yakkha*, and becomes a cannibal in this life until converted by his own son Sutasoma, the Bodhisattva. But this legend is itself only a pseudo-

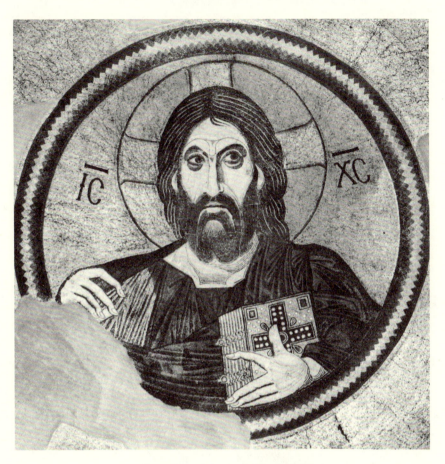

Figure 20. Christ Pantakrator, Daphni

historical and transparently euhemerized version of the Urmythos: Brahma-datta ("Theodore") is an incarnation of the Brahman-Yakṣa of the Vedas and Upaniṣads, and plays the part of Death (Mṛtyu, Māra, Yama) as Overlord of the World (represented as usual by "Benares"), until overcome by Sutasoma (as Māra is overcome by Gautama, Aṅgulimāla converted by the Buddha, etc.). The monster of the sword grips is essentially Death, and the reference only accidentally, if at all, to the *Jātaka*. The application of the "Death's head" to the handle of a weapon is as appropriate as that of the *siṃha-mukha* and *"t'ao t'ieh"* to the hub of a wheel, noted above and in n. 77. The "Death's head," whether in a leonine, aquiline, reptilian, or "glutton" form, is the Face of God who both "kills and makes alive." As Carl Hentze has rightly seen, "Die *T'ao-t'ieh*-Darstellungen verbinden Nacht- und Dunkelheitssymbole . . . mit Licht und Erneuerungssymbolen. . . . Der *T'ao-t'ieh* ist gerade derjenige Dunkelheitsdämon, der Licht und Leben aus sich entstehen lässt," thus com-bining lunar and solar characters (*Frühchinesische Bronzen- und Kulturdar-stellungen*, Antwerp, 1937, p. 85). This is the unity of Mitrāvaruṇau, Love and Death: "The Divine Dark is the inaccessible Light . . . all who enter are deemed worthy to know and see God" (Dionysius, *Ep. ad Dor. Diac.*); "And the deep of the darkness is as great as the habitation of the light; and they stand not one distant from the other, but together in one another" (Jacob Boehme, *Three Principles of the Divine Essence*, tr. John Sparrow, London, 1910, XIV.76).

The same relations can be studied in the Ravenna sacrophagus of Figure 21, in which the rectangle of the Cosmos is surmounted by the vault of the supra-solar Paradise, the Sun and Face of God being represented by the lion-mask (*siṃha-mukha*) placed at the center of the roof of the worlds below and base of the heavens above. We recognize in descending order Lion, Dove, and Cross, i.e., Sun, Spirit, Christ—or, in Sanskrit, Āditya, Vāyu, Agni. The Cross is supported in and rises from a vessel (*kumbha* of RV VII.33.13) which, insofar as this is specifically a representation of the Baptism, signifies Jordan (as was pointed out by J. Strzygowski), but also the Nether Waters impregnated by the descending ray, or, in other words, the Theotokos, Mother Earth. The more detailed our knowledge of Vedic ontology and its later iconog-raphy, the more obvious will be the parallels. Here, as regards the Theotokos, we can merely allude to the birth of Agni from the Waters, which is also that of the Prophet Vasiṣṭa in the lotus = vessel = (earth-) ship (RV VII.33.11–12 and 88.4), and to the frequent iconographic representation of Śrī Lakṣmī by the Brimming Vessel (*pūrṇa-kumbha*, etc.) in early Indian art. More immedi-ately pertinent to the present study is the fact that the Lion's open mouth is the Janua Coeli, the uppermost Self-perforate, from which the Spirit proceeds; and the mouth of the vessel below, the corresponding terrestrial Self-perforate, the birthplace of the Son, who is also himself the Lion and whom it is for us to follow in his return to the Father through the Lion's jaws. It is, of course, the point of intersection of the arms of the Cross that corresponds to the in-termediate Self-perforate of the Vedic altar.

Analogous forms occur in more remote areas. The handle of an Aztec sacri-

490

Figure 21. Sarcophagus from Ravenna

In the rectangle of the cosmos the Baptism of Christ is represented sym-
bolically by the dove (Spirit), Cross (Christ), and Vessel (Jordan); John and
the angel by affronted doves. The open mouth (the "strait gate") of the
Lion-mask of the Sun (the Sun of Men, Skr. *sūryo nṛn*), at the junction of this
rectangle with the vault of the Celestial Paradise above, is the passageway from
the one to the other state of being. The axial Descent of the Dove is the Sun's
spiration (*sūrya ātmā*, RV 1.115.1) and the Sun-kiss, as much as to say, "This
is my beloved son" (*ātmā tvam putra*, Kauṣ. Up. 11.11, cf. n. 15). The forms
below are repeated in principle above, where however we do not see the Spirit,
for "the Gale blows only on this side of the sky" (ŚB VIII.7.3.9–12).

ficial knife, for example, is composed of a Garuḍa having a man's head, in this context assuredly the victim's, in its open mouth (P. Radin, *The Story of the American Indian*, New York, 1927, facing p. 108). We say "Garuḍa" only descriptively and without begging the question of formal sources or influences; the representation is in any case of the Sunbird in its rapacious aspect. It would be farfetched to invoke the Jātaka here, and rash to take for granted a specifically Indian influence; reasonable, however, to explain the Indian (see "The Rape of a Nāgī" [in this volume—ED.]), Chinese (see Carl Hentze, *Objets rituels, croyances, et dieux de la Chine et de l'Amérique*, Antwerp, 1936), and American Indian (Radin, Hentze) formulae in accordance with the universal principle most explicitly stated in Vedic contexts, but not less clearly expressed by Eckhart (Pfeiffer ed., p. 399) when he says that the soul is swallowed up by God "als diu sunne die morgenroete in sich ziuhet, daz si ze nihte wirt." For in every sacrifice, a God is "fed"; or, in other words, the soul, or rather spirit, of the victim is returned to its source; in the last analysis, it is himself (*proprium*) that the sacrificer kills, and himself (*esse*) that he returns alive to Him that gave it. Hence the question asked in the Upaniṣads, "Which is the self? (*katama ātmā*, BU IV.3.7)," "Which one is it?" (MU II.1), and the corresponding Buddhist, "By which self (*ken'attanā*) does one attain the Brahma-world?" (Sn 508), i.e., whether by the "lesser" or the "greater" self of A I.240; cf. Luke 17:33, Matt. 16:25, John 12:25; Song of Songs 1:8 (*si ignoras te, egredere*); and also n. 58.

⁴ J. Eggeling uses this word in SBE, XLIII, 155, n. 8, but in ŚB VII.4.2.2, where *svayamātṛṇṇā* is explained, he renders correctly that it is so called because the Breath thus "bores itself (*svayam ātmānam ātṛntte*)." *Ātṛd* is used of "piercing the ears." In RV III.30.10, *alātṛṇaḥ*, derived by Yāska from *tṛd* (*Nirukta* VI.2), can best be understood if taken to be, in accordance with Sāyaṇa's first explanation of *alātṛṇasaḥ* in I.166.7, *anātṛṇaḥ, ātardana-rahitaḥ*, "not pierced." Here the Maruts are "not pierced" in the simple sense of "unwounded": in III.30.10, Vala, about to be opened up by Indra (cf. II.24.3, *abhinat valam . . . acakṣayat svar*) is "not yet pierced." Max Müller's explanations in SBE, XXXIII, 227–228, are implausible.

⁵ For the return of the spirit to its source.

⁶ *Suvarga* = *svarga*, heaven or light-world; and/or *su-varga*, goodly fellowship, from *vṛj* as in *vṛjana*, "fold, camping ground," etc.

⁷ *Ad visionem coeli coelesti. Anukhyātyai* corresponds to *dṛṣṭaye* in Īśā Up. 15 and parallel texts. In TS V.2.8.1, Keith's "to reveal" is correct, but in V.3.2.2, "for the lighting up of" misses the point. It is just as when one looks through the door of the Sadas or the Havirdhāna (ŚB IV.6.7.9–10), "freely one may look through the door, for the door is made by the gods."

⁸ *Samyānī* = *ākramaṇaḥ* in JUB 1.3.2, etc. In TS V.3.9, special bricks are laid down as stepping stones: ŚB regards this as inordinate, the Universal-Light bricks being all that is required. The symbolism of the cosmic ladder is unmistakable. Cf. Gen. 28:12, 17–18: "He dreamed, and behold a ladder set up on the earth, and the top of it reached to heaven: and behold the angels of God ascending and descending on it. . . . And he was afraid, and said, 'How dread-

ful is this place: this is none other but the house of God, and this is the gate of heaven. And Jacob rose up early in the morning, and took the stone, . . . and set it up for a pillar." [Cf. Figure 22.] Meister Eckhart cites this ladder as an example of the first class of parables (symbols), in which "every word, or virtually every word of the parable considered by itself has a symbolic meaning," and says that "this ladder signifies and expresses parabolically and in a likeness the one entire universe and its chief parts" (*Expositio sancti evangelii, secundum Johannem, 175*). Cf. also J. ben Gorion as cited by U. Holmberg, "Der Baum des Lebens," *Annales Academiae Scientiarum Fennicae*, XVI (1922–1923), 28, n. 2.

In DhA III.225 the Buddha is described as descending from the Trayastriṃśa heavens on a ladder (*sopāna*), his intention being to "tread the human path" (*manussapathaṃ gamissāmi*). From the top of this ladder can be seen upward into all the Brahmalokas, downward into the depths of hell, and round about the whole extent of the universe in the four directions. The foot of the ladder is at the gate of the city of Saṃkassa ("Place of manifestation"), where there is a shrine called "Immovable (*acalacetiya*)." This ladder is illustrated in reliefs at Bhārhut and Sāñcī.

D I.243 describes a ladder (*nisseṇi*) erected "as if at four crossroads" (sc. at the navel of the earth) and leading to an unseen palace (cf. the *nisseṇi-gehāni* at Sīhagiri described in n. 3). The reference (although intended contemptuously) is to such means of ascent as have been cited above from various Brāhmaṇa sources.

[9] Such a descent is told of in JUB III.29, where Uccaiśravas Kaupeyaya ("Clarion-voice, the Child of the Well"—i.e., of the *Fons Vitae*), who has "shaken off his bodies and found the Warden of the World," appears to his still-living nephew in a recognizable shape. This is not, of course, a "spiritualistic" manifestation but a resurrection, or *avataraṇa*. The nephew, indeed, can hardly believe that the uncle has appeared to him here on earth, since it is commonly understood that "when anyone manifests himself (*āvir bhavati*), the fact is that others [to whom he manifests] ascend to *his* world [not that he descends to theirs]." Uccaiśravas explains that it is as one that has found God that he is a "Mover at Will"; he can, therefore, assume the form once worn on earth as readily as any other.

[10] See Sir John Marshall, *Mohenjo-Daro and the Indus Civilization*, 3 vols. (London, 1931), I, 62, with further references (for ERE ii, read *Encyclopedia of Religion and Ethics*, xi), and Coomaraswamy, "The Darker Side of Dawn," 1935, n. 21. At Dabhoi a stone slab with a circular opening is used for ordeals: the stoutest man, if innocent, can pass through it; the guilty, however thin, cannot. For the Śatruñjaya stone see Forbes, *Ras Māla* (1878), p. 574, and for the Śrīguṇḍi stone at Malabar Point, which absolves from guilt, p. 576.

[11] The Universal Lights are laid down "in proper order" (*samyañcī*), so that Agni shines upward and the Sun glows downward, and the Gale blows between (athwart, *tiryan*) in the midspace (ŚB VIII.7.1.20). In RV x.85.2 the *vyāna* is the axis (*akṣa*) of the cosmic chariot—i.e., Axis Mundi. The *vyāna* (*vi-āna*) is so called both as being the distributive Breath whereby the Gale

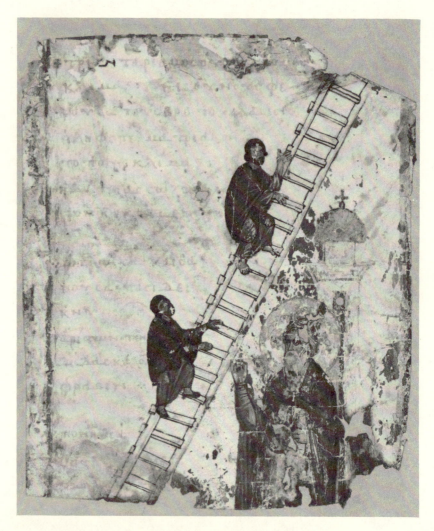

*Figure 22. The Heavenly Ladder, Byzantine, early 12th century
(from a Klimax MS)*

blows everywhere and with reference to omnipresence (*vibhava*), and disjunctively, inasmuch as it separates heaven and earth (which are as one beyond the Sun, "where no Gale blows" (ŚB VIII.7.3.9), and "where heaven and earth embrace" (JUB 1.5.5). The disjunctive function of the trans-spiration is, of course, the same as that of the Spirit when the latter is thought of as a bridge which not only connects but also separates heaven from earth, as in BU IV.4.22, *eṣa setur vidharaṇa eṣāṃ lokānām*, and similarly CU VIII.4.2; cf. Acts of John 99, "This cross, then, is that which fixed all things apart."

¹² This life-giving kiss is both a breathing and a shining, between which there is no distinction *in divinis*, but only logically. "Light is generation" (*jyotiḥ prajananam*, ŚB VIII.7.2.16–17; Witelo, *Liber de intelligentiis* IX, "Lux in omne vivente est principium motus et vitae"). A like conception is implied when Aditi is addressed as "O thou breathed on by Vivasvat" (*vivasvad-vāte*, TS IV.4.12). It is in this way that the "sole Saṃsārin" (Śaṅkara on *Vedānta Sūtra* 1.1.5) is universally born: "It is as the Breath that the Provident Spirit (*prajñātman*) grasps and erects the flesh" (Kauṣ. Up. III.3); "inasmuch as the Breath indwells the extended seed, so It takes birth" (*sambhavati*, JUB III.10.5); "it is by the rays (*raśmibhiḥ*) that all these offspring are imbued with the breaths-of-life" (*praṇeṣu abhihitaḥ*, ŚB 11.3.3.7). "The power of the soul, which is in the semen, through the spirit enclosed therein fashions the body" (*Sum. Theol.* III.32.1). "That divine Truth is the Light, and its expressions (*expressiones* = *sṛṣṭayaḥ*) with respect to things are, as it were, luminous rayings (*quasi luminosae irradiationes* = *raśmaya iva*), albeit inward (*licet intrinsicae* = *antar-nihitā api*), and which particularizations (*determinata* = *bhāgāḥ*) lead and point the way to that which is expressed" (*id quod exprimitur*, St. Bonaventura, *De scientia Christi* 3c, concl. 4, = *tatra nayanti yatra sarjaḥ*). Or, as Plotinus expresses it, "Under the theory of procession by powers, souls are described as rays" (Plotinus VI.4.3). "The Light is progenitive" (*jyotiḥ prajananam*, ŚB VIII.7.1.17); the many rays of the Sun are his sons (JUB 11.9.10); the pharaoh speaks of himself as "Thy child who came forth from the rays" (James H. Breasted, *Dawn of Conscience in Egypt*, New York, 1933, p. 291); in Navaho ritual, virgins are simply "non-sunlight-struck girls."

Cf. *Mathnawī* 1.3775 ff., "When the time comes for the embryo to receive the spirit, at that time the sun becomes its helper. This embryo is brought into movement by the sun, for the sun is quickly endowing it with spirit. . . . By which way did it become connected in the womb with the beauteous sun? By the hidden way that is remote from our sense-perception."

¹³ "And the Lord God formed man of the dust of the ground, and breathed into his nostrils the breath of life; and man became a living soul" (Gen. 2:7). See Coomaraswamy, "The Sunkiss," 1940. "It is the breath of life in the nostrils to behold thy rays" (Egyptian hymn to the Sun-god, Breasted, *Dawn of Conscience*, p. 291).

¹⁴ Primarily the Keeper or Herdsman (*gopa*) of the Worlds, Prajāpati in JUB III.2.10–11 = Agni in RV 1.164.31, *ā ca parā ca pathibiś carantaṃ bhuvaneṣv antaḥ*, to be considered with JUB III.37.3, *tad ye ca ha vā ime prāṇa amī ca*

raśmaya etāir ha vā eṣa etad ā ca parā ca pathibiś carati ("Now verily what these breaths here and those rays there are, it is by these 'paths that he comes and goes hitherwards and hence'"). For "ray" as "path" cf. JB 1.49.9, *ṛtūnām eko . . . raśminā pratyavetya*, "one of the Seasons having descended by means of a ray." Cf. "converse ascent by means of a ray" in MU vi.30 and JUB iii.37.3, where breaths and rays are paths. In Egyptian religion the Sun-god is also the "Valiant Herdsman," as in Christianity the "Sun of Man" is the "Good Shepherd."

[15] That is, as Sāyaṇa says, feels that he is *labdhātmaka*, has gotten a "self"; cf. Sāyaṇa on RV x.72.6, *susaṃrabdhaḥ = suṣṭhu labdhātmanaḥ*. *Labh* here in the common sense of "know" and "be aware of" = *vid* in BU 1.4.10, where it is "inasmuch as It knew Itself (*ātmānam evāvet*), that 'I am Brahman' (*ahaṃ brahmāsmi*, 'I am that I am'), It became the All." In the same way, whatever is quickened by the Breath can say "I am" such and such, in accordance with the extent of its knowledge, partial or total, of "itself," or the Spiritual Self; cf. BU 1.2.1, *ātmanvī syām*, where the Godhead assumes essence.

The Sunkiss is the archetype of the so-called sniff-kiss (see E. W. Hopkins, JAOS, XXVIII, 1908, 120–134). Of this kiss, which is quite distinct from the erotic kiss called the "joining of mouth to mouth" (BU vi.4.9), there is a description in Kauṣ. Up. ii.11.7; cf. ŚA iv.10, where "a father who has been abroad, on returning should kiss (*abhijighret*, v.l. *abhimṛṣet*, 'should touch' [*anugraha*, 'grace']) his son's head, saying 'Indeed, my son, thou art myself (*ātmā tvam putra*): live thou a hundred autumns long.' . . . Then he grasps (*gṛhṇāti*) him, saying 'Wherewith Prajāpati grasped (*paryagṛhṇāt*) his offspring for their weal (*ariṣṭyai*), therewith I grasp (*parigṛhṇāmi*) thee.' He 'grasps' (*gṛhṇāti*) his name. . . . Thrice he should kiss (*avajighret*) his head." "Wherewith Prajāpati grasped"—i.e., as above and Kauṣ. Up. iii.3, where it is the Breath (*prāṇa*), the Provident Spirit (*prajñātman*), that "grasps and establishes the body" (*śarīraṃ parigṛhya utthāpayati*) [cf. ŚB 1.6.3, where Indra grasps Vṛtra, limb to limb]. Thus AV xi.4.10–15 (summarized), "the Breath, the Gale, Prajāpati, Death, indwells (*anuvasati*; not 'clothes'—cf. RV viii.3.24, *ātmā pitus tanūr vāsaḥ*; AV xi.4.20, *pitā putraṃ pra viveśa*; AB vii.13, *jāyamā praviśati . . . tasyām punar navo bhūtva jāyate*, etc.) his offspring, as a father a dear son. Within the womb he both expires (*apānati = mriyate* in JUB iii.9.1) and comes to life (*prāṇati = carati* in AV x.8.13 and xi.4.20). When thou, O Breath, quickenest (*jinvasyatha*—i.e., makest to be a *jīva*, 'living soul,' as in Genesis 2:7 [cf. MU ii.6]), then is He born again" (viz. the Person, sole Saṃsārin, Agni as in RV viii.43.9, *agne . . . garbhe saṃjāyase punaḥ*; the Sun in AV xiii.2.25, *sa yonim aiti sa ujāyate punaḥ*). As Schiller also realized, "es ist der Geist der sich den Körper (baut) schafft" (*Wallenstein*, 2nd ed., rev., New York, 1901, iii.13).

The so-called sniff-kiss is a *salutatio* as distinct from an *osculatio*. It is either a communication of being or an acknowledgment of an essential identity (*ātmā tvam putra*, for example). It is rather a ritualistic gesture of blessing than an expression of personal feelings. The "holy kiss" or "kiss of charity"

of the New Testament and early Christianity may have been of this sort; at any rate, St. Cyril of Jerusalem ("Catechetical Lectures, Lecture XXIII: On the Mysteries, V. On the Sacred Liturgy and Communion," 3) says, "This kiss is the sign that our souls are united and that we banish all remembrance of injury," and if it is to this "union of souls" that Clement refers when he speaks of this kiss as a "mystery," the parallel with the Indian greeting would be close. Some trace of its "originally" salutary significance survives in the expression, "kiss the place to make it well." Closely related to this is the American Indian hunter's practice, when a bison has been killed, of smoking the ritual pipe (calumet) and directing the smoke (ordinarily blown toward the six directions of space) toward the muzzle of the slain animal in order to compensate for the taking of life by a gesture implying the gift of life. Analogous rites have been recognized among the Siberians, Ainus, and African Pygmies, and one may say with ŚB xiii.2.8.2 that the slayer of the victim "thereby lays the vital airs into it, and thus offering is made by him with this victim as a living one," in accordance with the principle enunciated in ŚB iii.8.2.4, "the food of the gods is living . . . and thus that food of the gods becomes truly alive, becomes immortal for the Immortals."

That the sni *i*-kiss, although a breathing upon and not an inhalation, involves a smelling of (*ghrā*, "to smell," as in JUB ii.3.9, *apānaḥ: surabhi ca hy enena jighrati durgandhi ca*; and in BU iii.2.2, *apānena hi gandhan jighrati*, where the meaning "exhalation" for *apāna* is assured by JUB iii.5.6, *pa ity evāpānyāt*, "He should simply breathe out saying '*pa*'"), is not a difficulty from the Indian and traditional point of view, according to which sense-perception depends upon an extension of the sense powers to their objects, rather than upon any reaction effected by the sense organs, which are merely the channels of perception and not themselves percipients. This depends, in the last analysis, on the doctrine (BU iii.7.23; MU ii.6d, etc.) that the sense-powers, as distinguished from the sense-organs, are those of the indwelling Spirit, whose perceptions are not determined, but only accompanied, by the physical and in themselves completely unintelligent reactions of the sense organs, which exist merely for the sake of their objects, as stated explicitly in KU iv.1 and MU ii.6. Hence it is not the sensations themselves that one should try to understand, but Him whose means of perception they are (Kauṣ. Up. iii.8).

[16] Identified with the Breath (TS vii.2.7.2, PB vi.10.5, ŚB viii.4.2.6, JUB iv.24, MU vi.1, etc.) and commonly also with Brahman and Ātman.

[17] Sāyaṇa adds that He who is the Inner Controller by means of this thread moves all things, as a puppet master moves his puppets. The outward man, the psycho-physical vehicle of the Spirit, has not *as such* any freedom, but this name and appearance are not his real being; he has only to know himself as he really is to be altogether free. The doctrine of the Inner Controller (*antaryāmin* = Gnostic ἡγεμών; cf. Scholastic "synteresis") is expounded at length in BU iii.7: "He is the unseen Seer, the unheard Hearer, the unthought Thinker, the uncomprehended Comprehensor, other than whom there is no seer, no hearer, no thinker, no comprehensor. He is your

spirit (*ātman*), the Inner Controller, the Immortal." Note that *yo antaro ya-mati* = Yama = Mṛtyu. *Ya enaṃ veda ... apa punar-mṛtyuṃ jayati, nainam mṛtyur āpnoti, mṛtyur asyātmā bhavati* (BU 1.2.7).

Plutarch describes the intellectual *daimon* of a man as a being floating in a higher world but connected by a cord with the soul below (vision of Ti-marchus, *De genio Socratis* 591D ff.). A Canadian Catholic once told me that she was taught by a priest that the soul is connected with God "as if by a rubber thread to a rubber ball."

[18] Hence at the end of the world there is a "severance of the wind-ropes" (*vraścanaṃ vāta-rajjūnām*, MU 1.4), and microcosmically, "They say of a man departed [from this life] that 'His limbs are unstrung (*vyasraṃsiṣatāsyāṅgā-ni*)'; for it is by the Gale, indeed, as thread, that they are tied together" (*samdṛbdhāni*, BU III.7.2), or that he has been "cut off" (ŚB x.5.2.16). This is also the "thread" that is spun by the Greek Fates and Scandinavian Norns (Past, Present, and Future); when the thread is cut, the man dies.

[19] Cf. *Tripura Rahasya*, tr. M. S. Venkataramaiah, 2nd ed. (Tiruvanna-malai, 1952), v.119: "This *Mr. Motion*, the friend of *Mr. Inconstant*, is most powerful and keeps them all alive. Though single, he multiplies himself, manifests as the city and the citizens, pervades them all, protects and holds them. Without him, they would all be scattered and lost like pearls without the string of the necklace. He is the bond between the inmates and myself; empowered by me, he serves in the city as the string in a necklace. If that city decays, he collects the inmates together, leads them to another and remains their master." Here the speaker, Hemalekhā, is clearly the voice of the *para-mātman*; Mr. Motion the *sūtrātman*, and Mr. Inconstant the *jīvātman*.

Unmistakable traces of the *sūtrātman* doctrine survive in Pāli Buddhist literature. Thus, in M II.17 (echoing ŚA XI.8, "Man is the jewel, breath the thread, food the knot," etc.), the body with its consciousness (the psycho-physical individuality) is compared to a transparent gem, and "even as a man with eyes to see needs only to handle it to see that 'this is such and such a gem (and strung) on such and such a thread,' even so have I taught my disciples the Way whereby to have such an understanding of the body and its con-sciousness"; in D II.13 the unborn Bodhisattva is visible in the womb, just as the colored thread on which a gem is strung can be seen within it; and in DhA III.224, where Moggallāna ascends to speak with the Buddha, then in the Trayastriṃśa heaven, "Diving into the earth right there, he willed that his ascent might be visible to the assembled multitude. Then he climbed up the center of Mt. Meru [*sineru-majjhena*; Bloomfield's 'side of' misses the point], in appearance like a thread of a yellow blanket strung through a gem, and the multitude beheld him." More often, such an ascent is represented as a levitation and breaking through the roof-plate of a building [a survival of which is found, for example, at J II.79 and IV.200, and Vin 1003, where, in order to escape from a deadly disease, the person wishing to secure health and life for himself has to make a hole in the roof or the wall and then run away]. In either case, of course, the miracle is primarily one of interior dis-position, and ascent from lower to higher levels of reference, the exercise of

such powers being always dependent on contemplation. In the *Sarabhanga Jātaka* (v.130), the Bodhisattva, "Keeper of the Light" (*jotipāla*), is a "target-cleaver" (*akkhaṇa-vedhin*, not without a side glance at *vedhin* in the epistemological sense of the word "penetrating"; cf. Vedic *vedhas* in this sense and Muṇḍ. Up. II.2.2–3, *viddhi*, the imperative here of *vyadh* but often of *vid*). Stationed in the middle of a stricken field, he attaches a scarlet thread to his arrow and shoots it so as to pierce (*vijjhitvā*) four plantain trees set up at the four corners of the field. The arrow passes through these four and a second time through the one that was first pierced (thus completing the round) and finally returns with the thread to his hand. This is called the "threading of the circle" (*cakka-viddham*). We have no doubt that the authors of these texts understood their ultimate significance, though it may well be that those who related them, like the scholars who read them today, did not. We agree with C.A.F. Rhys Davids (JRAS, 1937, p. 259) that the Buddha took the *ātman* doctrine for granted and that, while *ātman* used reflexively must be rendered by "self," it is unfortunate that in those contexts where the rendering "Self" has been customary, "we have not consistently and persistently used, not soul or self, but spirit" (*What Was the Original Gospel in "Buddhism"?*, London, 1938, p. 39; cf. also Coomaraswamy, "The Re-interpretation of Buddhism," 1939).

[20] Cousens' suggestion that the Indus Valley ring-stones may have been "threaded to form columns" (Marshall, *Mohenjo-Daro*, p. 61) is by no means altogether irrelevant, though it need not be taken to mean that pillars of actual buildings were thus constructed. Earthenware rings superimposed to form a columnar finial have been found at Paharpur (*Archaeological Survey of India, Annual Report*, II, 1934, pl. 53d). The very varied scale of the Indus Valley ring-stones is no objection in principle (they vary from half an inch to four feet in diameter), because symbolic constructions do not depend on scale for their significance; as, for example, in the case of miniature carts, which cannot be thought of as having been merely toys (cf. R. Forrer, "Les Chars cultuels préhistoriques et leurs survivances aux époques historiques," *Préhistoire*, I, 1932, 122 ff.), any more than the gigantic processional cars of today are toys. In any case, the ring-stones of our texts were thought of as threaded on a spiritual pole.

[21] See Oertel in JAOS, XVIII (1897), 26 ff., and Coomaraswamy, "The Darker Side of Dawn," 1935.

[22] It will be seen that in the Indian eschatology the "end of the world" is reached and the "last judgment" pronounced immediately; this appears to have been the doctrine taught by Christ himself, for in Matt. 24:44 we find the words "in such an hour that ye think not the Son of Man cometh" immediately followed by the parable of the wise and foolish virgins in which the former are admitted by a door that is shut upon the latter.

[23] *Nirodha* here = *avarodhanaṃ divaḥ* (RV IX.113.8). This *nirodha* as "barrier" corresponds to the Islamic *jidāriyya*, or "murity," which separates the inward aspect (*al-bāṭin, al-'amā* = Skr. *avyakta, asat*, Para Brahman, Varuṇa) from the outward aspect (*al-ẓāhir, aḥadiyya* = Skr. *sat, satyam, mahat*, Apara

Brahman, Mitra) of the Supreme Identity (*al-dhāt* = Skr. *tad ekam, sadasat, vyaktāvyakta*, Brahman, Mitrāvaruṇau). It is the line of demarcation between the hidden (*guhā*) and manifested (*āvis*) operations (*vrata*). It is the "wall of Paradise by which none can pass but those who have overcome the Reason that guards its gate" (Nicholas of Cusa, *De visione Dei* IX, where "Reason" = *satyam* in JUB 1.5.3, *satyam haiṣā devatā*). As cited above, CU VIII.6.5 corresponds to Matt. 25:10, "they that were ready went in with him to the marriage: and the door was shut."

It may be observed that in Buddhist contexts, e.g., A II.48–50, *loka-nirodho* (= *lokānta*) is the "end of the world" as much in a temporal as in a spatial sense: "there is no surcease from sorrow until world's end is reached"; and it is emphasized that world's end is "within you." The end is similarly temporal in JUB IV.15.1, "I will tell thee that, which knowing, ye perceive the door of the world of heaven (*svargasya lokasya dvāram* = *januam coeli*), and having successfully come unhurt to the end of the Year, shall speedily attain the world of heaven" (*esyathe*, "shall speedily attain," from *is*, suggests the motion of the Aśvins, compared to arrows in RV 1.184.3, and the symbolism of Muṇḍ. Up. II.2.3–4, where the Brahman is the target "to be penetrated" and one makes of oneself the arrow); cf. ŚB X.2.6.4, "it is thus the immortal that lies beyond this" (Year, temporal existence, the 101-fold Prajāpati of ŚB X.1). The connection of the "end of the Year" with the "door of heaven" will be evident from the Capricorn symbolism described in n. 3. Cf. ŚB 1.6.1.19, "He alone gains the Year who knows its doors; for what were he to do with a house who cannot find his way inside? . . . Spring is a door and likewise Winter is a door thereof. This same Year the sacrificer enters as the World of Heaven." Consider also JUB 1.35, where the "two ends of the Year are Winter and Spring": just as these are united, making the Year "endless" or "infinite" (*ananta*), so is the "Endless Chant." The separation of these "ends" is the sundering of Heaven from Earth, the Sun from the Moon, Essence from Nature; their reunion, effected by the Comprehensor, the perfect circle of eternity ("die Schlange, die sich in den eigenen Schwanz beisst, stellt den Äeon dar").

[24] And is thus in Rūmī's sense "a dead man living" (*Mathnawī* VI.744, "Walking on the earth, like living men; yet is he dead and his spirit gone to heaven"); Skr. *jīvanmukta*. So also Eckhart, "The kingdom of heaven is for none but the thoroughly dead. . . . These are the blessed dead, dead and buried in the Godhead." For initiation as a death, cf. JUB III.7–9, as well as ŚB III.8.1.2, *yo dīkṣate tasya riricāna ivātmā bhavati*. The *samnyāsin*, or "truly poor man," is one for whom the funeral rites have already been performed (*Sannyāsa Upanishad* 1; cf. Paul Deussen, *Philosophy of the Upanishads*, tr. A. S. Geden, Edinburgh, 1906, p. 375; René Guénon, "De la mort initiatique," *Le Voile d'Isis*, XXXIX, 1934; *The Great Liberation*, tr. Arthur Avalon, 2nd ed., Madras, 1927, p. LXXXV; Hermes, II, 370; Firmicus Maternus, describing pagan mysteries, says that the initiand is spoken of as *homo moriturus*—see van der Leeuw, "The ΣΥΜΒΟΛΑ in Firmicus Maternus," *Egyptian Religion*, I, 1933, 67). It need hardly be said that no one who

still is anyone is qualified to pass through the midst of the Sun (JUB iii.14.1–5 and *Mathnawī* 1.3055 ff.). This "ableness" (*arhaṇa*), as the author of the *Cloud of Unknowing* expresses it, "is nought else but a strong and deep ghostly sorrow . . . and well were him that might win to this sorrow. All men have matter of sorrow; but most specially he feeleth matter of sorrow, that wotteth and feeleth that he is" (ch. 44). This "sorrow" corresponds to Skr. *vairāgya*, and "ableness" corresponds both to *arhaṇa* and to the root meaning of *dīkṣā* ("initiation"), from *dakṣ*, "to be able," the *dīkṣita* being precisely "enabled" (cf. the series of articles on initiation by René Guénon in *Études traditionelles*, XL, XLI, 1935, 1936).

On the other hand, we have seen, and for excellent reasons, that the Sacrificer, who departs from himself and during the ritual operation is no longer himself, by name So-and-so, actually says, when he redescends to earth and finds it inconvenient to say in so many words that this is a descent from reality to unreality, "Now am I again 'myself,' " and thus, as we might express it, returns from the supersensual to his senses, the world of "common sense."

[25] Cf. Coomaraswamy, "*Kha* and Other Words Denoting 'Zero' in Connection With the Metaphysics of Space" [in Vol. 2 of this selection—ED.]. *Tṛd*, "to pierce or perforate" (the root of *svayamātṛṇṇā*), is commonly found with *kha*, e.g., KU iv.1, *parāñci khāni vyatṛṇat svayambhūḥ*, "The Self-existent pierced the holes outwards," i.e. (*adhidaivatam*) opened the doors of perception by which the transcendent Spirit surveys all things from without and at the same time (*adhyātman*) opened the doors of the senses by which the immanent spirit looks forth. It is in the former sense that It surveys all things through the eagle Eye of the Sun (RV *passim*). These two (the *prajñātman* of the solar Eye and *antarātman* that looks out through the microcosmic eye) being one for the Vedas, as for Eckhart, it is not "I" that see, but "God's Eye that sees in me." There is no other seer than He (JUB 1.28.8, BU iii.7.23), just as there is no other agent (JUB 1.5.2 and iv.12.2, BG *passim*), no other transmigrant except the Lord (Śaṅkara on *Vedanta Sūtra* 1.1.5).

The *khāni* are likewise the floodgates through which the imprisoned waters are let run free, as in RV ii.15.3, *khāny atṛṇaḥ nadīnām*, "opened the sluices of the streams," and vii.82.3, *anu apāṃ khāny atṛntam*, "Ye, Indrāvaruṇā, have pierced the sluices of the waters."

In Plato, *Republic* x.614 ff., there are two holes, εἰς τόπον τινὰ δαιμόνιον, and two on earth below, all of which are called χάσματα, the etymological equivalent of *khāni*. Of the two above, one on the right is for the entry and ascent of the righteous, and one on the left for the exit and descent of the unrighteous; the latter corresponds to the jaws of Āmmit in the Egyptian and those of Hell in the Christian Judgments, and to the unfavorable aspect of the Śiṃśumāra-graha in the Indian. The two openings on earth from which the unrighteous from (Hell) below and the righteous from (Heaven) above are reborn may be compared to the *gārhapatya* and *āhavanīya* hearths, by which one is born respectively of the flesh and of the spirit. It is noteworthy that the passage of the former is an ordeal; only those whose sins have been purged

below can come forth, while the most evil tyrants are kept below (cf. the Dabhoi ring-stone used for ordeals, as mentioned in a previous note). Cf. also the interpretation of Numenius, cited by Émile Bréhier, *La Philosophie de Plotin* (Paris, 1928), p. 28, as follows: "Le lieu de jugement devient le centre du monde; le ciel platonicien devient la sphère des fixes; le 'lieu souterrain' où sont punies les âmes, ce sont les planètes; la 'bouche du ciel' par laquelle les âmes descendront à la naissance, est le tropique de Cancer; et c'est par le Capricorne qu'elles remontent." Capricorn is significant here in connection with what has been said above regarding the Śiṃśumāra, the ultimate reference being, no doubt, to the Sun in Capricorn. Finally, it may be remarked that the rebirth is thought of as taking place at the commencement of an aeon, as follows from the "thousand years" that intervenes between the death and rebirth of the individual principles. See further René Guénon, "Les Portes solsticiales" and "Le Symbolisme solsticial de Janus," *Études traditionelles* XLIII (1938), 180–185 and 273–277.

[26] RV VIII.91.7, *khe rathasya khe'nasah khe yugasya.*

[27] *Mathnawī* VI.1203, "The veil before the face of the Sun, what is it but excess of brilliance and intensity of splendor?" The multiplicity of the rays conceals the unity of their source.

[28] RV x.16.3, *sūryaṃ cakṣur gacchatu, vātam ātmā*; x.92.13, *ātmānaṃ vasyo abhi vātam arcata*; x.168.4, *ātmā devānām . . . tasmi vātayā haviṣa vidhema*; BU v.10–11, *yadā vai puruṣo'smāl lokāt praiti sa vāyum āgacchati, tasmai sa tatra vijihīte yathā-cakrasya khaṃ, tena sa ūrdhvam ākramate ādityam āgacchati . . . paramaṃ haiva lokaṃ jayati . . . ya evaṃ veda.* All this is implied also in the "ascent after Agni" (*agner anvārohah,* TS v.6.8.1), for *yadā vā agnir udvāyati vāyum apyeti.*

A Vikarṇī brick representing the Gale is laid down with the last and uppermost Self-perforate and immediately north of it, for the Gale "blows only on this side of the Sky" (ŚB VIII.7.3.9–12). That the Gale of the Spirit, which "goeth as it listeth" (*yathā vaśaṃ carati,* RV x.168.4), "never sets" (*nimlocantīhānya devatā na vāyuḥ*) "nor ever goeth 'home'" (*anastam itā devatā yad vāyuḥ,* BU 1.5.22), just as "Death does not die" (ŚB x.5.2.3, *mṛtyur na mriyate*), is whereby He is "the one whole Godhead" (*ekā ha vāva kṛtsna devatā*), and that He never "goeth" home is because He *is* the "home" to which all other Persons of the deity return (*sa haiso' staṃ nāma . . . tam etam evāpītaḥ,* JUB III.1.1–11). "Whence the Sun arises, and where he goeth home (*astaṃ yatra ca gacchati*) . . . beyond that nonesoever goes" (*na atyeti,* AV x.8.16, KU IV.9; cf. M II.39, etc., *nāparam itthatāyāti*); "From the Breath he rises, verily, and in the Breath he goeth home" (*prāṇe' stam eti,* BU 1.5.23, *prāṇa* corresponding to *vāyu* in 1.5.22). "Verily, when one finds a ground in that invisible, despirated, homeless (*anilāyana*) [non-being of the Godhead], he has passed beyond all fears" (TU II.7). It is in the same sense that "the Red Bird has no nest" (RV x.55.6) and that "the Son of Man hath not where to lay his head" (Luke 9:58), being himself *our* bed and pillow. To JUB III.1.1, *ekā ha vāva kṛtsna devatā,* corresponds BU 1.4.7, where insofar as the Brahman is designated by what are "merely the names of his actions (*karma-*

nāmāny eva)," he is "incomplete" (*akṛtsna*), and "one should worship Him as 'Spirit' only (*ātmety evōpasīta*), wherein verily all these are unified" (*ekaṁ bhavanti*—i.e., *tad ekaṁ*, as in RV x.129.2): "God is a Spirit: and they that worship Him must worship Him in spirit and in truth" (John 4:24).

With respect to the deceased Comprehensor, Sn 1175–1176 asks, "Has he 'gone home,' or is he no more?" and answers "He who thus 'goes home' is without measure (*na pamāṇam atthi*). There is nothing by which he can be named. This unification of all qualities (*sabbesu dhammesu samūhatesu*) involves the unification of all wordways (*samūhatā vādapathā pi sabbe*)." "Just as a spark blown away by the wind 'goes home' (*atthaṁ paleti*) and is inconnumerable (*na upeti saṅkham*), so the Sage, released from a name and a body, 'goes home' and is inconnumerable" (Sn 1074).

[29] Whereas Oertel's rendering assumes in this sentence *vā . . . vā . . . vai*, ours is based on *vai* throughout. *Vyūhati* here is "disperses" in the sense of "does away with," not as in *vyūha* in the sense of "distributor, emanation, manifestation."

[30] That immortality lies beyond the Sun is regular; the second part of the sentence is not altogether clear to me. Cf. BG ii.28, "Beings are unmanifested in origin, manifest in their middle state, unmanifest again in their dissolution." All that is logically "knowable" lies within the cosmos, between the limits of heaven and earth; what lies beneath and what lies beyond are equally inexplicit (*anirukta*). All within the cosmos is in the power of Death, all creatures are his food. The atmosphere is the abode of creatures (*antarikṣāyatanāḥ paśavaḥ*, ŚB viii.3.1.12), but has no "place" of its own as if it were one of these. All that is external to the cosmos is continuous and immortal; whether we think of an indefinite "below" or an infinite "above" or of nether and upper waters, these are only our logical distinctions, invalid for the Supreme Identity, circumambient and interpenetrant, "manifested and unmanifested" (*vyaktāvyakta*).

[31] Cf. JUB 1.5, where the Sacrificer who has ascended these worlds, as one would climb a tree by steps (JUB 1.3), is accepted by the Sun, who is the Truth inasmuch as he, the Sacrificer, tells him truth and thus invokes the Truth. The identification of the Sun with Truth or Real Being (*satyam*) recurs throughout the tradition (RV x.121.9 and x.139.3, TS v.1.8.9, ŚB iv.2.1.26 and v.3.3.8, Muṇḍ. Up. 1.2.13 and iii.1.5–6, etc.). This Truth, which must be literally penetrated (*veddhavyam*, hence *vedhas*, "penetrating"; in many texts, the equivocation *viddhi*, imperative equally of *vid*, "to know," and of *vyadh*, "to pierce or penetrate," is very significant), is the outward aspect of the Sun and the same as his disk, light, or rays, as is clearly seen in BU 1.6.3, where *satyena channam* corresponds to *raśmibhis saṁchannam* in JUB 1.3.6. It is through the Sun, the Truth, that whoever would "win beyond the Sun" (CU ii.10.5, *paramād adityāj jayati* = BU iii.3.2, *apa punar mṛtyuṁ jayati ya evaṁ veda*) must find his way. All this is as in Christianity, where Christ, the Sun of men, is "the way [*marga, satyam, prāṇa*], the truth, and the life: no man cometh unto the Father, but by me" (John 14:6), and "the door: by me if any man enter in, he shall be saved" (John 10:9; cf. *sūrya-*

dvāra, mukti-drāva); and as in Shaman theology where, just as in Vedic climbing rites, a tree is set up in connection with a fire altar, and "this birch symbolizes the 'Door-god' (*udeśi-burchan*) who opens the entrance to heaven for the Shaman" (Holmberg, "Der Baum des Lebens," p. 28; cf. pp. 30, 142). Christ is in precisely this sense assuredly the "Door-god" (*per passionem Christi aperta est nobis janua regni caelestis, Sum. Theol.* III.49.5c; cf. Micah 2:13, "He who opens the breach will go up before them," etc.); as is Agni ("Agni rose aloft touching the sky: he opened the door of the world of heaven . . . him he lets pass who is a Comprehensor thereof," and "Were the Sacrificer not to ascend after him, he would be shut out from the world of heaven" (AB III.42 and TS v.6.8.1); or Viṣṇu ("Viṣṇu, indeed, is the Devas' Janitor; He opens that door for the sacrificer," AB 1.30). Similarly, Heimdallr, the Sun ("his teeth were of gold, his horse hight Gulltoppr") who, in the *Prose Edda* 27, "abideth in the place hight Himinbiörg by Bifraust [Asa-bridge], he is warder of the gods, and sitteth there at heaven's end to keep the bridge against the Hillogres; he needeth less sleep than a bird . . ." (cf. George Webbe Dasent, tr., *The Prose or Younger Edda*, London and Stockholm, 1842). Cf. *Bokhāri* LXXXI.48, "The bridge that is set between Paradise and Hell. It is there that men pay the price of their misdeeds. . . . When they have settled their account and are purified, they are allowed to enter Paradise."

Note that *channa*, cited above from BU 1.6.3, is also "thatched" and "thatch." It is clear from UdA 56, *tasmā channaṃ vivaretha*, "So open up the thatch," that the Buddha's constant epithet *vivata-chadda* means "whose roof is opened up"—i.e., for whom the way out of the worlds is open; cf. J 1.76 [and Dh 154], *gahakūṭaṃ visaṅkhitam*, "the roof-plate shattered"; Sn 19, *vivaṭā kuṭi, nibbuto gini*, "the hut is opened up, the fire slaked" [*vivaṭa chadda*, Sn 1003]; and KU 11.13, "An open house (*vivṛtaṃ sadma*), methinks, is Naciketas." ["The roof of the house is, as it were, a veil over the sun's beauty. Make haste to demolish the roof with the mattock of divine love" (Rūmī, *Dīvān*, Nicholson's commentary, p. 218).] On the Buddhist *arhat* "breaking through the roof," see also "The Symbolism of the Dome" [in this volume—ED.].

With *veddhavyam* and *viddhi*, cited above from Muṇḍ. Up. 1.2, cf. Ud 9, *yadā ca attan'āvedi . . . pamuccati*, Woodward's rendering of *āvedi* being "hath pierced (unto the truth)," where, however, I would omit the "unto."

[32] *Vihīyete*, "are opened up," from *vihā*, as in RV v.78.5 *vijihīṣva*, "be opened up"; AV XII.1.48, *vijihīte*, "opens itself" (Whitney); and BU v.10, *ādityam āgacchati, tasmai sa tatra vijihīte yathā lambarasya kham*, "he reaches the Sun, it opens out for him there like the hole of a drum." Keith's rendering of *vihīyete* in AĀ III.2.4 by "are separated" is indeed "not very logical." "The fissure of the moon typifies nothing else but renunciation of the external for the internal" (*Dabistān*, III, 201, quoted in Rūmī, *Dīvān*, Nicholson's commentary, p. 224).

"Are opened up" because the Sundoor is normally "closed"—e.g., JUB 1.3.6, *saṃchannam*; Īśā Up. 15, *apihitam*. In JUB III.21.3, the Sun is said to "close the opening (*devānāṃ bilam apyadhāḥ*)," which "opening" is another designation of the World-door, as in CU III.15.1, where the "opening atop of

the World-chest is the sky (*dyaur asyottaraṃ bilam*)"—the "sky," that is, as represented in the construction of the Fire Altar by the uppermost Self-perforate (ŚB viii.7.1.17, *dyaur vā'uttamā svayamātṛṇṇā*). With the symbolism of the world as a box or chest in CU iii.15, cf. W. R. Lethaby, *Architecture, Mysticism and Myth* (New York, 1892), p. 13, "this vast box whose lid is the sky."

[33] "When one is about to go forth (*utkramiṣyan bhavati*) he sees that Orb quite clean (*śuddham*), nor do its rays any more reach him" (BU v.5.2); cf. *vimalo hoti sūryo* as an omen of future Buddhahood in J 1.18. Many of the signs listed in AĀ iii.2.4 recur in ŚA viii.7 and xi.3, 4. These are not "old folklore ideas" in Keith's sense (AĀ, p. 251, n. 5), but the technical language of the *sūtrātman* doctrine according to which, as Plotinus expresses it, "souls are described as rays" (Plotinus vi.4.3). Cf. Coomaraswamy, "The Nature of 'Folklore' and 'Popular Art,'" in *Why Exhibit Works of Art?*, 1943.

[34] Similarly in the Christian tradition: Ecclesiastes, *passim*; *Sum. Theol.* 1.103.5 *ad* 1, "These things are said to be 'under the sun' which are generated and corrupted," and iii. Supp., 91.1 *ad* 1, "The state of glory is not under the sun."

[35] The Sun, Prajāpati, "who slays and quickens" (*yo mārayati prāṇayati*, AV xiii.3.3, which hymn is closely related to RV iv.53.3). Similarly, in ŚB x.5.2.13, Death, the Person in the Solar Orb, who is the Breath, plants his feet in the heart and, when he withdraws them, the creature dies. The "feet" are the same as the "rays" of the Sun (*hṛdaye pādāv atihatau*, corresponding to MU vi.30, *ananta raśmayas dīpavad yaḥ sthito hṛdi*). Cf. BG xiii.16, *taj jñeyaṃ grasiṣṇu prabhaviṣṇu ca*; Deut. 32:39, "I kill, and I make alive"; similarly 1 Sam. 2:6 and ii Kings 5:7.

[36] In the Vedic tradition the primordial Yakṣa, the "one-fold," is the Brahman, and the tree the Brahma-*vṛkṣa*. The Buddha can still be called a Yakkha, and the Bodhi-*rukkha* in at least one passage (*Kāliṅgabodhi Jātaka*, J iv.228) is defined as the only kind of *cetiya* that is not in the last analysis a "groundless and fanciful" substitute for the Buddha's visible person as a recipient of offerings (*pūjanīya-ṭṭhāna*). For *Yakṣa* = Brahman see Coomaraswamy, "The Yakṣa of the Vedas and Upaniṣads," 1938. [Cf. Figure 23—ED.]

[37] For the forms of *bodhi-gharas* see Coomaraswamy, "Early Indian Architecture: I. Cities and City Gates, II. Bodhi-gharas," 1930. For similar representations of hypaethral *yakkha-cetiyas* see Coomaraswamy, "Yakṣas" [Pt. 1], 1928, pl. 20 on the lower left, and *Archaeological Survey of India, Annual Report*, 1928–1929, pl. xlixa; for Chinese examples see Figure 14.

[38] The ascent is to a marriage: as the commentator on TS vii.4.19p *te'agra vṛkṣasya rohataḥ* expresses it, *maithunam-artham-ekam . . . ārohataḥ*. As in Matt. 25:10, "they that were ready went in with him to the marriage," where "ready" corresponds to *arhati* in our texts. The true union prefigured by the rite is a nuptial fusion apart from the consciousness of "I" and "thou": "As a man embraced by a darling bride is conscious neither of a 'within' nor a 'without,' so the Person embraced by the Providential-spirit knows naught of

a 'within' nor a 'without' " (BU iv.3.21); "Prepare thyself as a bride to receive a bridegroom, that thou mayst be what I am and I what thou art" (Irenaeus, 1.13.3, quoting the Gnostic Markos; cf. F. R. Montgomery Hitchcock, tr., *The Treatise of Irenaeus of Lugdunum against the Heresies*, London, 1916); "The expressions 'this' and 'that' have no meaning of themselves. 'I' and 'thou' also are meaningless. *Thou* art the same as *he*. . . . Resignation from thinking, speaking, acting from oneself . . . is resurrection" (*Kalāmi Pīr*, vii.8 [ed. and tr. W. Iwanow, London, 1935]); "each is both" (Vidyāpati).

Figure 23. Solar Tree (aśvattha, Ficus religiosa),
with Sun-Disk and Guardian Dragons.

[39] We propose to treat in detail the doctrine of the "Bridge" later. [See W. Haftmann, "Die Bernwardsäule zu Hildesheim," *Zeitschrift für Kunstgeschichte*, viii (1939), 150–158.] We wish to say here only that although the rainbow can be regarded as a bridge (e.g., Bifraust in the Eddaic tradition), the Indian "Bridge of the Spirit," with Christian and other European parallels, is by no means the rainbow, but the Axis Mundi, also thought of as a ladder, or, to express this architecturally, by no means a rafter of the World-roof, but the king-post of the cosmic structure—"eam columnam a qua culmen sustentatur, quam Firstsul [elsewhere 'Irminsul'] vocant" (*Monumenta Germanica, leges* iii.308, cited by J. Strzygowski, *Early Church Art in Northern Europe*, New York, 1928, p. 85).

[40] For Agni's ascension, see AB iii.42 and TS v.6.8.1, cited in a previous note.

[41] RV iv.40.5, "The Gander seated in the Light, the Vasu whose seat is in the air, the Priest whose seat is at the altar, the Guest whose seat is in the house," referring to forms of Agni and the Sun. The Gander is regularly the Sunbird, with particular reference to his movement in the worlds, who plunges even into the waters and again rises aloft: "To and from the outer hovers the Gander . . . the Gander unique in the midst of the world" (Śvet. Up. iii.18 and vi.15); "the Golden Bird indwelling heart and Sun" (MU vi.34); "the Golden Person" of BU iv.3.11, at the same time *Oiseau-soleil et oiseau-âme*.

[42] In the same connection, "Just as men set sail on the ocean, so they set

sail who perform a year or a twelve-day rite; just as men desiring to reach the other shore mount a ship well found, so do they mount the Triṣṭubhs [chants]."

[43] "Feet," both as metrical units or, rather, quarter verses, and as "steps."

[44] As in PB XVIII.10.10, "Just as he would descend holding on to branch after branch, so thereby he descends to this world, to obtain a support therein."

[45] PB IX.1.35, "Then they made the Sun their goal (kāṣṭhām) and ran a race" (viz. in the beginning; it is this race that is imitated in the rite). KU III.11, "Beyond the Person there is no more, that is the goal, the last step (sā kāṣṭhā sā parā gatiḥ)" = Eckhart, "On reaching God all progress ends." Kāṣṭhā (like sīmā, as cited in n. 1) is "terminus" in the designation Jupiter Terminus. In the same way Ra or Re, the name of the Egyptian Sungod (whose symbol is a post) is literally "End." On kāṣṭhā see Coomaraswamy, "Notes on the Kaṭha Upaniṣad," 1938, p. 107, n. 2 [see JUB 1.10.9, sky-supporting sthūṇa, and RV x.5.6, ciyor skambham pathaṃ visarge].

[46] "When there is dementation, that is the last step" (MU VI.34, yadā amanībhāyaṃ, tadā tat paraṃ padam); Eckhart, "This knowledge dements the mind" (Evans ed., I, 370). And just as the Sacrificer, not wishing to die prematurely, makes due provision for a converse descent from the height of truth that has been attained, so he is careful not to let go of his "mind" beyond recall. He looks at the victim, which is by symbolic intention himself, and that he can do so is proof that he is still "alive," for "He who cannot see himself would be dead . . . he should look at it, for in it he sees himself. . . . He whose mind has departed should look at (the victim, saying), 'That mind of mine which hath gone away, or which hath gone elsewhere, by means of King Soma, we keep within us'; verily (thus) he keeps his mind in himself, his mind has not departed" (TS VI.6.7.2). The cited text, "That mind of mine, etc.," summarizes the content of RV x.57–58 and its application in TS explains this content.

[47] Similarly, "metaphysically [i.e., in a manner disguised] they employ the anuṣṭubh, and that is, verily, Prajāpati [cf. PB IV.5.7 and AB III.13]: if they literally employed the anuṣṭubh, they would go unto Prajāpati," PB IV.8.9; i.e., as Sāyaṇa explains, would attain prajāpateḥ sāyujam, which is indeed their "last end," but an end which they do not propose to reach prematurely. The distinction between the sacrificial and the actual death of the sacrificer corresponds to that of nibbāna from parinibbāna in Buddhism.

[48] This principle, so often enunciated in the Brāhmaṇas, explains why it is that the Sacrificer, although desiring to go to heaven, does not think of doing so until the natural term of life has been reached, and similarly explains the traditional prohibition of suicide. The Brāhmaṇa formula recurs in the same words in the Kalāmi Pīr (W. Iwanow, ed.), "A hundred in this world in the next life will become a thousand."

[49] "No one becomes immortal with the body" (ŚB x.4.3.9; cf. JUB III.38.10). In JUB III.29–30, Uccaiśravas Kaupayeya, who "has found the Keeper of that world" (tasya lokasya goptāram; cf. III.37.2, prāṇo vai gopaḥ, and III.38.3, prāṇo vai brahma) cannot be taken hold of, for "a Brahman who was a

Comprehensor of the Chant sang a Mass (*udgītha*) for me with the Chant, by means of the 'Incorporeal Chant' he shook off my bodies (*śarīrāṇy adhunot*)." One should employ as a chanter only one who is thus a Comprehensor (*evaṃvit*, JUB III.14.12). In place of "shaking off," one can say either "cuts off" (PB IV.9.20–22, here "part by part," as in JUB III.39.1), or "redeems" (*spṛṇvate*, JB II.374).

[50] *Padavī* = *padanīya* in BU 1.4.7, in accordance with the well-known parable of the tracking of the Hidden Light by its spoor (*vestigium pedis*).

[51] *Dvāra-vivaraḥ*. The door that was opened by Agni (*dvāram apāvṛṇot*, AB III.42), by the Buddha (*aparuta tesaṃ amatassa dvārā*, D II.33, etc.), by the Christ (*per passionem Christi aperta est nobis janua regni caelestis*, as cited above), and which must be opened by Everyman ascending after them but is "shut" for those who have not trimmed their lamps (Matt. 25:7–12)—i.e., the light of the Spirit in the heart (RV IV.58.11 and VI.9.6; TS V.7.9; CU VIII.3.3; MU VI.30, *ananta raśmayas tasya dīpavadyaḥ sthito hṛdi*; BU IV.3.6, *ātmaivāsya jyotir bhavati*, etc.), as also implied in D II.100, "Be ye such as have the Spirit for their lamp . . . such as have the Truth for their lamp" (*attadīpā viharatha . . . dhammadīpā*).

[52] Like *kaṇṇikā-maṇḍalaṃ bhinditvā*, DhA III.66, and *pāsāda-kaṇṇikam dvidhā katvā*, J III.472 = *pandens*, as in Micah 2:13. For a fuller account of the departure of Buddhist *arhats* by way of the *kaṇṇikā*, or "roof plate," see Coomaraswamy, "The Symbolism of the Dome" [in this volume—ED.].

[53] *Kṛtakṛtyaḥ*, here and elsewhere, like *kataṃ karaṇīyam* in Buddhist texts, is "having reduced all potentiality to act." Cf. *kṛtyā* as "potentiality" regarded as a coil to be rid of, RV x.85.28.

[54] "By that"—i.e., by that one of the seven rays of the Sun which is called the "seventh and best"; see "The Symbolism of the Dome."

[55] World's end, end of the road, end of the Year, etc., and Heaven's end (= beginning, if considered from below). For example, JUB 1.5.5, *divo'ntaḥ: tad ime dyāvapṛthivī saṃśliṣyataḥ*; IV.15.4, *svargasya lokasya dvāram anuprajñāyānārtas svasti saṃvatsarasyo'dṛśaṃ gatvā, svargaṃ lokam āyan*; KU III.9, *adhvanaḥ pāraṃ . . . viṣṇoh paramaṃ padam*, where there is the Well at the World's end, RV 1.154.4, *viṣṇoh pade pade parame madhva utsam*, which never fails; RV VIII.7.16, *utsam duhantoakṣitam*, Varuṇa's place where the Rivers of Life arise; RV VIII.41.2, *sindūnām upodaye*, the source of the Sarasvatī (JB III.124, *sarasvatyai śaiśavam* = *hrada* in ŚB IV.1.5.12), in which Cyavāna is rejuvenated.

The expression "World's end" and its import survive in Buddhism, vividly in A II.48–49 (S 1.61–62, a version of the Rohita story of AB VII.15): "There is no release from sorrow unless World's End is reached (*na ca appatvā lokantam*). So should a man become . . . 'world-ender' (*lokantagū*) . . . being assuaged (*samitāvi*)." In Sn 1128–1134, in a series of solar epithets, the Buddha is spoken of as *lokantagū*. Note that *samitāvi*, "quieted," is from Skr. *śam*, "to quiet," "give a quietus," "kill," and implies what Eckhart means when he says "the soul must put itself to death." The derivative *śānti*, "peace,"

always implies a death in some sort—a profound and poignant truth [see Nicholas of Cusa, *De visione Dei* ix]. The use of *samitāvi* (= *nibbuto*) in the present context echoes the position of the Brahmaṇas, where it is repeatedly explained that the Sacrificer is really offering up *himself*; similarly, in the Christian sacrifice (the Mass), *Quicumque quaesieret animam suam saluam facere perdet illum* (Luke 17:33).

[56] What is metaphysically an infallible necessity ("ask and ye shall receive"; "knock, and it shall be opened") becomes, when Deity is considered in a more personal way ("thinking, He is one and I another"), a "being justified freely by His grace" (Rom. 3:24).

[57] CU viii.4.2, *naitaṃ setuṃ . . . tarato . . . na sukṛtaṃ na duṣkṛtam*, and many similar statements elsewhere. Whoever breaks out of the cosmos through the Sundoor leaves his good and evil deeds behind him as a bequest (JB 1.50.5, *dāya*, and BU 1.5.17 and Kauṣ. Up. ii.15, *sampratti, sampradānam*). Being beyond the Sun is supra-individual, superhuman (*amānava*, CU iv.15.5–6). To conceive that "I" have done either good or evil belongs to human egotism (*ahaṃ ca mama ca*; Buddhist *anattā, na me so attā*; Bernard's *proprium*) and would lead to a belief in salvation by merit. To have realized the Truth ("*Thou* art the doer thereof") is therefore an indispensable condition of acceptance by the Sun (JUB 1.5.2–3). "If any man come to me . . . and hate not his own life (*psyche, anima*) also, he cannot be my disciple" (Luke 14:26); "By their works they cannot go in again. . . . If man is to come to God he must be empty of all work and let God work alone . . . all that God willeth to have from us is to be inactive, and let Him be the Working Master" (Johannes Tauler, *The Following of Christ*, London, n.d., pt. ii.16–17); "For in truth the teaching by which we receive a command to live soberly and rightly is 'the Letter that killeth,' unless the 'Spirit that giveth life' be present" (Augustine, *On the Spirit and the Letter* 6); RV viii.70.3, *nakiṣ-taṃ karmaṇā naśat . . . na yajñaiḥ*, "No man getteth Him by works or sacrifices"—but only those who know Him, hence JUB 1.6.1, *ka etam ādityam arhati samayāi'tum*, "Who is able to go through the midst of the Sun?" (= KU ii.21, *kas taṃ . . . devaṃ jñatum arhati*, "Who is able to know that God?").

[58] He does not know himself as he is in God, but only as he is in himself, and is accordingly rejected and literally dragged away by the factors of Time. "He answered and said . . . I know you not" (Matt. 25:12; cf. JUB ii.14.2); *si ignoras te . . . egredere* (Song of Solomon 1:7, Vulgate = "if thou knowest not thyself, depart"). Eckhart, "As long as thou knowest who thy father and thy mother have been in time, thou art not dead with the real death. . . . All scripture cries aloud for freedom from self" (Meister Eckhart, Evans ed., I, 323, 418). " 'Know,' he replied, 'that I am harsh for good, not from rancor or spite. Whoever enters saying "Tis I," I smite him in the face' " (Rūmī, *Dīvān*, p. 115).

The two "selves" (cf. JB 1.17.6, *dvyātmā*; AĀ ii.5, *ayam ātmā . . . itara ātmā*) are the "soul" and the "spirit" of St. Paul, Heb. 4:12, "The word of

God is quick and powerful, and sharper than any two-edged sword, piercing even to the dividing asunder of soul and spirit." See also the conclusion of n. 3.

[59] *Tasmin hātman pratipattaṃ ṛtavas sampalāyya padgṛhitam apakarṣanti.*

[60] "That art thou" (*tat tvam asi*, CU vi.9.4). Cf. TS 1.5.7.5, "That thou art, thus may I be." Hermes, *Lib.* v.11, "Am I other than thou? Thou art whatsoever I am." Eccles. 12:7, "the spirit shall return unto God who gave it"; St. Paul, 1 Cor. 6:17, "But he that is joined unto the Lord is one spirit."

[61] The regular Sūfī use of the designations "Friend" and "Comrade" as names of God parallels the similar use of the words *mitra* and *sakhi* as epithets of Agni, the Sun, and Indra throughout the Vedic tradition.

[62] The metaphor of maturation or cooking (\sqrt{pac} covering both ideas, whether of fruit as ripened by the sun or food as cooked by fire) is used throughout the Vedic and Buddhist literature in the same way.

[63] Marie Saint-Cécile de Rome (1897–1929) speaks of hearing Jesus address her as *Ma petite Moi-même*; see the *Vie Abregée* published at Sillery, Quebec.

[64] *Mathnawī* 1.2936, "Thou art the end of the thread," as in the *sūtrātman* doctrine and the symbolism of the Sun and Spider. The camel and needle recall Luke 18:25, but are not necessarily derivative. The camel is the outer and existent man, So-and-so, as distinguished from the "thread" or "ray" of the spirit, which alone is his veritable essence and by which alone he can return through the "eye" of the needle, which is also the solar "eye," to the source of his life (cf. the Sun as Varuṇa's all-seeing eye, RV *passim*). The phallic significance of the Spirit (*ātman* = Eros) in the Indian and Christian ontology has been touched on in a previous note. For the "needle" as a phallic aspect of the Axis Mundi (and in this respect analogous to the plowshare and planting stick) cf. RV 11.32.4, *sīvyatv apaḥ sūcyācchidyamā-nayā, dadātu vīraṃ (putram)*, Sāyaṇa's *yathā vastrādikaṃ sūcyā syutam*, pointing to RV viii.3.24, *ātmā pitus tanūr vāsaḥ*; similarly, Loki "Nadelsohn" (see L. von Schroeder, *Arische Religion*, Leipzig, 1916, II, 556); for Axis Mundi as "nail," see Holmberg, "Der Baum des Lebens," pp. 10–11, 18, and 23. The widespread prehistoric use of *Ringnadeln*, or pins with annular heads, may also be remarked.

Such are the "mysteries" of needlecraft and weaving. The "eye" of the "needle" through which the "thread" is passed is always the Sundoor; the "thread," the Spirit or Breath. Hence the talismanic significance of tied threads, "sacred threads," and girdles (cf. AV vi.133.5, *sā tvaṃ pari ṣvajasva māṃ dīrghāyutvāya*; *mekhale*, used in the *upanāyana* ceremony, correlating *pari ṣvajasva* with BU iv.3.21, *prajñenātmanā samparisvaktaḥ*), and strings of beads ("All this universe is strung on me like rows of gems upon a thread," BG vii.7; and JUB 1.35.8, where the *niṣkas samantaṃ grīvā abhiparyaktaḥ*, the necklace of which both ends meet about the neck, is a symbol of *anantatā*, literally "in-finity"). [Also note ŚA xi.8 and xii.33.]

It is accordingly in or as this thread (DhA iii.224, as cited in a previous note) or by the thread, as if by a rope ladder, that one climbs the Tree that is also the Needle and reaches its top or eye. This is the *paramārthika* sig-

nificance of the "rope-trick." Almost all traditional "jugglery" has in this way symbolic values, which it is much more profitable to understand than it is to ask whether such tricks are "really" performed. So in story no. 377 of E. Chavannes, *Cinq cents contes et apologues extraits du Tripiṭaka chinois* (Paris, 1910–1934), II, 377, the snared or lassoed wolf, not yet realizing what had happened, "veut faire croire que '*la corde*' au bout de laquelle il se trouve *est une échelle qui lui permettra de monter au ciel*" (italics mine). The rope-trick itself is described in J IV.324, where the performer, producing an appearance of "Vessavaṇa's Mango, 'Nonpareil,'" throws up into the air a ball of thread (*sutta-gula*) and, making it hang to a branch of the tree, "climbs up by the thread" (*suttena . . . abhirūhi*). Vessavaṇa's servants cut the body to pieces and throw them down; the other performers put them together, sprinkle them with water, and the first performer stands up alive again (cf. the Old Irish version in S. H. O'Grady, *Silva Gadelica*, London and Edinburgh, 1892, II, 321, where the performer is Manannan). It is impossible not to recognize in this narrative a demonstration of the doctrine of PB XIV.1.12–13, "Of those who ascend to the top of the great Tree, how do they fare thereafter? Those that are winged fly off, those without wings fall down. The Comprehensors are winged and the foolish those without wings," and TS v.6.2.1–2, "The waters are the 'Water of Life'; therefore they sprinkle with water one who is faint; he does not go to ruin, he lives all his life, for whom these are set down, and who knows them thus"—i.e., understands their formality. This "understanding" corresponds to "having faith" in many of the miracle contexts of the New Testament—e.g., Luke 7:50, "thy faith hath saved thee," and Luke 17:19, "thy faith hath made thee whole"; for "through faith we understand" (Heb. 11:3), and "The nature of faith . . . consists in knowledge alone" (*Sum. Theol.* II-II.47.13 *ad* 2).

From an Indian point of view, the question of whether such phenomena are "real" (in the modern sense of the word) is of little or no interest; the world of "facts" (in the same sense) is one of appearance only, the work of a Master Magician, and it cannot be said of any of these appearances that they "are" what they seem. It is taken for granted, in fact, that the magician's performance is "unreal" (MU VII.10, *satyam ivānṛtaṃ paśyanti indrajālavat*). What matters is the meaning-and-value (*artha*) of the appearance, a thing in this sense being more "really" what it means than what it "is," just as the bread and wine of the Eucharist are more really the flesh and blood of Christ than they are bread and wine, although the Catholic knows perfectly well that both have been made by human hands and will be digested like any other food. And this is all that the famous "participation" of Lucien Lévy-Bruhl's "primitive mentality" amounts to: an intellectual ability to operate on more than a single (and that the lowest) level of reference at one and the same time. It is precisely the man "who knows what is mundane and what not mundane, whose purpose it is to obtain the immortal by means of the mortal," that in AB II.3.2 is distinguished as a "Person" (in the classic sense of Boethius' definition) from those "others, animals whose keen discrimination is merely in terms of hunger and thirst," or, in other words,

such as are literalists and pragmatists, for whom "such knowledge as is not empirical is meaningless." If we accept Lévy-Bruhl's designation of "primitive mentality" as collective and prelogical, and of "civilized mentality" as individual and logical, it may well be asked how it can be possible from such a point of view to speak of "progress." The comparison of primitive man to a child and civilized man to an adult is essentially only self-congratulatory. "Civilized man" is much rather senile than adult. The old "animists," as distinguished from the "psychologists," were right in assuming the constancy of the form of humanity: but in whom is this form most clearly manifested—in the "primitive" metaphysician or in the "civilized" "nothing-morist" (Skr. *nāstika*)? See Coomaraswamy, "Primitive Mentality" [in this volume—ED.].

[65] H. Blodgett, "The Worship of Heaven and Earth by the Emperor of China," JAOS, XX (1899), 58–69 (an admirable account); L. C. Hopkins, "On the Origin and History of the Chinese Coinage," JRAS (1895); Laufer, *Jade*, pp. 120–168 (he rightly speaks of *pi* and *ts'ung*, together with the four other jades that represent the Quarters, as "images" of the cosmic deities); R. Schlosser, "Chinas Münzen als Kunstwerke," OZ N.S. II (1925), 283–305 (on p. 298 "cash" or ring-money is called *pi* because of its likeness to the jade symbols of the same form and name); E. Erkes, "Idols in Pre-Buddhist China," *Artibus Asiae*, III (1928), 5–12 (*pi* and *ts'ung* are images of the Sungod and Earth Goddess; cf. Laufer, *Jade*, p. 144); C. Hentze, "Le Jade 'pi' et les symboles solaires," *Artibus Asiae*, III, 119–216 (comparison of the *pi* with neolithic flattened mace-heads and spindle-whorls and with solar symbols from various sources; the *pi* "n'est point l'image directe du soleil . . . mais de la roue solaire," a sound observation, since the wheels of the solar chariot are Heaven and Earth, and it is Heaven rather than the Sun that is represented in a likeness by the *pi*. The Sun itself should be represented by an unperforated disk or by a disk containing a central point which represents the "seventh or best ray" of the Sun's "seven rays," which ray alone passes through the Sun and thus out of the cosmos; "le jade *pi* était symbole de ciel, objet de sacrifice et de présent").

Quite in the Upaniṣad style is the text of the Chung Yung (*The Chinese Classics*, trans. James Legge, 2nd ed., Oxford, 1893–1895, I, 404), "*He who understands* the rites of the sacrifices to Heaven and Earth, and the *meaning* of the several sacrifices to ancestors, would find the government of a kingdom as easy as to look into the palm of his hand."

[66] "Only the Emperor can perform the rites; and if he sits on his throne, but is without virtue, he will be unable to give effect to the ritual offices and the music. . . . The Emperor is not, indeed, 'The Son of Heaven' because of his political position; it is the effective guardian of the Tao that is really the 'Son of Heaven,' possessing inwardly the virtue of holiness, and outwardly the 'becoming' [hermeneia of *we*, 'becoming,' '*werden*,' and *we* 'throne'] of a sovereign" (E. Rousselle, "Seelische Führung im lebenden Taoismus," *Chinesisch-Deutscher Almanach*, Frankfurt, 1934, p. 25). Is not the Tao itself, in fact, a rider in the "ancient jade chariot," in the sense of KU III.3, *atmānam*

rathinaṃ viddhi, "know that the Spirit is the charioteer" [and J VI.242]? ["The wise ruler practices inaction, and the empire applauds him. . . . Charioted upon the universe, with all creation for his team, he passes along the highway of mortality," Chuang-tzu, ch. 23].

[67] Cf. Forrer, "Les Chars cultuels préhistoriques," p. 119, "L'invention du char est due aux idées religieuses que l'homme préhistorique au début de l'âge de métal s'est faites sur le soleil, sa nature et ses qualités bienfaisantes." Practical values are, normally speaking, secondary applications of metaphysical principles, to which applications the name of "inventions" or "findings" is properly given; a later age resorts to the more uncertain method of experiment ("trial and error"). In the present connection, another good illustration of the application of metaphysical principles is afforded by Vedic *kha*, originally the "chasm" represented by the Sundoor and World-door, and subsequently the mathematical zero (cf. Coomaraswamy, "*Kha* and Other Words Denoting 'Zero' in Connection with the Metaphysics of Space" [in Vol. 2 of this selection—ED.], and the discussion by Betty Heiman in JISOA, V, 91–94), and in ethics the source of good and evil (*su-kha, duh-kha*). In the same connection, see *Tao Te Ching* XI, "it is on the space where there is nothing that the utility of the wheel depends."

[68] Cf. E. Rousselle, "Die Achse des Lebens," *Chinesisch-Deutscher Almanach*, Frankfurt, 1933. *Shēn-tao* (Shinto) = *devayāna*.

[69] The ritual *fang-ming*, to which the body of the deceased is thus assimilated by the placement of the six jades, is itself a six-sided, probably cubic slab, marked with six colors representing the six directions and on which six jades are placed, apparently in the same way as described above. In the expression itself, *fang* means "square," or "plane," in the sense of a direction (quarter, airt), and *ming* means "light," especially the light of dawn or day. There can be no doubt that the *fang-ming* is an image of the cosmos; cf. *szu fang*, "the four quarters"—i.e., the rest of the world outside China; *wu fang*, "the four quarters and center"—i.e., the outer world and China; and *fang wai*, "extracosmic" or "supramundane." The intention is therefore literally to "universalize" the body of the deceased, and thus to provide for the deceased a cosmic body of light. It may be added that the T'ang Commentary which Laufer cites but does not name is the well-known *Chou li chu su* of Chia Kung-yen; I have been able to make use of this only by the kind help of my learned colleague, Miss Chie Hirano.

[70] E. Rousselle, "Seelische Führung im lebenden Taoismus," *Chinesisch-Deutscher Almanach*, Frankfurt, 1934, pp. 42–43. It may be observed that instead of treating the six jades as the centers of limiting planes, we treat them as points and connect them by lines; the figure of a diamond replaces that of a cube, while the axes (which are the same as those of the "Cross of Light") remain unchanged. Cf. Coomaraswamy, "Eckstein," 1939.

[71] Cf. Hentze, *Frühchinesische Bronzen- und Kulturdarstellungen*, pp. 13–16.

[72] The following citations are taken from Holmberg, "Der Baum des Lebens," and Casanovicz, "Shamanism of the Natives of Siberia," *Smithsonian*

Report for 1924 (Washington, D.C.); cf. Uno Holmberg, *Finno-Ugric, Siberian Mythology* (Boston and Oxford, 1927), Vol. 4 of *Mythology of All Races.*

[73] "The Dolgans call the square column, the apex of which is topped by the image of the eagle which represents heavenly powers, the 'never failing support' (*tüspät turū*) and they imagine that its counterpart, which 'never alters nor falls,' stands before the dwelling place of the high god. One often sees, in addition, below the bird image on these columns a sheltering roof which represents heaven" (Holmberg, "Der Baum des Lebens," p. 15).

[74] Just as, in the *Volsunga Saga* (tr. E. Magnusson and William Morris, London, 1901), "King Volsung let build a noble hall in such wise, that a big oak-tree stood therein, and that the limbs of the tree blossomed fair out over the roof of the hall, while below stood the trunk within it, and the said tree did men call 'Branstock' [i.e., 'Burning Bush']." Indian hypaethral temples were similarly constructed; cf. illustrations in Coomaraswamy, "Early Indian Architecture: II. Bodhi-gharas." For the corresponding cults in Greece, see Arthur Evans, "Mycenaean Tree and Pillar Cult," JHS (1901), p. 118, "Wooden columns . . . often take over their sanctity from the sacred tree out of which they are hewn" (see also p. 173, "the Sun-god as a pyramidal pillar," etc.). For climbing rites cf. Lucian, *De Syria dea* 28–29 (cf. John Garstang, tr., *The Syrian Goddess*, London, 1913, pp. 66–69). Climbing rites are illustrated in later European tradition by St. Simon Stylites, and in the popular milieu by the sport of climbing a greased pole in order to secure a prize attached to its summit. For some further references to climbing rites, see P. Mus, *Barabuḍur* (Hanoi, 1935), p. 318 [and R. A. Nicholson, *Studies in Islamic Mysticism* (Cambridge, 1921), pp. 105, 111].

[75] Cf. Janus (whence *janua*, "gate," "ingress," cf. Skr. *yāna*), so called *quod ab eundo nomen est ductum*, Cicero, *De natura deorum*, II.27.67. With Janus as two-faced (one essence and two natures), cf. the Indian double-headed Sunbirds, Eagle or Gander, and the Sun as symbolized in the Vedic rites by the Golden Disk that shines downward, and the Golden Person laid upon the Disk, face upward (ŚB VII.4.1.7–13, VIII.3.1.11, and X.5.2.8, 12, etc.)— "The one so as to look hitherwards and the other so as to look away from here" (ŚB VII.4.1.18). For the Janus type cf. P. Le Gentilhomme, "Les Quadrigati Nummi et le dieu Janus," *Revue numismatique*, ser. 4, XXXVII (1934), ch. 3, "Les Doubles Têtes dans l'art antique"; for the "two faces" as spiritual and temporal power, and the assimilation of Christ to Janus, see René Guénon, *Autorité spirituelle et pouvoir temporel* (Paris, 1930), p. 125, and "Le Symbolisme solsticial de Janus." For Marduk, a Janus type, with reference to the course of the sun by day and night (*ab extra* and *ab intra*: Mitrāvaruṇau), cf. S. H. Langdon, *Semitic Mythology* (Boston and Oxford, 1931), p. 68, Vol. 5 of *Mythology of All Races.*

[76] Similar formulations are found among the North American Indians. It may be added that among these there are some tribes who regularly enter their houses by the smoke-hole and a stepped ladder (C. Wissler, *The American Indian*, 3rd ed., New York, 1950, p. 113). Attention may also be called to the post-mortem perforation of skulls, no doubt to facilitate the ascent of

the spirit of the deceased, as in India, by way of the cranial foramen (*brahma-randhra, sīma, dṛti*); see Wilbert B. Hinsdale and E. F. Greenman, "Perforated Indian Crania in Michigan," *Occasional Contributions from the Museum of the University of Michigan*, No. 5 (1936). Similar post-mortem perforations of the skull have been observed in European and African Neolithic cultures. See Alexandra David-Neel, *Magic and Mystery in Tibet* (New York, 1932), p. 208. [Analogous to the perforation of skulls is that of bowls and vases, which, in the case of examples from the Mimbres Valley (New Mexico), "were generally perforated or 'killed' before being buried with the dead . . . the thought, as we know from certain Pueblo Indians, being to allow the escape of the breath body or spirit of the bowl in order to permit it to accompany that of the former owner to the land of shades." When the body is buried sitting, such bowls "are placed on the cranium like a cap" (J. Walter Fewkes, IPEK, 1925, p. 136).]

[77] Cf. the remarkable account of a descent into the nether world in Peter Freuchen, *Arctic Adventure* (New York, 1935), pp. 132–137, where the practitioner is spoken of as having trained himself to "swim through the rocks" and, on his return journey, as "fighting his way up through the granite"; an exact equivalent is the "power" (*siddhi*), ascribed in numerous Pāli Buddhist texts (e.g., A 1.254 ff., S 11.212 ff. and S v.254 ff.) to the *arhat* who is perfected in the practice of the Four Contemplations, of "plunging into and emerging from the earth as though it were water." Associated "powers" are those of walking on the water, levitation, and ascent in the body even as far as the Brahmaloka.

The Christian tradition is also acquainted with One who "can" (*arhati*) descend into hell or ascend to heaven at will.

[78] This "penfold" corresponds to the stable (of *aśvattha* wood) put up for the sacrificial horse at or near the offering ground (TB III.8.2, Commentary).

The word *aśvattha*, denoting the tree of which the sacrificial post is typically made in the Indian rite, means "horse-stand," and is equivalent to *aśvastha* in this sense—that of TS IV.1.10.1, where the offering is made to Agni kindled at the navel of the earth, "as it were unto a standing horse (*aśvāyena tiṣṭhante*)." It is, accordingly, noteworthy that in the Yakut saga cited by Holmberg, "Der Baum des Lebens," p. 58, the World-tree, of which the roots strike deep into the earth and the summit pierces the seven heavens, is called the "Horse-post of the High-god Ürün-ai-Tojon."

For analogous relationships of horse and tree or post in China, see Hentze, *Frühchinesische Bronzen- und Kulturdarstellungen*, pp. 123–130. The very remarkable Han grave relief reproduced in Figure 13 may be said to illustrate at the same time Indian, Siberian, and Chinese formulations. A horse, designated royal by the umbrella on its head, is tied to a sacrificial post that *rises* from an altar. Above is a *t'ao t'ieh* mask holding a ring. Cf. A. Salmony, "Le Mascaron et l'armeau," *Revue des arts asiatiques*, VIII (1934). Like a *pi*, it is assuredly through this ring that the spirit of the horse, when it has been slain, must pass to heaven. The ring is held or guarded by the *t'ao t'ieh*, just as in the previously cited case of the bronze axle or hub

(Laufer, *Jade*, pl. xvi, fig. 1). The relief itself is more eloquent than any description of it could be. And as Janse comments, "Tous ces monuments ont ceci de commun: leur décor témoigne de croyances et de légendes relatives à la vie, à la mort, à l'idée de l'immortalité, croyances . . . qui ont dû être très répandues parmi les gens d'alors, car souvent l'artiste s'est contenté d'évoquer des scènes entières par quelques éléments isolés. Souvent nous ignorons encore le sens exact du décor, mais, d'autre part, il y a de nombreux éléments qui sont faciles à déterminer" ("Briques et objets céramiques," p. 3).

It may be added that this Han relief interpreted above throws a vivid light upon the traditional form of even our own door knockers, so often composed of an animal mask holding a ring. It would seem that no more appropriate or significant form could have been found. The more, indeed, we learn of the origins of the forms of traditional and folk art, the more we realize that their application is inevitable and see that they are neither products of convention nor of "artistic" choice, but simply *correct: ars recta ratio factibilium*.

[79] In TS 1.7.9, the *mantra* "We have come to the heaven, to the gods; we have become immortal; we have become the offspring of Prajāpati" is enunciated by the Sacrificer on reaching the top of the post, where he stretches out his arms, no doubt in imitation of a bird; cf. JUB iii.13.9, "Verily he who without wings goes up to the top of the Tree, he falls down from it. But if one having wings sits at the top of the Tree, or on the edge of a sword, or on the edge of a razor, he does not fall down from it. For he sits supported by his wings . . . sits without fear in the heavenly world, and likewise moves about"—i.e., as a *kamācārin*, a "mover at will." See also PB xiv.1.12–13. The bird of the Shaman's song corresponds to "the Gander whose seat is in the Light" (KU v.2); "to and from the external hovers the Gander" (Śvet. Up. iii.18); "the Golden Bird, indwelling heart and Sun" (MU vi.34); etc. As for the "quacking" of the goose, it is, of course, the Shaman that quacks; insofar as the Shaman is beside himself and is in the spirit, he *is the goose*, and is flying; cf. PB v.3.5, "as a *śakuna* the Sacrificer, having become a bird, soars to the world of heaven."

Horse and bird are essentially one, as is explicit in ŚB xiii.2.6.15. Mahīdhara on this passage "identifies the horse with the horse-sacrifice [as in BU 1.2.7] which, in the shape of a bird, carries the sacrificer up to heaven" (J. Eggeling; cf. SBE, XLIII, xxi–xxii).

[80] ŚB xiii.2.8.1, "Now the Devas, when ascending, did not know the way to the world of heaven, but the horse knew it," and more fully in xiii.2.3. [Cf. TS vi.3.8, on grasping the victim as guide on the way to heaven; the victim is the psychopomp. It is similar for Christ in the Christian sacrifice, and in the "mounting after Agni."]

[81] Cf. TS v.2.11–12 and AB vii.1 with its elaborate account of the ritual dissection of the horse.

[82] Verbatim, except that italics and some capitals are mine.

[83] In addition to previously cited references to the ladder, cf. Vis 10, *saggaārohana-sopāna*.

" 'L'Échelle du Ciel,' suivant une formule toute byzantine d'inspiration,

était représentée sur le manuscrit de l''Hortus deliciarum' de l'abbesse Herrade de Landsberg: un chevalier, un clerc, un moine, un ermite gravissent les échelons, mais, attirés par les vices, ils sont précipités dans le gouffre; seuls quelques élus, protégés par des anges qui battaillent contre les démons tirant des flèches, reçoivent la couronne tendue par le main divine" (Louis Bréhier, *L'Art chrétien*, Paris, 1918, p. 294). For the earlier history of the representations of the Christian "Heavenly Ladder" see Charles R. Morey and Walter Dennison, *Studies in East Christian and Roman Art*, 2 vols. (New York, 1914–1918), pp. 1–28. It is from this ladder (κλίμαξ) that St. John Climacus takes his name.

[84] The deceased assuming the name of the God, to whom he thus enters as like to like. Cf. RV x.61.16, "Himself the bridge"; the Shaman "Door god"; St. Catherine's Christ "in the form of a bridge"; the Bodhisattva *attānaṃ saṃkamaṃ katvā* (J iii.373), with TS vi.6.4.2, *akramanam eva tat setuṃ yajamāna kurute suvargasya lokasya samaṣṭyai*.

[85] The psychostasis survives in Christian iconography, where St. Michael plays the part of Thoth; cf. e.g., Émile Mâle, *L'Art religieux du XIIIᵉ siècle en France* (Paris, 1893), fig. 237; Louis Bréhier, *L'Art chrétien*, Paris, 1918, p. 293. Cf. Koran 7:8: "The balance of that day is true, and whosesoever's scales are heavy, they are prosperous; but whosesoever scales are light, it is they who lose themselves." Maat, as Truth and Daughter of the Sun, corresponds to Vedic Sūryā-Vāc and Neoplatonic and Christian Sophia.

[86] The beatitude of the blessed dead is represented in terms of feasting in all traditions—e.g., RV x.135.1, *sampibate*; Matt. 22:4, "Behold, I have prepared my dinner." As remarked by St. Thomas, " 'The ray of divine revelation is not extinguished by the sensible imagery wherewith it is veiled,' as Dionysius says" (*Sum. Theol.* 1.1.9 *ad* 2), and as "Avalon" has remarked, those who comprehend the eternal truths are not disturbed by the symbols by which they may be expressed.

[87] "He," in this context "Osiris-Ani"—i.e., the deceased Ani, now assimilated to Osiris and entering as like to like.

[88] So also Ikhnaton "regularly appended to the official form of his royal name in all his state documents, the words 'Living on Truth' " (Breasted). In the same way, the Comprehensor speaks of himself as *satya-dharmaḥ* (Īśā Up. 16).

[89] For Egyptian representation of the Sundoor, open and closed, see H. Schäfer, *Aegyptische und heutige Kunst und Weltgebäude der alten Ägypter* (Berlin, 1928), p. 101, Abb. 22–24 (here Figure 14), and T. Dombart, "Der zweitürmige Tempel-Pylon," *Egyptian Religion*, I (1933), 92–93, Abb. 7 (the closed door surmounted by the winged disk and guarded by Isis and Nepthys). As Dombart remarks, "The Egyptian temple as a whole appears accordingly in monumental architecture as the microcosmic image of the earthly world structure in which the deity dominates, above all the sun god who can here live and reign as ruler of the world." Dombart rightly protests against the customary interpretations of monumental architectural forms in Egypt and elsewhere as *bloss-dekorative* or even as merely functional; cf. in

this connection, my review [in this volume—ED.] of W. Andrae, *Die ionische Säule: Bauform oder Symbol?* See also Lethaby, *Architecture, Mysticism and Myth*, ch. 8, "The Golden Gate of the Sun." It may be added that just as Javanese gateways are guarded by the solar Kālamakara (Kāla, "Time," being one of the names of Death as the "Ender," Antaka), so also Mexican lintels bear a mask which, if it occurred in an Indian context, could only be called a *makara* (e.g., Herbert Joseph Spinden, *Ancient Civilizations of Mexico and Central America*, 2nd rev. ed., New York, 1922, fig. 21).

In Christian art the closed door is represented already at Dura-Europas in the third century A.D.; see Pijoan in *Art Bulletin*, XIX (1937), fig. 3, facing p. 595. In this composition the Bridegroom is represented by the risen Sun ("I am the door"). The virgins with their lighted candles ("The spirit indeed is their light," BU IV.3.6) are entering into the Kingdom of Heaven by this door (if the building resembles a tomb, this accords with Eckhart's "The Kingdom of Heaven is for none but the thoroughly dead" and Rom. 6:8, "if we be dead with Christ")—"through the midst of the Sun . . . there Heaven and Earth embrace [*saṃśliṣyataḥ*, JUB 1.5.5]."

[90] This Āmmit, with whom as "devourer" cf. *agni kravyāt*, evidently corresponds on the one hand to the jaws of hell that await the Christian soul that is weighed in the balance and found wanting, and on the other to the "crocodile" that lurks in the way of the Indian sacrificer's heavenward ascent, with respect to whom they ask, "Who will today be delivered from the Śimśimāri's jaws," as noted above.

[91] Indian *aśaikṣa mārga*. On this path, described in Kauṣ. Up. 1.3-7, the guide is the "non-human Person," and those who proceed therein never again return to the human condition (CU IV.15.5-6).

[92] In the *Paradiso*, accordingly, Virgil cannot act as Dante's guide beyond the Lower Paradise. The distinction of a lower heaven attainable by merit and a higher attainable only by *gnosis* is one of the basic formulae of the Philosophia Perennis and is strongly emphasized in the Upaniṣads.

[93] This no more implies any vagueness of thought or confusion of two things than when we say of a portrait, "That's me." We do not mean (in fact, of course, we no longer know what we mean by such expressions and many others of like origin) that this pigment is my flesh, but that the "form" (principle, idea, essence) of this representation *is* my form; we are not identifying natures, but essences. At the same time we are distinguishing our "real" self (which we no more identify with the flesh than with the pigment) from its accidents. The pigments themselves are not the picture, but only its vehicle or support. If, then, it is a "portrait" of God with which we are dealing, we say with perfect logic that worship paid to it is paid to the archetype and not to the aesthetic surfaces themselves. In the case of the Eucharist, our modern inability to believe is an inability to believe what no one has ever believed, that a carbohydrate becomes a protein when certain words are spoken over it. Vagueness of thought and confusion of different things are products not of the primitive but of our mentality; *we* read the words, "This is my body" and "I am that bread of life" and overlook that "is" and "am" assert

a formal and not an accidental identity—"This is that bread which came down from heaven: not as your fathers did eat." "He that eateth of this bread shall live for ever. . . . He that eateth Me, even he shall live by Me": "paroles dont le symbolisme ne serait pas possible s'il ne se référait pas à une réalité correspondant à leur sens immédiat et littéral" (Frithjof Schuon, "Du Sacrifice," *Études traditionelles*, XLIII, 1938, 141). And, as Jesus also asked, "Does this offend you?" It does, indeed. *Our* anthropomorphism prevents us from recognizing the formality of the bread, as it does from recognizing the informality of the actual flesh, whether that of the Christ or of anyone else; *our* refinement prevents us from acknowledging that "on ne peut affirmer que l'anthropophagie, par exemple, constitue par elle-même une déviation . . . qu'elle soit, au contraire, susceptible d'une signification positive et élevée" (Schuon, "Du Sacrifice," p. 140). Cf. ŚB xiv.1.1, where Indra swallows Makha-Soma, the Sacrifice, the victim, and thus obtains his qualities, and the corresponding rite described in AB vii.31, where men partake of the Soma, not literally but metaphysically "by means of the priest, the initiation, and the invocation," just as in the Eucharist men partake of the body of Christ by means of the priest, the consecration, and the invocation.

[94] I.e., who speak it originally and with awareness. A language, verbal or visual, can be misunderstood only by those who speak it later on, symbols then surviving as art-forms or clichés of which the whole or part of the meaning has been forgotten. Then it appears to those who have forgotten that those who remember are arbitrarily reading meanings into forms that never had one, whereas the fact is that those who have forgotten and for whom the symbol is nothing but a literary ornament or decorative motif have, by a progressive substitution of sensible for intellectual preoccupations (commonly described, in connection with the Renaissance, as an awakening of a curiosity with respect to the "real" world), gradually subtracted meanings from the expressions that were once alive. It is only in this way that a "living" language can come to be a dead one, while what is called a dead language remains alive for the few who still think in it.

[95] More vivid, too, inasmuch as "in Indian vehicles the different parts are held together by cords" (Eggeling on ŚB xiii.2.7.8), and *ratha* as the typical "vehicle" is employed throughout the Indian tradition as a valid symbol of the bodily "vehicle" of the Spirit.

[96] "On ne saurait trop admirer la solennelle niaiserie de certaines déclamations chères aux vulgarisateurs scientifiques, qui se plaisent à affirmer à tout propos que la science moderne recule sans cesse les limites du monde connu, ce qui est exactement le contraire de la vérité: jamais ces limites n'ont été aussi étroites qu'elles le sont dans les conceptions admises par cette prétendue science profane, et jamais le monde ni l'homme ne s'étaient trouvés ainsi rapetissés au point d'être réduits à de simples entités corporelles, privées, par hypothèse, de la moindre communication avec tout autre ordre de réalité!" (Guénon, *Études traditionelles*, XLIII, 1938, 123–124).

[97] We have, for example, no right to boast that "owing to mental development, the values of ritual as practiced today by the Christian Church are

different from those possessed by ceremonial among primitive peoples. Christian ritual is largely symbolic" (Alan Wynn Shorter, *An Introduction to Egyptian Religion*, New York, 1932, p. 36); the final statement here, to the effect that other rituals are not "symbolic," is a pure *niaiserie*, as should be evident on the limited basis of materials collected in this paper alone. Is Shorter writing as a missionary, as a serious scholar, or merely as one of those "observers [who] note the differences which mark off their 'religion' from ours, and cautiously apply some other term, describing the beliefs as magical or taboo, or secret or sacred" (A. E. Crawley, *The Tree of Life*, London, 1905, p. 209), or simply as one of those who think that wisdom was born yesterday? Equally reprehensible and even more ridiculous are the remarks of Jacques Maritain, who distinguishes the "common sense" of first principles "from the common sense of primitive *imagery*, which conceives the earth as flat, the sun as revolving round the earth, height and depth as absolute properties of space, etc., and has no philosophical value whatsoever" (*St. Thomas Aquinas: Angel of the Schools*, J. F. Scanlan, tr., London, 1933, p. 165, note). However wounding it may be to our conceit, the truth is that, as expressed by J. Strzygowski, "the ideas of many so-called primitive peoples are essentially more thoroughly infused with mind and spirit (*durchgeistiger*) than those of many so-called cultured peoples. We must indeed altogether dispense with the distinction between natural and cultural peoples in religion," and that, as he also says of the Eskimo, "they have a much more abstract image of the human soul than the Christians" (*Spuren indogermanischen Glaubens in der bildenden Kunst*, Heidelberg, 1936, p. 344); that "when we sound the archetype, then we find that it is anchored in the highest, not the lowest. . . . Sensible forms, in which there was once a polar balance of physical and metaphysical, have been more and more emptied of content on their way down to us; so we say, this is an 'ornament'; and as such it can indeed be treated and investigated in the formalistic manner" (W. Andrae, *Die ionische Säule*, Berlin, 1933, pp. 65–66). In other words and *for us*, a "superstition" (cf. W. Andrae, "Keramik im Dienste der Weisheit," *Berichte der Deutschen keramischen Gesellschaft*, XVII, 1936, 623–628). As I have said elsewhere, the symbolic references of traditional and folk art are "so far abstract and remote from historical and empirical levels of reference as to have become almost unintelligible to those whose intellectual capacities have been inhibited by what is nowadays called a 'university education.' " "Later ages . . . have, in more senses than one, made an error of identification, and have taken the Tree of Knowledge for the Tree of Life" (Crawley, *Tree of Life*, p. viii).

Symplegades

Hinter den Klappfelsen in der andern Welt ist die Wunderschöne, das Lebenskraut, das Lebenswasser.
Karl von Spiess

All waits undreamed of in that region, that inaccessible land.
Walt Whitman

The subject of "Clashing Rocks" is dealt with at considerable length by Arthur Bernard Cook in *Zeus* (Cambridge, 1914–1940), III, ii, Appendix P, "Floating Islands," 975–1016. We shall take it for granted that the reader will have consulted this article, in which material has been brought together mainly from classical sources, but also from many other parts of the world, India excepted. Although so fully treated, the subject is by no means exhausted, and remains of absorbing interest, especially if we are concerned at the same time with the universal distribution and with the significance of the motif.

The distribution of the motif is an indication of its prehistoric antiquity, and refers the complex pattern of the Urmythos of the Quest to a period prior at least to the population of America. The signs and symbols of the Quest of Life which have so often survived in oral tradition, long after they have been rationalized or romanticized by literary artists, are our best clue to what must have been the primordial form of the one spiritual language of which, as Alfred Jeremias says (*Altorientalische Geisteskultur*, Vorwort) "the dialects are recognizable in the divers existing cultures." Here, for the sake of brevity, we are considering only a single component of the complex pattern, that of the "Active Door."[1]

[This essay was published in *Studies and Essays in the History of Science and Learning Offered in Homage to George Sarton on the Occasion of his Sixtieth Birthday*, M. F. Ashley Montagu, ed., New York, 1947.—ED.]

[1] Here, in addition to A. B. Cook's references and those given below, we can only cite from the vast literature of the whole subject such works as G. Dumézil, *Le Festin d'immortalité* (Paris, 1924); J. Charpentier, *Die Suparnasaga* (Uppsala, 1920); S. Langdon, *Semitic Mythology* (Boston, 1931); J. L. Weston, *From Ritual to Romance*

It has been quite generally recognized that these Wandering Rocks, "in order to pass among them, you must discover a means for yourself" (Jülg), are the "mythic forms for that miraculous gate, behind which lies Oceanus, the Isle of the Blessed, the realm of the dead," and that they divide "the familiar Here from the unknown Beyond" (Jessen in Wilhelm Heinrich Roscher, *Ausführliches Lexikon der griechischen und römischen Mythologie*, Leipzig, 1884–19?): that, as Cook, endorsing Jessen, says, they "presuppose the ancient popular belief in a doorway to the Otherworld formed by clashing mountain-walls." The Planktai Petrai, in other words, are the leaves of the Golden Gates of the Janua Coeli,[2] of which in the Christian tradition, St. Peter, appointed by the Son of Man, is now the Keeper.

We begin with the problems of distribution of the motif, of which the meaning will develop as we proceed. In certain contexts, as pointed out by Cook (pp. 988–991), "dancing reeds" replace the floating or dancing islands, and although there is no indication in the classical sources of the notion of a dangerous passage between a pair of dancing reeds, this appears elsewhere, and it can hardly be doubted that it belongs to the original form of the story. Murray Fowler[3] has called attention to an Indian context (ŚB III.6.2.8–9) where Soma, the plant, bread, or water of life, is to be brought down from above by the aquiline Gāyatrī (Suparṇī, Vāc), Agni's vocal and metrical power, and we are told that it had been "deposited [for safekeeping] within, i.e., behind, two golden leaves (*kuśī*, or? *kuśyau*),[4] that were razor-edged, and snapped together (*abhisaṃdhattaḥ*)[5] at every winking of an eye." She tears out these leaves,

(Cambridge, 1920); R. S. Loomis, *Celtic Myth and Arthurian Romance* (New York, 1927); A.C.L. Brown, *The Origin of the Grail Legend* (Cambridge, 1943); E. L. Highbarger, *The Gates of Dreams* (Baltimore, 1940).

[2] For other material on this subject see Coomaraswamy, "The Symbolism of the Dome," and "*Svayamātṛṇṇā*, Janua Coeli" [both in this volume—ED.].

[3] "Ambrosiai Stelai," *American Journal of Philology*, LXIII, 215–216.

[4] These *kuśī* (or -*kuśyau*) are primarily a pair of "leaves" or "blades," as of swordgrass, at the same time that they are in effect the two "leaves" or possibly "jambs" of an active Door; and in this connection it is not insignificant that Kuśī is also a synonym of Dvārakā, Krishna's "City of the Door." In ŚB the *hiraṇmayau kuśī* are said to be *dīkṣā* (initiation) and *tapas* (ardor), cf. ŚB III.1.2.20 and III.4.3.2, where it is *in* these as a "new garment" that the Sacrificer is qualified to enter the Sadas, analogically the Otherworld. JUB I has *hiraṇmayau kuśyau* (v.1) for *ṛk* and *sāma* (typical *contraria*, cf. JUB 1.53.1–2).

[5] "Snapping together," for a door is also a "mouth" (*mukha; ostium*), and our "leaves" or "rocks" are really the fiery Jaws of Death; as in RV x.87.3, where the same verb (*saṃdhā*) is used of the bite of Agni's iron teeth, the upper and the

and appropriates the life-giving power, which Indrāgnī "extend for the generation of offspring" (*saṃtanutāṃ prajānāṃ prajātyai*, ŚB 13). In other words, the Falcon, successful Soma thief, passes safely between these "two Gandharva Soma wardens" and returns with the rescued prisoner, namely, that King Soma who "was Vṛtra" (ŚB III.4.3.13, etc.) and now "made to be what he actually is,"[6] the Sacrifice (*ya evaiṣa taṃ karoti yajñam eva*), is now himself a god restored to the gods" (ŚB III.6.3.16, 19). From the point of view of the Titans this translation of the "gefängene, streng-behütete Soma-Haoma"[7] is a theft, but from that of the gods a rescue and a disenchantment.[8]

lower. Cf. Kauṣ. Up. II.13, where the rolling mountains "do not devour" (*na . . . tṛnviyātām, √ tṛn* = G. *fressen*, and as in *tṛna*, "grass," "fodder") the Comprehensor.

In RV VIII.91.2 (cf. IX.1.6) and the Brāhmaṇa versions, *Śāṭyāyana Br.* and JB 1.220 (translated by H. Oertel in JAOS, XVIII, 1897, 26–30), also PB VIII.4.1, Apālā (alias the Daughter of the Sun = Śraddhā, Faith; Gāyatrī; Akupārā, etc.), prepares Soma (as *kawa* is prepared in the South Sea Islands) by chewing (*jambhasutam . . . dantair damṣṭvā dhayantī*), and Indra takes it directly from her mouth (*asyai mukhāt*)—"and whoever is a Comprehensor thereof, if he kisses a woman's mouth, that becomes for him a draught of Soma." Thus *in divinis*; in the ritual mimesis, where the Soma (substituted plant) is crushed in a pestle and mortar or more usually between two stones (as it were "clashing rocks"), and two sides (*adhiṣavane*) of the Soma press are "jaws," the stones (*grāvāṇā*) are "teeth," and the skin on which they move is the "tongue," while the other "mouth" into which the juice is poured is that of the sacrificial altar (*āhavanīya*), in which also the Sacrificer identifying himself with the victim, offers up himself. Thus the gates of entry (birth, from the human standpoint, death from the divine) and exit (death from the human point of view, birth from the divine) are both equally "jaws"— "the soul—every great soul—in its cycle of changes must pass twice through the Gate of Ivory" (Highbarger, *The Gates of Dreams*, p. 110). The Sacrifice is always a prefigured *Himmelfahrt*; it is not that one does not wish to be "swallowed up" by the deity *by* whom one must be assimilated if one would be assimilated *to* him (cf. Coomaraswamy, *Hinduism and Buddhism*, 1943, pp. 23, 24, and RV VII.86.2, "When at last shall we come to be again *within* Varuṇa?"), but that one would not be demolished by the "upper and the nether *mill*stones" through which the way leads; and hence "the Brahmans of yore were wont to wonder, Who will today escape Leviathan's (*śiṃśumārī*) jaws?" and it is actually only by the substitution of a "victim" (a "sop to Cerberus") that one "comes safely through his maw" (JB 1.174). On the Jaws of Death see further Coomaraswamy, "*Svayamātṛṇṇā*: Janua Coeli," n. 3.

[6] The bringing down of Soma to earth, which is his coming into his kingdom, involves a passion and a resurrection. He comes forth in triumph: "even as Ahi, slipping out of his inveterated skin, Soma flows like a prancing steed" (RV IX.86.44).

[7] L. von Schroeder, *Herakles und Indra* (Vienna, 1914), p. 45.

[8] The contrary values are very clearly developed in the *Argonautica*, where the Rape of the Fleece and carrying off of Medea are, from her father's point of view,

It will be recognized immediately that the Falcon's Quest—and we use this word deliberately to imply that this is, in fact, a Grail Quest—is identical with that of the doves that fetch ambrosia[9] for Father Zeus from beyond the Planktai Petrai, always at the price of one of their number, caught on the way as they pass the Clashing Rocks (*Odyssey* xii.58 ff.); and that it corresponds at the same time to the Quest of the Golden Fleece, where it is, indeed, a winged "ship" that Athena (Goddess of Wisdom) drives between the Clashing Rocks that she holds apart, but it is like a bird that *Argo* flies through the air, and even so can only escape with the loss of her stern ornament (or, as we might almost say, "tail-feather"), after which the rocks remain in close contact, barring the way to other mortal voyagers (*Argonautica* ii.549–609). The door is thus normally "closed"; for as we shall presently realize, it is one that can only be opened, in what would otherwise seem to be a smooth and impenetrable wall, by a more than normally human wisdom.[10]

the acts of a high-handed marauder; and (iv.1432 ff.) Herakles' slaughter of the Serpent and theft of the Golden Apples are from the point of view of Jason's companions heroic feats, but from the point of view of the Hesperides themselves acts of wanton violence. In the same way, as Darmetester says, "In the Vedic mythology the Gandharva is the keeper of Soma, and is described now as a god, now as a fiend, accordingly as he is a heavenly Soma priest or a jealous possessor who grudges it to man" (SBE, Vol. 23, 63, n. 1). In such contexts, however, "grudge" (= φθόνος) is not the word; it is not with malice that the Cherub "keeps the way of the Tree of Life," or invidiously that St. Peter keeps the Golden Gates, or that Heimdallr guards the Bridge, or that the door is shut against the foolish virgins, but only to protect the fold against the wolves who have no right to enter.

The opposing interests of gods and titans are only reconciled when, as in the Vedic and Christian traditions, the Sacrifice is indeed a victim, but not an unwilling victim. It is only from our temporally human point of view that "good and evil" are opposed to one another, but "to God all things are good and fair and just" (Heracleitus, *Fr.* 61); and this is the essential meaning of the Clashing Rocks, that whoever would return home must have abandoned all judgment in terms of right and wrong, for *there*, as Meister Eckhart says, in full agreement with Chuang-tzu, the Upaniṣads, and Buddhism, "neither vice nor virtue ever entered in." The gods and titans are the children of one Father, and have their appointed parts to play, if there is to be a "world" at all (cf. Heracleitus, *Fr.* 43, 46), and though one of these parts may be ours "for the time being," the Comprehensor must act without attachment, dispassionately, remaining above the battle even while participating in it.

[9] On *ambrosia* and *amṛta* see M. Fowler, "A Note on ἄμβροτος," *Classical Philology*, XXXVII (1942), 77–79.

[10] The door as an obstacle is the "barricade of the sky" (*avarodhanam divaḥ*, RV ix.113.8), which divides the world of mortality under the Sun from the world of immortality beyond him; the Sundoor is the "Gateway of Truth" (Īśā Up. 15, etc.), and as such "a forwarding for the wise and a barrier to the foolish" (CU viii.6.5),

An example of this "open sesame" motif (best known in connection with Aladdin's cave) can be cited from southern Africa: "In one of Schultze's [Hottentot] stories the fleeing heroine drops food behind her, delaying the pursuing Lion, who eagerly devours it. When the pursuer endeavours to follow, the rock closes and kills him. The opening and closing rock occurs in various combinations in South African mythology" (from a review of J. Schultze, *Aus Namaland und Kalahari*, Berlin, 1907, in *Journal of American Folklore*, XXXXI, 1908, 252). In such a sequence it it easy to recognize in the heroine, Psyche, and in the pursuer, Death.

To return now to the Cutting Reeds, we can cite an American Indian myth in which, among the series of living obstacles that bar the way of the hero Nayaṇezgani there are not only "Crushing Rocks" which he stays apart, but also "Cutting Reeds," which "tried to catch him, waving and clashing together." We are also told of these Cutting Reeds that "when anyone passed through them, the reeds moved and cut the person into little pieces and ate him" (M. C. Wheelwright, *Navajo Creation Myth*, Santa Fe, 1942, pp. 71, 96). Another reference to the "Slicing Reeds" will be found in the Franciscan Fathers' *Ethnologic Dictionary of the Navaho Language* (St. Michaels, Ariz., 1910), p. 358.

The Cutting Reeds are, of course, only one of the many forms of the Active Door, of which the passage is so dangerous. We shall consider now some of the other forms of the Wunderthor and, to begin with, the Clashing Rocks or Mountains themselves. Different forms of the Door may be associated in one and the same story. In a more elaborate Indian text, parallel to that of the Brāhmaṇa already cited, the "golden blades" are represented by "two sleepless, watchful, razor-edged light-

cf. Matt. 25:1–12, Luke 11:9, John 10:9, etc., and also "*Svayamātṛṇṇā: Janua Coeli,*" nn. 23, 31, 51.

In marriage, the bride is assimilated to Sūryā, the married couple's journey to a *Himmelfahrt* (even the crossing of a "river" is provided for), and their new home (in which they are to "live happily ever afterwards") to the Otherworld of Immortality. An analogy of the doorway to the dangerous Janua Coeli naturally follows, and we find that when it is reached the incantation is employed, "Injure her not, ye god-made pillars, on her way," these pillars being, of course, the jambs of "the door of the divine house" (AV xiv.1.61,63). No doubt it is for the same reason that the bride must not step on the threshold as she enters (*Āpastamba Gṛhya Sūtra* ii.6.9), for, evidently, to do so might release the trap, and therefore the bride must step over the threshold without touching it. There can be no question but that the European custom of carrying the bride across the threshold has an identical significance; the husband plays the part of psychopomp, and it is easy to see why it should be regarded as most unlucky if he stumbles and does not clear the threshold safely.

nings, striking from every side," and it is asked "How did the Vulture [Garuḍa, Eagle, Soma-thief] transgress (*ati piparti*) these Soma wardens, 'Fear' (*bhayā*) and 'No-Fear' (*abhayā*) [= Fear and Hope]?" (*Suparṇā-dhyāya* XXIV.2,3). These names of the Soma wardens, also to be thought of as snakes or dragons, are significant because, as we shall presently come to see more clearly, the two leaves or jambs of the Active Door are not merely affronted by the very nature of a door, but at the same time stand for the "pairs of opposites" or "contraries" of whatever sort, between which the Hero must pass in the Quest of Life, without hope or fear, haste or delay, but rather with an equanimity superior to any alternative. When Alexander sought, he did not find what Khizr found unsought (*Sikandar Nāma* LXIX.75). Taken superficially, "seek, and ye shall find" is a very comfortable doctrine; but it should be understood that whoever has not found has never really sought (cf. *Nafaṭu'l Uns* as cited in Rūmī, *Dīvān*, Nicholson's commentary, p. 329).

In the same context (xxv.5) we find an obstacle described as consisting of "two razor-edged restless mountains." The text is obscure and admittedly in need of emendation,[11] but there is a clearer reference to moving mountains in ŚA IV.13 (= Kauṣ. Up. II.13), the importance of which has been hitherto completely overlooked: here we are told of the Comprehensor of the doctrine that the powers of the soul are an epiphany of Brahma that "verily, even though both mountains, the northern and the southern, were to roll forth against him, seeking to overcome him instantly, indeed, they would not be able to devour him."[12] The immediate reference may be to the Himālayas and Vindhyas, normally separated by the Gangetic Madhya-deśa, but must be indirectly to Sky and Earth, who were originally "one," or "together," and can be reunited. The door of the world of heavenly light is to be found, indeed, "where Sky and Earth embrace" and the "Ends of the Year" are united (JUB 1.5.5,

[11] The text has *parvatāṣṭhirāḥ* which, although it could mean "mountain domes," is implausible. Charpentier's suggestion of *parvataḥ sthirāḥ* ("stable mountains") contradicts the required sense. I have assumed *parvataḥ asthirāḥ* (an equally possible resolution of the crasis), "restless mountains"; the following *subudhnyah* need not imply "firmly grounded," but rather "deeply rooted," which is not inconsistent with motion, as will be obvious if we remember that our "floating islands" are, as it were, lotus leaves or flowers, not detached from their stems, but swinging upon them, as the leaves of doors swing on hinges.

[12] "Devour," √*tṛṇ*, see n. 5, and cf. "All flesh is as *grass*." "No one becomes immortal in the flesh," ŚB x.4.3.9), and whoever reaches the Otherworld and the attainment of all desires does so "going in the spirit" (*ātmany etya*, ŚB 1.8.1.31 and JUB III.33.8), "having shaken off his bodies" (JUB III.30.2–4)—the Platonic *katharsis* (*Phaedo* 67c).

1.35.7–9, IV.15.2–5).[13] The expert, for whom the antitheses are never ab-
solute values but only the logical extremities of a divided form (for ex-
ample, past and present of the eternal now), is not overcome by, but
much rather transits (*ati-piparti, atyeti, διαπορέυεται*) their "north-and-
southness" or, as we should say, "polarity," while the empiricist is crushed
or devoured by the perilous alternatives (to be or not to be, etc.) that he
cannot evade.[14]

[13] On the Doors of the Year, and World's End see further "*Svayamātṛṇṇā*:
Janua Coeli," nn. 3 and 25, and "The Pilgrim's Way," 1937. The "Year" is
Prajāpati, the Imperishable World, and, like a house, is only his "who knows its
doors" (ŚB 1.5.3.2,3, 1.6.1.19) or "ends," Winter and Spring. The end of the Year is
also its beginning, so that the Year is endless or infinite (*ananta*), like a wheel
(AB III.43). "Das grossartige Symbol der Schlange, die sich in den eigenen Schwanz
beisst, stellt den Äeon dar" (A. Jeremias, *Der Antichrist in Geschichte und Gegen-
wart*, Leipzig, 1930, p. 4).

[14] On the one hand, *omne compositum ex contrariis necesse est corrumpi* (*Sum.
Theol.* 1.80.1; cf. *Phaedo* 78c and D II.144), on the other, *rationes contrariorum in
intellectu non sunt contrariae, sed est una scientia contrarium*, and *Impossibile est
ergo quod anima intellectiva sit corruptibilis* (*Sum. Theol.* 1.75.6). That, in fact,
eadem scientia oppositorum (*est*) (*Sum. Theol.* 1.14.8) is remarkably illustrated by
the fact that in the oldest languages we so often meet with words that embody
contrary meanings. On this important subject see Carl Abel, *Über den Gegensinn
der Urworte* (Leipzig, 1884) (also in his *Sprachwissenschaftlichen Abhandlungen*,
Leipzig, 1885; Freud's discussion in *Jahrb. f. Psychoanalytische und Psychopatho-
logische Forschungen*, II, 1910, contributes nothing); R. Gordis, "Effects of Primi-
tive Thought on Language," *American Journal of Semitic Languages and Literature*,
LV (1938), 270 ff.; B. Heimann, "Plurality Polarity, and Unity in Hindu Thought,"
BSOS, IX, 1015–1021, "Deutung und Bedeutung indischer Terminologie," *XIX
Congr. Internaz. d. Orientalisti*, and "The Polarity of the Indefinite," JISOA, V
(1937) 91–94; Chuang-tzu, ch. 2 and *passim*; Coomaraswamy, "The Tantric Doctrine
of Divine Biunity" [in Vol. 2 of this collection—ED.]; M. Fowler, "The Role of Surā
in the Myth of Namuci," JAOS, LXII, 36–40 (esp. n. 18), and "Polarity in the Rig,
veda," *Rev. of Religion*, VII (1943) 115–123. Also, on the ἐναντία generally, Plato,
Theatetus 157B, etc., and Philo, *Heres* 207, 215, etc., as discussed by E. R. Goode-
nough in *Yale Classical Studies*, III (1932), 117–164.

For example, one Egyptian sign stands for "strong-weak," and which is meant
depends on the determinant employed; one Chinese ideogram, "big-small," means
"size," and generally speaking, abstract nouns are combinations of two opposites.
So zero (Skr. *kha*, see Coomaraswamy, "Kha and Other Words Denoting Zero" [in
Vol. 2 of this collection—ED.] is the totality of + and − numerical series and, ac-
cordingly (like God), *et unicum et nihil et plenum*.

That in so many of the oldest languages (with survivals in some modern) the
same roots often embody opposite meanings, only distinguishable by the addition of
determinants, is an indication that the movement of "primitive logic" is not abstrac-
tive (from an existing multiplicity) but deductive (from an axiomatic unity). The
same synthetic bias can be recognized in the old duals (e.g., Mitrāvaruṇau) that
denote, not the mere association of *two* "persons," but the biunity of *one*. Many of
our profoundest religious dogmas (e.g., that of the divine procession *ex principio
vivente conjuncto*) stem from these insights.

527

An unmistakable reference to the Clashing Rocks is to be found in RV VI.49.3, where the "Rocks" are *times*, namely, day and night, described as "clashing together and parting" (*mithasturā vicarantī*); *mithas* (\sqrt{mith}, to unite, alternate, dash together, understand, and also kill, cf. *mithyā*, contrarily, and *mithuna*, pairing) here in combination with *turā* (\sqrt{tur}, to hasten, rush, overpower, injure), corresponding to *tustūrṣamāṇau* (ŚA IV.13 = Kauṣ. Up. II.13), rendered above by "seeking to overcome instantly" in connection with the two "rolling mountains." This is an important case, whether we consider day and night as *times* or as *light and darkness*—Mitrāvaruṇau. Its bearing will be realized if we recall that the Vedic Hero's greatest feat is performed at dawn; Indra has agreed that he will not slay Namuci (Vṛtra and Buddhist Māra) "either by day or by night," and keeps his word to the letter by lifting his head at dawn, thus dividing heaven from earth and making the sun rise (for references see JAOS, XV, 143 ff. and LV, 375)—dividing the light from the darkness, and day from night. It is no wonder, then, that the Mahāvīra's feat is so often described as having been performed "suddenly" and "once for all" (*sakṛt*, etc.), for whatever is done when it is neither day nor night (cf. RV X.129.3) is done *ex tempore, sub specie aeternitatis,* and forever.

Conversely, for those who are already in time and would be liberated, would *s'eternar*, day and night are, as it were, two impassible, revolving Seas or wandering Pillars, and one should not perform the Agnihotra (sacrifice of the burnt offering) either by day or by night but only at dusk (after sunset and before dark), and at dawn (after dark and before sunrise, JB I.5).[15] "Night and day are the sea that carries all away, and the two twilights are its fordable crossings (*agādhe tīrthe*); and as a man

[15] Similarly, in ŚB II.3.9, 1.36; and in the *Avesta* (Albrecht Weber, *Indische Studien*, IX, 1853, ch. 9, 292), where the *daevayaśna* is to be performed after dark and before sunrise. The contrary argument of AB V.29 seems to me illogical. Indra had also agreed not to slay Namuci "with anything moist or anything dry," and does so with "foam." Both formulae recur in TS VI.4.1.5 and 2.4, where the heart of the sacrificial victim is deposited "at the junction (*sandhi*) of wet and dry," and the sacrificial waters, originally liberated when Vṛtra was slain, are to be collected "at the junction (*sandhi*) of shade and shining," viz. of night and day. The first of these actions "atones" or sacrifices ($\sqrt{śam}$) the contraries, the second secures the "color of both" at once; and that is, of course, the "color" of the Otherworld, Brahmaloka or Empyrean in which the darkness and light are not separated, but dwell together in one another (KU III.1 and VI.5, and Jacob Boehme, *Three Principles* XIV.76), and of Dionysius' "Divine Darkness, blinding by excess of light."

would cross over (*atiyāt*) it by its fordable crossings, so he sacrifices [performs the Agnihotra] at twilight.[16] . . . Night and day, again, are the encircling arms of Death; and just as a man about to grasp you with both arms can be escaped (*atimucyeta*) through the opening (*antareṇa*) between them, so he sacrifices at twilight . . . this is the sign (*ketu*) of the Way-of-the-Gods (*devayāna*), which he takes hold of, and safely reaches heaven" (KB 11.9).[17] In the same way for Philo, day and night, light and darkness are archetypal contraries, divided in the beginning "lest they should be always clashing" (μὴ αἰεὶ συμφερόμεναι) by median boundaries (μέσοι ὅροι), dawn and dusk, which are not sensible extents of time but "intelligible forms (ἰδέαι) or types" (*De opificio mundi* 33); and though he does not say so, it is evident that if anyone would return from the chiaroscuro of this world to the "supercelestial" Light of lights he will only be able to do so—if he *is* able—by the way of these "forms" in which the day and night are *not* divided from one another.[18]

Thus the Way "to break out of the universe" (Hermes, *Lib.* XI.2.9; see note 48) into that other order of the Divine Darkness that Dionysius describes as "blinding by excess of light," and where the Darkness and the Light "stand not distant from one another, but together in one another" (Jacob Boehme, *Three Principles*, XIV.78), is the single track and "strait way" that penetrates the cardinal "point" on which the contraries turn; their unity is only to be reached by entering in there where they actually

[16] The parallel to the crossing of the Red Sea, from the Egyptian Darkness of this world to a Promised Land, will be obvious. The Agnihotra performed at twilight is a "Passover" in Philo's sense. By the same token, *brahma-bhūti*, "becoming Brahma," "theosis," is also "Dawn."

[17] The return is obviously to the primordial condition of RV x.129.1-3, where all is One, without distinction of day and night. KB continues, describing night and day as the Dark and the Dappled (*śyāmā-śabarau*, the "Dogs of Yama"): an important datum for the iconography of Cerberus, but one that cannot be further discussed here.

[18] "Of every land, that Dark Land is the best, In which there is a Water, the Giver-of-Life" (*Sikandar Nāma* LXVIII.18). "There shines not sun, nor moon, nor any star. . . . His shining only all this world illuminates" (KU v.15); "There neither sun, nor moon, nor fire give light; those who go there do not come back again; that is My supreme abode" (BG xv.6); "There shine no stars, nor sun is there displayed, there gleams no moon; (and yet) no darkness there is seen" (Ud 9). "When sun and moon have gone home, when fire is doused and speech is hushed, what is this person's light? The Spirit (*ātman*, Self) is his light" (BU iv.3.6, cf. JUB III.1): "And the city had no need of the sun, neither of the moon, to shine in it: for the glory of God did lighten it, and the Lamb is the light thereof" (Rev. 21:23).

coincide. And that is, in the last analysis, not any where or when, but within you: "World's End is not to be found *by walking*, but it is within this very fathom-long body that the pilgrimage must be made" (S 1.62)—

> Our soul is, as it were, the day, and our body the night;
> We, in the middle, are the dawn between our day and night.[19]

H. Rink[20] records from Greenland the myth of the Eskimo hero Giviok, whose way to the Otherworld, in which he finds his dead son living, is confronted by "two clashing icebergs" with only a narrow passage between them, alternately opened and closed. He cannot circumnavigate them because, when he tries to do so, they always keep ahead of him ("for there is no approach by a side path here in the world," MU vi.30!). He therefore speeds between them, and has barely passed when they close together, bruising the stern-point of his kayak. As Professor Cook sees, this is "a mariner's version of the gateway to the Otherworld." In this northern setting, the floating islands are naturally thought of as icebergs.

In a more recent collection of Eskimo folktales,[21] the Clapping Mountains are connected, significantly, with the migrations of birds. "All of the birds who fly south must pass between them. Every little while they clap together, just as you clap your hands, and anyone caught between them is crushed to death." This dangerous passage is an ordeal appointed by the Great Spirit, and "any geese that cannot fly fast will be crushed." Whether or not the narrator "understood his material" we have no means of telling; but it is impossible to doubt that the talking geese originally represented souls, or that among them those who could not fly fast represented ἀτελεῖς.

"Rocks-That-Come-Together" are well known all over America. They are mentioned by the Franciscan Fathers' *Ethnologic Dictionary* as "cliffs which bound together [crushing]"; in Berard Haile, *Origin Legend of the Navaho Enemy Way* (London, 1938), p. 125, as "two rocks that clap together"; and in Wheelwright's *Navajo Creation Myth* as "crushing rocks" between which the Hero must pass. Other examples of the motif are cited from American sources by Paul Ehrenreich;[22] in the South Ameri-

[19] Rūmī, *Dīvān*, cited in Nicholson's "Additional Notes," p. 329.

[20] *Tales and Traditions of the Eskimo* (London, 1875), pp. 157–161.

[21] C. E. Gillum, *Beyond the Clapping Mountains, Eskimo Stories from Alaska* (New York, 1943).

[22] "Die Mythen und Legenden der Südamerikanischen Urvölker und ihrer Beziehungen zu denen Nordamerikas und der alten Welt," *Zeit. f. Ethnologie*, XXXVII (1905), Supplement.
For some other parallels see S. Thompson, "European Tales among the North

can Tupi saga of the *Himmelfahrt* of two brothers, respectively human and divine, the way leads between clashing rocks, by which the mortal is crushed. In one North American version the door of the king of heaven is made of the two halves of the Eagle's beak, or of his daughter's toothed vagina, and with this Ehrenreich compares the Polynesian tale of Maui's brother crushed between the thighs of the Night Goddess. Ehrenreich holds that the "clashing rocks" are heaven and earth, the cleft between them being that at the horizon.[23] Franz Boas[24] cites the North American Indian story of the *Himmelfahrt* of two brothers, who on their way must strike out the wedges from certain cloven tree trunks, by which they will be in danger of being crushed as the sides spring together. T. Waitz records that the Mexican dead "had to pass clashing mountains" (*Anthropologie der Naturvölker*, Leipzig, 1864, IV, 166); and in Codex Vindobonensis (leaf 21) there is a picture of two individuals climbing over a succession of mountains, of which two are cloven and no doubt to be understood as "clapping," which might illustrate this deathway, though W. Lehmann describes it as "the aged pair of deities climbing up mountains"

American Indians," *Colorado College Pub., Language Series*, II (1919), 319–471; A. H. Gayton, "The Orpheus Myth in North America," *Journal of American Folklore*, XLVIII (1935), 263–293; Coomaraswamy, "The Sun-kiss," 1940 (esp. pp. 55–57), and comment by M. Titiev, JAOS, LX (1940), 270. Many or most of these parallels have to do with the metaphysics of light, the progenitive power (see "The Sun-kiss," n. 13, for some of the references). One of the most remarkable is that of the Jicarilla Apache birth rite, "where a cord of unblemished buckskin, called in the rite 'spider's rope,' is stretched from the umbilicus of the child towards the sun" (M. E. Opler, *Myths and Tales of the Jicarilla Apache Indians*, New York, 1938, p. 19). This combines the Indian symbolism of the Sun as a spider (cf. JAOS, LV, 396–398) whose threads are rays (*sūtrātman* doctrine), with the concept of the Sun equated with the vivifying Spirit, at the same time that it corresponds exactly to the Orthodox Christian conception of the Nativity, where (as at Palermo and in many Russian ikons) the Madonna is evidently the Earth Goddess, and a (seventh) ray of light extends directly from the (otherwise six-rayed) Sun to the Bambino.

Independent origins for such complex patterns are almost inconceivable: we are forced to suppose that we are dealing with a mythology of prehistoric and presumably neolithic antiquity. This is a consideration that will present no difficulty to anthropologists such as Father W. Schmidt, Franz Boas, Paul Radin or Josef Strzygowski, who recognize no distinction of mental ability as between "primitive" and modern man—who, if capable at all of such abstract vision, is radically disinclined for it, and certainly does not found his art and literature upon it.

[23] Cf. BU III.3.2 where, at the ends of earth, there is an interspace "as thin as the edge of a razor." This seems to mean at the horizon; but it is normally at the Sun-door that one reaches "World's End" and "breaks out of the universe."

[24] *Indianische Sagen von der Nordwestküste Amerikas* (Berlin, 1905), p. 335.

531

(*"Aus der Mexikanischen Mythologie," Zeit. für Ethn.*, XXXVII, 1905, 858, fig. 7).

The notion itself of "Floating Islands" is typically, although not by any means exclusively, Indian. The "worlds" or states of being are often spoken of as "islands" (*dvīpa*); India, for example, being Jambudvīpa. That Earth, in particular, is such an island, originally submerged, and brought up in the beginning from the depths, is the basis of the adequate symbolism of Earth by a lotus flower or leaf, expanded upon the surface of the cosmic waters in response to the light of and as a reflection of the Sun, "the one lotus of the sky": hence the lotus, or lotus-petal moulding (which becomes in late Greek art the "egg-and-dart") represents the archetypal "support" of existence. By the same token the terrestrial Agni is "lotus-born" (*abja-ja*);[25] and that the manifested gods and the Buddha are represented with lotus pedestals, thrones, or footstools (as in the parallel case of the Egyptian Horus) is as much as to say that their feet are firmly based upon a ground that is really an "island" floating upon and surrounded by an ocean of all the possibilities of manifestation from which the particular compossibles of any given world must have been derived. For all this, moreover, there is a close parallel in the case of Rhodes, the "Island of the Rose"; for, as has often enough been demonstrated, the rose is the precise equivalent in European symbolism of the lotus in Asiatic, and Rhodes, a land that rose from the depths of the sea, is preeminently the Island of the Sun, who made her his wife and begot seven sons upon her (Cook, p. 986). The famous Colossus of Rhodes was of course an image of the Sun, and however late the legend may be that the legs (*jambes!*) of this image straddled the harbor, to form the *jambs* of a mighty door through which every ship must pass on entering or leaving port, the figure is manifestly that of a Sundoor.[26]

[25] In this connection cf. L. von Schroeder, *Arische Religion* (Leipzig, 1923), II, 555–557. Von Schroeder justly assimilates Loki, "Sohn der Laufey, d.h. der 'Laub-insel'" i.e., son of Leaf-island as his Mother, to Agni, the lotus-born, and to Apollo of Delos, an island that, having arisen from the sea, might be compared to the "water-born" (*abja* = lotus). Von Schroeder also compares Loki "Nadelsohn" to Agni *saucīka*, but cannot make out what the "Needle" is; it is, in fact, the Father, viz. the Thunderbolt, *vajra* (κεραυνός), lightning from above, "leaf" (Earth) and "needle" (Axis Mundi) being the lower and upper "fire-sticks" in this generation. For the "needle" as the "tool" with which the Mother Goddess "sews" her work, see RV 11.32.4.

[26] How such a figure could have been imagined can well be realized from Dürer's woodcut of the Angel, whose "face was as the sun and his feet as pillars of fire: And he had in his hand a little book open: and he set his right foot upon the sea,

It is a highly characteristic feature of the "Active Door" that whoever or whatever passes through it must do so with all speed and suddenly, and even so may be docked of its "tail"; which tail may be, in the examples already considered, either the stern-point of a boat, or one of two brothers, or if there is a flock of birds (doves of Zeus or Eskimo geese), then the last of the line; or if the Hero wins through, his pursuer may be caught. Striking examples of these features can be cited in the widely diffused art and folktale motif of the "hare and hounds." We need hardly say that the hare is one of the many creatures ("birds," men, or animals)[27] that play the part of the Hero in the life-quest, or that the dog is one of the many types of the defender of the Tree of Life; whatever details are suited to the symbolism of the robbery of a defended "garden enclosed" or "castle" are to be found among our variants. The *Hasenjagd* has been discussed at length by the great folklorist Karl von Spiess,[28] who cites a riddle, of Greek origin, but also widely diffused in Europe. It runs: "A wooden key, a watery lock; the hare runs through, the dog was caught." One modern answer is: bucket and sea. But the original reference is to the crossing of the Red Sea, Moses being the hare and the Pharaoh the dog. It will be seen immediately that the divided sea is a type of the Active Door (cf. above, on day and night), which in this case closes upon the pursuer. But the hare does not always escape scot-free. Then, in the words of von Spiess, "This is the situation, viz. that the hare has run into another world to fetch something—the Herb of Immortality. Thereupon the guardian dog, pursuing the hare, is hard upon it. But just where both worlds meet, and where the dog's domain ends, it is only able to bite off the hare's tail, so that the hare returns to

and his left foot on the earth" (Rev. 10:1 ff.). This revelation was made to St. John in Patmos, also an island risen from the sea. For a reproduction of Dürer's cut and its later imitations see *Jahrbuch f. Hist. Volkskunde*, II, 153 ff.

[27] For example, the Boar, "thief of the Fair" (*vāma-moṣa*), i.e., of Soma, TS VI.2.4.2. An excellent Rumanian version explains "Why the Stork Has No Tail": the Water of Life and Death can only be reached by passing between two constantly clashing mountains into a valley beyond them; it is fetched by a stork, who on his return barely escapes with the loss of his tail (F. H. Lee, *Folktales of All Nations*, London, 1931, pp. 836–838).

[28] "Die Hasenjagd" in *Jahrb. f. Hist. Volkskunde*, V, VI (1937), 243–267. Cf. L. von Schroeder, *Arische Religion* (Leipzig, 1923), II, 664 ff. The Hare is normally the Hero, but may be the Dragon in disguise (A. H. Wratislaw, *Sixty Folk-Tales Exclusively from Slavonic Sources*, London, 1889, no. 43). See also John Layard, *The Lady of the Hare* (London, 1945), and my review in *Psychiatry*, VIII (1945); and Philostratus, *Vit. Ap.* 3.39.

its own world docked. In this case the dog's jaws are the 'Clapping Rocks.' " In the other and more typical case in which the Hero is a "bird," and the Defender an archer,[29] the "minor penalty" is represented by the loss of a feather or a leaf of the herb, which falls to earth and takes root there, to spring up as a terrestrial tree of life and knowledge; in this case the Hero's wound is in his foot, and his vulnerability in this respect is related to the motif of "Achilles' heel."

Whoever seeks to interpret myths in a purely rationalistic way, and considers the story of the hare by itself, might argue that it represents no more than an aetiological myth of popular origin. But actually, that such myths are transmitted, it may be for thousands of years, by the folk to whom they have been entrusted, is no proof of their popular origin; it is in quite another sense than this that *Vox populi vox Dei.* As von Spiess clearly saw, the hare is not only to be equated with the heroic "bird," but also with the human and knightly heroes of other-world adventures. We have, in fact, introduced the Hare at this point in order to lead up to the remarkable Celtic forms of the motif of the Active Door, in which the Hero escapes from its closing jaws almost literally by the skin of his teeth. In a typical form, the story occurs in Chrétien's *Iwain* (vv. 907–969).[30] Iwain is riding in pursuit of the Defender of the Fountain Perilous, whom he has already wounded, and reaches the gateway of his palace, which was very high and wide, "yet it had such a narrow entrance-way that two men or two horses could scarcely enter abreast without interference or great difficulty; for it was constructed just like a trap which is set for the rat on mischief bent, and which has a blade above ready to fall and strike and catch, and which is suddenly released whenever anything, however gently, comes in contact with the spring. In like fashion, beneath the gate there were two springs connected with a portcullis up above, edged with iron and very

[29] For a part of this material, which I propose to discuss more fully elsewhere in a paper on "The Early Iconography of Sagittarius-Kṛṣānu" [the paper exists as an unpublished fragment—ED.], see Karl von Spiess, "Der Schuss nach dem Vogel" in *Jahrb. f. Hist. Volkskunde,* V, VI (1937), 204–235.

[30] W. W. Comfort, tr., *Chrestien de Troyes* (London, 1913), p. 192. Cf. G. L. Kittredge, *Gawain and the Green Knight* (Cambridge, Mass., 1916), p. 244, and A.C.L. Brown, *Iwain* (Boston, 1903), p. 80.

The Russian hero Ivan is, doubtless, Gawain-Iwain; at any rate, a Prince Ivan brings back two flasks of the Water of Life from where it is kept between two high mountains that cleave together except for a few minutes of each day, and as he returns, they close upon him and crush his steed's hind legs (W. R. Ralston, *Russian Folk-tales,* New York, 1873, p. 235 ff.). Cf. Wratislaw, *Sixty Folk-Tales,* pp. 280, 283.

sharp. . . . Precisely in the middle the passage lay as narrow as if it were a beaten (single) track. Straight through it exactly the (wounded) knight rushed on, with my lord Iwain madly following him apace, and so close to him that he held him by the saddle-bow behind. It was well for him that he was stretched forward, for had it not been for this piece of luck he would have been cut quite through; for his horse stepped upon the wooden spring which kept the portcullis in place. Like a hellish devil the gate dropped down, catching the saddle and the horse's haunches, which it cut off clean. But, thank God, my lord Iwain was only slightly touched when it grazed his back so closely that it cut both his spurs off even with his heels."[31]

Another variant occurs in *La Mule sans frein*;[32] here Gawain has crossed the Perilous Bridge of Dread (by which the Active Door is always approached) and reaches the castle from which he is to recover the stolen bridle; the castle is always revolving, like a mill-wheel or top, and the gate must be entered as it comes round; he succeeds, but the side of the moving gate cuts off a part of the mule's tail. In any case, as A.C.L. Brown justly remarks, "a revolving barrier, or an active door of some kind, was a widespread motive of Celtic Otherworld story . . . before the time of Chrétien." So, too, for Kittredge, "these traits are not the personal property of Chrétien."[33]

The Sky is, of course, the "revolving barrier" (cf. Philo, *De confusione linguarum* 100, and *De opificio mundi* 37), and the Sun the "active door." It should be superfluous to emphasize that the traditional symbols are never the inventions of the particular author in whom we happen to find them: "the myth is not my own, I had it from my mother." Euripides, in these words, shows that he knew better than such naïve scholars as Sir J. G. Frazer and A. A. Macdonell, of whom the former saw in the theme of the Clashing Rocks "a mere creation of the storyteller's fancy" and the latter in the related and almost equally widely distributed motif of the Fallen Feather "probably a mere embellishment added by the

[31] Motif of Achilles' heel. Cf. AB iii.27, where the Soma guardian, Kṛśānu (Sagittarius), cuts off a claw from Gāyatrī's foot.

[32] See Brown, *Iwain*, pp. 80, 81, with other "variants of what may be called the active door type": and "The Knight of the Lion," PMLA, XX (1905), 673–706. Incidentally, we consider that "Symplegades" (= Skr. *mithasturā*) is the best "catch-word" for our motif, because the contraries involved are not always "rocks," or even always the leaves of a door in the most literal and restricted sense of the word.

[33] G. L. Kittredge, *Gawain and the Green Knight*, pp. 244, 245. On the Bridge, HJAS, VIII (1944), 196 ff.

individual poet"! Our scholars, who think of myths as having been invented by "literary men," overlook that the traditional motifs and traditional themes are inseparably connected. The traditional raconteur's figures, which he has not invented but has received and faithfully transmits, are never figures of speech, but always figures of thought; and one cannot ask which came first, the symbol or its significance, the myth or its ritual enactment. Nor can anything be called a *science* of folklore, but only a collection of data, that considers only the formulae and not their doctrine, "que s'asconde sotto il velame dei strani versi." The materials collected even in the present short article should suffice to convince the reader that, as the late Sir Arthur Evans once wrote, "The coincidences of tradition are beyond the scope of accident."

"The whirling castle," as Kittredge says, "belongs to the same general category as perpetually slamming doors and clashing cliffs [symplegades]. . . . The turning castle has also its significance with respect to the Other World." This Otherworld is at once a Paradise and the World of the Dead,[34] and in post-Christian folklore to be identified with Fairyland; it may be located overseas to the West, or Underwave, or in the Sky, but is always in various ways protected from all but the destined Hero who achieves the Quest. It is the Indian "Farther Shore" and Brahmaloka, and we are especially reminded of the latter by the fact that it is so often called the "land of no return" or "val sans retour." This Otherworld can be regarded either as itself a revolving castle or city, or as a castle provided with a perpetually closing or revolving door. A notable example of the turning castle can be cited in the *Fled Bricrend*,[35] where it belongs to Cu Roi (to be equated with Manannan mac Lir and the Indian Varuṇa) and revolves as fast as a millstone, while that its gateway is really the Sundoor is clearly indicated by the fact that the entrance "was never to be found after sunset." The protection of the Otherworld

[34] "Or Zeus or Hades, by whichever name thou wouldst be called" (Euripides, Nauck, fr. 912); Plato, *Laws* 727D, "Hades . . . realm of the Gods yonder"; cf. *Phaedo* 68AB, "Hades," where and where only is pure wisdom to be found. The distinction of heaven from hell is not of places but in those who enter; the Fire, as Jacob Boehme is fond of saying, is one and the same Fire, but of Love to those who are lovers, and of Wrath to those who hate. So in the Celtic mythology, Joyous Garde and Dolorous Garde are one as places, differing only according to our point of view. This is important for the iconography of the "Door."

[35] Ed. G. Henderson, Irish Texts Soc. (London, 1899), II, 103, §80; cf. Loomis, *Celtic Myth and Arthurian Romance*, p. 365; Brown, *Iwain*, pp. 51–55; Kittredge, *Gawain and the Green Knight*, pp. 244–245.

and its treasures may consist in whole or part of a rampart of fire;[36] and whether it be the Empyrean or, more rarely, the Terrestrial Paradise, the Door itself has terrible defenders, of types including Scorpion-men, sleepless and baleful Serpents or Dragons, Centaurs (notably "Sagittarius"), Gandharvas, Cherubim (Gen. 3:24, etc.) and in many cases armed Automata. We shall discuss these elsewhere in a longer article to be devoted to the "Early Iconography of Sagittarius."[37]

Here we are primarily concerned with the Active Door itself and its significance. We shall conclude with a brief reference to the type of the Active Door that is described as a Wheel. A western example can be cited in *Wigalois*:[38] here, in pursuit of the magician Rōaz—"a parallel figure to Curoi" (Brown, *Iwain*, p. 81)—Wigalois reaches a castle with a marble gate, in front of which there turned a wheel "set with sharp swords and clubs." The *Mahābhārata* (Pūna ed., I, ch. 29) describes what is assuredly the same Wheel much more fully: "There before the Soma, Garuḍa beheld a razor-edged Wheel (*cakra*) of steel, covered with sharp blades, and continually revolving, as terribly bright as the sun, an engine (*yantra*) of unspeakably dreadful aspect, fitly devised by the gods for the cutting to pieces of Soma-thieves; the Skyfarer (*khe-cara*),[39] seeing an opening therein, hovered, and making a cast of his body suddenly (*kṣaṇena*)[40] darted through between the spokes . . . flew off with the

[36] *Imran Maeile Dúin*, §32; William Larminie, West Irish tale of "Morraha" in *West Irish Folk-Tales and Romances* (London, 1893); *Mahābhārata* (Pūna ed.) I.29; *Suparṇādhyāya*, xxvi.5; Dante, *Purgatorio*.

[37] [Cf. n. 29—ED.]

[38] Ed. Pfeiffer, Leipzig, 1847; see Brown, *Iwain*, p. 80.

[39] *Khe-cara* here, however, with special reference to the penetration of the *kha* (= *ākāśa*, αἰθήρ, *claritas, quinta essentia*) of the Sundoor ("like the hole in the chariot wheel," *yathā ratha-cakrasya kham*, BU v.10, cf. JUB 1.3.6 and RV viii.91.7), an aperture that as Void or Space-absolute is to be equated with Brahma (CU iii.12.7, iv.10.4, BU v.1 and see above, n. 14); and is "within you" (MU vii.11). "Diese Ringschiebe als Bild des Himmels mit der Sonne war das höchste göttliche Symbol der Urreligion—auch der chinesischen" (R. Schlosser, "Der Ursprung des chinesischen Käsch," *Artibus Asiae*, V, 1935, 165): "I saw Eternity the other night, Like a great *Ring* of pure and endless light. . . . Some . . . soar'd up into the *Ring*" (Vaughan).

[40] The "moment" (*kṣana*) of transition here corresponds to the "single moment of full awakening" (*eka-kṣana-abhisambodha*) which in Prajñāpāramitā (Mahāyāna Buddhist) doctrine is the last step of the Via Affirmativa (*śaikṣa mārga*) and is an awakening to "Nonduality" (*advaya*), i.e., from the illusion of Duality, followed immediately by the attainment of Buddhahood (see E. Obermiller, "The Doctrine of Prajñāpāramitā," *Acta Orientalia*, XI, 1932, 63, 71, 81). Cf. Acts 2:2 (the "sound" of the Holy Ghost signifies suddenness). All spiritual operations are necessarily

Water of Life" (*amṛta*, Soma). So, too, in the *Suparṇādhyāya* (xxv.3, 4), there is a mind-made Wheel of Indra's, ever revolving faster than the winking of an eye, which Garuḍa, the Soma-thief, with his "more than speed," passes (no doubt, through) and leaves behind him. To this very Wheel there is an illuminating reference in the much later *Kathā Sarit Sāgara* (Bk. vi, ch. 29; in C. H. Tawney's version, KSS I, 257–259). Here Somaprabhā is a daughter of the Asura Maya, the well-known titan, "artificer of the gods" (to be identified with Tvaṣṭṛ, described in RV x.53.9 as *māyā*[41] *vet*, Sāyaṇa *devaśilpi*—and in the last analysis with Thaumas, father of Iris [Hesiod *Theogony* 265, cf. Plato, *Theatetus* 155D],

"sudden," because whatever is eternal is also immediate; "the now that stands still is said to make eternity" (*Sum. Theol.* 1.10.2). So mythical events are eternal (*nitya*), "once for all" (*sakṛt*), "today" (*sadya*) or "now" (*nu*) (RV, *passim*); and this "once for all" is what is really meant by the "long ago" and "once upon a time" of our fairy tales. In any case, the passage of an interval that is "not a sensible extent of time" must be "instantaneous" by hypothesis.

[41] Māyā (√*mā*, measure, fashion, make), the "Art" or "Power" of creation and transformation, is an essentially *divine* property and can be rendered by "Magic" only in Jacob Boehme's sense (*Sex puncta mystica*, v.1, see Coomaraswamy, *Hinduism and Buddhism*, 1943, n. 257). In connection with the Titan Maya, Māyā must be identified with his wife Lilāvatī, who can be called "Illusion" only in the literal and etymological sense of the word, as being the "means" of the divine Lilā, and the "Wisdom" who finds out the knowledge of "witty inventions" and belonged to the Lord "in the beginning of his way, before his works of old" (Prov. 8:12 ff.).

The creation is always conceived in these terms, viz. as *māyā-maya*, a "product of art"; this Vedantic *māyā-vāda* doctrine must not be understood to mean that the world is a "delusion," but that it is a *phenomenal* world and as such a theophany and epiphany by which we are deluded if we are concerned with nothing but the wonders themselves, and do not ask "Of what?" all these things are a phenomenon.

When Indra himself is the Soma-thief and Grail-winner, it is by overcoming the "devices" (*māyāḥ*) of the Titans that he makes the Soma "his alone" (RV vii.98.5): and wielding this "power" himself, "he casts appearances upon his own lifethread" (*māyā kṛṇvānas pari tanvam svām*, RV iii.53.8). It is by his Art (*māyayā*) that the Lord, *questi nei cor mortali è permotore*, moves all these elemental beings "that are mounted on their engines" (*yantrārūḍhāni*); at the same time the Operator himself is concealed by the Art in which he is "wrapt up" (*sam-āvṛtta*), and that is very "hard to penetrate" (*dur-atyaya*), but which those who reach him are said to "cross over" (BG xviii.61, vii.14.25). It is in this way precisely that Rājyadhara in KSS vii.9 populates his "city"; this man and this world being the stages on which the archetypal Thaumaturgus and Playwright exhibits himself. There can be no greater mistake than to suppose that such stories as those of KSS were composed only to amuse; it is a form of the pathetic fallacy that likewise explains the forms of primitive and popular art as products only of a "decorative" instinct. On *māyā*, cf. JAOS, LXVI (1946), 152, n. 28.

and with such *black*smiths[42] as Daedalus, Hephaistos, Vulcan, Wayland, and Regin). Somaprabhā ("Soma-Radiance") assumes a human form and entertains her mortal friend Kalingasenā with a variety of Automata, described as "self-empowered wooden puppets" (*kāṣṭha-mayīḥ sva-māyā-yantra-put-rikāḥ*).[43] There she explains to Kalingasenā's father as fol-

[42] In connection with "smiths," compare the ballad of the "Two Magicians" (Child, no. 44), "then she became a duck, and he became a drake," etc., with BU 1.4.4, "she became a mare, and he became a stallion," etc.—a good illustration of the fact that "la mémoire collective conserve quelquefois . . . des symboles archaïques d'essence purement métaphysique . . . surtout les symboles qui se rapportent à des 'théories,' même si ces théories ne sont plus comprises" (Mircea Éliade, in *Zalmoxis*, II, 1939, p. 78). The "catchwords" of folklore are, in fact, the signs and symbols of the Philosophia Perennis.

[43] For Automata in analogous western literature see n. 45, and M. B. Ogle, "The Perilous Bridge and Human Automata" in *Modern Language Notes*, XXV (1920), 129–136. N. M. Penzer, in discussing Automata (*The Ocean of Story* [KSS], III, 1925, 56–59 and IX, 1928, p. 149) rather misses their "point" and so fails to make them move; that is, he considers them only from standpoint of the historian of literature and makes no attempt at exegesis. Even here we can only deal with the theme very briefly. Not only is the world itself an "engine" devised by the Great Engineer (from whom, as St. Augustine says, all human *ingenium* derives), but all its inhabitants are in the same way wooden (hylic) engines driven by his power (cf. MU II.6)—"wooden," because the "material" of which the world is made is a "wood" (*dāru, vana* = ὕλη); and for the same reason the Artist "through whom all things were made" is inevitably a "carpenter" (*takṣa*, τέκτων, ἁρμοστής).

From this point of view, the myth of the City of Wooden Automata in the KSS VII.9 can be understood if we compare its wordings with those of MU II.6, where Prajāpati (the biunity of the Sacerdotium and Regnum, represented in KSS by the carpenter brothers Prāṇadhara and Rājyadhara) beholds his conceptions (*prajāḥ*), as it were, as stones or stocks until he enters into them, and from within their heart, by means of his rays-or-reins (*raśmayaḥ* = ἀκτῖνες, Hermes *Lib.* x.22, cf. xvi.7) operates and governs them, as the potter or charioteer drives his wheel or vehicle—*questi nei cor mortali è permotore, Paradiso* 1.116. Rājyadhara's city is assuredly the same as that of the *Tripurārahasya* (Hemacuḍa section, v.119–124) where the Prime Mover "though single, multiplies himself, manifests as the city and the citizens, and pervades them all, protects and holds them. Without him, they would all be scattered and lost like pearls without the string of the necklace [cf. BG VII.7]. . . . If that city decays, he collects the inmates together, leads them to another, and remains their master" (as in BU IV.4.3–4). Alike for the Vedic tradition and Plato, Man is the "City of God" (*brahmapura*), and there can be no doubt that it is to this city that the myth of KSS really points.

Śaṅkarācārya often explains the Aupaniṣada formulations of the "thread spirit" (*sūtrātman*) doctrine, to which the "string of the necklace" refers, by the metaphor of the "wooden puppet" (*dāru-putrikā*, in comment on BU III.4.1 and 7.1), as in KSS. It is in the same way that for Plato (*Laws* 644–645, 803–804) God is the Puppeteer and men his toys ("and as regards the best in us, that is what we really are"), and that for Philo (*De opificio mundi* 117) we are puppets of which the

lows: "O king, these cunning engines, etc. (*māyā-yantrādi*), in their endless variety, are works of art (*śilpāni*) that were made by my father of old. And even as this great engine (*yantra*), the world, is in essence a product of the five elements, so are these engines. Hear about them, one by one: that one of them in which Earth is the basis is that which closes doors and the like, and even Indra could not open what it has closed; the forms that are produced from the Water device seem to be alive; the engine that is wrought of Fire gives forth flames; the Air engine performs such acts as coming and going; the engine of which Ether is the constitution utters language distinctly.[44] All these I got from my father. But the Wheel-engine (*cakra-yantram*) that guards the Water of Life (*amṛtasya yat rakṣakam*), that he only, and no one else, understands." Here it is highly significant that the magician, master of the Active Door, is also a maker of Automata, and further, that he is not originally a god, but a titan. The Automata in this context are significant because, as remarked by J. Douglas Bruce,[45] the European "mediaeval automata . . . are created for some special function, usually to guard an entrance." In the *Perlesvaus*, for example, Gawain comes to a turning castle, the door of which is guarded by two men "made by art and necromancy," while in the prose Lancelot the gate of the Dolorous Garde is defended by copper figures of armed knights.

The sun-bright Wheel that guards the suprasolar Otherworld is, naturally, the Wheel of the Sun himself which Indra tears away from the Great Fiend when either he, or the Falcon for him, robs the Scorcher of "all life's support" (RV IV.28.2, etc.).[46] It is also, in other words, the

strings are moved by the immanent Duke (ἡγεμονικός, *netṛ*). This operation of his toys on the world stage is precisely what is called God's "Game" or "Sport" (*līlā*), and it is by no means accidentally that KSS describes the working of his puppets as Rājyadhara's "royal game" (*rajño-līlāy-itam*);

> Dies Alles ist ein Spiel, das ihr der Gottheit macht;
> Sie hat die Kreatur um ihretwillen erdacht
> (Angelus Silesius, *Cherubinische Wandersmann* II.198).

For further references see Coomaraswamy, "*Līlā*," and "Play and Seriousness" [in Vol. 2 of this selection—ED.].

[44] The natural connection; cf. JUB 1.23.1, "the Voice speaks from the Ether" (*ākāśāt*); so also Mbh III.156.13, "an incorporeal Voice from the Ether" (*ākāśāt*). Cf. JUB 1.28.3–4; Acts 2:3–4.

[45] "Human Automata in Classical Tradition and Mediaeval Romance," *Modern Philology*, X (1913), 524 ff.

[46] See also RV IV.30.4, IV.31.4, V.29.10, VI.20.5, 6, VII.98.10. In IV.28.2, *ni khidat* (Sāyaṇa, *āchinnat*) corresponds to *ācicheda . . . ākhidat* in ŚB III.6.2.10, 12, *sam ākhet* in *Suparṇādhyāya* XXIV.3 (see Charpentier, *Die Suparṇasaga*, p. 261) and *sam akhādat* in JB 1.220 and ŚB (see JAOS, XVIII, 28).

sparkling sun-hued Brahma Wheel of Fire (*alāta-cakram*) of MU vi.24;
and the guarded Sundoor of JUB 1.3.5 and 6, where the "opening in the
sky" is covered all over (concealed) by rays (the spokes of the "Wheel"),
and it is only by his Truth that the Comprehensor "is enabled to pass
through the midst of the Sun" and is thus "altogether freed," attaining
that Immortality, or Water of Life that rises in the Land of Darkness
"beyond the Sun." Hence also the invocation, "Disperse thy rays and
gather in thy radiance, that he-whose-norm-is-truth may see thy fairest
form" (Īśā Up. 15,16, etc.); "disperse" because these rays are the multi-
tude of his powers (*prāṇāḥ*) by which all things are quickened and
moved, and collectively the actuality or truth (*satyam*) by which the
"truth of the truth" (*satyasya satyam*) is concealed (*satyena channam*)
(BU 1.6.3, ii.1.20, with JUB as above), just as also for Philo (*De opificio
mundi* 71) and Dionysius the uncreated is hidden "by the piercing splen-
dor and rushing torrent of the rays."[47] The Sundoor itself, thus hidden
by the dazzling rays that illumine and enliven every living being, in
whom they operate as the "powers of the soul," is precisely the "point"
at the center of the fiery Wheel, at which they intersect; and since, in
the most general case, the Sun is "seven-rayed,"[48] and is situated in the

[47] JUB 1.3.5, *ādityaṃ samayā'timucyate . . . tad raśmibhis saṃchannam*, "through
the midst of the Sun, concealed by rays," corresponds exactly to Plato, *Phaedrus* 247B,
ἄκραν ὑπὸ τὴν ὑπουράνιον ἀψῖδα . . . ἀθάνατοι . . . ἔξω πορευθεῖσαι ἔστησαν, and
Philo, *De opificio mundi* 71, πρὸς τὴν ἄκραν ἀψῖδα . . . σκοτοδινιᾶν; BU v.15, *rūpam
kalyānatamam tat et paśyāmi*, to Plato's τὸ ἀληθείας ἰδεῖν πεδίον (*Phaedrus* 248B)
and Philo's ἐπ' αὐτὸν ἰέναι δοκεῖ τὸν μέγαν βασιλέα (*De opificio mundi* 71). The
reader is urged to collate these passages.
[48] For the "seven-rayed" Sun see Coomaraswamy, "The Symbolism of the Dome"
[in this Vol.—ED.], and JUB 1.28–29. Cf. n. 22. This pattern, again, is one of almost
worldwide distribution; it is represented, for example, in the "seven gifts of the
Spirit" and by the "seven eyes" of the Lamb, and those of Cuchullain. Note that the
"seventh and best ray," passing through the center of the Sunwheel to "break out
of the dimensioned universe, intersecting everything" (πάντα δὲ διατεμοῦσα . . .
διαρρήξασθαι . . . ἐκτὸς τοῦ κόσμου, Hermes, *Lib.* xi.2.9) and so "bursting through
the Sundoor," as MU vi.30 expresses it ("for there is no approach by a side path"),
bisects the three pairs of contrary spatial diameters; coinciding, also, throughout
its extent to the Axis Mundi, vertical of the σταυρός, and Vedic *skambha*, it "divides
all things of the right hand from those of the left." This "seventh ray" is, then,
precisely the principle that is represented by Philo's (probably Pythagorean) "Sever-
ing Word" (λόγος τομεύς, *Heres, passim*); and, accordingly, by "the central and
seventh light" of the seven-branched golden Candlestick, which "divides and sepa-
rates the threes," and corresponds to the Sun attended by the other six planets
(*Heres* 215 ff.).
It follows naturally from these lucid formulations that the point at which the
severing Axis intersects whatever plane of reference will be the "Sundoor" of the
realm next below it, and so on through the ascending hierarchy of the worlds until

middle, whence the six directions of the cosmic cross (*trivṛd vajra*) extend, so that the universe is "filled" with light, it will be seen that the way in by what is called the "seventh and best ray," viz. that which passes through the solar disk and so out of the dimensioned universe, leads as before in the case of the Clapping Rocks between contrary pairs, in this case east and west, north and south, zenith and nadir. The Way is always a "Middle Way," or as Boethius expresses it, "Truth is a mean between contrary heresies" (*Contra Evtychen* VII).

It remains only to consider the full doctrinal significance of the Symplegades. What the formula states literally is that whoever would transfer from this to the Otherworld, or return, must do so through the undimensioned and timeless "interval" that divides related but contrary forces, between which, if one is to pass at all, it must be "instantly." The passage is, of course, that which is also called the "strait gate" and the "needle's eye." What are these contraries, of which the operation is "automatic"? We have already seen that the antitheses may be of fear and hope, or north and south or night and day. These are but particular cases of the polarity that necessarily characterizes any "conditioned" world. A "world" without pairs of opposites—good and evil, pleasure and pain, love and hate, near and far, thick and thin, male and female, positive and negative, "all these pairs" (*sarvāṇi dvandvāni*, Kauṣ. Up. 1.4, cf. Philo, *Heres* 132, 207-214)—would be an "unconditioned" world, a world without accidents, change or becoming, logically inconceivable and of which experience would be impossible.

It is, then, precisely from these "pairs" that liberation must be won,

we reach the ἄκραν ἀψῖδα τῶν νοητῶν and capstone of the cosmic roof, which is the "*harmony* of the whole edifice" (ἁρμονία παντὶ τῷ οἰκοδομήματι, Pausanias IX.38.3, cf. διὰ τῆς ἁρμονίας, Hermes, *Lib.* I.14, 25), "like a great *Ring*" (Vaughan) or Flower (Pāli *kaṇṇikā*), through which the Way leads on to the "Plain of Truth," of which there can be no true report in terms of human speech (*Phaedrus* 247c, Kena Up. 1.2-8, etc.). In other words, the Severing Logos is at once the narrow path that must be followed by every Hero, the Door that he must find, and the logical Truth and Highest Spirit of Reason that he must overcome if he would enter into the eternal life of the land "East of the Sun and West of the Moon." This is also the "Logos of God," the trenchant Word that like a two-edged sword "sunders" soul from Spirit (Heb. 4:12); "sunders," because whoever enters must have left himself (Achilles' heel, all that was vulnerable in him) behind him; our sensitive soul being the "mortal brother" and the "tail" or "appendage" of which the Master Surgeon's knife—Islamic *Dhū'l-fiqār*—relieves us, if we are prepared to submit to his operation.

from their conflict that we must escape, if we are to be freed from our mortality and to be as and when we will: if, in other words, we are to reach the Farther Shore and Otherworld, "where every where and every when are focused," "for it is not in space, nor hath it poles" (*Paradiso* XXIX.22 and XXII.67). Here, under the Sun, we are "overcome by the pairs" (MU III.1): here, "every being in the emanated world moves deluded by the mirage of the contrary pairs, of which the origin is in our liking and disliking . . . but to those who are freed from this delusion of the pairs (*dvandva-moha-nirmuktāḥ*) . . . freed from the pairs that are implied by the expression 'weal and woe' (*dvandvair vimuktāḥ sukha-duḥkha-saṃjñaiḥ*), these reach the place of invariability" (*padam avyayam*, BG VII.27.28 and XV.5), i.e., the place of their coming together or coincidence (*samayá*), through their midst or in between (*samáya*) them.

It is then deeply significant that in the Greenland saga, the Hero, on his way to the Otherworld in which he finds his "dead" son "living," cannot circumvent the paired bergs (which are the "lions in his path"), for they "always get ahead of him" however far he goes to either side. It is inevitably so, because the contraries are of indefinite extension, and even if we could suppose an equally indefinite journey to the point at which "extremes meet,"[49] this would be still a meeting place of both extremes, and there would be no way through to a beyond or a within except at their meeting point: a cardinal "point" that has no fixed position, since the distinction of the correlated members of any pair of contrary qualities (e.g., long and short) is only to be found where we actually make it; and without extent, seeing that it is one and the same "limit" that simultaneously unites and divides the contraries of which it is no part—"strait is the gate, and narrow is the way, which leadeth unto life, and few there be that find it" (Matt. 7:14). It is for the same reasons that the passage must be made so "suddenly": it is from the world of time (i.e., past and future) to an eternal Now; and between these two worlds, temporal and timeless, there can be no possible contact but in the "moment without duration" that for us divides the past from the future, but for the Immortals includes all times.

The "moment" has come at last to understand the poignant words of Nicholas of Cusa in the *De visione Dei* (ch. IX, fin.): "The wall of

[49] "That eternal Point where all our lines begin and end" (Jan van Ruysbroeck, *The Seven Cloisters*, ch. 19); Dante's *punto a cui tutti li tempi son presenti, Paradiso* 17.17; Meister Eckhart's *daz punt des zirkels* (Pfeiffer ed., p. 503).

the Paradise in which Thou, Lord, dwellest, is built of contradictories, nor is there any way to enter but for one who has overcome the highest Spirit of Reason who guards its gate," and to recall the promise, "To him that overcometh will I give to eat of the Tree of Life, which is in the midst of the Paradise of God" (Rev. 2:7).[50] In this doctrine and assurance are reaffirmed what has always been the dogmatic significance of the Symplegades and of the Hero's Quest: "I am the Door" and "No man cometh to the Father but by Me."

[50] "It is not for you to know the times and the seasons, which the Father hath put in his own power" (Acts 1:7). . . . "Je persiste donc à penser que l'Apocalypse n'a pour but de nous renseigner sur 'le déroulement évolutif' de l'Eglise et sur 'les étapes successives' de ce déroulement, mais de nous faire saisir par la foi la contemporaneité du Jugement de Dieu aux événements de l'histoire, la présence de l'éternité au sein du temps historique, jusqu'à la résorption de celui-ci dans celle-là" (J. Huby, "Autour de l'Apocalypse," *Dieu Vivant* V, 1946, 128, 129).

General Index

made, 29; the "life" of a work of art
formerly a deliberate animation, 177;
the manifestation of an informing
energy, 105; Māyā, the "art" or "pow-
er" of creation, 538; a means of ex-
istence, 92; a means of reintegration,
92; the mechanical arts, 16n; mediae-
val, 43–70, 189–232, 257; modern,
28–29, 37n, 43, 48, 54, 70, 104, 107–
108, 114, 126–27, 256, 279, 296, 333,
341–43, 427n; in monumental art,
what affects us is the power of a
numinous *presence*, 202n; a name of
the Spirit, 32; neolithic, 175; no dis-
tinction between art and contempla-
tion, 165; no good use without art,
38; no room for private truths in art,
50; the norm of workmanship, 225;
normal view of, 257; not a gift but a
knowledge, 49; not a kind of feeling,
13; not a mere matter of aesthetic
surfaces, 124; not in any special sense
an aesthetic experience, 318; the once
indivisible connection of religion with
art, 104; Oriental art concerned with
the nature of Nature, 112; our arts
that are not arts, 96; painting, com-
ponents of, according to Indian aes-
thetic, 244n; pathos in, 184; Persian,
260–66; the practice of art is a voca-
tion, 95; prehistoric, 53; primitive, 22,
53–54, 235, 241–42, 253, 256, 280,
286–307, 317, 339, 431, 439–40, 481;
principial, 299; the principle of manu-
facture, 62n; reduction of art to
theology, 168; representative, 52n,
86–87, 90, 97–98, 102, 112, 114–15,
158, 161, 184, 209n, 260–66, 296,
309 ff.; ritual arts the most "artistic,"
34; Romanesque, 226, 317, 488; royal,
307; sacerdotal, 4, 307; sacred and
profane, 28; Sarmatian, 299; the shock
of conviction that only an intellectual
art can deliver, 184; a significant and
liberating art, 40; the signs constitut-
ing the language of a significant art
are injunctive and speculative, 319;
a skill appropriate to every operation,
94; a skill exercised for the sake of
the angels, 79; the spectator's effort

is art in him, 69n; statement informed
by ideal beauty, 104; the study of art
has begun to be a bore, 342; the task
of art, 36n, 231; theology and art
in principle the same, 196n; tradi-
tional, 48, 50, 53, 58, 66, 70, 126–27,
289, 432;

it is not the *aim*, but rather the
method of traditional art, to please,
66; traditional art distinguished
from academic, 165; traditional art
is an applied art, 178; traditional
art an incarnation of ideas rather
than idealization of facts, 435; the
object is merely a point of depar-
ture, 154;

transmitted knowledge of ultimately
superhuman origin, 423; the true
philosophy of art always and every-
where the same, 36; Vedic mantra
as the exemplum of all art, 8on; we
cannot give the name of "art" to
anything irrational, 13n, 185n; we
desire art but not the things that make
for art, 259; we have come to think
of art solely in terms of upholstery,
343; we have the art that we deserve,
259; a yoga, 91n

art, work of, 71–73, 75–76, 78–79; as
a means of reintegration, 145; abstract,
88; can be called beautiful only by
ellipsis, 74n; the chart of a Way, 308;
conceived in accordance with law,
82; experience in the presence of a
work of art, 183 ff.; idiosyncrasy in
works of art, 201n; an intelligible
construction, 73n; is always occasional,
194; is a reminder, 241, 278n; the last
end of the work of art is the same as
its beginning, 138; the natural model,
86; nourishes the spectator by its
meaning, 85–86; an occasion of ecstasy,
106; ought to be an epiphany of
things unseen, 315; pertains to our
"life" when it has been *understood*,
217n; polar balance of physical and
metaphysical, 248, 297, 304–306, 317;
the real presence of the theme, 279;
regarded as a food, 72; a "station"
where the shock of awe should be

Index of Greek Terms

ἄγριος (pagan), 40
ἀέναος (ever-flowing), 405, 406
ἀθάνατοι (deathless ones), 541n
αἴθω (to kindle), 157n
αἰνίγματι (in riddles), 34n
αἰνιττόμενοι (showing darkly), 172n
αἴσθησις (sense perception), 13n, 21, 61, 182, 232, 367n
αἰσθητικός (tangible), 268, 285n
αἰσθητόν (the sensibly perceptible), 13n; (aesthetic surface), 277
αἰσθητός (sensible), 159n
αἰσχρός (ugly), 221
ἀλήθεια (truth), 21, 236, 541n
ἄλογος (irrational), 13n, 17, 230
ἁμαρτία (error), 24n
ἀναλογία (analogy), 22n, 278; (proportion), 324
ἄναψις (kindling), 172n
ἀνελεύθερα (unbecoming free men), 30
ἄνεμοι (breaths), 408n
ἀπάθεια (impassibility), 19n
ἀπεργασία (operation), 25n
ἁπλότης (simplicity), 20
ἁρμοστής (carpenter), 539n
ἄτακτος (disordered), 37n
ἀτελεῖς (unaccomplished), 530
ἄτεχνος (artless), 16
ἄτομος νῦν (the Now-without-duration), 406
αὐτὸ τὸ ἴσον (adequacy), 22n, 278, 324
αὐδὴν (voice), 32
ἀφομοιόω (to liken), 284n
ἀχειροποίητοι (not made by hands), 163
ἁψίδα (vault), 541n

βαναυσικοί (base mechanics), 132n
βασιλέα (king), 541n
βούλησις (intention), 25, 26, 267

γέγονεν (what is born), 151n
γίγνομαι (to become), 33
γλώσσῃ (voice), 184n
γόνιμον (productive), 305n

δαιμόνιον (divine), 501

δαίμων (Genius), 32
δηλόω (to make manifest), 285n
δημιουργία (creation), 16; (practice), 33
δημιουργός (demiurge), 16
διαπορεύεται (transits), 527
διατεμοῦσα (intersecting), 541n
διοπετεῖς (fallen from the sky), 435
δύναμις (power), 17n, 24, 33, 236, 408n

ἔγγονον (descendant), 151n
εἶδος (form), 285n
εἴδωλον (image), 22n, 282
εἰκών (likeness), 159n, 161n, 282, 284n
ἔκφρων (out of one's wits), 33n
ἐμπνέω (to breath into), 32
ἔνδεια (need), 25
ἐνδεικτικόν (indicative), 157
ἐνέπνευσε, ἐνέπνευσαν, see ἐμπνέω
ἔνθεος (God-indwelt), 16, 32, 33, 284n
ἔννοια (intuition), 25n
ἐνοικῶν (in-dwelling), 407
ἔντεχνος (in possession of one's art), 16
ἐντύνω (to equip), 249
ἐξηγέομαι (to interpret), 22, 133n
ἐξομοιῶσαι (to assimilate), 35
ἐξορθόω (correct), 30, 35
ἐπίσες (neutral), 209n
ἐπιστήμη (knowledge), 368n
ἐποικίζων (entering into), 408n
ἔργον (deed), 14n, 151n
ἑρμηνῆς (exponents), 34
ἐρωτικά (lore of love), 191
εὐφροσύνη (delight), 231

ἡγεμονικός (Duke), 540n
ἡδονή (pleasure), 13n, 17, 18, 223, 230, 367n
ἦθος (character), 21

θεός (god), 25n, 33, 159n
θεωρία (contemplative act), 25n
θορυβοῦνται (are shaken), 185
θύρα (door), 465

ἰδέα (form), 21, 24, 132n, 236, 285n, 529
ἰδιωτικός (private), 231, 279

Index of Sanskrit and
Pāli Terms

NOTE: This index, compiled by Kenneth J. Storey in consultation with Roger Lipsey, is arranged according to the Devanagari alphabet. Translations are those of Coomaraswamy when these are given in the text, and standard modern translations elsewhere. In the case of Sanskrit and Pāli cognates, the Sanskrit form appears first and the Pāli second.

Library of Congress Cataloging in Publication Data

Coomaraswamy, Ananda Kentish, 1877–1947.
 Coomaraswamy.

 (Bollingen series; 89)
 Includes index.
 CONTENTS: v. 1. Selected papers, traditional art,
and symbolism.—v. 2. Selected papers, metaphysics.—
v. 3. His life and work.
 1. Art—Addresses, essays, lectures. I. Lipsey,
Roger, 1942- II. Series.
 N7445.2.C68 1977 700′.8 76–41158
 ISBN 0–691–09885–9 (v. 1)